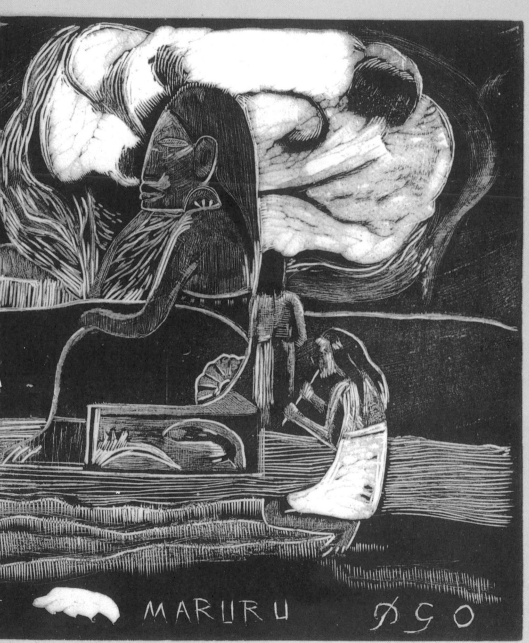

MARURU

By the same author:
*The Love of Many Things:*
 *A Life of Vincent Van Gogh*

# PAUL GAUGUIN

*A Complete Life*

◆

David Sweetman

*A John Curtis Book*
Hodder & Stoughton

British Library Cataloguing in Publication Data

Sweetman, David
Paul Gauguin
I. Title
759.4

ISBN 0 340 55222 0

Designed by Tim Higgins

Photoset in Linotron Janson text and Galliard by
Rowland Phototypesetting Ltd, Bury St Edmunds, Suffolk

Printed and bound in Great Britain by
Mackays of Chatham plc, Chatham, Kent

Hodder and Stoughton
A division of Hodder Headline PLC
338 Euston Road
London NW1 3BH

*For my mother*
ELIZABETH SWEETMAN
*with love*

# Contents

# Part One

◆

# WHERE DO WE COME FROM?

# 1

◆

# *The Awakening of Evil*

Fifty-four, on the remote island of Hivaoa, and by his own account still suffering from a failed attempt to poison himself, Paul Gauguin had only a few months left to live as he struggled to write his memoirs. These disjointed thoughts were the means by which he hoped to persuade the world of his version of an adventurous life, mixed up with his theories on art and literature, his opinions on politics and religion and, above all, sex.

> At night my wife seeks my caresses. She knows I am afraid of her and she abuses my fear. Both of us, wild creatures ourselves, lead a life full of fear and bravado, joy and grief, strength and weakness. At night, by the light of the oil-lamps, half suffocated by the animal stenches, we watch the stupid, cowardly crowd, ever hungry for death and carnage, curious at the shameful spectacle of chains and slavery, of the whip and the prod, never satiated of the howls of the creatures that endure them.

Gauguin was living in what he called 'The House of Pleasure', though by then the fourteen-year-old 'wife' he was writing about had already left him. She was pregnant and refused to return after the birth of their daughter, unwilling to share the bed of a man suppurating with syphilitic sores and given to bouts of dementia.

Vaeoho was the third of his child-brides, his innocent, simple Eves in the unspoiled Eden of his erotic imaginings. He boasted about them in *Avant et après* (*Before and After*), the book that was eventually made out of his last notes, and painted them as dream figures, the inhabitants of the Pacific paradise he had invented, a dream which has seduced countless admirers since his death in 1903. Much of the world-wide veneration for his art has been based on the public's belief that it offers a vision, sensual yet pure and untainted by the foulness of Western industrialized society and its corrupted ways. Within a few years of his death, Paul Gauguin, the renegade, syphilitic paedophile had been transformed into the artist-hero, the happily married Parisian stockbroker who sacrificed

everything in his search for the primitive life on an unspoiled tropical island, a mythic figure who devoted himself to immortalizing an innocent native dreamworld.

This is all the more astonishing when one considers just a few of the points where reality veers away from the legend. Far from being a conventional bourgeois Frenchman, Gauguin was raised by his widowed, half-Spanish mother who had been abused by her father and frequently ignored by her own extraordinary mother Flora Tristan, the early Socialist and one of France's first Feminists. Perhaps this may explain Gauguin's ambiguous feelings towards strong women, feelings of attraction and repulsion that he never finally resolved. It may also explain why so much of *Avant et après* is obsessed with sex.

After years at sea, about which his memoirs reveal little save for his whoring and fighting, Gauguin married a large Danish Viking whom even the staid French dictionary of national biography describes as masculine in appearance, and who in later life took to wearing increasingly mannish clothing. At the same time Gauguin's love for their infant daughter Aline touched on the dangerously erotic, feelings which finally found expression on Tahiti with its tropical Lolitas, especially in the painting, *Manao tupapau*, which shows a young girl – thirteen and his wife, according to Gauguin – lying face down on his bed, her pert buttocks offered to the lascivious gaze of artist and spectator, her eyes wide with fear. Small wonder that feminist critics today have seized on that prurient image as proof that Gauguin was no more than a sexual tourist, the prophet whose art called into being a dream of golden sand, blue skies, waving palms beneath which there is an abundance of cheap-and-easy sex for wealthy white males with a yen for exotic holidays.

Of course, much of the responsibility for this can be laid at Gauguin's own door, at the way he peppered his writings with sexual braggadocio to an extent which obscures or distorts his other concerns. To confront both the myth he helped create and the criticism that has reached a new intensity today, one needs to examine his life and his thinking in considerable detail, carefully picking a way through the boasting and the half-truths which the artist himself scattered in the path of those who would try to understand his work.

The sheer range of his life is daunting – from South America to the Polar Wastes, from Paris to the South Seas – which is probably the underlying reason why so many biographers have found it easier to limit the tale to more manageable proportions – France to Tahiti, Sex to Art. It is this narrowing of focus which similarly affects many attempts to analyze his thinking, for just as his life spanned the planet, so his art was conceived at a time of momentous political and social upheaval on a global scale. Gauguin lived through the late nineteenth century when

an economically triumphant Europe spread outwards conquering and colonizing other races and cultures. Yet he was both a calculating Frenchman and a child of the tropics, a one-time seaman turned financial speculator, a political revolutionary and a visionary artist. Because of this he felt himself uniquely placed to confront the maelstrom of change which was transforming and destroying even the smallest and remotest islands in the furthest ocean. Beneath the enchanting surface of his art is the painful modernity of that struggle, his agonizing over Western culture, everywhere triumphant yet everywhere destructive, his rage at the impossibility of reconciling material advance with traditional spirituality. He saw this as the presence of death at the moment of love and believed he could re-create such things in his art because he was, in his own eyes, half-civilized, half-savage. This is the real message of *Avant et après*, his 'Idle Tales of a Naughty Boy' as the sub-title so coyly and so misleadingly puts it. He even opens this last attempt at autobiography with the challenging statement: 'This is not a book', as if to warn the reader that he or she is embarking on something other than a dry assemblage of facts and dates. What follows is certainly rich in poetic licence as Gauguin assiduously re-creates himself in the light he finds most favourable, veering away at key points in his narrative, as if he has something to hide. But the truth is always there, lurking in what his first critic, Albert Aurier, called 'the fantastic shadows in the forest of enigma,' a phrase equally applicable to Gauguin's life as to his art.

To penetrate these shadows the reader must accept that the one thing about which Gauguin was fastidiously honest is his frequent claim that he wasn't. You have been warned, he seems to say, yet having planted the seed of doubt he then goes on wilfully to tell the truth, certain that no one will now believe him.

'I am,' he wrote, 'a savage from Peru. If I tell you that on my mother's side, I descend from a Borgia of Aragon, Viceroy of Peru, you will say it is not true and that I am giving myself airs.'

This is typical Gauguin, first boasting then subtly hinting that it is all a joke. Small wonder few have taken such claims seriously – yet, fantastic as it may seem, this is one of the rare occasions when Paul Gauguin *was* telling the truth and was, in his own devious way, giving us a key to the locked secrets of his life. To make sense of this, and to understand his work, one must make the same journey he made, beginning, where else but at the beginning. . . .

# 2

◆

# A Savage from Peru

High in the mountainous desert of the western Andes, the city of Arequipa is little changed from the languid years of the late eighteenth century, when it was a quiet provincial outpost in the colonial Viceroyalty of the River Plate, a vast territory which included present-day Peru and Bolivia, Spanish for two centuries. Today, in the shabby little room which serves as Arequipa's civic archive, there is a fading daguerreotype of a surprisingly fresh-faced man, in a wing collar with loose black bow. Along the bottom of the picture runs the stirring caption:

*Field Marshal*
*Pio Tristán Moscoso*
*Governor of Arequipa (1814–1817)*
*Last Viceroy of Peru, proclaimed in Cuzco (1824)*
*Prefect and General Commander of Arequipa. President of Southern Peru*
*during the Confederation. Born in Arequipa (1773), died in Lima (1860) –*
*Donated by the successors of Snr. Juan Vidaurrazage.*

The dust that has settled on the frame, and indeed on everything in the shaded room, is mute testimony to the scarcity of visitors in this remote place. In any case, that bland face, behind its dimmed glass, reveals little to the rare passer-by who chances upon it. If Don Pio de Tristán y Moscoso – Field Marshal and Viceroy – is remembered at all outside his home town, it is as the great-uncle of Paul Gauguin the artist, and even then he merits little more than a passing phrase in the usual biographies of his illustrious great-nephew.

Don Pio was already old, very old, when he first encountered the future painter, but that is the measure of his importance in Gauguin's life, for old as he was, he provided a link with an era already long gone when the boy was born. Don Pio himself came into the world sixteen years before the French Revolution changed everything, at a time when men wore knee-breeches and carried swords and could still expect to take part in hand-to-hand combat. By the time he died, his image had

been immortalized by a camera and the railway revolution was under way. Born under a colonial monarchy, he ended his life in a rapidly evolving republic, and all these momentous events found an echo in his own story, for Don Pio de Tristán y Moscoso was no mere spectator to the events of his time – in many ways he helped shape them.

The essential element in any attempt to understand Don Pio is to remember that he was a man who had lost his faith – not in God, *He* was unquestioned; Pio Tristán had lost his faith in Spain. He had been brought up to believe in it. As an unseen deity in heaven ruled the earth through the Church, so the faraway monarch in Madrid ruled over his American empire and Don Pio's father, a former soldier and by then the judge of Arequipa, most beautiful city in Peru, was in a sense his priest. The Tristán y Moscosos knew their worth; they were, so they claimed, descendants of the Borgias of Aragon, a branch of whose family had given the Church its most notorious pope. In fact, this was true, though it is unlikely that Don Pio realized the full extent of his family tree, which would only be uncovered long after his death when one of his brother's descendants patiently traced their antecedents back to the seventh century, when they were minor noblemen in the Western Kingdom of the Franks, spreading through the Bourbon kings of France and the Spanish kings of Castile and Leon. The Castilian branch of the family came to prominence when Alonso Borgia set off for Rome to make his fortune, ending up as Pope Calixtus III while his sister's son Rodrigo became Pope Alexander VI, most infamous of Renaissance tyrants, father of a brood that is still synonymous with treachery and depravity. It was the descendants of Alexander's first son Juan who provided the link with the present, when a daughter married into the Moscosos, a family of soldiers and adventurers, and it was a son of this alliance, Pablo de Moscoso, who left for the Americas with the conquistadors and established the family in Peru. Lest they become too divorced from their homeland, the family continued to marry with newly arrived Spanish grandees and it was Don Pio's mother, Mercedes de Moscoso, who linked them to the minor aristocratic Tristáns when she married a Spanish major-general serving in the Viceroyalty, Joseph Joachim de Tristán.

This was the extraordinary ancestry of the painter Paul Gauguin, and by the standards of Peru, and especially of Arequipa, the Tristán de Moscosos were certainly grand, able to claim affinity with Cesare Borgia, to whom Machiavelli dedicated *The Prince*, and to his sister Lucrezia, the legendary seducer and poisoner. Of course by Don Pio's day the family had been in Spanish America for five generations and much had happened to dilute their nobility, but if anyone had been foolish enough to suggest to Don Pio's face that his short stature and perpetually

youthful look were due to a hint of Indian blood in his ancestry, such a man would surely have died. He may not have been tall but Don Pio was physically fearless and very dangerous.

To be born into the wealthy landed colonial gentry was indeed heaven. Sugar plantations and a refinery on the coast worked by African slaves brought the money which allowed a settled pleasing existence. Yet despite these advantages, neither Pio nor his elder brother Mariano was content with his lot. When Mariano left for military training in Madrid, Pio asked that he try and arrange for him to get a modern education – quite unobtainable in Peru at a time when the Church attempted to impose a rigid censorship on all academic subjects. The young Don Pio wished to become a scientist and that meant going to France. To achieve this he trained as a military cadet and was sent to Spain where Mariano now had a post at court. With his brother's help Pio began his scientific education across the border in France. It was 1788, he was fifteen, but a year later it was all over, revolution had engulfed France, schools were closed and refugees from the Terror were streaming across the Pyrenees into Spain.

Pio joined the Wallon Guard and fought against the revolutionary army near Roussillon, acquitting himself well. Mariano was less committed to Spain, having fallen in love with a young French exile, Anne-Pierre Thérèse Laisnay. When France under Napoleon as First Consul seemed to offer the liberties promised by the Revolution without its horrors, Don Mariano abandoned his career and in 1802 moved with Thérèse to Paris. A year later she gave birth to a daughter, Flora.

Pio, meanwhile, had returned to South America, and using his family connections, he obtained a post as assistant to the viceroy of Buenos Aires. The brothers were never to see each other again and such news as filtered through from Paris to South America hardly helped maintain cordial relations between them. While Pio struggled to get by on a colonial salary it was evident that all the money the family business could produce was being used to maintain Mariano and his wife in some style. Visitors brought back stories of a large mansion in Vaugirard, then on the outskirts of Paris, though near enough to the fashionable Luxembourg Gardens. A second child, a son, had been born and the family's position was reputedly far beyond someone of Don Mariano's means. Worse, Pio's brother was known to entertain Simón Bolívar, one of several revolutionary leaders, advocating independence for the Spanish colonies in South America, and as such, prime enemies of the viceregal authorities.

It was probably the need to sort out the family finances which led Don Pio to return to Arequipa. In 1808 he became mayor of the city just as things began to fall apart. In that same year Napoleon, now

emperor of the French, forced his ally King Ferdinand VII of Spain to abdicate in favour of Napoleon's brother, Joseph Bonaparte. In Spain a popular uprising led to the setting up of a Junta of Regency in Cadiz which called on the Spanish colonies in America to join the struggle, only to find that many of the *mestizo* or mixed-race élites preferred to seize their chance for independence. Peru was not amongst them – the ruling caste in the capital, Lima, the 'City of the Kings', thought of themselves as pure Spaniards and in any case had too much to lose from the break-up of the viceroyalty. Don Pio shared these loyalist sentiments and determined to fight with those opposed to independence. With civil war on a continental scale to contend with, it is likely that the embattled Don Pio was unaware that his elder brother had died suddenly the previous June of what was believed to be apoplexy. Indeed, there was little chance now to think of anything but survival. One of Don Pio's cousins, General Manuel de Goyeneche, assumed command of the royalist forces in Peru and Don Pio joined him in 1809 but the subsequent campaign was a succession of disasters. In 1812, acting without orders, Don Pio advanced from Potosí with 3000 troops, intending to penetrate Buenos Aires itself, only to have the utter misfortune to find himself confronted with General Belgrano, Argentina's national hero and a military commander of genius who, with a mere 800 soldiers and a handful of irregulars, twice defeated the royalist forces and took the forty-year-old Don Pio prisoner.

An old-style gentleman, Belgrano magnanimously agreed to release his captives 'upon their agreeing, with the usual solemnities, not to bear arms against the republic' – an oath which Don Pio broke as soon as he was free and could join up with General Pezuela who succeeded in fighting off Belgrano for a time. What gave Don Pio renewed hope was the continuing resistance of Lower Peru, roughly modern Peru, and when he assumed command of his native Arequipa he was to have twelve years of relative calm as the struggle for independence washed back and forth across the viceroyalty, each side cheated of final victory by betrayals within its own ranks. It was not until 1824 when Simón Bolívar assumed command of the revolutionary forces in Peru, that a defeat for the Viceroy General La Serna looked likely. Realizing the gravity of the crisis, Don Pio left his stronghold and marched his troops across country to Ayacucho for the final confrontation.

Don Pio was appointed field marshal but the battle quickly became a rout. La Serna was captured and three days later Lima surrendered. Only a handful of loyalist generals managed to flee the battlefield, among them Don Pio who was elected their leader, and thus became the last viceroy of Peru – in a sense, the last Spanish ruler of the Americas. 'If I tell you,' Paul Gauguin would write, 'that on my mother's side, I

descend from a Borgia of Aragon, Viceroy of Peru, you will say it is not true and that I am giving myself airs.' But true it was.

Don Pio, however, was well aware that he was viceroy in name only, though this hardly bothered him any longer – he had undergone a radical change of heart. He had lost his faith. Spain was the God that had failed and from then on all the energy and effort he had put into serving the distant Spanish crown could at last be redirected towards his personal advancement. Hence his irritation at the unpredictable arrival of letters from a woman in France who claimed to be the rightful widow of his deceased brother – she had even taken to calling herself Thérèse Tristan and it was all too clear that what she wanted was money. Because she and Mariano had not had a civil wedding there was considerable confusion over the property in Vaugirard. At first Thérèse and the two children had moved into a smaller house on the estate but a year later, when Spanish property in France was sequestered following protests in Madrid against Napoleonic rule, Mariano's 'widow' lost everything. Now she was a pauper living in the village of L'Isle-Adam, her infant son had died and she was struggling to survive with the daughter she called Flora Tristan. It was obvious from the tone of her letters that the poor woman was demented and utterly convinced that there was a fortune in Peru which was rightfully hers. Don Pio ignored them and never wrote back.

In any case he had more pressing things to think about. He had decided to change sides – without, of course, letting his remaining supporters know. His ambition was dizzying – from Spain's last viceroy he was now determined to become nothing less than president of the new republic – and swallowing any last vestiges of honour, Don Pio surrendered Arequipa to Colonel Otero, leader of the republican force and was rewarded with the governorship of the safely remote city of Cuzco, the former Inca capital, high in the Andes and several weeks' arduous travel from the coast. At forty-two, after a long exhausting war, Don Pio was no doubt glad of the chance to gather his strength, for if the quarrelsome *caudillos*, manoeuvring for power in Lima, thought they had buried Don Pio they were mistaken. He governed Cuzco for six years, long enough to carry out a number of public works which helped raise support in the National Assembly which would elect a new president in 1829. It was to be the bitterest disappointment of his life. Neither side, new-republican nor old-monarchist, trusted him, though in the end he lost by a mere five votes, which can only have made defeat harder to bear.

Nevertheless, he was now firmly established in the politics of the new nation and was compensated with the Prefecture of his home town Arequipa. When he returned to the family home, after so many years away, his aged mother announced that the time had come to divide the family wealth between her surviving descendants and it was while the

first tentative moves were being made that a letter arrived which threw
Don Pio into agonies of indecision. This time it was not from Thérèse
but from the daughter who called herself Flora Tristan and was clearly
not the ranting of a bitter woman but a coolly reasoned presentation of
her legal right, as the daughter of his brother, to have a share of his
wealth. To someone as devious as Don Pio it could only mean that,
fantastic as it might seem, this Flora person had heard about his mother's
decision and was determined to have a part in any settlement. This time
he replied.

## The Peregrinations of a Pariah

Had he known something of the reality of his niece's situation Don Pio
would almost certainly not have bothered. For all the formal-sounding
claims in Flora Tristan's letter most of her belief in her rights to an
inheritance had been fuelled by her mother's fantasies. As they had sunk
deeper into pauperdom, Thérèse had taken refuge in a mythology of
her own devising – the Tristáns, she told her little daughter, were
descended from Montezuma – the difference between Aztec and Inca
being lost on her. And somehow, at one and the same time, Don
Mariano's family were pure Iberian aristocrats. When Flora was six and
they moved to the hovel in Paris, Thérèse had barely noticed the squalor,
the cold, the dirt, living in a dreamworld, awaiting the letter from Peru
which would transform their lives. But as she grew up, the daughter was
imbued with a deep anger and a longing for better things which she
believed had been denied her by her family, those noble Peruvians – for
she accepted the essential truth of her mother's stories. Mindful of her
paternal family's ancient and aristocratic origins, she imagined some
great destiny for herself, though the little education her mother had
been able to get her made that seem very remote. All Flora learned to
do was paint a little, and at seventeen, desperate for money, she was put
to work handcolouring engravings at the nearby workshop of André
Chazal. Although this was a new business venture, the Chazals were a
long-established family of engravers – André's mother practised as did
his elder brother Antoine, though the latter had artistic pretensions and
hoped to become a painter. A set of flower prints published in 1818
under the title *Flore Pittoresque, ou Recueil de Fleurs et de Fruits. Peints
d'Après Nature. Dédié aux Dames*, reveals a rather fussy style with over-
elaborately arranged bouquets of ill-assorted flowers springing from
classical vases resting on plinths decorated with bas-relief putti. Antoine
was no purist and even with a loose arrangement of fruits he could not
resist adding several fluttering butterflies. Such illustrations are now
considered so eccentric that they are occasionally reproduced as post-

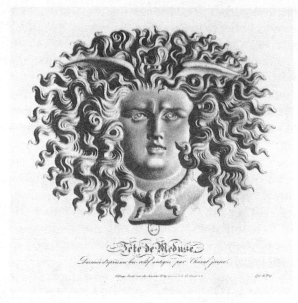

*Head of Medusa* by André Chazal.

cards and posters, so it is not surprising to learn that Antoine's floral
studies – 'Dedicated to Ladies', as the cover puts it – should have been
reprinted in 1953, making them the only works by one of Gauguin's
artistic forerunners to be available in our own time. Equally intriguing
is the possibility that some of the surviving copies of the original edition
of *Flore Pittoresque* may have been coloured by Flora Tristan.

André Chazal's artistic inheritance has proved less fortunate than that
of his brother, despite the fact that his was an infinitely superior talent.
One of his few surviving engravings, a *Head of Medusa* in the Bibliothèque
Nationale de France, shows an exceptional ability to reproduce light and
depth in a linear medium, though such pieces were not his real trade –
much of the Chazals' business was commonplace printing, mundane if
lucrative. Chazal was clearly a good match for someone in Flora's position
and despite objections from his family, she and André were married on 3
February 1821. She was frail and demure – her portraits show a sweet
pretty woman with the wide eyes of her father and rather girlish ringlets
that would always make her look younger than her age. She had, however,
deluded herself into thinking that this was to be her great passion, and the
relationship was doomed from the outset. That she behaved badly cannot
be doubted – when she realized that he was only an ordinary printer her
interest waned. They had two children but she left them in the care of her
unstable mother. When André began to protest she became even more

quarrelsome. He neglected his business, getting into debt. She was furious and discovered a belief in the rights of women to own their own property and thus to have an independent life.

In 1825, pregnant again, she left him. Their daughter, whom she named Aline, was born that October, though by that time the father had no idea where mother and child might be. The marriage had lasted a mere four years. Flora was now twenty-two and spent the next five years in a fruitless search for her great passion, while paying scant attention to her infant children. She worked as a shop-assistant for a time and even got a job as a governess in England, but nothing satisfied her. She was intelligent but untrained, she had unformed ambitions but no idea where to direct her undoubted energies. That is until 1829 when, on a visit to Paris, she met a ship's captain – another potentially great romance which failed to materialize – who had recently returned from Peru and who told her of the importance of her family in Arequipa, reawakening the dreams her mother had instilled in her of the great wealth which was hers by right. Thus inspired she wrote to her uncle Don Pio expressing a desire to re-establish contact with her estranged family and boldly enquiring after Don Mariano's inheritance.

Her uncle's response was a long letter from Arequipa dated 6 October 1830.

> Mademoiselle and my estimable niece,
>     I have received with as much surprise as pleasure your dear letter of 2nd June last. The death of your father was officially reported to me by the Spanish Government, but on account of hostilities breaking out between France and Spain I received no further news of you, and following this the civil war in South America has so fully occupied all my attentions that I have not been able to devote time to anything else.

Don Pio went on to claim that he had tried to track her down but had failed, that none of her mother's letters had ever reached him and that while he was not prepared to accept that her mother was legally his brother's wife he could accept Flora as Mariano's natural daughter and would send her an interim payment of 2,500 French francs, via his business agent in Bordeaux, though he cautiously enclosed some documents to prove that nothing remained of her father's money which he had been administering.

A permanent allowance never materialized and the interim payment lasted little more than two years. When it was almost spent Flora took action. Leaving her daughter Aline in a boarding school in Angoulême, she set sail for Peru on 7 April 1833, the day of her thirtieth birthday.

In the days before the Panama Canal she had embarked on one of the longest and most difficult sea voyages possible – almost half-way round

the planet from Europe to Peru, a journey of 133 days. She was sea-sick on every single one of them. But it was an adventure that was to make her famous and which would ultimately set a course for her grandson, by re-establishing her family's roots in Latin America and bringing into their lives the man who would dominate the early childhood of Paul Gauguin.

She had chosen one of the lesser moments in her uncle's highly charged existence. When his term of office as prefect of Arequipa had ended he had discovered that without the trappings of power his old enemies, those who had still not forgiven his betrayal, were apt to be troublesome. He had found it prudent to retire to Chile until memories were blunted, and had only just returned to Arequipa to take up his business interests when the disagreeable news of his niece's impending arrival reached him. Even as the mule train brought her the arduous hundred miles overland from the Bay of Islay to Arequipa, he was already travelling in the opposite direction, to Camaná on the coast where he had his sugar refinery and where he planned to brood about how best to handle this troublesome interloper.

He brooded for three months, much to his niece's chagrin. She settled into the shady Spanish house, duly noting its sombre Ferdinand and Isabella style, and got to know her relations while learning all she could of the various political intrigues currently preoccupying the country. When Don Pio eventually returned their impressions of each other were initially favourable. 'I love her as if she were my own daughter,' he wrote to his agent in Bordeaux. While she, in typical fashion, was more preoccupied with his looks, noting in her journal how agreeably surprised she was by a man who, although turned sixty and a mere five feet tall, with skin turned sallow by the sun, still had: 'features delicate and regular, his eyes blue and sparkling with wit.' None of which precluded her from noting in her journal that avarice was responsible for his cruellest actions. It was this side of his character which was revealed to her when she asked for her share of Don Mariano's inheritance, only to be bluntly rebuffed on the grounds of the irregularity of her mother's status. She was furious, and though Don Pio eventually agreed to a modest increase in her allowance, this was conditional upon her returning to France. They were at odds from then on.

Accepting that she had failed to move her uncle, Flora eventually left for Lima where she was able to capture the follies of a society entirely devoted to pleasure yet built on wealth derived from the miseries of slavery. Her journal of the fifteen months she spent away from France is both a record of her personal odyssey as a woman coming to self-awareness and maturity and the first blasts on the trumpet of social reform which would thenceforth be the main preoccupation of her life.

As she said of the woman she had been at the outset of her voyage: 'In 1833 I was still very narrow-minded. . . . I did not see that all men are brothers and that the whole world is their home.'

She left Peru in July 1834 and the publication two years later of *The Peregrinations of a Pariah* brought her fame and recognition as a leading socialist thinker. The following autumn she began to attend the Thursday meetings of feminists organized by the *Gazette des Femmes* but this new independence and her recent success were suddenly disrupted by the now demented behaviour of André Chazal who had traced their daughter Aline's whereabouts and succeeded in abducting her. The poor child was ten years old, her father was mad, unhinged by his wife's extraordinary behaviour and the collapse of his business. Pursued by his creditors he was a near-tramp, living in filthy lodgings, obsessed with his wrongs. When Flora's lawyers alerted the police there was a violent scene as the young girl was taken from her father. Once more, Chazal managed to kidnap her and tried to keep her prisoner in his attic in Montmartre. She escaped and was placed in a boarding school. This time he succeeded in getting a court ruling in his favour and she was handed back to him, struggling and screaming violently. She was only twelve and was now trapped in the squalid attic with her brother Ernest and her crazed father. It was winter, Chazal had no money and they were slowly starving and freezing to death. One night, shivering with cold, Aline asked if she could get into bed with her father and Ernest in an attempt to keep warm. She had no sooner slipped into sleep than she was awakened by the appalled realization that her father was touching her. She managed to prevent the ultimate tragedy but he had gone far enough for her to realize what he had been trying to do.

The next day Chazal was unwell and Aline managed to get outside and somehow sent a note to her mother. Flora hastily despatched a friend who found the girl wandering about in the street, distraught and almost unrecognizable. Collecting her pitiful belongings he hurried her back to her mother who had Chazal arrested and imprisoned only to find how heavily weighted in favour of men the law could be in such cases. Unable to sustain a charge of attempted incest, Flora was stunned when the courts released her husband, though at least she was able to keep Aline with her for the moment.

Chazal, however, was too mad to give up the struggle for revenge. He now bought a pistol and hung around the Rue du Bac where Flora was lodging. In the afternoon of 10 September 1838, as she was returning home, he stepped out of the shadows and shot her in the chest. She nearly died but at the later trial looked wan and ethereally innocent, whereas Chazal seemed like a mad animal. This time he was sentenced to twenty years' hard labour.

Despite this high drama, Flora had, in the years since her return to France, been trying to find ways to give practical expression to the radical political views which had been aroused by her experiences in Peru and it is here that her activities again prefigure those of her grandson Paul. Flora was to involve herself in both political and economic research but also in what would today be called 'alternative studies'. On the political front, she hoped to find an economic theory that would act as a basis for her largely instinctive socialism and for a time she attended one or two of the meetings organized by Prosper Enfantin who did much to spread the ideas of the Count de Saint-Simon. In reality, Saint-Simonism meant different things to different people and where Flora found support for her left-wing views she was sharing the room with others who looked on the count's ideas as underpinning their own hopes for a new surge in capitalist enterprise. Perhaps what Flora really liked was the fact that Enfantin had transformed Saint-Simonism into a new religion, with a female deity at its core, for alongside the serious political studies went a parallel interest in mysticism. Flora had formed one of her more bizarre friendships with a defrocked priest who still called himself the Abbé Alphonse-Louis Constant and who was to become a leading advocate of esotericism in France, blending mysticism with notions of intellectual and political freedom. When Flora knew him, he was only at the outset of his search, mixing with a group that worshipped the god Mapah. Small wonder that Paul Gauguin would eventually describe his grandmother as: 'A blue stocking, a socialist and an anarchist, she was credited with having founded together with Père Enfantin the trade union movement and a certain religion, the religion of Mapa of which he was the God Pa and she was Goddess Ma. I cannot disentangle fact from fable and I give you all this for what it is worth.'

But despite her strange friends and her 'passionate' nature, Flora Tristan was no longer the idle dreamer that she had once thought herself to be. In 1843 she published *The Workers' Union*, a call to arms in which she appealed to the downtrodden slaves of the industrial revolution to rise up and save themselves by forming trade unions which would use their pitifully small subscriptions to found schools and clinics and improve working conditions. Not content with writing about it, Flora set off on a gruelling tour of the industrial towns of France, haranguing vast public gatherings, harried by police and *agents provocateurs*, urging her weary, sad-eyed listeners to join the union.

In the end, her work for the *Union Ouvrière* was too much for a woman already weakened by an attempted murder. She was driving herself too hard. Her one indulgence in this period of dedication was the great romantic passion which had been denied her in her youth – a lasting love affair with the painter Jules Laure, a pupil of Ingres, who painted

a portrait of her which she adored and who was the one faithful friend of her final years. In 1844, after weeks of public meetings, with much police harassment and exhausting travel, Flora contracted typhoid fever. She tried to struggle on but died in Bordeaux on 14 November. Her last, and most famous book, *The Emancipation of Women*, was published the following year. In France she was dubbed 'The Workers' Saint', though her gentle ideas on human progress were soon swept aside by Karl Marx who absorbed many of her ideas into the Communist Manifesto of 1848, while carefully leaving out any of her sense of balance, her desire to see both oppressor and oppressed move towards her ideal society. Time has proved inconstant to her memory – twice she has been rediscovered, first by the French suffragettes, who revived her ideas on women's rights, and most recently by modern French feminists who rightly view her as one of their earliest forerunners. But too often, in her periods of obscurity, she has been written off simply as 'Gauguin's grandmother', the unkindest cut of all.

## Don Pio Reborn

For a short time after Flora Tristan's departure from Peru in 1834, her uncle continued to pay her the tiny allowance he had agreed, probably worried lest she come back to confront him. As the 1830s progressed, he decided it was time to revive his grand plan. At sixty-five he had not given up his dream of taking over the entire country, though he was realist enough to accept that he would not now achieve this in person. But there were other ways for a patient man, and in 1835, the year after Flora Tristan returned to France, he arranged the marriage of his daughter Victoria to a rising young soldier with political ambitions, José Rufino Echenique, who had been born in Puno on 16 November 1808 and whose family had sensibly chosen to side with the revolutionaries during the wars of independence. For Don Pio this was a godsend, reviving all his old ambitions. Victoria would have a very welcome dowry to help smooth her husband's path to power, with her father clinging to his coat tails.

The only thing which disturbed this tranquil manœuvring was the unwelcome arrival of *The Peregrinations of a Pariah*, Flora Tristan's account of her visit to Arequipa and Lima, completed three years earlier and irritatingly dedicated: 'To the people of Peru'. How Don Pio in Arequipa received his copy is not known, though one suspects that Flora may rather mischievously have sent him one, fully aware of how he would hate the portrait of himself which lies at the heart of her story. And hate it he did, ordering up a public ceremony and having the offending book burned in the Plaza de Armas as if the Holy Inquisition had

returned. He also stopped paying her allowance, though she probably expected that he would and might well have done so anyway.

The book-burning was virtually Don Pio's adieu to Arequipa; he was off to Lima and greater things, moving into Echenique's substantial mansion in the capital and thoroughly enjoying himself. Only a year after the wedding, Don Pio was appointed Minister of War and the Marine and during the brief union of Peru and Bolivia he became provisional president of Southern Peru. The Union collapsed but Don Pio was by then part of the inner circle. When Ramon Castilla took over as president in 1845, Echenique became a deputy in the National Assembly then a counsellor of State. Castilla offered stable government for the first time in Peru's short history and the Republic flourished – owing in no small part to bird shit. Castilla had ushered in 'the guano age', a period of economic boom as vibrant as the American gold rush, based on the exploitation of the reeking mountains of bird-droppings, a rich source of fertilizer, found on the arid Pacific coast. By 1848, Echenique was vice-president and because the constitution barred the president from serving two consecutive terms, Castilla would have to step down in 1852, leaving Don Pio's son-in-law as the most likely man to succeed him.

How Don Pio must have savoured his triumph, particularly when he heard of Flora's death in 1844. It was all the more infuriating, therefore, just when everything seemed to be going so well, that he should receive a letter from her daughter, informing him that she was in some kind of trouble and needed to get away to safety and where else could she go but to her relatives in Peru? We may imagine the old man hanging his head in despair as he learned this news. Apparently, she planned to bring her husband and two children with her, for she was now Madame Gauguin.

## The Mother

Aline Chazal had been only nineteen when her mother died, leaving few friends to help her. The ever-faithful Jules Laure did all he could, but without other resources she had been forced to take a job in a dress shop and was only saved from the same Dickensian existence that her mother had known by the intervention of the novelist George Sand.

Flora Tristan and George Sand had both campaigned for a re-establishment of the divorce laws in France, though Sand's refusal to throw her considerable public reputation behind the campaign to win French women the vote had not endeared her to Flora. Yet despite the publicly proclaimed antipathy between these two forceful personalities, it was Sand who offered to take care of Aline after her mother's death

in 1844. A year later Sand wrote to her friend, the author Edouard de Pompéry, that Aline was:

> a young girl seemingly as affectionate and as pleasing as her mother was imperious and quick-tempered. This child has the air of an angel; the sadness in her beautiful eyes, her mourning, her obvious loneliness, her modest and affectionate manner, all touched my heart. Did her mother love her? Why were they thus separated? What marriage to a cause can make a mother forget and leave so far away from her in a dressmaker's establishment a creature so charming and adorable? I would much rather spend money on her future than on erecting a monument to her mother, whom I have never cared for despite her courage and her convictions. She was too vain. When people die, everybody pays lip service to their memory. It is right to respect the mystery of death, but why lie?

The relationship between the famous author and the young girl was entirely impersonal and the hint of lesbianism often levelled at Sand's relationships with other women is even less appropriate here than elsewhere. The help offered came from afar – in the same letter Sand admits that she cannot recall the girl's name and refers to her merely as Madame Tristan's daughter. But Sand did do the best thing possible in placing Aline in the boarding school to which she had earlier sent her own daughter Solange, a school run by a Madame Bascans at 70 rue de Chaillot, Paris. This was to be the first period of true calm in Aline's tormented life. The Bascans provided a liberal education rarely available to a woman at that time, but more crucially they offered stability and affection. Despite all she had suffered at the hands of her parents, Aline Chazal blossomed into a beautiful, well-balanced young woman, both resilient and self-sufficient.

George Sand's interest did not stop at providing Aline with a good education. Aware of the difficulties facing a poor girl at the time, Sand decided that the only solution to Aline's long-term well-being lay in a suitable marriage – she even exhorted the elderly Pompéry to fall in love with the nineteen-year-old girl – 'which wouldn't be difficult' – and marry her. But Pompéry had other ideas and the task was left to a rising young journalist in his early thirties, Clovis Gauguin.

## The Father

Gauguin is an unusual name. There are Gaug*ains* aplenty in France but the two families are unrelated. The surviving French Gauguins are today concentrated in and around Orléans and believe that they originated in Les Gauguins, a hamlet about fifty kilometres from Courtenay in the Loiret. They appear to have been market gardeners from time immemorial and to have mainly married the daughters of other market gar-

deners, even when some of them were established in Orléans by the end of the eighteenth century. The generation before Clovis were the first to break with this horticultural tradition – Clovis's father Guillaume kept a grocery shop, and Guillaume's younger son Isidore, known in the family as Zizi, was a jeweller. In common with most small businessmen, Guillaume's main ambition was to ensure that his son rose higher than he had done and no doubt considerable sacrifices were made to give young Clovis a good education. The boy's exact history is lost to us, but by the time he encountered Aline in 1845, at the weekly salon maintained by Madame Bascans, the 31-year-old Clovis had left provincial journalism and moved to Paris where he was an editor on *Le National*, a radical, republican newspaper founded by, amongst others, the politician Adolphe Thiers and which then had its office and printing works at 3 rue Le Pelletier.

Although the paper's two principal founders Thiers and Armand Marast supported the Orléanist regime, the tone of its leading articles became increasingly critical of laissez-faire government and began eventually to promote the open republicanism of its journalists – not least Clovis himself whose political opinions would have earned the approval of his late mother-in-law Flora Tristan had she known him. Aline and Clovis were married in 1846 with Jules Laure as the principal witness at the wedding. The young couple moved into 52 rue Notre-Dame-de-Lorette (today 56), near the Place Pigalle, next door to George Sand's intimate friend, the painter Eugène Delacroix.

It was probably about now that Laure painted Aline's portrait in his softly romantic manner. Though her face is fuller, there is much of her mother's prettiness about Aline, who also has Don Mariano's wide Spanish eyes. We have no portrait of Clovis but as his children by Aline would be well built, where the Tristan line tended to thinness, we can presumably see something of the father there.

The first child, a daughter, was born the following year, on 25 April 1847, and christened Fernande Marcelline Marie. A year later, on Wednesday 7 June 1848, their son Eugène Henri Paul Gauguin completed the ménage. The birth was registered at one p.m. the next day and witnessed by François Duras, chief editor of Clovis's newspaper and Joseph Peysonnée, another of the assistant editors. For those who wish to see dramatic portents surrounding the cradle of the famous, there is the satisfaction of learning that little Paul's arrival was met with uproar – in Paris the barricades had gone up, bad harvest and economic crisis had toppled the fragile government of the 'citizen-king' Louis-Philippe who, together with his queen, fled to England as Mr and Mrs Smith. The Second Republic had happened by accident and would not last long.

Four months after her daughter gave birth to Paul, the workers of Bordeaux unveiled a monument to Flora Tristan in the city's cemetery, the result of a national subscription amongst the poor and downtrodden to honour her name – 'The Workers Remember' was engraved and gilded on the plinth of the marble column, and below it: *'Liberté – Égalité – Fraternité – Solidarité'*. For a brief moment it seemed that the poor might at last rise up.

Panic-stricken, the Assembly turned to the War Minister, General Louis Cavaignac, who promptly administered to his fellow citizens the same treatment he had recently used against some recalcitrant North Africans – he slaughtered them. A fortnight after Paul Gauguin's birth, order had returned but so too had the Bonaparte pretender Prince Louis-Napoleon, who realized that his hour had come. Presidential elections would be held on 10 December, the candidates being Napoleon and Cavaignac, 'the butcher of the barricades'. It was a war of the newspapers, in some ways the first modern election campaign – 103 journals backed Napoleon, 190 Cavaignac, among them *Le National* which swallowed its aversion to the killer general out of its dread of the imperial revivalist. The leading caricaturist of the day, Rigobert, drew a satirical outline of these opposing forces, with *Le National* at the very forefront of Cavaignac's supporters and though the paper sported no by-lines, its leader writers were well known in political circles, so that as December approached, Clovis Gauguin was widely seen as one of the most outspoken critics of the Bonapartist cause. It was thus, with considerable consternation that he and Aline received word that their enemy had won by an astonishing five to one of the votes cast.

At first Napoleon was simply president, but there was little doubt in anyone's mind that he was playing out a charade of republicanism and that his ultimate aim was the restoration of the empire with himself as Napoleon III – the first Napoleon's infant son (the short-lived King of Rome) being theoretically honoured as the second, though uncrowned emperor. Clovis Gauguin could see all this coming and knew what it would mean for him and his family. But where to go, to avoid the inevitable? It was at this point that the fantasy that Thérèse Laisnay passed on to Flora Tristan resurfaced in Aline. Why, she argued, did they not sail for Peru, there to claim the rightful inheritance which had so long been denied her branch of the family? They could go to Lima where Don Pio was now living and where Clovis would be able to find work as a journalist – he might even start a newspaper of his own. When fresh disturbances broke out in June 1849, around the time of Paul's first birthday, they decided to delay no longer. The baby was hastily christened at the nearby church of Notre-Dame-de-Lorette on 19 July, though the ardently republican Clovis did not attend. Instead, Paul's

grandfather Guillaume came from Orléans for the ceremony and acted as the child's godfather. Before leaving Paris the parents asked Jules Laure to paint the baby's portrait. He depicted Paul, sitting upright, a hand across his bare chest, staring straight out at the spectator with confident blue eyes.

The family sailed from Le Havre that August on a small two-masted brig, the *Albert*, which pitched and tossed so badly little Paul woke one night with everything thrown about the cabin. It was his earliest memory, screaming in fear until his mother comforted him and he could sleep again.

Everything about the *Albert* was odious. The captain was a brute who appears to have quarrelled incessantly with Clovis and may even have made a pass at Aline. The stress in such a confined space was unbearable and it was little wonder that when they weighed anchor off Port Famine at the furthest point in Patagonia in the Straits of Magellan, the Gauguins seized the chance to go ashore briefly, before the long haul up the west coast of South America to Peru. But Aline had no sooner settled the two children into their places in the whaleboat which had come to row them ashore, than she was appalled to see Clovis keel forward, dead from a heart attack.

The whaleboat continued to the town where the cause of death was diagnosed as a ruptured aneurism. A funeral was hastily organized – presumably because the captain, whom Aline naturally blamed for Clovis's death, refused to delay his planned departure. Thus, the long-suffering widow was forced to continue, with two little children, towards an uncertain welcome, in a strange land, with no one to help her.

## The City of the Kings

Some time in November 1849 Aline, Marie and Paul Gauguin disembarked at the port of Callao and made the short coach journey into Lima. Aline's first impressions would have been favourable – Callao was better maintained than the capital, with wide avenues and the long arched colonnade of the imposing royal fortress with its tiered clock-tower. At a distance Lima itself must have seemed just as appealing, with its neat lines of low stuccoed houses, their pretty carved balcony windows projected over the streets, the skyline pierced with the baroque towers of the major churches. Visitors often commented on the entirely Spanish look of the town, referring to Seville or more exactly Granada, for beyond Rimac, its northern suburb, rose the mountains, often hazy in the dust-filled air in a place where rain was virtually unknown.

But by the time her coach reached the Portada del Callao, the rundown entrance to the west of the old centre of Lima, Aline would have realized

that much of the city was dilapidated, its streets unpaved, its public buildings in a state of disrepair, the removal of refuse left to the buzzards who were far from efficient. The country towns of Arequipa and Cuzco had retained their former colonial elegance, but in the endless power-struggle which had marked the republic's early years, no one had bothered to maintain or to beautify the capital. Individual mansions were still as sumptuous as they had been under Spanish rule but the public domain had become dilapidated. As Paul Gauguin was to write, a lifetime later: 'I still see our street with the chickens pecking among the refuse. In those days Lima was not what it is today, a great sumptuous city.'

Echenique's house, where Don Pio was staying, was in the Calle de Gallos (today: 253 Avenida de la Emancipación), then in a fairly new part of the city to the west of the old centre. From the outside the one-storey structure – a wise precaution in a city plagued by earthquakes – offers a simple classical façade whose narrowness belies the true size of the building, which runs back the width of an entire city block. The original house had been built for Francisco de Carrajal, one of the con-quistadors, executed when he fell out with the Pizarro brothers, but the building must have been substantially restructured after the earthquake of 1746 which severely damaged most of the city. Since the Echeniques had acquired it, the house had been modernized in accordance with the current taste for all things European: the floors fashionably covered in imported Italian terracotta tiles in a bold red, yellow and green floral pattern.

There was ample room for the three new arrivals – three inner court-yards succeeded each other, each giving onto rooms lit from above by the upright *ventana teatina* windows, introduced to Peru by the Jesuits, which also acted as doorways onto the wide expanse of flat roof, where in the perpetually arid climate, much family property was stored.

Perhaps because he was riding high, with all his ambitions coming to fruition, or perhaps because he was genuinely touched by the sight of the pretty young widow with her baby children, Don Pio took to Aline much as he had originally done to her difficult mother – though in Aline's case the attraction persisted. They were welcomed, given rooms and servants and made to feel that all the horrors of the past were behind them. Lima would be their home for as long as they wished.

Eighteen months old when he was brought to Lima, Paul Gauguin was seven and a half when he left. Because of his youth, his biographers have hurried over this period in his life, assuming that he was too young for it to have had any appreciable effect on him. Only those scholars who have correctly identified the Peruvian roots of his art have realized the importance of those six years, though even they did not attempt to

retrace his steps by visiting the city itself. Yet Lima's significance to him
is made quite clear in his memoirs:

> I have a remarkable visual memory and I recall this time of life, our house
> and ever so many things that happened; the monument at the Presidency,
> the church the dome of which was entirely of carved wood, put on later.
> I still see the little negro girl who, as the custom was, carried to church
> the little rug on which we knelt to pray. I also see that Chinese servant
> of ours who was so clever at ironing. He was the one who found me in
> a grocery-shop, sitting between two barrels of molasses, busily sucking
> sugar-cane, while my weeping mother was having them search for me
> everywhere.

As Aline had a 'Spanish' temper such behaviour usually resulted in a
sharp slap from a hand which was 'as flexible as rubber'.

Of course his earliest recollections are limited to his mother and Don
Pio's house. Aline would dress in the *tapada*, the Peruvian silk mantilla
which rather seductively covered the entire face except for a single eye
– described by her son as 'so soft and so imperious, so pure and caressing'.

Living in Echenique's rambling mansion was an adventure in itself.
The law obliged householders to give shelter to someone mentally ill in
lieu of tax and the young Paul was intrigued to discover that there was
a lunatic lodged on the large expanse of flat roof. One night this mysteri-
ous figure slipped his chain, and Paul and Marie watched him climb
down into the courtyard near their room.

> The moon lighted up the court. Not one of us dared to utter a word. I
> saw, I can still see, the madman enter our room, glance at us, and then
> quietly climb up again to his terrace.
>
> Another time I was awakened at night and saw the superb portrait of
> my uncle, which hung in the room, with its eyes fixed on us, *moving*.
>
> It was an earthquake.

Two years after the Gauguins' arrival, José Echenique fought and won
the election for the presidency and in 1852 he moved into what was
then called Pizarro's Palace in the Plaza de Armas – not the classical
edifice of today's presidency but a rather seedy building, its façade blank
save for an ornate central window and a collection of ragged canvas
awnings running along the length of the ground floor. The square was
unpaved, with an open ditch cut across it, while the palace itself was
completely overshadowed by that of the archbishop at its side, and by
the grandeur of the nearby cathedral. Only the square's central fountain
is much as it was in Gauguin's day and is undoubtedly the monument
he wrote about in his memoirs – a tiered bronze column from whose
summit water dribbles into and out of three basins until it gathers in a
pool at the base. What probably gripped the young Gauguin's imagina-

tion were the eight hunched gryphons perched on the octagonal rim, each with a clawing lion on its back and each gryphon spitting a stream of water at a coat of arms embossed on the base of the fountain proper.

With Echenique and his wife in the presidency, Paul, Marie, Aline and Don Pio had his huge mansion to themselves. Little Paul was understandably overawed by his ancient great-uncle, believing him to be well over a hundred years old though he was only in his eighties. True, Don Pio was no longer as youthful looking as Flora had found him, his hair was receding and he was certainly out of touch with the times, but to Paul he must have seemed like a character out of a fairy story, as was so much of life in Lima to a little boy.

For Aline is was all a blessed relief after the terrible things she had suffered throughout her childhood. Doted on by Don Pio, cosseted by servants, surrounded by luxury, it was more than she could ever have hoped for and all the more comforting when she heard the news from France. In 1852, Clovis Gauguin's fears were fully justified when the Prince-President, having staged a *coup d'état*, engineered a referendum which restored the Bonaparte dynasty with himself as Emperor Napoleon III. There were local uprisings all over France. Clovis's brother Zizi, another ardent republican, took part in a protest occupation of the town hall in Orléans, on 3 December 1851, was arrested and transported to Algeria. At first, the family was devastated, but like much in Napoleon III's peculiar empire, things were not always as they first appeared. Zizi was reasonably free, under colonial surveillance, to pursue life as he wished. As France was to discover, the new Napoleon was an oddly languid despot and eventually his empire proved a forcing house for economic growth – the years following Napoleon III's accession to the throne saw an unprecedented economic boom, the effects of which rippled outwards to the guano-rich shores of Peru. In exchange for guano money, goods from Paris poured into Lima. Beneath their *tapadas* the rich women of Lima wore crinolines by Worth, a garment originally designed to mask the pregnancy of the French empress – a perfect symbol for that odd, ill-digested cultural mix.

During the Gauguins' time in Peru the former attitude which looked upon anything Indian or *mestizo* as barbaric began to change. Castilla had been the first *mestizo* president and Echenique found it politic to recount how he had been carried off by Indians at the age of six and been raised by them, until he was rescued two years later – thus making him a sort of honorary *mestizo*. Yet until Aline's day few paid other than scant regard to the ancient art of the Indians. If you wanted a scene from Peru's past you turned to the painter Louis Montero, whose vast canvas depicting the conquistadors with the body of the dead Inca Atahualpa was painted while the Gauguins were in Peru, in the manner of

the French *artistes pompiers. Atahualpa's Obsequies* was a Salon piece, a work of doctored history, with grieving Indian maidens dressed like a chorus from Carmen. It was, of course, much admired at the time and still dominates the entrance to the Museum of Art in Lima.

Yet by a curious reversal of taste, it was French interest in pre-Columbian art which triggered a response in the Spanish Peruvians. Businessmen with Peruvian contacts had begun to collect pre-Columbian pottery and silverware, and so, in a small way, had Aline.

While Aline was in Lima, one French collection was on display in what had been the Palace of the Inquisition. But aside from the official excavations, much of the material available to the amateur collector came from the Indians who brought pieces into the city for sale, having simply taken them from one of the countless unrecorded grave sites around the country. Few had any knowledge of the differing styles they were purchasing – the very rare Chavín stirrup-spouted vessels portraying stylized half-animal, half-human characters; the more common Chimú double-spouted funerary vases, and Mochica or Moche ware from the north coast. Some were a rich earthy red, others an almost lacquered black. Many were surprisingly lifelike: potatoes, beans and tubers, victuals for the after-life and a toby-jug portrait with a bump in its cheek where a ball of coca-leaf and lime had been secreted, a common means of deadening pain and increasing stamina.

Aline collected such vases and solid silver figurines. Her son Paul would always refer to them as Inca, a common misconception. They were probably Chimú and Mochica pieces – the most easily available in mid-century Lima. Both styles are really as much sculpture as pottery, highly decorated and ill-adapted for use, other than as grave offerings.

Mochica vases often depict a shrouded skeletal figure similar to the mummies hunched in the foetal position, wrapped doll-like in cloths, which, in pre-Columbian times, had been placed back into the womb of the earth to fertilize it. Whether Gauguin saw one of these while he was in Peru or only knew of them from the Mochica pots, he does not say, though when he did see one in Paris much later, it became one of the most persistent images to resurface in his work. One thing at least is sure – Aline's little collection was the first art Paul Gauguin knew.

Inevitably, Peru was a dream-like interlude which could not last – José Rufino Echenique was a failure whose presidency has gone down as one of the most corrupt in Peruvian history. Under the pretext of settling the nation's debts by using the guano revenues to pay the interest on the many bonds which various governments had issued, Echenique and his cronies were able to get rich by slipping through a great number of false claims and even going so far as to issue new bonds to their supporters, all of which were duly settled by the treasury. In this way, Don

Pio became one of the ten largest holders of Consolidated Bonds, having a total of 124,000 American dollars, an incredible sum at the time. He and Echenique belonged to the old system of factional politics which his predecessor Castilla had attempted to change. Under Echenique, the old guard returned, though their days were numbered – the flow of money from the guano contracts meant that there was a newly rich class to challenge the power of the old landed families. This new bourgeoisie was not particularly interested in Castilla's social reforms but they wanted the new roads and railways and financial institutions that went with them and which his forward-looking administration had begun to create before Echenique and his placemen began to unpick it all. While Aline was enjoying herself at his presidential receptions, a popular desire to see Echenique removed was taking hold, and eventually Castilla decided that he could no longer wait until his successor's term of office ran its course. In 1854 he gathered his forces at Cuzco and had himself proclaimed provisional president.

Aline began to sense that it was time to go. Napoleon III was proving less of a tyrant than Clovis Gauguin had anticipated. Uncle Zizi was pardoned and allowed to return home to Orléans and Guillaume Gauguin wrote to say that he had decided to divide his inheritance between Zizi, who had not married, and his two grandchildren by Clovis, Zizi being named as their guardian until they came of age. It was clear from Guillaume's letters that he did not expect to live much longer and was hoping to see Aline and the children before it was too late.

Aline hesitated, unwilling to leave the one place where she had found a measure of tranquillity, and it was only when Castilla's advance became unstoppable and each passing day brought the certainty of Echenique's overthrow nearer, that Aline accepted that things would not continue as they had. She arranged their passage to France either at the end of 1854 or early 1855. For the children the noise of it all – the coach to the coast, the first sight of the boat and the hustle and thrill of putting to sea, must have pushed aside any sadness at saying goodbye to their old uncle and all the rest of the family, the mulatto servants, the old Chinese launderer, even the madman on the roof. Only later would there be a deep sense of loss and an aching desire to return.

As the endless sea voyage unfolded, with day after day of nothing but the limitless ocean merging into long dreary months, the excitement must have quickly evaporated. To keep her son amused, Aline encouraged him to pass the time carving pieces of wood, his first recorded artistic efforts, though none has been preserved.

## The Patriarch

The Gauguins had left just before the government's unenthusiastic troops were overrun at the battle of Las Palmas and Echenique was forced into exile. It was a bleak moment for Don Pio – the family's political ambitions were shattered and with Castilla only a few days from Lima, his personal position was hardly comfortable. Fortunately the victorious Castilla was more concerned with reforming the government than settling old scores.

With his usual combination of nimble footwork and low cunning, Don Pio quickly adapted to the moralistic ethos of the new regime, spending his last years supervising the construction of a charitable hospital for Lima's female poor. He was now quite bald and took to wearing a brown wig as he set off on his daily walk. He had managed to attain a certain venerability, with people pointing him out to visitors as the last Spanish viceroy, a piece of living history. For the next five years he enjoyed the only period of calm in an extraordinarily vibrant life. Born into a dusty outpost of a decaying empire he saw out his days in a bustling city yearning for the modernity of Europe and North America.

Today, the house in Lima is a ruin. In 1992, the imposing main entrance still survived, flanked by two classical columns, each topped by a screaming gargoyle head, mimicking the rictus grin on the skulls of the Peruvian mummies. In 1898 in Tahiti, Gauguin used this image for the hunched figure who represents death and rebirth in his major work: *Where Do We Come from? What Are We? Where Are We Going?* Lima was always with him. 'I am a Savage from Peru,' he repeated, mocking his disbelieving listeners, knowing that it was true.

When exactly Don Pio died is unclear – his memorial in Arequipa says 1860 but the *Enciclopedia ilustrada del Peru* has it a year earlier in 1859 and Gauguin later recorded it as 1856, which is unlikely, though typically cavalier of his great-nephew, who also stated that he believed the old man to have been 113 when he died.

As was the way in Peruvian politics, Echenique had been quietly allowed back and was once more operating on the fringes of government. All in all it had been a good life and as Don Pio lay dying in his son-in-law's mansion, surrounded by his enormous family, he announced a change in his Will – Aline and her children should have their long-awaited inheritance after all.

# 3

◆

# *The Scramble*

The France to which Aline Gauguin and her children returned in 1855 must have seemed little different from the one she had left seven years earlier. In Orléans, they were welcomed by Clovis's family and moved into the home of the children's paternal grandfather Guillaume at 25 quai Tudelle. Orléans was a backwater; the city had resisted the coming of the railways, standing apart from the rapid industrial expansion which the Second Empire had launched. Safe within this settled world, it seemed clear that the catastrophe which Clovis had believed would follow the rise of Louis-Napoleon had not happened, indeed it could only be assumed that nothing much had taken place: Uncle Zizi was safely back, grandfather Guillaume was reasonably well off, problems were few.

The seven-year-old Paul's initial distress had a much simpler cause; he was unable to understand what was being said to him. He spoke only Spanish and although he quickly mastered the language of his father's country, he would always feel sentimentally drawn to, and more at ease amongst those who spoke his first language. In his early days in Orléans he spoke French haltingly and was, by his own account, driven to stamping his foot in frustration. On one occasion, when Uncle Zizi asked him what was the matter, Paul stamped all the harder saying: 'Baby is naughty!'

As well as the new language, eight-year-old Marie and seven-year-old Paul were immediately faced with the rigours of nineteenth-century schooling, though the small amount known about Paul's schooldays has to be gleaned from his rare memories, some of which have the hollow ring of myth-making about them. In *Avant et après* he describes an old woman who saw him whittling at a piece of wood with a dagger and exclaimed: 'He's going to be a great sculptor.' Later there was a teacher at his first day-school in Orléans who said: 'That child will either be an idiot or a man of genius.'

The general impression his memories leave is that he was rather miser-

able at school. He records how, at the age of nine, he saw a painting of a traveller with his stick and bundle over his shoulder and thus inspired ran away to the forest of Bondy with a handkerchief full of sand at the end of a stick. In the end, the butcher found him and dragged him home for punishment, though Gauguin jokingly transforms this into a warning about the danger of art and how it can affect the unwary.

In 1856, to add to Aline's worries about how the children were settling down, she received disturbing news that her father André Chazal, after serving eighteen grim years of hard labour, was to be released from prison. She believed him to be capable of anything, and knew he was still consumed by a demented desire for vengeance and was much reassured when the local justices proved deaf to his pleas to be allowed to travel to Paris, to sort out what little remained of his affairs. That her father was obliged to eke out his days in Evreux, far enough from Orléans, brought some peace of mind to the daughter he had once tried to rape.

It wasn't until he was eleven, in 1859, that Paul's real education began. He was sent as a boarder to a school in the pretty little village of La Chapelle-Saint-Mesmin, about six kilometres from Orléans, where he was to pass the next five years and where he would receive the instruction that formed the intellectual basis of his life. In this he was extraordinarily lucky: the school was part of the Petit Séminaire de la Chapelle-Saint-Mesmin, a training college for priests, and while this meant that there would be a good deal of religion crammed down his throat, it also ensured that he got a very high standard of formal education. Set in magnificent buildings – the word 'junior', or as it is sometimes translated 'little', is a misnomer for the grandiose three-storey structure with its imposing wings, a central steeple over its vast chapel, an arcaded *cour d'honneur* and spacious assembly hall, an ensemble said to be the most beautiful of its kind in France, set in a charming park on the banks of the Loire. And far from the Little Seminary being some quiet provincial school for the children of the local tradespeople, it was in many ways the epicentre of the massive reform in Catholic education being put into practice by the leading liberal cleric of the time, the bishop of Orléans, Monseigneur Félix Dupanloup, who was to exercise an enormous influence on Paul Gauguin, though one that the bishop would hardly have relished, had he ever learned how it finally bore fruit.

Dupanloup was an extraordinarily energetic character, who mixed piety and politicking in equal measure – he was said to have converted Talleyrand on his deathbed and he rose within the Church at a time when it was still demoralized and impoverished as a result of the Revolution and the various violent swings in French society in the first half of the nineteenth century. By contemporary standards, Dupanloup was

a liberal and a moderate, forcefully resisting the more reactionary pro-
nouncements of the Vatican and attempting to reconcile the Christian
faith with the massive changes in knowledge, particularly in science,
which had convulsed theological studies and seriously undermined
religious education. Dupanloup's six-volume *De l'Education* (1850–66)
brought together the thoughts of a man whose ambition was to combine
the teaching of the catechism with that of chemistry, who was a pioneer
in the field of the education of women, and who accepted the bishopric
of Orléans in 1849, so that he could endeavour to put his theories into
practice.

Despite such liberality, the education given was rigorous. At five in
the morning, although it would still be pitch dark in winter, a bell would
waken Gauguin and his fellow pupils in the long dormitory with its lines
of forty or so beds, whereupon a teacher would intone *Benedicamus domine*
and the shivering little creatures would respond *Deo gratias* before begin-
ning the process of washing, dressing and tidying away their things, with
military precision, before walking to chapel for the morning service at
5.45. Lessons began at 6.30 and continued until 7 in the evening, broken
by meals in the large refectory under a vast reproduction of Leonardo
da Vinci's *Last Supper* and accompanied by a sermon from the high pulpit
delivered by the superior. There were other breaks for visits to the
chapel and interludes for exercise, until the day finished with a period
of religious study, before bed at 8.00 – after personal prayers, of course.

It is hard to imagine Gauguin accepting so hard a programme and his
later memories do paint a portrait of a child who took refuge in solitude
and introspection:

> I formed the habit of concentrating on myself, ceaselessly watching what
> my teachers were up to, making my own playthings, and my own griefs
> as well, with all the responsibilities they bring with them.

But this is somewhat deceptive. Despite the watchful priests and teachers,
despite the long hours of study and religious observance, the pupils were
as mischievous as boys anywhere. One assistant master, known to his
pupils as Daddy Baudoin, had been a grenadier at Waterloo and would
dolefully reminisce in the manner of old soldiers. Safe in their dormitory
the boys would mock him with a typically smutty game, lifting their
shirts and shouting out 'Attention! Present arms!'

What Gauguin derived from all this was mixed. Bishop Dupanloup
was very keen on languages, especially the teaching of Latin and French,
and while the former seems to have passed Gauguin by, the latter left
him with an enthusiasm for literature, though with a total inability to
spell even the simplest words. If nothing else, the Little Seminary taught
him habits of intellectual application which would serve him well in later

life, enabling him to study deeply any subject which interested him, even down to forcing himself to read difficult, even boring, works if he felt they might yield what he needed. The bishop left nothing to chance: his summer palace was near by and he was in the habit of strolling along the banks of the river of an afternoon, to give the boys talks on theology. Thus Gauguin received at least part of his religious education from one of the leading theologians of his day and while his French may have remained fairly crude, his religious education was quite outstanding; though he left the Little Seminary without much faith, he nevertheless retained a thorough grounding in Monseigneur Dupanloup's attempts to marry the Gospel to the modern scientific spirit.

Not that this made the young Gauguin a dutiful Catholic. He would later assert that it was at the school that he learned 'to hate hypocrisy, sham virtue, tale bearing (*semper tres!*) and to distrust everything that was contrary to my instincts, my heart and my reason' – hardly the affirmation of one who has learned obedience to received truths.

One final part of this thorough education was certainly relevant to his future: under a Monsieur Dumontel he learned *Dessin* or drawing, probably rather rigid instruction in simple perspective and conventional reproduction, though this did not deter him from continuing to draw after he left school. The high quality of his earliest surviving sketches, which date from some eighteen years later, indicate that he must have kept up this hobby throughout his teenage years. We know that it was this side of his studies which interested Gauguin most, rather than Latin and French or the bishop's religious homilies, for he quickly decided that he was destined for a practical career rather than one requiring academic study. While still at the seminary, with memories of Peru ever fresh in his memory, he let it be known that he wished to become a sailor, though he must have known that this would hardly please his mother.

## The Spanish Connection

Aline had not had an easy time since their return. Guillaume Gauguin had died a few months after they moved in with him, and while this meant that she would have the inheritance promised to his two grandchildren, it turned out to be tied up in land, a vineyard and a few houses, none of which were bringing in much rent. It would have been about then that she learned of Don Pio's death in Lima and of his deathbed wish that she be included in his Will. Any joy this brought was short lived when she discovered that the family flatly refused to pay the inheritance he had wanted her to have, even though this was only a tiny proportion of his huge wealth.

Even as she was trying to decide how best to handle this difficult matter, Aline learned of her father's death in Evreux. Despite his appalling behaviour, it was hard not to feel some pity for a man who had been the victim of a terrible tragedy. His original mistake had been to marry a supposedly demure young woman who turned out to be quite exceptional, with no way of expressing herself other than by breaking free from the constraints of her time and becoming in effect an adventuress. To add to his sufferings André Chazal had lived long enough to discover that even his art had been taken away from him. He had always signed himself either 'Chazal the Younger' or simply 'A. Chazal' and since his disappearance it had been assumed that these works were by his elder brother Antoine. Antoine had had a brief period of official

An illustration for Buffon's *Natural History* by Antoine Camille Chazal.

success, exhibiting at the salon, but it had not lasted and he had settled into the mundane role of Professor of Iconography at the Jardin des Plantes in Paris where he was expected to produce exact images of the plants and animals being studied in the various pavilions dotted about the large park. He was one of the illustrators for the bird section of the authoritative twenty-volume edition of the *Œuvres Complètes de Buffon* published by Pourrat Frères in 1835. Sadly, he was no Audubon – his birds are indistinguishable from the work of the other engravers save for his signature and a certain irrepressible tendency to go too far. His ostrich – *Struthio Camelus. L.* – strides across a prairie with a distant mountain and a rather unconvincing clump of cactus in the right foreground. Today, of the two brothers only Antoine merits an entry in the French dictionary of national biography where he is clearly referred to as *Chazal jeune*. Thus, poor André, Paul Gauguin's grandfather, has been written out of history.

Of the three deaths, only that of Guillaume Gauguin had brought Aline any money. 'Although never in actual poverty,' her son wrote, 'from this time on our life was extremely simple.'

The main difficulty was finding the fees to pay for Paul's training if he was to be anything other than a common seaman. With Uncle Zizi's co-operation Aline set about selling whatever they could of Guillaume's property but when this proved insufficient she left Paul at the boarding school in Orléans and moved to Paris to take up her old career in the fashion trade, moving to 33 rue de la Chaussée d'Antin and working as a seamstress.

She still hoped to get something out of the family in Peru but during her first year in Paris, Echenique, by then re-established in government circles, turned up on diplomatic business and tried to persuade her to accept a compromise. Aline was her mother's daughter and there was a furious row which ended with her insisting on all or nothing. Echenique left knowing the family had all the cards and it was, predictably, nothing that she got. She never saw any of them again. Echenique died six years later in 1867 at the age of fifty-nine, after a final career as an elder statesman on the fringes of power. In later life Paul Gauguin would occasionally wonder about his surviving cousins in Lima but made no attempt to contact them in any way.

Life for Aline was far from easy. To be a seamstress in mid-century Paris was to be at one remove from destitution, and indeed it was commonly accepted that women who were reduced to such low-paid work had to be at the beck and call of any man willing to pay for their services. The major European cities all had a vast population of impoverished women whose only hope of survival lay in prostituting themselves. At one end of the scale were the famous courtesans, the women of the

theatre, the '*grandes horizontales*', the mistresses of the nobility and the haute bourgeoisie. But the operatic image of these gilded creatures only masks a squalid reality of thousands of poor women who had no choice if they wished to feed their children and themselves. Aline was not quite in such desperate straits but there can be little doubt that she would have found survival near to impossible had she not met Gustave Arosa.

Arosa was a most unusual man. A rare photograph, taken in later life by his friend Nadar shows him posed in a family group, all rather formal and conventional: Gustave stands to the left, his plump, comfortable-looking wife Zoë is seated before him, with their youngest daughter Marguerite kneeling on the floor at her feet. To the right is another, older daughter Irène with her husband Adolpho Calzado; they are already in mid-life and Gustave with his full greying beard is portrayed as a typical nineteenth-century patriarch. It is a deceptive image, perhaps an in-joke on Nadar's part, for Gustave Arosa was far more interesting than such a hackneyed cliché suggests.

Gustave was born in 1818 the year after his father François-Ezéchiel moved the family from Madrid to Paris. The Spanish connection remained strong and was the origin of a successful venture into the Peruvian guano trade which made old François a fortune. He did not, however, stay with import trading, moving quickly into financial specu-lation, working with the French branch of the Rothschild family who had already made themselves France's leading bankers. So close was he to the Rothschild business that he lived in the same street, Rue Laffitte, as their main offices and held power of attorney on their behalf and that of the bank. By the time François-Ezéchiel's two sons were ready to follow him into the world of finance, the Arosas were well placed to profit from the economic boom which the Second Empire had un-leashed.

## The Scramble

Living in Paris and mixing with the Arosas, Aline could now see how deceptive had been her quiet life in Orléans. Since she had left for Peru, Napoleon's economic policies had brought changes to almost every aspect of French life and the engine of those changes was clearly identi-fied by the writer Emile Zola as money, though his final judgement on this was not unmixed: 'Money,' he wrote, 'poisonous and destructive, became the ferment of all social vegetation ... Was not money alone the power capable of razing a mountain, filling in a stretch of sea, making the earth at last a fit dwelling place for men? ... All good came from money, which was also the source of all evil.'

Zola entitled his novel of the boom years of Napoleon's empire *La*

*Curée* (The Scramble). In it he recreated the mad dash for wealth which had characterized the era, though writing with the benefit of hindsight, he also recognized that it had had its positive side. 'Without speculation,' said one of his characters, 'there would be no living and fertile enterprises, no more than there would be children without lust.'

As an ardent republican, writing after Napoleon's empire had been swept away, Zola saw little reason to praise what, from a less prejudiced viewpoint, can be seen as a remarkable period of prosperity. Before illness and a misguided foreign policy dragged him down, Napoleon attempted to liberalize French business and emulate the industrial growth of neighbouring Britain. Railways began it and the transformation of Paris under the Prefect of the Seine Baron Georges Haussmann was its most visible achievement, though behind that lay a multitude of new business enterprises, celebrated in the huge Universal Exhibitions which were such a thrilling feature of the period. The first to take place in Paris, held in 1855 on the right bank of the Seine between today's Grand Palais and the Palais de Chaillot, was a vast display of technological prowess and was intended to be Napoleon's answer to the first Universal Exhibition, held in London in 1851, which he believed had given the English a head-start in the promotion of their new industrial products. The organization of the huge enterprise was put in the hands of the emperor's cousin, the Prince Jérôme-Napoleon, known to his detractors as 'Plon-Plon', who was charged with the delicate task of demonstrating that France too could cut a dash amongst the nations. An enormous Palace of Fine Arts went up, its imposing entrance facing the Avenue Montaigne, and into it went a staggering 5000 works of art, over half of them French. Amongst them, the large retrospectives of Ingres and Delacroix were undoubtedly worth while; for the rest Plon-Plon erred on the side of the official favourites, stacking the walls of the Grand Salon Carré with absurd historical fantasies like Couture's *The Romans of the Decadence*, which was at least funny, and Chasseriau's *Defence of the Gauls*, which wasn't.

Small wonder that the crowds shunned the arts in favour of the far more intriguing inventions on display in the Palais de l'Industrie, a wholly unsuitable fussy Beaux-Arts building topped by a forerunner of the Statue of Liberty. Far from presenting a vision of the new scientific age, most of the exhibits were a product of the country's predominance in the decorative arts. Spectacularly effusive settings of Sèvres china vied with florid Gobelins tapestries and brash Christofle silverware. Any surface that could be carved, moulded, inset and coloured was and the star turn had to be a monstrous candelabra by Baccarat, five and a quarter metres high, which sprouted a 'bouquet' of ninety crystal light holders from the top of a towering cut-glass palm-tree.

This was the opulent taste of the Second Empire. A brash mix of Gothic, Romanesque, Baroque, Classical, it set the tone for the rest of Europe and much else of the world, and has endured well into our own century as the basic design style of those who wish to give immediate and showy evidence of wealth and success. Its spread was rapid, it was certainly successful, and was already in vogue in Lima while Aline and her children were still living there with Don Pio.

In the same way, the Second Empire sanctioned an art which was undoubtedly popular, as witness the crowds which flocked to the annual Salon, but which was, in the words of E. H. Gombrich 'painfully easy to read'. It was often hypocritical, using the supposed respectability of a classical subject to present the naked female form in clearly seductive poses. It was an art which laid great emphasis on technical skill and finish. Works by the Orientalist Gérôme or the history painter Scheffer had clearly taken time and effort to produce, and thus the solid bourgeois businessman who purchased them could know that he was buying value when he handed over the huge sums of money demanded for the Salon prize winners. Henry James in his *Parisian Sketches* tells how A. T. Steward, the American department store owner, bought a painting by Meissonier for 76,000 dollars *by cable* – it was the ultimate triumph of bourgeois taste, an art which one did not even have to see.

## Money

Six years after that spectacular exhibition, in 1861 when Aline moved to Paris and took up with the Arosas, Napoleon III and his empire were well into their stride: the massive reconstruction of Paris was everywhere under way – entire areas of old, insalubrious dwellings had been razed and new boulevards driven through the open spaces; at the same time a liberal economic policy had allowed business to flourish and the industrialization of France to move forward. Fortunes were being made and Gustave and his brother Achille-Antoine had grown rich as the economy blossomed.

While Gustave Arosa's role in the life of the young Paul Gauguin was clearly important, we know little of his activities except that he acquired his wealth through the Bourse, the Paris Stock Exchange. Later records show that he was associated with a Paul Bertin, one of the *agents de change* who handled the sale of shares, but it may well be that Arosa had started out working for Bertin's predecessor, a Monsieur Bagier, a post that was probably arranged by old François-Ezéchiel Arosa who, as a senior employee of the Rothschilds, would have had just that sort of contact.

The members of the Chambre syndicale de la Compagnie des Agents

de Change should not be confused with the jobbers and brokers of the London Stock Exchange; the *agents de change* were officials, strictly controlled, with clearly prescribed functions. They were limited to sixty in number, with younger men serving their time until they could inherit or purchase the *charge* of a retiring *agent*. The *agents* did not issue shares in new companies; that was done by major bankers such as Rothschild, who loaned the original credit to a business. The *agents*, and thus the Bourse, handled all subsequent trading in the shares and to cover these transactions each agent was expected to have access to funds totalling about two and a half million francs in the mid-century. To obtain this the agent formed a limited partnership, each partner bringing in his own money, or having himself created a syndicate of investors. Some of these *commanditaires* might work with the agent, handling the sale and purchase of shares, but most were simply sleeping partners. The agents and their associates made their money from the commission charged on each trans-action which was divided up in proportion to the sum each associate had placed with the group. Gustave Arosa appears to have begun as a simple cashier, but even in that humble role he would have received bonuses on the group's profits, though it is clear from the rapidity with which he became an associate himself that he used his earnings to trade in shares himself and thus acquire a substantial fortune. By the end of the 1860s the records for the Bertin group show that Jean-Dominique Gus-tave Arosa was then the second largest of the associates with 600,000 francs to Bertin's 1,400,000 francs, though as most of Bertin's money was probably held on behalf of others, it may be that the largest personal sum was that of Arosa himself. Translating money from an historical period to the present day is virtually meaningless, but if one allows that at the time 600 to 900 francs was a reasonable year's wages for most people, then one can see that Gustave Arosa was by then seriously rich.

In many ways the Arosas' progress echoes that of the more famous Pereire brothers, Emile and Isaac, who had also moved from Spain to France, via Portugal, and whose father had also made a fortune out of Peruvian guano. As young men the Pereires had attended Enfantin's quasi-religious meetings, but where Flora Tristan had looked on Saint-Simonism as a route to Socialism, the Pereires saw it as a blueprint for industrialization. Emile was the theorist of the two and when *Le National*, the newspaper on which Clovis Gauguin worked, was founded in 1830 the young Pereire quickly offered his services as a writer on economic affairs. His 230 articles in *Le National*, published in a mere three years, constitute a brilliant chronicle of the economic life of Spain, Britain and France at the time, but his aim was not merely intellectual enlighten-ment; he was trying to change the climate of opinion in France, and it was hardly surprising that the newly arrived Napoleon should have

picked him out as one of the young technocrats he would need to spear-head his economic revolution. The Pereires began by building railways and when the emperor decided to pull down and rebuild his capital city, Emile and Isaac and their supporters were more than happy to help, setting up the Société du Crédit Mobilier, which drew in investments to be used for property development, notably along what is now the Rue de Rivoli, and in the new luxurious apartment blocks in the area around the Parc Monceau, where a style of life was maintained which Zola would later caricature in *La Curée*.

This was the world in which the Arosas moved, but while both brothers had emulated the Pereires in making huge fortunes out of the empire's heady rush for riches, neither Gustave nor Achille-Antoine quite matches Zola's descriptions of the vulgar nouveaux-riches. Far from living in the gilded and velvet-swagged halls of the Plaine Monceau, Gustave occu-pied a charming old house at 5 rue Breda (today the Rue Henri-Monnier), facing the pleasing little tree-lined Place Breda (today the Place Gustave-Toudouze). This was undoubtedly the most substantial house in the street, but the area itself was far removed from the excesses of the Second Empire. The narrow streets of this part of Paris were untouched by Haussmann's changes. Arosa's street leads up to the notori-ous Place Pigalle and thence to Montmartre, and runs off the Rue Notre-Dame-de-Lorette where Gauguin was born and where Delacroix once lived. George Sand was a near neighbour in the Rue La Bruyère and the area's literary and artistic connections say much about Gustave's own taste, for he moved in quite other circles to those of his fellow financiers. Typical of his friends was Félix Tournachon, who under the pseudonym Nadar, ran one of the most unusual photographic studios of Second Empire Paris and was certainly the most prescient recorder of the age. His influence on Gustave Arosa can be seen in the latter's purchase of works by many of the people his friend had photographed. First among these were seventeen works by Eugène Delacroix, bought at a time when the artist's reputation was still not firmly established and an early sign that Gustave's collecting was different from the usual slavish following of Salon prize-winners and well outside the ranks of those mocked by Zola in *La Curée*.

It was this world, rich but cultured, moneyed but mildly Bohemian, which Aline Gauguin entered when she moved to Paris in 1861 and became a close friend of the Arosas. They may, of course, have known of each other earlier through the Peruvian connection, but however they met, Gustave at forty-three was to assume the role of protector of the 36-year-old widow. Was she his mistress? Gustave had certainly had a number of liaisons before Aline moved to Paris. He belonged to a milieu which set little store by the usual, albeit hypocritical morality of the

middle-classes – his married sister Irène had left her husband and was openly living with a painter – all of which must make it likely, though unprovable, that he and Aline were lovers. Why else should he have given such unstinting help to her children? Without Gustave Arosa, Paul Gauguin would have been no more than the poor son of a seamstress, while with him he had an entrée into a world both rich and cultured. As a wealthy Spaniard in the Second Empire, Gustave was not only well off, he was fashionable. A few weeks after Napoleon's accession, the new emperor had married a stunningly beautiful, if politically meddlesome, minor Spanish aristocrat, Eugenia de Montijo, thus starting a vogue for all things Spanish – *Carmen* the play, Flamenco dancers, even the once ignored Spanish art in the Louvre. When in 1862, Aline brought the fourteen-year-old Paul from school in Orléans to Paris it was inevitable that he should quickly merge into the world Arosa offered. How much better to be Spanish, the offspring of a colonial aristocracy, than the impoverished grandchild of an Orléanais shopkeeper?

## The Guardian

In 1862 Gustave Arosa took over Uncle Zizi's role as Paul's guardian, though the position would not be formally legalized for another three years. Given all he owed to him, Paul was remarkably reticent about Gustave in his later writings and anything known of their relationship has to be inferred from other sources. It is a silence which suggests that the boy suspected that there was more to link Arosa and his mother than mere friendship. Paul must have known of the similar situation involving Gustave's brother Achille-Antoine and his mistress, Clémentine de Bussy, who was also a dressmaker. There may well have been a connection between the two seamstresses, Clémentine's home in the Boulevard des Capucines was near Aline's shop and Clémentine became the mistress of Achille-Antoine in 1863, only a short time before Gustave Arosa became Gauguin's protector. Despite her aristocratic sounding name, Clémentine was as impoverished as the rest of her family, most of whom had already adopted the more humble spelling of Debussy.

In 1864 Clémentine and Achille-Antoine agreed to be joint god-parents to her nephew Claude, the future composer. Gauguin must have seen the young child in those early days in Paris – they were in a sense cousins – though he was to remain curiously silent about it, even when Claude Debussy was beginning to make a name for himself in Paris and could have been useful to an artist who was struggling to get himself noticed. Both men were probably unwilling to associate themselves with an irregular relationship, especially Paul, who, despite the obvious advantages of luxurious homes and an entrée into a world otherwise beyond

his mother's means, seems not to have been happy with the situation. This may have been why it was reluctantly decided that he could have his wish and be allowed to go to sea. He should, however, at least try to get into the Naval Academy where he could train as an officer and to that end he was registered as a student at the Loriol Institute at 49 rue de l'Enfer near the Place Saint-Michel where he would be crammed for the Academy's entrance examinations. Unfortunately, he learned little at the Institute except how to fence. Being raised by a working mother with no father to control him had not brought out the best in someone who had already had an unstable childhood. He appears to have become something of a quarrelsome brat, arguing with Aline and his sister Marie and upsetting his mother's friends and in 1864, aged sixteen, he was sent back to Orléans to finish his education as a boarder at a local lycée. If this was an attempt to shake him up, it had little effect. His work was so poor the teachers refused to enter him for the examinations – his last chance as there was an age limit of seventeen for entrance to the Academy. The only alternative was to enter the Merchant Marine as an ordinary seaman, in the hope that he would gain experience and could thus apply for a commission later. It was the same route taken by the painter Edouard Manet who had also wanted to be a sailor thirty years earlier and who had also failed the exams. By another odd coincidence the young Gauguin's first voyage would be exactly that of the young Manet's – from Le Havre to Rio de Janeiro.

Aline in the meantime had, for the sake of her health, given up her business and moved out of Paris to the Village de l'Avenir where she and Marie lived in a small house at 3 rue de la Paix, on the route to Romainville. That November, worried about her own future and even more concerned over that of her difficult son who was about to sail out of her life, she drew up a Will, dividing her few things between the two children, leaving Paul her pictures, books and amulets, and confirming Gustave Arosa as his legal guardian. She concluded the document with the wish that Paul would 'get on with his career, since he has made himself so unliked by all my friends that he will one day find himself alone.'

## A Lady in Brazil

On 6 December 1865, in Le Havre, the seventeen-year-old Paul Gauguin signed his papers as a trainee officer and the following day set sail aboard the *Luzitano*, a three-masted vessel, of 654 tons, belonging to the Union des Chargeurs, for the fifteen-week voyage to Brazil. His only point of contact was a letter of introduction to a lady who lived in what he called the Rue d'Ouvidor in Rio, given to him in Le Havre by the young man

whose place he had taken on board ship, and who had enjoyed her favours on the *Luzitano*'s previous visit.

Paul Gauguin was a sailor for six years, from 1865 to 1871, from the age of seventeen to twenty-three. No one can doubt that so long a period, with all the new experiences it brought, must have radically affected his thinking. He grew up during those six years and the Gauguin who left Le Havre a gauche, difficult schoolboy must quickly have learned adult ways. Surprisingly for someone so self-obsessed and usually so willing to commit his heroic struggles to writing, Gauguin recorded virtually nothing of his life at sea except for three anecdotes – two of which seem to contradict each other – and a couple of passing references in his later correspondence that do no more than help identify the places he visited. This has not stopped his biographers from imagining a highly romantic interlude. One French writer, Henri Perruchot, waxed lyrical over the salt sea wind which made Paul 'feel a new man' and described a first encounter with the 'natives': 'The sunlight playing on the tamarinds, the oleanders and the palms'. For Paul this was, in Perruchot's purple prose: 'virgin earth peopled by a primitive and simple race'.

Actually all Gauguin's recorded memories are about sex – hardly surprising in a seventeen-year-old boy cooped up on a ship for nearly four months. He claims he 'first sinned' in Le Havre before sailing and appears to have spent much time on board listening to the older sailors fantasizing about their randier exploits. Standing watch one night, a lieutenant told him how, when he was a cabin boy, he fell overboard, was picked up by a passing ship and dropped off on a remote Polynesian island where he was forced to lose his virginity and spent two years in sexual ecstasy until another passing ship took him back to France. Confusingly, Gauguin rather undermines this tale by claiming later that it was the cabin boy on the *Luzitano* who was washed overboard as they approached Rio and was only saved when one of the negro sailors dived in and hauled him out.

All Gauguin tells us of Rio is how he followed up his introduction to Madame Aimée, a leading actress in the Offenbach operas, who, despite being the mistress of a son of the Tsar of Russia, takes in the young Paul, even though, by his own admission, he was short of stature and looked about fifteen.

'Aimée overthrew my virtue,' he would confide in *Avant et après*. 'The soil was propitious, I dare say, for I became a great rascal.'

On the return journey to France there was a Prussian woman among the passengers whom he managed to pleasure in the sail-store near the main companionway. When she wanted to see him again, he gave her a false address. 'It was very bad of me . . . but I could hardly send her to my mother's house.' Quite.

The following year, between May and September 1866, he made a second voyage to Rio aboard the *Luzitano*. For all the sexual boasting, Gauguin's later letters indicate that he was not particularly thrilled by life at sea. He was paid twenty francs for the voyage, living conditions were cramped and the work was hard and repetitive. He seems to have stayed with it for lack of anything else, since he had no qualifications and no burning ambitions and little with which to occupy himself except what he refers to as 'the breeches-end'.

That October, while he was on home-leave, Aline moved to Saint-Cloud, then a pretty village on the ridge looking down over the Seine and the newly laid-out Bois de Boulogne and thence to Paris itself. Since the Compagnie Pereire had built a railway link from the capital, many business families, the Arosas among them, had acquired substantial country mansions on the outskirts of Saint-Cloud. Despite the opposition of the Empress Eugénie, who preferred the imposing residence of the first Napoleon at Compiègne, the emperor found the Château de Saint-Cloud conveniently near to Paris for grand receptions and a useful place to house foreign dignitaries. Queen Victoria and Prince Albert had stayed at Saint-Cloud during their visit to the Universal Exhibition in 1855 and her Majesty had recorded in her diary her enthusiastic impressions of the sumptuous décor in the suite she and her consort had shared. Much of the palace was still decorated in the style of Napoleon III's predecessor Louis-Philippe, but the Galerie d'Apollon had been encrusted with all the excessive abandon of Second Empire taste.

Gustave Arosa had a substantial villa, also in Second Empire style, on the Rue du Calvaire a little way from the centre of town, heading north, between the new railway and the river. Aline, however, lived in a modest house, 2 rue de l'Hospice, behind the village church, one of the winding streets that mount the steep cliff which gives Saint-Cloud its pleasing views over Paris. Her little house was decorated with the souvenirs of her uneasy life – the Peruvian pottery and silverware, her books and the odd memento of the father and grandmother Paul had never known. Aline's health had continued to decline and she may have chosen what was to be her last home because of its proximity to the famous hospital founded by Marie-Antoinette.

Paul's home leave after the second return from Rio was the last time he would see his mother. Aline seems to have suspected that she had not long to live and had made arrangements for Marie to return to Orléans to complete her education. She seems to have washed her hands of Paul who was clearly going his own way no matter what she might say or do.

On 27 October 1866, Paul sailed from Le Havre aboard the *Chili*, another three-master, though twice as big as the *Luzitano*. He had been

promoted to second mate on 50 francs' pay and the voyage was due to last over a year. The boat put in at Cardiff in Wales before setting off across the Atlantic for the Straits of Magellan where Clovis Gauguin was buried. We know that the vessel called in at Valparaiso and Iquique on the coast of Peru but from then on we are left with guesswork and unreliable accounts of later friends who tried to piece together what Gauguin had told them of his early life. The assumption has always been that the *Chili* sailed round the world but the evidence for this is very unreliable. In truth, the journey seems to have been something of a disappointment. Although they reached Peru he did not visit Lima and the voyage aboard the *Chili* can only have confirmed Gauguin's belief that a romantic life at sea was proving a chimera. Far from circumnavigating the globe, it is just as likely that after Peru the *Chili* turned round and retraced its passage back down the coast of South America and across the Atlantic to Le Havre where it docked on 14 December 1867, thirteen and a half months after it first sailed.

Paul was now determined to leave the merchant marine though he would remain a sailor for some time yet. He was due to undertake his military service and would obviously spend it in the French Navy.

Where and when he learned that Aline had died on 7 July the previous year is not known. They had not been close at the end, though all his later recorded memories are exceptionally tender, especially his accounts of their earliest days in Lima. He returned to Saint-Cloud to find the house empty – Marie was already at the boarding school in Orléans which their mother had arranged for her and it is probable that Paul stayed with his guardian at the villa on the Rue du Calvaire.

He was now the owner of the family papers, including the surviving books and documents of his grandmother Flora Tristan. The records of his grandfather's trial would have revealed more than enough of the horror his mother had experienced and probably account for his amnesia over anything relating to his Chazal forebears and his subsequent refusal to have anything to do with that side of the family.

## The Brilliant Empire

Paul's stay in Saint-Cloud was only a short rest between ships – on 22 January of the new year 1868, aged nineteen, he formally enlisted in the Navy in Paris and a month later was registered in the Cherbourg Division as a seaman third class. But although brief, that shore-leave must have been deeply unsettling. On top of any sadness over the death of his mother there was much going on in the wider world that would have puzzled someone used to the enclosed life of an ocean-going vessel. The year 1867 was at once the high point of Napoleon III and Eugénie's

glittering empire and the moment when their world began its slide towards a chaotic end. On the surface, their successes were everywhere apparent: the new Paris was largely complete and undoubtedly merited Walter Benjamin's remark that 'it was the capital of the nineteenth century'. There were, of course, tensions pulling at the social and economic fabric of the empire. Napoleon III, with his supporters such as the Pereires, was an advocate of free trade, hoping to emulate British success as an international commercial power, but many of the big industrialists, while they had profited from the emperor's policies, believed in protectionism. At a broader level, Napoleon III's government had been enormously beneficial to the lowest levels of society: peasant-farmers had never been so well-off and the urban workers counted themselves lucky to have full-time employment at last, instead of the casual labour of an earlier age. But this success with the poor alienated the middle classes who felt their social position threatened and when Napoleon III gave his support to the Italian nationalists, struggling for the unity of their country, he created a groundswell of right-wing Catholic opposition which took its lead from the aggrieved Pope in Rome.

In 1867, it was still possible to ignore such opposition. On the surface, Napoleon III seemed perfectly secure. He had even granted new laws which would allow freer elections the following year, at which point he would graciously permit some of his one-time critics to take office and thus usher in the new 'Liberal Empire'. Many of those who had formerly attacked him and fled into exile were now reconciled to a man who never seemed to do too much harm and seldom persecuted anybody. However, by 1867 those closest to the emperor knew he was sick and increasingly hesitant over crucial matters of policy. While there had been little he could do to impede the increasing power of Prussia under Bismarck and could only look on in alarm at the defeat of Austria at the Battle of Sadowa, the collapse of his own attempt to gain a foothold in the New World by launching the Austrian Prince Maximilien as emperor of Mexico, was very much a personal failure. The scene of the wretched Maximilien's execution in June 1867 was painted by Manet – the firing squad dressed in *French* military uniforms to drive home the message of where the guilt should lie. The act was aptly described by the terrified Eugénie as 'the beginning of the end of the dynasty'.

Little of this had much effect on the ordinary citizen, but in 1867 the property bubble suddenly burst, taking the Pereires with it, and bringing financial ruin to a broad swathe of French society. The Rothschilds had always said this would happen and the collapse of the Crédit Mobilier shook the confidence of those speculators who had seen no end to the leap-frogging financial success of the booming Second Empire. On 20 September 1867, with shares in the Crédit Mobilier in free-fall, the

Pereires resigned, though they later astounded their more vicious critics by handing over a large part of their personal fortune to recompense the smaller shareholders who had lost so much.

Fortunately for Paul Gauguin, his guardian seems to have avoided this débâcle. With a market depressed in the wake of the Crédit Mobilier's collapse, the *agents de change* could not make the sort of high commissions they had known in the boom years, but Bertin and Arosa were secure enough to sit out the recession. In any case, it is clear that Gustave did not play the active role that he once had. By 1867, he no longer worked in the Bertin office but had become a simple *commanditaire*, a sleeping partner, and was content to take up his many interests as a collector.

It was Arosa's interest in art, more than any financial help, that was to be his most enduring gift to Paul Gauguin, allowing him access to a wide range of work that he was able to study at his leisure, either in Paris or at Saint-Cloud. From the first, Gustave's taste ran to the more adventurous painters such as Delacroix and Courbet, artists who had stood out against the academic system. As the 1860s progressed he went on to collect works of the Barbizon School – Harpignies, Théodore Rousseau – which still had a whiff of radicalism about them, landscapes painted outside and not as officially ordained, safely in a studio and blessed with a respectable classical touch – by, say, a Doric temple on a distant hilltop. Where, today, Barbizon paintings look solid and sombre, when Gustave Arosa was collecting them, they were thought to be dangerously light, enough to strike at the very roots of national culture. To go out into the forest of Fontainebleau, near to Barbizon, and paint direct from nature was in itself a protest, a statement that reality with all its flaws was more vital than the ordered antique dreamworld created in the studio. Such action, so the opponents of the *plein air* painters believed, undermined the hierarchical order which sustained the nation and which was replicated in the world of art by the established structure of the Academy and the Salon jury. Anything else was revolution and by admitting it to his drawing room, Gustave Arosa was placing himself firmly amongst the avant-garde and was, although he was unaware of it, offering Paul Gauguin, the future artist, an introduction to some of the most recent ideas on art, bypassing completely the conventional *art pompier* favoured by court and salon and the art schools of the day. Through his personal taste, Gustave Arosa enabled his ward to avoid the long process of growing out of academic convention before moving onto the new, the laborious journey that most artists were forced to make. Instead, Gauguin was propelled into the here and now – and not only by Gustave. Achille-Antoine collected too, keeping works in Paris and Cannes. Because these collections were never sold at auction, as

Gustave's would be, there are no catalogues to reveal what Gauguin might have seen. But we know from Debussy's later memories that Achille-Antoine also patronized the Barbizon artists and that his houses contained works by Théodore Rousseau, Boudin and Corot, works which Gauguin must surely have known.

There was, however, more to it than painting. Most people collect out of a love for the thing collected, a few simply collect, and Gustave Arosa appears to have been one of the latter. In 1867 one of his friends, Auguste Demmin, published the magisterial *Guide for the lover of Faiences and Porcelain*, in which the entries for Gustave's collection were only outnumbered by those of Demmin himself, even though Gustave had been collecting his pieces for only four years prior to the book's publication. (He is not even mentioned in Demmin's earlier, 1863, edition.) And because the Guide concentrated on European pottery it gave only a hint of the scope of the Arosa collection, for by then Gustave was already buying pieces from all over the world, including the pre-Columbian ceramics from Peru that his ward was familiar with from his years in Lima.

In some ways the most interesting thing about Demmin's Guide is not what it shows of the range of Arosa's taste, which was clearly broad, but that it also indicates another fascinating sideline, photography: the illustrations in the book are of a very high quality and are marked with the name of 'G. Arosa and company', a business which began in the year of so many changes, 1867, after Gustave had visited the second Universal Exhibition and stumbled on the invention which would allow him to combine his creative interests with his flair for business.

## The Servant of Science and Art

For this second exhibition, the emperor prudently decided not to leave the honour of French industry in the hands of Plon-Plon: he would be honorary president, the real work was to be done by the ultra-efficient Haussmann. But even Haussmann was unable to prevent bad spring weather from turning the Champ-de-Mars into an unfinished mud patch when the imperial couple declared the Fair open on 1 April 1867. Haussmann had wisely kept art in the background, though he still offered space to the usual official stars. Pride of place went to Cabanel, the favourite painter of the emperor, who had lent a picture from the imperial collection, of Venus floating atop the waves, surmounted by some disporting overfed cupids. The great exclusion of this exhibition was Manet, who opened his own one-man show across the river near the Pont de l'Alma. Nadar went up in a balloon to photograph the huge circular pavilion covering 16 hectares, which housed 52,000 exhibits, the heavy

machinery and mechanical wonders of the leading industrial nations, and Manet duly painted him doing so.

With hindsight, there were great portents to be read in the exhibits offered by the industrial giants. Britain sent the sort of highly practical steam engine which would ensure her international commercial supremacy for another twenty years, while France proudly presented Monsieur Edoux's wonderful new hydraulic lift – just the sort of thing that would appeal to the owners of all those fashionable apartment blocks towering over the Parc Monceau – had they the money left to buy one. Most visitors ignored what the Prussians had sent. It was rather dull, a huge squat cannon manufactured by Krupps in Essen, though in a mere four years, it would be brought back to Paris to reduce those same apartment blocks to rubble.

For Gustave Arosa, and thus for Paul Gauguin, the most interesting section in the whole exhibition was that devoted to photography, one area where the manufacturing superiority of the British was not so evident. Of the three men who can be jointly credited with the invention of the earliest forms of photography – Daguerre, Fox-Talbot and Niepce, two were French, and as far as applying the new techniques was concerned Nadar was unsurpassed, whether perfecting aerial photography from his balloon or making subterranean images in the new sewers running beneath Paris. Until 1867, it was the daguerreotype which had the most effect on everyday life – those families who might once have hired a jobbing painter to immortalize an ageing parent or a newborn infant now turned to the photographic salons, leaving the painted image as the province of the very rich. But what the exhibition now made clear was that the next moves would be less to do with the human image or with photography as art, and more to do with printing. The principal pre-photographic means of mass reproduction had been the sort of wood-block engraving practised by the Chazal brothers, Gauguin's fore-bears. So far photography had had little impact on this, for while the daguerreotype was suitable for studio-based subjects who were able to remain motionless for the considerable exposure times, it had proved hopeless at photographing inanimate objects such as works of art, which did not offer the dramatic contrast of tones sufficient to surmount the limitations of the process, which usually turned even the mildest sitter into a character of glowering melodrama. It was therefore with under-standable excitement that the 49-year-old Gustave Arosa, walking through the exhibition in 1867, came across a new process, *phototypie*, invented by Cyprien Tessie de Mothay and his colleague Charles Maré-chal, which offered an incredibly detailed standard of printed repro-duction of sculpture and paintings, with a far greater definition than anything Gustave had so far seen. It was also impressively convenient.

Instead of the usual heavy lithographic stones, thin metal plates were covered with light-sensitive gelatine upon which an object could be exposed. Once the light-hardened gelatine image had set, the pliable metal plates could be turned onto a circular drum, allowing the rapid printing of up to seventy sheets before the gelatine peeled. It was enough to transform the relationship between art and the general public, allowing Fine Art printers to reproduce easily and cheaply the master-works of the great artists and it was Gustave Arosa who saw all this, contacted the inventors and bought the patent.

It was precisely the sort of business he was made to undertake, one in which he could combine his commercial skills with his extensive under-standing of art and photography. He set up his company at his residence at Saint-Cloud and began work immediately. Within a year he had pub-lished his first major collection, *Les Frises du Parthénon par Phidias* (1868), a series of twenty-two photolithographs of the casts made by Choiseul-Gouffier of sections of the Parthenon frieze, accompanied by a short essay by the critic Charles Yriarte. *Phototypie* would later be improved by others so that more copies could be printed and the process was given the name *collotype*, by which it is best known, but even in its original form it was a marked advance on former methods of reproduction.

Gustave Arosa's bubbling enthusiasm for his new venture must have been one of the rare things to lighten the gloom of Paul Gauguin's shore-leave in 1867. That Paul was gripped by the results of the new method is well documented. He studied the Parthenon figures avidly, and was given off-prints of those he liked, some of which he jealously hoarded until his death, carrying them with him wherever he went. He was well aware that artists he admired like Delacroix and Courbet used photography as a useful resource, collecting nude poses which they could draw on for their figure studies. Courbet was discreet about this but Delacroix rejoiced in the progress of the medium and interested himself in new technical developments as now did Gauguin. We do not know when Paul acquired his first camera but it is certain that he was familiar with photographic apparatus from this time on and showed none of the snobbish resistance to the mechanical image so often maintained by the Fine Art community.

## Hair: Chestnut, Eyes: Brown, Nose: Average

With so much happening in Paris and Saint-Cloud, Gauguin must have been less enthusiastic than formerly at the prospect of another long stint at sea. His few recorded reactions to this period in his life indicate a gradual disenchantment with his chosen career. He arrived at Cherbourg on 26 February 1868 to take up his post as a seaman third class. His

*livret militaire*, the official document recording his military service, has survived, giving his number as 1714 and describing him as: Height: 1 metre 630 millimetres, Hair: chestnut, Eyes: brown, Nose: average, Forehead: high, Mouth: average, Chin: round, Face: oval. He is listed as having no particular distinguishing marks, no vaccinations, no previous service, no battles, no wounds, no *actions d'éclat*.

Such documents were hastily compiled and often far from accurate – as is the case here. Gauguin's hair was reddish, his eyes greenish and his nose had quite obviously been broken in a fight – though he claimed, if asked, that its hooked quality was a sign of his Aztec ancestry.

In general, accounts indicate that he was tall, though the height given in the *livret* is less than average for the time. One or two witnesses did record that he was smaller than most and one suspects that he was well-built, stocky even, and that allied to a swaggering manner, this left most people with the impression that he was a big man.

As he waited to be posted to a ship he must have experienced some trepidation – life aboard the average warship for a third-class seaman would hardly be pleasant. Fortunately, there was an older family friend who may have used her influence on his behalf. Berthed at Cherbourg was a wooden-hulled clipper. She was schooner-rigged, though with a steam-driven engine, and had been acquired by the navy in 1866, transformed into a yacht, renamed the *Jérôme-Napoléon*, and placed at the disposition of the emperor's cousin Plon-Plon – the man who had organized the Universal Exhibition of 1855. This prince was something of a cuckoo in the Bonaparte nest. He espoused republican ideas which his enemies said was due to his pique at losing his place as heir to the throne at the birth of Eugénie's son the Prince Imperial. Plon-Plon also collected fashionable art, the sort of thing he had promoted at the Universal Exhibition, and maintained a salon at his flamboyantly over-decorated residence in the Avenue Montaigne to which writers and intellectuals were bidden. He was as short and as stocky as most of the Bonaparte clan, but where the emperor won friends by being polite, reserved and unfailingly charming, Plon-Plon was gruff, ill-tempered and disagreeable. Yet even someone as rigorous in her choice of friends as George Sand visited his residence and maintained an embarrassingly unctuous correspondence with him, and this may explain Gauguin's lucky break. Given that a young conscript would have had little chance of a desirable posting on an imperial yacht, we may assume that George Sand, the woman who had once taken care of Aline Chazal, had now intervened on behalf of her son.

Paul Gauguin, seaman third class, was assigned to the *Jérôme-Napoléon* on 3 March 1868. As the prince was unlikely to go cruising until the summer, this was initially an easy posting, with nothing but maintenance

duties and plenty of time ashore. The boat, however, was not merely a pleasure ship. Plon-Plon saw himself not only as a Medici of the arts but also as a man of science, and would from time to time undertake 'scientific expeditions' with invited scholars aboard.

In June 1868 the *Jérôme-Napoléon* sailed for Toulon to await the arrival of Plon-Plon and his wife the Princess Clotilde for a cruise in the eastern Mediterranean and the Black Sea. Once under way, life aboard for such as Gauguin must have been considerably less agreeable. The vessel was only 259 feet long with much of its upper section given over to state rooms for the imperial party and the extensive galleys where the prince's chefs could prepare the long and sumptuous banquets considered obligatory at the time. All of this would have required a large crew, confined to a small space – the figure of 150 has been published but this seems barely imaginable. It is little wonder that Gauguin found his fellow sailors coarse and violent, and that frequent fights broke out below decks. Fortunately, although short, Gauguin was tough and able to take care of himself and was usually left alone, but it was a far from pleasant existence. At some point he took to sketching, more to pass the time than out of any thoughts of achieving anything special, though one imagines that this activity can hardly have endeared him to some of the roughs in the cramped galleys.

His temper now burned on a short fuse. Having been reprimanded by a quartermaster for some misdemeanour, Gauguin grabbed the man and forced his head into a bucket of water. He was nearly court-martialled and it was two years before he was given further promotion.

That first cruise lasted through June and July. In September the prince rejoined his yacht which crossed the Channel and sailed up the Thames to London, no doubt to the irritation of Queen Victoria who disliked Plon-Plon intensely and usually threatened to leave for Scotland whenever he was due to arrive.

If Gauguin had shore-leave in London, we know nothing of what he saw and did. Unlike Van Gogh who always wrote about his visits to museums and exhibitions, carefully detailing his reactions to individual paintings, Gauguin left nothing. This is all the more annoying when one realizes that in that year alone he had already visited Constantinople and the Greek Islands, which must surely have had some effect on him.

In April and May of the following year, 1869, there was another Mediterranean cruise calling at Bastia, Naples, Corfu, Trieste and Venice – but still no record from Gauguin of anything seen or done. He was now twenty-one and legally an adult and in June of that year he and Marie inherited nearly 33,000 francs from their mother and a further 6,200 francs from the estate of their grandfather Guillaume, a not

inconsiderable sum though it was still mainly tied up in property in Orléans, along with some stocks and other assets which produced little return.

In September he was hospitalized for a month, why we do not know, and for the first six months of 1870 there was a complete hiatus, with the *Jérôme-Napoléon* berthed at Cherbourg awaiting the whims of the prince.

What Gauguin and his fellow sailors did not know was that Plon-Plon could not leave Paris because of a desperate crisis threatening his cousin's empire. Napoleon was ill, a stone in his bladder meant that he could only urinate with the aid of a catheter and that while constantly weakened with pain he was unable to control the bellicose actions of his empress. Napoleon understood how fragile the balance of European diplomacy was, and knew that making warlike noises was a dangerous game. Eugenie, with her southern temperament, most assuredly did not.

It is probable that Gustave Arosa, with his Spanish connections, had a better inkling than most of just what was brewing in the chancelleries of Europe, for Spain, or rather the vacant Spanish throne, lay at the heart of the growing dissension. Having rid themselves of the licentious Queen Isabella ii two years earlier, the military rulers in Madrid had been casting about for a replacement and had settled on a Hohenzollern prince – an idea much encouraged by Bismarck who was only too happy at the prospect of a Hohenzollern regime along two of France's frontiers. Reactions to this proposal in France were wildly bellicose and Napoleon found himself dragged by public opinion into unofficially threatening war unless the Prussian-backed prince withdrew his candidature. Yet even as war approached, Plon-Plon pressed ahead with a 'scientific' voyage to the polar seas. The *Jérôme-Napoléon* sailed from Cherbourg on 3 July, nine days before the deadline for a Hohenzollern withdrawal insisted on by an increasingly worried Napoleon. The principal guest on board the *Jérôme-Napoléon* was the forty-seven-year-old Ernest Renan, historian and Hebrew scholar, who had just published the third volume of his six-part *Life of Jesus*, the first major work of scholarship to seriously question the divinity of Christ and a work which has formed the basis of all succeeding debate on the historical truths of the Christian faith. Excoriated by the Catholic hierarchy, Renan had just the sort of notoriety which appealed to Plon-Plon. His dismissal from the post of Professor of Hebrew at the Collège de France, his intellectual republicanism which nevertheless allowed him to reluctantly support the Empire, sat well with the prince's views.

It began well. The *Jérôme-Napoléon* crossed from Cherbourg to Peterhead, in Scotland, to Norway, arriving in Bergen on the 9th. Once ashore they admired the wooden houses and noted details of the flowers

and vegetables they saw, much as if they were anthropologists in Africa, instead of tourists in northern Europe.

While it is highly unlikely that the ratings, below decks, would have had more than a glimpse of the grandees above, the future importance of Renan and his family in Gauguin's life makes it equally hard to believe that they never met. Renan's son Ary was to become a painter and an admirer of Gauguin, willing to intercede on his behalf when he needed help from officials who were impressed by the Renan mystique. While the father did not play a personal role in Gauguin's life, his work became so central to the younger man's thinking and such a strong influence on his work that Gauguin eventually became known as a 'Renanist', an avowed disciple of the author and his school of followers.

Unfortunately, the cruise was to offer little chance for peaceful discussions on the religious and historical topics for which Ernest Renan was already notorious – the day after their arrival in Bergen the prince received a telegram from Paris warning him of the seriousness of the situation and requesting that he stay within reach of a telegraph-office. He ignored this, and when the party arrived in Trondheim went salmon fishing. At first his insouciance, or indifference, seemed justified. At Tromsø on the 13th the news was good: the king of Prussia had backed down and persuaded his kinsman to withdraw. All might have been well if the warmongers in the French government had not insisted that Napoleon humiliate the king by sending a telegram insisting he renounce all future claims to the Spanish throne on behalf of anyone in his family. Bismarck in Berlin was not to be cheated of the war which he believed would unite Germany under the Prussian crown and carefully edited the king's reply to make it look like a deliberate snub to Napoleon's representative. Copies were sent to all Prussian embassies, then leaked to the press, provoking the French to heights of war fever. 'To Berlin!' screamed the enraged Parisian mob, and a sick and despondent Napoleon caved in and wearily gave them their wish.

On the night of 14 July, in his cabin, aboard the *Jérôme-Napoléon* in the harbour at Tromsø, as yet unaware of what had taken place between the two powers, Ernest Renan the great rationalist, the man who believed that science would one day explain everything, had a nightmare: he could see his little house in Sèvres with his wife and children and tried to join them but no matter what he did he could not get near. The next day Plon-Plon received a telegram with the fatal news of how events had swung back towards war. That same day he and Renan set off on horseback to visit a Laplander camp but they had not got far before they were summoned back by a cannon shot from the yacht. This time there was a message that even Plon-Plon could not ignore: 'The Emperor requests you to return as quickly as possible. War inevitable. Reply at once by telegraph.'

'This is their last folly,' he said, handing Renan the final telegram. 'They'll never commit another.' For once he was right.

They sailed for Aberdeen where the prince and his guests disembarked, though he first offered a drink to the crew who joined him in singing patriotic songs. To Gauguin the outsider, conditioned to the less vain-glorious, more earthy ethos of Latin American politics, all this romantic warmongering must have seemed slightly silly. It is amusing to picture him, glass in hand, bellowing out a rousing call to arms, though less so when one thinks of the appalling carnage such foolishness was about to unleash, for like it or not, Paul Gauguin now found himself a sailor in a Navy at war.

## A Forgotten War at Sea

While the prince and his guests travelled by train to Paris via Edinburgh and London, the *Jérôme-Napoléon* headed at full speed to Boulogne, then on to Cherbourg where it joined those elements of the French fleet which had managed to make port. There was a state of considerable disarray. War had been imminent since 8 July and by the time the *Jérôme-Napoléon* put into Cherbourg the formal declaration of hostilities had been in effect for almost a week, yet there was still no one appointed to overall control of the maritime forces of the Empire. The French Navy was in many ways the best in Europe, built expressly to fight its eternal enemy across the Channel, but with forty-nine massive ironclads, constructed for naval engagements on the high seas, this was the wrong war against the wrong enemy. Prussia had only recently built a small Navy and had a mere five ironclads, but one, the *König Wilhelm*, was superior to anything in the French fleet.

As with the armies massing in the east of France, nothing was ready. The *Jérôme-Napoléon* was hastily fitted out for war but only given four decent-sized guns and some smaller armaments from the limited stock in the much depleted stores. All those aboard the boat knew it was a botched job, with no one paying proper attention to where the guns were positioned, a fact which would cost them dear as the war progressed.

For once the emperor had the good sense to resist the blandishments of Plon-Plon, who longed for command, and on 22 July, a whole week after the war had officially begun, and on the eve of his departure to join the army, Napoleon finally appointed Vice-Admiral Count Bouet-Willaumez, a flamboyant figure, thought to have the Nelson touch, to the command of the fleet at Cherbourg.

The only positive thought anyone had had was that the Danes, dis-gruntled by Prussia's annexation of Schleswig-Holstein in 1864, might join a march on Kiel or Hamburg if the French could effect a landing some-

where near by. Thus when the vice-admiral reached Cherbourg he found messages ordering him to bottle up the Prussian ironclads and explore the possibility of a joint Franco-Danish invasion of northern Germany.

As Bouet-Willaumez inspected the fleet he realized that he would probably have to take his ships round Denmark and into the Baltic. For so distant a line of communication he would need fast despatch boats, essential in the days before radio when telegrams stopped at the coast. It must therefore have been a considerable relief for him to learn that he had the *Jérôme-Napoléon*, a speedy frigate, or corvette as they were then called, which could outrun the old and slow vessels which were usually allocated this thankless task.

One of the oddest coincidences in this whole affair was that a second corvette assigned to the admiral, the *Decrès*, had amongst its crew a young trainee midshipman by the name of Julien Viaud, who would later exercise as much influence over Gauguin as Ernest Renan, perhaps more.

Engraving of the Empress Eugénie aboard the *Coligny*, reviewing the French naval squadron sailing from Cherbourg on 24 July 1870 for action in the North Sea. The picture is wrongly captioned: the yacht *Jérôme-Napoléon* on which Gauguin sailed is actually the two-masted vessel on the right, behind the small tug.

CHERBOURG. — L'Impératrice assiste, sur le vaisseau le *Coligny*, au départ d'une division de l'escadre française. — (D'après les croquis de M. de Bérard.)

Le Coligny.　　　La Surveillante.　　　L'Océan.　　Le yacht le Prince-Jérôme.　　　Le Rochambeau.　　　Le Taureau.

Viaud was a frail, dreamy young man of twenty-one who kept a cat, a tortoise and a monkey in his cabin along with his paints and sketchbooks and was thus, not surprisingly, described by one of his superior officers as a 'spoilt child, sickly complexion, artistic temperament' – no doubt the latter being the worst of the three in the officer's canon. But the young Viaud was about to surprise such critics: a decade hence, under his *nom de plume* Pierre Loti, he would be considered the most flamboyantly adventurous Frenchman of his time, one of the most famous men of the century. And where Viaud/Loti led, Paul Gauguin followed. They may have bumped into each other – how not? – but if they did, Gauguin never made the connection, for by the time the artist was aware of the young man's work, Viaud had become Loti and seldom referred to that dismal period in the choppy waters of the Atlantic, except to note in his journal that it was 'a useless, sacrificed time'.

That was after the adventure had soured, for when Bouet-Willaumez and his ships set sail from Cherbourg on 24 July at five o'clock, seen off by the empress herself, they were cheered by the townsfolk milling along the quays and crowded on the roof of the casino, thrilled at the stirring sight. Of course, they could not have known that such great behemoths as the ironclads were useless in the shallow coastal waters of northern Europe. The massive boats had no proper charts of the Danish seaways and would be sailing at the limit of the reach of the numerous colliers needed to constantly refuel them. Amazingly, no one in French naval circles seems ever to have anticipated such an eventuality. Worse, no one had bothered to do a little rudimentary spying on the tiny Prussian fleet, so that Bouet-Willaumez was forced to make a cautious progress up the Channel lest the highly dangerous *König Wilhelm* suddenly appear. If the Prussian fleet were encountered, the *Jérôme-Napoléon* had orders to make for Dunkirk to alert the Ministry. Otherwise it was to steam back from Heligoland to report that the squadron was in position.

In the end nothing went according to these early plans. The Prussian ironclads had made for the port of Wilhelmshaven on the western side of the narrow entrance to the Jahde where they were now safely hidden, and the great draught of Bouet-Willaumez' ironclads, in no case less than 23 feet, the missing charts and the lack of pilots to help navigate the treacherous shoals and sandbanks of the North Sea coast made it impossible for him to flush them out.

After despatching the *Jérôme-Napoléon* to obtain further orders the admiral was eventually instructed to proceed to Kiel, the only other Prussian port of any significance and the most likely candidate for the planned invasion. It was a voyage made with great difficulty. Once through the Great Belt, the waterway between the Danish islands leading from the Kattegat to the Baltic, the French found that the Prussians had

extinguished all coastal lights and removed or misplaced any warning buoys. Bouet-Willaumez succeeded in getting through but saw at once that an invasion was impossible. Kiel stands at the entrance to the Kiel Fiord and was undoubtedly the finest harbour in the Baltic but there, guarding the estuary, was massive proof that someone should have paid better attention to the Prussian exhibits at the last Universal Exhibition – among them an enormous fifty-ton Krupp breach-loaded cannon. This mighty ordinance was capable of firing a 1200-lb shot and for Bouet-Willaumez to have got anywhere near it would have been suicide. Bowing to the inevitable, the vice-admiral contented himself with a blockade of German maritime trade while at the same time tying up the 150,000 Prussian troops, busy hastily reinforcing the German coastal defences. The Prussians prudently avoided risking their inferior fleet save for one dramatic encounter when the German corvette *Nymphe* tried a surprise attack on the ironclads but was quickly seen off by the French corvette *Thetis*. It was probably a diversionary tactic, for the *Jérôme-Napoléon* suddenly saw its opposite number, the Prussian despatch boat *Royal Eagle*, making a dash for the open seas and promptly gave chase. It was then that the chaos of the refit at Cherbourg took its toll as the French vessel had no gun on its bows and was unable to seriously threaten the enemy. By the time two larger vessels, the *Hermite* and the *Thetis*, joined the chase, the Prussian ship had taken refuge in a bay to the east of the Hiddensee Island where two of her sister gunboats could protect the retreat.

It was not until 10 September that a letter arrived informing the vice-admiral of the extent of the catastrophe that had befallen his country. Written in longhand and signed by the new minister of the Marine and the Colonies in the provisional government, it is a catalogue of horrors – the fall of the empire, the proclamation of a republic, the disastrous check-mate sustained by the army of Marshal MacMahon, the surrender at Sedan, the capture of Napoleon III, and finally the immobilization of the forces of Marshal Bazaine which, held before Metz by considerable forces, had not been able, despite a few successes, to disengage from the grip of the Prussian army.

The dismal letter went on to explain that the enemy was now marching on Paris and that there was nothing anyone could do to prevent them laying siege to the capital. It was a message of despair and it ended with no more than a vague appeal that the vice-admiral should continue to display his usual patriotism.

After the fall of the empire, on 4 September, there was nothing for Bouet-Willaumez to do but leave the Baltic so as to sustain the blockade of the Prussian fleet at Wilhelmshaven and prevent it from attacking the coasts of northern France. It was not until 29 October, when Marshal

François Bazaine finally surrendered at Metz, that the Prussians were able to despatch enough troops to completely seal off Paris. From mid-September all thought in the capital had been directed towards holding back the remorseless advance of the enemy. It is all the more bizarre therefore, that on 19 September, as the first Prussian lancers were entering Saint-Cloud and the encirclement of Paris began, some vengeful soul in the Ministry of the Marine should have found the time to despatch an order to the fleet that no vessel should any longer be named after a member of the disgraced imperial family. The *Jérôme-Napoléon* was henceforth to be called the *Desaix*. Under this name the vessel was to sail to the Scottish coast and await its new captain, Louis Chevalier.

For Gauguin and his fellow sailors, what had begun as a possible invasion of Germany now settled into little more than the policing of the Channel, boarding any suspicious-looking ships which might be carrying goods to any of the North Sea ports. None of them was armed and it was tame stuff – on 9 October, operating alone, they captured a three-masted cargo vessel, the *Don Julio* operating out of Hamburg, twelve days later the crew seized the *Ludwig* carrying timber between Riga and Tynedock on the north-east coast of England, but on 28 November, when the crew boarded the schooner *Frei*, they found themselves accused by its irate captain of being inside British territorial waters aboard a vessel loaded with planks which were the property of two English companies, one in London, the other in Liverpool. They ignored his protests and continued to impound his vessel but the account brings into focus the delicacy of their mission which, given the collapse of authority in France, bordered on piracy. It is that which makes the fate of a fourth ship all the more puzzling. On 11 October the *Desaix* captured the bark *Franziska* sailing out of Rostock and recently available East German archives reveal that it was never returned after the war. In all the confusion it completely disappeared and what the crew of the *Desaix*, Gauguin among them, did with this ship will probably never be known.

One last element must be added to this curious period in Gauguin's life. When the fleet was finally disbanded, the young midshipman Julien Viaud was sent aboard a ship to South America, where he was transferred to the frigate *Flore*, an admiral's flagship leading a mission to the island of Tahiti in the South Seas. It was to be the turning point in Viaud's life, the adventure that would make him one of the most popular authors of his day and in turn the source of the great dream that would haunt Paul Gauguin and which, in the end, would transform his life and his art.

# The End of the World

Paris was by now completely surrounded and the only messages to leave the embattled city were borne out by Nadar in his balloon. The Arosas had already fled. Long aware of the political dangers involved in meddling in Spanish affairs, the family had been more prepared than most for the subsequent nightmare. Seven days before war was declared, Gustave's daughter Irène and son-in-law Adolpho Calzado left for Madrid. That same night his old father François left for Saint-Ideuc near Paramé on the coast of Brittany where, over the next few months, he was joined by Gustave and his wife Zoë and youngest daughter Marguerite along with Marie Gauguin. Their prescience was amply rewarded when the horrendous news of a starving Paris and the bombardment of Saint-Cloud reached their distant refuge.

The last attempt to break out of the besieged capital on 18 January ended in a débâcle and the deaths of 4000 men who had joined the National Guard. Most of the fighting had been concentrated to the south-west but the following day a futile attempt to retake Saint-Cloud resulted in utter catastrophe when the irate Prussians began to fire the town. They first torched the Château which had been so admired by the emperor's foreign visitors, but quickly set to work on the town itself, which was soon burning so furiously the blaze continued for over three weeks until 17 February.

Realizing that all the coastal towns were now in danger of the advancing Prussians, the Arosas took ship on 14 January and sailed to Saint-Aubin in Jersey where, on British territory, they could watch in safety the denouement of the appalling tragedy. News was scarce and always bad but they tried to keep up their spirits as best they could with Marie accompanying Marguerite when she went sketching in the surrounding countryside. It was harder for the older members of the family who could only imagine that everything they had worked for was now being destroyed.

By mid-January Paris was silent as illness spread among the hungry population. On the 23rd the Government of National Defence gave up the unequal struggle and five days later an armistice was agreed. But the unforgiving Bismarck now insisted on massive reparations – a huge financial indemnity and the ceding to the newly proclaimed German Empire of France's eastern provinces: all of Alsace and part of Lorraine. While the French negotiators could do nothing but agree, Bismarck doubted their authority to sign and insisted on a general election on 8 February. Following this, a reluctant Adolphe Thiers, sometime founder of *Le National* newspaper, was elected leader of a defeated France and put his name to the peace treaty.

The war was over. The Navy was instructed to abandon the blockade

and to proceed to port. The *Desaix* was ordered to Toulon in the Mediterranean, from which there was a brief visit to Algiers then finally back to Toulon where Gauguin was given a renewable ten-month leave. He had no intention of ever returning and his *livret militaire* is signed off six years later with the laconic comment: 'provisionally stricken off as missing without any news.'

He did no more than tens of thousands of other disillusioned servicemen, joining the countless displaced persons wandering the country, hoping to find family and friends and trying to discover what had happened to their homes and indeed their lives. Gauguin was unable to enter Paris which was now in the throes of its deepest agony. Unwilling to bow to Bismarck's harsh terms, the citizens of Montmartre in the north of the city had risen up, seized arms and declared themselves an independent commune. In a single day the rebels were in control of the whole city and Thiers' government was forced to repair to Versailles. It was not until 21 May that Marshal MacMahon's forces broke into the city and brutally annihilated the last of the Communards, some of whom had set fire to parts of the city including the sumptuous Tuileries, the palace where Napoleon and Eugénie, now exiled in England, had so flamboyantly displayed their imperial grandeur.

When Paul Gauguin was finally able to get to Saint-Cloud he found that the fire which had engulfed Marie-Antoinette's hospital had also consumed his mother's house. We can get an accurate eyewitness account of what he must have seen from the record of the diarist Edmond de Goncourt who visited the town a month after the fire. 'Saint-Cloud is no more,' he wrote. 'It is a field of stones, of rubble, of plaster – where, on caved-in cellars, rise burned and broken walls, still decorated at their most inaccessible heights with fragments of furniture: here the niche by the stove, there a daguerreotype portrait, further on a billiard table with the scoreboard ready, further still, in a cupboard, whose door bangs in the wind, the gaping mouth of a bidet.'

According to Gauguin, everything he had ever known and loved was gone – every souvenir of his childhood in Peru: the 'Inca' pottery was all smashed, the silver amulets had melted in the heat, all the family papers were burned. This was not quite true – the worst loss was the Peruvian art which meant so much to him, but the portrait of himself as a child by Jules Laure survived, as had some of Flora Tristan's books. But the significant point is that Gauguin always ignored them, insisting that *everything* had been ruined, that every memento of his past had been totally and utterly destroyed. After what he had been through, one can understand why. Eugène Henri Paul Gauguin at the age of twenty-three had quite simply decided to begin again, as if what had gone before had never been.

# 4

◆

# *The Bourgeois Gentleman*

Gustave Arosa returned to Saint-Cloud fearing the worst. News had reached Jersey that his house had been looted then torched by the Prussians and that everything, including his art and pottery collections, had been destroyed. He was thus overjoyed to find that he had been misled, that the Rue du Calvaire had been far enough from the centre of the little town to escape the fire and that all the villa had suffered was a single Prussian shell, which had passed through the building without causing too much damage. The pottery and the paintings were safe. As he quickly discovered, he had indeed been lucky. Much else, especially in Paris, had been destroyed, first in the long siege and later during the final demented days of the Commune.

Bertin and his associates now set about re-establishing their businesses within an economy distorted by the obligation to pay off the 3,500 million franc indemnity demanded by Bismarck in final settlement of the war. Far from this being the out-and-out disaster that is usually portrayed, it actually caused an inflow of capital as speculators in Berlin and London rushed to lend money at favourable rates to the French banks who were charged with the payment, a circulation of capital that was to make the 1870s hugely profitable for the Paris Bourse and thus for Bertin and Arosa.

The damage to property in and around Paris was far more serious, though given how terrible the siege and the last days of the Commune had been, it was truly astonishing how quickly life returned to something approaching normal. Indeed there seems to have been an unspoken desire on the part of the entire nation to sweep away the debris and return whatever could be rebuilt to its former state, as if the nightmare had never happened. Few paintings made at this time show anything of the desolation that lay all round – there are even landscapes where the burned buildings and scorched fields are edited out, as if by refusing to accept the horror, the more quickly would it be put to rights.

Given all he had to do, it is praiseworthy that Gustave found the time to discharge his obligations to Marie and Paul whom he had promised Aline he would protect. There was little problem with Marie who after the long exile was now part of his family. She was close to Gustave's daughter Marguerite and continued to live with them in Paris and Saint-Cloud. Aline's Will had requested that Gustave arrange for Marie to be placed in some sort of business, if he thought this best for her, but in the end he decided to treat her exactly as his own daughters and maintained her as a gentlewoman without the necessity to earn her living.

Paul was more problematic. A rough, tough ex-sailor was hardly an ornament to a cultured drawing room, nor was there much in the way of employment for which he was suited. Years at sea had hardly improved his gruff manner and he was noticeably devoid of any ambition or direction in life. The solution Gustave found was to persuade his friend and associate Paul Bertin, the *agent de change*, to employ him in some capacity, in the hope that Paul might emulate his own success and make money on the Stock Exchange. This 'career', if something so haphazard merits the name, has been so misunderstood that it has done more to distort the common view of Gauguin's life than anything else. He is variously credited with being a stockbroker or a banker, even though a moment's reflection must lead anyone to ask how an unqualified seaman could have suddenly leapt into either role, even assuming that he had had the urge to do so.

Much of the confusion arises out of an ignorance of the workings of the Paris Bourse, even in France. Outside the official *agents de change* was a second group of traders which filled a gap in the market that the *agents* were unable to tackle. The *agents* could not issue shares; that was left to the banks. The Bourse was effectively a secondary market where shares were traded once the initial stock had been issued. This made capital harder to raise than on the more open London Stock Exchange and so a sort of second or parallel market grew up whose practitioners were known as *coulissiers* because they originally gathered in the *Coulisse*, or inner courtyard of the old palace near the present Bibliothèque Nationale which housed the first Bourse des Valeurs. The *coulissiers* ran a virtual parallel stock market and although from time to time the *agents* attempted to suppress them or at least ban them from the proximity of the Bourse proper, successive governments tolerated their activities, aware that the wider the market the more share prices tended to stabilize, avoiding the rapid fluctuations caused by the limited trading on the Bourse proper. A stable market created confidence in investors and made it easier for the State to raise money through the sale of government bonds. By Gauguin's time the Bourse des Valeurs had moved to its

splendid building, originally decreed by Napoleon 1 but only completed in 1827. Outside the building, under the great colonnaded peristyle, the *coulissiers* gathered, trading with all the fury of the London and New York exchanges, while the *agents* conducted their affairs at the *corbeille*, the round balustered area that was their exclusive preserve within the arched interior hall. The *coulissiers* spent the day outside but if trading was brisk they would move on to the hall of the nearby Crédit Lyonnais which allowed them to run a *petite Bourse du soir* after banking hours.

Because the *agents* seem fusty and the *coulissiers* gung-ho and piratical, biographers of Gauguin have perpetuated the myth that their hero must have been one of the latter. Up to now no one has bothered to search through the uncatalogued records of the Bourse which reveal that he was in fact an ordinary employee of an *agent de change* and not a *coulissier*. Every year each of the sixty members of the Compagnie des Agents de Change was obliged to publish a list of its associates (partners in effect) showing the percentage of the company's stock they held, while another document had to list each of the company's employees down to the messenger boys, showing their annual bonus from the firm's profits. The annual return for 1874, two years after Gauguin joined Bertin, shows Arosa still holding the second largest sum, though at 450,000 francs, a

'The Bourse, Paris, in 1893'

somewhat diminished amount from earlier years, while a Léon Galichon has entered the lists with 200,000 francs. Gauguin is listed on the record of employees as a *liquidateur*.

Such a role was far removed from the milling crowd of *coulissiers*. On the official Bourse there were two varieties of share dealing: *le comptant* where the buyer settled at once, and the *marché à terme* where it was agreed to settle at a fixed date. The latter was thus a form of futures trading, the buying or selling of stocks in the hope that their value would have changed favourably before the day of settlement came round. The *liquidateur* was nothing more than a chief accountant, who had the difficult and unenviable task of sorting out all these paper deals and getting all sides to settle up exactly on time, twice a month for railway stocks and government bonds and for shares issued by the Banque de France and the Crédit Foncier, and once a month for other shares. Far from being some sort of romantic cavalier figure from the world of high finance the *liquidateur* was an office-bound drudge, furiously busy as the hours ticked away to the final settlement days – four at the beginning of the month and another four starting on the first working day on or after the 15th. How Gauguin had the mathematical skills, let alone the temperament, for such tedium is a mystery. He was however well recompensed for any boredom he must surely have experienced. The *liquidateurs* were paid on commission with a good annual bonus, and with the economy booming Bertin was soon doing very well indeed, and so too was Gauguin. By July 1872 a consortium of the Rothschilds, the Crédit Lyonnais and the Banque de Paris had successfully guaranteed the national subscription which raised the money to pay off the Prussians and get the last of their soldiers off French territory. With that resolved and with all the capital that had flooded into the country, the result was predictable, yet another boom, highly reminiscent of the Scramble under the Second Empire. Once more there were fortunes to be made.

Paul Bertin was a hard-faced man, peering myopically across his office through the hooded eyes, magnified behind tiny, round, metal-framed spectacles, but whatever he lacked in humour he made up for in fairness and loyalty to his juniors and Gauguin seems to have settled into his new humdrum existence like an actor playing the part of a city clerk, the perfect bourgeois gentleman. We know from the later recollections of those who worked with or near him that he did not join in the noisy café life enjoyed by the young bucks of the financial world in the bars and restaurants near the Bourse. He seems to have done his day's work dutifully then gone quietly back to the flat he had found at 15 rue La Bruyère at the bottom of the Rue Breda where Gustave Arosa lived. Once home, Paul spent his evenings sketching, the hobby begun at school and continued on board the *Jérôme-Napoléon* and now growing

into something of an obsession, much reinforced by the fact that the Rue Laffitte where he worked was also the street where commerce met culture – the Rothschilds' bank, where François-Ezéchiel Arosa had worked, was set between most of the city's major private art galleries which gave the thoroughfare its nickname: the *rue des Tableaux*, the street of pictures. There Gauguin could happily pass his lunch breaks surrounded by the contemporary paintings on display at Durand-Ruel, George Petit, Carpentier and the host of other dealers.

At weekends Paul would take the train out to Saint-Cloud to join Marie at Gustave's villa – though brother and sister appear to have been frequently at odds. Marie, at twenty-four, had all the assurance of her extraordinary female forebears and was little inclined to give way to her brother's bullying manner, so that Paul found more congenial company in Marguerite with whom he would go sketching. At Saint-Cloud he was surrounded by Gustave's ever increasing collection of works by painters of the Barbizon School, still somewhat shocking to his more staid acquaintances, though growing less radical as newer, more daring ideas began to emerge.

Gauguin was thus surrounded by the very latest thinking on art, in an atmosphere open to experiment. Among the regular guests at Saint-Cloud were the critics Philippe Burty and Adrien Marx of *Le Figaro*, and the talk revolved around art and culture in their widest senses. The Arosas were keen travellers, especially Achille-Antoine who, in March 1844, had set off on a year-long, around-the-world tour which had included a memorable visit to Tahiti and Hivaoa, one of the Marquesas Islands where he had sketched and made water-colours of the main beauty spots. An interest in 'exotic' cultures, as they were then known, was still rare and Gustave with his Peruvian pottery and Achille-Antoine with his interest in Polynesia were both ahead of their time.

After such stimulating weekends, Paul's weekdays must have seemed even greyer and he does seem to have had a lonely first year in Paris. After work he was in the habit of taking a solitary meal at a nearby *pension* in the Rue des Martyrs and it was only at the end of February 1872 that he found any real friendship when he was joined at Bertin's by another junior, Claude-Emile Schuffenecker, who might have been created to be his friend.

## Good Old Schuff

As his Germanic name implies, Schuffenecker's family origins were Alsatian, and he always spoke with the distinctive accent of that province so recently and tragically ceded to the Prussians. His childhood had been as unsettled as Gauguin's. Emile's father, a successful tailor who had

worked for Napoleon III, had died in 1854, when the boy was only
three, and he was eventually adopted by a Monsieur Cornu, his mother's
landlord, who ran a successful coffee-roasting business near Les Halles,
the main Paris food market. It was probably this that gave Emile his
embarrassingly humble and grateful manner. If he and Gauguin had
merely been fellow employees it is doubtful whether the sometimes
cringing 'Schuff' would have been accepted so warmly by his ebullient
and overpowering colleague – but the little man, three years his junior,
with his stooped shoulders and hang-dog eyes, had other qualities which
quickly intrigued the more robust Gauguin. While his adoptive father
had been paying for young Emile to study commerce, the boy had shown
an indefatigable obsession with art and what today would be called
'alternative beliefs' which included an interest in Buddhism and other
oriental faiths. Monsieur Cornu was a tolerant man and did nothing to
hinder the boy's fancies, taking him to see Paul Baudry, the most famous
of the Second Empire's decorative artists, who allowed Emile to watch
him working on his final great mural *The Triumph of Music* for the foyer
of the new Paris Opera House.

The first thing which must have struck Gauguin about his new friend
was that despite his unprepossessing appearance, Emile seemed to be a
hard worker. While studying with Baudry and finishing his commercial
course, Emile had also attended night classes in drawing and in 1868
came first in the annual competition organized by the City of Paris. All
this ended with the war when the siege of Paris virtually ruined the
Cornus' business and Emile was forced to earn his living, starting as a
trainee in the Tax Office. For once in his life he showed considerable
energy, largely because his one aim was to earn enough to relieve himself
of the necessity to work so that he could get back to art. When Gauguin
first met him he was doing two jobs, working during the day for Léon
Galichon, Bertin's associate, then working a second long session for
Bertin himself as a *liquidateur* with Gauguin. Thus Paul was confronted
by the intriguing figure of someone who was the exact mirror-image of
himself – where he was only dabbling in art as a way of adding a little
interest to the dull life of a *liquidateur*, Emile Schuffenecker saw work
as a useful means of living the artistic life. Fascinated, Paul followed
where his junior led. In such limited free time as they had, the two men
visited galleries and museums, with Schuffenecker pouring out all he
had gleaned over the previous decade of artistic study. Best of all, from
Paul's point of view, Emile was an enthusiastic and ever gentle critic of
his early drawings, always encouraging.

Of course this was still no more than a hobby, but the fact that almost
everyone Gauguin associated with was keen on art was a stimulus to
greater effort. Most of all there was the latest work bought by the Arosas

which was a constant source of interest. Achille-Antoine seems to have been first here, having discovered an artist called Camille Pissarro, recently returned from wartime exile in London, whose work was alive with the new luminous colours. Achille-Antoine commissioned Pissarro to paint four panels, representing the four seasons, to go above the salon doors in the new house he was building for himself at 7 rue Brunel in the elegant *quartier* surrounding the Avenue de la Grande-Armée.

For Gauguin, such work was no doubt intriguing, though hardly applicable to the sort of amateur sketching he was doing to pass the time. In any case he had things other than art on his mind: he had met the woman he was going to marry.

## The Beauty with a Heart of Stone

On 22 November 1872 Paul Gauguin attended a party at his guardian's house where he was introduced to a young Danish woman, Marie Heegaard, the daughter of a leading Danish industrialist, and her travelling companion, a Miss Mette-Sophie Gad. The two women had recently arrived in Paris and were staying at a *pension* owned by a friend of Gustave's wife Zoë. Other invitations followed and Marie revealed in her letters home that another frequent visitor at the Arosas' home was a young man called 'Goguain' – she was no speller – and that he was interested in Mette who played the 'beauty with a heart of stone'. Marie noted that Mette could be a little brutal and that she had not won the friendship of Gauguin's sister. For her part Marie Heegaard was interested in Pepito Sanjurjo, one of the Arosas' many Spanish friends who worked with Gustave's son-in-law Calzado. It was probably a similar romantic illusion about darkly passionate southern men that persuaded Mette to give up her role as the stony-hearted beauty and to allow herself to be won over by Paul who was clearly smitten. The two were soon inseparable.

For Mette, this well-dressed, lively and above all 'southern' businessman had much to recommend him – dark passionate looks safely harnessed to a steady job. Perhaps wisely, he had not confided in her his nascent interest in art. For his part, the attraction of this well-built blonde, with her gruff way of talking, can only be understood if one remembers that Paul Gauguin was used to strong independent women. He might satisfy his sexual urges in the complacent arms of a paid girl, but where companionship was concerned he believed he needed someone forceful, and Mette-Sophie was certainly that. Beautiful no, but large and vivacious and full of character, yes.

They appear to have learned little about each other in the short period – just under a year – that they could be said to have courted. She had

had a failed love affair with a cousin in Copenhagen and seems to have decided that passion was dangerous and that it was better to concentrate on a settled, if amusing existence. She liked Paris and while Paul was a trifle rough at the edges, he was good company in a pleasingly unconventional way. For his part, he had effectively found his mother and his grandmother rolled into one. Mette had much of the force of a Flora Tristan – she always remembered overhearing her father saying to her mother: 'The strange thing about Mette is that despite her intelligence she's really quite stupid, because she's never learned to be afraid.' The father, Theodor Gad, had been the local magistrate on the island of Læsø in the Kattegat – through whose waters the *Jérôme-Napoléon* had once patrolled. He had died when Mette was ten and her mother had taken her, with her sister and two brothers, to live with their grandmother in Copenhagen, a stately woman, the widow of a lieutenant-colonel, who had a barrack-room vocabulary to prove it. Mette never played with dolls and remembered little feminine tenderness but a good, healthy, self-confident atmosphere left her with few complexes. As she grew up, Mette adopted much of her grandmother's manner and was able to use language with the same vivacity. One quite sees how this would have appealed to the gauche ex-sailor as they began to spend more and more time in each other's company. When the Arosas gave a fancy-dress party to see in the New Year 1873, Mette turned up dressed as a man. This must have appealed to Paul for, by February he was writing to Marie Heegaard's mother thanking her for the message of congratulation she had sent on his having become engaged to Mette. 'Rest assured,' he wrote, 'that in carrying off from Denmark so precious a pearl, I will do everything possible, and even impossible, so that she will not regret leaving all her friends, whom she will love, in spite of that, as in the past.'

No one could accuse him of not trying to play the part of the courtly lover. Mette, however, seems to have looked on the whole thing as pure fun – a note on the back of the letter fairly fizzes with excitement. It was still a bit of a romp to be in Paris – the Arosas gave another costume ball for Mardi Gras and the two girls went in crêpe-paper costumes designed by Paul and painted by Marguerite Arosa – Marie as a fisherwoman, Mette as a little girl, Paul as a soldier, with others turning up as a bottle of champagne, a chandelier and a fan. At another ball in March the young lovers danced through the night and, for the last reception of the season, the Arosas invited such a huge crowd of young people to Saint-Cloud that each had to bring a plate, a knife and a fork.

There is a sense in which Paul and Mette were living out a youth they had both missed – he in the navy, she as a young working woman. In 1867, at the age of seventeen, Mette had been appointed a home-tutor

to the five children, three boys and two girls, of one of Denmark's leading landowners, Jacob Elstrup. This was three years after the country had been torn apart by Prussia's seizure of the Duchies of Schleswig and Holstein, which, in 1866, had led King Christian ix to appoint a minority right-wing government from among the great landed families. Mette's new employer, Elstrup, had been given the post of Minister of Foreign Affairs and his opposition to the liberal groups in the lower house of parliament and his deep conservatism made him the arch-representative of aristocratic rule.

Moving between the Copenhagen residence and Elstrup's great estate at Skaffogaard, the very grandeur of her surroundings served to remind Mette how far she had slipped. Although a fatherless girl was fortunate to have such a post, Mette was sensitive to the fact that she, the cosseted daughter of a prominent provincial official, was now a sort of 'upper' servant. It was a stigma which would affect her behaviour in later life, giving her a love of luxury and an unwillingness to consider any lessening of what she considered her rightful place in society. Certainly her time with Elstrup did much to strengthen her will – if she had been bold and outspoken before, this proximity to wealth and power only confirmed her individuality. Elstrup, though a right-wing supporter of his fellow landowners, was a libertarian with unconventional views on social matters who encouraged her to speak her mind. She was certainly not afraid of him and defended the children whenever he was angry.

It was therefore something of a surprise to the family when they discovered that their usually robust tutor was pining with unrequited passion for her cousin. They knew that she had perfected her French while teaching it to the children and when they heard that Marie Heegaard, the daughter of a family friend, was planning to visit France and wanted a companion, it occurred to the Elstrups that this might offer the perfect means to cheer up the lovelorn Mette.

Some of this background has curious similarities with that of Gauguin's grandmother Flora Tristan. They were both girls who were thrust from humble circumstances into a world of riches, and both had a tendency to be governed by violent passions while being at the same time strong-willed and independent. Men are said to marry their mothers, but in Paul Gauguin's case it would be truer to say that he had skipped back a generation.

In the summer of 1873, Mette went home to Denmark to break the news to her family that she intended to marry what she called 'a funny sort of Frenchman'. Whatever they may have felt, they knew there was no point in trying to persuade her otherwise. Mette was not one to be deflected from her chosen path.

## The Sunday Painter

With Mette away Paul occupied his spare time by taking up drawing again, working alongside Marguerite Arosa on their weekends at Saint-Cloud. They persuaded Marie Heegaard to pose for them and one of Gauguin's sketches has miraculously survived – his first known work to have done so – a rough pencilled outline of Marie, full-face, which he made in a notebook. Marguerite then nudged him towards the use of colour and for the rest of her life Marie Heegaard kept his first attempt on a carefully folded sheet of paper, a watercolour of the woods near the villa in deep green and greys. On the other side of the paper was what Marie called a 'Peruvian motif' with the word 'White' in Gauguin's handwriting. Although mysterious they at least indicate that the 'Savage from Peru' had not been totally obliterated by the Bourgeois Gentleman.

Paul quickly moved to oil paints, getting Schuffenecker to show him how to mix his colours, though for the moment he preferred to buy his canvases ready stretched and primed. He accompanied Emile to the Louvre where, still industrious, the younger man made copies of the Old Masters which he hoped to sell. Back at Saint-Cloud, Paul got down to perfecting these new skills. Of the surviving oil paintings made in that year and the next, all five are landscapes in the rather sombre style of the Barbizon School. When he needed inspiration Paul looked to the Corots in Gustave's collection with an occasional glance at other members of the school – Harpignies, Diaz, Rousseau. At some point, we don't know exactly when, he discovered Edouard Manet and in particular his *Olympia*, which was to remain a powerful influence throughout Gauguin's life. Manet never sold the painting but it was exhibited at intervals throughout the 1870s, each time encountering almost as much criticism as had been whipped up when it was first shown at the Salon of 1865. The fury that greeted the nude portrait of Victorine Meurent, posed full-length on a day-bed and attended by a black servant holding a large bouquet of flowers, marks one of the turning-points in nineteenth-century art – some say the opening shot in the battle between the old and the new. No one interested in art at the time was untouched by it and Manet's *Olympia* went on provoking extremes of enmity and adulation for another twenty years. Gauguin admired it hugely and obtained a photograph of it which he always kept by him, though why he should have done so is not absolutely clear. Certainly what was generally accepted by the painting's admirers, back in the mid-century, was that it indicated an enormous advance in the representation of the modern. While the pose of the figure clearly refers to Titian's *Venus of Urbino* of 1538, Victorine/Olympia is evidently a living breathing woman of her day. But there opinion divides – is she a courtesan awaiting her next

customer who has sent her the flowers brought in by her servant? Is she merely a pretty young woman waking on her wedding morning with the arrival of her bridal bouquet? Manet has not told us and today the polarization of judgements on the artist himself are as acute as those which now rage over Gauguin. Does the painting, as some argue, 'exploit' Victorine or is she, as another writer has put it, in control of events? Is she gazing at us with the same insouciance as our own prying observation of her nudity? One art historian has even suggested that the unusual flat blocks of colour which Manet used for *Olympia* are evidence that he was familiar with stereoscopic photography, an early sort of 3D which was very popular at the time. Mid-century Paris and London had hundreds of shops purveying pornographic stereoscopic images, mainly female nudes posed in vague imitation of high art to give them a veneer of respectability. The purchaser stared down a binocular apparatus at a double image which merged with a slight overlap, giving the figure an illusion of form and depth. Is Manet's work a reversal of this, turning a piece of titillating pornography back into High Art, while wittily using the conventions of the flattened photographs before they are 'activated' by the stereoscope? The interpretations seem endless yet what is perhaps most extraordinary to today's sensibilities is that most studies of the painting – and they are legion – fail to comment on the other unexplained puzzle: why is Olympia's servant black? We now know that this second model was an Afro-Caribbean woman named Laure, hired along with Victorine to pose for the scene. Moorish bath scenes of the white odalisque attended by her female black slave were a convention of the Orientalist art of Manet's day, but such images were definitely meant to titillate, contrasting the muscular black form against fleshier white limbs. Manet, however, totally covers Laure in a voluminous robe, thus annihilating the convention. Yet we can surely see that this presence must be part of the reason why Gauguin was so intrigued and why he spent so much time contemplating his precious photographic record of Manet's still controversial and enigmatic work.

Not that his appreciation was expressed in his own art, which was modest though competent – hardly surprising when one of Marie's letters reveals that he spent a Sunday painting for a solid ten hours and on another occasion made her pose for four hours for a portrait, now lost, which looked 'well-enough' like her. That first year he was able to paint an accomplished *Paysage*, which shows a low landscape leading to a wide river, possibly an estuary, whose high expanse of sky recalls the Dutch landscapists, in colours that evoke Corot. It was a style already out of date by a good twenty years but for someone with no clear ideas of his own, it was a useful way to learn how to handle oils.

With Mette's return, life resumed its former merry round, with picnics

and parties at the Arosas', and no time left for painting. This no doubt explains Mette's somewhat aggrieved protests in later years, that before her marriage she had had no inkling that her future husband was interested in art. For her own part, Mette was not ashamed to admit that she had no aesthetic sense and that she looked on paintings as decoration. What she liked was fun, of which there was plenty, and it is little wonder that Marie Heegaard was sad to leave Paris at the end of September. At the farewell party at Saint-Cloud, she noted how close Paul and Mette were, indeed there is every indication that after Marie's departure the two became lovers. The marriage took place two months later on the morning of 22 November in the town hall of the ninth *arrondissement*. The assistant mayor carried out the civil ceremony in the presence of the secretary of the Danish consulate. All the Arosas were there, as well as Paul Bertin, Gauguin's employer. Gustave gave the bride away and after lunch the entire party progressed to the Danish Lutheran church in the Rue Chauchat, to satisfy the wish of Mette's mother in Copenhagen who had insisted they undergo a religious ceremony.

To celebrate, they had their photographs taken, separately, with each giving the impression of playing the part the other expected – he is the fresh-faced young city gent, she has fluffed up her hair in a somewhat saucy way that would never be repeated.

Paul had already set up a larger apartment in the pretty little Place Saint-Georges, as usual near to Gustave, where the couple now settled. All his Parisian life had been spent within walking distance of this new home – the Rue Notre-Dame-de-Lorette where he had been born was a minute away, and near by were all the places associated with the present revolution in art, the studios of Manet, Renoir, Bazille, Degas and Sisley and the cafés associated with them: La Nouvelle Athènes in the Place Pigalle, the Guerbois in the Avenue de Clichy. It was a *quartier* of artists' shops selling canvases and paints, of sympathetic restaurant owners used to exchanging paintings they little appreciated for the meals their clients obviously did. It ought to have given Mette pause for thought, as it was hardly the sort of area a thrusting young businessman would have seen as enhancing his prestige. But then she was still somewhat dazed by the Bohemian ways Paul and the Arosas had brought into her life. This was most evident in the style Paul had chosen to decorate the new apartment, rejecting the heavily ornamented furnishings normally associated with bourgeois living, in favour of simple hand-crafted pieces and unusual oriental rugs. There was even a Peruvian wall-hanging in thick crude folkweave instead of the more usual reproduction tapestries you would expect to find in the home of someone working on the Stock Exchange. It was a taste which even stretched to their tableware, with Paul choosing

craft pottery with bold patterns and colours. What Mette did not realize was that such choices went beyond aesthetics and were in many ways a protest against the overpowering vulgarity of much nineteenth-century design, especially the new mass-produced objects which pandered to the worst excesses of middle-brow taste.

If none of this gave Mette any idea that her husband was interested in art, and her later protests do seem hard to believe, then she cannot have remained in ignorance for long. Shortly after the wedding they were again spending their weekends at Saint-Cloud and almost at once the painting recommenced. At first Mette seems not to have minded – they even did some embroidery together, stitching a design based on the woven cloths the Indian women had worn when they came into Lima to the city's markets. It was as if Peru was always there, just below the surface, though the thought of two such boisterous people patiently applying themselves to needlework does raise a smile. It was only one sign that the first year of their marriage was perfectly contented. They seem to have avoided the usual problem of not getting on with each other's friends – her family had not been much taken with the idea of her 'funny sort of Frenchman' but they were in Denmark. That Paul's sister did not care for Mette hardly mattered as the two siblings were not especially close. Mette was fond of Emile Schuffenecker, whom she took to be a good influence on her husband's career, choosing only to see the hard-working side of Emile's character while ignoring the dedication to art which would prove the one real threat to the success of her marriage. She might have realized that something was wrong with Schuffenecker's attitude to business if she had compared his earnings to Paul's, for while Emile appeared to work all the hours God gave, he was now so preoccupied with painting that the apparently less industrious Gauguin was actually earning far more in bonuses than he was. Both men were on a monthly salary of 200 francs, a good basic wage when compared to the 90 francs a manual worker was lucky to earn. But that was as nothing compared to the final income of an employee of a successful agent – the real money came from the annual bonuses in which everyone shared. In 1874 Paul was paid an astonishing 3000-franc bonus on top of his regular salary – the same amount as Léon Galichon, one of Bertin's principal associates, who was on a far higher rate of remuneration. On top of that there was nothing to stop both young men using this capital to play the stock market themselves, on their own behalf. And there was equally nothing to stop them using the inside information they had on how shares were moving. All they had to do was to get one of their *coulissier* chums to buy or sell stocks for them hoping to make a killing at the monthly liquidation. This is presumably what the Arosas had done before them, and as his guardian had shown, it was to prove

very easy for Paul Gauguin to make a great deal of money despite the supposedly modest status of his actual job.

One thing is certain, Mette quickly learned how to spend what he earned, living high and well, but Paul seems to have taken this in his stride – happy to indulge her, especially now that she was carrying his child.

During the pregnancy they were joined by the husband of Mette's sister Ingeborg, the Norwegian artist Fritz Thaulow who wanted to find an atelier in Paris where he could continue his studies. Thaulow was a giant of a man who reminded everyone of a Viking, only to be confused by his mild manner and sunny disposition. He had already studied at the Academy in Copenhagen, then in Karlsruhe where he had achieved something of a reputation as a rebel, reacting against the prevailing German academism and showing early signs of an interest in the new lighter art. It was an interest which inevitably led him towards France where the avant-garde was stronger. What Mette made of all this art which had suddenly cropped up in her life, we can only guess – one suspects that she looked on it as a rather over-demanding hobby indulged in by the menfolk in her family and was no doubt grateful that Paul did not go in for whoring and gambling, the usual pastimes of Parisian men of his social position.

## Tongue-lickings of Paint

Fritz Thaulow had arrived in Paris at a particularly auspicious moment. In April 1874, many of the new artists who had been working in the new lighter manner first appeared before the public as a group. Under the deliberately neutral title of the *Société coopérative d'artistes, peintres, sculpteurs, graveurs*, and with a charter partly copied by the left-wing Pissarro from the rules of a Union of Bakers, these artists were given space in Félix Nadar's old photographic studios on the second floor of 35 boulevard des Capucines. On 25 April, 165 works by thirty artists were put before a generally unsympathetic public. The deliberately neutral title of the group was swept away when a mocking art critic, Lucien Leroy, entitled his scathing attack in the *Charivari*: 'The Exhibition of the Impressionists'. There had long been talk of art as impression or sensation and Leroy was only picking up on the title of one of Claude Monet's entries, *Impression Sunrise*, but the name stuck, and what had formerly been a loose, disconnected set of painters at most working in twos, as Monet and Pissarro or Monet and Auguste Renoir had sometimes done, was now a school, a movement, a thing with a name – the Impressionists.

Where most joined Leroy in mocking these 'funny impressions' and

'tongue-lickings' of paint, Gustave Arosa bought, drawn first to Pissarro but also picking up works by Jongkind the Dutch painter who had had an early influence on Monet. But despite the efforts of Gustave and his friend Nadar to encourage interest in the new art, that first exhibition, while an undoubted *succès de scandale*, did not attract buyers as the organizers had hoped, and it would be two years before another was attempted.

For outsiders like Paul Gauguin and Emile Schuffenecker, the effects of the first Impressionist exhibition were varied. In Emile's case, there was interest but no application to his own art which remained firmly under the influence of Baudry. For Paul it was something altogether slower and more subtle, a gradual process of lightening his palette, of adding shorter brushstrokes with more translucent colour to his still basically Barbizon landscapes.

Not that he had much time for art just then. He was working hard to keep Mette in funds and was soon overwhelmed by the birth of their first baby, a son, on 31 August. They named him Emil, partly in honour of Emile Schuffenecker, though they dropped the final e, to make the name more Nordic. This led to a peculiar contretemps when Gauguin went to register the birth and told the petty official at the Town Hall that the child's name was *Emile sans e* or Emil without e. This pedant took the remark literally and registered the boy as Emile Sanze and it took Gauguin an irritable quarter of an hour to sort the thing out.

It was about now that it began to dawn on Mette that there was something odd about their situation. At first this had little to do with art which in Paul's case was still no more than a hobby. It was more to do with their friends who, apart from Schuffenecker, were nearly all Spanish, or Latin-American, in origin. That same year, 1874, Marie Gauguin became engaged to a Colombian businessman Juan Uribe. Everywhere Mette turned she found Spaniards and what must first have seemed a rather romantic idiosyncrasy was soon to become something more sinister. These friends were not merely business associates of the Arosas who just happened to have some past connection with Spain; many were political exiles with an abiding interest in the politics of their homeland. It was soon clear to Mette that their revolutionary ideas held a disturbing attraction for her husband. Paul had met many of them through Adolpho Calzado, Gustave's son-in-law, who was deeply involved with events in Madrid.

The question of the Spanish monarchy had not disappeared with the outbreak of war between France and Prussia; it had festered and eventually exploded. While the war was in progress the Spanish Cortes, under its Prime Minister Manuel Ruiz Zorilla, had voted to hand the throne to an Italian prince, Amadeo of Savoy, but Zorilla's régime was unstable and the country had effectively slipped into near civil war before Amadeo

abdicated in February 1873. The Cortes now proclaimed a republic for the first time in Spain's history. When this foundered after a year the old Bourbon dynasty was restored under Alfonso XII, Isabella's son, at which point all those who had actively supported the republic were forced into exile, some as followers of the ex-prime minister Ruiz Zorilla, many ending up in Paris where they gathered to plot the downfall of the new régime. It was these romantic revolutionaries, forever on the verge of provoking a military coup d'état or a peasants' uprising, that Gauguin found so attractive. Something of his grandmother's radicalism and his father's republicanism had rubbed off on him, while the years below decks on an imperial yacht had fed his socialist ardour. Whatever the reason, he clearly found it fascinating to join the exiles in their favoured cafés and talk of revolution.

For Mette, this Spanish connection was as yet no more than an irritant, for the real threat to the stability of her family now came from the unlikely source of the humble, stoop-shouldered Schuff. In 1875 his adoptive father died, leaving Emile 25,000 francs which he invested in a man called Fontalirant, who had come up with a new method for manufacturing what is variously described as rolled gold, or gold leaf or even gold plating. Whatever it was, Emile was soon earning a handsome income from his share of the proceeds, and while he went on working at Bertin's, it was now understood by all his friends that it was only a matter of time before he became a full-time artist. It was probably at this point that Mette began to suspect that Paul envied his friend and that he was not exactly the dedicated career businessman she had believed him to be when they married. But if she was worried about the turn things were taking, her doubts were greatly allayed when they decided to leave the cramped accommodation in the Place Saint-Georges for an apartment in the Rue de Chaillot (then 54, today 30). This was no minor move nor a mere search for more space by a growing family. The Rue de Chaillot was near to the Avenue d'Iéna, at the heart of the sixteenth *arrondissement*, which at the time was on the outer edge of the city, and while this was yet to become the prestigious home to rich businessmen and diplomats with some of the most expensive properties in the capital that it is today, it was no doubt a move upwards from the Bohemianism of the area around Pigalle. Apart from the cost, there was the spiritual change involved – in Paris, Paul had always lived within walking distance of his birthplace, and by choosing the grander avenues of the sixteenth, he was turning his back on one side of his life and emphasizing his role as an employee of the Stock Exchange. Perhaps Mette wanted it that way, or perhaps he was fighting a rear-guard action with the uneasy doubts which had begun to unsettle his life.

Whatever the reason, this new life seems to have stretched Paul's

income to the limit. There were occasional quarrels over money – Mette had, as he put it, 'no idea about saving' and clearly enjoyed spending for the sake of it. Nor does the move appear to have finally resolved Mette's doubts, for any worries she had had about the wisdom of Paul getting involved in the artistic life were confirmed when he introduced her to Julie Pissarro, the wife of the painter Camille Pissarro.

## The Anarchist

Gustave Arosa had recently bought a Pissarro, which meant that he was now on the artist's visiting list – the group of potential patrons he was obliged to call on from time to time to see if he could persuade them to purchase another work. All Pissarro's problems came down to money. Outwardly, with his large white Santa Claus beard and quiet gentle manner, he looked like a contented man, an image quickly dispelled whenever his wife appeared. Although he loved her dearly, Julie the peasant girl who had been his mother's maid, was never reconciled to life with an impoverished painter – and said so often. With a large brood and little income she found it impossible to understand why her husband insisted on producing paintings nobody wanted. Even his friends Monet and Renoir had found subjects which aroused some interest: the boating parties, the outings by the Seine, the bars and cabarets which would one day perpetuate an entirely erroneous myth of the lighthearted life led by artists in the mid-century. In truth, they were no more successful than Pissarro was – Monet was frequently destitute and could only survive by begging off sympathetic critics like Zola. But Julie Pissarro saw only her intransigent husband painting nothing but landscape, landscape, landscape. Not for her the quiet loyal support of the devoted wife of a misunderstood avant-garde artist: she nagged and fussed, driving him out of the house in the village outside Paris where they attempted to live as cheaply as possible, sending him into the city for the day, to tramp round to the houses of anyone who had ever shown any interest in his work, hawking his recent canvases like a brush salesman.

'Does your mother believe,' Pissarro wrote to his eldest son Lucien, after an especially gruelling and fruitless trek, 'that business can be hustled on? Does she really believe that I enjoy running in the snow and mud from morning till night, without a penny in my pockets, scrimping on the cost of a coach when I am dog tired, hesitating before spending on a meagre lunch or dinner? I can tell you, it is no fun.'

One of the more sympathetic stops on this dismal round was 5 rue Breda where Gustave Arosa occasionally bought Pissarro's work and where he probably introduced him to Paul. That Gustave and Paul and Camille should have sympathized with each other was predictable for

reasons beyond art – Pissarro's father was a French Jew of Portuguese descent who had emigrated to Saint Thomas in the Virgin Islands which were then part of the Danish Antilles. He had opened a hardware business and married a Creole, Raquel Manzano and there was much about his early life in the port of Charlotte-Amalie which must have reawakened Paul's precious memories of Lima. Pissarro too had tried to balance a business career while painting in any free time he could get, but had eventually settled in France in 1855, the year of Plon-Plon's Universal Exhibition where he discovered the work by Corot, outside the official salon. Two years later, Pissarro met Claude Monet, ten years his junior, and was drawn even further towards the study of light and colour in nature, moving towards that fresh, quick, grasp of sunlight now called Impressionism. Ironically, it was in wartime exile in grey, foggy London that the two men began to create the purest form of the new art, shimmering white views of the Thames with just the hint of a building, leafy lanes in the city's outer suburbs. But Julie hated England as much as she despised art. When they got back to France she was more concerned about the condition of her house where Prussian troops had been billeted, than the fact that they had destroyed nearly all Camille's paintings, virtually the entire output of his early years. He wanted to go back to London – he had not been completely happy there but had at least found a new maturity in those wintry landscapes. Pissarro was probably the only major French artist to have a passion for cricket, he almost bought a house, which he hated, at L'Isle-Adam because it had a garden large enough for a full-sized pitch. Amid such amiable folly it is easy to see why his seven children adored their father, filling a succession of houses, in the countryside around Paris, with fun and laughter as they beavered away on the family newspaper or worked at becoming painters themselves, to Julie's despair. One of the editions of the children's journal includes a drawing of their mother in a rage, attacking Pissarro with her fists yet through all these tribulations he maintained that aura of calm and gentleness for which he is best remembered.

## Experiment and Change

When Gauguin first met him, Pissarro lived and worked near L'Hermitage not far from Pontoise in the countryside to the north-west of Paris. Except for the occasional encounter on one of Pissarro's money-searching trips to Paris, contact between the two men was initially rare and the influence of the older man on Gauguin's work slight. There is a surviving landscape from the end of 1875 – *Paysage avec Peupliers* – which shows a slight lightening of colour and the use of shorter, more

energetic brushstrokes, which suggests that Paul was aware of Impressionism while still unwilling to use its techniques fully. More interesting than the *facture*, the surface elements of the painting, is the mysterious aura with which he imbued the scene: the strangely scrawny and otherworldly trees, like alien creatures gathered at the low horizon, which leave the spectator with the feeling that this is an invented rather than a real landscape. This was not the sort of thing to gain Pissarro's approval and it is clear that Gauguin was at this point uncommitted to any particular style and willing to try anything that caught his eye. There is a *Still Life with Pheasant and Oysters* which parodies seventeenth-century Dutch 'food' paintings, while in that same year, 1876, he painted a river scene which is pure Monet. All part of the learning process.

Given this growing interest in such a variety of art, it is surprising that Gauguin made no attempt to contact his second-cousin Charles-Camille Chazal, the son of his mother's uncle Antoine, the painter of flowers and birds. Though now entirely forgotten – save for a portrait of Saint-Saëns as a young man which is occasionally reproduced in biographies of the composer – Charles-Camille was then a well-established painter of conventional religious subjects and had been exhibiting at the Salon since 1849. He was fifty-seven and living in Paris when Gauguin left the navy and would have been easy enough to locate. No doubt his art was not to Paul's taste but one suspects that the real reason the younger man made no effort to track him down was the disgust at his Chazal blood aroused by all he had learned of his mother's treatment at the hands of his grandfather. Charles-Camille Chazal died in 1875, and with him passed the final opportunity for Paul Gauguin to make contact with his only artist forebears.

In December that same year, Paul gave his sister Marie and her fiancé Juan a painting *Sous-Bois à Viroflay* as a wedding present. This work remains unidentified or missing, but it cannot have been too far removed from the Barbizon ethos, for in the spring of 1876 Paul borrowed it back from the Uribes and entered it for the annual Salon, where anything remotely Impressionist would have been automatically rejected.

To even think of submitting a work to the Salon at this stage showed either tremendous confidence or downright cheek on the part of someone who had only been using colour for little more than five years. Though why he wished to do so need not be questioned – despite all the criticism levelled at the jury's conventional taste, a successful appearance at the Salon could transform an artist's career. And so he joined the thousands of hopefuls on the April submission day, jamming the streets around the Palais de l'Industrie on the Champ-de-Mars, clutching their canvases, some in carriages, others on the upper decks of horse-drawn omnibuses.

The task before the much criticized jury was awesome – days of standing like prisoners behind a restraining rope in one of the larger halls as almost eight miles of canvases passed before them. Works by medal-winners of previous Salons were automatically accepted; for the rest it was down to the jury's vote – a unanimous decision meant you were through and would be hung 'line-centre', at eye level on the walls of the succession of vast halls spread through the Palais. Such a position also put the lucky artist in the running for a medal. A simple majority vote got you through, but hung in the second or third line, while if you were selected on the final run-through, the *repêchage* or 're-fishing' which happened on the final judging day, then you would probably be 'skyed', hung right up at ceiling level, where as likely as not your precious work would be virtually invisible.

Given that 3,500 paintings, as well as over 1,000 pieces of sculpture survived this process, it was a little miracle that Gauguin's small Barbizon-style landscape got through, though where it was finally hung we do not know. Nevertheless, to have been accepted at all would have been a tremendous boost to his confidence, though his pleasure must have soured next time he met Pissarro. The Impressionists had come together originally because of the Salon jury's rejections and in April 1876 the second exhibition of the group was held at Durand-Ruel's gallery at 11 rue Le Peletier. This time the critic Albert Wolff turned on the 'six madmen – with one woman among them' in a vicious attack in *Le Figaro* which described how passers-by fell about with laughter at the misguided works of these 'lunatics'. 'Do tell Monsieur Pissarro,' Wolff went on, 'that trees aren't really purple and that the sky isn't really the colour of butter.'

Faced with such vituperation some of the group, led by Degas, felt that they should show more solidarity by refusing any longer to submit to the Salon jury. Thus Pissarro, who already looked on Gauguin as a sort of pupil, would not have been best pleased to hear of his supposed success in gaining a place in the camp of the enemy. It seems to have been at this point that the older man decided that his protégé should actually join the Impressionists and began to take him to the Nouvelle Athènes, the café in the Place Pigalle where Monet, Renoir, Degas and the others occasionally gathered in a back room to exchange ideas and plan future strategy for the group exhibitions. Mostly Gauguin sat quietly listening, though if moved to intervene he was usually nervously aggressive – Degas was a formidable presence and to question anything he said took considerable courage if one was not to start blustering, which Gauguin tended to do when challenged.

On one memorable occasion he met Manet but when the great man made a flattering remark about his work, all Gauguin could do was

A private view at the salon of 1879

stammer something about only being an amateur. Between self-deprecation and nervous bluster he failed to win friends, except for Pissarro, and he too, despite his kindly manner, had his troubles with the other members of the group. Monet could be shifty and disloyal, Degas was a sarcastic snob and virulent anti-Semite, who later avoided Pissarro during the Dreyfus Affair lest he be accused of associating with a Jew, as indeed did Renoir who referred to his supposed friend as 'the Jew Pissarro' behind his back.

Mette now had to accept that the pleasant young businessman who

had sat at home embroidering cloth with her had become as much a man about town as any other young blade, even if his reasons for staying out were more serious. Between meetings with the Impressionists, the gatherings of the Spanish revolutionaries and the weekends in the country painting, there was hardly much time for her. He even managed to turn their new address to his advantage, going down to the nearby river to paint. The Seine was a subject dear to the Impressionists – Monet and Renoir had often worked a little further down stream near Asnières. Gauguin set up his easel near the Pont d'Iéna and painted the stretch of the Seine down to the Pont de Grenelle. But such pleasant excursions hardly justified the enormous expense of living in an increasingly fashionable part of the city while attempting to maintain a way of life way beyond his income.

Marie and Juan Uribe had taken a sumptuous three-storey apartment in the nearby Avenue d'Iéna and Mette's sister Ingeborg and her husband Fritz Thaulow also moved into the neighbourhood. Not to be outdone Mette had hired a maid called Julie, who had once posed for Delacroix, though this was nothing beside her in-laws the Uribes who lived in some style and entertained magnificently. Trying to keep up with people far wealthier than they were was clearly unwise and Marie Heegaard on a visit to Paris wrote to tell her mother that 'Paul's affairs seem to be in a bad way; I do not think his job is any too secure, it must be harassing for Mette.'

The archives of the Chambre syndicale de la Compagnie des Agents de Change, for March 1876 make it clear that a change had taken place at Bertin's. That stern-faced old man had retired and handed over his charge to Léon Galichon. Bertin was still an associate, but Gustave Arosa, at 350,000 francs, had further diminished his holding. The Annual Report of April 1876 still lists Gauguin as a *liquidateur* and puts his bonus at 3,600 francs, which is an improvement on two years before though it may not have been sufficient to keep up with his new lifestyle. Indeed from the establishment of Galichon as head of the agency things appear to have gone wrong for Gauguin. Perhaps the new *patron* was unsympathetic to his junior's increased interest in art or perhaps the withdrawal of Gustave had weakened his ward's position. Either way, by 1877 the records no longer mention Gauguin while Schuffenecker appears to have taken his place. What exactly Gauguin was now doing is not known, the local government registers which list citizens by address and occupation reveal that he was an 'Employee of the Stock Exchange' which tells us little. He may have moved to another agent who may have offered him a higher salary and bonus than Galichon would but no record of this has so far been traced, and whatever he was doing was inadequate to cover his expenses. The change, when it came, was brutal

and must have stunned Mette – they were to leave the Rue de Chaillot, not for a more reasonable apartment somewhere modest like Pigalle, but way across the Seine to the still remote Vaugirard district where once Don Mariano and Thérèse Laisnay had lived with their daughter Flora. This was not so much a move as a completely new life. Paul had met a young sculptor, Jules-Ernest Bouillot, and had arranged to rent a studio and apartment in his building at the end of a small impasse which led off the Rue des Fourneaux (today 74 rue Falguière near the Gare Montparnasse). The area was so run down there was a great deal of large cheap space suitable for sculptors and many of the little alleyways led down to studios and workshops. At a stroke, they had moved from bourgeois luxury to Bohemian squalor. It must have devastated Mette, who was again pregnant, though Julie the maid, who had worked for artists before, was better able to take the transition in her stride, and Paul was clearly delighted.

## Money Into Art

Everyone who writes about Paul Gauguin comes to a different conclusion about when exactly the Sunday painter became a full-time artist, but that move, in 1877 was undoubtedly significant. He may have wanted to assert his individuality in the face of the already advanced artists, such as Pissarro, with whom he was now associated, having recognized quite early on that the difference between a great and minor artist was not necessarily a question of talent or skill – both Schuff and Fritz Thaulow had both – but of a driven bloody-mindedness, an unstoppable desire to do something unique. The only conclusion was that one had best avoid being sucked into someone else's wake and in immediate terms that meant putting some distance between himself and the Impressionists. Fortunately, the solution was to hand – once he had settled into his new home, he had only to cross the little yard at the end of the impasse to get to the workshop of his landlord Jules-Ernest Bouillot. This young man was at the first stages of his career and it would be another eleven years before he made his first appearance at the Salon. He was then earning a living as a marble cutter and probably did a little monumental masonry to supplement his income.

Encouraged by Bouillot, Gauguin began by modelling Mette's head in clay. Having first carved wood as a child, he was undaunted by the difficulties in mastering another medium. His image of Mette is noticeably thinner-faced and softer than her photographs, though her gentler appearance front-on is somewhat belied by the harder impression offered by her profile. That done, Bouillot next showed him how to carve the head in marble, doing much of the actual cutting but letting Paul work

on the finish. The result is an extraordinary eighteenth-century bust, quite unlike anything Gauguin ever painted. A second attempt, almost entirely achieved by Gauguin, was a bust of Emil which could have been sculpted by Canova and one imagines that even the unaesthetically inclined Mette must have been well pleased with these handsome, traditional objects.

Once again, Gauguin had shown an amazing capacity to master a new craft at great speed, but he was still not satisfied. Another of Bouillot's tenants was the sculptor Jean-Paul Aubé, then aged fifty. His bust of Mérimée had been accepted for the Salon of 1861, though his most famous work, most notably the monument of Gambetta for the Place du Carrousel in Paris, was still ahead of him.

Gauguin was far less interested in Aubé's sculpture than in his unusual way of earning money by modelling clay figures in white plaster to decorate vases made by the Havilland pottery company. These unusual objects – hardly practical and clearly meant as decoration – seem to have reawoken Gauguin's memories of the strange pots and vases which had been such a feature of his childhood. Indeed, a renewed interest in ceramics had been growing for some time. In 1875 Demmin had published his second great catalogue, the *Histoire de la Céramique*, again photographed by Arosa et Compagnie, which now showed the full extent of Gustave's collection. Many of the book's large-format plates were of his pre-Columbian, especially Peruvian, pottery, equally divided between Chimú animal or vegetable pieces – say a spout in the form of a beak or a vase inspired by a gourd or a cola nut, and the more openly figurative Mochica ware, in which the animal and human forms are so complete that the pieces are really ceramic sculptures.

The year after Gauguin moved to Montparnasse, such pieces were brought centre stage by the third Universal Exhibition held in 1878 with an Exposition des Arts Anciens organized by the Orientalist painter Jean-Léon Gérôme, which included one of the largest displays ever assembled of what was then called American Art, but which was, in essence, those pre-Columbian works from Peru sent back by the various French archaeological missions which had been allowed into the region following the collapse of Spanish rule. The following year, the collection was permanently established in the Palais du Trocadéro as the Musée d'Ethnographie de Paris where it remained until the 1930s when the building was demolished and reconstituted as the present-day Musée de l'Homme.

Gauguin became a frequent visitor to the new museum and we can work out some of the things he most admired by looking at the illustrated catalogues of the period which reveal a distinct preference for the more naturalistic figure vases of the Mochica culture. The Trocadéro collec-

tion contained a Devil Crab with an elaborate tiara headdress, an earthenware portrait stirrup vase and a pink moulded ceramic figure. Such vessels were ceremonial rather than functional and usually involved a mixing of opposites: transforming a human figure into a bowl, an animal into a vase, a head into a container for sacred liquids. They were unlike anything in European pottery at the time. Aubé's moulded figures were decorative elements stuck onto thrown pots, here the figures *were* the pots. Best of all, they could not be fully explained and were, in a word, mysterious, which we know Gauguin found refreshing after the blunt realism of so much art at the time. He would later write of the 'sustenance and vital strength in the primitive arts', which Western artists could use to refresh their own work.

And even more than the pottery, the one thing which gripped him most was a Peruvian trepanned mummy brought back from excavations in the Urubamba Valley in 1877 by the traveller and naturalist Bidal-Seneze. This figure, disquieting to Western eyes, was to the Peruvian a symbol both of death and of rebirth. It sat, hunched behind drawn-up legs bound with cords, the slightly comic lop-sided tilt of its opened skull offset by a hideous wide-mouthed rictal scream. This ragged, foetal object was the principal reason for Gauguin's return visits and he noted every detail – the crossed feet, the hollow sockets, the hairless babyishness of death.

It was just the sort of thing to stir up longings in Gauguin. It was six years since he had given up the sea, and while he had been happy to do so, the sight of so much strange beauty was enough to reawaken his desire to travel. Matching these fantasies about faraway places was another new fashion: the postcard, the ubiquitous souvenir of the day. Most events – exhibitions and performances – now offered them and lest he forget the things he saw, Gauguin bought them whenever he could, adding them to the bank of images begun with prints from Arosa et Compagnie – photolithographs of the Parthenon Frieze and Trajan's column, as well as reproductions of some of Gustave's Impressionists.

The main effect of the exhibition on Gauguin was to lead him towards building his own collection of Peruvian pottery, more easily available once the new Ethnographical Museum had opened and launched a vogue for such things. Gauguin's home was by then quite extraordinary, its walls covered in bright new paintings and every surface set with some intriguing object. No matter how modest the neighbourhood might be, the interior was strange and unusual, a living testament to the way art had come to dominate his life.

## A Second Scramble

Mette's reaction to this sea-change in her husband's life was no doubt blunted by her frequent pregnancies. The move to Montparnasse had at least given her more money to spend and Paul had done his best to make the place livable before their second child and only daughter was born on Christmas Eve 1877. From the first, Paul was totally besotted with the little girl and would remain so all his life and Mette could hardly demur when he asked that she should be named after Paul's mother Aline. We can sense that part of this grew out of his feelings of guilt over the estrangement from his mother caused by his crude adolescent behaviour but another part had to be the simple fact that the child was the softest, gentlest, most vulnerable thing in his life. He himself was something of a swaggering tough guy and the wife he had chosen was no wilting lily. Both were fond of smoking: he a pipe, she a cigar. While she had never been sylphlike, childbirth had filled Mette out and exaggerated her mannish looks, which she further exaggerated by the masculine cut of her clothes. With her hair severely pulled back from her forehead there was little left of the feminine about her appearance. By contrast Aline was delicate and vulnerable – Paul drew her asleep sucking one of her fingers. That she awoke in him previously unrecognized longings would later become worryingly apparent, though for the moment Mette must have been relieved that they had found one area of common interest at a time when they were beginning to drift apart. Most worrying of all was the absence from their lives of the man who was most responsible for their well-being – Paul and his guardian Gustave Arosa were no longer close.

Just as Paul and Mette left the sixteenth *arrondissement*, Gustave began building himself a much grander residence in the Rue de Prony. He had inherited his father's wealth, François having taken his own life in 1877 rather than go on getting more and more decrepit. Gustave's family were now out in the world. Marguerite had become a professional artist, still rare for a woman at that time, and would make her début at the Salon of 1882 but already her father was withdrawing from active participation in the arts, selling off his collections and ceasing to buy new art. Whatever had caused the rift with Paul, it is clear that Marie Gauguin took Arosa's side for, in a later letter, she angrily berated her brother for having left his job at Bertin, which indicates that this had been the source of the quarrel. Marie and her husband Juan had had a daughter in 1878, and twins in 1879, and the following year, when Gustave's new house in the Rue de Prony near the Pereires' Parc Monceau was completed, the Uribes moved into a vast apartment fifty metres away so that Marie could still be close to her guardian.

Now that Paul had left Bertin and his home was no longer near to the Arosas, it was inevitable that they should all see less of each other, but by now there are hints of a disagreement of some sort. Gustave may have disapproved of Gauguin's new job – there were many doubtful enterprises connected with stockbroking and Gauguin's unknown employer may have operated one of them, which would explain his total silence about it.

In 1879 he changed again, joining one André Bourdon at 21 rue Le Peletier, a short walk from the Bourse. Bourdon is described as a banker but as the title was not defined by law until the wartime Vichy régime it tells us nothing. In 1879 anyone could call themselves a banker and it is probable that Bourdon was really a *coulissier*. Because the *coulissiers* were legally non-existent, few records of their activities were kept and it is now impossible to discover exactly what Gauguin did – whether he continued as an office-based accountant or whether he joined the dealers under the portico of the Bourse or, when they were occasionally barred from the premises, in the hall of the Crédit Lyonnais in the Boulevard des Italiens where they continued their noisy wheeling and dealing.

Whatever he was doing, either from his bonuses with Bourdon or from investments on his own account, Gauguin earned an astonishing 30,000 francs in 1879, a fortune at the time. He was not the only one to be making quick money. France was slipping into another period of frenetic financial speculation, a boom to rival that of the 1860s. It had been largely triggered by the activities of a new investment bank, the Union Générale, whose founders set out to raise investment capital from the country's Catholic majority and who were not averse to playing on the anti-Semitic and anti-Protestant sentiments of their potential investors – the Union's original prospectus was blessed by the Pope and bore his signature urging good Catholics to invest as a religious and patriotic duty. Not surprisingly it worked. Normally cautious country *curés* and members of the provincial nobility handed over their savings, believing that they were supporting the *ordre moral* proclaimed by the country's right-wing Catholic politicians, while making a handsome profit at the same time.

Launched in 1878, with a huge capital of 25 million francs, it was eventually controlled by Eugène Bontoux, an ex-student of the prestigious Ecole Polytechnique, an undoubtedly clever man, though one with a poor record of success. Bontoux had been deeply involved in speculating in Austrian railways but a downturn on the Vienna Stock Exchange had ruined him. The Union Générale came just in the nick of time, but he had not changed his ways and before long he was using the vast funds raised from the faithful to invest in railway construction all over eastern Europe, from Hungary to Serbia. Each new deal required

more and more money – the sums were so vast the noughts crossed the balance-sheet like the wheels of the trains meant to link the continent. As the fever of speculation rose, the Union Générale constantly issued more bonds as it stumbled into new areas – banking, mining, there seemed no end to it, but with confidence high the spiral of investment went up and up and seemed unstoppable.

There was much to feed a boom. In 1879 Ferdinand de Lesseps announced his intention of joining the Atlantic to the Pacific by the digging of a canal across Central America to the Bay of Panama. It is hard to imagine today the psychological effect of this announcement on both the general public and the financial markets which were asked to underwrite the venture. It was to be the biggest engineering project of all time – far greater than the Suez Canal, incomparably more complex than any of the vast railway schemes which had until then reigned as European capitalism's most romantic endeavours. At seventy-four, de Lesseps was universally known as *le grand Français*, the hero who had dug the Suez Canal and covered the nation with glory. To most of his fellow countrymen, he was the beloved paterfamilias – fourteen children, nine born after his sixtieth birthday, but he was also proud and stubborn and unable to back down once he had started something. Most often described as an engineer, he was really a promoter, a powerful orator able to win over adoring crowds and sway committees and commissions, but the banks and the Bourse were cautious.

Dissenting voices tried to point out that the only conceivable way the project might work was to accept the mountainous terrain and build a canal at different levels, linked by a series of locks, which would raise and lower the ships on their passage between the oceans. But this was the one thing de Lesseps's pride would not allow. Like Suez, his new child would be a river dividing the land while uniting the seas. There would be no locks. And if the banks refused him the money, then he would turn to the people, the ordinary people of France who worshipped him. Thus determined, the old man set off on a speaking tour across France. Mothers sent him their children's savings wrapped in handker-chiefs, no one bothered about adverse reports, the canal was a patriotic duty – in any case the press were being bought, expensively and ever more widely: large sums for editors threatening revelations, small handouts for local journalists who might ask awkward questions. It was the biggest time-bomb ticking away beneath the financial structure of the Third Republic, though initially the deception was everywhere successful, stok-ing the fires of speculation and helping to generate a flurry of dealing within and without the Paris Bourse.

To Gauguin and his colleagues, the fever-ridden jungles of Central America were a long way away and the Canal was just the biggest of the

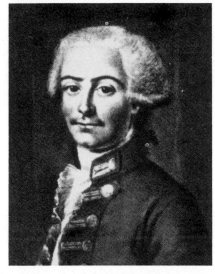

A photograph in the dusty municipal museum in Arequipa, of Don Pio Tristán, last Spanish Viceroy of the territory which is now Peru and great-uncle of Paul Gauguin.

Don Pio's brother, Don Mariano de Tristán y Moscoso, Paul Gauguin's great-grandfather who established his family in France after the collapse of the Spanish Empire in South America.

Paul Gauguin's grandmother, the radical feminist Flora Tristan.

Portrait by Jules Laure of Gauguin's mother Aline.

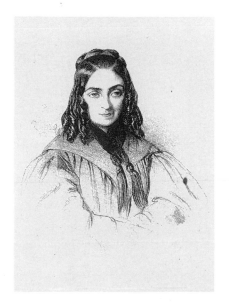

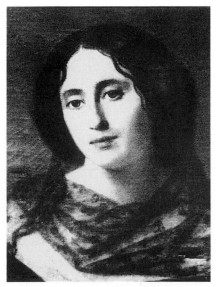

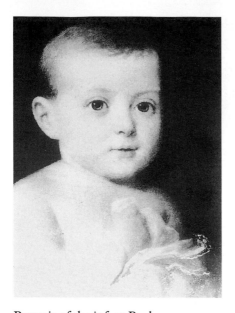

Portrait of the infant Paul
by Jules Laure.

Gauguin's sister Marie.

Street scene in Lima around 1866, showing the sort of houses Gauguin would
have known as a child.

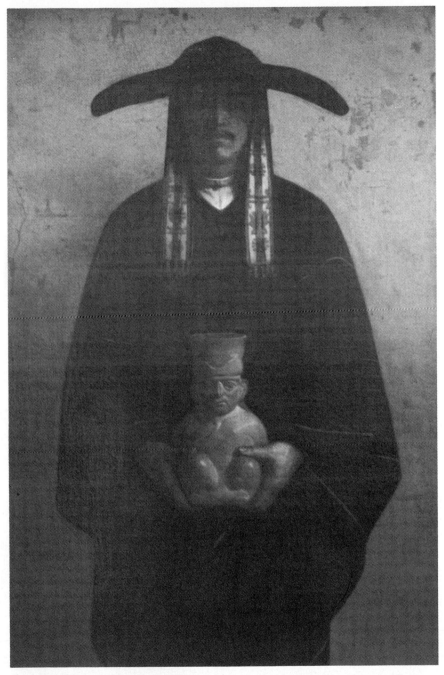

*El Alfarero* (*The Potter*) by Francisco Laso, *c.* 1850. While the painting shows the European academic style adopted by many Peruvian artists in the nineteenth century, the Mochica ceramic held by the figure reveals the sort of pre-Columbian pottery available when Gauguin lived in Lima, an art which formed the basis of his mother's collection and that of his guardian Gustave Arosa.

RIGHT Bishop Félix Dupanloup, the senior Catholic cleric who taught Gauguin theology.

BELOW Gauguin's school, the Petit Séminaire de la Chapelle-Saint-Mesmin near Orléans.

The Arosa family. From left to right: Gauguin's guardian,
Gustave Arosa, the youngest daughter Marguerite,
Gustave's wife Zoé, their eldest daughter Irène with her
husband Adolpho Calzado.

The Place de l'Hospice, Saint-Cloud, near the home of Aline Gauguin, just after the town was destroyed by the Prussians in 1871.

Paul Gauguin aged 25 and Mette-Sophie Gad aged 23, photographs taken for their marriage in 1873.

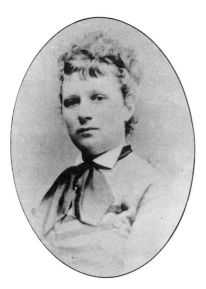

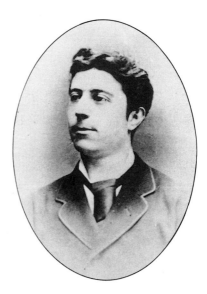

The dissolution of the Republican Congress in Madrid, 1873.
Manuel Ruiz Zorilla is the left foreground figure with
his foot on the barrier.

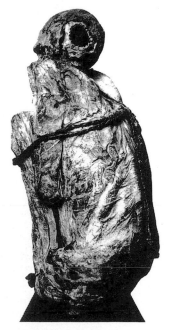

The Peruvian
trepanned mummy in
the collection of the old
Musée du Trocadéro,
an image that haunted
Gauguin throughout
his life as an artist.

The Schuffenecker
family. Emile is standing
behind Louise who holds
their daughter Jeanne.
Their infant son Paul is
seated on the lap of an
unidentified friend.

Mette Gauguin
photographed in 1888–89
in Copenhagen with her
children: Clovis, Pola
seated on his mother's
lap, Aline standing
behind Jean-René and
the eldest son Emil.

many money-making ventures that kept everything spinning along nicely. Like crazed gamblers, the young *coulissiers* were getting to the point where they would bet on anything. Even art was not immune to their craving for quick profit and many of them took to buying paintings in the galleries near the Bourse, taking art on credit, selling on, and settling the original purchase price out of the profits just as the *liqui-dateurs* did with company shares. They had plenty of time on their hands for such extra-mural activities for, as Gauguin wrote in a letter to Pissarro, he only worked from ten to eleven in the morning, and four to five in the afternoon, which tends to confirm the notion that he was a *coulissier*, working outside the normal hours of the Bourse itself, which were 12 a.m. or 1.00 p.m. to 3.00 p.m. For the rest of the time, the *coulissiers* passed among their fellow brokers in the cafés near the Place de la Bourse, recommending stocks and keeping an ear open for inside information. It was a congenial life for someone with other interests and attracted a number of writers like Octave Mirbeau, who would one day be a useful supporter. Nor was Gauguin alone in dabbling in painting itself: several of his colleagues, such as the young Achille Granchi-Taylor, were Sunday painters as well as collectors and with such pleasant pastimes and congenial company no one seems to have given an instant's thought to the last time there had been such a Scramble and the disaster it had led to.

Finance and Art were intertwined in other ways, especially in the case of the one dealer who supported the Impressionists, Paul Durand-Ruel. The son of a stationer and picture dealer, Durand-Ruel had transformed the family business first by selling artists' materials, later by making more space to show paintings until he opened his handsome gallery in the Rue Laffitte. Significantly, Durand-Ruel was a devout Catholic and as such was looked on with favour by the Union Générale. One of Bontoux's associates, Jules Feder, decided to invest in Durand-Ruel and thus transformed what had been a hopelessly idealistic failure into a going concern. Suddenly Durand-Ruel was able to exhibit, and even occasionally sell, some of the many works by Monet, Renoir, Pissarro and others which he had been stock-piling since before the Franco-Prussian War and the purchase of which had seemed, until then, little more than an act of charity. With art 'moving', other speculators joined in, sure they would make a profit when everything was going up as if by magic.

## The Temporary Impressionist

Gauguin's own picture dealing in his lucky year 1879 was more personal than was usual with the *coulissiers*. He was buying for reasons other than pure speculation. His success at the Salon had convinced him that his

work was ready for a public airing and he wished more than anything
to exhibit with the Impressionists, not for financial reasons – he knew
they sold almost nothing – but because he had realized that all the fury
which surrounded them was a sure sign of their importance. He had
noted how Pissarro had managed to get one of his protégés into the
Third Impressionist Exhibition and he now decided that this was the
route he should take. It was not difficult to ingratiate himself – he was
rich and they were miserably poor. The previous two years had been
the lowest moment for most of the group. At a sale in June 1878 a Monet
had gone for only 35 francs, a Renoir for 31 francs and two Pissarros
for 7 and 10. In 1877 when Pissarro tried to organize a lottery of one
of his works in a last desperate attempt to raise money, only a handful
of local people bought tickets. When the little girl who finally won asked
if she could have a cream bun instead of the painting on offer, it was
thought best to give her one. In the early part of 1879 Gauguin bought
three Pissarros and thus found himself on the visiting list.

The relationship between Gauguin and Pissarro was now that of
patron to teacher, with both needing the other to continue their work.
There is an oddly revealing sheet from a sketchpad on which Gauguin
drew Pissarro as a gentle old patriarch, while Pissarro scratched in a
sharp image of Gauguin as an anxiously observant young attendant.
But whatever their inner feelings, just as Gauguin had hoped, Pissarro
persuaded his fellow organizers to let him invite Gauguin to participate
in the Fourth Impressionist Exhibition which was due to open on 10
April 1879 at 28 avenue de l'Opéra. Under normal circumstances there
would have been little justification for such a move but the absence of
Renoir and Cézanne, who had submitted work to the Salon in defiance
of Degas's rule that the group should boycott the official exhibition,
meant that there was now room for someone new.

Gauguin was thrilled and replied to the invitation from Pissarro and
Degas with a humble letter promising to abide by all the rules which
governed their association. He nevertheless succeeded in stretching those
rules to the limit by submitting not an Impressionist painting but his
marble bust of Emil, the only piece of sculpture in the show and one
hardly of a style to match the surrounding canvases. It was the gesture
of a man determined to stake a claim for his own individual talent in
the presence of some of the greatest figures in nineteenth-century French
art.

It was too late for his name to appear in the catalogue, where he was
listed simply as the owner of three of the Pissarros in the exhibition, but
Edmond Duranty in *La Chronique des Arts* referred to 'a small, agreeable
sculpture by M. Gauguin, the only sculpture there,' which made up for
the omission.

Despite having achieved his objective, Gauguin continued to buy more works from Pissarro after the exhibition closed and this led to an invitation to visit Pontoise and spend the summer holiday painting there. It was exactly what Gauguin needed, a period of consistent work on his art with a little gentle guidance and that summer, as the two men worked side by side, out in the fields, he absorbed the Impressionist technique from the perfect guide, a man who did not attempt to dragoon his junior into a set style but let him take what he felt he needed. A painting made later that year, a view near his house in Paris, *Les Maraîchers de Vaugirard*, shows the results of his summer's labours. The choice of subject, the suburban edge, that curious hinterland between the advancing city and the receding countryside, was a key motif of the new art and had been a major preoccupation of Pissarro's since his return to France. And Gauguin also tried to follow the older man's practice of applying short, broken brushstrokes onto a light background to give an increased luminosity. He did not entirely succeed. *Les Maraîchers* is very much a trial piece – critics have written of the 'acid' or 'garish' greens and it is clear from Gauguin's letters to Pissarro that he was giving this sort of open-air painting a trial without being absolutely convinced of its merits. By 1881 he was already suggesting to the older man that 'a note of the open air can be pretty here and there ... but it doesn't add up to a painting.' And by 1882 he was telling him that it was time 'to do more in the studio'. Hardly what Pissarro wanted to hear, but another sure sign that Gauguin was still refusing to be anyone's disciple. In that same letter Gauguin writes that he already has it 'in mind to become a painter,' though only when he has been able to arrange things so that he can earn a living from his art. There is no evidence that he vouchsafed this intention to his unsuspecting wife. She would have been even less happy had she had any inkling of the other side to Pissarro's influence on her husband, for despite Gauguin's resistance, Pissarro's influence was there and went much further than painting. There is a tendency to think of Pissarro as calm and untouched by the tribulations of the world – but that is merely a perception of the mask he himself maintained. Beneath lies the real Pissarro, a man of passion and commitment. He had witnessed and approved of the slave revolts on Saint Thomas and when he eventually settled in France the current wave of anarchism, a reaction to what radicals saw as the stultifying corruption of the Second Empire and later the Third Republic, drew him to the writings of Kropotkin, though he vehemently rejected the latter's disparaging view of art as a bourgeois luxury.

The anarchist side of Pissarro was crucial to Gauguin's developing world-view, reinforcing his predisposition to radical and republican politics. It makes the relationship between the two men even more curious

– at weekends the white bearded figure like an Old Testament prophet would be out in the fields all day, with the dandified businessman, painting and discussing revolution. During the week Gauguin would go to the Bourse where he would try to persuade his colleagues to invest in Pissarro and from time to time the latter would call at his office in the Rue Le Peletier to see if there was any money for him. While Paul's earnings never again matched the heights they reached in 1879, he went on buying large amounts of art for a further two years, a matter of great importance to Pissarro who relied heavily on his interest.

The following year 1880, Gauguin was one of only eighteen exhibitors in the Fifth Exhibition at 10 rue des Pyramides, though at Degas's insistence the word 'Impressionist' was omitted from the title and replaced with the more neutral 'Independent Painters'. This was just as well, given that Monet and Renoir and Sisley did not participate, allowing Degas to introduce a number of his young friends, artists like Zandomeneghi and Raffaëlli who were only loosely interested in the new art. With the original impressionists absent, the show effectively marked the end of a unified movement, though at least the visitors laughed less and the critics had given up trying to swamp the artists with ridicule. Charles Ephrussi in the *Gazette des Beaux-Arts* even went so far as to complain about the missing artists on the grounds that their absence prevented him from passing an overall judgement on the new school.

Not that this mattered much to Gauguin, who was happy to have room to exhibit eight works, the result of his labours with Pissarro, most noticeably *Les Pommiers de l'Hermitage* (*Apple Trees near Hermitage*), a reworking of a scene already painted by Pissarro that had been bought by Gustave Arosa. Gauguin, too, painted more than one version of the scene, following his mentor's method of returning again and again to the same motif in an attempt to know it intimately in different seasons and times of day. All his versions are as bright and luminous as Pissarro's but without his limpid tranquillity – Gauguin applied his colours in sweeping curves which create a sensation of movement as if a light breeze were playing about the hilltop orchard.

Such differences were slight, however, and compared to Degas's protégés Gauguin was by then sufficiently Impressionist to be reasonably established within the group, if still slightly resented by older hands like Monet and Renoir. Despite this Gauguin still went on buying their pictures, though his reasons were now different from the early days when he had wanted merely to ingratiate himself with Pissarro. He now bought to learn, choosing those artists whose work he wished to study at leisure. And to his intense delight some of them now wanted his work too. He seems to have exchanged a painting with Degas and he certainly sold one of his own paintings to Degas's protégée, the American artist Mary

Cassatt, a sale which shows that Gauguin had ceased to be a stockbroker playing at painting. Having successfully integrated himself among the professionals he had now become a professional himself, recognized as such by his fellow artists. The change-over had finally happened.

## Stormclouds and Crisis

It brought him little satisfaction. Just as his chosen world recognized his worth, his marriage collapsed. Anyone less absorbed in himself than Paul Gauguin would have seen it coming. While he was away painting or promoting himself, Mette was either preoccupied with the children or distracting herself by spending money. As he was dealing with the Fourth Exhibition in 1879, she was giving birth to their third child, another boy, whom they named Clovis after the father Paul had never known. That over, she could start shopping again.

Flushed with the large sums of money Paul earned that year, Mette had been able to indulge herself with impunity. But by 1880 things were settling back to a more normal level while she proved unable to restrain her spending. Even though the boom was still under way, it was now at a level much reduced from the first frenetic year when speculation had run riot. But when they argued, Mette had a stick with which to beat Paul in the person of Schuffenecker, with whom she always remained on close terms, and who was clearly doing very well out of his investment in the gold-working process.

Despite this security, Schuffenecker's art had not progressed with the evolution of his ideas. He was interested in Impressionism yet in his art he continued to emulate Baudry who used his influence to get Emile admitted to the Salon of 1877, a year after Gauguin, with a decoration for a library ceiling, much the sort of thing the master was known for. There was as yet no indication in his work that Schuff had been exposed to Impressionism. He even took lessons from one of the most conventional of the *artistes pompiers*, the celebrated Carolus-Duran, and continued to produce architectural drawings and decorative schemes, presumably in the hope of following the conventional route to Salon fame and a secure income from the sale of his art. It was only when Baudry saw some slight signs of Impressionism in one of Emile's paintings and withdrew his support, that the pupil gave up on the master and started to experiment with the new art.

Schuff married in 1881, though even in that he appears to have been fairly supine, allowing members of his family to arrange his betrothal to Louise Monn, a distant cousin from a branch of the family in need of someone well-off. He ought to have been alerted to the nature of this union by the stunning beauty of his bride who would hardly have married

him for love. It was a disaster in the making – he was ever more hunched and pathetic where she was tall, elegant and ethereal, and no doubt well aware of why she was in such a position. At first the marriage followed its course. In 1881 their daughter Jeanne was born and in 1884 a son, Paul. But from the first there were storm signs and warnings of future grief.

He was no sooner wed than Schuff decided to resign from Bertin at last. He had his gold-working investment and had clearly thought the whole thing through. At least so it appeared to Mette who had by now guessed that Paul might be thinking of following his friend's lead, without making any of his wise provisions. Unlike Schuff, Paul was handling it all wrong, wasting his time with the Impressionists, spending money on them while simultaneously criticizing her for the bills she ran up with the local tradespeople.

By 1880 the arguments over money were proving too much and Mette did the classic thing – she went home to mother, taking Emil, their oldest child, with her to Copenhagen. In a letter to Schuffenecker, Paul poured out his anger at having to settle her debts and announced that he had written to her mother '*pour divorcer*' though whether it was this threat which brought Mette to her senses, or whether it was still her affection for him which brought her back is hard to say. Either way, she decided to return, though without Emil who was left in the care of a close friend, Karen Lehmann. Why she did this is not clear. She may have wanted her firstborn to have a Danish upbringing safely away from the French bohemianism she now distrusted. One of Elstrup's daughters, whom Mette used to teach and who was now the Countess Moltke, offered to pay for Emil's schooling. But Mette must have known that Paul had always been entranced by his children and, if she was looking for a way to punish him, she had certainly hit on a devious way of doing so.

Whatever lay behind all this, Mette was, according to Paul, 'forgiven'. He even changed jobs once more, presumably another attempt to raise his income to cope with her extravagances, joining an Agence Financière des Assurances run by A. Thomereau at 93 rue de Richelieu where he was to be involved in the sale and purchase of insurance company stock.

On the surface this seemed a highly respectable business. Alfred Thomereau himself was the managing editor of the respected *Moniteur des Assurances*, a professional journal based at 48 rue Laffitte which had been founded in 1868 and which flourished until the 1920s with general articles displaying all the ghoulish relish with mayhem and death which so preoccupies actuaries – tables of longevity, statistics of steam-engine accidents, morbid accounts of theatre fires in Massachusetts. But this frock-coated façade may have masked what the junior salesmen were

getting up to at grass-roots level. As with insurance companies and pension funds today, the boardroom preferred not to know about the hard-sell tactics used by their junior employees eager to earn their commissions. Many insurance businesses had thrust themselves into the market place in the wake of the Union Générale and the flood of easy money it had unleashed. Their business methods were simple – they put what amounted to 'get-rich-quick' advertisements in local newspapers all over the country calling on the public to invest a regular if small amount in the agency, which would then play the stock market on behalf of all their investors, while creaming off its commission and doing a good deal of speculating on its own behalf. Because of the vast sums they were able to move around, they could use their financial muscle to influence the market and were in effect operating a sort of free-wheeling equivalent of today's unit trusts. As the minimum investment on the Bourse was 500 francs, a sum beyond ordinary folk, millions of people, convinced by all the stories of riches to be made, rushed to send in whatever they could afford to agencies like Thomereau's. What nobody ever explained to them, assuming that their greed would have let them listen, was that this form of speculation could only work in an ever-rising market, in other words during a boom. In a normal, balanced economy such funds would have been spread to minimize the risk and this would have stabilized income to a steady growth, rather than a rush for riches. Such madcap investing was totally vulnerable were the market to turn down, a fact which must have been obvious to Gauguin. If this was what he was doing – and there is no proof to show that he was – then it suggests just how far he had moved from his early days with Arosa and thus how desperate for money he was.

He also changed addresses yet again. It wasn't enough to have the use of Bouillot's studio, he now wanted one of his own and managed to rent an atelier from the history painter Félix Jobbé-Duval, which had, until recently, been occupied by the artist's son. Although Jobbé-Duval senior's brand of salon art was not of much interest to Gauguin, the two men shared a common allegiance to republicanism; the older man was an elected member of the local municipal council and made a living painting murals on public buildings. More interesting was the fact that Jobbé-Duval was a staunch Breton, born in Carhaix in the centre of Brittany, who aroused Gauguin's interest by describing the simple unspoiled life in what still seemed like another world. As well as simplicity there was mystery – the old traditions lived on – and, given the cheapness of living there, it is hardly surprising that all this had already attracted many indigent artists in search of beauty at low cost. Jobbé-Duval had even heard of an inn, somewhere near the coast in Finistère, whose proprietress was said to be touchingly sympathetic to painters, to

the point of accepting their paintings in exchange for room and board. For the moment, Gauguin filed away this intriguing news, as yet unaware of how important it was to be.

The new studio was not far away – at 8 rue Carcel near the Vaugirard church – and had a three-room apartment attached to it. The large living room seems to have stimulated Gauguin's interest in craft design, for he set to work and made his own bookcase, a curious folk-piece, actually two cupboards laid one across the other in a T-shape, fronted with carvings which he did straight onto the wood fascia. There is a vaguely medieval air about it, reminiscent of the arts and crafts furniture more commonly associated with England or Germany. It is the first surviving example of Gauguin's attempts to re-create what was once called 'primitive' carving, before the word became a term of abuse of non-European peoples and their cultures and was thus rendered unusable. At the time – in the sense that Gauguin would have understood it – it was a means of denoting something honest and natural, as opposed to the gaudy industrial products which littered the salons of the nineteenth century. Making furniture in your own primitive way was an artistic and political gesture. He also bought an upright piano for Mette, then painted a picture of the dining room with both of them in the background – she, half-hidden behind the instrument, with himself, almost back-view, leaning on it as he listens to her. The dominant element in the picture is an enormous bunch of zinnias in a ceramic bowl, on the table in the foreground. In French the painting has a somewhat bland title: *Intérieur du Peintre rue Carcel* and it is even duller in English: *Flowers, Still Life*. The picture is, however, very human and is a sort of reconciliation, with the married couple tucked safely into the interior of their comfortable home, while the husband's gift of flowers is the most prominent thing in the room. They were certainly reconciled, for Mette was pregnant again. But while on the surface life had returned to what it had been before their rupture, certain differences still remained. Mette preferred her Scandinavian friends with whom she felt more at ease. There were times when she attempted to fill the role of artist's wife but her difficulty was that she had no idea of the sort of artist her husband was trying to be. Hoping that her brother-in-law Fritz and his friends might fit into Paul's world, she invited them round, only to discover that they had little in common. Most Scandinavian artists in Paris tended to gravitate to the atelier of the academic painter Léon Bonnat, whose historical and religious scenes would today be dubbed photo-realism. It was the sort of stuff guaranteed to provoke Gauguin's choicest scorn and as Mette's friends still reverenced the master, and saw nothing amusing in Gauguin's derision, the encounter was not a success. Gauguin could be brusque with those he admired, so that one does not have much trouble

imagining how rude he could be with those who irritated him. There is no doubt that Mette must have been hurt and dismayed at what she could only interpret as a deliberate attempt to snub her friends and exclude her from his own circle. Worse, she was beginning to suspect that he drank a little too much, cognac usually, and his liking for lonely sessions playing the mandolin was not encouraging to one as gregarious as she obviously was. Mette liked to be surrounded with her lively Scandinavian friends and the idea of standing alone in a field all day with nothing but a canvas for company was not one she easily appreciated. Despite the reconciliation they were drifting apart again and were once more spending less and less time together.

## Towards Another Art

The main reason for Gauguin's absences was a new and more compelling reason to visit Pontoise: the return of Paul Cézanne, early in 1881, to work alongside Pissarro as he had nine years earlier. Gauguin was immediately intrigued by someone about whom he had heard a great deal but who, until then, had been only a name. There is a comic sketch by Pissarro's son Manzana entitled *An Impressionist Picnic*, which shows Guillaumin and Pissarro eating, with Gauguin standing to one side watching, while Cézanne paints, Julie cooks and the infant Manzana sprawls on the ground taking in the scene. Every writer on Gauguin states that he was influenced by Cézanne, though few offer any precise evidence as to what exactly he is supposed to have taken from that moody and difficult figure, nine years his senior. As the painter Maurice Denis put it: 'I have never heard one of Cézanne's admirers give clear and precise reasons for his admiration.' But it is true that by mid-1881 Gauguin was writing, half-humorously, to Pissarro to ask if Cézanne has 'discovered the exact *formula* for a work that would be accepted by everyone? If he should find the recipe for concentrating the full expression of all his sensations into a single and unique procedure, try, I beg you, to get him to talk about it in his sleep by administering to him one of those mysterious homoeopathic drugs and come directly to Paris to share it with us.' Despite the defensive sarcasm, Gauguin began buying Cézannes – he owned six after a time – with the clear intention of finding out exactly what the other man was doing.

Gauguin's interest came at a moment of transition in Cézanne's work, his move from the heavy, darkly coloured early works, inspired by Manet, and the use of light geometric line and shade to re-create the volume and depth of landscape. There is an unfinished self-portrait he was working on around this time which is almost exactly poised between the two methods. It also tells us much about the artist: the thick black beard

compensating for the balding head, the suspicious eyes of one who has known mental illness and can no longer trust anything or anyone. He certainly thought Gauguin was trying to steal his ideas and fled back to the south of France to escape his prying questions. It made no difference, Gauguin was not really after his new technique in any direct way – though he dabbled in it for a time, it was more the fact that the older man was pulling away from the spontaneity of Impressionism, which intrigued Gauguin. As Cézanne put it: 'I wanted to make of Impressionism something solid and durable, like the art of the museums' – a notion similar to Gauguin's suggestions to Pissarro that they should get back to the studio, away from first sensations, returning to a more considered art, in opposition to the setting down of the immediate flickering moment which had preoccupied the early Impressionists. Gauguin seems to have decided quite quickly that Impressionism had broken with the depiction of ideas, with the thread running through European art from the Middle Ages up to the beginning of the nineteenth century, when it had been abandoned by the open-air landscapists in favour of an art of sensation – of emotional response to the real world. That Gauguin believed something had been lost is shown by his ever growing image-bank of prints and postcards which now contained reproductions of Botticelli's *Triumph of Venus* and Fra Angelico's *Annunciation*. He thought, wrongly as it turned out, that Pissarro had similar doubts – he was always encouraging his sons to study Holbein – but this was more a question of technique than of subject matter. In the end, Pissarro remained true to the underlying ethos of the school he had helped found and the two men would eventually find themselves on opposite sides of an artistic divide.

Gauguin's interest in Cézanne was one of the first clear signs of that division. For a time, in the early 1880s, Gauguin was happy to sniff around Cézanne's pictures, trying out things which caught his fancy – a perfectly normal working practice among creative artists, but so quickly did the two drift apart that any talk of influence needs to be modified. One picture which can be safely said to have had a direct effect was a Cézanne nude which Gauguin bought, and used for a painting of his own. Now lost, Cézanne's painting is known to have been a large work depicting a haggard model, far removed from any stereotype of female sensuality, and unusual enough to have provoked Gauguin into trying his hand at figure painting. According to Gauguin's son Pola, in his later account of his parents' marriage, the actual model was a maid whom he calls Justine, though as he was frequently inaccurate over names and dates there is no way of confirming this. There is a photograph of a maid-servant holding baby Emil but she looks nothing like the nude, sitting on a bed sewing, which Gauguin painted. If it was Justine, then

the sitter can hardly have been best pleased with the results and would no doubt have been relieved that she was not recognizably the pallid, slump-backed figure that Gauguin dreamed up, in direct imitation of Cézanne's worn-out woman. Not that the picture is really an honest attempt at harsh realism – women aren't usually naked when they sew, nor is there anything natural about the surroundings – the woven cloth, probably Peruvian, hanging on the wall behind, with Gauguin's mandolin hung below, are too artificially set up for that. Irony? Possibly. He could have been making a reference to the much admired *Olympia* and the way Manet seems to be playing off one cliché, the odalisque, in an oriental setting, against another, the contemporary realism of Victorine Meurent.

Whatever Gauguin's intentions, the effect was not easily achieved and the canvas shows signs of much reworking. Its tentative nature is reflected in the eventual title: *Nude Study, Suzanne Sewing* which undermines the Justine theory. It was exhibited at the Sixth Impressionist Exhibition in April 1881. That the painting was not Impressionist was of little moment, as were so few of the other works exhibited. They were almost exclusively from Degas's circle, a fact which was beginning to annoy Gauguin who, despite his own differences with Impressionist theory, felt that some of these artists were effectively Salon painters using a slightly lighter palette, but who had no real interest in the ideas of the group.

Whatever his misgivings, the nude brought him his first in-depth critical assessment in a long article by Joris-Karl Huysmans, a critic who a little later would publish his novel *À Rebours*, a key work in the coming years. Huysmans referred to the painting as being indisputably modern: 'The flesh is rudely alive; this is not the smooth, even skin, the skin dipped in a vat of pink and then gone over with a warm iron, that all the other artists produce; here is skin beneath which the blood flows and nerves twitch; and finally what truth there is in all the parts of the body, in the large belly that spills over the thighs, in those folds beneath the sagging chin, ringed with dark patches, in the angular knee joints, and the prominence of the wrist . . . .' Huysmans noted that the picture evoked Rembrandt's unidealized treatment of the plump female form and he may indeed have hit on one of the sources for the work. His review concluded with a stirring fanfare: 'Monsieur Gauguin is the first artist in years to have attempted to represent the woman of today . . . . He has roundly succeeded and has produced a bold and authentic painting.'

If Gauguin was thrilled by such an unreserved encomium he wasn't going to let on and wrote dismissively to Pissarro, complaining that '. . . in spite of the flattering part, I see that he is attracted only by the literary dimension of my female nude, and not by how it is painted.' One suspects that had it been the other way round he would still have feigned indifference.

He had other reasons to be pleased – Durand-Ruel had bought three of his paintings for a total of 1,500 francs which, when one remembers the miserable sums offered to Monet and the others only three years earlier, was positively munificent. Of course, the economy was still booming merrily, there was cash about and everyone was feeling flush. Gauguin reciprocated by buying a Manet seascape from Durand-Ruel and when the dealer sold Gauguin's painting of the church near his house in Vaugirard he gave him two Renoirs in payment. So the dealing ran on, to and fro throughout 1881. Mette gave birth to another boy, Jean-René, in April and nobody had any idea that they were dancing on the rim of a smouldering volcano.

To complete this year of progress, Gauguin painted what must be the first canvas where he truly enters his own world – effectively the first real Gauguin. Called *The Little Dreamer: Study* (the final word again denoting a hint of insecurity about what he had achieved) this painting is utterly different from anything he had so far attempted. In the first place, he had now mastered a working style of light, pastel colours applied in short strokes which replicated the effect of chalk on paper, an echo of Degas's theatre drawings. Gauguin's scene is open to multiple interpretations. A child lies, back to the spectator, on a boat-bed which is carrying it into the dreamworld, represented by the flight of birds on the wallpaper behind and by a line of music printed on the wall beneath. A doll, dressed as a clown, is propped against the wrought-iron bedhead. At first reading this is a charming vision of innocent childhood but with a slight narrowing of the eyes and a hardening judgement, it can be seen as something less simple. The doll/jester seems almost alive, standing by the bed, mockingly inviting us into a scene in which the music one hears is the terrifying slapping of wings of the birds trapped in the tiny room, a nightmare when one takes in the disturbing androgyny of the child. This short-haired figure was long thought to be the Gauguins' firstborn Emil – but he was in Copenhagen, where Mette had left him. Only much later, from a photograph, was it shown that the child was not a boy at all but their daughter Aline, whose hair was kept close-cropped by her mother, while the younger boys had theirs curling to their shoulders, as if they were the daughters. Aline was now four years old, and in the painting her night-shirt has rucked up to just below her buttocks, exposing her legs. In the scumbled dark paint of the lower wall, what could be a face stares out at her, the face of her father.

What on earth did Mette make of it, this image of her child, spied on out of the shadows. And what was the figure, his face half-hidden in the background, thinking of when he painted it?

## The Crash

If there was a nightmare in Gauguin's life it was no longer confined to the imaginings he put in his paintings – it was out in the real world where he earned his living. Like everyone else connected with the Bourse he had been watching the activities of Bontoux's Union Générale with increasing concern. The bank had recently launched a number of new activities in eastern Europe and required one of its biggest stock issues to date, an attempt to raise an enormous capital sum. The shares of the Union had already moved from 50 million francs to 100 million in a year and for the first time doubts began to circulate, not least because the movement of funds needed to assure the new issue seemed to be based on a piece of creative accounting which many thought dubious.

Confidence might have held if the general financial climate had been more favourable but the first half of 1881 saw a number of bankruptcies amongst small businesses, which led to a run on the banks. From November, the Union's credibility began to evaporate. Initially, the Bourse in Lyons was worst hit, the Union having concentrated much of its fund-raising in the provinces. With delicious irony, the local trains were able to make a great deal of money laying on special carriages to bring in the countless suburban investors who were now desperate to offload what were rapidly becoming worthless shares in foreign railway companies. As 1882 opened, the inevitable chain reaction began – the Banque de Lyon et de la Loire collapsed. A desperate Bontoux tried to save himself by using the Union's own funds to buy up the stock falling due at the January *liquidation* – a fatal move as there could not possibly be enough to provide for such a circular movement of money and on 21 January, the Union Générale suspended trading and Bontoux and Feder were arrested on suspicion of theft. All over Europe stock markets trembled, while in France the economy shuddered into stagnation as businesses were sucked into the descending vortex of financial ruin.

Convinced that the fall of Capitalism had come at last, left-wing groups organized protests which became riots and which led to bombings and other acts of violence around the country. Many of Pissarro's anarchist friends, including Kropotkin, were rounded up and people began to talk of the downfall of the State.

For the *coulissiers* it was the end of the line – nobody was investing anything, the Bourse was effectively shut down. The larger, more established *agents de change* hung on – Gustave Arosa's holding in Galichon in 1882 remained what it had been the previous year at 350,000 francs, which would indicate that they had prudently avoided getting drawn

into the maw of the Union Générale and were able to survive. Even Thomereau, where Gauguin worked, still trading in insurance stock, was not immediately toppled in the way the *coulissiers* were. But it was evident from that January that the good times had been swept away and that earnings would now be pitiful. Presumably to save money, Thomereau closed down the Rue Laffitte office and moved his journal, *Le Moniteur*, to the main office in the Rue de Richelieu. This is the only sign in the magazine that anything untoward has occurred but despite the *Moniteur*'s reticence everyone at Thomereau was well aware that the days of insurance companies trading in shares were effectively over.

Gauguin, however, was still employed, thus laying to rest the myth that he only became an artist because he had been thrown out of work by the financial crash. By the time the Union Générale fell he was effectively a professional artist and if he entertained any thoughts that the crisis might liberate him from the drudgery of earning a living, he was quickly disabused when he saw the effects of unemployment on those around him. A few, like Octave Mirbeau, moved into other fields. Mirbeau became a journalist and art critic. Others were less fortunate and some of the young *coulissiers* like Achille Granchi-Taylor, who had dabbled in art speculation and had been, like Gauguin, Sunday painters, now tried to sell their own work, hoping to move into art as they had once entered finance. This was a forlorn hope for even if they had talent there was no market for art either – many of the *coulissiers* had been unable to liquidate their debts to the galleries in the Rue Laffitte so that the art market also crashed. Gauguin was left with debts for paintings which no longer had any commercial value and all he could do was hang on at Thomereau hoping the situation would improve.

In the midst of this crisis, it is small wonder that the planning of the Seventh Impressionist Exhibition was concluded in an atmosphere of some ill-feeling. Monet and Renoir were persuaded to return but Degas withdrew when it was clear that no one save himself was prepared to tolerate his protégés. Gauguin exhibited eleven paintings, a pastel and a sculpture but there was little satisfaction any longer – Huysmans wrote that he had made 'no progress' since the previous year, and the general view was that his contribution was somewhat mediocre. He made himself go on working, travelling out to Pontoise at weekends, but it was hard to concentrate when the comfortable world he had known was now in such disarray. By November, he was forced to ask Pissarro to buy back a painting for which he had paid 800 francs, though he must have known that the older man was unlikely to have kept the money which was bound to have been spent. Like the other Impressionists, Pissarro had relied heavily on Durand-Ruel but with the arrest of Bontoux's associate Feder, the gallery owner was effectively ruined, with debts running into hun-

dreds of thousands of francs. Amazingly, he decided to go on, but only holding one-man shows of the better-known impressionists – Monet and Renoir – who he believed might interest the public and stimulate sales. To Gauguin, who knew that at this point he had little hope of such an exhibition, Durand-Ruel's decision was just one more blow among the others raining down on him. His most pressing problem was a debt of 1,000 francs to a friend, Emile Bertaux, who had worked for the broker-age firm of G. Lafuite in the Avenue de l'Opéra. Bertaux, another Sunday painter and small-time dealer, had sold Gauguin some paintings just before the crash for which he was still awaiting settlement. The only ray of hope was that Bertaux had family money and was as keen on the new art as he was and might just take some of Gauguin's own paintings in lieu of cash.

With all these difficulties, it is hardly surprising that Gauguin was unsure which way to turn. His remarks to Mette, that he was thinking of leaving Thomereau, can only have unnerved her, raising memories of her childhood, of the humiliation of being forced into service, of being poor again. It was now, at the worst possible moment, that death finally deprived them of all hope of protection. Gustave Arosa died at his new house in the Rue de Prony on Saturday, 14 April 1883 and was buried two days later. Gauguin did not attend the funeral or the memorial Mass the following Thursday. Indeed, he only mentions the event in passing, in the course of a letter to Pissarro, where he suggests that the older man might care to send a card to the family.

With such indifference passed from his life the man who had given him his start in business and who had treated his sister as a daughter. We are unlikely to know now what had divided them but whatever it was proved irreconcilable, even in death. Gauguin would never refer to his guardian in any of his many writings, barring from his thoughts the one who had introduced him to art and directed him towards the life he wished to lead.

Mette, meanwhile, was showing no sign of any willingness to adjust to their reduced circumstances. If her husband could not give her the money she required she simply borrowed it – from Schuffenecker or Marie Heegaard in Denmark. Not that Paul was as prudent as he liked to claim – in 1883 he got his wife pregnant again, hardly wise for a man facing ruin, who already had four children to feed.

There was no Impressionist exhibition that spring and Gauguin began to show signs of desperation and it was at this dangerous moment, when his judgement was weakest, that he agreed to a proposal that in other circumstances he might well have rejected out of hand. He was approached by one of his Spanish friends to see if he would travel to Spain carrying messages from the revolutionary leader Manuel Ruiz

Zorilla to his underground agents across the border. He would be paid but it is clear that it was as much the appeal of a schoolboy adventure, at a time when he was bored and depressed, that made him accept.

## Spanish Business

Ruiz Zorilla was the man of action every dreamer like Gauguin wishes to be. With his full black moustache and his burning sincerity he was the archetypal revolutionary plotter of the latter part of the nineteenth century, one of those caped and secretive figures passing between London, Paris, Geneva, communicating in code, holding clandestine rendezvous in the back rooms of cafés, discussing the latest hopes of a *coup d'état* in their homeland.

Little wonder that Paul Gauguin, with his revolutionary grandmother and his republican father, his anarchist friend Pissarro and his Spanish connections, should have been drawn to Manuel Ruiz Zorilla and should have been more than willing to offer him his services – especially if there was money involved.

Since his flight from Spain in 1875, Ruiz Zorilla had been trying to build up a network of disaffected army officers who might be nudged into fomenting a putsch which would lead to his return as head of a republican government. To Gauguin all this seemed irresistibly romantic and he does not seem to have realized that in common with other political exiles Ruiz Zorilla was by then out of touch with changes in his homeland. It was ten years since Alfonso XII's return and much of the opposition had fallen away. Initially the army had been largely sympathetic to the Republican cause but this support was no longer as solid as Ruiz Zorilla believed, though a certain amount of dissatisfaction over pay and conditions within the ranks did give the impression that a call to arms might lead to a mass uprising.

The first we hear of Gauguin's involvement is a cryptic reference in a letter to Pissarro, thought to have been written in Paris on Monday, 13 August 1883. After a few opening pleasantries Gauguin writes:

> At the moment, I am very interested in Spanish Business, with which I am slightly involved, I'll explain all this to you later in secret. In any event, if this revolution succeeds or lasts a month, in any serious way, it may turn out that in the future I may come out of it with a little money.

Whatever mysteries Gauguin was alluding to, Pissarro would certainly have been aware that there was a crisis in Spain at that time. From the beginning of August confused stories of an attempted military coup had begun to appear in the French press but why Gauguin should have been involved could only have puzzled the older man.

What had been taking place in Spain was a mixture of tragedy and farce. From his exile in France, Ruiz Zorilla had set up a secret Association of Republican Soldiers, within Spain, which had recruited adherents in most of the principal military bases. Feeling that resentment in the ranks was now sufficient to provoke an uprising, it had been decided in late July to set 5 August as the day for the troops to seize power. Unfortunately for the conspirators this message had no sooner gone out than their agent in Barcelona telegraphed the warning that it was impossible for this key base to comply at such short notice. At once the revolutionary command in Paris countermanded its original order, moving the date to the 10th , but it was here that the system broke down when supporters at the military base in Badajoz, near to the Portuguese frontier, failed to receive the second message and duly began their uprising on the original date.

For the exiled Republicans news of the unwanted revolt provoked something akin to panic. Orders were now issued calling on all supporters to immediately rise up in support of their brothers in the west but by then the confusion was such that it was only on the 8th that the base at Santo-Domingo de la Calzado in the northern province of Rioja took up arms, followed the next day by that in Seo de Urgel in Catalonia near the eastern frontier with France. Having been alerted by the premature outbreak in Badajoz, the authorities in Madrid were able to take rapid action to prevent others from joining them – especially the essential base in Barcelona on which all of Ruiz Zorilla's hopes were centred. For days the news from Spain was garbled and contradictory so that it is perfectly possible that someone like Gauguin, an avowed supporter, might have been approached to help in some way. All that Ruiz Zorilla could do was to get as close to Barcelona as possible in case the longed-for uprising should happen and to this end he travelled to Cette (today Sète) on France's southern border to await events. What we do know is that Gauguin also left Paris and headed south for there is a surviving landscape dated 18 August 1883 of a view near Cerbère close to Sète. A mere coincidence seems very unlikely, though whether this was anything more than just a rallying round of interested supporters, gathering to give encouragement to Ruiz Zorilla, it is hard to tell. Years later Schuffenecker revealed how Gauguin had told him that he had been paid to smuggle Ruiz Zorilla across the frontier into Spain under the nose of a border guard and that when the uprising collapsed he had managed to get him out again hidden under a cart-load of hay, travelling from Port-Bou back to Cerbère. In his later memories Gauguin would claim that upon their re-entry into France he was stopped by a gendarme who suspected that he was a Spanish spy and who demanded to know if he was French. When Gauguin said yes, the guard then said, in the heavy

dialect of the region – 'That's funny, you haven't got a French accent' with Gauguin making a joke out of the way the man pronounced the word 'accent'. All of which has added to the general feeling that this was just another useful anecdote, to amuse his friends at table.

Whatever the truth about the incident, Ruiz Zorrilla and his companions were forced to hurry back to Paris where they studiously avoided all contact with the press so that it is certain that Gauguin could only have invented his part of the story – if invention it was – from the standpoint of an insider. He could not have known of the events in Cette if he had not been party to the highly secretive doings of that small inner circle of conspirators, though whether or not he actually made a dangerous cross-border mission remains uncertain. If he did, then the ultimate irony is that on the one occasion when his actions should have merited some attention, his tendency to romanticize his life has ensured the universal dismissal of his tale.

## Drifting

Either way this doomed adventure may have been the last straw for his employer Thomereau who, in the present difficult climate, would have been in no mood to put up with Gauguin's prolonged absence. Whether he was fired or simply encouraged to resign is unclear, but some time after his return to Paris the break came. Even then he did not accept that his business career had ended but went on trying to get work, desperately clinging to the belief that a new job with a good salary lay just around the corner. He even made an attempt to bring his two worlds together by approaching the art dealer Georges Petit to see if he would take him on – a hopeless dream given the state of the art market.

Despite Mette's former extravagances, they must have made some savings, though with no salary coming in these would clearly not last long, hence his decision to revert to an earlier plan and to get out of Paris where life was proving cripplingly expensive. Pissarro, who was also casting about for some way out of the ever worsening situation, had already left on an extended visit to Rouen, the capital of Normandy, where one of his few patrons, a restaurateur called Eugène Murer, had just opened a hotel. Rouen was a holiday for Pissarro, a break from Julie's nagging and the fruitless visits to Paris where no one was buying art, but the unexpected arrival of Gauguin, full of enthusiasm and brandishing his contacts, all of whom were sure to buy paintings, raised the older man's flagging hopes.

Not for long. If anything, the businessmen of Rouen were in deeper trouble than their Parisian counterparts and it quickly dawned on Pissarro that he had placed an exaggerated faith in Gauguin's business

acumen. The disillusion is obvious in his letters to his sons where he begins to make disparaging references to Gauguin's 'commercialism' – though it is noticeable that this was a criticism which never arose when he thought the younger man might still buy some of his work.

Gauguin was less easily discouraged and remained convinced that it was only a matter of time until he flushed out the buyers. Before Pissarro returned to Pontoise Gauguin persuaded him to help find accommodation for Mette and the children as he was now certain that life in Rouen would be more congenial, and certainly cheaper than Paris.

Having rented the property, the two men returned to Paris where, on 6 December, earlier than expected, Mette gave birth to her fifth child and fourth son, Paul Rollon – called Pola to distinguish him from his father. When the latter went to register the birth he gave his occupation as 'Artist-painter' for the first time, though this did not mean that he had entirely abandoned the idea of returning to the world of finance should the opportunity arise.

In January 1884, he and Mette along with Aline, Clovis, Jean-René and baby Pola moved to Rouen. It was over three years since any of them had seen Emil and now they were cutting themselves off from all their friends and contacts. On the positive side, Rouen was delightful, with its medieval cathedral quarter, its narrow streets and close-packed houses. Gauguin's fascination with wood-carving was revived by the famous Renaissance half-timbered houses whose naïve carved figures must have set off echoes of Peru. The most spectacular, the house of Diane de Poitiers, has an almost Asian feel to it, so dense and intricate are the carvings. Mette, predictably, was not impressed. Their lodgings, at 5 impasse Malherne, looking down over the old town, were cramped, and there was barely enough room for the family, let alone a new maid, Christine, whom Mette had insisted accompany them. Gauguin spent much time chasing after potential buyers, beginning with Pissarro's friend Murer, while Mette looked up any Scandinavian contacts she could find, not attempting to disguise her increasing disgust with the feckless French who she believed had reduced her to penury.

It is surprising, in the midst of all this, that Gauguin found the time to paint. There were some harbour scenes in Rouen, but the landscapes in the surrounding Normandy countryside and the occasional still life could have been painted anywhere and are only remarkable for his use of broad angular brushstrokes derived from Cézanne's technique of building up his landscapes in geometric blocks. For the rest of the time, he tried to make money out of his art by launching himself as a portraitist. Using Mette's connections he painted a Monsieur Manthey, the Consul for Norway and Sweden, and later his daughter. When Uncle Zizi came on a visit from nearby Orléans, he too was persuaded to sit – though he

reciprocated by making Mette, Paul and the children pose for a photograph. But it was only another hopeless pipe-dream. Even Murer had proved no saviour, buying only a single canvas. 'What a joke this Murer is,' Gauguin wrote to Pissarro bitterly, then set off for Paris to see if he could get any profit out of the older man's system of trailing round the art dealers, hoping to interest them in his work. He left seven pictures on consignment with Durand-Ruel but he too was barely surviving and there was little hope that anything would come of it.

While in Paris, he looked up his Spanish friends. After the previous year's débâcle Zorilla had returned to the French capital with the captain of the garrison at Seo de Urgel, who had managed to slip across the border as loyalist forces began putting down the last traces of the uprising. Unwilling to antagonize their neighbours, the French authorities had obliged them to move to Geneva but the government in exile continued to hatch its plots in the cafés of Montmartre. As Gauguin quickly discovered, their hopes had been raised by resentment in Spain over rigged elections to the Cortes and he found the band of revolutionaries preparing to move south again, in the expectation of another army mutiny which might finally bring them to power. Gauguin happily agreed to join them and persuaded his friend Emile Bertaux to travel with him. They set off that April having let it be known that the reason for their journey was to visit the Musée Fabre in Montpellier. Of course they carried out the visit, happy to see the stunning collection of the late Alfred Bruyas, which had recently been installed. Already familiar with Delacroix's North African paintings from the Arosa collection, Gauguin was thrilled to find one in Montpellier with the oddly apt title: *Aline, the Mulatto Woman*. It was a portrait whose Arabic costume and setting were clearly destined to trigger something in a man whose disillusion with life in Europe was growing by the minute. He made a sketch of the painting and began to dream of more exotic settings for his own schemes.

As for the revolution in Spain, Gauguin and Bertaux were given 20,000 francs to hire a boat to get Zorilla down the Mediterranean coast when the time came. On 28 April a small band of insurgents crossed the frontier and captured the police post at Valcarlos, seized the arsenal, and marched towards Burguete. But once again, the expected mass uprising did not occur, and as soon as a party of soldiers and police caught up with them, most of the invasion force was wiped out.

When news reached Montpellier, there was nothing to do but pack up and go back. Gauguin had spent most of the money on hiring the boat and a crew, and had little left to show for the venture save an enjoyable and instructive visit to the museum. For his part Ruiz Zorilla left for exile in England, still hoping, though less sure when his dream might come true.

After all this high adventure, Gauguin's return to Rouen was dispiriting, and it was at this low moment that a Danish boat docked at the harbour and Mette's uncle, William Lund, appeared. The ship ran a regular cargo service between Rouen and Esberg in West Jutland and Lund was its chief mechanic. It was an opportunity not to be missed – her uncle could arrange the two-month round trip which would allow her to visit her family. There was no suggestion of another marital breakdown, when she left in July she took only Aline and Pola, leaving Jean and Clovis with Paul.

Her departure did nothing to ease the financial crisis and in desperation Paul cashed in his life insurance for 1500 francs, half its nominal value. But even that was soon spent and he was writing to Pissarro to say that he hadn't so much as a radish.

It was perfectly predictable that as soon as Mette got home all her ideas would change. She hadn't seen Emil, let alone her mother, for four years and after the tribulations of the past gloomy year, Copenhagen in the summer must have seemed heavenly – a feeling confirmed by the offer of her old employer Elstrup to help her get work teaching French. She wrote to Paul telling him that she was coming back but only to collect her things and would then return to Denmark for good.

Once again, Gauguin persuaded himself that this would be just the move he needed. He wrote to Pissarro that there was every chance he could succeed in winning over the Danes to Impressionism, and as if to clinch the matter, an old friend in Paris, Charles Favre, put him onto a business deal which seemed to offer some chance of making money in Scandinavia. Favre acted as Parisian sales representative for a textile company in Roubaix, the industrial town near Lille in the north of France. The Etablissement Dillies et Frères advertised itself as making 'Manchester-style' cottons, though its main income came from the more prosaic production of tarpaulins and other heavy-duty materials. According to Favre, Dillies were looking for a Scandinavian agent, a good post as there was the possibility of a big contract supplying wagon hoods to the Zeeland Railway Company. At Favre's prompting Gauguin wrote to Roubaix emphasizing his highly placed connections in Copenhagen – not least Mette's cousin, her one-time love, who was now a senior officer in the Navy, and her former employer Elstrup with all his useful political associates. Dillies were impressed and when they hired him Gauguin must have thought his problems were over and that before him lay a new life and a new career.

Mette now travelled to Paris to say goodbye to her friends, among them the Schuffeneckers. It is one of the stranger things about the slow disintegration of her own marriage that she should have sided with 'Good Old Schuff' in the collapse of his. By then his wife Louise had trans-

formed her cool beauty into an arrogant disdain for her shuffling husband and one might have expected that Mette would have considered her a soul-mate, someone to agree with her judgement about the uselessness of the artistic life. Instead Mette perversely chose to support the henpecked husband, who was to remain her friend and ally in her disputes with Paul over the years to come. Before saying goodbye she borrowed 420 francs from him, so that she could buy a 'superb dress' she had seen, leaving Emile with a piece of paper on which she had written 'I owe Schuffenecker 420fr.' – which one presumes she expected Paul to redeem at some unspecified future time.

## The Tarpaulin Salesman

Much has been made of the coldness of Mette's family to her husband when he moved into her mother's house at 29 Frederiksbergalle that December 1884. In reality, they were initially perfectly correct, despite the lack of room caused by the arrival of so large a family, and given their obvious distress that Gauguin had failed to provide for their daughter. Indeed their first instinct was to try and help him succeed with his new agency, help which he definitely needed as he spoke no Scandinavian language. Not that all the offers of assistance he received were entirely disinterested: Hermann Thaulow, brother of Fritz, who was working as a pharmacist in the Norwegian capital offered to act as sub-agent in Christiania, splitting the commissions. The offer seemed reasonable but it was a deal Gauguin would live to regret.

Mette quickly found a small apartment at 105 Gammel Kongevej but from the start made it quite clear that in their present straitened circumstances any further children were out of the question. It would, she insisted, be safer if he slept in one of the attic rooms while she remained below.

Part of Mette's difficulty lay in having a Bohemian for a husband when she again relied heavily on her former employer Jacob Elstrup. He had been appointed Prime Minister in 1875 and had so resisted the slow rise of the left in Danish affairs that he had been forced to rule virtually by decree in order to get his budgets through an increasingly hostile legislature. Many in Denmark were trying to move the country from the isolated, inward-looking state which Elstrup seemed to represent, towards something more in tune with its larger European neighbours. In 1871 a young university teacher Georg Brandes had given a long series of lectures on 'Main Currents in European Literature in the 19th Century' which had rallied all those who felt that Danish life, both politically and culturally, contrasted badly with the intellectual dynamism of Britain, France and Germany. It was an issue which split the country, turning

art into a weapon of social reform. On one side was Elstrup's United Right which he had founded in 1876 to defend Danish culture from foreign influences. On the other was Georg Brandes's brother Edvard, who in 1880 was elected to the Folketing, giving the nation Edvard the Political Left and Georg the Literary Left. As Georg put it, 'My brother is the most hated man in political life.'

To be Bohemian, even in dress, was to take a political stance. In a country with a population of little more than two million there was small room for diversity, hardly a suitable ambience for one as uncompromising as Paul Gauguin.

For Mette the situation was doubly delicate. Being again reliant on the Elstrups, especially their daughter Magda, whom she had once taught and who now paid Emil's school fees, she had to be careful not to appear part of any cultural opposition. Magda's marriage into the Moltke family, aristocratic and also politically active, made Mette's situation even more problematic. It was all a question of money – because Elstrup had arranged for Mette to give French lessons to young trainee diplomats from the Ministry of Foreign Affairs, a certain amount of tact was required. These urbane young men were to come to the apartment for tutoring and it was clearly unthinkable that they share the place with the unpredictable Gauguin. The solution was that Mette sat with her students in the dining room, laughing and talking and annoying the disgruntled husband, shut up at the top of the house. As they were the only source of money, he was unable to complain, though his temper, never good, was by then on a knife-edge.

It has been suggested that he was less than enthusiastic about selling Dillies products, but recent access to his correspondence with the company in Roubaix shows that he threw himself into the role of salesman with unrestrained vigour and imagination. He immediately requested samples of the tarpaulin and asked Dillies to make up a model of a railway carriage canopy the better to show any potential customers just what was on offer. Not content with the Zeeland railways he had discovered a friend of the Gads, a Colonel Thulstrup, who was one of the directors of the Jutland Railways, and set about trying to get an order from him, though he could do little until he had something to demonstrate. His main difficulty was that most Danish commerce was primarily in the hands of the British and the Germans with the French lagging far behind. Dillies seem to have had almost no experience of exporting their products and left their new salesman floundering. On his arrival they sent him a 500 francs advance – a ridiculously small amount given that he needed a carriage to take round his bulky samples – though even they took some getting as most of his frantic requests to Roubaix were ignored and the few that were sent were usually damaged en route.

The worst thing was being dependent on others to speak for him. His encounters with Danish businessmen and official purchasers were grim. They would look at his samples and ask whoever he was with to explain them, then they would say that they would consider the matter, after which Gauguin would hear nothing further.

Hermann Thaulow did manage to interest a hospital in Christiania, and Gauguin arranged for some samples to be despatched, only to discover that there was now a second sub-agent involved. Hermann had failed to point out that his professional code as a pharmacist forbad him to indulge in other forms of commerce, so that he had been obliged to sub-let the task to a friend, which meant that any portion of the commission which might eventually make its way back to Gauguin would be virtually worthless. As if that were not bad enough, he was now having trouble with the authorities who insisted he take out a patent on his cloth. This cost 220 kroner and finished off the advance from Dillies. He had earned nothing, despite all this running around. There was no money left to travel to Jutland to visit Colonel Thulstrup and all he could do was send some samples and hope for the best, though he now knew enough about Danish business practices to realize that it would take a long time to get a final decision and even longer for Dillies to fill the order, all of which meant that any earnings would be way in the future.

Family and friends did try to help, though there was little they could do. In mid-February Marie Heegaard's father ordered a modest amount – about a hundred metres of tarpaulin. A businessman caller Moller ordered twenty metres and the following month a distant relative of the Gads, who worked for the Ministry of the Marine, put in an order which brought Gauguin 401 francs in commission. As he was by then desperate, he insisted that Dillies count this as a second advance. Allowing for all he had paid out, he had earned no more than 78 francs in five months and was effectively in debt to Dillies and was only saved by the unexpected arrival of 1300 francs from the art dealer Portier in Paris who had managed to sell his Manet to Alexander Cassatt, brother of the painter Mary. It was not lost on Gauguin that it was art rather than commerce which had got him out of a very tight corner.

As his rent was horrendous – 850 francs paid so far – he decided to move to something more reasonable, a flat in Norregade 51 which, as Mette was not slow to remark, was not a good part of the city. Her shame was palpable, though she did try to defend her husband against the taunts of her family, who were now somewhat disgruntled with his failure in business and who had begun to refer to him as 'the missing link'. They were increasingly unwilling to forgive his gruff ways and while Mette was initially not too worried, believing he could give as

good as he got, she was soon aware that as before she was losing him to art. Not that he was painting much. All the travelling around, trying fruitlessly to get orders, left little time. The oil paints available were of poor quality and Copenhagen did not inspire him. He attempted some views of the city's open spaces: *Skaters in Frederiksberge Park*, *The East Park*, and a couple of nostalgic pictures of remembered scenes in France: a *Snow Scene in the Rue Carcel* and the *Route de Rouen* but he had to accept that he was not making much progress. The only truly original picture was his first real self-portrait: *Gauguin Before His Easel*. There is an earlier drawing of himself and a rather bland oil painting which bears little resemblance to him. This time, however, he got it right. He painted it in the attic room to which he had again been banished – the steeply raked beam of the mansard roof can be seen behind him and the light falls from a small roof window. He seems to glance almost hesitantly into the mirror which must have been posed to his left, as if afraid of getting it wrong. Perhaps it was this intense concentration which took his mind off his troubles, for he looks decidedly unconcerned for a man with no money and a marriage in poor shape.

He and Mette were now embarked on the classic route of each finding the other at fault. She seemed to him to be taking it out on Aline and Clovis, as if they were to blame, while he seemed to her to be making no effort to get on with her friends. It was true that he wasn't much struck by the artistic milieu in Copenhagen, with the exception of the painter Theodor Philipsen, and that was mainly because he had asked if he could borrow one of Gauguin's paintings the better to study it. It would, however, be wrong to imagine that Gauguin was looked on as some sort of freak amongst the younger Danish artists. Many had heard about the scandals surrounding the Impressionist Exhibitions and were intrigued to know more. All over Europe there had been moves similar to that in France, of painting out of doors and using a lighter palette – the Impressionists had simply gone further faster and were thus looked on with an unresolved mixture of envy and doubt. Gauguin's collection, hanging on the walls of the apartment, were a great attraction and Philipsen had no trouble persuading the other members of the Copenhagen avant-garde to come and meet this notorious representative of the new French art. He had more difficulty in getting Gauguin to like them, in fact there was only one apart from Philipsen himself, Johan Rohde, who passed the test.

To her credit Mette tried to promote his work, getting in touch with someone she knew in the Artists' Union with a view to arranging a one-man show. That went too far for the committee, who vetoed the idea, and in any case he had hardly produced enough work for such a large exhibition. Most of his effort had been concentrated on trying to

clarify his ideas. He had bought a notebook in Rouen, a simple thing covered in plain grey cloth, quite small, about six and a half inches high, and in it he began to jot down his thoughts on where art was, or ought to be going in the wake of the Impressionist revolution. He called them his *Notes synthétiques*, and they are as much musings on what art does, as a coherent philosophy for a new movement. We are not even sure if he wrote them all in Copenhagen; the majority of the little book, some sixty pages, is filled with drawings done later in Brittany. Nor is it absolutely clear why he wrote them, as no one seems to have seen them until they were found among his effects after his death in 1903, and they were only published in 1910, under the title *Vers et Prose*, which is something of a misnomer. They were probably no more than an attempt to work out for his own benefit the ideas he had been grappling with over the previous decade. They are somewhat disjointed but add up to a loose theory, which was to guide his work over the coming years and thus exercise considerable influence on modern painting, first in Europe, later throughout the world – an awesome responsibility for a child's exercise book, scribbled in by a man who was at the end of his tether and unsure what the morrow might bring.

The notes are not easily summarized because their author set little store by literary polish or well-turned arguments, believing such things to be a sign of dishonesty. To Gauguin the very roughness of the first untouched effort was a hallmark of its sincerity. Overall, the *Notes* are a first attempt to define an art of the imagination, one which works by awakening sensations in the spectator rather than by simply representing the tangible world. It was an art which would begin not with some object or scene in nature but with the feelings and emotions of the artist. It would no longer be realistic or scientific but subjective and symbolic. In Gauguin's words:

> You may describe a tempest to me with talent – you will never succeed in conveying to me the sensation.

This was, of course, precisely what the Barbizon painters, and their successors the Impressionists, had tried to do. Courbet had said: 'Painting is an essentially physical language made up of what is visible. That which is abstract and invisible does not belong to the domain of painting.' Gauguin was now saying exactly the opposite.

He was not the first. Even as the early Impressionists were embarking on their revolution in art, other ideas were also beginning to emerge from artists such as Gustave Moreau and Odilon Redon, who had been producing strange mysterious images with magical and religious undertones since the end of the 1870s. True, such works looked odd and individual when set beside the great movement released across Europe

by the Impressionists, yet just as Gauguin began writing his *Notes*, others, mainly writers, were beginning to assemble ideas which were not dissimilar in spirit to these mysterious paintings. Already, in Paris, young poets were tentatively suggesting that Zola's earthy novels about the political and social ills of supposedly 'real' people were not the summit of literature that a previous generation had believed. The poet Stéphane Mallarmé and the critic Joris-Karl Huysmans, who had written so forcefully about Gauguin, were emerging as leaders of the new thinking and they took as their starting point Baudelaire's belief that 'the whole of the visible universe is only a storehouse of images and signs to which the imagination assigns a place and a relative value, it is a kind of nourishment that the imagination must digest and transform.' Which in his own way was what Gauguin was saying, quite independently, in his Danish attic, far away from the mainstream of intellectual life in France.

In a long letter to Schuffenecker, dated 14 January 1885, presumably when he was starting work on the *Notes*, he set out the background to his thoughts even more dramatically.

> See a huge spider, a tree trunk in a forest; both unaccountably give you a sensation of terror. Why does it disgust you to touch a rat and many other such things: it is not reason behind these feelings. All our five senses arrive *directly at the brain*, conditioned by an infinity of things which no education can destroy.

Another part of his letters to Schuff reveals a renewed interest in Delacroix who had died in 1863 but whose work was currently on display at a large retrospective exhibition at the Ecole des Beaux-Arts in Paris. Gauguin longed for news of this and it is clear from the *Notes* that he had been thinking long and hard about Delacroix's own theories of line and colour. Gauguin's assertions that it was necessary to use exaggeration in art can only have come from an awareness that in his lifetime Delacroix had often been criticized for having exaggerated, especially in 'dramatic' works such as the Othello and Desdemona series which Gauguin knew so well from Arosa's collection, works which were also nudging him away from landscape painting towards the possibility of large figure compositions. If nothing else, this otherwise grim stay in Copenhagen had allowed him a period of deep reflection, a chance to work out ways of breaking free from the art that had dominated his thinking since he had been a teenager in the house of Gustave Arosa. Alone in his attic, Gauguin was at last able to consider something radically different, both stylistically and intellectually, from the art of both Barbizon and the Impressionists, which had thus far been the limit of his experience.

One doubts whether 'the good Schuff' made much of these tentative thoughts and even to their author they still remained a theory with no

work done which used it in any way. Yet here he was, brimming with ideas while trapped in a tiny flat in a cold and distant country, forced to sell tarpaulin and suffer the laughter of his wife's students below and the bloody-minded rudeness of his in-laws. As it became more and more apparent that his attempt at being a salesman had failed and that he was settling into the role of unemployed artist, the family could no longer restrain their disapproval. The leader in this was Mette's sister Ingeborg who had always tried to dominate her younger siblings and seems to have taken an especial delight in exacerbating the Gauguins' marital difficulties. What no one yet knew was that this was because her own marriage to Fritz Thaulow was collapsing, though Paul certainly sensed a good deal of hypocrisy amongst these outwardly strict Protestant folk. There is a telling painting entitled: *Still Life in an Interior*, which is similar in conception to the painting of the living room in the Rue Carcel, which he had done three years before. But whereas that was meant as an act of reconciliation with his wife, the Denmark version sets out the reasons for their rupture. Again the picture space is divided in two, with a still life in the foreground and the figures half-hidden in the background. But where the first picture of the Rue Carcel offered a gift of flowers, the second offers a scattering of kitchen purchases: four onions and two dead birds while at the distant table, in the high bay window, four figures – Mette on the left, Ingeborg on the right – sit in silence, conveying an atmosphere of stifling bourgeois gentility. This grim, wintry scene contrasts oddly with the vivid flowers on the wallpaper of the dividing wall, on which is hung a portrait of Clovis, as if to highlight his youth with the deadly ennui of the adults.

The first four months of 1884 were as crushingly wearisome as that picture implies. The only thing which kept Gauguin's spirits up was the promise of an exhibition which Philipsen, and some of the others who were interested in Impressionism, were trying to organize through the auspices of the Society of the Friends of Art, a group which tried to keep up with current trends and which stood in opposition to the hide-bound views fostered by the official Academy.

The exhibition was eventually set for 1 May and as before, Gauguin immediately assumed that this would be the great launch that had so far eluded him. At the very least he imagined that there would be a tremendous fuss. Given the right-wing opposition to foreign ideas, an exhibition by the revolutionary Gauguin would surely stir up passions and lead to a noisy scandal at an especially delicate moment. A series of elections had weakened Elstrup's position and he was only holding on because the left could not unite against him. Edvard Brandes's newspaper was whipping up emotions and another of Elstrup's budgets that April had caused considerable unrest, all of which came to a head just as Gauguin's

exhibition was launched. It was opened on a Friday, by the following Tuesday, after a mere five days, it had closed. Gauguin wrote to Schuffenecker to tell him that this had been by order of the Academy and all his life he would insist that the Danish artistic establishment and its allies in the press had damned his work and vilified his character. In his own eyes he was a martyr, the aggrieved hero of what Georg Brandes had called 'The Modern Breakthrough', and the incident has always been a significant part of the Gauguin myth, placing him on a level with the earlier Impressionists as a lonely hero struggling against the forces of ignorance. But once again, there is no truth in it. Exhibitions by the Society of the Friends of Art were small-scale affairs which never lasted more than a few days. The Academy exercised no control over the Society's affairs and had it attempted to do so the latter would have asserted its independence vigorously. Likewise, had anyone in the Press attacked Gauguin and his work, there is not the least doubt that Edvard Brandes would have leapt to his defence.

The truth was that Gauguin's exhibition passed off as planned and was no doubt liked by those who liked that sort of thing and disliked by those who did not. There was no outcry, no voice raised in anger, save that of an aggrieved Gauguin who went on exaggerating the event until the end of his life. The truth was more that his Danish début had ended not with a bang but a whimper. What he had not yet realized was that his ideas and his art were as yet out of step. His theories, as he was beginning to express them in the *Notes synthétiques*, were certainly revolutionary, but his paintings were still firmly within the range of conventional Impressionism. In Denmark this was fairly avant-garde but not very, not enough to cause a riot.

What was true was his account to Schuffenecker of the reactions of those nearest to him. His family, no doubt encouraged by Ingeborg, were furious with him. With art and culture having such a strong political emphasis, this wild Bohemian was bound to bring trouble and when Mette's students began staying away and the Countess Moltke let it be known that she would be unwilling to go on paying Emil's school fees, as long as the father remained on Danish soil, their worst fears seemed to be realized.

But even that was not the cause of Paul's decision to go back to Paris. It was more the realization that by hanging on in Copenhagen he risked losing his wife permanently. He was not walking out on her. As his letters would make clear, he thought of little in the years ahead except getting himself set up in a way which would allow the family to be reunited. He even decided to take little Clovis with him back to France, away from his mother's carping, but also as a gesture that he was not leaving them all behind. That he believed this would be only a temporary

separation is witnessed by the fact that he left his precious art collection with Mette.

The main lesson he had learned in Denmark was the impossibility of combining any sort of business life with that of a painter. His attempt at being a bourgeois gentleman had not exactly failed, for a time he had been a huge success, but with the collapse of the French economy his career had simply evaporated. In Denmark, lonely and frustrated, he had devoted all his thoughts to art and to his attempt to define a role for himself in developing it, devising a theory that he would now have to put into practice.

Before leaving he wrote to Pissarro, evidently in the depths of depression, to say that he sometimes thought of going up to his attic and hanging himself. He went on to say how he hated the Danes, how the Academy had now ordered the frame makers not to work for him, and that 'the worst cannibal is nothing compared to a Danish landlord . . . .'

The one thing about his departure which worried him most was leaving Aline with Mette, who still seemed to resent the way she loved her father best. In the end he decided that it would be impossible for him to take care of a little girl and when he left in June he took only Clovis, hoping that when he was gone, Mette would begin to show her daughter more affection.

He arrived in Paris virtually broke, with a six-year-old child to take care of, and with no prospects whatsoever. There was nothing to be done except go to the Schuffeneckers' new apartment at 29 rue Boulard, near the Montparnasse Cemetery, where he invited himself and the boy to stay. His host and hostess do not seem to have had much choice in the matter, but by then Gauguin was indifferent to other people's feelings. He had decided to go his own way and those around him would just have to make the best of it.

# Part Two

♦

# WHAT ARE WE?

# 5

◆

# *A Place in the Sun*

Paul Gauguin arrived back in Paris around the time of his thirty-seventh birthday on 7 June 1885. The journey from Copenhagen had been long enough for him to take stock of his position – not that any conclusions would have been especially reassuring. He was now a professional artist, more because other employment eluded him, than from any decision on his part. His style was still an uneasy mix of Barbizon and Pissarro, with only a few extra flourishes of his own, and while there were those among his contemporaries who claimed to see an original talent lurking within these rather sombre works, their voices were muted in his defence. Gauguin felt isolated, aware that his attempts to make a splash, to define a piece of artistic territory as his own, had all flopped. He knew he needed to do something distinctive, something that would mark him out from the general run of young painters, jostling for position in the Paris art world. The days when he had used his money to wheedle his way into the Impressionist circle were over. Struggle as he might, he was no longer in full control of his own destiny and to his chagrin was about to find himself buffeted around by forces which he could not control. For the one-time high-spending financier, it would to be a deeply galling experience.

His most immediate troubles were entirely of his own making. Clovis was only six, hardly of an age to be taken from his mother and carted about Europe by a man who was effectively a penniless vagabond. Staying with the Schuffeneckers helped. They now had two children of their own, though they were too young to be real companions to Clovis – the daughter, Jeanne, was only four and the baby, Paul (named after Gauguin), only one. But at least it was a family and there was food on the table and loans from 'Good Old Schuff' to tide them over.

Gauguin did try to find work. When he heard that his old friend and mentor, the sculptor Jules-Ernest Bouillot was about to get his first major commission, Gauguin hurried round to offer his services as an

assistant. Whether the sculptor actually agreed or merely failed to reject him forcefully enough hardly mattered – to the over-anxious Gauguin the matter was decided and it was only a question of waiting until the commission actually arrived and they could start work.

But hanging about Paris was too expensive and it was not long before the Rouen fantasy was revived, only this time he hit on Dieppe, having heard that it was currently something of an artist's colony, with Degas and a number of his followers in residence for the summer. Warm weather, seaside air, congenial company, rich patrons would all be waiting. There was little Clovis of course, but his sister Marie would surely help. She agreed but without enthusiasm, still incensed over his behaviour towards Gustave Arosa. Not that he cared – the hard knocks he had received in Denmark had brought out the latent arrogance of his Spanish forebears. A disdainful exterior masked any lack of confidence within, even though such haughtiness looked odd from one who now dressed like a tramp. He had been unable to carry much with him from Denmark and when Mette despatched a case with his and Clovis's belongings, she misspelled the address, confusing the *rue Boulard* with the meaningless *rue Boulevard*. With his wardrobe lost, Gauguin's few items of clothing were getting shabbier, a state he tended to exaggerate rather than disguise. He wore nothing but vest and trousers like a common labourer but offset this with a large costume ring which he wore on his index finger, a mix of eccentricity, pride and flamboyance. His temper, never good, was now strained to breaking-point by constant harassment from his old employers, Dillies and Company, whose accounts with Hermann Thaulow had never been settled and who expected Gauguin to repay the advances. As the correspondence grew increasingly acrimonious, so Dieppe beckoned. He left in July.

There is no record of where he stayed, though we can tell from the paintings that the stretch of beach at the foot of the cliffs below the castle that is today the town's museum and art gallery was his preferred place of work. The posts for fishing nets, visible in one picture, are still there but the extraordinary house, the Chalet du Bas-Fort-Blanc, that he passed on his way to and from the patch of rocks where he liked to set up his easel, has gone. This was the home of Jacques-Emile Blanche, the son and grandson of the famous alienists who had made names for themselves specializing in the psychological problems of the creative mind, treating writers like Gérard de Nerval and Guy de Maupassant. Jacques-Emile had not followed them into medicine, having decided to become an artist himself, studying under the fashionable portraitist Henri Gervex in Paris while making frequent visits to London, where he was soon well known in literary circles as a sort of cultural bridgehead between the two countries. Blanche enjoyed the role of confidant to

many different artists, but tended to absorb too much of them – his work shows traces of Degas and of the American artist, James McNeill Whistler, both of whom were part of his Dieppe summer circle, and while the occasional portrait has merit, the greater part of his output was competent rather than inspired.

In the 1880s however, his ostentatious villa was the centre of the town's artistic life. Renoir had decorated part of the living areas and alongside the usual Anglo-Norman building, Blanche's mother had added a studio made from parts of a Swiss chalet bought from one of the Universal Exhibitions, which even Blanche conceded was of a 'quite inexcusable hideosity'. Nevertheless it was there that the art crowd gathered to drink and gossip, though it was soon apparent that Gauguin was not going to be invited to join them. Why Blanche should have taken against the man he could see from the balcony of his villa making his way along the beach to paint, is a matter of speculation.

Opposition may have come from Degas, who was staying at a nearby villa rented by the author and librettist Ludovic Halévy. Degas had not been best pleased when Pissarro had opposed some of his protégés for the later Impressionist exhibitions and Gauguin, in Degas's eyes, was a creature of Pissarro's. Degas was not one to take lightly anything perceived as a challenge. Even his humour was noticeably self-regarding. That summer, Degas brought together Blanche and Halévy's guests and posed them in a group to act out a spoof version of Ingres's painting *The Apotheosis of Homer*. A keen photographer, Degas set a delayed time-shutter so that he could run round and take up position as the poet at the centre of the group, surrounded by the women and children from both house-parties, acting as his adoring admirers. Even those accepted by the Blanche set were not spared his sarcasm, as witness his remark that the 'pseudo-Impressionists' such as Fritz Thaulow, 'shoot us, but first they pick our pockets'.

Whoever was responsible, the result was that Blanche ignored Gauguin, excluding him from the company at the Bas-Fort-Blanc, leaving him to work alone. Progress was slow but there were minute signs of change. A small painting, *Swimmers at Dieppe*, shows four women splashing about in the waves, wearing the now risible frock-and-pantaloons beachwear of the period, and while the rocks are recognizably those near the Chalet, a closer look shows that this is no simple snapshot of reality. The picture has been divided into broad bands of colour: blue for the sky, emerald green for the distant sea, lighter for the nearer waves, the sort of reduction and exaggeration he had written about in the 'notes'.

Not that life was easy. He was alone for much of July and August, just at a time when he needed the company of like-minded souls to fill

the hours after work with talk and the inevitable drink. In Paris there were cafés and galleries with their gossiping factions. In Dieppe, he was being cold-shouldered and when he read a newspaper report of further disturbances in Spain, he was understandably intrigued to know what was going on and whether there might be a role for him to play. His Spanish friends were in London and, at the end of August, Gauguin took the boat from Dieppe to England and made his way to Cecil House in Lawrie Park, Sydenham, where Ruiz Zorilla was now living.

It was another false hope. There would be two incidents in Spain, one that October at a military base, another the following year, both quickly suppressed. Only Gauguin seems to have gone on believing in the revolution; cooler heads amongst the plotters now knew that the dream was over.

The usual comic-opera secrecy means that there are few details of what he saw and did in London but two things are likely. He probably visited the British Museum because he acquired a reproduction of a Theban wall-painting in the Egyptian collection, which has been identified with reasonable certainty as coming from a tomb on the West Bank which may have belonged to a scribe and counter of grain called Nebamun. While Gauguin was unlikely to have been much concerned about such historical detail, he was attracted by the design of the piece – a long, narrow scene split into two rows of seated figures, feasting and drinking, one above the other, a sense of light-hearted conviviality conveyed through rigid, stylized gestures rather than any 'tricks' of naturalism. Even more appealing must have been the simple outlines and blocks of colour which the anonymous artist had used, millennia before the idea began to intrigue artists in France.

It is also likely that it was on this London visit that Gauguin discovered the work of the English potter Christopher Dresser, a leading member of the Arts and Crafts Movement, who tried to break away from the fussy, over-elaborate ornamentation of the time by turning to other cultures. Dresser visited Japan in 1886 and China the following year, exchanging works between British and Japanese museums and collecting pottery for Tiffany and Company in New York. What is less clear is how he became interested in Peruvian art, for that is the connection which has intrigued students of Gauguin. Although he never visited Peru, Dresser may have seen Peruvian pieces in New York or Philadelphia and when he was asked to design models for the Linthorpe Pottery near Middlesbrough in North Yorkshire in 1879, he offered them several works which drew directly on Peruvian sources – stirrup-handled vases, some with faces in the Chimú or Mochica style. 1885 was in many ways Dresser's year. Examples of Linthorpe pottery were on display at the Alexandra Palace International Exhibition, where they had been awarded

a Gold Medal, with several pieces being bought by the Princess of Wales. Given Gauguin's passion for that sort of mammoth exhibition, he may well have visited it and seen how the sort of Peruvian art with which he was familiar could inspire modern work. The moulded figures Aubé had made for the Haviland company had been 'added on' as decoration, whereas Dresser's Peruvian heads were an integral part of the vessel.

There were other elements in English design which appealed to Gauguin. He admired the new wave of children's book illustration, especially Kate Greenaway with her flat 'Japanese' look, so far ahead of what English painters had dared to attempt – the pre-Raphaelites, with their medieval-religious subjects, had broken away from the solid natural-ism of much European art, but they were still too literary and plodding to be of any real interest.

Gauguin stayed in London for about three weeks. It would be his last visit to England and the last time he would have any contact with Ruiz Zorilla and his waning band of revolutionaries. So impotent did the movement become, that shortly afterwards the Spanish government pardoned Zorilla and allowed him to return home, where he died in 1895. Thirty years later, time having blurred his failures, the reborn Spanish Republican movement chose to look on him as one of their founding fathers, though much of his story remains obscure, not least the part Paul Gauguin may have played in his one moment of high adventure.

Gauguin returned to Dieppe by the longer Folkestone–Boulogne route. Out walking one day, he happened to pass Degas who 'recognized me despite his poor eyesight.' Degas expressed surprise that he was in Dieppe and asked Gauguin to visit him at Halévy's. Two days later Gauguin took up the offer, but as he passed the Chalet du Bas-Fort-Blanc he saw Degas working in Blanche's studio and went to ring the bell. The door was answered by a maid who told him that Degas and Blanche were out, making it all too clear just what the 'group' thought of him. Years later, Blanche published his version of events, ending with the final cutting remark that his father, the doctor, had thought that Gauguin had 'the air of a megalomaniac.'

Snubbed by Degas, Gauguin returned to his solitary life. His only friend was a local artist, Horace Mélicourt, who made a precarious living painting seascapes on shells as souvenirs for the summer trippers. Think-ing to help, the kindly Mélicourt tried to engineer a meeting with the English artist Walter Sickert, who, although a friend of Blanche, might have proved less exclusive. Mélicourt seems to have hoped that Sickert would give some professional advice to the inexperienced newcomer and to that end he steered the Englishman to a street in the town where Gauguin was doing some sketching. In his memoirs, Sickert recalled 'a

sturdy man with a black moustache and a bowler' who, as far as Sickert could see, was working rather in the style of Cézanne. Sickert thought he was still a Sunday painter who was considering 'throwing up a berth in some administration,' and was less than encouraging: 'I am ashamed to say that the sketch I saw him doing left no very distinct impression on me, and that I expressed the opinion that the step he contemplated was rather imprudent than otherwise.'

In later years Sickert was prepared to admit that he had been completely wrong and wrote in praise of Gauguin's art at a time when it was still reviled, but back in 1885 none of that future support was of any help to the insecure Gauguin who had found just another discouraging professional, keen to tell him he was wrong to try and make a living out of his art. Dieppe had been a disaster, and it was at this low moment that a letter arrived informing him that Bouillot had finally got his commission but had already hired someone else as his assistant. Gauguin travelled back to Paris in early October, though by then he had few expectations that there would be any dramatic improvement in his circumstances.

## Necessity Makes Law

The advent of winter, a particularly bad one in 1885–86, made his misery complete. With only his summer clothes he shuffled round various addresses, staying for a short time with Favre, the Dillies representative, before finding cheap lodgings at 10 rue Cail, in the run-down area near the Gare de l'Est. Marie sent Clovis back, even though they had no furniture and Gauguin was forced to rent a little bed for the boy, while he slept on a mattress on the floor, wrapped in a travelling blanket. He was by then feeding Clovis on a little boiled rice, with an egg when he could afford one. How he survived at all is nowhere made clear. There may have been a little money from the rented property in Orléans. The small hand-outs from Schuff were clearly crucial though there must surely have been some of his savings left to cover the basic necessities such as his lodgings. Repeated requests for clothes and bedding went unanswered by Mette, even though she must have known that her vengeful action was hurting her child. When some pieces were eventually sent to Marie, she took over a week before coming round to deliver them and even then her only comment on their miserable lodgings was to point out that no one had been polishing the floors.

Near the end of the year, Gauguin found Clovis a place at a local school, though that meant expenses he could hardly hope to meet. The Jobbé-Duvals tried to help by taking the little boy on trips to the country at weekends, feeding him up as best they could. Despite everything,

Gauguin still went on trying to paint: a winter landscape, a still life and a portrait of his old colleague from the Bourse, Achille Granchi-Taylor. The style was still impressionist, though there are signs of an increased interest in bold decorative effects. But his present condition made it unlikely that he would have the energy or the optimism to make any radical break with the past. As he explained to Mette in January of the new year 1886: 'Necessity makes law; and sometimes it lifts a man above the limits which society imposes. When the child went down with small pox I had 20 centimes in my pocket and had been eating dry bread, bought on credit, for three days.'

It was dreadful news. Clovis had come home from school shivering with fever. He would need medicines and proper food. Near the Gare de l'Est were the offices of the Société de Publicité diurne et nocturne, an advertising company with contracts to put up posters in the main railway stations. A desperate Gauguin went in and asked for a job bill-posting. The manager was amused by this ill-dressed, yet evidently bourgeois figure, wanting such a menial task. All pride gone, Gauguin told him about Clovis and asked for charity. The man relented; he could have five francs a day for three weeks.

It was a pitifully small amount but it got them through and as soon as the fever abated Gauguin set about finding a boarding school for the boy, reckoning that only somewhere clean and warm would enable him to fully recover. He settled on the Pension Lennuye, in the village of Antony, just south of Paris, which was easy to visit by train along the *ligne de Sceaux* – not that he could do so very often, for apart from the long hours bill-posting, he dared not appear at the school if any of the fees were outstanding, which was most often the case. The kindly Schuffenecker visited when he could, but one imagines Clovis must have felt as lonely as his grandmother Aline had done when farmed out by Flora Tristan so often during her childhood.

Gauguin himself was now seriously undernourished. Mette's rare letters were distressingly cold. When he wrote back, he scribbled 'Your husband' at the bottom, as if to remind her of the fact, but in the end he cracked under such unremitting indifference and wrote to say how angry he was that none of his children were growing up speaking French, that her family had won the victory they wanted – though he pulled back at the end and cautiously signed off with: 'A thousand kisses to you all whom I adore'.

At such a low moment, a means of escape was dangled before him – a contract as inspector and administrative secretary of the poster company at 200 francs a month, with the promise of more. Because he spoke Spanish they would consider sending him to their Madrid office, in which case there would be a further 100 francs. It was a new career, a

promise of security, a future. he could get Mette and the other children to join him. They could relaunch their lives together. He could be a bourgeois gentleman again.

He was tempted but just as he was about to decide, word reached him that the artist Berthe Morisot and her husband Eugène Manet were trying to revive the old Impressionist group, with a view to having one more exhibition. That was enough for Gauguin. Were this to go ahead he would need as much liberty as possible if he were to produce sufficient good work to make any sort of mark. He refused the contract and resigned his job. He had survived the hardest test so far.

## Those Damned Dots

It was now four years since the Seventh Impressionist Exhibition, and much had changed. Even before the exhibitors were known, there was a feeling that something radical was about to happen, that the exhibition was bound to move beyond Impressionism. From the start, there were those who were not happy with this. Durand-Ruel announced that he would be in New York drumming up interest in his artists and that it would not be possible for the exhibition to be held in his gallery, an unconvincing excuse. Monet and Renoir let it be known that because of a commitment to exhibit in Brussels they would be unable to take part and as this left a large gap, there was a sudden outbreak of intense manœuvring as younger artists fought for the chance to fill it.

Feeling himself beholden to 'Good Old Schuff' Gauguin put him forward to Eugène Manet as a possible exhibitor. Sensing the way things were going, more conventional painters like Caillebotte and Sisley found reasons to be elsewhere, so that, by the time it opened, the Eighth Impressionist Exhibition had little to do with Impressionism and more to do with the new generation of artists who were trying to leave Impressionism behind. Ironically, it was Pissarro, who had formulated the rules of the first exhibition and who had fought hardest to preserve the original group, who was now responsible for bringing in the one man who would do most to cast all this aside – the 28-year-old Georges Seurat.

Seurat had already caused a stir two years earlier, when a group of Salon rejects had organized a Salon des Indépendants and Seurat had exhibited *Bathers at Asnières*, a formal arrangement of stiffly posed figures enjoying their leisure on the banks of the Seine, which brought down the usual fire-storm of critical fury. His fellow exhibitors, however, were mightily intrigued, not so much by the subject as by the technique: short strokes of pure colour laid side by side leaving the spectator's eye to mix them. The original Impressionists had used this method, though only on an instinctive basis. Here was something altogether more rigid, more

'scientific'. Many who saw the painting, Pissarro included, began to experiment with Seurat's technique, and by the time of the exhibition in 1886 the older man had become a disciple, a role which earned him considerable scorn from his former colleagues.

It was Seurat's latest work, *A Sunday Afternoon on the Island of the Grande Jatte*, which now dominated the room at the Restaurant Doré on the Rue Laffitte, which Eugène Manet had taken over for the exhibition. The painting was shocking, Seurat's technique even more rigid than before. Close-to, the surface broke down into a kaleidoscope of coloured dots – indeed it was hard to get far enough back for the eye to be able to mix them, while the rigidity of the method left the figures looking hieratic and frozen, quite the opposite of the vivacity that Monet and Renoir had tried to capture in their riverside scenes.

Whatever Gauguin thought of it, he could not doubt that the *Grande Jatte* stole the show. His own tentative efforts were barely noticed. Beside the massive Seurat, his eighteen canvases, most of them landscapes, still looked decidedly gloomy, and while *Swimmers at Dieppe* showed signs of progress, this was nothing beside the shock of Seurat's statuesque figures produced out of the blizzard of uncountable dots, the product of unimaginable patience and resolve. Even if you disliked the painting you could not help but be awed by the thought of the labour it had taken to produce it. And if it did not dawn on the viewer that it was the work of someone obsessed, then one had only to meet the intense and difficult Seurat for the message to be driven home. If Seurat's approach was as 'scientific' as he liked to claim, then he was definitely more in the mould of the mad inventor, more Frankenstein than Newton. The shrewish Degas called him the 'notaire' – the lawyer – which would be better translated as the 'bookkeeper', but that failed to take account of the fact that his tight little systems and his rigid theorizing were masks used by Seurat to hide an altogether different personality, one that was tormented and quite unlike the strait-laced figure he presented to the outside world.

The only major review of the exhibition was almost entirely given over to the *Grande Jatte*. Written by a new personality in the artistic milieu, the poet and journalist Félix Fénéon, it appeared in a brochure entitled *The Impressionists* in which Fénéon spoke of a new movement which he dubbed 'Divisionism', praising it as 'a kind of painting where cheating is impossible and stylish handling quite pointless. There is no room in it for the bravura piece. The hand may go numb, but the eye must remain agile, learned and perspicacious.'

Gauguin was not so easily won over. He would try what he later called 'those damned dots' in a couple of paintings but only to understand and then reject the technique. For all his interest in the power of colour to

create emotional responses, Paul Gauguin never believed that this was all there was or should be to art – neither, one suspects, did he believe that it was Seurat's only interest.

Even today, a hundred years on, we know little more about Seurat's intentions than his contemporaries did. There has been speculation that the *Bathers* and the *Grande Jatte* are two halves of a diptych – the workers on one side, the bourgeoisie on the other – and thus in some way a political statement. Later works are even more puzzling: his *Parade de Cirque*, begun in 1877, shows a nightmare world of spectral musicians outside their circus booth, in thrall to a ringmaster and his whip and dominated by an oddly garbed trombonist whose vague bearded features are surely those of Seurat himself. As long as we know so little about him these works are easy victims to theory; without biography there is only speculation, for what can one make of a man who was so secretive that his mother only learned that he had a mistress and a one-year-old son a week before his death, at the age of thirty-one?

Gauguin seems to have been alone in seeing something more in Seurat's work than mere exercises in colour technique. He made a deliberate attempt to cultivate the younger man, sending him a copy of a strange book he had found, written by a Turkish sage called Professor Mani Vehbi-Zunbul-Zadi, which contained a number of mystical reflections on the nature of colour and sensation. It was undoubtedly a pointed gift, for some of the sage's precepts echo Gauguin's own theorizing, which he clearly hoped Seurat would share: 'It is good for the young to have a model, but let them draw the curtains on it while they paint. It is best to paint from memory; in that way your work will be your own; your feelings, your intelligence, and your soul will then survive the amateur's eye.'

But if Gauguin expected Seurat to respond in some way he was wasting his time. They were both far too individualistic and arrogant ever to subsume their personalities into a joint effort of any sort. In any case, Seurat already had a close colleague in the person of the even younger Paul Signac and had no need of another.

Despite this coolness, it was Seurat, more than anyone, who showed Gauguin the direction he would have to take. Seurat had caused a stir, both within the tight-knit group of younger artists but also outside, in the realm of the popular press, whose scathingly abusive critics could turn an obscure painter into a notoriety by the sheer virulence of their attacks. Gauguin now knew that he would have to do something big, something extreme, if he too were to rise above the rest. It was not lost on him that Seurat had been able to make his leap forward because his father's money had allowed him the freedom to work without interruption and Gauguin now accepted that if he wanted to do anything serious

he would have to move to somewhere cheap and peaceful and that could only mean somewhere out of Paris. He had already written to Mette to tell her that he wanted to go to Brittany that summer. It was a well-worn route for Parisian painters who could find inexpensive hotels and amusing subjects in what was still looked on as a distant provincial backwater. Jobbé-Duval had already whetted his appetite with stories of an inn in the pretty little village of Pont-Aven near the coast, whose proprietress was sometimes willing to exchange board and lodging for paintings. If he could sort out Clovis's school fees and raise enough cash for the train fare, then that was where Gauguin intended to go.

## The Kiln in the Rue Blomet

No sooner was the decision made than things began to improve. He even managed to sell a painting from the exhibition for 250 francs to the husband of a fellow exhibitor, Marie Bracquemond, and it was Félix Bracquemond who was to cause the radical shift in Gauguin's work. A highly successful engraver and graphic artist, Bracquemond was one of those prescient figures with an unerring instinct for the best of the new, picking out and promoting talent before anyone else had recognized it. When he accidentally discovered a complete volume of Hokusai which was lying about at his printers, Bracquemond became one of the first to realize that these were not just anonymous posters but the work of an individual artist of considerable stature. It was Bracquemond's support which did much to raise the status of Japanese prints in France, but even allowing for his fine judgement, it is hard to see what it was that gave him the idea that Paul Gauguin would make a good potter. Of course, Gauguin was interested in ceramics, as witness his own collection of Peruvian works, but he had never made any himself, and there was no evidence of any interest in doing so. Yet we may assume that Bracquemond was basing his judgement on something more than instinct when he suggested to Gauguin that he should meet his friend, the potter Ernest Chaplet, who had been Haviland's master-ceramicist when Bracquemond had used his knowledge of Japanese graphics to help create new designs for the pottery at Auteuil.

Chaplet was the single most important figure in the transformation of French ceramics in the second half of the nineteenth century. He had joined the Haviland studios in 1874 where he perfected the use of Barbotine, a revolutionary way of glazing which allowed ceramics to be painted as if they were pictures on canvas, with as much over-painting as the artist wished, the finished work being fired at a very high temperature which created a rich, deep surface. This was a considerable achievement but in 1881, just when he was thinking of retiring, he went on a

long holiday on the Normandy coast and saw what it was that he had been groping towards. A visit to a local manufacturer of simple earthenware pots – butter jars and milk jugs – brought Chaplet into direct contact with precisely the sort of things which had inspired the Arts and Crafts designers in Britain. At first, Haviland was doubtful but Chaplet took the simple wheel-turned vases and bowls and fired them in a range of colours, beyond the usual light brown, placing a modest band of floral decoration or a simple pattern along the rim and sometimes adding touches of gold at a second firing, occasionally with patterns or natural forms incised directly into the clay. And Chaplet was proved right, the 'new' pottery sold and Haviland, keen to keep him, fixed up a Paris studio at 153 rue Blomet in the Vaugirard district of Paris, not far from Gauguin's old home, on condition that Chaplet continue to work exclusively for him. The agreement lasted four years until 1885, when Chaplet bought out the studio and acquired the Rue Blomet studio and kiln. He was now freelance and it was at this crucial point in his career, in 1886, that the 51-year-old ceramicist came into contact with the 38-year-old artist Paul Gauguin. Happily, they had much in common. With his broad knowledge of pre-Columbian pottery and a shared taste in craft design, Gauguin had a great deal to recommend him, and it was quickly agreed that they should work together, with a fifty-fifty split on the profits of any sales.

As Gauguin had definitely decided to leave for Brittany in the summer, their first month together was little more than a chance to introduce the painter to the new medium, but despite its brevity, those few weeks were enough to convince Chaplet that Gauguin was not just another Bracquemond or Aubé, willing to add a little decoration to his usual studio output. The two pots which can with any confidence be attributed to that first May/June period are like nothing in the Haviland–Chaplet canon. Judging by the strange shapes, Gauguin must simply have taken hold of the clay and kneaded it into whatever rough, natural form took his fancy. The first is a pot in the form of a tree trunk with a female face or mask on its front, the second, a 'bottle', which consists of a low hemisphere with a long thin neck. Both are rather playfully glazed with mottled colours, with touches of gold added for a second firing, all of which suggests that Gauguin was simply trying anything to hand. Surprisingly, perhaps, Chaplet was completely unfazed by this and though he was quick to point out that the results were far from commercial, he in no way regretted his decision and even toyed with the idea of accompanying his new colleague on the projected visit to Brittany, so that they would go on working together.

In the end Chaplet was unable to go and Gauguin found it difficult to raise the money he would need for the journey even though he had

rather precipitately given notice to his landlord who was about to repossess his flat. Paul Signac offered him the use of his studio while he was away for the summer, but when Gauguin arrived he found his way blocked by Seurat, who had his own studio on the same corridor and who, knowing nothing of the arrangement, refused to surrender the key. The real reason seems to have been a suspicion on his part that Gauguin was trying to worm his way into the room in order to get a look at some new paintings by Pissarro which the older man had been storing there. Gauguin was understandably furious. There was a blazing row and Seurat, a short man, was lucky that the matter did not come to blows.

The quarrel blazed on long after Gauguin had stormed out. Pissarro was dragged in when Seurat wrote to all concerned, in an attempt to justify his somewhat mean-spirited behaviour. The result was an emotional, as well as an artistic, rupture between the Seurat set, which now included Pissarro, and an increasingly isolated Gauguin. It even touched on the ever-loyal Schuffenecker who was experimenting with the new dots and was thus part of the Seurat/Pissarro camp. When Schuff asked Gauguin to take part in the second Salon des Indépendants he was brusquely rebuffed, on the grounds that Gauguin would not even consider showing beside the man who had insulted him. The worst thing about this silly quarrel was the way it drove a wedge between Pissarro and his one-time pupil. Pissarro was convinced that Impressionism had to move forward and that Seurat's 'scientific' route was the only one possible. Unaware of the changes in Gauguin's thinking, the older man assumed that Gauguin was opposed to Seurat because he wanted to maintain the original Impressionist style, which Pissarro dubbed 'Romantic Impressionism', making no secret of the fact that he considered it reactionary and reprehensible.

Given this highly charged atmosphere, it was hardly surprising that Gauguin longed to get away. Everyone else seemed to be going to Brittany ahead of him. Renoir had already left for Saint-Briac and Monet would be going to Belle-Ile-en-Mer later; even the normally hesitant Schuffenecker had set off for Etretat. In desperation Gauguin approached anyone who might help. Marie yielded at last, agreeing to help with Clovis's school fees rather than have Gauguin cart the poor child off to Brittany and God knew what privations. He then looked up a vague relative, Eugène Mirtil, who was in banking and with whom he had had some connections during his business career. Mirtil offered a small loan. Félix Bracquemond bought two more paintings and Gauguin's old colleague Achille Granchi-Taylor said that he would come to Brittany with him and would buy their tickets. Liberated at last, Gauguin sent a note to Bracquemond that he was off – 'to paint in a hole' as he rather damningly put it, and on the evening of 27 June 1886

he and Achille steamed out of the Gare Saint-Lazare on the train to Quimperlé.

## Breton Women Gossiping Over a Wall

It was a simple enough journey: Paris to Lorient, a connection to Quimperlé which arrived at midday, then a rather irritating wait until half past six when the last train of the day pulled in, whereupon a horse-drawn cart would take all those who had arrived that day to the little town of Pont-Aven, an inland port, at the point where the narrow River Aven suddenly widened into a navigable estuary, before continuing seven kilometres to the sea.

Gauguin's few remarks about Brittany, remarkably few given its importance in his story, are peppered with words like 'savage', 'primitive', 'simple' though these are no more than the conventional judgements of city dwellers at that time. Far from revealing any considered opinion, they indicate a lack of any serious attempt to understand the world he had now entered. Gauguin had come to Brittany because it was cheap and might allow him the freedom to get on with his work. He had not come specifically to paint Breton scenes or to study its people and customs. As far as he was concerned, if someone had told him that somewhere else, say Provence, was cheaper he would probably have gone there.

As he walked from the expensive Hôtel des Voyageurs, where the cart was unloaded, to the modest pension owned by the widow Marie-Jeanne Gloanec, which the Jobbé-Duvals had recommended, he must have been struck by the pleasant fact that no one was bothered by his appearance. Artists had been coming to Pont-Aven for over sixty years and the townsfolk were well aware that, poor as many of them might be, they were generally good for business. The original arrivals, after 1820, had been painters looking for an alternative to the classical models of Ancient Greece and Rome, searching for a medieval past which they found in the Breton landscape with its dolmens and menhirs, its simple Gothic churches and roadside calvaries, as well as the people themselves with their dress and folklore. Here, they could still find a 'primitive' Catholicism, supposedly infused with older pagan traditions, made visible in the festivals and 'Pardons', the quasi-religious gatherings which combined traditional Breton costumes, music and sports, in a colourful open-air spectacle.

These first Romantic painters interpreted such things with a brooding sense of drama and unease, imposing their own notions of a mythic otherness on the things they found. But after 1860, they were followed by more conventional academic artists, the usual Salon-fodder, who were

happy to spend their summer holidays out of Paris, capturing a few
scenes of quaint peasants going about their simple tasks – scenes that
they knew would find a ready market with their fellow Parisians who
liked a little rural cheerfulness on their walls. All this was possible thanks
to the new railways – a line had been run from Paris to Rennes as early
as 1857 and six years later was extended north to Dinan and south to
Quimper.

Encouraged by the 'quaintness' purveyed by the visiting artists, others
followed, holiday-makers and foreign tourists, including a steady stream
of Americans, who arrived each summer to stay in the many hotels and
inns which now opened to accommodate the visitors. The Bretons were
not the simpletons they were often portrayed to be. They knew full well
that it was an illusion which had attracted these monied folk and one
that was to be encouraged. In consequence, the gap between what the
summer crowds believed they would find and what was actually there
narrowed as the century progressed. Part of Brittany is a wild windswept
region, sometimes harsh and pitiless, yet the picture which emerges from
postcards of the time shows a pleasant place of neat, ordered farms
bordered by trees, while holiday towns such as Pont-Aven have well
tended paths and flowerbeds and an air of genteel prettiness. It is obvious
that the 'quaintness' depicted by many of the visiting painters gradually
became a self-fulfilling prophecy. Where trees had once been ruthlessly
cut down for fuel, now they were carefully preserved, while more were
planted round holiday homes by the summer visitors keen to shut out
the often piercing west wind. At the mid-century many of Brittany's
ancient ways were on the verge of dying out. Even the extraordinary
costumes, the women's with their high coifs and elaborate lace bands,
the men's with knickerbockers and broad fishermen's hats, had been
considerably altered since the French Revolution. Before they had been
a rigid indication of the wearer's social position, afterwards they became
no more than a matter of changing fashion or of family tradition and
looked set finally to disappear. Yet by the end of the century such things
were once again a fixed part of Breton life – in Pont-Aven the women's
coif had two starched loops, always wider on one side than the other,
though no one could have said why. A confused mix of nationalism and
the tourist trade had turned this local Breton costume into a sort of
uniform. As with the Irish, the Scots and the Welsh and their cousins
in British Cornwall, the Bretons' 'Bretonhood' was partially formed by
writers and artists in search of a romantic Celtic past, though in the end
this took on a reality of its own as the costumes and the festivals became
a fixed part of life, frozen in time as if they had always been that way.

It was an amiable enough exchange and one profitable to both sides,
which was why, in 1842, Joseph Gloanec, a local licensed victualler in

Pont-Aven, had been happy to transform his home, a modest two-storey
building with a shop on the ground floor and with living space on the
first floor and in the attics above, into a guest house. Standing where
the triangular main square came to a point near the river, the place was
soon busy from spring to autumn, largely because of the excellent food
provided by his wife Marie-Jeanne, who took over the running of the
place after Joseph died. Aged fifty when Gauguin first came, the Widow
Gloanec still ran the place with the aid of four local girls brought in to
cook, serve and clean for the often strange band of artists who had settled
on the Inn as their headquarters. Photographs of the period show them
grouped on the pavement outside as if for a school album. Some had
been coming since 1863, no doubt drawn by the generous terms offered
by Marie-Jeanne, as imposing as a mother-superior in her starched white
coif and voluminous black dress, well aware that the other visitors, the
Parisian businessmen and American holiday-makers in search of the
simple life, would make up the profits.

    Paul Gauguin arrived when this cross-over between the old, harsher
Brittany and its softer, quainter renaissance was at its half-way point.
Pont-Aven was already a cosy holiday spot, geared to tourism with a
range of hotels and restaurants and offering pleasant strolls by the river
past the old windmills or in the nearby forest, the Bois d'Amour, or

An artist returning from the Bois d'Amour near Pont-Aven;
an illustration by Randolph Caldecott for *Breton Folk* by
Henry Blackburn, 1880

farther, to the ruins of the Castle of Rustephan. Of course, there was far more to Brittany than that, but for the moment Paul Gauguin had no particular interest in looking for it. If one assiduously hunts down the actual sites where he painted during that first four-and-a-half month stay, it becomes clear that he never walked more than 300 yards from the Gloanec to set up his easel. The one painting supposed to have been done outside Pont-Aven is of doubtful dating and all the other evidence indicates that he did not leave the little town.

The reason why he clung so close to Marie-Jeanne's pension was quite simply the food. Meals at the little hotel were not only on credit, they were delicious and copious and wine was virtually free and for the first time in a year he had enough to satisfy him. It was heaven. He wrote to Mette: 'What a shame we didn't come to Brittany before; the hotel costs only sixty-five francs a month, full board. I can feel myself putting on weight as I eat. If I can gradually find a steady market for my paintings, I'll stay here all the year round.'

But this refusal to stray far from his food does not mean that Gauguin was not working hard. He quickly filled the remainder of the same Rouen notebook in which he had written the *Notes synthétiques*, with drawings of local people – the good citizens of Pont-Aven had reasonable, clearly established rates for posing and it was no problem to find a cowherd or shepherdess whose routine allowed them to sit for a morning or after-noon while he sketched them. These preliminary drawings in pencil and crayon are among his most charming pieces: a Breton boy carrying a jug, tending his geese, climbing a ladder, a young girl stretched out on a wall watching her sheep. He transformed this last scene into one of the four paintings which we know with some certainty were made in 1866. The resting girl is looking down on her sheep grazing below, in a scene hazy with the peace of a warm summer's afternoon. It is Gauguin's purest attempt at Impressionism and owes much to Pissarro in the way the canvas was first prepared with a white ground, over which thin, cross-hatched lines of colour could be lightly laid, while allowing some of the undercoat to come through, so that an overall effect of bright luminosity is created. Oddly enough, he was also following advice handed out by the otherworldly Professor Mani Vehbi-Zunbul-Zadi: 'Let your paper itself lighten your colours and be your white, but never leave it absolutely bare.'

While Pissarro and the professor influenced the technique, it is the figures in the four paintings which are of most interest, for they owe much to Degas in the way they are posed, often at an unusual angle, the body twisted and bent in the course of some quite mundane action – fixing a shoe, turning to look to one side, or stretched full length to wash clothes in the river. But these are not so much a leap forward as

an ending, a coming to terms with the various Impressionist influences Gauguin had admired so that he could now be free of them. Where he did part company with standard Impressionist practice was in completing some parts of the paintings later, away from the actual scene. We can see this with the little shepherdess in her traditional Breton costume which she would have put on for work only because she was being paid to pose. He first drew her in his sketchbook and because he used the same, oddly distorted, stretched-out pose in one of the paintings, it is reasonable to assume that he went out and painted a landscape, then added the figure later, copying the pose from his own drawing, a thing the Impressionists always resisted.

## The Gang

Achille Granchi-Taylor proved an excellent companion, every bit as flamboyant as Gauguin, parading about Pont-Aven in frock-coat and top-hat with his feet encased in a pair of wooden clogs. Gauguin, for his part, had acquired a Breton fisherman's outfit of blue jersey, with a beret jauntily on the side of the head which would eventually be imitated by generations of painters, many of whom would never know who had first created this classic image of the Bohemian artist. With his rolling gait and swaggering manner, Gauguin still resembled a sailor; word had got out that he could box and fence, and that he had a short temper, and was not someone to trifle with. Nevertheless, he quickly became the centre of attraction within the little community, especially for the younger artists, intrigued by what they had heard of recent events in Paris. Most had got as far as trying to imitate the style of Jules Bastien-Lepage, a successful Salon painter who had taken on some of the Impressionist technique while still remaining acceptably academic. To a young artist with a career to build this must have seemed a safe way out of the problem, but there was still a keenness to know more, especially since word of the scandalous dots had got round. As in Copenhagen, Gauguin arrived bearing an irresistible air of metropolitan avante-garde glamour and was no sooner ensconced at the Gloanec than the other artists started to take sides. As he wrote to Mette: 'You may think I'm lonely. Far from it. There are painters here winter and summer alike, English, Americans, etc. There are hardly any French, all foreigners. A Dane, two Danish women, Hagborg's brother and plenty of Americans.'

One painter who tried to play the role of neutral observer was a Scottish artist, Archibald Standish Hartrick, who later published his memories of that summer in Pont-Aven, noting the extreme reactions Gauguin provoked and capturing the incident which brought matters to a head. According to Hartrick, one of the old guard, a Dutch artist who

he refers to as 'V', but who was almost certainly Hubert Vos, a history
painter who had studied with Cormon, was so incensed by the presence of
such an outrageous radical under the same roof that he tried to confront
Gauguin as he came into the hotel's dining room for lunch after a
morning's painting. When 'V' tried to bait him, egged on by a crowd
eager for a little free fun, Gauguin refused to be drawn and elbowed his
way through, leaving the Dutchman fuming.

Hartrick goes on to say that Gauguin had his revenge when a pupil
of 'V', whom Hartrick calls 'P', began to talk with the newcomer and
eventually adopted him as a teacher. A little later 'V' was completely
humiliated when word spread around Pont-Aven that he had been asking
'P' to explain Gauguin's technique and had even begun to alter his own
work as a consequence. From then on, Hartrick concludes, Gauguin was
treated with respect.

'P' was certainly the 22-year-old Ferdinand Loyen du Puigaudeau,
who was for a short time very close to Gauguin. Despite his own shortage
of money – his family had also lost much during the financial crash –
du Puigaudeau tried to help his new teacher by settling his bills at the
Gloanec and letting him use a studio he had rented in Les Avens (some-
times Lezaven or Lezavin), whenever he wanted to work indoors. While
he was with Gauguin, du Puigaudeau worked in the sort of late impres-
sionist style – a mix of Pissarro with touches of Seurat's technique –
which would become almost a universal visual language across Europe
over the next twenty years. And although du Puigaudeau would later
break free from this, developing a more original palette, richer and
romantic, which he used with dramatic effect for evening and moonlight
scenes, he was very much Gauguin's creature, the first of what was
soon being called 'Gauguin's Gang'. Two other young painters, Henri
Delavallée and Henry Moret soon joined him. Delavallée was twenty-
four, a brilliant student who had taken a degree at the Sorbonne while
simultaneously studying at the Ecole Nationale des Beaux-Arts. He had
been visiting Pont-Aven for five summers before the encounter with
Gauguin, which was undoubtedly the turning-point in his artistic life,
nudging him towards a complete adherence, first to Gauguin's modified
Impressionism and later, in Paris, to a complete submission to Seurat's
dots. Delavallée's art is less interesting than his life. He swung between
styles too often, on occasion reverting to his academic roots, so that
nothing seems fully developed, but while he eventually settled in Pont-
Aven, where he died at a great age in 1943, he did have one fascinating
adventure. In 1893 he set off for Turkey where he became the official
portrait painter to the Grand Vizier and had the curious distinction of
opening the first cinema in Constantinople. Since the 1960s there has
been a growing band of admirers for the 'oriental' scenes he produced

during his nineteen-year stay in the Near East, which are certainly among the best of the various styles he attempted.

Henry Moret, the third member of the gang, although older than the others – thirty in 1886 – was the one most immediately overwhelmed by Gauguin's ideas. So much so that there are probably several museums displaying Gauguins which may well have been painted by Moret and signed later by unscrupulous dealers. Moret did not stay at the Gloanec but rented a studio from Monsieur Kerluen, the harbour-master, but he quickly formed the habit of looking out for Gauguin and setting off to paint with him, hence the problem, as he not only absorbed the master's style but worked on precisely the same scenes. Not that Gauguin minded, Moret was simple and affectionate and loyal – but as far as being the main disciple was concerned he was outstripped by the fourth member of the gang, Charles Laval, who virtually threw himself at Gauguin's feet. At twenty-eight Laval already looked like the born acolyte, hunched and lanky, a puzzled expression half-hidden by a thick black beard and a pair of pince-nez which gave him the air of a perpetual student. Laval was probably nudged towards art by the fact that his architect father also dabbled in painting and occasionally exhibited at the Paris Salon, though as Eugène Laval died when Charles was only eight, the connection could only have been slight. Along with his elder brother Nino and their Russian mother, Charles lived comfortably in Paris on the rent from property left by his father. Laval suddenly surfaced at the Salon in 1880, aged nineteen, with a conventional painting of a Barbizon farmhouse and an address which reveals that he already had a studio near the Nouvelle Athènes café – which could mean that he was hovering on the fringes of the avant-garde. He was said to have worsened an already poor health by loose living, probably from following Toulouse-Lautrec, a fellow student for a time.

By 1886 Laval had finished studying and was living at 23 rue de la Chaussée-d'Antin, not far from Gauguin's and Gustave Arosa's old *quartier*, but what sort of work the 25-year-old was doing prior to his arrival in Pont-Aven we do not know. There is a conventional portrait of his brother Nino which tells us little. With his family money, Laval was reasonably comfortable and secure and not especially ambitious, which may explain why he attached himself to Gauguin, and in the short time it took to master the new technique, Laval was painting in a style virtually indistinguishable from that of his new master.

After the misery of Dieppe, Gauguin relished this attention. Life was very soothing in the midst of such admiring company. Hartrick records how one day, while painting by the Aven, he watched a boat pass, rowed by two Bretons. Du Puigaudeau was among the passengers, while Gauguin, stripped down, was being hauled along in the wake by a rope.

'Like a dead porpoise,' as Hartrick put it, 'but evidently enjoying himself hugely.'

Not that all the newcomers became instant converts. On 15 August Gauguin was approached by a young man, little more than a boy, who introduced himself as Emile Bernard, a painter. He had a card from Schuffenecker whom he had met at Concarneau and who had encouraged him to look up Gauguin while he was passing through Pont-Aven. Bernard had been on a long walking tour which had begun in Normandy in April and which was now taking him across Brittany where he was keen to study the Gothic churches and roadside calvaries and the other signs of the ancient faith of the region. Bernard had strolled along the country roads happily reciting Baudelaire and generally behaving like a dreamy eighteen-year-old with artistic pretensions. A nascent goatee beard did little to hide his extreme youth, which is probably why Gauguin was not particularly impressed at their first encounter.

The two did have one rather odd thing in common – Bernard's father had been involved in the textile business in Lille and may well have had dealings with the Dillies family, Gauguin's old employers. But there was nothing about the young Emile's northern upbringing which especially inclined him towards art except for his maternal grandmother who encouraged him to draw, when he lodged with her while attending his first school. As both he and his younger sister Madeleine were not in robust health, the family moved south to the outskirts of Paris when the boy was twelve. But despite this supposed weakness, Emile Bernard was to prove remarkably energetic over anything which caught his interest – at the incredibly young age of sixteen, despite his father's opposition, he was able to persuade the history painter Cormon to let him be a pupil at his studio in the Boulevard de Clichy, where he was befriended by fellow students Toulouse-Lautrec and Louis Anquetin, a threesome which spent as much time outside in the cafés and galleries trying to discover all the latest notions, as inside actually working in the studio. This did not please Cormon who still refused to allow a hint of Impressionism among his pupils and when Bernard painted the gloomy backdrop draped behind the life model, with a series of brightly coloured stripes, he was asked to leave. Full of the self-confidence which so irritated his elders, he set off on his great walking tour, unclear as to where exactly he was headed, either geographically or artistically, but sure that he was about to discover something important. It was in this frame of mind that he stumbled on Schuffenecker and discovered a mutual interest in the new dots. Gauguin, however, was a different matter, for the work he was then doing in Pont-Aven must have seemed to Bernard somewhat old-fashioned, when set against the very latest Parisian ideas. The young man stayed at the Gloanec throughout August and September and he

and Gauguin ate together in the dining room, but that was all, and by the time Bernard set off on his travels again, there was no hint that he would one day have a considerable role to play in the older man's development.

The only shadow over Gauguin's otherwise idyllic summer was his concern for Clovis or rather Mette's lack of any. Her rare letters were a sure source of irritation. Her writing style, admittedly in a language other than her own, came across as hard and prosaic, her manner cool and practical where he was affectionate, passionate even, much in the manner of his ebullient grandmother Flora Tristan. This clash of opposites was a recipe for epistolary disaster. Her tone implied that he had been thrown out and his replies were a confused mix of naïve attempts to wound her while appealing for her understanding. What he could not know, because she chose not to tell him, were the problems she was having in Copenhagen. She was lonely. She now knew that her sister Ingeborg had interfered too much in her marriage. The air of moral outrage Ingeborg had always adopted when referring to Paul seemed somewhat shallow, now that she had announced her intention of marrying Edvard Brandes so soon after leaving Fritz Thaulow. Mette was confused. Despite Gauguin's accusations and complaints she still refused to listen to her family when they tried to encourage a divorce, even though the Danish courts would certainly have favoured her in any settlement.

Apart from the Elstrups, who had resumed their patronage once Paul had left, the only one to help Mette was Edvard's brother Georg Brandes, who had commissioned her to translate Zola into Danish. Unfortunately for Gauguin, she was currently at work on L'Œuvre, the novel that dealt with the Impressionists in a none-too-favourable light. Reading Zola's exposé of his one-time friends can hardly have done anything to improve Mette's reactions towards her husband's decision to become an artist. Unfortunately, she failed to communicate any of this, and continued to believe that she was behaving loyally towards someone who had betrayed her. It was no doubt this bottling up of her emotions which increased her harshness towards the children. Her work obliged her to leave much of their day-to-day existence in the hands of a maid but she seems to have felt that she should take on the role of the absent father. Not that this new strictness was entirely out of character, as her former coolness towards Aline and her lack of interest in Clovis shows. In the end, the main rift between Mette and Paul was due to the way both held directly opposed interpretations of the same situation. He believed that he was struggling unaided towards something of great importance which would one day allow him to be reunited with his wife and children. The main evidence for this was his unexpected sexual abstinence. While the artistic

and holiday crowd in Pont-Aven was notorious for the frequency of their passing summer affairs, Gauguin appears to have remained aloof. According to Hartrick, he was notorious for his indifference to sex – an indifference which the waspish little Scotsman believed to border on a revulsion towards women. Hartrick claims that he once overhead Gauguin referring to 'the fatter mistress of a fat painter as his "slop-bucket"'. For her part, Mette believed that it was her duty to maintain the family home until the day when her reprobate husband would see the light and choose to come back to them. Tragically, she seems never to have realized that the assumption of moral superiority which this led to, and which lies over her letters like a layer of frost, could only make such an outcome unlikely.

Just as Paul prodded her with accusations of coldness and indifference, Mette too had ways of sticking in the knife. Towards the end of July she slipped into one of her letters the news that she had discovered what appeared to be a tumour on one of her breasts. Predictably, this drove Gauguin into frantic speculation about cancer. He filled a letter with advice on what she should do and begged for more information which, of course, she chose not to give, never referring to the matter again. If he asked for a photograph of Aline she ignored him or then sent one of Emil. It was all very petty. As late as September, he was still referring to her cancer but getting nothing by way of reply.

## Geese and Idle Gossip

This was a wearisome distraction for someone trying to make a significant change in his art. His diagnosis, that he needed time and a decent standard of living before he could begin to do anything important, had been reasonable enough, and he had certainly found both in Pont-Aven. At a purely technical level the cure had worked, his drawings of local people were more assured than his earlier figure studies and his paintings show a lighter touch and a far more subtle use of colour, which finally broke with the sombreness of Barbizon. But this hardly added up to the sort of major eye-catching change that he had contemplated when he stood before Seurat's *Grande Jatte*, and as summer gave way to autumn it began to look as if that would be as far as he was going to get. His plans to stay on in Brittany after the season ended were beginning to look doubtful. Marie was unwilling to go on paying Clovis's school fees for ever and in any case, with the colder weather Pont-Aven was no longer the jolly place it had been. Emile Bernard had left at the end of September, off to Lorient, Rennes and Vannes before returning to Paris by train. And, as the autumn winds began to bite, the others, too, started to drift away. For Gauguin, now used to a measure of adulation, the

original idea of staying all year round in the little town, no longer seemed so appealing. 'The evenings at Pont-Aven are a bit long,' he wrote to Mette, 'when you are alone and work is over for the day . . . there is complete silence around me. It's not much fun, I admit. Every day is like the one that went before, so I have nothing to tell you that you haven't already heard.' He went on to tell her that Clovis seemed to be happy at his school and that he intended to try and make money out of his ceramics and would be travelling back to Paris in a month's time.

With the colder weather there was less incentive to paint out of doors, and more inclination to use du Puigaudeau's studio in Les Avens – which was probably the initial reason for the sudden shift in direction which took place in what was probably the last painting he made before setting off back to Paris. All the previous paintings had been of specific, recogniz-able places near to the Gloanec, this last – which may have been finally completed after his return to the capital – was an imagined work, done from memory in the studio, and as such marked a distinct break with Pissarro's 'romantic impressionism'.

The painting is sometimes entitled *The Four Breton Women Gossiping over a Wall* and at one level it was precisely that: one woman stands on the far side of a wall which runs straight across the picture, while three are on the other side nearest the spectator. Nothing much is happening. The four women are lost in conversation, the woman on our right adjusts her shoe, the four large figures completely fill the picture space in their voluminous Breton costumes, allowing only a glimpse of some geese in the field behind, and a second small space where a man is scything hay.

But at another level, the way the picture is painted marks a sharp shift away from the atmospheric effects of Gauguin's masters. The four figures with their large Breton coifs are posed in a flat pattern, almost like cut-out shapes or sections of stained glass, and even the geese are a step away from direct realism, owing less to any outdoor sketching Gauguin may have done than to the children's books he had seen in England. Hartrick recalls how he once saw Gauguin coming back to the Gloanec carrying some drawings of geese and as they passed he held up one of Randolph Caldecott's illustrated books to show him a picture of geese, praising them 'almost extravagantly'. Of all the English illustrators Caldecott was the one with the strongest links to the English Art Move-ment – there is a classic Caldecott illustration from *Frog He Would a-Wooing Go* which has Miss Frog seated on a William Morris ladder-back chair, while the mirror over her chimney piece is decorated with a peacock's feather, symbol of Whistler's Aestheticism. Caldecott had recently died and Gauguin may well have read his obituary in *L'Art Moderne* which praised his drawings for Henry Blackburn's *Breton Folk: An Artistic Tour of Brittany*. Caldecott had spent many summers in Pont-

Aven, and it was sad that the two artists were so narrowly deprived of the chance to meet.

As an act of pure composition *The Four Breton Women* was clearly a satisfying achievement, but there is clearly more to the picture than just its 'abstract' qualities. The word 'gossiping' in the title seems to indicate that we are looking on something more than a neutral scene such as the little shepherdess on her wall and that we are meant to read something into the picture, to see something significant in these four women idly passing the time while the man in the background labours away, cutting hay. If one follows this line, then the geese have their part to play in the story – there are four of them too, one for each woman, and calling someone *une oie*, a goose in French, or *une oie blanche*, a white goose, was a way of saying that they were simple-minded. If that is what Gauguin meant us to understand then this otherwise bucolic painting is transformed into a rather harsh comment on a group of indolent peasant women – which could in turn be seen as a reflection on his attitude to women in general, perhaps the result of his quarrels with Mette.

This is probably going too far – the painting is little different from the sort of anecdotal work done by the visiting Salon painters with their resting farm workers and mischievous children at a wedding feast or frolicking couples at a festival. There is a long tradition in European art, from Breughel onwards, of depicting country folk as sly bumpkins or bibulous fools, and if Gauguin was harsh about women in this picture then it has to be set against an earlier work, *Washerwomen at Pont-Aven*, where it is the women who are slaving away, dunking clothes in the river, while it is the solitary male who sits on the bank indolently watching them.

It is likely that Gauguin had no fixed ideas about what he was doing as yet, and was still trying things out in a fairly random way. What is important is that the painting moved him forward, like cresting a rise and seeing a different landscape spread out below, leaving him both clearer about where he was going and about how he would get there.

## Out of a Little Clay

Before leaving Pont-Aven, he sent another letter to Mette to tell her that she could write to him at 257 rue Lecourbe (again in Montparnasse) where Schuffenecker had found him what he called a little 'slum', adding that he was in the middle of packing the many studies that he had made, the stack of pencil drawings and pastel sketches that would keep him at work over the coming months.

Back in Paris, the apartment was indeed little short of a slum, but was

at least within walking distance of Chaplet's studio in the Rue Blomet, where he went as soon as he had settled in. He wanted to get down to work at once but it was soon clear that Chaplet had now decided that his collaborator needed a degree of control if he were not to go on making the same rather wild pieces he had turned out before leaving for Pont-Aven. What followed was a period of creative tension between the two men, which may have been valuable for both of them. To start with, Chaplet threw the pots on the wheel, his usual simple, Japanese-inspired shapes: slim vases, jugs barely swelling outwards with plain, unadorned handles; then Gauguin decorated them. With his head still stuffed with the imagery of Pont-Aven, he took the first of Chaplet's pots and added Breton scenes drawn from his sketchbook – the little shepherdess stretched out on her wall, two of the women gossiping over the wall – incising the outlines directly into the clay then filling in the shapes with different glazes to create patches of colour, further advancing the idea of flat patterns marked by clear outlines, a decorative style similar to a stained-glass window in a medieval church or to one of Caldecott's illustrations. It was a happy alliance of image and material, applying pictures of simple country life to stoneware, the material implicitly associated with farming communities. But there is some evidence that Gauguin looked on these pieces as more Chaplet's than his. A cylindrical vase with two Breton women, and a rectangular *jardinière* with the seated shepherd-girl, both have Chaplet's rosary symbol imprinted on the bases and Gauguin does not seem to have been much concerned about either piece – the vase was left behind at the Rue Blomet and later exhibited by Chaplet as part of the studio's output, rather than as a piece specifically by Gauguin. Certainly Chaplet was doing most of the work, first throwing the pots then firing them – the trickiest part of the whole operation. But this sort of collaborative enterprise, with a distinct division of tasks, was unlikely to satisfy Gauguin, who liked to be involved with every stage of anything he produced, and eventually Chaplet let him have his way, allowing him to make the pots himself while the studio took over when he was ready to have them fired. There was no question of Gauguin using the potter's wheel. Even if he had been able to, which is doubtful, he certainly did not wish to, preferring to build up his shapes from coils of clay or to hollow out a form from a block of solid material. As soon as he got his hands into the thick earth there was no stopping him, moulding and pulling the clay into what must, to the studio assistants, have looked like weird faces and heads with handles looped across them, and animal figures which hardly looked like pots at all. The influence of Christopher Dresser and of Gauguin's love of the Peruvian ceramics which he collected is clear, and he confirmed this when he wrote of his belief that: 'Ceramics are not futile things. In the remotest times among

the American Indians the art of pottery was always popular. God made man out of a little clay.' Of course, the sort of Chimú and Mochica pieces which inspired him were not made for everyday use; they may have been grave goods or used as part of religious ceremonial, and what most strikes people today is the incongruity of an object which blends a figurative image with a suggestion of usefulness, which then turns out to be false – a head is a vase which in reality is only a sculpture. In Europe this sort of visual pun is used almost exclusively for comic effect, as in a toby jug or a child's piggy bank, where the joke lies in the clash of opposites. But in pre-Columbian ceramics the effect is often unsettling, with hints of what would later be called Surrealism, the simul- taneous flicker between one level of reality and another. This is what makes Gauguin's pots so intriguing, though one can see why they were hard to understand at the time. Even the usually sympathetic Bracque- mond felt forced to tell Pissarro that he thought they were no more than: '. . . the art of a sailor, inspired by that of Peru'. And as if to confirm such doubts, Gauguin began to refer to his 'ceramic sculptures', distancing them from pottery but leaving them in a no-man's-land, stranded between art and craft. All Chaplet knew was that these pieces were no more commercial than the earlier efforts, though once again the older man seems not to have been too bothered, for he let Gauguin turn out an astonishing fifty-five pieces, all of which he dutifully fired.

The unexpected event of that winter was the reconciliation between Gauguin and Degas. They did not like each other but Gauguin was too great an admirer of Degas's work, while Degas had a fair idea of Gauguin's potential, for them to remain at odds indefinitely. Pissarro was so amazed by this, he wrote to his son Lucien to tell him of the unexpected reunion in the Nouvelle Athènes: 'The hostility of the romantic impressionists is more and more marked. They meet regularly, Degas himself comes to the café, Gauguin has become intimate with Guillaumin once more, and goes to see him all the time – isn't this seesaw of events strange? Forgotten are the difficulties of last year at the seashore, forgotten the sarcasms the Master hurled at the sectarian, forgotten all that he (Gauguin) told me about the egotism and common side of Guillaumin. I was naïve, I defended him (Gauguin) to the limit and I argued against everybody. It is all so human and so sad.'

Pissarro was wrong to see the thing as an artistic conspiracy. He had also misunderstood what Gauguin was trying to do, having concluded that his opposition to Seurat came from a desire to cling to the original tenets of early Impressionism. Thus Pissarro dubbed Gauguin and his friends 'Romantic Impressionists' when no such school existed. Of course there were factions, but they were entirely personal and not a little stupid – as witness Gauguin's anger with Seurat over the key to the studio. Of

course, Gauguin was under considerable stress, especially over Clovis's school fees. The bills were piling up and he was again unable to visit the little boy until he found some way to settle the quarterly bill. The apartment was barely habitable, the onset of winter was unbearable and some time around mid-November Gauguin succumbed to a vicious attack of tonsillitis, no doubt exaggerated by poor living and all his worries. He was hospitalized for twenty-seven days and when he emerged most of his anger was directed towards his sister Marie, who he believed had betrayed him by failing to go on paying Clovis's bills. This was unfair as the real reason for her withdrawal of support was the unexpected collapse of her husband's business. Although the details are now lost, there can be little doubt that Juan Uribe's problems were related to the Panama canal scheme which had begun as an easy way to make a fortune but which by 1886 was turning into a financial disaster, which would far surpass the collapse of the Union Générale.

## The Land Divided

It had been only five years earlier, on 1 February 1881, that Armand Reclus, one of the senior engineers in charge of the canal project, had wired back to France the thrilling news, carefully passed on to all those bribed journalists: *travail commencé* – work begun. It was the last truly good news, as opposed to the fictions printed in the company newspaper the *Bulletin du Canal Interocéanique*, to come out of the wretched Isthmus of Panama. A brilliant survey had already mapped out a route for the canal, roughly alongside the railway which ran the forty-odd miles from the town of Colón on the Atlantic, across the narrow neck of land, to Panama City on the Pacific. But the report had also pointed out the alarmingly varied terrain, from basalt rocks to swatches of volcanic lava and ash, much of it covered in impenetrable rainforest, and hopelessly flooded with torrential rivers in the rainy season. The first construction firm quickly smelt disaster and withdrew, suggesting that it would be better for the project if it was carried out in different sections by a variety of entrepreneurs. The Canal Company agreed to this but each of these subcontractors used different methods and equipment and engineering gauges – none compatible with the other and all beavering away as if in isolation. This is probably how Uribe got involved, for with so many workers now engaged all over the isthmus, there seemed to be unlimited opportunities for small businesses to supply them with all the goods and services they would need. This might well have proved true, had it not been for one final disaster – a tiny insect. After the first year, the deaths among the various working parties were horrendous, some from yellow fever but most from malaria. It would be another twenty years before

the connection was made between the mosquito and the disease – at the time it was thought that the humid atmosphere, the miasma as it was known, was the source of the killer fever. Everything the company did only made matters worse. Nuns were sent out from France and a hospital built according to the latest, most up-to-date notions of hygienic design, surrounded by kitchen gardens to provide fresh food for the patients. To protect the plants from ants, they were grown in pots, standing in ponds whose water proved an excellent breeding place for the anopheles mosquito which multiplied accordingly, making the clinic itself a major death-trap. Word began to seep back to France. Skilled white labour dried up with only the most vicious and the most desperate willing to risk their lives in the hell-hole the Isthmus had now become. Work was only completed at great cost to the landscape and was no sooner done than the annual flood washed away much that had been achieved. As the sides of the canal sections caved in, the engineers brought in ever larger equipment, widened the sections, further wrecking the environment. It was as hopeless as it was destructive and by 1886, the year of Uribe's collapse, the game was almost up. The financing of the project had been wildly over-optimistic and de Lesseps had had to refinance the company several times with ever increasing difficulty. To add to his woes, 1885 had witnessed a totally unexpected act of lunacy when a Haitian mulatto, Pedro Prestan, appeared on the Atlantic seaboard at the head of a force of West Indian negroes and proceeded to massacre any whites he encountered. There was a bloody battle. Prestan was captured and hanged – a grim photograph shows him swinging from a scaffold over the main railway line – but not before he and his band of desperados had set fire to Colón, razing it to the ground. Even the *Bulletin* could hardly suppress that piece of mayhem and as the company's reputation plummeted, the banks withdrew support and all the smaller companies which had grown up around the project began to go under, one after the other, as confidence evaporated.

With his investment lost, Juan Uribe seems to have concluded that the only way he could salvage anything was to try and make some money directly on site, in the Isthmus itself, and in 1886 he left Marie and the children and went to Panama. It was a desperate time for them. The following year Marie was forced to take the children to Germany where she took up her mother's old trade as a seamstress, until she had raised enough money to join Juan. In the meantime she tried to keep up appearances, carefully disguising from family and friends just how far she had fallen. Certainly her brother had no idea of the scale of the problem, for she appears to have let him believe that Juan was working as a banker in Panama – a dangerous thing to do, as Gauguin immediately seized on the idea that there would be a place for him in such an enterprise.

Before long he was dreaming of travel to Central America or to some distant outpost of the French Empire, all paid for by Uribe. Madagascar was much in the news at the time as the French military struggled to bring the great island off the coast of East Africa within their sphere of influence and Gauguin quickly convinced himself that it would be logical for Uribe to want to have a branch office there, with him running it.

## Big Business in Madagascar

If things had been going better in Paris, this might have been no more than an idle fancy. But things were not all right. It was getting ever harder to make a splash. After Seurat's dots, it was difficult to shock the critics. Nor was it easy to find sufficiently original subjects to get oneself talked about – Degas had his dancers, Renoir and Monet their boating parties and popular cafés, while the new city and the burgeoning suburbs had been worked to death. One would have to look further afield to attract a public satiated with novel views of modern life.

But where to choose? Distance was a problem, as it might be unwise to disappear totally from the tight-knit Paris art world – one could too easily be forgotten. Then there was the problem of getting paints and other necessities if the place was too remote. What Gauguin reckoned he needed was an untouched tropical haven, not too far away from a reasonably civilized colonial city, where he could get supplies and keep in touch with Paris. That still left plenty of choices to agonize over. France was by then well on the way to becoming a colonial power to rival Great Britain, with a new territory being added to the empire almost every year. Between 1883 and 1885 there had been French activity in such disparate places as The Congo, Madagascar, Somaliland and Tonkin (today's North Vietnam), developments Gauguin watched with great interest.

He was not alone in believing that a collection of idyllic lands, peopled by happy natives, disported themselves under the benign rule of a motherly France. A Society for the Promotion of the Colonies encouraged such a view, going to considerable lengths to play up the unlimited possibilities for personal advancement in the overseas territories. An efficient propaganda machine juggled two somewhat contradictory inducements – on the one hand, the citizen was told that it was his patriotic duty to work for the enlargement of the nation on other continents. Such sacrifices, it was claimed, would defeat the tendency towards decadence which was undermining the vigour of the mother country. Yet at the same time, the colonies were portrayed as a sun-lit heaven, in which pampered white masters lived luxurious lives tended by grateful

natives. But the influence of the Press was as nothing beside the books turned out at regular intervals – often one a year – by the travel writer Pierre Loti, whose best-selling accounts of his world-wide voyages entertained both the literary world and a mass public of astonishing proportions both in France and elsewhere in Europe. His first book, *Aziyadé*, written in 1877, was set in Turkey but it was his second, published in 1880, which made his name, quite literally, as he was from then on to call himself after the hero of the story *The Marriage of Loti*. In it, Loti recounts the amorous adventures of a young naval officer on the island of Tahiti for, of course, the author was that same midshipman who had served with Gauguin during the ill-fated Baltic mission during the Franco-Prussian War, the former Julien Viaud, who had sailed for Tahiti when the battle-fleet was disbanded. It is doubtful whether his romantic tale bore much resemblance to his actual life there. Viaud was of ambiguous sexuality, and an inveterate fabulist – which was just what his public demanded of him. His story of how a young English naval officer Harry Grant arrives on the island, meets and undertakes a form of marriage with the nubile fourteen-year-old Polynesian beauty Rarahu, rekindled the old mystique of the South Sea islands and the sensuality of its women. When Grant 'marries' Rarahu he is given the name of a local flower, 'Loti', and by taking the name as his own, Viaud/Loti succeeded in merging fact with fiction in a way that ensured that his every word was taken as a gospel account of life on the island. In reality, though that is a distinctly inappropriate word in this context, the book is just another in the long line of nineteenth-century novels which dwell lovingly on the plight of the fallen woman – Rarahu sinks to prostitution, physical decay and an early death after Loti's departure and he displays only the mildest remorse over the fate of his child-bride and makes no wider philosophical or political judgements about the colonial situation which had allowed him to have a love affair which would have been hard to arrange in Europe even in an age which tolerated a degree of child prostitution. The lascivious descriptions of Rarahu's physical charms were the literary equivalent of the thinly disguised 'Orientalist' erotica available at the annual Salon, the sort of art Gauguin affected to despise, yet which in book form he consumed avidly.

He was hardly alone. Where previous accounts of visits to the island by such as Bougainville and Cook had begun European fascination with the 'Island of Venus' or the 'New Cythera', as Bougainville dubbed it, it fell to Viaud/Loti the honour of communicating this dream of heaven to a vast public, eager to believe that there was still a place of untrammelled passion, one where the bleak workaday life and firm moral restraints of the new industrial age were as yet unknown. What Loti offered was Eden before the Fall, a world without sexual shame, which

was fair enough, as long as the book was taken for what it really was, a novel. But by changing his name, Viaud/Loti had succeeded in clouding the issue and before long his book was, despite its palpably romantic style, being quoted as a standard work on Polynesia, even in official journals, as if it were a straightforward anthropological study.

Loti, as we must now call him, for he was never known by his original name again, had an acute nose for where fashionable interest was turning and his subsequent books kept up with public taste. *Madame Chrysan-thème*, another love story, this time between Loti and his *mousmé*, his Japanese mistress, the inspiration for the opera *Madam Butterfly*, did for Japan what *The Marriage of Loti* had done for Polynesia, appearing in 1887 when public interest in all things oriental was at its height. Morocco, the Holy Land, frequent visits to Turkey, which offered the sort of pleasures for which Viaud rather than the fictional Loti truly craved, as well as a 'pilgrimage' to Angkor Wat in present-day Cambodia, were all devoured by a faithful readership of armchair travellers, happy to let him transport them on the voyages of their dreams.

Because he is now a minor figure in the history of French literature, it is essential to see Loti in his place as a commanding influence on late nineteenth-century thought. While he may not have intended it, his books were a crucial part of the process of convincing the French people that their future lay as much in far distant places as it did in the farms and cities of France itself. And, yearning for an unspoiled Eden, the inhabitants of those overcrowded, smoky cities had no wish to be told that such a paradise did not exist – least of all a fantasist like Paul Gauguin, who read Loti and through him came to see in the colonial romance a solution to his troubles, both financial and artistic.

The difficulty was which to choose from the many places on offer. When he read about French activity in Madagascar, that seemed the ideal place: wild, barbaric, but with a well-run shipping service that could keep him in touch with Paris. He mentioned the idea to various friends but no one was very encouraging and the dream might have foundered had not Marie put the idea in his head that her husband was doing well out of banking in Panama. On the day after Christmas 1886, Gauguin wrote to Mette complaining about Marie's unwillingness to help with Clovis but adding that he now knew that Juan needed someone to help with his business, someone he could trust, who would not rob him and who knew something about finance. There was, he explained, no one like that in Panama, where even bad employees were highly paid. Where all this information came from is not stated. It must be doubted that Marie went so far as to tell lies on that scale, so that one can only assume that this was a mish-mash of hearsay and half-remembered publicity material, which the Canal Company was always bribing journalists to print.

For the moment that was as far as it went. In the New Year, there was nothing but pottery with Chaplet, as Gauguin once more faced a bad winter, with never enough to eat. All references to Panama disappear from his letters and Mette can only have assumed that yet another fantasy had evaporated, but then, in mid-March, with no warning to cushion the blow, he suddenly wrote to say that he was leaving for America on 10 April. This was quickly followed by a second letter in which he confirmed his decision: 'I am going to Panama to live like a savage . . . . I will take my colours and my brushes and I will rebaptize myself far from humankind.'

He had decided to go, even though there was no precise offer of a job from his brother-in-law. He had even convinced Laval and du Puigaudeau that they should go with him, and that once in the tropics they would be able to live on fruit and fish like simple natives. Both were keen on the idea, but for the moment only Laval could get away – du Puigaudeau said he would join them later, when they had found a place to settle. Interestingly, it was the normally vague and supposedly incompetent Laval who proved most practical in getting the project off the ground. He managed to make contact with Henri Cottu, a director of de Lesseps's company, who agreed to write letters of recommendation to the project managers in the Isthmus, to help them get decent lodgings in Colón and reasonable work away from the worst fever zones. Still believing that Uribe would get him into banking, Gauguin no doubt dismissed these moves as an unnecessary precaution. After listening to Pissarro's descriptions of life in the Danish Antilles and with his own affectionate memories of Peru, Gauguin had no reason to imagine anything other than good times ahead. The one thing holding him back was Clovis and he wrote to Mette asking her to find some way to get the boy back to Copenhagen. When she ignored this, he wrote again, begging her to find someone who could accompany Clovis on the train journey, as he was now booked to sail to Panama from Saint-Nazaire in mid-April. She still did not reply and at the beginning of April he wrote her a farewell letter, pointing out that Uncle Zizi was seriously ill and that he had made arrangements for any inheritance he might get to be passed on to her, as well as any monies that might result from the sales of his pottery which he was leaving in the hands of the art dealer Portier. As she had done nothing about Clovis, the little boy would stay at the school until something could be arranged and in the meantime Schuffenecker had agreed to do what he could for the child. But this time Gauguin ended on a softer note: 'I kiss you a thousand times, tenderly as I love you.'

Just before he and Laval left Paris on 9 April, Gauguin went round to the Schuffeneckers to say goodbye and to his utter astonishment

discovered that Mette was there. She had come to Paris to collect Clovis without telling him. Left alone, they sat in the Schuffeneckers' salon, talking awkwardly. She said she had not wanted to see him because she was afraid that if they were together she might get pregnant again. He told her that his only wish was to reunite the family again, just as soon as he could sort out his art and his finances. It was a pathetic encounter, which resolved nothing, and they said goodbye almost like strangers.

The next day, Mette and Schuffenecker went to collect the little boy but when they arrived at the school, Mette decided she was so incensed at the treatment of her child, she started to pick a quarrel with the innocent Schuff, despite the fact that he had always taken her side, and tried to visit Clovis whenever he could. When they got back to Paris, Mette collected up as many of her husband's paintings, drawings and ceramics as she could carry, and carted them back to Copenhagen. She had never pretended to like his work, but it might have some value one day. She even removed some of his books, including his grandmother Flora Tristan's *Promenades dans Londres*, one of the few family mementoes which had survived the burning of Saint-Cloud.

One can but imagine Gauguin's feelings as the train took him to Saint-Nazaire to join his boat. Seeing her had confused him. He had gone on insisting that his only wish was for them all to be together again, but there can be little doubt that finding her hiding from him at Schuffenecker's had brought him nearer to the point when he would have to accept that their marriage was truly over.

# 6

◆

# *Among the Mangoes*

Bad weather and the fact that the third-class passengers were, in Gauguin's words, 'packed like sheep', made the Atlantic crossing unpleasant, at least for Laval – as an ex-sailor Gauguin was hardly bothered. The *Canada*, a steamer of the Compagnie Générale Transatlantique, called in at the island of Guadeloupe in the French Antilles before docking at Saint-Pierre, second city of the colony of Martinique, on 23 April. This pretty little outpost, its houses rounding a wide bay, with the volcanic Mount Pelée rising in the background, was almost a vision of Japan, as if the Mount Fuji of the much admired prints had been somehow set down on this pleasant-looking island. If they had stayed while they still had a little of Laval's money, they might have lived out the dream, but they were driven by the illusion of Panama and like so many adventurers before them they left the calm waters of Saint-Pierre Bay as soon as possible for the four-day journey across the Caribbean Sea to the port of Colón where the canal workings began.

After Saint-Pierre the shock was brutal. The settlement had boomed from 3,000 inhabitants before digging commenced, to a sprawling camp of temporary structures and workshops, straggling across marshland to the north-west of the harbour. Without proper drainage, over 20,000 settlers lived in a filthy hell-hole, so disease-ridden that passengers on ships which were only calling in were often warned to stay on board, rather than risk their lives for a day ashore. As the great project had deteriorated, so had the people who had come to work on it. The over-crowded huts were crammed with the dregs of Europe and the Americas. The invasion led by Pedro Prestan the previous year had resulted in most of the temporary structures being razed to the ground, but far from this purging the hideous slum, new hovels had sprung up among the ashes and rubble of the old, with nothing being cleared away. The main thoroughfare, the Calle Bolívar was heaped with rubbish and alive with rats. Because the authorities could think of nothing but the floundering

canal project, there was a total absence of civic order, a sort of filthy, putrescent anarchy. Worse, the rainy season brought sudden tropical downpours, so violent that being caught in one was like standing under a waterfall, which swirled the detritus about the cluttered thoroughfares, turning the paths into filthy rivers of mud.

As no letter from Henri Cottu had arrived at the company's headquarters the two friends decided to travel across the Isthmus to Panama City where they were sure Uribe would help them. Though it was only a three-hour rail journey from coast to coast, that was quite long enough to see that all was not well. The original railroad had barely dented the lush forests and slopes over which it wound the forty miles to the Pacific, but now the five zones of excavating along its route had devastated the landscape as each engineering company had gone about its section of the project in its own way. For some it was a case of blasting through the mountains, others had undertaken deep dredging which had gouged out rivers and valleys which in turn had led to massive erosion during the rains. Despite the original attempts to provide decent housing, the workers' settlements along the line had degenerated into rotting camps dominated by the looming hulks of rusting machinery – giant dredgers and massive excavators, covered in creepers, as the triumphant jungle reclaimed the battered land.

For Gauguin, whose memories of Spanish America were all of love, warmth and colour, this atmosphere of putrefaction and collapse must have been doubly hideous. Despite the financial disasters of recent years, he had never had any reason to doubt the underlying value of the great surge forward of what was loosely defined as 'progress', that headlong rush to industrialize, to build and to make, which had characterized his years in France. His artist friends might choose to escape to the country, to immortalize a gentler pre-industrial world, but they were grateful for the trains which took them there and the clever new paint-tubes which allowed them to work in the open air. In Paris, criticism of the new, of the progressive, was little more than a pose adopted by cultured folk, a snobbish way of looking down on the vulgarities of bourgeois capitalism. There was a confusion, an ambiguity about all this, a feeble attempt to reconcile the advantages of progress: better drains, medicine, greater wealth and leisure, with the manifest disadvantages: the growing slums and industrial waste which had spread around Europe's burgeoning cities. In Panama, any ambiguity vanished, the place was a dystopia, clear and horrific. For Gauguin, who had accepted the Saint-Simonism of both his great-grandmother and the Pereires, which allowed him to believe that universal well-being would result from ever larger public works, this first view of the greatest engineering project of the nineteenth century was a vision of apocalypse.

It was a relief to arrive in Panama City, the one outpost that bore some signs of civilization. Here was a real city with history and character: a cathedral, a decent hospital, even a casino. But just as the two travellers were beginning to think that they had put the nightmare behind them, they had the worst shock of all. Juan Uribe's establishment was far from the grand bank Gauguin had fondly imagined – his brother-in-law was running a general store, and not a very grand one either, just a large shop providing goods to anyone left with the cash to buy. No wonder Marie had kept quiet about it. For Paul, the revelation was the death-knell for all his dreams.

At least Uribe was a little more generous with cash, now that his wife was not there to restrain him, but given his own problems, the two travellers could hardly expect Uribe to do much more. They decided to press on to the island of Taboga across the bay, which Gauguin believed to be almost deserted, and where it should be easy to find a piece of land where they could live cheaply and paint an unspoiled world in peaceful solitude. Taboga was only an hour and a half's sail from Panama on the Company's twice-weekly steamship, so the scheme was feasible as far as it went, though it must have been obvious that Uribe was far from willing to get involved in any of the enterprises, agri-cultural or artistic, that Gauguin imagined might be possible on the island.

They made the crossing in early May and were quickly disabused. Where the Isthmus had offered industrialized hell, Taboga was that other by-product of western expansion, the tourist trap. To escape the inexplicable diseases of the mainland, the company had built a sixty-two-bed sanatorium on the island, making it a Rest and Recreation centre for its favoured workers. Apart from those convalescing, there was a constant stream of little boats ferrying Sunday trippers and family groups coming across on outings and picnics. The island's fishermen and fruit growers had quickly adapted to this new source of income and had organized a tour which ended in a native village, where the occupants, dressed in gaily coloured costumes, offered succulent local pineapples and other tropical fruits to the visitors before leading them off to visit the thatched '*ranchos*' and the groves of tamarind trees which were the island's principal attraction. It was all very well organized and not a little sham – 'native' musicians could be hired to play guitars and violins for picnic parties. Gauguin was appalled. Even if he had wanted to stay, the local people were far too canny to sell land to foreigners other than at an exorbitant price.

They sailed back to Panama City and weighed up the odds: Uribe was unlikely to come up with anything, hotels were hideously expensive and what little money they had was seeping away. The only hope of work

depended on whether Cottu would write to the Company in Colón on Laval's behalf, and as that was all they had, they retraced their journey, back to that cess-pit on the Atlantic.

When no letter awaited them, they began to get desperate. The only idea they could think up was to offer to make cheap portraits of some of the better-off company officials – though Gauguin immediately backed out, claiming that he was above such stuff, probably to hide the fact that he was unable to turn out the sort of formal academic portrait which Laval, who had once trained under Bonnat, was able to do with relative ease. So, while the younger man got down to preparing his materials, Gauguin set off to sell his services on the Canal. In order to get some advantage out of this he wrote to Mette telling her that he was going to have to go out and 'swing a pickaxe . . . from half past five in the morning until six in the evening under the tropical sun and in the rain. At night devoured by mosquitos'. He even added, tongue in cheek, that the death toll wasn't that bad – 'only 9 out of 12 of the negroes die while for the rest it is a mere half'. One result of this heavy-handed and macabre sarcasm has been to leave the impression that he had been forced to go out to the diggings and work alongside the hungry ex-slaves and the desperate white trash that had drifted into the Isthmus – the 'tropical tramps' as they were known locally. The truth was less drastic. He had come across a Monsieur Liesse who ran one of the six companies subcontracted to dig the canal and build the surrounding earthworks and roads. Liesse's company, the Société des Travaux Publics et Con-structions, had its offices at the Steamship Agency in Colón, from where it administered the building of the massive dam to hold back the Chagres River, whose rainy season torrents had done most to thwart de Lesseps's plans. As the rains were now at their height it is unlikely that there would have been much actual construction work taking place out at the dam itself but the Société also supplied equipment and haulage vehicles and maintained workshops in Colón and it was probably somewhere among these activities that Liesse found Gauguin a place. The fact that he was able to write to Schuffenecker on a sheet of the company's letter-head and that he was able to give the Colón address for his own corre-spondence, suggests that he was working in the main office and was only piling on the agony when he wrote to Mette about his hardships. By his own account he was to be paid 550 francs a month, though there would be no severance pay if work were suddenly terminated – a distinct possi-bility in the current climate. Though the fact that the company had between twelve and fourteen thousand workers, mostly Chinese and Jamaican, makes it safe to assume that Gauguin was working as a book-keeper or accountant and that he had every chance of being employed for some time. The one drawback about the work was its similarity to his

worst days as a *liquidateur*, and a letter to Schuff gives a clear indication of his dismay at the way things had worked out.

> Martinique is a fine country where life is cheap and easy. We ought to have stayed there; we should have been working by now, with half the passage in our pockets. Nothing is to be got out of my brother-in-law. In short, in all this we have been stupid and unlucky. Anyhow, we must repair our errors, and I intend (by working on the Canal for two months) to save a little money to take us to Martinique. If Portier has been clever enough to sell something for me, send me the proceeds quickly so that I can clear out of here.
>
> I will write you shortly my impressions of the country. Our address: M. Liesse (Public Works Company) Steamship Agency, Colon. (to be handed to M. Laval).
>
> We are both well in health (Laval always a little frail but I never felt stronger). Despite this, every precaution must be taken, I am told some are swept off in two or three days.
>
> Regards to all who think of me.

For once he had a perfectly practical plan to save money and move to Martinique, but even that was to be blown aside in the chaos that was Panama. Six weeks earlier, in March, de Lesseps's son Charles had returned to Panama on his father's behalf to review the desperate situation. By then, an alarming 1,400 million francs had been squandered on removing only half the earth that would need to be got out if a sea-level canal was still to be completed. To the realistic Charles, it was no longer possible to go on tolerating his father's monumental illusion that such a miracle could happen. He would have to return and convince him that the only glimmer of hope was to accept a canal with locks – though even that would be impossible without a massive injection of new money, which would be very difficult to raise. Despite Charles's eloquence, it was November that year before Ferdinand finally admitted that he had changed his mind and hired Gustave Eiffel, later designer of the eponymous tower, to create the locks for him. The delay was fatal and throughout the intervening period, the spring and summer of 1887, word began to leak out that bankruptcy was imminent. All who could, made desperate attempts to save something from the impending débâcle and only a fortnight after he was hired, Gauguin, along with ninety other employees of the Société des Travaux Publics et Constructions, was peremptorily discharged, as the management in Paris ordered all activity to be halted, while it awaited the results of de Lesseps's latest attempts to float another stock issue. For Gauguin, it was one blow too many, and without work there was no longer any reason to stay on in so disagreeable a place. We do not know whether Laval had had sufficient time to finish a portrait and earn any money, but with Gauguin's 275 francs from his two weeks'

work, they had enough to pay the fare aboard the *Amérique*, which left
some time about 8 June, arriving in Martinique three days later.

## A Memory of Africa

The little island was no more than the width of the Isthmus, about forty
miles, between its farthest points. Fort-de-France, on the south-west
coast, was the administrative and bureaucratic capital, but it was only
half the size of its northern rival, Saint-Pierre, which was the undoubted
commercial and cultural hub of Martinique, variously known as 'The
Little Paris' or 'The Pearl of the Antilles'. Pretty stone-built houses,
painted yellow, with red tiled roofs, pierced with dormer windows,
fronted the sweeping horseshoe bay in which up to thirty ships were
generally riding at anchor, waiting to be loaded with sacks of sugar and
casks of rum, or to discharge the French luxuries which gave the town
its cosmopolitan air. Cobbled streets, none of them level, twisted up to
the slopes of the surrounding hills where the yellow-stone warehouses
rose in lines above the town. Many of the buildings were seventeenth
century and reminded visitors of the French quarter of New Orleans.
With its double staircase, Saint-Pierre's Theatre was a replica of that in
Bordeaux and French players would come out for a season, bringing new
productions. The annual Mardi Gras carnival was famous for its vivacity
and colour, but there was a miniature version every evening when the
seafront promenade offered the spectacle of the town's mulatta beauties
parading in their voluminous, vividly coloured skirts, bright headscarves
and parasols.

Beyond a few charred traces, none of this exists today. Saint-Pierre and
all its inhabitants were wiped out in 1902 when Mount Pelée, the bald
mountain, usually hidden in cloud, suddenly erupted and swept away the
Pearl of the Antilles in a river of searing lava, so hot the boats in the harbour
burst into flames. There had been some premonition of such a catastrophe
in 1851 when Pelée covered the town in volcanic ash. But since then the
brooding presence had done no more than give off the occasional terrify-
ing rumble before falling back into its usual threatening silence.

In 1887, Saint-Pierre was thriving, though surely too smart and expen-
sive for Gauguin. If he was to stay long enough to get any painting done,
he would have to leave the town and find somewhere simple and cheap.
Outside, things were very different, though there was not an unlimited
choice. Although small, much of Martinique was impassable. The north
of the island, with its spectacular high peaks covered in thick rainforest,
had only a few well-worn tracks linking the plantations in the interior
to the coastal towns. As there was no decent road north he took the
southern route to the little settlement of Le Carbet, about two miles

away, which provided the city with most of its fresh food. This was hardly wild – some of the richer inhabitants of Saint-Pierre had country houses set among Le Carbet's famous coconut groves, but it was sufficiently exotic for Gauguin's purposes and definitely cheap. They managed to find an abandoned hut – a *case à nègre*, a negro shack, at the back of a compound with a house and a number of outbuildings which is believed to have been the Marc-Cyrus Estate, which lay to the north of Carbet itself. As the huts were abandoned, Gauguin and Laval could live for nothing and could survive by picking wild fruit. It seemed ideal, in Gauguin's words, 'a paradise'. Le Carbet was quite high up and the sea below was fringed with coconut palms, but they were only twenty-five minutes from the town if they needed anything and Gauguin quickly arranged for a Monsieur Victor Dominique in the Rue Victor Hugo, Saint-Pierre's principal thoroughfare, to receive his mail.

One result of his leaving the town was probably incidental but still very important – he had stepped out of what was predominantly a white society and was now living in a community which was largely black. Although slavery had been abolished in 1848 the island was still divided along racial lines. The original Caribs were long gone, as were the first Spanish colonists; over eighty per cent of the inhabitants were the descendants of the negro slaves who lived and worked mainly in the plantations on the flatter south of the island or, as at Le Carbet, on small-holdings beyond the towns. In a city like Saint-Pierre it was possible to have a false impression of the island's population as there were few negroes living there. The city-dwellers were divided into three groups. The *blancs* were whites who had come out from France, and who were usually involved in government or trading. The *créoles* were whites born on Martinique and not, as now, people of mixed race and, because they had been on the island longest, they were the largest landowners and the richest section of the community. It was the *mulâtres* who were of mixed race, though the name *créole* gradually changed its meaning and took its place. The *mulâtres* were further divided up according to the graduation of colour (or, more bluntly, the percentage of black to white in their ancestry). There was and is a great variety of skin tone among the Martiniquais, who are always lauded as being among the most beautiful people in the Caribbean. Their love of richly coloured Madras scarves and shawls had drawn a number of Indian traders to the island, as well as other poorer Indians brought in as indentured labour. It was a rich mix but one that tended to leave out the negroes, those of pure African descent, who were mainly hidden away in settlements some distance from the main towns. And while the initial impression offered by the island was pleasingly exotic, it was soon obvious that this was inherently superficial. The original Carib inhabitants had been driven away and there was no indigenous art save for

what was later called 'Creole basketwork', and the closest one could get to
a truly 'other' culture were the traces of an African past which survived
among the descendants of the slaves.

It was unusual for a white visitor to live, as Gauguin put it, where
'negroes and negresses are milling around all day murmuring their
Creole songs and perpetually chattering.' He was quick to add that he
did not find this at all monotonous. The accounts of European travellers

Rue Victor Hugo, the main street in Saint-Pierre, Martinique.
Gauguin gave number 30 as his forwarding address. He may have
met the American writer Lafcadio Hearn at the studio of
the photographer Joseph Depaz in the same street.

at the time tend to emphasize the indolence of the black males while enthusiastically highlighting the vivacity of the women. Near to Le Carbet, a breathtakingly vertiginous path cut through the tangled rainforest, over the peaks, from Saint-Pierre to the Atlantic coast, along which walked the *porteuses*, women porters, trained from an early age to carry trays on their heads bearing anything up to 100lbs of goods between the two coasts, along a route so steep in places that a modern vehicle would find it difficult to cope. Barefoot, walking up to fifty miles in fifteen-hour stretches, and with only a little rum and cake to keep them going, the women were famous for their stamina and their elegance.

But this vision of statuesque beauties was deceptive. The mulatta women might parade along the promenade in Saint-Pierre in their imported Indian finery, a sort of invented costume, attractive to Europeans in search of the exotic, but the negro women, the *porteuses*, were different. Their heavy earrings and thick necklaces carried traces of their West African homelands, while the supposedly grinning, sleepy males played out a comedy which masked a different reality, one which had not been crushed by slavery and which found expression in the violent cock-fights and in the harsh, fiery dancing performed in the villages, quite different from the pleasantly exotic carnival performances put on by the mulattos in the towns.

## Mangoes on the Beach

Gauguin stayed at Le Carbet for six months and towards the end of the period wrote to tell Schuffenecker that he was planning to return with a dozen paintings. Two a month is quite a small amount, given his rate of production at other times, but the results are more important than their numbers would imply, for these few paintings mark the definitive appearance of a Gauguin style, quite different from that of his Impressionist mentor Pissarro.

This reference to twelve paintings has caused some confusion, as there appears to be a much larger number spread around various private collections. The reason is that, once again, some of these 'Gauguins' were painted by a faithful disciple, in this case Laval whose signature was scraped off or over-painted later. Because the two men worked so closely together it is impossible to say with any certainty who did what, which gives the lie to the common assumption that Laval was just a dull plagiarist – on Martinique, both men worked closely together, exchanging ideas and for once the pupil was as good as the master.

There is a great deal to be learned from studying those paintings which we know for sure were by Laval. Those that are definitely signed by him show he was more interested than Gauguin in the specific area

where they were living, so that his canvases reveal something of the world they both knew. He shows us Carbet and the buildings at the back of the Marc-Cyrus Estate, simple white dwellings, block-like and solid, in contrast to the effusions of plants and trees which surround them. Laval's paintings of the neighbouring countryside show how much they were shut in by the surrounding forest, with only narrow paths and clearings and distant glimpses of the bay and Mount Pelée to break the mass of vegetation. By contrast, Gauguin's work is both less realistic and more open: a canvas entitled *Tropical Vegetation* seems to show the view from the headland near their hut, with a glimpse of an unspoiled bay below, yet if one stands at about the same spot today, one can see that in Gauguin's day, Saint-Pierre would have been clearly visible to his left, in a space on the canvas which he covered with a burst of luxuriant foliage, a tangle of wild cane and guavas, dwarf-palms and giant ferns. He also left out the monumental statue of Notre-Dame-du-Port which had been erected in 1870 and which would have been directly in front of him. The sole evidence of human activity was a distant glimpse of the roofs of some local huts near the cliff edge, but there is no mark of the colonial presence, only the impression of an unspoiled 'native' world. The one sign of life is a small rooster emerging from a clump of foliage in the middle ground and while this may be there to give a sense of scale, one cannot rule out the possibility that Gauguin was making an ironic comment: the Gallic Cockerel, symbol of France, lurking in the undergrowth of this otherwise untouched Eden.

The attempt to make an ideal, pre-colonial world is even clearer in another painting called simply *The Pond*, where he shows a part of the rainforest with a glimpse of red roof which has been identified as the farmhouse of a Monsieur Bouchereau, which the artist would have passed on the road between Le Carbet and Saint-Pierre. Once again, rather than painting what was undoubtedly a European dwelling, Gauguin has transformed it into a simple native hut, lost in the wild.

What we are seeing is the imposition of an ideal where it had ceased to exist. Panama had been a rude awakening, and while Martinique was heaven by comparison, it too had been spoiled by the European presence, an intrusion which he could erase as he painted. Laval's Martinique is a fond evocation of the island as it was, whereas Gauguin's is an astute selection of elements which matched his dream.

## Charms and Zombies

The paucity of surviving letters and Gauguin's reticence about his time on the island leave a number of tantalizing gaps in our knowledge of what was, by any judgement, the moment when he finally began to

discover himself. There are, however, some intriguing possibilities. We know that he painted *Tropical Vegetation* on a property called the Morne d'Orange, owned by a Henri Depaz, whose brother Joseph was a photographer working in Saint-Pierre. The connection, albeit a slight one, comes from the fact that Joseph was a friend of the American journalist and travel writer Lafcadio Hearn, who was staying on the island at the time, and might thus have met Gauguin – which, if true, offers a fascinating insight into the paintings that Gauguin was then doing.

The American author was a great admirer of Julien Viaud and Hearn's *Two Years in the French West Indies* did for Martinique what Viaud's *The Marriage of Loti* had done for Tahiti, using the same mix of reportage and romance which was so popular with French readers at the time. Like Viaud's, Hearn's technique was to mix acute perceptions of daily life with elements of local folklore. There is a wonderful description of the *blanchisseuses*, the washerwomen at work on the banks of the River Roxelane which ran through Saint-Pierre, where Hearn notes how the women never looked down for too long, always glancing upriver because of the flashfloods which could suddenly come roaring down from Mount Pelée, turning the Roxelane into a swirling death-trap. This is travel writing at its most observant yet a few pages later Hearn is merrily describing a *Guiablesse*, a female zombie, said to use her charms to lure men to their deaths, much as if she too really existed.

This was just the sort of stuff which would have appealed to Gauguin and it is reasonable to suppose that he would have read Hearn – whether or not they actually met. There are certainly elements of Hearn's mix of realism and fantasy in one of the most revealing comments Gauguin made about his time on Martinique in a letter to Mette written that June. He began with his by then standard complaint that they had all forgotten his birthday – thirty-nine on the 7th – but quickly passed on to a colourful description of the local women that he had been painting:

> Nearly all are coloured from ebony to dusky white and they go as far as to work their charms on the fruit they give you to compel your embraces. The day before yesterday a young negress of 16 years, damnably pretty, offered me a split guava squeezed at the end. I was about to eat it as the young girl left when a yellow lawyer standing by took the fruit out of my hand and threw it away: 'You are European, sir, and don't know the customs of the country,' he said to me. 'You must not eat fruit without knowing where it comes from. This fruit has been bewitched; the negress crushed it on her breast and you would surely be at her disposal afterwards.' I thought it was a joke. Not at all; this mulatto (who had nevertheless passed his examination) believed in what he said. Now that I am warned I will not fall and you can sleep soundly, assured of my virtue.

This is the sort of anecdote Hearn would have seized on, the right blend

of reality and folk-tale – though there was also a sense in which Gauguin was still carrying on his war of attrition against Mette, letting her know that there were exotic beauties keen to get their hands on him. Fortunately, there was more to it than that and his interest in the local women went beyond mere anecdote or petty vengeance. After he had moved on from landscapes it was to be figure paintings, studies of the black women in Le Carbet, which would complete Gauguin's break with the past.

Once again, Laval chose to follow him, but as before it is the difference in approach between the two men that highlights how fast Gauguin was changing. Laval was content to paint a tourist's view of the local women – dressed like the Saint Pierre creoles in voluminous flowing robes, the sort of thing worn for Sundays and carnivals, much as the visiting artists in Brittany tended to paint Breton women in their best costumes rather than in the more prosaic working clothes that they would normally have worn out in the fields. Gauguin took the opposite route, concentrating instead on those aspects of life which were not dependent on the European craving for native glamour. As in Brittany he began by sketching direct from nature, drawn to the animated morning scene where the women, wrapped in their brightly coloured cloths, gathered to collect the produce to be carried to market in the town, or later down on the beach where they could be seen drifting back, resting a moment under the coconut palms.

In his first letter to Schuffenecker, three weeks after arriving on the island, Gauguin wrote to say that, 'What I find so bewitching are the figures, and every day here there is a continual coming and going of black women decked out in all their colourful finery, with their endless variety of graceful movements . . . carrying their loads on their heads.' What he wants to do, he explains, is to make sketch upon sketch in order to get inside the character of the people. But when he turned to painting, the observed scenes are subtly transformed. At first glance realism dominates. In both *Among the Mangoes* and *By the Sea*, we are shown real working women, their short skirts hitched up to reveal bare feet splayed sturdily on the ground. They are independent and quite indifferent to our presence, and in the triumphalist colonialist era of the 1880s, such a gentle, unassuming study of black working women, secure in themselves and their world, was revolutionary. Indeed the lasting impression of the four main figure paintings of the Martinique months is one of affection, of the Savage from Peru rediscovering the dark-skinned feminine warmth of his childhood. A warmth that is conveyed through colour – both *Among the Mangoes* and *By the Sea* have strong bands of colour applied in a manner which marks a clear break with the evanescent Impressionism of Pissarro. While Gauguin is still using short brush-

strokes, the technique he had learned from the older man, there is now a positive attempt to try bolder, more decorative effects. Nor are his colours 'natural' in the Impressionist sense: colour in the tropics is not warm as one might automatically assume, the sun is white, the sea blue, both colours that are hard, bright and cold. Yet Gauguin emphasizes reds and greens and violets, the warm autumnal hues most often associated with northern, temperate climates. The sea in the background of *Among the Mangoes* is a band of nearly pure blue/violet, sensuous and inviting and quite unreal – an entirely invented lushness.

Yet as with *Four Breton Women Gossiping over a Wall*, which is its nearest precedent, there is something more to *Among the Mangoes* than simple abstract qualities. There are signs in the painting that Gauguin had learned something about local folk traditions, and that his source for these was either Hearn's book or Hearn himself. In the painting, the women are wearing the elaborately wound headscarves which Hearn said had great significance among the *mulâtres* and the negroes – *Tête à un bout* (the scarf raised with one point) meant 'my heart is for the taking'; *Tête à deux bouts* (two points), 'my heart is taken'; and *Tête à trois bouts* (three points), 'my heart is taken but there might be room for another'. And it is only a short step from this to speculate that the message of the scarves is the underlying message of the painting and thus that the 'damnably pretty' sixteen-year-old, as described in his letter to Mette, had succeeded in her attempts to bewitch him.

This may explain why the letter seems so insecure, one moment boasting about the girl, the next hastily assuring Mette that he was looking forward to her coming out with the children to join him – 'don't be alarmed there are schools in Martinique'. But there is a something about his description of the black girl and her charms which goes beyond his usually heavy-handed attempts to attract his wife's attention. There is much to suggest that the chattering *porteuses* with their colourful dresses and magic spells had, like Hearn's *Guiablesse*, succeeded in finally loosening the grip of the woman to whom he had been completely faithful since they first met at Gustave Arosa's party fifteen years earlier. All the evidence from Pont-Aven was that Gauguin, despite every opportunity to do otherwise, had remained loyal to his wife. All references to other women in his letters had been nothing but fruitless goading but now there is something which suggests that this has changed. There is a wood-carving entitled simply *Martinique*, which he probably made later in 1889, after he had left the island, which shows a naked girl reaching up to pluck fruit from a bough in the surrounding jungle. From the top corners of the wooden rectangle she is watched by two faces; in front of her is a goat and playing near by are two monkeys. There were no monkeys on the island, but they exist in Caribbean folk-tales, and while

it has so far proved impossible to relate Gauguin's carving to a specific story, there is little doubt that the goat and the monkeys are symbols of sexual licentiousness and mischief and that the girl is a Martiniquan Eve whom they are urging on, telling her, like the biblical serpent, to pluck the forbidden fruit. The watching faces seem to grow out of the surrounding trees and could be wood spirits – or, judging by their malevolent expressions, forest demons of some sort. Whatever the undiscovered folk-tale might have been, the underlying message of the carving is clearly one of sensuality and wickedness. The girl with her breasts exposed is young, perhaps the sixteen-year-old of his letter, and one imagines that having picked the fruit she will rub it against herself before offering it to the Adam she hopes to bewitch.

## Marsh Fever

Of the dozen paintings that Gauguin produced on Martinique, *Among the Mangoes* tells us most about the way his thoughts were turning. The strangeness of Brittany had begun the process, though it is hard to say with any certainty exactly how far one can go in interpreting a painting like *Four Breton Women*, which may have been a reflection of his anger with Mette, but might just as easily have been no more than a formal exercise in shape and colour. With *Among the Mangoes* we are on surer ground. It is impossible to ignore the evidence that Martinique had reintroduced him to the non-European world from which he had come and reawoken in him emotional and sexual responses which had long been suppressed. He might well have stayed, which would have radically altered the course of his art, but his health did not allow this. That first letter to Mette, back in June, reported that Laval had gone down with yellow fever almost as soon as they arrived, though it had no doubt been picked up in Colón. At first, Gauguin believed that he had cut it short with one of the homoeopathic cures which he had learned from Pissarro, who was a devotee of alternative medical treatments. But he was wrong, the fever had only abated and quickly reappeared, more virulent than before. One of Laval's landscapes seems to have been executed somewhere in the interior, which would indicate that he travelled up into the mountains to Morne-Rouge where sufferers from tropical diseases often went, hoping to benefit from the cooler air. By August, however, it was Gauguin who was ill and even allowing for his usual attempt to win Mette's sympathy his description of the symptoms is pretty harrowing:

> During my stay at Colon, I was poisoned by the malarious swamps of the canal and I had just enough strength to hold out on the journey, but as soon as I reached Martinique I collapsed. In short, for the last month I have been down with dysentery and marsh fever. At this moment my body

is a skeleton and I can hardly whisper; after being so low that I expected to die every night, I have at length taken a turn for the better, but I have suffered agonies in the stomach. The little that I eat gives me atrocious pains and it is an effort to write, as I am light headed. Our last supplies of money have gone to the chemist and on doctor's visits. He says it is absolutely necessary for me to return to France, if I am not to be always ill with liver disease and fever.

A few days later he wrote an equally plaintive letter to Schuffenecker describing the same symptoms and again emphasizing that they had spent all their money on medicines. As late at September he was still ill and very weak and to make it all the more irritating, word had come to Laval that Cottu, the director of the Canal company, had at last sent the letters of recommendation which would have obtained decent jobs for them both, had he written them six months earlier. It was too late now, though in the circumstances it was amazing that Cottu remembered them at all, with his own world collapsing around him. The Compagnie Universelle du Canal Interocéanique would finally go under in December the following year, 1888, and Cottu, along with Ferdinand and Charles de Lesseps, would be one of the main participants brought to trial for fraud. From then on they would be branded with the word *panamiste*, a new insult from journalists who would vent all their spleen on those they had once been bribed to praise. Justice would hardly figure in all this – Ferdinand was guilty of self-deception rather than fraud and never profited personally from the disaster. Too old to be jailed it would be his ever loyal son Charles who would suffer along with Cottu, though he would be later reprieved on a technicality. All were ruined and by the end 20,000 miserable souls had perished trying to achieve what the Americans would later complete.

For Gauguin it had been shattering to experience at first hand the utter folly of Western technology imposing itself on previously untouched lands. The wretched condition he and Laval now found themselves in was all part of the lesson, as if they too had been ruined by the destructive forces unleashed on the rainforests of the Isthmus. There are some accounts that Laval was so defeated by his illness that he tried, unsuccessfully, to kill himself – but even without that, it was clear that there was no end in sight for either of them.

Back in Paris, the other disciple, Ferdinand du Puigaudeau had finally decided to travel out to join them, only to be hastily discouraged by news of all their difficulties. In the end he left for Naples, from where he crossed the Mediterranean to Tunisia, though he was to encounter the same problems in North Africa as Gauguin and Laval had in the Antilles. While there were picturesque landscapes and costumes, all bathed in an intense sunlight quite different from anything in Europe,

living was not as cheap as du Puigaudeau had hoped and the heat and
the dirt soon meant that he too was dogged by ill-health. It was the
usual colonial deception – the dream of riches or of strange beauty,
shattered by a reality of insanitary, run-down places, often peopled by
resentful 'natives' who seldom matched the poetic image created by
writers like Loti or Hearn.

On Martinique, Gauguin's stomach cramps and continued weight-loss
were probably due to amoebic dysentery which had by then developed
into what would today be diagnosed as hepatitis. But even with the
limited knowledge then available, the doctor who was treating him was
quite right to insist that he was unlikely to recover as long as he went
on living in the hut at Le Carbet, on a diet of fruit and whatever else
he could scavenge in the neighbourhood. Although Gauguin wrote to
tell Schuff that he was still trying to paint, he also added that he was
unable to ignore the doctor's advice without risking permanent damage
to his health. It was not easy to get away, however. Mette did not answer
his letters, presumably out of pique at his sexual insinuations, and the
Compagnie Générale Transatlantique flatly refused to advance tickets
on credit to the many now indigent Frenchmen longing to get home in
the wake of the collapsing situation in Panama. Their problems were
partially eased when Laval received word that someone was interested
in Gauguin's pots and Schuff was eventually able to pass on some money
from the sale of several pieces. There is a tradition that Gauguin was
forced to work his passage home aboard a two-masted schooner – not
a large or comfortable vessel – but there is as much possibility that the
money from Schuff was enough to get him a third-class ticket on one
of the regular boats to France.

Laval was still too ill to travel and would have to convalesce for several
months before being repatriated. But Gauguin left in relatively high
spirits, intrigued to find out more about the man who had bought some
of his pottery. As he sailed for France, a new fantasy began to take shape:
surely such a man would be able to put up, say, 20,000 to 25,000 francs
to buy him a partnership in Chaplet's business and launch him on a new
and profitable career. One should not laugh at these instant enthusiasms
– for while they were nearly always based on the feeblest of foundations,
they were the means by which Gauguin kept going against considerable
odds. Laval might despair, but Gauguin forced himself to believe that
just over the horizon lay the solution to all his problems. He had gone
to Martinique, as he had gone to Brittany, more by accident than design,
and just as Pont-Aven had given him a new thrust to his art and brought
him his first followers, so his stay in Le Carbet had presented him with
the sort of subjects he needed if he was to create something of his own,
free of past influences. Later, in 1890, he wrote to a friend, to explain

the importance of those six months on the island. 'I had a decisive experience on Martinique. It was only there that I felt like my real self, and one must look for me in the works I brought back from there rather than in those in Brittany, if one wants to know who I am.'

It is extraordinary just how far this self-confident tone distances Gauguin from the failure who had left Denmark and crawled back to Paris only two years earlier. He was now thirty-nine, sick and emaciated, broke as always, still lonely and depressed about his children, but there can be no doubt that as far as the one thing which mattered most, his painting, was concerned, he no longer doubted that the results were beginning to match the ideas formulated in the attic in Copenhagen, when the concept of an art of inner meaning and imagination had first occurred to him. His time on Martinique was short, the paintings he produced few, but it and they mark the turning-point in his art.

# 7

◆

# *The Vision after*
# *the Sermon*

Gauguin was back in Paris in November 1887. Once again the good
Schuff took him in, dutifully admired the work he had brought back and
helped him through the bouts of colic which continued to give him so
much pain. He was more emaciated than ever, and more demanding, but
Schuff bore it with customary patience, a commodity much in demand,
considering the parlous state of his own marriage. The imperious Louise
no longer dissembled over the extent of her indifference towards the
unassertive little man her family had obliged her to marry – an attitude
which may account for Schuffenecker's increasing interest in *plein air*
painting, which took him out to the countryside well away from her
sharp tongue. This, in turn, explains the rumours that Gauguin took
advantage of his absences to have an affair with Louise. The stories vary
– in some, she leads him on and then refuses to let him have his way;
in others it is Gauguin who makes the first move only to be humiliatingly
rebuffed. Either way, there is no solid evidence.

There were more pressing problems with his work. If he had imagined
that he would return to stun the Paris art world with his new Martinique
paintings, nudging aside Seurat and his dots, he was quickly disabused;
the art world had moved on. Despite his having been away less than a
year, he found himself struggling to keep up with the changes and with
the new faces that were now appearing in the galleries and cafés. The
most noticeable feature of this ferment was a rapid increase in the
number of magazines, largely literary, though usually with an art critic
or reviewer of some sort. It added a new twist to the eternal search
for publicity, as most of these budding journalists were young writers,
predominantly poets, struggling to attract attention themselves, so that
if a painter hoped to be noticed then he had best get himself firmly
inside one of the circles where these newcomers moved. At one point
there were as many as 200 literary journals in operation, some were quite
small and ran for only a few issues, but others were large and well

subscribed, and two or three survived into the next century and had considerable influence on the intellectual and even the political life of France.

It did not take Gauguin long to work out the prevailing ethos of most of these imprints – the key element was Symbolism, a word that had been bandied about for half a century, but which was only then taking on the force of a movement. Most of the younger poets thought of themselves as Symbolists, though few were at pains to explain exactly what they meant by it. Artistic movements are often more certain of the things they are opposed to than those for which they are supposed to stand, so it is hardly surprising that they are often called into being by their enemies. Emile Zola provided one of the best descriptions of Symbolism in a long article in *The Messenger of Europe*, a Russian publication, when he set out to castigate the fantastic, richly hued paintings which Gustave Moreau had exhibited at the Salon of 1876. Turning on Moreau's weirdly exotic image of the severed head of John the Baptist appearing to a sensuously naked Salome, an infuriated Zola wrote of the artist's 'hatred of realism', of this 'retrograde movement', thundering that he had '. . . plunged into *symbolism*. He paints pictures partly composed of riddles; rediscovers archaic and primitive forms . . . He paints his dreams, not simple, naïve dreams such as we all have, but sophisticated, complicated, enigmatic dreams which are difficult to understand immediately. What value can such art have in these days?' By contrast, according to Zola, Manet was 'a modern artist, a realist, a positivist (who) painted people as he saw them in life, in the street or at home, in their ordinary surroundings, dressed according to present-day fashion, in other words, contemporary.'

Thus Symbolism was defined as anti-realist and anti-positivist, with a hint that it was also reactionary. Not that such feelings of loathing were anything but mutual, for if one thing united the Symbolists it was their dislike of Zola and the naturalistic novel, and far from abandoning Moreau after that attack, the younger writers virtually deified him. When Joris-Karl Huysmans, the critic who had once stood up for Gauguin, published his first novel *À Rebours (Against Nature)* in 1884, it was the first overtly Symbolist work of fiction and thus a direct attack on everything Zola stood for, and it was significant that its effete, decadent anti-hero Des Esseintes lavished praise on Moreau's Salome, describing her in terms which many at the time thought were frankly unhealthy.

Two years after *À Rebours*, in 1886, while Gauguin was in Pont-Aven, one of these new young writers, Jean Moréas, brought the whole thing into greater focus when he published what he called the 'Symbolist Manifesto' in *Le Figaro*. This attracted a great deal of attention, largely because it was one of the first sightings of the word in a popular news-

*Soyez Symboliste*, an ink-drawing by Gauguin
of the poet Jean Moréas

paper. But despite the clarion call of the word 'Manifesto', Moréas's
readers still had to infer much of what his new movement stood for,
though some things were beginning to emerge at last. The young Sym-
bolists seemed to want suggestion rather than description and desired
that poets should be seers and sages rather than teachers; they preferred
the irrational to the literal and believed that the outer appearance of
things was of less importance than their inner meanings which were on
a higher, spiritual plain, one which only those of an elevated sensibility
could penetrate. It was the task of the artist to represent this higher
experience and to achieve this, writers and artists must bring together
elements from the real world and those from other works of art. Put
together these would *synthesize* – a key word in the Symbolist lexicon –
into a newer, more thrilling reality. Moréas, of course, was only a minor
poet concerned primarily with self-promotion, but his manifesto and the
huge literary banquet held to launch it had the merit of bringing to the
attention of the wider public some of the other important figures of
the new aesthetic. Of these perhaps the most significant was Stéphane
Mallarmé, by then forty-six, and already something of an elder statesman
to the coming men. Beyond the Symbolist circle few read his poems,
which were richly evocative, with image piled on image – dreaming
seraphs, vaporous flowers, the sobs of dying viols, sounds, sights and
smells that were dazzling and intriguing, though hardly destined for a

wide audience. More were aware of his translations of the work of the American author Edgar Allan Poe, who since his death in 1849 had been sanctified by the Symbolists as their founding father. The Anglo-Saxon world has always delighted in Poe's macabre tales *The Pit and the Pendulum*, *The Fall of the House of Usher*, *The Murders in the Rue Morgue*, most recently in cinema adaptations, but his poems have not weathered well and it is becoming rare in England or America for him to be treated as anything other than a good story-teller. In France, by contrast, he is thought of as a genius of the evocative mood, a precursor of the decadent obsessions with death and violence that are a feature of late nineteenth-century writing. Mallarmé's translation of Poe's gloomy verse tale *The Raven*, first published in France in a limited edition, in 1875, was a defining point for the budding movement. Poe's text is certainly freighted with portents and suggested meanings – on a stormy midnight a black raven flies into a room where a weary student is brooding on the loss of his love 'Lenore'. The student questions the bird, asking whether he can hope to meet his love in the next world – but the bird can say only the single word 'Nevermore', which becomes the chorus of the poem, whose eighteen six-line stanzas move to an insistent rhythmic beat as the fatal word is repeated and repeated and repeated until all hope of resurrection is driven out and the student is left with nothing but the raven as a symbol of his own black despair.

Mallarmé, as Poe's translator, came to embody the very essence of the new movement, though no one could have been a less likely candidate for artistic glory. So impressive is his reputation that one supposes he must always have been a towering literary figure – perhaps editing a leading journal or at least lecturing at some prestigious academy. It is always something of a surprise, therefore, to realize that he passed his entire working life as a teacher of English in various secondary schools, and not very successfully at that. Originally stuck away in the provinces, he was for years at the lowest levels in both status and pay, was once effectively sacked and demoted and struggled to make ends meet by writing not very accurate text-books and doing hack-work translating rather boring books for English publishers. Somehow, amongst all this, he found time to write poetry, never very much and never very popular, except with those younger writers moving away from realism, towards an as yet undefined Symbolism. Yet, while never well off, Mallarmé was no impoverished Bohemiam – unlike the drunken Verlaine, absinthe made him dyspeptic – and there was little about him that conformed to the romantic ideal of the impoverished poet.

In 1871, at the age of twenty-nine, he finally managed to secure a teaching post in Paris, at the Lycée Condorcet, and he and his German wife Marie moved into the new, though modest residential area around the

Gare Saint-Lazare. But despite this conventional setting, within a decade he had become one of the central figures of the dominant artistic movement of the last quarter of the nineteenth century, and by that time his *Mardis* or Tuesday evening gatherings in his tiny flat in the Rue de Rome attracted anyone in the world of the arts who was making a name for himself.

Mallarmé's interests extended well beyond poetry to painting and music. It was in part owing to his influence that the movement began to edge outwards into the other arts. The idea that a work of art should seek to evoke all the sensations was only a short step from the realization that theatre was the art-form in which this was best fulfilled and lyric-theatre best of all. This in turn led to the worship of 'the god Richard Wagner', a composer once ignored in France but raised by the Symbolists to the level of supreme genius, lavished with praise in Edouard Dujardin's *La Revue Wagnérienne*, which for a time was the movement's leading theoretical journal. From a Symbolist perspective the greatest of all Wagner's operas was *Parsifal* with its synthesis of Christian and Teutonic myths, in a quest based on esoteric sources, overlaid with personal mysticism. One of the aims of the literary Symbolists was to find a French Wagner, a composer who would be to music what they sought to be in poetry. In the same way, Mallarmé and his friends were keen to find a painter who could take on the role of pictorial Symbolist and thus give the movement the same range that Zola had achieved when he succeeded in linking the naturalist novel to Impressionism. Mallarmé had been close to that world – Manet had depicted him as the dreaming poet, a sage with full moustache leaning back in his chair, resting from his creative labours, and it was Manet who provided the illustrations for that limited edition of *The Raven*, even though he was himself no Symbolist. There were few candidates – Moreau led a withdrawn, almost cloistered life and was not one to join any group no matter how vague its aims, which left only the painter Odilon Redon, another of Mallarmé's friends, who spent his summers at Samois near Valvins where the poet rented a holiday home in which he could recover from the weary months of teaching and translating. More than Moreau's exotic fantasies, Redon's suggestive images: a flower with a single eye at its centre, a grotesque one-eyed giant peering over a cliff-edge at a sleeping nude, a monstrous green serpent uncoiling itself to reveal its human torso – equally mysteriously entitled *Green Death* – left almost everything to the imagination of the spectator. Redon himself gave few clues to what could be read into these nightmarish images but while many of the new writers followed Mallarmé's lead in admiring him, Redon never quite achieved the role of their approved painter. Part of this was due to his own difficulties with Symbolist theories, and part due to the distinctly anti-literary nature

of his work which, to an exaggerated extent, depended on the sensations evoked by amorphous colours. While this would seem, in theory, to sit well with what the writers wanted to achieve, the complete absence of context and the impossibility of translating what Redon was doing into words inevitably distanced him from them. In some way, he was far ahead of his time and has come to look like an early Surrealist rather than a member of any of the *fin de siècle* movements. Born in 1840 he was of the same generation as the main Impressionists but always at odds with their naturalist concerns. While admired, his successes were modest, his exhibitions never making the sort of public stir that would have given him notoriety in the art world. But he was admired by younger painters – Schuffenecker introduced him to Bernard who became an enthusiastic advocate and brought him to Gauguin's attention. But the effects of this are hard to define. Gauguin could not fail to be intrigued by such *outré* work – that single eye at the centre of a flower or the middle of the cyclops's forehead was hypnotic, as if we, the spectators, are the art and the painting is studying us. But for Gauguin it was more Redon's audacity than his actual paintings which attracted his interest. They eventually met and became reasonably friendly, if not close, but there was little that Gauguin could take directly from his work, which was highly personal and no doubt explains why Redon remained such an isolated figure, without followers or successors, until he was taken up after his death in 1916 by the likes of Dali and Ernst.

For Mallarmé and the Symbolists this left a gap in their scheme of things, they needed an artist and if he had known this, there can be little doubt that the publicity-hungry Gauguin would have beaten a path to Mallarmé's apartment in the Rue de Rome and proposed himself for the post. But in 1889, such things were only beginning to impinge on his consciousness. Initially, he appears to have been vaguely amused by these *cymbalists*, as he jokingly called them, having picked up the term from Verlaine, who had been astonished to find himself lionized by the new movement. But despite the off-hand humour, Gauguin could not entirely avoid their theories, given the furore they often caused. In any case, his own views on an art of the imagination, as tentatively set out in his *Notes synthétiques*, were already very close to ideas being advocated by Moréas, Mallarmé and others, and though Gauguin may not have realized it, there were some Symbolist ideas which he was already putting into practice. He was of course working without theory, intuitively reaching here and there for things that had passed his way, ideas raised in conversations, things gleaned from articles in little magazines, things which were 'in the air' and, despite his illness, he was quick to percieve that a change was under way and to respond to it – though not in painting as yet.

One of his first moves after his return was to look up the collector

who had bought some of his ceramics while he was away. This turned out to be a young businessman called Albert Dauprat who had been encouraged to visit Chaplet's pottery in the Rue Blomet by Laval's brother Nino. Dauprat was fascinated by Gauguin's work and was so taken by the Martinique paintings and Gauguin's descriptions of the island that he later travelled there with a view to launching a farming business near Le Carbet. But the idea that he might put up money to finance a Gauguin/Chaplet pottery was never practical. In Gauguin's absence Chaplet had sold the studio and the kiln to August Delaherche and moved out to Choisy-le-Roi just south of Paris. Chaplet continued to admire Gauguin's unusual efforts and when he borrowed his old studio back for a short time, to prepare some pieces for an exhibition, Gauguin may well have joined him for a period. But after that brief interlude, collaboration became increasingly difficult. The new studio at Choisy-le-Roi was too far away and in any case Chaplet was no longer interested in working in stoneware and was now concentrating exclusively on porcelain, trying to reproduce the vivid *flammé* glazes of Chinese pottery. This left little room for the individually modelled pot which was Gauguin's sole concern. He still visited the studio in Montparnasse and seems to have got on reasonably well with Delaherche, though he did not admire his pottery to the extent he had Chaplet's, and just how far he was able to work with the new owner of the kiln remains open to question. Until then, Gauguin had been considerably 'mothered' by Chaplet who had handled all the technical matters related to his ceramics including firing them. Delaherche may have been prepared to take on this role, but there are some notes in Gauguin's hand listing formulae and firing temperatures for a variety of glazes which suggest that he was now able to undertake the task himself. Every potter has his own pyrometric scales and such notes would have been pointless if Delaherche had been left to do what Gauguin scathingly called 'the cookery bit' (*la partie cuisine*).

Despite these changes, Gauguin still managed to produce some important pieces. A portrait-pot of Louise Schuffenecker which he made at this time has turned out to be one of those seemingly minor pieces which, when seen in its true context, has a much greater significance than its modest size might indicate. The pot's origins are clearly Peruvian: the body is shortened, swelling out to make a jar, which then swells further to a wide rim onto which the head is moulded. The details are Mochica in inspiration: from the overall brown glaze to the eyelashes and a belt which are picked out in a contrasting slip. But it is that belt, in the form of a serpent wrapped round Louise's body, that tells us most, for it is too prominent to be simply a decorative afterthought. Serpents have a long mythological history and, given the rumours circulating about

Madame Schuffenecker and her house-guest, this apparently innocent item of dress takes on a quite different meaning: the serpent belt is a common image in pre-Columbian art, symbolizing fertility, though there can be little doubt that Gauguin was also referring to the Serpent in the Garden of Eden, who represents temptation and evil. The somewhat demure expression that he gave to Louise Schuffenecker's face is in sharp contrast to this symbol of the erotic and demonic power of women, and it is impossible to avoid the assumption that something had indeed passed between them, and that in making this image of her, he was trying to lay the blame on his supposed temptress. In this light, the swollen belly of the pot begins to suggest pregnancy and thus one more symbol of the Temptation and the Fall. Not surprisingly this was one ceramic which did not end up as a gift for the Good Schuff.

The merging of pre-Columbian and Christian myths was entirely in tune with Symbolist thought, as was Gauguin's treatment of Louise Schuffenecker as a fallen temptress. The Symbolists were much preoccupied with what they saw as the mysteries of femininity. The movement was entirely male and in many ways anti-feminine, dividing women into the classic male fantasy roles of complete saint or utter sinner. Women were either bland and ethereal or dark and enigmatic, hence the predominance of Madonnas and Sphinxes, Eves and Salomes in Symbolist art. There is a little-known photograph of Oscar Wilde *en travesti*, dressed for the lead in his stage version of Salome, his arms twined about with serpent bracelets. And when Des Esseintes in Huysmans's *À Rebours* looks upon Moreau's painting of the temptress, he sees how she 'had become in some way the symbolic deity of indestructible lust, the goddess of immortal Hysteria, the accursed beauty exalted above all other beauties . . . the monstrous Beast.'

It is impossible to say precisely how much Gauguin was aware of all this or how much was simply the result of his being attuned to the spirit of the times. But the connections do seem too close for mere coincidence. The argument about whether or not Gauguin was a Symbolist will never be fully resolved but that he swam in the same sea is undeniable. Much of the Symbolist aesthetic: the pleasure in hidden meanings, the preference for suggestion over outright statement, the yearning for the *outré* and the esoteric were already present in Gauguin's work before he was fully aware of the movement. But what had been merely hinted at in a painting like *Among the Mangoes* was fully apparent in the ceramic bust of Louise Schuffenecker. With that small pot, Gauguin and Symbolism met, and it was now a question of when and how this would manifest itself in his paintings.

## The Little Boulevard

Only the overwhelming urge to see and hear what was going on in the galleries and cafés could have got him out of the house – being back had not automatically cured him and the continuing colic pains and persistent weight loss left him weak and listless. It is probable that he was still carrying the amoebas which had caused the original dysentery but as there was neither the means to analyze the malady, nor to cure it if there had been, he was obliged to suffer.

Despite the pain, he struggled to find out what had been going on in his absence. Schuff had artist friends who called round occasionally, but they were hardly at the forefront of the avant-garde. They saw themselves as a sort of school and were currently involved in making images of the city – Schuff had been doing some studies of road-menders – but Gauguin was dismissive, the city was already a well-worn theme and unlikely to command much interest. One can imagine Gauguin moodily listening in on their conversation, occasionally offering a withering comment before relapsing into gloomy silence.

Only one of Schuff's friends, a neighbour and frequent visitor, managed to penetrate Gauguin's indifference and even went on to become his most devoted supporter, the one person who would stand by him in his greatest need. He was introduced to Gauguin as Georges-Daniel, his first names, and initially made no more of an impression than the other members of the group. They were hardly cut out to be friends. Georges-Daniel was twelve years younger and while he tried to look artistic with a dark pointed beard and curls dropped forward to hide a receding hairline, his bohemianism was of the moderate Schuffenecker variety, rather than Gauguin's genuine ragged scruffiness. Artistically too, there was little to encourage contact – the younger man seemed content to work in an adapted version of the Barbizon style and showed little interest in the wilder ideas which were beginning to circulate and which so gripped Gauguin.

It worked both ways: Georges-Daniel was repelled by Gauguin's 'haughty look' and his 'thin-lipped mouth closed in mysterious silence'. And when Gauguin did deign to speak, the younger man found his ideas on art 'bewildering'. It was only gradually that they came to appreciate each other. In Gauguin's case this was hastened by the discovery that the other man was not as conventional as first appearances suggested. For a start there was the confusion over his name: it was some time before Gauguin learned that his new friend was called Georges-Daniel de Monfreid, though even then there were mysteries to be unveiled. One rumour claimed that his father was an American called Read who had had an affair with an actress from Perpignan who called herself

Margarite de Monfreid – perhaps a stage name. No one seemed too sure of the truth. The official records of Georges-Daniel's birth had been destroyed during the Commune and the other surviving documents omitted any reference to a father, which lent some credence to the wildest rumour of all: that he was the love-child of the Belgian king Leopold II. The only evidence for this was the way his actress mother was never short of money – the young Georges-Daniel had been able to study art in Paris and marry and start a family, without needing to earn a living. He even owned a sea-going boat which he sailed in the Mediterranean.

It was while Monfreid – as he is now usually known – was studying at the Académie Colarossi in 1882 that he first met Schuff and thence Gauguin, and though there was that initial antipathy, the two men eventually found a common interest in sailing. Monfreid had travelled widely in his 36-tonne schooner and 'The Captain', as he was sometimes called, was soon swapping sea stories with the one-time matelot. When they first met, Monfreid was already married, with a nine-year-old son Henry who would go on to achieve fame as a travel writer, covering much the same ground as Gauguin. But even then, the marriage was not a success, leaving Monfreid with time to enjoy the café life so important to the Paris art world and over the coming year he and Gauguin saw more of each other, until the Captain gradually became the most faithful of all the devoted admirers. After their initial coldness, there was to be a trust between them which had none of the slightly bitter edge that one senses in Gauguin's dealings with Schuffenecker, whom he simply did not respect. Because Monfreid's own art was modest, still within the Barbizon tradition, there was never any question of him becoming a rival, while his practical manner acted as a needed counterbalance to Gauguin's wilder fantasies.

## Between Art and Nature

The one thing Monfreid and all the other visitors to Schuff's house would have agreed on, was that Gauguin should visit that November's exhibition, at Durand-Ruel's gallery, of works by Pierre Puvis de Chavannes who alone seemed to inspire admiration in all the avant-garde factions. In a way, Puvis was the official artist par excellence, with murals decorating public buildings across France and America, yet in his own stubborn manner, he was as revolutionary as the Impressionists. He had taken Courbet and Manet as his starting-points and gone on, lightening his palette while still painting supposedly antiquated allegorical subjects – War, Peace, Work, Rest – to create a fusion which is still difficult to situate among the main currents of late nineteenth-century art. Younger artists seemed to admire him for three reasons: first because

he had challenged the Salon and won, second because he seemed to offer a modern approach to the problem of making large-scale compositions and last because, while his subjects might be classical, his use of flat, unshaded areas of light bright colours seemed both curiously old – like the Italian Primitives – yet at the same time thrillingly of the moment. Gauguin certainly thought so and was much taken with Puvis's painting *Le Pauvre Pêcheur* (*The Poor Fisherman*), a dramatic scene which shows a fisherman standing at prayer in his boat, waiting for the catch to come into his submerged net, while his wife and child play on a nearby spit of land. No doubt what most struck Gauguin was the perfect marriage of simple emotion with a simplicity of design and colour which was as effective as anything in a Japanese print, while at the same time remaining true to the long tradition of European art.

The winter of 1887 was especially rich in exhibitions and it was difficult for Gauguin to keep track of the great crowd of new people who had flooded into Paris, each trying to make a mark amongst the rapidly swelling artistic community. A month after Gauguin's return saw the opening of an exhibition which revealed a whole range of new figures all clamouring for attention. It was held in the somewhat seedy district of Clichy at the rather pompously named Grand Bouillon, Restaurant du Chalet, a large space transformed into a temporary gallery by an unknown Dutchman called Vincent van Gogh. This newcomer had been working at the nearby studio of Ferdinand Cormon in the Boulevard de Clichy, and wanted to display his own work and those of his fellow students and friends. The fact that he chose to hold his exhibition in a restaurant in Clichy was significant because Van Gogh called his group 'the Impressionists of the *Petit Boulevard*' as a way of emphasizing their difference from the now more established artists whom he called 'The Impressionists of the *Grands Boulevards*' because they were able to exhibit their work in the galleries of the Rue Laffitte and the Rue Le Peletier which ran off the Boulevard Montmartre near the Opera.

Van Gogh's aim had been to unite all the younger artists working in ways that led on from Impressionism – the neo-Impressionists as the critics sometimes called them – though the two leading advocates of the 'dots', Seurat and Signac, had decided not to take part. Those who did, Louis Anquetin, Henri de Toulouse-Lautrec and the young Emile Bernard whom Gauguin had met in Pont-Aven, had no precise theory or programme to unite them in the way Seurat and Signac had with their 'scientific' approach to colour. Perhaps the only unifying element was an interest in the bolder use of Japanese techniques than had so far been attempted. Anquetin in particular had seized on the dramatic angles and foreshortened perspectives of the Hokusai prints but all of them were, in varying degrees, intrigued by the possibility of using pure colour

within clear outlines in the Japanese manner. When the exhibition opened the label *Japonisme* was attached to it, in the way *Divisionism* had been given to Seurat, and though it did not catch on, there was enough interest generated within the small avant-garde community for the Grand Bouillon, Restaurant du Chalet to become the centre of attention that winter.

There seems little doubt that Gauguin first met Van Gogh at the exhibition, a fateful encounter for both men, though initially no more than a groping for information on Gauguin's part, while Van Gogh would have known of Gauguin's participation in the later exhibitions of the Impressionist circle, events which were already assuming a mythic quality. They had much in common, Van Gogh was then thirty-four, Gauguin thirty-nine. Both had come late to art: the Dutchman after a career as an art-dealer in Holland, London and Paris followed by a failed attempt to be a minister of religion and a desperate period as an unpaid missionary amongst the poverty-stricken miners in the Belgian coalfields. They even resembled each other: Gauguin's continuing illness had left him as gaunt as Van Gogh, whose long history of mental instability and physical privation had given him a narrow, haunted look.

Whether Gauguin fully appreciated the true mental state of the excitable figure with the red hair and piercing eyes who welcomed him to the exhibition, it is hard to say. He probably thought Vincent was just another neurotic artist and left it at that. One doubts he was much impressed by the Dutchman's paintings, which were at the mixed Impressionist-Divisionist stage his own art had been in before he had left for Martinique. Van Gogh had talent and verve, that much was obvious, but among the various moves to attract attention with something bold and new, these rather *passé* works were hardly a threat.

There was more cause for concern from another quarter: the unexpected partnership between Emile Bernard and Louis Anquetin. Of all the artists of the period Anquetin remains the least known. He is barely mentioned individually in the major studies of the period. Yet for a brief moment in the mid-1880s his ideas were the key formative influence on a number of artists, largely through the Cormon connection. Anquetin would subsequently withdraw from the modern movement, becoming devoted to the art of Rubens. He was to spend much of his life in a long attempt to revive the techniques of the old masters with paintings and murals of mythological subjects and such a complete change of heart has made it hard for art historians to see him as anything other than a passing phenomenon whose youthful precocity allowed him to exert a momentary influence over Van Gogh, Emile Bernard and to a lesser degree Gauguin. But that influence was undeniable and in 1887 it was at its height.

It is easy to be seduced into sporting metaphors and to think of both Bernard and Anquetin as talented runners who peaked too early in what turned out, finally, to be a marathon. Anquetin was certainly precocious: born in Normandy in 1861, he had a recognized talent for drawing, even as a schoolboy in Rouen. Later, in his early twenties, when he studied under Bonnat, it was quickly assumed that Anquetin would be the master's chosen successor but that was before Impressionism and the move to Cormon's studio removed him from the world of the Salon painters. It was, however, the sheer brilliance of his technique which allowed Anquetin quickly to absorb the lessons of the Japanese prints – unusual angles, sharp perspectives, unexpectedly cropped figures 'bleeding' out of the picture frame – all the ways of challenging the orthodox 'head-on' academic approach which saw a painting as a scene in a theatre or as the view through a window, the approach which had dominated Western art since the Renaissance. A painting like Anquetin's *Avenue de Clichy: Five O'Clock in the Evening*, in which the street sweeps away to the left where all activity is congregated and where the female figure walking off to the right is chopped in half as she disappears out of the scene, is possibly the best example of *Japonisme* at work and shows why many came to such things through Anquetin rather than learning directly from the original prints. Certainly his fellow student at Cormon's, Toulouse-Lautrec, acquired more from Anquetin than from any other source and there are paintings by Van Gogh which are virtual copies of Anquetin's odd perspectives and his distinctive way of dividing up space by crossing it with tree trunks and branches, much as Hokusai had.

But if there was a single aspect of *Japonisme* which was to assure Anquetin his brief glory, it was the way figures and objects were boldly outlined and the spaces filled with flat patches of colour, a by-product of the wood-block printing technique. To those searching for ways out of the impasse of naturalism, this 'look', as a fashion writer might put it, appealed because it allowed figures, events and actions to be represented without the 'slavish' adherence to photographic exactness. Anquetin's *Avenue de Clichy* was so exciting in its day, because of the extent to which he followed 'the look', outlining the shoppers and the awning of the shop as if he had printed, not painted them, on the canvas.

All of which might have passed unrecorded save that Anquetin had had the good fortune to go to school in Rouen with Edouard Dujardin, founder of *La Revue Wagnérienne* who, like all the leading Symbolist theorists, was constantly on the look-out for visual artists who could be seen to exemplify the Symbolist ethos. By the mid-1880s, Dujardin had become managing editor of the critical journal *La Revue Indépendante* and now decided to give his old school friend a helping hand, by writing a long piece about his 'rather novel and special manner'. How much this

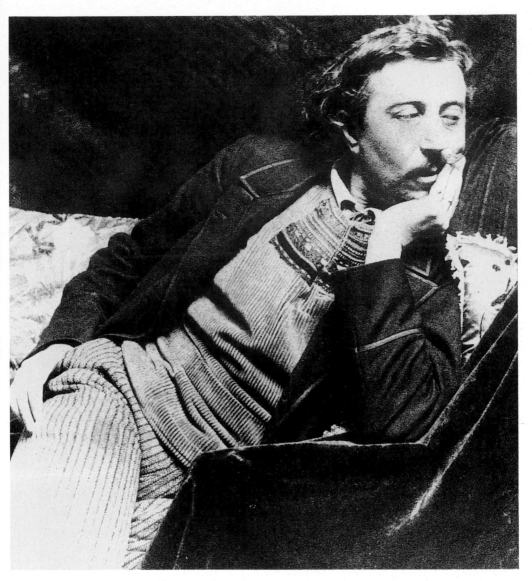

Paul Gauguin in a Breton waistcoat, 1891.

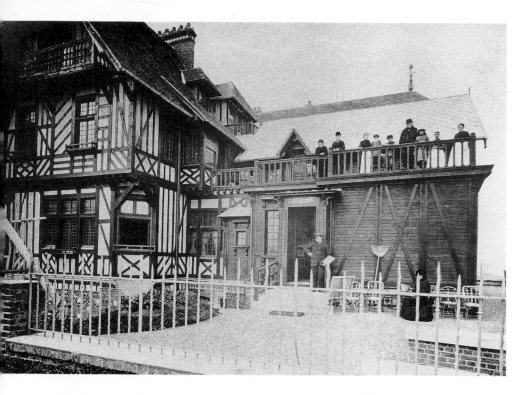

OPPOSITE ABOVE  Le Bas-Fort-Blanc, villa and studio of Jacques-Emile Blanche on the beach at Dieppe.

OPPOSITE BELOW  *The Apotheosis of Degas* – a staged photograph set up by the artist Degas as a parody of the *Apotheosis of Homer* by Ingres, with Degas playing the central character.

ABOVE  Banqueting Scene from the Tomb of Nebamun, Egypt, from the collection of the British Museum, a photograph used by Gauguin as the basis for several paintings.

LEFT  Georges Seurat, whose use of dots of pure colour provoked a revolution in painting.

The Nizon Calvary, evidence of the ancient faith of the Bretons and source for a painting by Gauguin.

ABOVE  Charles Laval; place and date unknown.

BELOW  The Place de Pont-Aven around 1880 with the Pension Gloanec on the right.

Marie Jeanne Gloanec seated, surrounded by her staff, 1892.

Emile Bernard with his sister Madeleine, photographed at his studio in Asnières
near Paris around 1890.

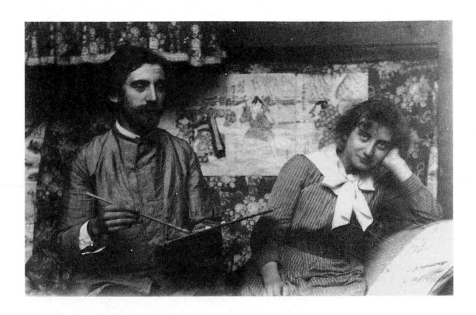

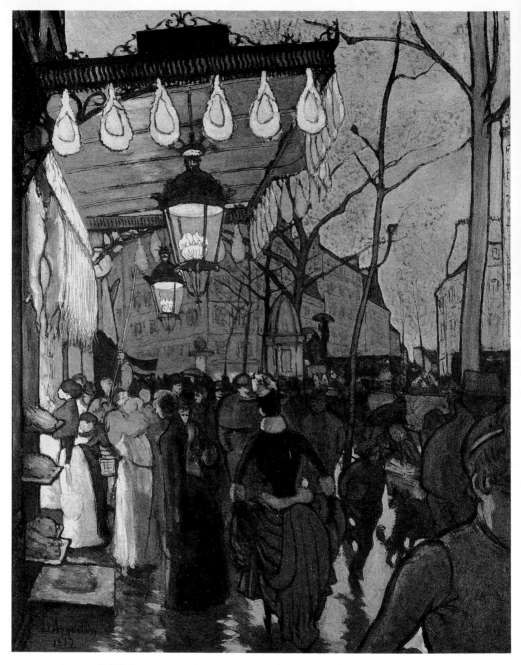

*Avenue de Clichy, soir, cinq heures* (1887). The painting which gave Louis Anquetin temporary leadership of the Parisian avant-garde.

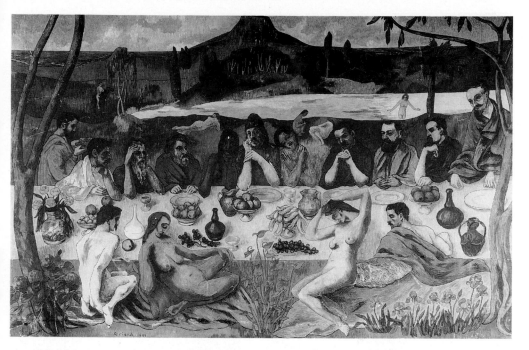

This *Hommage à Gauguin* by Pierre Girieud was painted as late as 1906 and depicts the artist as Christ holding a Last Supper in an imaginary Tahitian setting. The male figures seated along the far side of the table are: Girieud, O'Conor, Daniel de Monfreid, Sérusier, Gauguin, Paco Durrio, Gustave Fayet, Maurice Denis, Charles Morice.

BELOW  The flamboyant Madame Blavatsky, co-founder of the Theosophical movement and a profound influence on Gauguin's art.

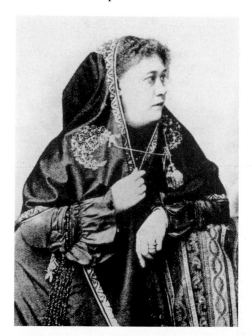

BELOW  Gauguin's Jug in the form of a self-portrait head whose bloody ear shows the after effects of the crisis with Van Gogh in Arles.

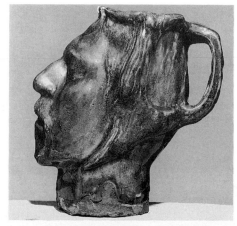

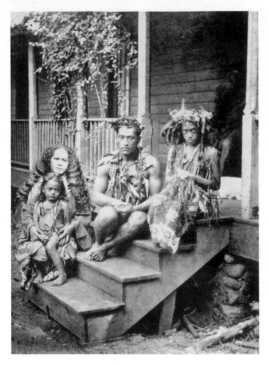

ABOVE  Tahitian servants
photographed in 1880.

BELOW LEFT  The southern road
around Tahiti that Gauguin took on
his journey to Paea and Mataiea.

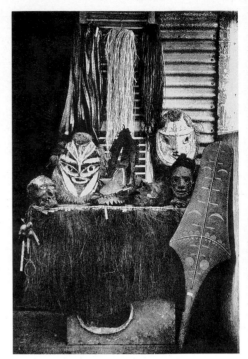

ABOVE RIGHT  A collection of
Polynesian art and artefacts
photographed by an English visitor
to Tahiti just over ten years before
Gauguin first arrived on the island,
one of the last records of the rapidly
disappearing objects that Gauguin
had hoped to find.

BELOW  *Carte de visite* style
photograph of an unknown Tahitian
*vahine* who is often identified as
Teha'amana. The photograph is
dated some time around 1894.

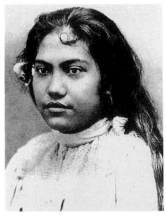

article reflected a fully worked out artistic philosophy on Anquetin's part or how much was simply Dujardin's personal musings is now impossible to disentangle, though one suspects more of the latter. But whatever its basis, Dujardin's critique transformed what had been only a vague groping towards a new aesthetic into a clear-cut school. Dujardin began by placing Anquetin in the context of Symbolism and in opposition to *trompe-l'œil* painting. '. . . the aim of painting and literature,' he wrote, 'is to give the *sense* of objects. . . . That which the artist expresses is not the image but the *character* of things.' Dujardin then proceeded to compare what Anquetin was doing with Japanese woodcuts and with the *images d'Epinal*, the tradition of popular wood-block prints which had flourished in the later Middle Ages and which were currently enjoying a cult revival.

> The artists of the *image d'Epinal* and Japanese [woodcut] albums first trace lines within which are placed colours according to the 'colour pattern' process. Likewise, the painter [Anquetin] traces his design with enclosing lines, within which he places his various [colour] tones juxtaposed in order to produce the desired sensation of general coloration. Drawing predicates colour and colour predicates drawing. And the work of the painter will be something like painting *by compartments* analogous to *cloisonné* [works of art], and his technique consists in a sort of *cloisonnisme*.

That last word was to be Dujardin's most significant contribution to the new art. *Les émaux cloisonnés* were the medieval craft jewellery in the Byzantine tradition in which metal partitions or cloisons were used to outline figures or objects, with the gaps or compartments being filled with powdered glass and metallic oxide colour agents which, when baked, produced the lustrous enamels. By making this connection, Dujardin had given the new style of heavily outlined painting its name – Cloisonism.

It was now possible to group all those working in a similar manner under this label and, as before, it was the young Bernard who acted as go-between. Bernard seized Anquetin's ideas and transmitted them to Van Gogh with whom Bernard had spent much time painting by the river near Asnières the previous summer. Thus Anquetin had his brief moment as leader of the avant-garde as his ideas passed into the work of his contemporaries. They can be seen in the posters of Toulouse-Lautrec and in Van Gogh's near-copy of Anquetin's *Avenue de Clichy* painting when he painted his own *Night Café in the Place du Forum*, in Arles.

When Gauguin first saw Anquetin's work and read Dujardin's article he may well have felt excluded from what had been going on in his absence. Fortunately for his peace of mind, the excitable Van Gogh expressed a passionate interest in the work he had brought back from

Martinique and asked whether he could bring his brother Theo to see them at Schuffenecker's. Gauguin must have already heard of Theo van Gogh – dealers willing to handle new art were rare and word quickly spread when a possible buyer appeared. And Theo van Gogh was more than just an amateur dabbling in modern art, he was an employee of France's largest firm of art dealers, Boussod et Valadon, successors to Goupil and Company, which had branches across Europe and in the United States. Despite having previously dismissed Vincent for showing more interest in the Bible than in selling art, the partners had given Theo control of the smaller gallery in the Boulevard Montmartre and permitted him to use the upper rooms for the display of new art. For eight years Theo built up his business, selling more popular works to support his purchase of paintings by Pissarro and Monet and the others, works which no one wanted to buy, while at the same time sending money to his elder brother who had suddenly abandoned religion and returned to art, only this time as an artist himself. From what Theo saw of Vincent's early efforts, there were few signs that he would be any more successful as a painter than he had been as a missionary, though it was impossible to deny his dedication and hard work as he moved around between Brussels, The Hague and Antwerp, in search of teachers and subjects while desperately struggling to work out what it was that he was trying to do. A period living in The Hague with a prostitute and her child ended in the painful collapse of his one attempt at a stable family life and it was soon clear to Theo that his elder brother was engaged in a desperate race between his art and the madness which threatened to engulf him, with no guarantee as to which might win.

Things came to a head in 1886 when Vincent turned up in Paris without prior warning and moved in with Theo, throwing his life into total confusion. From the beginning, Vincent was overwhelmed by the city and its conflicting artistic movements – both Impressionism and Divisionism were swallowed in a single gulp as the tenebrous depictions of peasant Holland were instantly discarded for luminous scenes of Montmartre and the Seine, for portraits of his new friends and, if it rained and he could not get out, for painting after brilliant painting of vividly coloured flowers.

For someone as unstable as Vincent, this adrenalin charge was danger-ous and the lure of the city's bars and hectic artistic social life a further debilitating assault on a mind already weakened by a possible combi-nation of a form of hereditary epilepsy, with the first stages of syphilis. Theo now had plans to marry a Dutch schoolteacher he had met while on holiday in Holland and was therefore hoping that Vincent might tire of big city life and move somewhere calmer. He was, however, perfectly happy to take a look at Gauguin's work. He knew of him as a follower

of Pissarro, whose work Theo had already shown at his gallery, so there must have seemed every chance that something fruitful might come of such an encounter.

The visit of the two brothers to Schuffenecker's house was outwardly a huge success. Each was a curious reverse image of the other – similar in looks, almost like twins, yet where one was jerky and scruffy, the other was a typically smart businessman in a city suit, calmly examining the works Gauguin had set out for them. Unknown to Gauguin, Vincent had been thinking of leaving the city and moving to somewhere further south, where living would be cheaper and far less fraught, away from the cliques and cabals of the Paris art world. Hence his interest in Gauguin's Martinique canvases, which were concrete proof of what could be done if one freed oneself from the inhibitions of metropolitan life. It was probably at this point that Vincent conceived the scheme which was to cause them so much trouble. The one thing both men had in common was an ability to construct elaborate fantasies from the flimsiest evidence and Vincent seems to have decided then and there that Gauguin would become a member of his 'Studio of the South', an artistic commune they would set up somewhere sunny and cheap, where they would be joined by other, like-minded artists.

For the moment, Vincent kept the idea to himself. Theo bought *Among the Mangoes* and two other paintings for a total of 900 francs and expressed keen interest in exhibiting some of the ceramics as soon as possible.

From Gauguin's point of view, this was highly satisfactory. He was convinced that in Theo van Gogh he had found the dealer he had been looking for, someone who would buy his work and keep him in funds. Unfortunately, Vincent too believed he had discovered a solution to all his problems in the person of Gauguin, who had just the sort of self-confidence required if he were to become both mentor and friend. It was the beginning of a grave error on Vincent's part, an assumption about Gauguin's solidity which had no basis in fact. Vincent would have done well to take note of a review which appeared that same January, when some of Gauguin's pots were put on display in the upstairs gallery in the Boulevard Montmartre. These attracted the attention of Félix Fénéon who now had a regular column in Dujardin's *La Revue Indépendante*, and in his article on the ceramics Fénéon astutely drew attention to the Peruvian origins of the vases, specifically mentioning the name of the Inca Atahualpa, though what Vincent should have noticed was how Fénéon tempered this praise with the equally astute observation that Gauguin himself was *grièche*, an obscure word meaning something between sore-headed and disagreeable. This was the first time Gauguin's aggressive manner had been committed to print, and Fénéon's remark

was to launch the notion of Gauguin's haughty arrogance, which would blossom over the years until it assumed mythic proportions. Far from being upset by the peculiar word, Gauguin appears to have rather relished the image it created of the isolated figure – the 'pariah' standing outside the normal run of society in much the same way that his grand-mother Flora Tristan had viewed herself, both as aristocrat and rebel. It is noticeable that from then on Gauguin refers to himself as the 'Savage from Peru' with increasing frequency, while discarding the last vestiges of bourgeois propriety in dress and behaviour.

All in all, the general reception of his Martinique paintings pleased Gauguin. Theo van Gogh had some on display at the gallery and while this was in no way a 'splash' on the scale of Seurat's *Grande Jatte* – there was after all no simple technical element like the 'dots' to catch the imagination – he had nevertheless carved out a distinctive piece of terri-tory and was being talked about. But to the bewitched Vincent, it went much further – for him Gauguin was now the undisputed leader of the artists of the *Petit Boulevard*. This was an exaggeration, though even the formerly aloof Emile Bernard showed how impressed he was when he next met Gauguin. The young man admitted that he had been to Pont-Aven again the previous summer, hoping to find Gauguin, not having realized that he was in the tropics. Basking in that sort of praise, Gauguin might have warmed to Bernard, who was now all of nineteen, but every time they got into a discussion, the younger man could never resist correcting him or offering another wilder theory. Lusting for admiration not instruction, Gauguin found this intolerable and their occasional encounters that winter were destined to end acrimoniously – much to Vincent van Gogh's distress, as such quarrels seemed to run counter to his dream of an artistic brotherhood, and any sort of aggression only worsened his already parlous mental state. By contrast, Gauguin assumed that struggle and battle were all part of the artistic process. He loved the cut and thrust, and where Vincent agonized, Gauguin bustled about, ready for a fight, keeping his eyes open for new opportunites to advance himself.

It was thus hardly surprising that he should have been gripped by the possibility of taking part in the next Universal Exhibition which would be held on the Champ-de-Mars in 1889. It was already impossible to ignore the four gigantic metal-frame legs, 100 metres high, the rising pillars of a tower destined to top 300 metres, the highest construction in the world, which Gustave Eiffel was building as the principal attraction for the event and a fitting symbol to mark the first centenary of the French Revolution of 1789. The sheer scale of the tower and all that was planned to surround it convinced Gauguin that there at last would be the place to make his mark. Each of the preceding World's Fairs

had witnessed an artistic scandal which had significantly enhanced the reputation of the artist involved – thus 1889 would be, so Gauguin decided, his turn. What he needed was the space and the solitude to get his ideas onto canvas in time for the great event and with all that in mind he left for Pont-Aven at the beginning of February determined to think of nothing but work.

With him gone, Vincent could see no further reason to delay his own departure for the south. That Gauguin was not travelling with him was a serious blow. The collapse of his faith in conventional religion had created a need for a God-like figure to replace God Himself. Had Gauguin realized the depth of Vincent's feelings, he might well have maintained his distance, but his own arrogance blinded him to the fact that this was far more than the usual adoration of a disciple. For the moment, the matter had been left vague. Gauguin had said he would *try* to visit Arles. Unfortunately, to the obsessed Vincent this was as good as a promise. He travelled south believing that, once he had found a home and a studio, his new friend would join him and that their brotherhood in art would then begin.

## Early Flowers in Brittany

Gauguin had no sooner settled into the Gloanec than he saw how much things had changed in Pont-Aven since his previous visit two years earlier. It was winter, the town was empty of the summer artistic crowd, and the local people were more preoccupied with farming and business than with dressing up and putting on a spectacle for their visitors. As a result Gauguin began to get a better sense of the place. As he put it to Schuff, he wanted to '. . . imbue myself with the character of the people and its landscape'. A major shift from his earlier, detached attitude when he had thought only of how cheap and convenient things were. This new interest is clear in the paintings. For one thing, he began moving further and further away from the immediate vicinity of the Gloanec, painting in the nearby woods or looking down onto the town from the surrounding hills. There is a feeling of opening out, of a wider interest than before, though this cannot have been easy, he was still very tired and often had to stay in his room for as many as three days a week when his stomach troubled him. Worse, he was lonely. There were no disciples to buck him up and the weather was miserable and the only other artist at the Inn was Gustave de Maupassant, the 66-year-old father of the writer Guy de Maupassant, an amateur painter who sat at his table bellowing out bumptious opinions intended to goad Gauguin – not an especially difficult task. Gustave de Maupassant was now an ageing rake, with only the vestiges of the dark good looks which had enabled him to

spend an indolent life, living off his family's money while chasing the
serving girls in his Normandy château. His son Guy never forgave his
father's treatment of his mother and took his revenge in the quasi-
autobiographical novel *Une Vie*, which depicted all the misery endured
by a wife, ill-treated by a philandering husband. Although Guy de Mau-
passant was obliged to see his father on holidays, there was no love lost
between them – fathers always get a bad press in his stories and novels.
How and why the old roué took to painting is a mystery, though his
gross behaviour towards Gauguin was hardly surprising, given what is
known of his past.

Despite these irritations, Gauguin worked diligently when health per-
mitted, though the dull Brittany skies drained away the colours of Mar-
tinique from his canvases, which almost return to their former muted
tones. There is, however, a clear sense of the changing seasons, as the
works progress from the dull days of February, until they brighten with
the first signs of spring, literally blossoming with colour in a painting
entitled *Early Flowers in Brittany*, in which most of the gains made in
Martinique are suddenly restored. Indeed, the painting is a clear refer-
ence to the works done near Le Carbet – two Breton women stand in
a clearing in a dense area of rich foliage with only a glimpse of distant
roofs to indicate human intervention in an otherwise unsullied landscape.
From then on, the paintings lighten and grow stronger, as if the approach
of summer, with its promise of company, was enough to drown out the
braying voice of de Maupassant, dominating meal times with his crass
opinions on art.

By June the weather was excellent and on one expedition he ended
up at the Château du Hénant, a large country house decorated with
turrets and mullions, about four miles from Pont-Aven. A public sale
was in progress and Gauguin stopped to watch the bidding. It was an
unlikely setting for him to acquire a new disciple, but the young man in
question – Ernest Ponthier de Chamaillard has left a graphic description
of the encounter:

> By chance I found myself, one day in the month of June 1888, at a public
> sale at the Château du Hénant near Pont-Aven when I noticed a man
> among the crowd of elegant peasants. He was wearing a close-fitting
> sailor's jersey, he had a beret on his head and extraordinary carved clogs
> on his feet. I was astonished to see this magnificent figure of a man wave
> to my companions and I asked them who this remarkable character might
> be. I was told that he was an extremely talented painter, but of such an
> original talent it was difficult to understand him. He was in fact one of
> the youngest and most audacious of the Impressionists, who was beginning
> to make a name for himself: Paul Gauguin. With my enthusiasm for art
> and poetry, I thought it would be nice to get to know this artist better,

so I was pleased to see him heading for our group. He expressed himself simply but authoritatively, developing his artistic theories. He spoke of these things with such feeling that I felt myself drawn towards this fine artist. I admitted to him that I had become interested in art during the past fortnight and that I had just been trying my first paintings on small canvases. This was all it took to make us friends.

Nothing could better convey the attraction Gauguin seemed to exert on these young people – de Chamaillard's account has something of the story of Christ's summoning his apostles about it, rather than the simple meeting of two men at a country-house sale. Presumably the young man was looking for a leader of some sort – he was twenty-three and had spent most of his brief adult life in reckless revolt against a stifling bourgeois background. His father was a barrister in Quimper and though the young Ernest had been destined to follow, he had succeeded in evading his fate, first by getting himself expelled from philosophy classes in Vannes, then by running up such outrageous debts while ostensibly studying law in Rennes that his bewildered family were forced to appoint a guardian in a futile attempt to monitor his finances. Under considerable pressure, he had managed to graduate in law in 1885 and had been leading a miserable existence as a probationer in Quimperlé when Gauguin burst into his life. After that fateful encounter at the château, it was farewell to the law and a wholehearted plunge into art, with Gauguin as his mentor, though it was clear from the start that it was more the Bohemian way of life than the actual production of paintings which really attracted the young man. Not that that bothered Gauguin – de Chamaillard was as generous financially as du Puigaudeau had been, and in any case the 'awkwardness' in his paintings was rather attractive to Gauguin, who looked on 'finish' as no more than academic slickness. On a more practical level, de Chamaillard was soon courting the appropriately named Louise Lamour, niece of the Pont-Aven postmistress, who lived above the post office in the Rue du Gac and was thus able to provide a meeting-place for Ernest's friends. Before long Louise's room became an annexe of the Gloanec where Gauguin could assemble his 'gang' away from the unwelcome attentions of the disagreeable de Maupassant.

This new, closer contact with the inhabitants of Pont-Aven was bound to alter Gauguin's perception of the place. He was no longer just another artist-visitor using the locals as models. He had lived through the empty winter months and had friends in the town. Something of this is reflected in the most important painting of the early summer, *Little Breton Girls Dancing*, in which three little girls in traditional black dresses, pinafores, coifs and clogs, back to back in a circle, execute a dance celebrating the early hay-making, in a glowing yellow field looking over the roofs and

the spire of the town. It is a picture of pure, sunny pleasure. At a push, one might see in it a reflection of Gauguin's loss at being separated from his own children, but there seems little reason to search so deeply. The painting was probably no more than a gesture of relief that winter had passed and that once again he had friends around him. The colours in the painting are sumptuous but like those in Martinique, they bear little comparison with the actual hues of a Breton spring, being 'exaggerated' to enhance this mood of warmth and well-being – yellow and orange with contrasting green-black dresses sharpened by scarlet posies – an exercise in 'musical' colour, that was in many ways similar to the sort of things Vincent van Gogh was then trying out in Arles.

Vincent had been writing to Gauguin since March in the hope of persuading him to come south, extolling the beauty of the light and colour of Provence and their effect on his painting. For a moment, the bad weather and the loneliness almost succeeded in convincing Gauguin that he should go. Theo too had added his voice, urging him to travel to Arles, no doubt hoping to reduce some of his outgoings by getting the two painters to share costs. But now, with the better weather in Brittany and the friendship of de Chamaillard, Gauguin began to prevaricate, hinting that he might go but that he was prevented from leaving Pont-Aven because of all the debts he had run up, especially at the Gloanec. By June, Theo had offered Gauguin a monthly allowance of 150 francs in exchange for a single painting, on the clear understanding that he would join Vincent as soon as possible. Gauguin accepted, though he no longer had any intention of leaving. Even his health seemed to be improving and as if to celebrate this return to fitness and vitality he began a series of studies of the local boys swimming and wrestling, preparing for the competitions which traditionally followed the local religious gathering, the annual Pont-Aven *Pardon* due to take place on 16 September. That he was very pleased with these works is shown by his readiness to write about them to friends like Schuffenecker: 'From time to time I have relapses which force me to take to my bed, but in general I'm getting gradually better, and my strength has returned. Also I have just done some *nudes* which you will be happy with; no Degas about them whatsoever. The latest is of two boys wrestling by the river, thoroughly Japanese, but seen through the eyes of a Peruvian savage. Upper area white, greensward, very crude.' This was a theme he took up again, in a later letter to Van Gogh, in which he emphasized that the painting was 'unrefined'. This seems an odd way to refer to what is surely an extraordinarily adept use of the picture space. The unusual sloping horizon is clearly taken from Hokusai, as is the way all the action is pushed to the top, leaving most of the right-hand side of the painting empty. This is a daring and sophisticated use of space and the word

unrefined must surely refer to the subject rather than his technique. These near-naked wrestling boys are on a par with the working women he had painted on Martinique, and one can get a better idea of what Gauguin was after in a remark he made to Schuffenecker about his new affection for Brittany, 'When my clogs resound on this granite soil, I hear the dull, matt, powerful tone that I'm after in painting. . . .'

## The Gang Returns

Towards the end of July, Gauguin spent several days at Plestin-les-Grèves on the northern coast of Brittany, between Roscoff and Lannion, staying at the family home of Yves-Marie Jacob, the head of customs in Pont-Aven. Captain Jacob was a plump bon viveur, who would some-times take time off from patrolling the river in search of contraband passing between Pont-Aven and Quimperlé, to transport his friends on gastronomic trips to the coast. He must have been an unusual man, hardly a conventional customs officer, for he and Gauguin certainly enjoyed each other's company. Gauguin painted a skittish portrait of his friend about to dive into the sea with his glasses still on. With his flushed drinker's face, Jacob looks as if he would have been terrific company over a long seafood lunch on one of those clear, bright, breezy Brittany days and one can quite see why Gauguin was no longer so keen to travel south, despite increasing pressure from Vincent in Arles and Theo in Paris.

In any case, by the time he got back from Plestin-les-Grèves at the end of July, the Gang had started to arrive, drawn from around the world. Laval had finally returned from Martinique and joined him at the Gloanec. Henry Moret came next and again found lodgings with Ker-luen, the harbour-master, and then du Puigaudeau arrived back from North Africa via Marseille, as rundown as Gauguin had been after Mar-tinique and, finally, last of the original crowd, Henri Delavallée travelled down from Paris. By now the reputation of the Gang was such that younger men came to Pont-Aven expressly to find out what was going on. Emile Jourdan later recalled, somewhat wryly, how he walked into the Gloanec intending to find the now notorious artist: 'I introduced myself, Gauguin greeted me coldly, looking on me as a high society type from Paris, the kind of person for whom he had no time! Taking no further notice of me he went on working. He was sculpting a piece of wood that he had set up near the fireplace. I must add, though, that within a few days we were good friends. . . .'

Once again we have that awed approach to the venerated leader and the humble admission that acceptance was an act of condescension by the master. Not that Gauguin was being entirely unreasonable – Jourdan

was only eighteen and looked self-consciously poetic with the middle parting and elongated face of the fashionably decadent – a feature of the Paris art world at the time. Yet it was Jourdan who proved the most dedicated of all Gauguin's new followers, to the point where his adherence to the master's style almost doomed him to complete obscurity. Of all the group who gathered round Gauguin, Jourdan is the least known. He chose to live in Pont-Aven until his death in 1931, shunning any contact with Paris, never exhibiting and frequently destroying works which did not approach some private ideal of perfection. It was not until the 1950s that he began to be rediscovered and accorded some status within the Pont-Aven School.

Jourdan had been studying in Paris before that first visit and must have had some inkling of who Gauguin was before he arrived. He must also have known that to side with such a figure would be a serious step for someone contemplating a career as a professional artist. As soon as he was part of the Gang he had immediate evidence of how the Salon world would react, from the behaviour of the opposition at the Gloanec. The students from the Paris ateliers had begun to arrive and while it was one thing to have to listen to de Maupassant's drivel, it was quite another to have to face the snide scorn of a younger crowd who saw that their world was being undermined by Gauguin and felt provoked by his arrogant manner. These 'Black' painters, as the Gang referred to them, chose to sit together at the largest of the dining tables and what began as offensively loud remarks at meal times now degenerated into heated arguments. Even Gauguin's work was not safe – he left a drawing lying around and one of the 'Black' artists scrawled on it: 'The local branch of Charenton' referring to the notorious lunatic asylum, the French equivalent of Bedlam.

When it became impossible to get any peace at the Gloanec, the six ate their meals as quickly as possible then disappeared to the room above the post office. For the younger men the sense of community was to make this the most important time in their artistic careers. There was the thrill of being part of a band of brothers, all the passion of a minority, under assault from the old guard at the Gloanec, and the excitement of taking part in the passionate discussions about art and life and the way ahead which went on long into the night. We can assume that Louise's aunt, the postmistress, was exceptionally understanding, for her attic was quickly commandeered as a studio and the walls covered in the sort of paintings which one doubts she would have appreciated.

## The Ancient Faith

Gauguin wrote to Schuff, listing the disciples who had come. 'The little Bernard is here, and has brought interesting things back from St-Briac. Here is one who is not afraid of anything.'

That Gauguin should have welcomed Emile Bernard that August was due in no small measure to the younger man adopting a more reverential tone than formerly. Bernard had been encouraged to return to Pont-Aven by Van Gogh, who was trying to manœuvre everyone into a spirit of co-operation, in the hope that they would then move south to join him. Nevertheless, Bernard wisely maintained a discreet distance, lodging with Moret at Kerluen's house rather than at the Gloanec. When they met, Bernard, perhaps half-mockingly, chose to call Gauguin *Cher Maître* while accepting to be addressed as *Petit Bernard* in return. No doubt this pretence of a Master/Pupil relationship went some way towards masking the fact that for the moment it was Gauguin who was having to learn from a much younger man.

The 'interesting things' Bernard had been doing had grown out of his interest in religion, especially his fascination with those surviving elements of the Celtic faith still visible in Brittany. At the time, Bernard's own faith had lapsed, though it would return forcefully in later life. That summer, in Saint-Briac, he had been less concerned with belief than with the techniques of religious art. He had always loved stained glass. As a child in Lille, he had visited a factory where church windows were produced, and now, with his mind full of sharp Japanese outlines and blocked-in colours, it was only a short step to see a further connection with the medieval enamel work that Dujardin had written about in his article on Anquetin. This idea of 'Cloisonism' had been much on Bernard's mind that summer and working in isolation in Saint-Briac, he had nudged the style to a more defined position, producing flatter figures with bolder outlines, much more like wood-block prints than any of the others had yet attempted. It this curious juggling for position within the avant-garde, it was now young Bernard who, momentarily at least, had moved to the front of the pack. Certainly Gauguin thought so, as witness his remarks to Schuffenecker, though his apparently good-natured acceptance of Bernard's efforts was soon to be sorely tried when the young man proceeded to make further advances shortly after his arrival in Pont-Aven – right under the master's nose as it were, and a direct challenge to his position as leader of the Gang.

What prevented a complete breakdown in relations was the arrival that August of Bernard's sister Madeleine accompanied by their mother. Madeleine was seventeen, ethereally beautiful and Gauguin was soon moodily in love for the first time since his early days with Mette. Not

that there was any question of her succumbing to his aggressive charms: Madeleine was devoutly Catholic and would be one of the main causes of her brother's eventual return to the church, while her unfailing belief in his talent would be his main support in the dark days when his earlier precociousness began to fail.

Madeleine certainly added a touch of freshness and charm to the Gang, taking her meals with them in the little side room at the Gloanec which they now used to avoid contact with the 'Black' painters, and lightening the somewhat self-regarding seriousness of the gatherings above the post office where the future of art was endlessly debated. Bernard had soon added two painted panels of his own to the collection which was rapidly covering the walls of the postmistress's home, turning it into an extraordinary art gallery. But despite their having decided to eat apart and to hold their meetings away from the Gloanec, they were still having trouble with de Maupassant and his friends. A contingent of American painters had tried to join the opposition until Gauguin threatened to hit one of them and there was peace for a time. Aggression boiled over again, in the run-up to what was called either the Fête Gloanec or the Fête de la Patronne, the celebration of Marie-Jeanne's birthday – or possibly her saint's day – on 15 August which happened to coincide with the Feast of the Assumption of the Virgin. It was by then traditional for the resident artists to present the patronne with a painting, and Gauguin decided to offer her a still life of flowers and fruit which he had just completed. When de Maupassant got wind of this he was furious and told Marie-Jeanne that she should not accept the painting, as Gauguin was simply making fun of her. Gauguin rather wittily undermined the plot by signing the canvas 'Madeleine B.' and offering it to Marie-Jeanne as if Bernard's sister had painted it for her – a thing she could hardly refuse.

This connection between the still life and the girl has led some writers to suggest that the painting must have a deeper symbolic meaning and that the clump of flowers below which are two pears is really a portrait of Madeleine herself – or at least of her head and breasts. This seems rather far-fetched given that when, shortly after the party, Gauguin did paint her portrait, he presented her quite straightforwardly as a beautiful woman somewhat older than her seventeen years. And if one compares this with a photograph taken a year earlier, one can see that Gauguin's view of her was almost reverential, her hair piled high and smoothly coiffed instead of wispily loose, a demure young woman rather than the jolly girl we can see in the photograph. In the portrait she is posed stiff-backed and formal, her blue dress echoed in the hint of shadow about her almond eyes and in the hue of her embroidered slippers on the floor beside her. The bottom edge of a Degas drawing of ballet

dancers on the wall behind her was undoubtedly meant as the ultimate
tribute, the touch of the master casting its reflected glory on the sitter
below – though the way Gauguin gave her a quizzical sideways glance,
suggests that she knew precisely what was on his mind and that the
knowledge amused her.

He was in love, but in an unexpectedly platonic way. In a letter written
in the autumn of 1888, he attempted to play the role of elder brother,
full of tender considerate advice, telling her that she should consider
herself 'an androgyne, without sex', and that everything, 'the soul, the
heart, everything which is ultimately divine, should not be a slave to
matter, that is to say to the body.'

Gauguin's awed view of Madeleine was matched by her brother Emile,
who painted her reclining on the ground, in a glade in the nearby Bois
d'Amour, as if she were a *gisant*, one of the tomb figures he had seen on
his visits to the Breton churches. Her blue dress and the way her left
hand is cocked to her ear add to the saintliness of the image, as if
Madeleine were Joan of Arc listening to her voices.

Everyone, including Gauguin, accepted that *Madeleine in the Bois
d'Amour* was one of Bernard's finest paintings. The fact that it was more
than just a portrait, that it contained a deeper symbolic meaning, can
only have added to Gauguin's concern that 'Little Bernard' was moving
ahead of the supposed master. It was a feeling much exacerbated after
16 September, when the annual Pont-Aven Pardon was held, an event
which provided Bernard with another subject and another chance to
show how far he could go with the new 'Cloisonist' technique.

## The Vision after the Sermon

As the name implies, the original reason for a Pardon was an expression
of penitence and while every local Pardon had its own customs and
variations, the common element was a large devotional procession to a
shrine or church where there would be prayers for absolution, and in
some cases divine intervention in the form of the healing of the sick and
other miracles. The origins of these huge gatherings are obscure but
were believed to date back to pre-Christian times and may have been
adopted by the early Celtic church from ancient Druidical ceremonies
centred on sacred groves or other spiritual centres. By the nineteenth
century, such distant historical details were largely irrelevant and the
Pardon, while still being based on a religious pilgrimage, with everyone
in traditional Breton costume, had become as much a social event with
the participants eating and drinking in the fields around the church,
followed by various sports where the young men could show off their
prowess to any marriageable girls. Sometimes there were horse-races,

more often wrestling – hence the young boys practising whom Gauguin
had painted.

It is unclear why Gauguin made no mention of the Pardon two years
earlier, when he was first in Pont-Aven. He must have known it was
taking place, for it was too big an event for him to have completely
avoided it. He may simply have been unwilling to join in the sort of
traditional Breton event which attracted the academic painters. This time
he was probably carried along by Bernard's interest in Celtic ceremonial,
though there is no reflection of the religious background of the Pardon
in the painting Bernard made in the following weeks. First called *Breton
Women in the Meadow*, the painting was later given the title *Pardon at
Pont-Aven*, though the original name is closer to the actual scene which
shows a number of people, mainly women, with two men and several
children in traditional costume relaxing after the procession and the
church ceremony. There is nothing mystical or even mildly religious
about the scene and given the importance art historians now attach to
this canvas, it never fails to disappoint. Its size, only 74 by 92 centimetres,
is a surprise, given the natural assumption that something so crucial in
the development of modern art must have had a commanding physical
presence. The figures too, some standing, some sitting in groups of
two and three, are quite crudely painted and set against a flat, neutral
background. Unlike the portrait of *Madeleine in the Bois d'Amour* there
is no deeper meaning, no aura of mysteries waiting to be unfathomed,
nothing more than an exercise in style – though therein lies its impor-
tance, for the painting was, and indeed remains, the Cloisonist work *par
excellence*. The meadow is simply a flat yellow-green background with
no horizon or shadows, against which the figures rest like a child's cut-
outs, the outlines around them as firm as the lead in a stained-glass
window. Yet there is no attempt to use this as a metaphor for any of the
religious aspects of the Pardon. The subject of the painting is not about
the faith of the Breton women, because, effectively, there is no subject
but the painting itself; it is an abstraction, an exercise in line and colour.

Gauguin saw at once the extent to which Bernard had pushed the
technique. Anquetin had retained some elements of pictorial illusion in
his *Avenue de Clichy* painting – his people bustle about over their shopping
before hurrying home in the failing light. But *nothing* happens in Ber-
nard's painting, he had gone just about as far as it was possible to go
without leaving out real people and objects altogether.

Clearly, such a painting fulfilled Dujardin's definition of Cloisonism
and if Gauguin wished to retain his position as leader of the group he
was going to have to take up the challenge and do something better.
Before the Pardon, he had already begun work on a painting of a group
of Breton women in a field, but now he started to rework it in a more

defiantly Cloisonist manner. Gauguin's title, *The Vision after the Sermon,
Jacob Wrestling with the Angel*, certainly indicates that he had been think-
ing about the subject as far back as early August – the breviary of the
Celtic church prescribes that particular story from Genesis 32 as the text
for the tenth Sunday after Trinity, which fell on 5 August in 1888.
Whether Gauguin actually attended a church in or around Pont-Aven
where a sermon on this text was preached, or whether he merely heard
about it second-hand is not known. In any case the scene is entirely
imaginary – a group of women in a field appear to be watching a man
wrestling with an angel, presumably a shared vision of the sermon they
have just heard preached in church.

The most obvious interpretation is that the painting is a depiction of
the literal faith of the Bretons, the sort of thing they believed might
occur at a Pardon, where miraculous happenings were considered per-
fectly possible once the community had purged its sins through mass
penance. But beneath that is a more subtle reading of the work based
on the complexities of the Biblical tale in which Jacob, the third Jewish
patriarch, is granted the land of Israel after fording the River Jabbok
one evening, and wrestling with a mysterious stranger until dawn.

It is usual for sermons based on this text to interpret it as the moment
when Jacob, through his submission to God, is ordained father of his
people, but the story has its ambiguities: just who exactly was Jacob
wrestling with – God, Man, Angel? Or was it really an internal struggle,
a duel with himself? It is easy to see why Gauguin, having begun such
a subject, should have decided that Bernard's strong Cloisonist outlines
would be entirely appropriate for his purposes. What could be better
than the implication that it had somehow been rendered in stained glass
or as an *image d'Epinal*? Not that Gauguin was after the same static
effect Bernard had achieved. The younger man's figures were decorat-
ively arranged across their 'Field' with no other aim than to harmoniously
fill the space. Gauguin, by contrast, was after a dramatic use of the
canvas. He divided the picture space from top left to bottom right with
the trunk of an apple tree, to make two triangular spaces, a device
borrowed from Hokusai with a passing nod in the direction of the dra-
matic simplicity of Puvis de Chavannes's *The Poor Fisherman*. He
arranged the watching women along the base and up the left-hand side of
the bottom triangle, leaving the upper triangle free for the two wrestling
figures. In this way the 'real' and the 'vision' have their own distinct
spaces, a tension Gauguin further enhanced by mixing 'real' elements
from Breton life and landscape with things gleaned from the biblical
story. The plain red background was probably a reference to the fields
of buckwheat which then surrounded Pont-Aven, while the style of wrest-
ling used by the sacred figures is said by experts to be the uniquely

Breton form of the sport, used by the young men after the Pardons. Set against these specific local details are the elements of the vision: the wrestling figures in their long robes, the angel's wings, and the band of mixed colours, white, light blue and green, which run along the top of the canvas and which probably represent the River Jabbok which Jacob had crossed. The thrill of the painting lies in the tension between abstract and naturalist details, between the real and the mystical. That Gauguin believed he had painted a truly religious work is confirmed by his use of the phrase in a letter to Van Gogh, but at another level, as he explained it himself, the work was also a personal statement. The story of Jacob and the Angel can be interpreted as the struggle of a man with himself, with his inner spiritual being, and thus the two figures could represent the artist 'wrestling with his inspiration' and 'grappling with a new art', in other words: Gauguin himself, struggling against the forces ranged against him, ever an outsider, a 'pariah', watched by the impassive Bretons.

This, in turn, has opened up another possible interpretation – one of the Breton faces on the extreme right could be a portrait of Gauguin himself, while a female profile on the left could be Madeleine Bernard. In which case the painting represents Gauguin's continued fascination with Bernard's sister, and thus the 'Vision' becomes a drama through which he reveals to her his inner torment.

## The Japanese, the Byzantines and the Rest

Gauguin knew that he had done something important and that this was not just any painting which he should try to sell in the ordinary way. His first thought was to offer it to a local church, preferably an ancient one, where the plain and simple beams would act as the perfect foil to the bright, stained-glass colours. The church in Pont-Aven was only thirty years old, so he settled on the medieval chapel at nearby Nizon, which had a vaulted roof of dark blue beams and simple carved figures in the chancel. He had the picture framed in plain white then signed the border 'The Gift of Tristan Moscoso', an extraordinary sign of his attachment to the work. Bernard and Laval helped him carry it to Nizon, a place almost excessively Breton, with an imposing, worn granite calvary before the church, depicting the deposition of Christ with the three Marys mourning the slumped body – a common Celtic theme, representing womankind grieving for their part in the Fall which had made such a sacrifice necessary.

Inside the church, Bernard and Laval manœuvred the canvas into the place Gauguin thought most suitable, then one of them went to inform the priest that an artist had come to present a major work to his church.

The Curé's stubborn refusal to even consider accepting the *Vision* is usually put down to his assumption that the whole thing was just a practical joke dreamed up by a bunch of irresponsible daubers from Pont-Aven, though it may equally be true that he had realized that the painting was no simple religious allegory, and that there were things in it which were not suitable for his flock.

One imagines the three of them carrying it back to Pont-Aven, with a defeated Gauguin bitterly reminding himself that such a rejection was only appropriate for a painting which represented the artist as a mis-understood outsider.

It a later letter to Schuffenecker Gauguin summarized this period in Pont-Aven as a year in which he had '. . . sacrificed everything – execution, colour – for style, because I wish to force myself into doing something other than what I know how to do. I believe this is a change which has not yet borne fruit, but which will one day do so.'

For once he was too modest. The *Vision* is, in the original sense of the word, a masterpiece – a work produced by an apprentice to prove that the period of learning is over and that he may now join the Guild to which he aspires. It marks his final departure from Impressionism, a school of which he had never been fully part, and signals his creation of something entirely new. While the work had all the hallmarks of the recently defined Cloisonism, it already left it far behind. More than that, with its many layers of meaning, with its merging of biblical symbolism and personal mythology, the painting marks as great a break with the realist tradition as Seurat's *Grande Jatte*. Indeed, the *Grande Jatte* and Gauguin's *Vision* are the two works which more than any others, finally prised nineteenth-century art away from the grip of naturalism, and began the process which is now gathered under the umbrella title of 'the Modern'. That this was so is best shown by the adverse reaction of those who had most to lose from such a lurch into the imaginative and the abstract. In a letter to his son Lucien, Camille Pissarro left no doubt as to his adverse feelings about what the painting meant: 'I have no quarrel with Gauguin on account of his vermilion backdrop, or his two struggling warriors, or his Breton peasant women in the foreground; but I do quarrel with him because he lifted all this from the Japanese, the Byzan-tines and the rest, and because he fails to apply his synthesis to our modern philosophy, which is absolutely social, anti-authoritarian and anti-mystical . . . This is a step backward.'

The key word here is synthesis for in their discussions about Gauguin's achievement and the way ahead, the Gang had decided against Cloison-ism as the stylistic name for what they were doing, preferring instead to refer to the new symbolist theories as well as to Gauguin's writings in Copenhagen, his *Notes synthétiques* and thus to call this merging of the

'real' and the imaginative a 'Synthesis' with themselves as 'Synthetists'. It was a clumsy word which never really caught on, but for a time it served to give a further sense of unity and purpose to the little band of brothers above the post office in the Rue du Gac, Pont-Aven.

## Four Portraits

Whatever they were calling themselves, it was clear to the Gang that Gauguin had pushed past Bernard and was once again their undisputed leader. Bernard would later complain bitterly that Gauguin had stolen his ideas but at the time he was equally in awe of the master. Bernard wrote to Vincent van Gogh in Arles, telling him of his veneration and Vincent passed on the remarks to Theo: 'He says he finds him so great an artist.' All of which made the lonely Vincent all the more keen that this protean figure should come and join him as soon as possible.

Because so many letters passed between them all, Van Gogh was able to monitor developments in Pont-Aven in considerable detail and was effectively a member of the group, swapping ideas and even commenting on paintings he had not seen but which had been eloquently described to him by one or other of the group – often, revealingly, by the artist himself. While Van Gogh's own work was moving down a somewhat different route from the Cloisonist/Synthetist path the group were taking, he shared the same deep interest in *Japonisme* which was responsible for the strong graphic quality which underpins his paintings. What the others could not tell from his letters was that Van Gogh had developed a wilder form of Seurat's divisionism, using sharp strokes instead of dots, in a vivid whirling fashion to bring the music of the bright colours to a clashing crescendo.

Vincent was now trying to persuade Bernard and Laval to come and join him, but while they all claimed to like his idea of a Studio of the South, none showed any signs of doing anything about it. Gauguin tried to fob him off again by raising the old difficulty of leaving without paying his many debts. He was once more dependent on Marie-Jeanne's charity and had so little money for materials, he had painted Madeleine's portrait on the back of an already completed picture. But nothing Gauguin said could dissuade Vincent from the conviction that his friend would soon travel south. He had found a rundown house, an odd place with a double pediment, its exterior painted bright yellow, on the far side of the square facing the main gate into the town, and his plan was to decorate it and move in so that it should be ready when Gauguin arrived. He bought some cheap old furniture and began to hang his pictures on the walls to cheer the place up – the flowering orchards he had done in the first spring weather, the lifting bridge on the outskirts of the town which

reminded him of Holland, and the flowers he had painted if the weather kept him indoors. What he had been unable to describe in his letters to the group in Pont-Aven was the sheer intensity of his colours, the achievement of an emotional pitch which in the end was the true subject of the paintings. Even something as supposedly neutral as the famous sunflowers was a sort of self-portrait, one which revealed his wildly fluctuating mental state – some blossoms bursting with sunny yellow life, others drooping under the unbearable heat and the oppressive mistral that descended on the town, driving him to despair. His taut nerves were not helped by the way he lived, drinking coffee after coffee during the day before launching onto absinthe for his evening trawl round the cafés near the house. And still Gauguin showed no sign of coming, despite Theo's insistence that the allowance he was being paid was on condition that he join Vincent in the south. Sometimes Gauguin prevaricated, or, if he was too busy, simply forgot to reply, silences which left Vincent in agonies of indecision about what was going to happen. It was not that he lacked friends in Arles. He would go drinking with an officer from the nearby barracks and the postman from the railway parcels office, and he was friendly with a local bartender and his wife. He painted them all, in strident contrasting colours, making them glow with life, yet still he wanted the notoriously difficult Gauguin beside him. Just when he despaired a letter would come, reviving his hopes and more decorating would be done and cheap sticks of furniture bought. The locals thought him crazy – to paint the bridge over the Rhône at night with the stars cascading on the scene below, he lit candles and stuck them in his straw hat, the better to see his canvas. But whatever his eccentricities he did not lack determination, and by mid-September the Yellow House was ready for occupation and after moving in he wrote to Gauguin and Bernard suggesting they paint each other's portraits while he would do a self-portrait, so that they could exchange images before meeting up again. Laval decided to join them but in the end no one felt capable of painting the other and it was decided that they should all paint themselves. The results were revealing. Laval was touchingly honest, showing his own rather droopy look, standing by a window looking out over a garden painted in much the same way he and Gauguin had pictured Martinique, as if his thoughts remained for ever fixed on their island paradise. Bernard's was a somewhat neutral Cloisonist attempt; he had begun to paint Gauguin's face but in the end he painted a frame round it and left it as a picture hanging on the wall behind his own head, as if to show that the master was present. Gauguin, however, produced a powerful image of himself loaded with significant elements which he explained to Vincent in a letter – the glow of the flesh, he explained, was the fire of creativity, the flat yellow background stood for

the purity of the Impressionist artist and the fact that the work was signed 'les Misérables' indicated that such an artist had the status of Hugo's hero Jean Valjean, a solitary victim hounded by the world.

When Vincent relayed this to Theo, the latter knew immediately what Gauguin was hinting at, and wrote at once to reassure him that were he to go to Arles, he would be well taken care of. Vincent meanwhile had despatched his own self-portrait, showing his shaven head and wary eyes, their intensity exaggerated by a lurid malachite green background. He described this image as that of a 'bonze worshipping the Eternal Buddha'. This suggestion that he was a humble Japanese monk awaiting the arrival of his monastic superior was no doubt very flattering to Gauguin, though when the canvas finally arrived he ought to have paused for thought – far from looking serene and Buddha-like, Vincent had the appearance of a wary and haggard criminal, cowed yet still dangerous. In many ways the portrait was a warning, but it was one that the ever confident Gauguin chose to ignore, having decided to stop wavering and to go to Arles at last.

What had finally convinced him was not so much the fact that Theo had sent more money from the sale of some pots, sufficient to settle the outstanding bill at the Gloanec, but the devastating realization that the servile, apparently faithful Laval was neither as docile nor as nondescript as he had always imagined. Not only was he in love with Madeleine but – and this was the truly amazing thing – she was in love with him. That was more than Gauguin's pride could take. Better to honour his agreement with Theo and head south where a less duplicitous disciple awaited him. He would go alone; the others were leaving for Paris. He despatched his finished work to Theo but set such a high price on *The Vision after the Sermon* that it was obvious he did not really want to sell it. With Bernard's permission he packed the *Breton Women in the Meadow*, in order to show it to Van Gogh. He would travel on 21 October.

When the day arrived he was waiting at the Gloanec, bags packed, with a few hours to kill, before the diligence for Quimperlé arrived to take him to the station and the train for Arles. He was not alone. A young man, only twenty-four, a student at the Académie Julian in Paris had been hanging around the Gloanec for some time trying to pluck up the courage to speak to him. Now that Gauguin's bags were packed and he was obviously on the point of leaving, the nervous figure finally approached, introduced himself as Paul Sérusier and asked for 'a lesson in painting'. Perhaps because he was still smarting from Laval's betrayal, Gauguin instantly agreed and led the young man from the inn, across the town and up to the Bois d'Amour, scene of Bernard's portrait of Madeleine. Gauguin then ordered this new disciple to paint what he saw. This was a considerable challenge to one trained in the highly

artificial academic tradition. Sérusier had just had an 'Honourable Mention' for his first Salon picture: an unremarkably conventional painting of weavers, so that he was hardly suited to the task Gauguin had set. To add to his difficulties, he had come ill-prepared and had to use the top of a cigar-box as a canvas. He was soon thoroughly mystified by the older man's commands: 'How do you see that tree? It's green? Well, then, make it green, the best green on your palette.' Sérusier obeyed, splashing down some pure colour. Told next that the shadows were blue he painted them a pure blue, trees were yellow and other shadows were another green. Whatever Gauguin said, he did and it was only later that he realized that the strange little sketch was the most liberating painting he had ever made. It was both alive and spontaneous, yet it captured the feeling of being there, with the light pouring through the branches. He called it *The Talisman* and carefully carried it back with him to Paris and his fellow students at the Académie Julian, where it caused a sensation. As far as Gauguin's reputation was concerned, the little cigar-box top was to do more for his status as a herald of the new than any of the pictures he painted himself.

## The Studio of the South

The train journey from Quimperlé to Provence took only two days and two nights so that Gauguin arrived in Arles on 23 October, at five o'clock in the morning, earlier than expected, and found no one there to meet him. It was cold and he was exhausted. The nearby Café de la Gare was open and looked slightly more welcoming than the Alcazar further round the square. Gauguin went in and was immediately greeted by the proprietor with a cry of 'You're his pal!' This was Monsieur Ginoux, a friend of Van Gogh's, who had been primed to watch out for the new arrival, and immediately pointed the way down to the Place Lamartine and the peculiar yellow building which the Dutchman had rented. As it was still too early to wake him, Gauguin decided to hang around till first light before banging on the door.

When he eventually woke his host, the reception he received was embarrassingly fulsome. The newly woken Van Gogh was over-excited and nervous, pathetically eager to please, showing his friend all the preparations he had made, the bits of furniture he had bought, the paintings he had hung to brighten up the sparse rooms. Gauguin said nothing. Despite Van Gogh's obvious need for some sign of appreciation, it was impossible to ignore the fact that the house was a mess – Van Gogh's notion of tidiness was very much his own. As for the paintings, Gauguin glanced at the work done in Arles, the vivid colours, the violent complementaries, and bit his tongue. Better to say nothing.

Before he could catch his breath, Van Gogh was insisting Gauguin see the town, bustling him out, leading him across the Place Lamartine, the pretty square bordering the River Rhône, which stood just outside the near-intact city walls. As they walked, Vincent babbled away enthusiastically about the glories of Arles and its women, the famously beautiful Arlésiennes. He led Gauguin through the Cavalry Gate into the narrow picturesque streets of the old town, reviled by Henry James for their 'villainous sharp stones'. No doubt Gauguin would have agreed, but he kept his counsel. He was still saying nothing when Van Gogh showed him the major sights – the Roman Arena and the church of St-Trophime with its wonderful Romanesque portico, the Musée Réattu which Van Gogh disliked and the Museum of Antiquities of which he approved. By now the town was alive with that rich mix of people Van Gogh had been painting over the previous nine months – the Zouave soldiers from the nearby Calvin barracks, the local women in their traditional dress, who at first glance seemed to Gauguin not so very different from the Bretonnes he had been painting. Indeed this may have been the start of the problem, for tired as he was, Gauguin was clearly disappointed to find that things were not as wonderful as he had been led to believe. The Yellow House was barely habitable and Arles itself was no paradise: by October the weather was already turning bad and the vivid sunlit beauty which had so liberated Van Gogh was no longer in evidence.

Sensing his lack of enthusiasm and desperate to please the new arrival, the over-eager Dutchman suggested they visit a brothel. From the moment he arrived in Arles, Van Gogh had been a regular customer of the Maisons de Tolérance in the *quartier réservé*, the jumble of streets not far from the Cavalry Gate and the Yellow House. He had quickly settled on the prosaically named Maison de Tolérance No 1 run by a Madame Virginie and was equally prosaic about his name for the activities which he undertook therein, referring to them as his 'hygienic practices'. But while he might have wanted to believe that he had put his dramatically unsuccessful attempts to find love behind him, and that he was visiting the Maison simply to cope with his physical requirements, the truth was that he had found a young girl called Rachel, somewhat shy and withdrawn, with whom he liked to pass the evenings. Regular visitors to such brothels did not always have sex. It was possible to treat the place like a café where one sat, drinking and talking with a woman who was paid for her company. Such a scenario looks bizarre to our eyes, a comic image of fully dressed men chatting to women in various stages of undress, somewhat humorous in the flouncy undergarments of the period. One doubts whether Gauguin was much taken with the proposal. If he wanted sex he had no difficulty in finding willing partners. Brothel-going was an activity he associated with his youth as a trainee

sailor. But with nothing else in prospect, the Maison de Tolérance No 1 was probably a welcome relief from Van Gogh's incessant chatter and such visits were to be a major feature of their life together – Van Gogh nervously talking with the demure Rachel, Gauguin no doubt indulging in more robust activities.

The very next morning they began work and Van Gogh's Studio of the South was under way, though not for long. From the start, disaster was inevitable though precisely why is still the subject of much debate. A large part of the problem is that the only first-hand account of their life together was written by Gauguin, fifteen years after the event and in a manner so biased in his own favour that most readers can only conclude that Gauguin was trying to disguise his responsibility for the tragedy which overwhelmed Van Gogh. From this, it is a short step to accept that it was Gauguin's domineering personality which shattered Van Gogh's creative flow and led to his breakdown.

None of this is supported by the other evidence that is available. The first thing that has to be borne in mind in how brief the whole business was. Gauguin arrived on 23 October and left, almost to the day, a mere two months later. Indeed, this was the very issue which caused Van Gogh most distress. Gauguin seems to have imagined he might stay for six months, while Van Gogh was determined he should remain in Arles for at least a year, in order to encourage Bernard and Laval, and any others who might hear of it, to join them in establishing the artistic brotherhood of which he dreamed. This was so central to the maintenance of Van Gogh's fragile mental equilibrium, that the least hint that Gauguin might leave was enough to tip him over the edge. The result, as Gauguin noticed from the first, was that Van Gogh became cloyingly solicitous, fawning upon his visitor in an ever more frantic attempt to please him but suddenly veering off into wild fury and recklessly manic anger at any suggestion that the relationship might not endure. Between Van Gogh's chatter and Gauguin's attempt at haughty indifference lay a terrifying void. Yet despite all that, Gauguin was not as brutally insensitive as his own inept account of his stay makes him out to be. He went to some lengths to get things off on the right footing. As the main reason for his coming to the Yellow House was to share expenses and live cheaply, he started by trying to get their finances into some sort of order. He insisted that all monies be kept in a box with sums earmarked for specific purposes, though it must be admitted that 'hygienic practices' headed the list, followed by 'tobacco', and that 'rent' was at the bottom. Still, it was better than the sloppiness which had prevailed before. Gauguin put a pencil on top of the box so that any withdrawals could be noted and a second box was reserved for shopping for meals, which would be cooked at home and by Gauguin – Van Gogh having attempted

to make a soup which neither of them could eat – as Gauguin wrote: 'How he mixed it I don't know; as he mixed his colours in his pictures, I dare say.'

It is a remark which reveals as much about the visitor's reaction to his host's work as his culinary skills for Gauguin's attempt at a controlled 'musical' sense of tone was now far removed from the thick impasto of paint and the heady use of pure colour which Van Gogh had been employing in Provence. Nevertheless, an attempt at diplomacy was made, with Gauguin telling him that he thought his *Sunflowers* were better than Monet's, which pleased Vincent inordinately. But despite Gauguin's initial doubts about the paintings in the Yellow House, the situation was not as clear as his reactions might indicate. Despite his outer arrogance, Gauguin could never resist trying out someone else's discoveries. While he may not have fully approved of the Dutchman's excesses, he was insecure enough, and intrigued enough, to try out some of his ideas, just as he had dabbled in Seurat's dots to find out if they had any value for his own work.

The first concession was to agree to paint out of doors, direct from nature, which for Gauguin was a step back to the Impressionist days with Pissarro. Still, he tried it with as good a grace as he could manage, heading off to the Alyscamps, the ancient Roman burial ground on the opposite side of the town to the Yellow House, where Van Gogh liked to paint. Of course, Gauguin transformed the long alley of trees and ancient stone sarcophagi, creating something not too unlike one of the forest clearings in Martinique – with the same rather arbitrary use of bright colours, as if he were still in the tropics. The main problem for Gauguin was that the flat Provençal landscape around Arles was far less pleasing to him than the valleys and woods of Brittany. But he did try, and completed six landscapes before he gave up and moved on from nature to interior scenes. Even then, he still took his cue from Van Gogh's earlier works. Vincent had painted the Ginouxs' *Café de la Gare* in clashing colours intended to express 'the terrible passions of humanity by means of reds and greens'. Perhaps to please him Gauguin made his own version, putting Madame Ginoux in the foreground with a collection of Vincent's friends – the Zouave soldier and Roulin the postman – behind her. Of course, Gauguin's use of colour was more restrained. His café is atmospheric where Vincent's is full of jarring, nervous emotion. Both approaches were valid, and it is fascinating to compare the two, but the use of complementary colours – blue and orange, red and green – was alien to Gauguin and a letter to Bernard, which included a sketch of his café scene, neatly set out the difference between the two ways of thinking:

> I've done a café which Vincent likes very much and I rather less. Basically it isn't my cup of tea and the coarse local colour doesn't suit me. I like

it well enough in paintings by other people, but for myself I'm always apprehensive. It's purely a matter of education: one cannot remake oneself. Above, red wallpaper and three whores, one with hair full of bows, the second (back view) in a green shawl, the third in a vermilion shawl. At left, a man asleep. A billiard table. In the foreground, a fairly well-finished figure of an Arlésienne with a black shawl and white (?) in front. Marble table. The picture is crossed by a band of *blue smoke*, but the figure is much too neat and stiff. Oh well.

Having made that declaration, there was little Gauguin could do except try to get back to what he had been doing before he left Pont-Aven, back to the imaginative, suggestive subjects that offered meanings beyond the surface image. What must have made this doubly distressing for Van Gogh was the way Gauguin virtually abandoned Arles and the Arlésiennes and began to paint scenes which owe more to Brittany than to Provence, a sure sign that he was disenchanted with his surroundings. The result is a curious jumble of conflicting elements, a reflection of Gauguin's own confused state. He entitled one painting *Vendanges à Arles* (*Grape Harvest at Arles*), even though the women picking the grapes in the fields are clearly dressed in Breton costumes. And he didn't stop there. In the foreground, he placed a girl sitting on the ground with her head resting on her hands in a position reminiscent of the hunched Peruvian mummy, which can only be read as a symbol of death and foreboding. She is the reason why a second title: *Misères humaines* (*Human Anguish*), is tacked onto the first, transforming the picture from a simple country scene, in the manner of Van Gogh, into a mysterious Symbolist poem. This dejected pauper girl looks disturbed and somehow remorseful. Her narrow eyes, set in an otherwise bland face, suggest Down's Syndrome, though what this means and why the poor creature is racked with guilt, is nowhere made clear, but Gauguin was certainly pleased with the result and for a long time considered *Grape Harvest at Arles, Human Anguish* the best painting of that year, only later accepting that *The Vision after the Sermon* was far more important. He painted sixteen canvases while in Arles, but the figure of the hunched, unhappy girl remains the most intriguing, and puzzling of them all.

There is no especial happening which might have provoked so bleak an image. If anything life was somewhat better than it had been, thanks mainly to Theo's money and Vincent's willingness to please. True, they more often disagreed than not, but their long conversations were a useful way of sounding out and firming up ideas, and as long as Vincent was still willing to play the sycophant, friction was kept to a minimum. He was genuinely fascinated by Gauguin's traveller's tales: his memories of Peru and his stories of life at sea; and the two were soon playing off each other's fantasies, planning to move to North Africa with the Yellow

House becoming a sort of way-station en route to the ultimate Studio of the South. When they met up with Van Gogh's friend Lieutenant Milliet of the Zouaves and he told them that he was about to be posted across the Mediterranean, Gauguin remembered his earlier scheme of going to Madagascar or even further, to where they would set up a Studio of the Tropics.

Although the Zouaves had originally been raised to fight in North Africa and still wore the dashing Arab-style uniforms of that region, Milliet and his regiment had recently returned from the campaign in Tonkin, a messy guerrilla warfare which had convinced many in France that colonial expansion was a waste of men and money. Milliet, however, was full of the opportunities on offer now that China had been forced to open its borders to trade; soon, it was believed, all of South East Asia would be French. Such stories were just what Gauguin liked to hear. He began to speculate about the possibility of heading East, maybe as far as Japan itself – dangerous stuff as far as Vincent was concerned. Whenever the topic arose he began to get edgy and difficult. Unfortunately, Gauguin merely put this down to his general moodiness and made no connection between his talk of leaving and his friend's curious bursts of ill-temper.

The threat seemed to subside when Milliet's posting came through, though there were echoes of Gauguin's fantasy in a painting he did of the local women walking in the formal garden of the Hôtel-Dieu, the town's hospital which would soon figure prominently in Van Gogh's life. This institution was also Arles's asylum for the mentally ill and Gauguin gave the place a strange otherworldly look, with a bush in the foreground that resembles the snout of a monster, and with a spindly garden seat near the top of the picture which could be a poisonous insect trying to clamber out of the frame. No doubt Gauguin was trying to drive home to Van Gogh the importance of imagination, of not merely painting what one saw but what one felt. It is likely, however, that all Van Gogh noticed was the women in the picture who were veiled like Arabs rather than Arlésiennes – a small thing, but enough for the tortured Van Gogh to assume that Gauguin was still thinking of leaving.

Desperate to persuade his guest to stay, Van Gogh tried to please him by following his theory that nature was all right as a starting point but that the next stage was to manipulate its elements into poetry. In truth this was no more than what Van Gogh had already been trying to do, only he had done it all outside, still in direct contact with his subject. His flowering spring trees, the scenes of the lifting bridge or the boats at Les Saintes-Maries-de-La-Mer, were no more exact reproductions of reality than Gauguin's scenes of Brittany – the vibrant colours, the intense reworking of the paint and the violence of the brushstrokes

all conspired to lift whatever Van Gogh painted onto another plane. Gauguin's insistence that this should be done away from the original inspiration, back in the studio, was simply an assertion of his own working method, elevated to an immutable principle, but the ever humble Vincent was determined to please him by giving it a try.

Gauguin responded by further attempts to put their affairs in order. He bought a chest-of-drawers and some kitchen equipment and made delicious meals. His efforts seemed to be rewarded when Theo wrote to say that he had exhibited some of his work at the gallery and that Degas had made favourable comments. Things might just have settled down, save for the one flaw in their otherwise well-managed existence. While the good food should have helped restore both of them to better health, its effects were undermined by excessive drinking. Gauguin would institute economies then blow any savings on a sudden binge at the Alcazar – now their preferred drinking place. Old Roulin, the postman, was highly amused by all this and liked to join them on a bender, but for someone like Van Gogh, who needed calm and order, the effects of these wild nights were extremely damaging.

He tried to please Gauguin by painting his own version of the garden at the Hôtel-Dieu in a more fully imaginative manner. First he painted the little courtyard, then he added figures, then he gave them the features of some of his family back in Holland. He was trying to be deliberately mysterious but it was hardly his style and he soon wrote to tell Theo that he had destroyed the picture – though he quickly added that he and Gauguin were still getting on famously. In the end each took from the other what he wanted – Gauguin's colour became brighter and clearer, while Van Gogh tried out more unusual, more adventurous subjects: a packed dance hall and the crowd at a bull-fight. But after the first attempts at sharing methods they eventually settled back into their own ways. Van Gogh made this clear in two paintings of chairs, one his, the other Gauguin's. Van Gogh's is the famous 'yellow chair,' a painting filled with sunlight. By contrast, the second painting is dark green, brown and blue. The lit candle and two books on Gauguin's chair indicate that it is night, and there are echoes of one of Vincent's earlier obsessions, an engraving he had seen in England of the empty chair in the study of Charles Dickens which a newspaper in London had published to mark the writer's death. Any hint of death or absence was a very bad portent, and when he saw the painting Gauguin ought to have sensed that things were going wrong.

The problem lay not so much in their work as in the weather. That autumn was one of the wettest in memory. Day after day the rain lashed down, cold and gloomy, keeping them incarcerated in the Yellow House during the day with nothing but drinking and hygienic practices to get

them out in the evenings. Gauguin was bored and Van Gogh's mood-swings were turning violent. Sometimes the Dutchman would come into his friend's bedroom when he thought he was asleep. On one occasion Gauguin woke to find him standing by his bed staring down. 'What's the matter with you, Vincent?' Gauguin claimed to have demanded, whereupon the silent watcher scuttled off, back to his own room.

It is possible that Van Gogh was befuddled with drink and trying to reassure himself that Gauguin was still there. But it was only one of a number of signs that things could no longer continue as they had.

Perhaps to cheer him up, Gauguin suggested they visit the Musée Fabre in Montpellier, which he had seen years before on his journey south on 'Spanish business', but the outing was not a success. Van Gogh refused to admire the paintings Gauguin liked and was disturbed when he enthused about Delacroix's *Femmes d'Alger*, taking this as further proof that his guest was about to go on his travels once more.

The arguing continued all the way back to Arles and went on for several days after, becoming so intense that Gauguin was forced to accept just how far Van Gogh's mental state had declined. But suggestions that Gauguin was an uncaring brute in his dealings with the Dutchman are dispelled when one reads his letter to Schuffenecker, written after the disastrous outing to Montpellier.

> My situation here is very awkward; I owe a great deal to (Theo) van Gogh and to Vincent, and, in spite of some discord, I cannot be angry with an excellent fellow who is sick, who suffers, and who asks for me. Remember the life of Edgar Poe who became an alcoholic as the result of grief and a nervous condition. Some day I shall explain all this to you. In any event I shall stay here, but my departure will always be a possibility.

It was a hopeless compromise. While he did his best to convince Van Gogh that he was not going to leave, the possibility was clearly there and the now demented Dutchman went on suspecting it. Inside the Yellow House the atmosphere was electric. Van Gogh's manner changed from fawning obsequiousness to moody irritation, punctuated by bouts of violent anger.

With the incessant rain, Van Gogh could not get out to the fields around Arles to paint, which would at least have given them both a break from each other. Obliged to paint in the house, Van Gogh tried to remain in direct contact with nature by painting another bunch of sun-flowers, while Gauguin, probably for want of anything else, proceeded to paint him doing so. It was a portrait which would have dire consequences. When it was finished and Gauguin invited him to see it, Van Gogh was appalled by the sight of the morbid, dazed figure hunched over his canvas. 'It is certainly I,' he exclaimed. 'But it's I gone mad.' That night

they went to a café, Van Gogh ordered an absinthe, picked up the glass and hurled it at Gauguin who ducked, grabbed his arm and frog-marched him home where he collapsed and fell instantly asleep. The next morning, 23 December, the day before Christmas Eve, Vincent tried to apologize and Gauguin said he would forgive him but he also expressed his concern that the scene might occur again and added that if he were struck, he might respond by choking him, so that it would be better for him to leave. It was the worst possible thing he could have said. Gauguin even wrote to Theo informing him of this decision, plunging Van Gogh into the deepest depression.

That same evening, the tension inside the house was palpable. Vincent was painting a curious portrait of Madame Roulin holding a cord with which she rocks an unseen cradle, just out of the picture. It was a very unwise subject for someone like Van Gogh, after the misery of his time in The Hague, with the prostitute and her baby. More than anything else, it had been the separation from the child, when their relationship collapsed, which had driven him to despair. Now, sitting cooped up in the Yellow House, painting this emblem of mother-love was a form of self-torture.

That night, after they had eaten their evening meal, Gauguin could stand the tension no longer and announced that he was going for a stroll in the nearby public gardens. Gauguin's account is the only authority for what happened next:

> I had almost crossed the Place Victor Hugo when I heard behind me a well-known step. Short, quick, irregular. I turned about the instant as Vincent rushed towards me, an open razor in his hand. My look at that moment must have had great power in it, for he stopped and, lowering his head, set off running towards home.

There is, of course, no longer any means of double-checking this vignette which clearly places all responsibility for the rupture firmly with Van Gogh and completely vindicates Gauguin's subsequent behaviour. That something happened is beyond doubt, for why else would Gauguin have spent the night in a hotel? Though it may simply have been a final quarrel, ending with Gauguin storming out, rather than this tale of potential violence against his person. Whatever the reason, Gauguin found a hotel and went straight to bed, though he was too agitated to sleep until three in the morning and even then was awake again by seven when he set off for the Yellow House, determined to have it out with Vincent as a prelude to his departure. He had no sooner entered the Place Lamartine than he saw a crowd gathered round the entrance, with a number of policemen guarding the door. He realized at once that Van Gogh must have done something drastic and pushed his way through

only to find himself confronted by a short man in a bowler hat, who turned out to be a superintendent of police and whose tone was far from friendly: 'What,' the little man demanded, 'have you done to your comrade, Monsieur?' Mystified, Gauguin was led into the house where to his horror he saw bloodstained towels scattered about the downstairs room, with a trail of blood leading up the staircase. It dawned on Gauguin that the question the policeman had put to him clearly implied that whatever violence had taken place was being laid at his door, apparently they believed him guilty of . . . what? Murder? They hurried upstairs, following the line of blood to the bedroom Vincent had painted in such sunny colours and where he now lay, curled up. Nervously, Gauguin went over to touch the corpse and to his intense relief realized that it was warm and that Van Gogh was still alive. His head was swathed in bandages, though whatever he might have done to himself was as yet unclear.

Gauguin turned to the superintendent and said: 'Be kind enough, Monsieur, to awaken this man with great care, and if he asks for me tell him I left for Paris; the sight of me might prove fatal to him.'

We may assume that his authoritative manner carried the day, for whatever his earlier misgivings, the superintendent did not object and Gauguin was allowed to gather up his things and leave. Before going he managed to get some of the details of what had happened, including the astonishing, though exaggerated news that Vincent had sliced off his left ear. Apparently, a policeman had been walking his beat outside the Maison de Tolérance No 1 when he heard screams, rushed in and found Rachel holding a sheet of bloodstained newspaper on which rested a piece of human flesh, a part of his ear, which Vincent had left at the door with instructions that it be taken to her. It was not long before the police tracked him down to the Yellow House where they were now arranging for a carriage to get him to the Insane Asylum in the Hôtel-Dieu.

Having seen and heard enough, Gauguin hurried to the telegraph office where he wired Theo, urging him to come at once. Theo must have rushed to the Gare de Lyon immediately on receipt of this, for he was able to get a morning train that arrived in Arles late that same day, where Gauguin met him, though he had little further to add. There was still no way of knowing precisely what Vincent had done in the interval between the time Gauguin had seen him last and the moment when the police tracked him to the Yellow House. Perhaps he had gone straight back and mutilated himself or perhaps he had gone out drinking before doing the deed. Either way Vincent was still too shocked to say and, ever after, had only the haziest recollection of the entire business.

When Theo got to the hospital, he was much relieved to find his brother in the care of a young intern, Dr Félix Rey, who had advanced

ideas on mental illness and was treating his patient with great solicitude. Vincent himself was listless and uncommunicative and the next day, Christmas Day, Theo went to see the local pastor of the Reformed Protestant Church to ask him to keep an eye on the patient, who might well be incarcerated for some time. As that was about all that could reasonably be done, Theo took the train back to Paris accompanied by Gauguin who was doubtless already rehearsing his version of events and trying to explain away his reasons for not having disarmed the demented man when he saw him wielding a razor. Unfortunately for Gauguin, everything he said, then or subsequently, only served to convince everyone that he was in some way responsible for what happened. Yet the fact is that Van Gogh was already profoundly unwell before Gauguin's arrival and his behaviour towards the Dutchman was only damaging because he chose to interpret it in a way which conformed to his more unbalanced fears. But still blame falls on Gauguin, despite the fact that it is surely wrong to attack him because a madman read into his every gesture the signs of betrayal and neglect which provoked him to the point of violence. Had Gauguin kept silent, he might well have avoided censure and earned merit for having tolerated the situation for two difficult months, yet as it is, the general conclusion has been that their time together was a disaster for both of them, even though such a judgement is not borne out by the evidence of their art. Despite the apparent rivalry, both artists benefited enormously from their brief time together, if only because the differences in their thinking forced them to clarify their ideas and did much to reinforce what had previously been only tentative theories. Having tried to return to painting direct from nature, Gauguin was more than ever convinced of the need to make imagination his primary resource, while for Van Gogh the precise opposite was the case. There had also been hours of useful talk, much of it about the part they had to play in the radical changes taking place in the arts, hammering out their ideas over café tables when the day's painting was done. Both were agreed on the need to escape the cloying grip of the Parisian art world and on the need for what we can now call a Studio of the Tropics, where both artist and art would find a new freedom. Gauguin had also been intrigued by Van Gogh's advances in portraiture, a subject he had barely dabbled in but which Vincent was imbuing with new psychological insight, especially with his self-portraits which were a virtual diary of his mental state. But it was the Dutchman's role as the *artiste maudit*, the accursed and abandoned figure, raging against the world, which affected Gauguin most, reinforcing his own view of himself as a pariah, the *Misérable* of Hugo's novel. Seen from a distance, the similarities between the two men far outweigh their differences.

For Gauguin, the real tragedy of Arles came less from his failure to create either the Studio of the South or of the Tropics with Vincent, than from his pathetic attempts to justify himself later. These were to seriously backfire, leaving him with a reputation for insensitivity bordering on the brutal, a reputation which colours many people's judgement of him to this day.

# 8

◆

# *Master, Prophet, Messiah*

If proof were needed that Gauguin was not as blasé about what had happened in Arles as he affected to be, it can be seen in one of his first actions after arriving back in Paris. Vincent had told him about a murderer called Prado, who had killed a customer in Le Tambourin, a café run by Vincent's one-time mistress, and who was due to be guillotined. At dawn, on the day following his return, Gauguin went to the Place de la Roquette to witness the public execution, a grisly spectacle that he later recalled in chilling detail: the executioner's assistants in their blue blouses, the murderous expression on the face of the priest, how handsome the prisoner was, the ghastly moment when the misplaced blade sliced into the man's face and the whole thing had to be repeated while the wounded creature writhed in agony, the way the watching crowd cheered the dead man when the business was finally done. In the days that followed, Gauguin made one of his strangest ceramics, a pot in the form of a severed head that was in fact a self-portrait, almost a death-mask, with eyes tight shut, fired with a dripping red glaze that covered the ears in a flow of what looked like blood. It was as if Van Gogh had succeeded in hacking away at him with his razor.

It was only the first of several works, made throughout that winter and on into the summer, that revealed the troubled state he was in after leaving Vincent in the Hôtel-Dieu. He found it hard to decide what to do, now that the Studio of the South had collapsed. Should he go away again, or try to settle in Paris where he could at least do more to try to exhibit and sell his work?

This was resolved when Theo van Gogh nobly paid him some money to offset the expense of his trip of Arles, though he had to rent a studio and felt obliged to send 200 francs to Mette, in yet another desperate attempt to maintain some sort of connection with his family. That done, he decided to concentrate on the Exposition du Centenaire, which would open in May. Gustave Eiffel's enormous tower was almost complete,

and though the reactions of the cynical Parisian public were inevitably mixed, no one doubted that the whole thing was going to be spectacular. For his part, Gauguin was determined that his work would be seen inside the grounds of the Exposition, even though he knew full well that the organizers of the official art exhibition – to be housed in a new Palais des Beaux-Arts, near the foot of the great tower – were hardly likely to welcome him with open arms.

This time, the usually mouselike Schuffenecker set about trying to set up his own show inside the grounds of the exhibition. Gauguin left it to him, not that he had any more respect for him than before. He continued to stay with him, borrowing money as and when he needed. He knew things were not going well for his host – there is a photograph, taken about then, of the family, Emile, Louise and their two children, which shows Schuff even more hunch-shouldered and hang-dog than ever, while Louise has acquired the sharp look of a very disappointed woman. For reasons best known to himself, Gauguin decided to paint a family portrait not dissimilar to the photograph. Perhaps he thought it would placate them, though in the end, the result was virtually a savage caricature, with Schuff, on one side of the picture, hand-wringing and humble, literally divided from his family by his easel, while Louise is depicted as a shrew, large and threatening, her hand like a claw, ready to strike.

Not surprisingly, Schuffenecker was distressed at this revelation of what his 'friend' really thought of him and the fact that the picture was not put on show can only mean that he made his distress clear. It was certainly an inept move on Gauguin's part. From then on, the Good Schuff became increasingly reluctant to give in to the off-hand demands for help, a change which would eventually cause Gauguin much hardship.

By contrast, Gauguin seems to have had considerable faith in Schuff's ability to sort out the forthcoming exhibition. Assuming that it was definitely going to happen, Gauguin embarked on a series of engravings which he intended to present in the form of an album which would be on sale at whatever show Schuff was able to organize. It was Emile Bernard who provoked his interest when he began to make wood-block prints of Breton scenes. At first, they planned to work together and decided to make lithographs rather than engravings, though they rejected the costly lithographic stones in favour of cheaper zinc plates. Zincographic prints were usually looked down on by the *cognoscenti* as being inferior to Bavarian limestone, which was thought to give a greater range of tone and detail. But the stones were heavy and as both men intended to use Schuffenecker's house as their print studio, the far lighter zinc sheets would be easier to carry around.

But there was more to it than mere convenience. It is clear that

Gauguin saw several aesthetic advantages in using zinc plates, which he exploited in a totally original manner. It is this, as much as anything, which separates his work from that of Bernard, who did little more than use the plates to create basic outline images, which he then water-coloured by hand. By contrast, Gauguin, who had always revelled in the process of making, seized on the way the zinc could be covered with mixes of ink and water and even crayon, to give subtle shades of grey on white paper or, as he finally decided to do, a rich range of browns when the thinner washes of black ink were printed onto the unexpectedly brilliant canary yellow paper that was his ultimate choice.

Bernard does appear to have been more adventurous in his choice of subjects, working on new themes, different from those in his paintings. At first glance, Gauguin appears to have done little more than set down the same Breton girls used for the Chaplet vase, four of the Arlésiennes he had worked on while with Van Gogh and even a scene of the *porteuses* from Martinique, but closer study suggests that there is some sort of theme linking the ten prints. Poverty and hard labour, melancholy and a sense of being confined can all be read into the series and are easily linked to Gauguin's own situation – the tragedy of Arles, the failure to establish the Studio of the South, or to escape to a longed-for exotic paradise. The figures in the prints are imprisoned by the small-scale daily grind, while those, such as the Breton fishermen who attempt to break free, are thrown back by the angry waves. The child-bathers in one of the Brittany prints may refer to his nagging sadness over his absent children – especially Aline whom he longed to see and of whom there was never sufficient news. His correspondence with Mette had become ever more fitful and lacking in information. And if all these elements are there in the prints then his choice of yellow paper as a brilliant background is all the more painful. Bright yellow, Vincent van Gogh's symbol of welcome and gratitude, used now as the support for these subtle yet intensely moving images of melancholy and unease.

By February he had completed the first three plates. They were so technically accomplished, it must have seemed to Bernard that there was something in Gauguin's genes which predestined him to be a printmaker. The following seven plates would be completed in Pont-Aven.

Before leaving Paris, Gauguin urged Theo to do more to display and sell his work, and the Dutchman's willingness to help shows that he at least did not hold Gauguin in any way responsible for his brother's breakdown. The news from Arles was mixed. At first, Vincent seemed to recover and had been allowed to paint but this had been followed by a sudden, violent relapse, requiring constant surveillance yet again. Despite the bad news Theo and Gauguin remained on friendly terms and it was at Theo's apartment that Gauguin was introduced to the man

who would become his new disciple, a Dutch artist, Jacob Meyer de Haan, who had come to Paris specifically to search him out, having been advised to do so by Lucien Pissarro, whom he had met in London. De Haan was a strange character who exaggerated his oddities in a light-hearted way. His family were business people from Amsterdam's promi-nent Jewish community, where Meyer and his three brothers had made a success of running a biscuit factory, despite giving a great deal of their time to music. They played in a quartet of professional standard, which gradually achieved considerable celebrity in Holland, though it was said that after giving a command performance for the Dutch Queen, De Haan and his brothers loyally vowed never to play for anyone else again. Meyer then took to art, producing dark Dutch genre scenes until the day he saw his first Impressionist painting, whereupon he immediately surrendered his share in the biscuit factory to his siblings, in exchange for a monthly allowance, and set off on the journey of discovery which ended up in Theo van Gogh's room and the encounter with Gauguin that would change everything. De Haan simply attached himself to his new master – and a pretty odd pair they must have seemed, the upright, tough Gauguin beside the bent and gaudy figure of his pupil. De Haan was short, just five feet and hunchbacked, with unruly red hair that gave him a somewhat startling appearance, exaggerated by brightly coloured clothes: a red fisherman's jersey and matching red skullcap with a loudly patterned kerchief. Whatever they looked like, they certainly got along well enough. De Haan had sprung from the strong intellectual tradition of the Dutch Jewish community and was widely read, with an astute mind and the sort of pithy way of expressing himself which appealed to Gauguin who was not averse to having complex ideas presented to him in easily digestible ways. In common with many Dutch people, De Haan was good at languages and, unlike Gauguin, read English easily, so that one of his main contributions to their working relationship was to intro-duce Gauguin to some of the British authors who were now being read by European intellectuals. De Haan was especially taken with a book by the Scottish author Thomas Carlyle, *Sartor Resartus* which at the time had not been translated into French but was gaining a cult following among the Symbolists as a key text. Carlyle, who had died in 1881, was known in France primarily for his historical works, especially his monumental study of the French revolution, but *Sartor Resartus* or *The Tailor Retailored* was a different animal, though the two works are not as unrelated as may at first appear. Neatly described as 'a motley concoction roughly in the shape of a novel', *Sartor Resartus* was Carlyle's first book, published in 1836. What is, on the surface, an account of the discovery by an anonymous English editor, of a book, *Clothes, Their Origin and Influence* supposedly written by a German philosopher, Diogenes

Teufelsdröckh, is in fact an opportunity for Carlyle to set out his views on the need for society to cast off old forms and ideas so as to replace them with new ones, in a constant process of regeneration – the theme which links it to the author's passion for the French revolution as a liberating force. Thus the invented German philosophy of clothes is an elaborate metaphor for human culture, dealing with revelation and secrecy, with honesty and fakery, disclosure and suppression.

We can tell how much Gauguin was intrigued by this from the way he began almost immediately to use such ideas visually in his paintings. Ever since the *Four Breton Women* there had been suggestions of double meanings, of visual metaphors in Gauguin's work, but from then on these were to be the central practices of his art, gaining in depth and complexity as new ideas crowded in and he became increasingly distanced from contact with the public and thus less and less concerned with whether anyone would be able to understand what he was doing.

Initially the paintings are easy to 'read' even if many of the clues remain obscure. This can be seen in a portrait Gauguin painted of his new friend later that year, which presents De Haan in his role as the purveyor of knowledge, which Gauguin sees as being both good and bad. De Haan is shown, seated at a table with his head resting on his hand, a pose similar to Rodin's *Thinker* and meant to identify him as a learned figure, perhaps a rabbi or Jewish teacher. He is reading by a lamp set beside a bowl of apples and the books before him are *Sartor Resartus* and John Milton's *Paradise Lost*. The lamp and the Carlyle represent enlightenment or wise knowledge, while the apples and the Milton convey the idea of temptation and the Fall, and thus bad or foolish knowledge.

These symbols are fairly obvious but even if the viewer misses them, the meaning of the work is still clear from the figure of De Haan, whose flaming red beard and wild drunken eyes are sufficient to reveal him as the mystic endowed with dangerous wisdom – a role he would play in future paintings now that he was established as a stock symbol for demonic knowledge. The two books add to that 'reading', though the obscurity of a work like *Sartor Resartus*, which was barely known in France outside the closest intellectual circles, has led to criticism that Gauguin was merely trying to add in a set of clever literary allusions to impress the young Symbolist poets who were the main art reviewers at the time. There may well be an element of truth in this – at least at first. Gauguin was hungry for recognition and not above using whatever came to hand to advance himself. But if the use of literary sources began as a ploy to gain attention, this was quickly overtaken when the practice became a central part of his working method, so deeply embedded in his art that he was unable to abandon it.

## Monsieur Volpini's Café

As Gauguin was now thinking of returning to Brittany it was agreed that
De Haan should join him as his pupil, and this was quickly advanced
when it became clear that there was little chance of Gauguin getting any
money from the sale of his work. Shortly after their meeting, the final
collapse of the Panama Canal Company sent the French economy reeling
into recession once again, knocking the bottom out of the art market.
Theo van Gogh made it clear that there was little he could do in such
circumstances and for Gauguin, there was no choice but to surrender to
the appeal of the Hôtel Gloanec and Marie-Jeanne's cooking. At the end
of February he quit Paris for Pont-Aven, intending to stay two months
until the opening of the Exposition du Centenaire on 6 May.

His trust in good old Schuff was not misplaced, for it was not long
before a letter arrived informing him that a room had been found within
the exhibition grounds where they could hang their works. One of the
galleries at the rear of the Palais des Beaux-Arts would be used as a
restaurant and the contract had been given to Monsieur Volpini who
ran the Café Riche which, Schuff pointed out, had been the scene of
monthly 'Impressionist Dinners' organized by the painter Gustave Cail-
lebotte. As Schuff quickly learned, work on the exhibition was in a chaotic
state and the decorations for Monsieur Volpini's café were less than half
finished. Volpini had ordered large wall mirrors which had failed to
arrive and was planning to cover the walls with plain fabric, at which
point Schuff suggested that so dull a solution could be improved if he
and his friends were given a free hand to hang their paintings. Probably
calculating that he had nothing to lose, Volpini agreed and Schuff wrote
in triumph to Gauguin that their exhibition was under way.

Gauguin promptly replied with a list of permissible participants,
including Schuff and Bernard, Guillaumin and Van Gogh, and at the
end of April set off back to Paris to supervise events, or in effect, to get
matters out of Schuff's hands and into his own. His first concerns were
personal, arranging with the printer Ancourt to make fifty sets of the
zincographs and buying stiff folders, covered in marbled paper, to put
them in. A number of the folders were faced with an eleventh zincograph,
a design for a plate decorated with a drawing of *Leda and the Swan*.

When he assumed command of the exhibition, his first disappointment
was the adverse reaction of Theo van Gogh, who advised Vincent not
to take part, on the grounds that Gauguin was trying to get into the
official exhibition by the back door. Guillaumin also demurred, probably
because he had guessed that it was bound to be a one-man show. It was
to be entitled the Groupe Impressionniste et Synthétiste, with the word
'Impressionniste' included because it was known and was still scandalous

enough to draw the crowds whereas 'Synthétiste' would mean nothing to most people, including some of the participants. In the end the gaps were filled by Gauguin's admirers: Laval and Georges-Daniel de Monfreid, along with two friends of Schuffenecker's. This was hardly the most inspiring collection and was no way comparable with the illustrious names who had made the early Impressionist exhibitions so astonishing. Guillaumin was right, it was to be a one-man show and that man was Gauguin.

As this was to be his first major exhibition in Paris he chose fifteen paintings, a pastel, a watercolour and the album of prints. For the paintings only *Among the Mangoes* from Martinique was allowed to represent his earlier work, anything with a trace of his Impressionist days was suppressed, so that the bulk of the canvases were from Pont-Aven and Arles.

That much was simple, less so the final organization of the framing and the hanging, for Gauguin and his friends proved no better than anyone else connected with the Centenaire in getting everything ready on time. On 6 May, while President Sadi Carnot was officially opening the Exposition and was being shown round those sections sufficiently tidied up for his inspection, Gauguin was pulling a hand-cart pushed by his friends, loaded with their paintings. These had been simply framed in white to contrast with the claret-coloured material which now adorned the walls of the Café des Arts – known among the group as the Café Volpini. The final hanging was a bit rough and cluttered and the catalogue, with two reproductions of Gauguin's work, was already out of date by the time it was printed. The zincographs were thought too fragile to be put on direct display and were publicized as 'visible on request'. These arrangements were far from satisfactory but at least they had done it and done it themselves.

Over the following weeks the various stands and pavilions were rapidly completed, though some sections were not in full working order until August. The Machine Gallery alone was 420 metres long and looked to one visitor like a huge upturned ship made of crystal and steel. Inside, visitors were transported along its awesome length by bridges which moved on overhead rails, appropriately re-creating the atmosphere of a giant factory, and thus, symbolically, the source of the exhibits themselves. Gauguin was hugely impressed by the sheer verve of the architecture which contrasted sharply with the slightly ludicrous Palais des Beaux-Arts which had been topped by a dome over 50 metres high, gaudily clad in white, turquoise, yellow and gold tiles.

But fume as he might, Gauguin could hardly deny that it was the likes of Gérôme and Cormon beneath that dome who were able to attract the crowds. The occasional visitor might drift into the Café Volpini after

visiting the official show but they hardly seemed to recognize that they were now taking tea amongst the very latest in avant-garde art. The canvases were lost amidst the frantic bustle of waiters and trolleys and looked mere elements in the exotic atmosphere, along with the Russian princess conducting her all-women orchestra of violinists (actually a solitary male cornet player had been slipped in) which Volpini had hired. Unfortunately, that view was shared by the critics, even those who were essentially sympathetic to the enterprise, such as Félix Fénéon, who praised Gauguin himself, but seemed to consider the event minor in comparison with previous avant-garde manifestations. It was obvious to Fénéon that the participants had little in common save their deference towards Gauguin, and that the use of the word Synthetism, as if it were a school like Impressionism, was essentially false. This was unarguable, and Gauguin was to use it far less frequently from then on. As for the general public, hardly anyone asked to see the prints and Gauguin eventually gave several sets to friends like Schuff, so that the whole effort appeared to have been a critical and financial flop. But such a snap judgement belied the real impact of the show, which was impossible to assess at the time. One of the first to appear at the café was the young Paul Sérusier, who had had that one rushed painting lesson in the Bois d'Amour just before Gauguin left Pont-Aven for Arles. The fact that Sérusier entitled his painting *The Talisman* seems less pretentious when one realizes all that sprang from it: Sérusier had taken it back to show to his fellow students at the Académie Julian, all of whom were as keen as he to break away from the stilted teaching and limited vision of their tutors. This group, a dozen young artists in all, included Pierre Bonnard, Maurice Denis, Edouard Vuillard and Félix Vallotton. They were all different but for a time shared certain common assumptions about art, happy to be part of a group. Largely forged by Sérusier, it lasted roughly from 1888, when he had his painting lesson with Gauguin in the Bois d'Amour, to roughly 1900, by which time each was going his own way. Because Sérusier had studied Arabic and Hebrew and was fascinated by Orientalism and Metaphysics, he put forward the idea of a new art, as yet unborn, of which they would be the prophets. They would, he claimed, be an artistic brotherhood and he suggested that each call himself *Nabi*, the Arabic for prophet, taken from the Hebrew *Navi*, though the word was promptly westernized and they and their movement are always known as 'The Nabis'. Within a year they had formulated many of the ideas that define the group – they wanted to challenge the limitations of easel painting and produce a large-scale decorative art. 'Walls, walls to decorate,' was their cry and with that in mind it is not hard to see why Gauguin, with his flat, 'decorative' colours, was seen as the first prophet. Subjects were of less concern to the young Nabis – some painted

exterior scenes in the parks and streets of the capital, others rather intense claustrophobic interiors, others stylized portraits; what mattered was the highly graphic style and here again, Gauguin was already a clear leader in the field they were trying to enter. Thus, Sérusier took on the role of ambassador to the Master, hoping to get Gauguin to play an active part in the group and perhaps actually to take command in some way – a vain idea, given the wilful independence Gauguin always displayed. Nevertheless, when Sérusier turned up at the Volpini he dramatically announced to Gauguin: 'Now, I am on your side,' as if he were a baptized convert. Gauguin seems to have found this a trifle foolish, his mind still yearning for a more widespread display of adulation. But he did nothing to discourage Sérusier from acting as a publicist for his work, though he had no real idea that the young man was in the process of constructing a sort of artistic religion, with himself, Paul Gauguin, as its unwitting Messiah.

At the time, Gauguin was far less concerned about the admiration of a young art student than with a young law student, Albert Aurier, whom Bernard had met in Saint-Briac and who was now starting to make a name for himself with his magazine, *Le Moderniste illustré*, one of the first uses of the word modern as a global description for all the arts following Impressionism. Aurier had begun publication that April, and because the Volpini show was the first major progressive art event to cross his path he decided to feature it strongly in the magazine, which has, in retrospect, invested the exhibition with some of the status of the first manifestation of the 'modern'.

Aurier was intrigued by Gauguin and that July and September he featured two articles by him, which used the Exhibition as a theme for the ideas on design and art and craft which he had been developing over the previous twenty years, articles which glorified the metal architecture while denigrating the pompous art it sheltered.

In the end, the devotion of his young admirers and this role as the leading voice of revolt brought Gauguin the status he had hoped to achieve through a single explosion of critical attention. The Impressionists were being reluctantly admitted to the pantheon of Acceptable Art, Seurat had ceased to shock, two days after the opening of the Centenaire Van Gogh was incarcerated in an asylum in Saint-Rémy; now only Gauguin remained as a hero of the new.

## Other Worlds

Sadly, the object of all this interest seems to have been unaware of his change of status and to have gloomily decided that yet again his plans had gone awry. Luckily there was much else at the Centenaire to take

his mind off his supposed failure – especially a second exhibition that was being held on the Esplanade des Invalides, the large open space in front of the Ecole Militaire, a short walk from the Eiffel Tower. The Esplanade had been divided into plots, one for each of the colonies, most with a typical village or a reproduction of some great monument, and peopled with groups of villagers or performers brought over from their homes to entertain the curious Parisians. With recent events in Tonkin still fresh in the public's mind, the supporters of colonialism felt it opportune to try once more to win over their still dubious fellow countrymen to the imperialist cause.

It is immediately obvious why such an event should have seemed like a personal gift to Gauguin. Disgruntled as he was by what he took to be his failure to make a splash in the Paris art world, his thoughts were increasingly turning towards escape. His artistic successes in Martinique had helped erase the memories of the hardships in Panama and his subsequent illness. A warm climate, cheap living, exotic subjects – why resist? And here they all were, a living catalogue of available primitive peoples – African potters, oriental weavers, strange spicy aromas from the restaurants, promises of easy living in the promotional brochures, beautiful women of every race, colour and shape. The art exhibition and the adventurous metal architecture were forgotten. Here was a world worth exploring.

Some of the displays were relatively simple, a few native huts containing photographs of the country, along with a troupe of musicians and dancers and craftsmen working away at their local products, living representatives of the *mission civilisatrice* in action. But not all were small in scale: some sites contained full-size reproductions of temples and palaces, the biggest being a reproduction, cast in plaster, of one of the three-towered stupas, often called a pagoda, from Angkor Wat, which had been made during the most recent scientific mission to Cambodia in 1887. It consisted of three towers three storeys high, which rose above a massive three-tiered entrance leading into a series of barrel-vaulted prayer rooms. The exterior was richly covered with Khmer religious statuary. The two-tiered staircase to the main doorway and the corners of the raised base were guarded by seated lions, while the entrance itself was flanked with Tevadas – elaborately costumed female deities in hieratic poses. There were more of these in the exhibition of Khmer art held within the temple. Other statues took the form of temple dancers, frozen in classical positions: a finger tip touching a thumb poised between the Tevada's breasts, another delicately gripping the stem of a lotus curving upwards around her left breast. The range of visual material on offer was stunning – Lucien Fournereau, the leader of the scientific mission which had made the casts, had published his magisterial *Les*

*Ruines Khmères* to coincide with the exhibition, and Gauguin made sketch copies of some of the plates. His pleasure was complete when he came across a piece of the plaster sculpture which had broken off the outside wall – constant rain and hasty workmanship had weakened many of the exhibits and the casts from Angkor Wat appear to have been left dangerously exposed. Gauguin quickly bent down and hid the thing in his clothes, no doubt reckoning it was meant for him.

Already much taken with the sculpture, Gauguin was overjoyed when he went into the nearby 'Kampong', a Javanese village set up by a group of Dutch businessmen to promote their products. Compared to the 'Pagoda' this was a simple affair of bamboo and thatch with a chief's stilt house and various huts – one a restaurant serving Javanese delicacies, another offering Van Houten Cocoa and Lucas Bols Spirits, but to attract the passers-by, the organizers had brought over sixty-five Javanese who lived in the Kampong during the exhibition, amongst whom was a troupe of temple dancers, little girls aged from twelve to sixteen, dressed in exquisitely bejewelled costumes, performing temple dances whose movements mirrored the Khmer figures on the temple next door.

Certainly, the juxtaposition of the Pagoda and the Kampong was fortuitous, coming at the moment when Gauguin was beginning to consider ways of combining Western and non-Western art-forms. A sheet from a sketchpad he was using at the time shows the Khmer figure of Apsara, set beside an outline copy of a fresco by Botticelli which had recently been transferred to the Louvre. Gauguin had noticed how the raised hands of one of the Botticelli characters echoed the gesture of the statue, a small thing but important at the time when there was a heavy line drawn between European art and work that was considered no more than amusingly primitive. Gauguin's ability to see a fragment of Cambodian sculpture in the same light as a work of the High Renaissance, marks a significant break with contemporary assumptions of a racial hierarchy of culture. Gauguin, with his Peruvian past, his foreign travels and his experience in Martinique, dismissed such a thing without a backward glance.

Not that his interest in the exhibition was constantly high-minded – the pleasure he found in the little Javanese dancers, moving with infinitely slow precision through the ordained angular patterns of their 'Hindu' dances was no doubt as much corporeal as spiritual. In one of the publicity photographs, two of the dancers are shown in performance, their fingers impossibly bent back, trained since earliest childhood to transform their slender limbs into living statues, a strangely unnerving blend of art and childlike sensuality. Indeed, with 'natives' from all parts of the French Empire strolling about among the visitors, it seemed as if the entire exhibition existed to offer temptation at every turn.

Surprisingly, given the expectations raised by Loti's novel, only the Tahitian stand failed to impress. Someone in the Colonial department had asked the governor of the island to ensure that only women of impeccable virtue be sent to Paris with the result that a troupe of plump, elderly matrons swathed in the ludicrous 'Mother Hubbard' gowns introduced by the prudish English missionaries, had arrived, much to the consternation of the exhibition organizers, who settled them into a hotel and forbade them to attend the show. They had no more luck with the male Tahitians who proudly insisted that as they had been granted French citizenship at the time of annexation, there was no reason for them to be exhibited like animals in a cage.

Unimpressed by Polynesia, Gauguin seems to have taken up with a Caribbean woman, a dark-skinned Mulatta with whom he may have had a brief affair. If so, then she may well have been the model for his ceramic sculpture *La Femme Noire*, a powerful figure who seems to rise by her own force out of the clay from which she was moulded. Her dramatic beauty was certainly intended to shock and one wonders if he took her with him on one of the several visits he made to the Porte des Ternes to see Buffalo Bill Cody in his Wild West Show. It is rather pleasing to think of Paul Gauguin in his scruffy Breton outfit, sitting in a ringside seat beside his statuesque black companion, cheering on the rough-and-tumble, macho spectacle. He loved the cowboys and bought himself a stetson to wear in Pont-Aven when he went back in early June, no doubt reckoning it would further irritate his enemies at the Gloanec.

## A Wild and Rocky Place

Sérusier went with him, though they made a strange pair, the young man hanging on the master's every word, then taking umbrage when Gauguin refused to be idolized and said something off-hand or sarcastic. Sérusier was about to be called up for military service and was keen to cram in as many lessons as he could, writing back to Paris to relate to his fellow Nabis the gems the master had imparted or to complain about his flippancy. All Gauguin wanted was peace and quiet and he saw at once that he would not get it in Pont-Aven. Even as early as June, the artistic season had begun, so that the town seemed full of men in corduroy trousers being creative and even the little tobacconist's shop now had a sign outside in the form of a palette, advertising artists' materials, though the words were misspelt. When he discovered that the serving women at the Gloanec had taken to wearing ribbons in their hair as part of the general tomfoolery, Gauguin decided to rent another studio in Les Avens, where he might be able to avoid such nonsense.

Even that proved small help. Pont-Aven was just too crowded and

after little more than a fortnight he gave up in despair. Captain Jacob was taking his boat down to the coast on 20 June and it seemed the perfect way to flee the overcrowded valley. The usual route was to cruise down the Aven, then follow the coast to a little hamlet called Le Pouldu (in Breton: 'Black stagnant water') from whence Jacob would sail up the River Laïta to Quimperlé. Gauguin had probably made the voyage before and knew that Le Pouldu was the exact opposite of Pont-Aven. It wasn't even a village, just an outpost of Clohars-Carnoët with a population of probably less than 150, most of whom were poor farmers, just able to grow enough grain to feed a few cattle and who were forced to supplement their income by early morning fishing. Even the children worked, collecting seaweed which was sold to make iodine, though the only real commerce in the place were the two café-hotels which provided meals and accommodation for inland farmers who came down to Les Grands Sables to collect the fine sand which they used to break up the thick soil on their land.

This part of the Atlantic coast was bleak: a few isolated houses set among the fields or along the dunes, looking out over the empty bay, the weather by turns brilliantly sunny or dramatically stormy. After the gentle valley of the Aven there was a wildness that Gauguin needed. There was none of the artificiality of the artistic town with its self-conscious Bretonism; the women wore simple caps instead of elaborate coifs and everyone scraped a living. No educated middle-class, no quarrelling artists.

Of the two café-hotels the largest was the Hôtel Destais, slightly inland to the west of the village where the roads to Quimperlé and Pont-Aven crossed. There were no tourists, but the hotel must have seemed too impersonal, for shortly afterwards Gauguin and Sérusier moved nearer the beach to the Buvette de la Plage, a bar and hotel run by a woman called Marie Henry, which was presumably more sympathetic as it became their main base from then on.

Not that they were planning to stay long – Sérusier's call-up was expected at any moment and Gauguin wanted to stay just long enough for the crowds to clear out of Pont-Aven. In any case, Marie Henry in Le Pouldu was noticeably less soft-hearted than Marie-Jeanne at the Gloanec, and could not be relied on for credit.

Their lives were simple: if the weather was fine they painted out of doors, which puzzled Sérusier who had assumed that Gauguin's art of the imagination meant that they would work primarily from memory. No doubt the prophets back in Paris were dismayed by this apostasy, and few of them followed the advice – which is probably why some Nabi art can seem pretty but empty. Gauguin avoided this by constantly pulling back from the brink of the abstract to reinvigorate his art through

the observation of reality. In Le Pouldu he concentrated on people at work, harvesting and collecting seaweed, in paintings less mild than those made in the valley of the Aven, more redolent of the hard, barefoot poverty of the coast – though the hardest task was persuading the impatient Sérusier to go along with it.

In the evenings, they ate, drank and talked ... and talked, and for once it was not all one way – Sérusier had a great many interesting ideas to impart, and Gauguin was happy to hear them, largely because they chimed well with the way his own thoughts were turning.

In common with most of his friends, Sérusier had been reading the book of the moment – Edouard Schuré's *Les Grands Initiés*, a study of world religions in which Christianity, Hinduism and Buddhism were given equal place. It was all part of the latest fad sweeping through French intellectual circles, the obsession with Theosophy, a new faith which claimed to have found the underlying truths of all the others and which offered nothing less than the secret of life itself. Of course Sérusier with his Hebrew and his interest in mystical practices was just the man to catch on to this new omni-religion, but it is easy to see why Gauguin would have listened carefully to such news. At a time when Renan had seriously weakened the solidity of belief in a Divine Christ and Darwin was thought to have unpicked the whole basis of Old Testament authority, many attempted to find replacements in once rejected practices – Occultism, to predict the future, Spiritualism to contact the dead, Freemasonry with its offer of a secret cult open only to initiates and strangest of all, Rosicrucianism, which meant whatever its proponents wished, and which resurfaced throughout the nineteenth century in several guises, appealing strongly to poets and artists, desperate to find a belief with more shade and subtlety than the blunt illumination of rational thought.

The proponents of these various expressions of esotericism would not approve of their being lumped together, but the fact is that many believers adhered to more than one, which meant that there was considerable overlap. Spiritualism was almost universally accepted, until the exposure of so many fraudulent mediums finally alienated popular belief and left the movement as a refuge for the sad, the lonely and the grieving.

Rosicrucianism ought to have faded away in the eighteenth century – everything it had promised had been supplanted by other systems, yet as science gave birth to technology which in turn created the industrialized world, the light of reason seemed to be blanketed by the smoke and filth of the new factories. In this atmosphere of change and disillusion the very irrationality and illogicality of Rosicrucianism, the sheer dottiness of its weird ceremonial, even the obvious fakery of its historical claims

became its strengths, and the one man who did most to revive it was none other than Flora Tristan's friend, the Abbé Alphonse-Louis Constant, the apostate cleric who had rejected Christianity for Magic, changed his name to the more biblical-sounding Eliphas Lévi and embarked on the series of books which was to make him famous. The first, *The Gospel of Liberty*, earned him six months' imprisonment for its radical politics, a clear echo of his friendship with Flora Tristan, but it was later works such as *Transcendental Magic, Its Doctrine and Ritual*, of 1855, in which he claimed to have discovered a connection between the 22 trumps in the Tarot and the 22 paths on the Tree of Life and the 22 letters in the Hebrew alphabet, which added up to a means of unravelling the mysteries of life, a large enough claim, but one which earned him a Europe-wide reputation as a modern prophet. By the time of his death in 1875, Lévi had provoked a renewed interest in 'invisible knowledge' that in turn led to the establishment of Rosicrucian societies, all of which claimed to be the lineal descendants of the original ancient order, though they were in reality the inventions of their founders. In 1866, a group of English freemasons was sufficiently moved by his writings to set up their own Rosicrucian order, but it was not until much later, only in 1888, the year before Gauguin and Sérusier moved to Le Pouldu, that the Ordre Kabbalistique de la Rose+Croix, was established in France by the Marquis Stanislas de Guaita. It may have been slow in coming, but the new order was to exercise a strong influence on a limited circle of adherents. De Guaita was a one-time poet, with a keen interest in the arts and the ambition to spread esoteric beliefs into artistic and literary circles. Eventually, Sérusier and his fellow Nabis would be drawn into the movement, but this was not for Gauguin, whose unpredictable sense of humour tended to preclude dressing up and ritual ceremonies. It was the new Theosophy that he found attractive.

## The Most Accomplished, Ingenious, and Interesting Impostor in History

In many ways Theosophy simply gathered in all the earlier cult studies, from Occultism to Spiritualism to Rosicrucianism. Of course, its adherents would have denied any suggestion of newness – to the believer, Theosophy was as ancient as its Greek roots: *theos* God and *sophia* wisdom, but while it may be true that the word can be traced back to Greek mysteries practised in third-century Alexandria, the movement was really no more than a few years old. The modern version only dated back to the founding in America, in 1875, of the first Theosophical Society by the extraordinary Madame Blavatsky, whose teachings penetrated European intellectual and artistic circles to what now seems an amazing degree.

Her new religion was to influence poets, playwrights and painters, especially Paul Gauguin, who would eventually surrender completely to a belief in the united universal faith, which this one-time spiritualist brought into being, almost single-handedly.

A Russian, born Helena Petrovna von Hahn, and briefly married at seventeen to one Nikifor Blavatsky before running off to make a life of her own, Madame Blavatsky had two lives, the one she told and the one she lived. According to the former, she learned magic in Egypt, dressed as a man she fought under Garibaldi in Italy, travelled on through China, Siam, Burma, and Tibet where she finally found her Masters who taught her wisdom in a remote mountain monastery.

The report in 1884, by Richard Hodgson of the newly formed Society for Psychical Research, which had been largely set up as a result of Madame Blavatsky's claims to communicate with spirits, was almost as awed in its condemnation as her followers were in her praise:

> We regard her neither as the mouthpiece of hidden seers, nor as a mere vulgar adventuress; we think that she has achieved a title to permanent remembrance as one of the most accomplished, ingenious, and interesting impostors in history.

While it is hard to get at the full truth of her life, it does seem to have been nearly as interesting as, if less spiritual than, the invented version. She certainly did a lot of travelling, though with a singer called Agardi Metrovitch by whom she had a child, who died at the age of five, thus provoking her unforgiving battle with the Christian God. In 1871 she lost Metrovitch when they were both shipwrecked off Egypt and she was literally washed up near Cairo, penniless but determined, surviving by practising what was essentially a minor branch of showbusiness, Spiritualism – performing as a medium for money. Two years on, her Tibetan Masters ordered her to America – a land then in the grip of what has been described as Spiritualist Fever. In New York she met an impoverished journalist, Colonel Henry Olcott, who hit on the idea of founding a Theosophical society as a way of making money. H.E.B., as she now liked to be known, was not much interested initially, and left most of the organization to the Colonel. The early years were difficult, there were frequent damaging exposures of her frauds, forgeries and deceptions, all of which H.E.B. blithely rode out until the publication of the 'Bible' of Theosophy, *The Secret Doctrine* which finally established her new religion and began to garner believers on an unprecedented scale. Subtitled 'The Synthesis of Science, Religion, Philosophy', *The Secret Doctrine* was, according to its 'translator', nothing less than the oldest book in the world, written in Senzar, a language previously unknown, on palm leaves, made resistant to water, fire and air through some magi-

cal process. On them were set out the account of the genesis of everything – how the universe came into being and thence on to a revelation of the Divine Thought which is the true 'root' faith behind all religious teaching. Her opponents quickly pointed out that the whole thing was nothing more than a mishmash of every religion and myth that H.E.B. had managed to lay her hands on: Hinduism, Judaism, all those revived and reworked esoteric rituals which had cropped up throughout history – Egyptological studies, Kabbalistic knowledge, Christian heresies and cults, oriental mystery-religions – but it was no use, those that wanted it swallowed it wholesale. Boiled down for the benefit of the members of her Theosophical Society, H.E.B.'s teaching was more Buddhist than anything else, offering a simple belief in reincarnation. Her ideas appealed to those who rejected the essentially crude materialism of the industrial age and found favour with budding Socialists, the spiritually tender and concerned and those vaguely dissatisfied with the general inhumanity of the times.

What appealed to Gauguin was the suggestion of a single wisdom, a universal truth that could be glimpsed in its various cultural manifestations amongst differing world cultures – a concept which sat well with his experiences at the Universal Exhibition. As he looked at his fragment of plaster from the Pagoda, he could see a tangible sign of this mystic message, for despite his wild behaviour, there was a deeply spiritual dimension to Paul Gauguin, a dimension nurtured during his school days, which had left him deeply marked by Catholic theology. It was no accident that he had turned to a religious subject for his first major painting, for his was precisely the sort of troubled, searching spirit to which Theosophy was created to appeal. Over the coming twenty years, the effects of Sérusier's enthusiastic sermons would grow and develop until finally, Gauguin's art would become the fullest expression of that belief in the oneness of mankind through a universal faith which Helena Petrovna Blavatsky had launched in such an off-hand manner.

## The Yellow Christ

Sérusier left for his call-up in early July and Meyer de Haan arrived, almost like a replacement. But Gauguin was finding it hard to settle; sometimes he wanted isolation, sometimes he longed for company. Near the end of August they returned to Pont-Aven but this time Gauguin rented a studio on the first floor of the Furic Farmhouse, an isolated building about two miles from the town, on the road which ran past the Bois d'Amour. He had no sooner moved in than he found the nearby Chapelle de Trémalo with its sixteenth-century bell-turret and spire, and this was to complete what Sérusier had begun. The interior of the

chapel was famous for its sculpted beams and wall panels and in particular
for a seventeenth-century carved and coloured wooden crucifix which
immediately engaged Gauguin's imagination. Those long talks with Van
Gogh and Sérusier, the esoteric theories, the notions of religion and
mysticism and symbolism simmering in Gauguin's mind, had left him
waiting for just such a trigger to release something onto canvas.

For his first painting, he took the Trémalo crucifix and set it in a
landscape based on sketches he had made of the view over the hills from
the high window in his old studio at Les Avens. In the foreground he
placed three female worshippers in Breton costumes, probably drawn
from the figures of the three Marys at the base of the large calvary, in
the grounds of the church at Nizon where he had tried to hang the
*Vision after the Sermon*, only to have it refused by the Curé. And like
that painting, this new work repeats the sense of ambiguity, the tension
between real and imagined. One can interpret it as another 'vision' –
the women are 'real' while *The Yellow Christ*, as he called the painting,
is the holy image their faith has conjured up. On the other hand this
could simply be a painting in the manner of the Italian or Flemish
Primitives, who recast biblical tales in local settings. There are touches
of this in the way a farmer clambers over the drystone wall at the end
of the field, unaware of the miracle taking place behind him, much as
the ploughman ignores the fall of Icarus in the famous Breughel. This
feeling is reinforced by the flat, decorative style which owes much to
Puvis de Chavannes whose own work was often seen as creating a bridge
between the late medieval and the modern. But whichever interpretation
one chooses, and both may be equally valid, the work remains, like a
Puvis mural, infused with gentleness and calm. The women squat on the
ground, eyes cast down, content with their privileged participation in
the holy moment.

Next, in *The Green Christ*, Gauguin took the calvary from Nizon and
set it on a desolate beach, probably the dunes at Le Pouldu, and placed
a solitary Breton woman at the foot of the cross, giving the two bodies
a similar pose, as if to emphasize the connection between the sufferings
of Christ and those of womankind, whose 'Fall' created the need for
redemption. It has been claimed that the woman is holding something
in her hand which is not unlike the cord in Van Gogh's painting of
Madame Roulin rocking the unseen cradle. If so, then the painting might
be a first attempt to offer the complete cycle of birth, death and redemp-
tion, in which case it probably owes as much to Theosophy's borrowings
from Buddhism as it does to the simple Celtic faith of the Bretons. There
are some signs that Gauguin was not entirely satisfied – the figures on
the calvary are rather sketchily done and one suspects that he simply
abandoned a work which he realized had become too complex – largely

because he had not yet fully worked out the religious concepts it was meant to embody. It was a problem which would continue in later works, where he would sometimes arrive at a point where the many ideas rolling around in his head failed to coalesce into an image which could convey to a reasonably informed spectator at least some of the many meanings. While *The Vision after the Sermon* and *The Yellow Christ* are not simple paintings, they remain open to an elementary 'reading' which at the same time helps lead the viewer into the more complex symbolism which the work contains. *The Green Christ* offers no such helping hand. It is hardly possible that anyone, other than an art historian, would ever draw the connection between the Van Gogh painting and the foreground figure, so that the work remains sealed off, little more than a display of inexplicable caricatures.

This tendency to exaggerate had already been apparent in the cruel portrait group of the Schuffeneckers, and maintaining the tension between reality and imagination without slipping over into an almost cartoon-like simplicity was not proving easy. It led to a difficult moment during that late summer when he embarked on a portrait of Marie-Angélique Satre, wife of a local builder, Frédéric-Joseph Satre, who became mayor of Pont-Aven. The Satres were rather fond of Gauguin and felt sorry about his lack of money and were thus disposed to let him have his way when he asked if he could paint Marie-Angélique, who was only twenty-one and thought by many to be the most beautiful woman in Pont-Aven. One supposes they might have bought the portrait if Gauguin hadn't rather wilfully transformed the woman into a strangely bovine figure with a dull expression and blank, expressionless eyes. Even less diplomatically, he painted a squat, Peruvian carving beside her and as Frédéric-Joseph was famously short and ugly, the whole thing began to look like a rather nasty joke. When they saw it, the husband was understandably furious and Marie-Angélique ordered Gauguin to take it away. Gauguin, surprisingly, was hurt and disappointed, as if they had all failed to understand him, a sign of how increasingly tetchy he was becoming over the way he felt he was being treated. He had grown a horseshoe beard around his chin, with a trimmed moustache on his upper lip, which made him look rather Christ-like. He even painted himself in the role – *Christ in the Garden of Olives*, in which the suffering figure of Jesus is given the artist's red hair and beard. The painting must have meant a great deal to him, given the number of times he felt the need to explain it. He first described it in some detail in a letter to Vincent van Gogh, posted to the asylum in Saint-Rémy: 'This year I have made unheard-of efforts in work and in reflection . . . It is Christ in the Garden of Olives. Blue sky, green twilight, trees all bent over in a purple mass, violet earth and Christ wrapped in dark ochre, vermilion hair. This

canvas is fated to be misunderstood, so I shall keep it for a long time.'
Though why exactly he felt this way was only made clear two years later
when he gave an interview with a journalist, Jules Huret on *L'Echo de
Paris*, to whom he finally revealed the real nature of the painting.

> There I have painted my own portrait ... But it also represents the
> crushing of an ideal, and a pain that is both divine and human. Jesus is
> totally abandoned; his disciples are leaving him, in a setting as sad as his
> soul.

It was a dangerous admission to make; while depicting real people as
saints may have been standard practice in Renaissance Italy, to use oneself
as Christ still smacked of blasphemy. Happily for Gauguin the journalist
was not offended and praised the work in terms that the artist must have
found very pleasing:

> The plebeian figure of Christ, iridescent with grandeur; a face drowned
> by sorrow, lost in boundless distress, grief personified. Indeed, why should
> Christ be a good-looking young fellow? He has thin, stick-like arms which
> emerge from his wide sleeves; the landscape is desolate with sorrowing
> trees under a poignant blue sky, and in the distance the shadows of the
> cowardly disciples retreat into the darkness. I no longer saw the vermilion
> of the hood and the beard, the heavy dark features, or the accented lines
> like window leads. On the contrary, I was moved and delighted by my
> insight into this powerful synthesis of Sorrow, and felt that I never had
> experienced a similar emotion except in the Louvre, before some few rare
> paintings ....

Huret was generous, but he had rather missed the point – the painting
was as much about Gauguin as it was about Sorrow, a fact made clear
in the last painting of this short series, in which the religious and the
personal were made perfectly clear. The *Portrait with Yellow Christ* shows
Gauguin from the chest up, his expression warily fixed on the spectator;
behind him to the left hangs *The Yellow Christ*, while to the right is
the tobacco jar, with its squat 'Peruvian' face, which he had made for
Schuffenecker – to one side of him, Martyrdom and Sacrifice, to the
other, Human Desire, or more simply, the Spiritual and the Earthly.

It is certain that most people who look at the painting see no more
than a confused and worried figure, plagued by doubt, which is probably
as near to the truth as one needs to get. But these attempts at deeper,
philosophic meanings cannot be ignored. Seen as a group, the religious
paintings of 1889 show Gauguin trying to participate in the theological
debates which dominated late nineteenth-century thought and which
revolved round the nature of Christ and thus of organized religion itself.
By placing himself in the frame, representing the suffering artist as a
Christ-like figure, Gauguin was enlarging on the underlying thesis of

Renan's *The Life of Jesus*, in which the author had used a contemporary psychological approach to present Christ's sufferings as those of a mortal man. When he first saw the *Portrait with Yellow Christ*, Emile Bernard accused Gauguin of simply following Renan, which was completely to miss the point, for while Gauguin was not in the least concerned with Christianity as such, he was, nevertheless, very much at odds with the humanistic and materialistic world which was beginning to emerge in the wake of Renan's books. In that sense his paintings are far more religious than Bernard's later studies of saints and biblical scenes, for Gauguin was attempting to create a spiritual art relevant to a world without faith and for that he was prepared to draw on all available sources, including Christianity, but not limited to it. In this regard his *Portrait with Yellow Christ* is far more important than it may at first seem, for despite its somewhat clotted symbolism, it does represent the two distinct halves of his divided artistic personality: on the one hand the lover of pleasure, the creator of images with a frank physical sensuousness, and on the other the searcher after a disappearing spirituality.

## Marie Henry's Inn

Why, with the tourists gone and Marie-Jeanne as considerate as ever, Gauguin suddenly decided, at the end of September, to leave Pont-Aven for Le Pouldu where the winter could only be harsher, is not clear. Perhaps his preoccupation with suffering and martyrdom drew him towards the bleak Atlantic coast. Later he would blame De Haan, claiming that the Dutchman had persuaded him to go by offering to pay his hotel bills in exchange for painting lessons – but that was a typical Gauguin reaction whenever things went wrong.

Whatever the reason, the two men arrived at Marie Henry's little auberge on 2 October and settled in for a long stay. De Haan rented a studio for them in the spacious attics of the nearby Villa Mauduit, on the edge of the dunes above Les Grandes-Sables, a large three-storeyed house, one of the most substantial on that part of the coast. At first Gauguin was fascinated by the sheer force of the approaching bad weather, watching intrigued as storms broke over the Atlantic, but as the winter set in so did boredom. The sudden burst of creativity which had led to his three large religious works seemed to evaporate and he wrote longingly to Bernard in Paris of his desire to go to Tonkin. Bernard's father had forbidden him to join Gauguin in Brittany that summer, a reminder of just how young he was. Longing for more company, Gauguin summoned Laval and Sérusier, who had been excused military service after all.

There has been some attempt in recent years to depict Le Pouldu as

Gauguin's first escape into an untouched Eden, his first encounter with the primitive life. But in reality, he was simply trapped by his debts in a barren cove in rotten weather. One cause of his dissatisfaction was his failure to seduce the mistress of the inn, Marie Henry. She would have no truck with a married man but was perfectly willing to extend her favours to someone as physically ill-favoured as De Haan, simply on the grounds that he was technically a bachelor. This infuriated Gauguin, not only because Marie Henry was often called Marie-Poupée or Marie-the-doll because of her looks, but also because she had already had a daughter by a previous lover so that her 'morality' about not sleeping with married men must have seemed, to Gauguin at least, somewhat exaggerated. Worse, from Gauguin's point of view, was the fact that De Haan got to sleep in Marie-Poupée's room, the main bedroom on the first floor, while Gauguin was confined to a tiny room on the same landing and had to creep down at night in search of the maid who slept behind the bar in the tap-room below. All very humiliating for one who was supposed to be the Master.

Not surprisingly, his thoughts turned affectionately to his affair with the Mulatta at the Exhibition, though not without a measure of guilt as he began to plan a major sculptural piece on the idea of love, sex and deception. Part of his inspiration came from the local Breton carvings, the sort of things he had admired in the Trémalo chapel and could now see on the carved panels of the traditional box beds which were still a feature of Breton homes in remoter places such as Le Pouldu. He even drew a design for carvings to front a bookcase, though he never carried it out, but he did get Schuffenecker to send him a large panel of good linden wood, a sign that he was planning something important.

When the wood finally arrived he worked on it with great care, finely smoothing the contours of the main figures to a high degree of finish and by early September he was able to write to Emile Bernard that it was the best thing he had done in sculpture, and the most strange.

Strange and complex, for the panel goes further than the paintings in moving away from anything resembling a recognizable scene, a tableau in the conventional sense. The *Four Breton Women*, the *Vision after the Sermon*, the *Portrait of de Haan* had all stayed fairly close to the accepted Western tradition of a painting as a window looking onto a room or landscape. Any symbolical elements – the light and the books on the table before De Haan – were fitted into this convention: there was nothing unreal about them being there, no matter what meanings they were meant to convey. But the carved panel broke with this tradition by not having a recognizable setting, the figures and the symbolic elements are placed where they best tell the story and their size varies according to their significance in the tale and not as the rules of perspective would

have ordained. This is a practice clearly derived from primitive or non-Western traditions, and the panel certainly attempts to emulate the bold imagery of the Breton furniture and even African sculpture. The dominant figure, occupying most of the left-hand side of the panel, is a woman who, from her features, may well be the Mulatta Gauguin had met at the Exhibition. She is naked, her right hand raised up into the top left of the panel where other hands reach out to seize her. She tries to use her left hand to pull herself free and on it we can clearly see that she wears a wedding ring. All this is observed from the opposite side by Gauguin – 'as a monster', in the description he sent to Bernard. Beneath him is a woman in considerable distress resting her head on her hands like the girl in *Human Anguish* and below her is a seated animal, a fox, with narrow slanted eyes, who faces directly out at us, the spectators, as if studying our reactions. At the very top of the panel, Gauguin carved the phrase: *Soyez amoureuses, vous serez heureuses* (Love, and you will be happy), though given the turmoil of the figures and their distorted expressions, this has to be ironic. The woman's ring indicates that she is married and is being seized against her will, hence the distress of the watching woman. Gauguin's role is less clear; is he fascinated or appalled by this? The clue seems to lie in the fox which Gauguin described to Bernard as 'the Indian symbol of perversity'. It is possible that it is Gauguin's hand which has curved round the outside of the panel to seize the woman's wrist, making him the violator – in which case that title becomes no more than the sort of persuasive line any seducer might use, shallow and unfeeling, as the fox's wickedly mocking expression makes clear, a gaze which seems to be asking us: 'Who amongst you is not guilty?'

## Angelic Boys

Gauguin had at least acquired another disciple – in some ways the oddest of them all. The 25-year-old Charles Filiger was short, with a prisoner's cropped hair which, along with a dreamy and withdrawn manner, gave him the look of an adolescent boy. This was deceptive, for whatever else, Filiger had a steely determination to follow his own voices, which makes it all the more peculiar that he should have gone to such lengths to get close to Gauguin.

Although from a conventional background, born into a perfectly ordinary Alsatian family, Filiger had refused to go into his father's cloth business, insisting on studying design, though his real ambition was to become an artist. Having finally convinced his family, he was allowed to move to the Académie Colarossi in Paris where he seems to have come across Gauguin or at least to have seen something of his work, which

produced an instant conviction that here was the master he needed. Filiger travelled to Pont-Aven in 1888, and in the same way as Sérusier, began to hang around the Gloanec, before Gauguin left for Arles. Whether they actually met that year, no one knows, but Filiger returned the following summer and seems to have tagged onto Gauguin's group without anyone paying much attention, so that when Gauguin and De Haan left for Le Pouldu, it was hardly questioned that the young fellow should be going with them. Filiger bedded down in the room at the Buvette, known somewhat pretentiously as the studio, a simple outhouse next to the main building. Quite why he felt this need to attach himself to Gauguin is not clear from his work, for of all those included in the Pont-Aven School, Charles Filiger was the least influenced by the Master. On the contrary, he was the one follower who had any lasting influence on the older man, though this has seldom been recognized. If Filiger owed anything to anyone it was more to the Italian Primitives, Cimabue and Giotto, or to the anonymous mosaicists of Ravenna, than to any living artist, for he was undoubtedly the most backward-looking and mystical of all the group, so unique that the Paris art world could never mean anything to him. His life would be spent in Brittany, supported by his patron the Count Antoine de la Rochefoucauld who sympathized with his religious mysticism and understood his desire to represent it in an art of simple biblical folk-images, glowing with the bold colours and transcendental spirituality of Byzantine icons. That was his real point of contact with Gauguin, for Filiger had encountered his ideal teacher at the very moment when Gauguin was most deeply involved with religious themes, and the first works Filiger did after their move to Le Pouldu were variations of Gauguin's *Yellow Christ*. In one, the Breton women from Gauguin's version were replaced by the sweetly angelic figure of a Breton boy, Filiger's ideal soul-mate. Variations on this youth would recur throughout his art, for while highly stylized, Filiger's boys always retained sufficient individuality to show that they were based on real people. It is the odd contrast between Filiger's obviously sincere, mystical faith and his equally obvious delight in these sensual, willowy, often-naked boys, passively adoring Christ's passion, which makes his art so fascinating. His was not entirely a unique vision: the English pre-Raphaelite Edward Burne-Jones had already used languid male nudes, their genitals so small as to be virtually non-existent, as part of his religious art. But this sort of Christian androgyny was just about acceptable, because the homosexual element remained sufficiently hidden below the surface – even though they came surprisingly close to the blatantly erotic work of illustrators such as Aubrey Beardsley.

Filiger's depictions of local Breton boys not only lay at the centre of his art but were also the cause of his personal sufferings. There was

already a story from his Paris days that he had been found one morning, lying unconscious in a street, bleeding from knife wounds to his hands and thigh – a scandal never fully explained. The contrast between such a squalid life and the sweetly ethereal angels and acolytes of his art was inevitably emotionally damaging and a combination of alcoholism and drugs would eventually provoke such acute persecution mania that Filiger would become a total recluse. When he died in 1928, he was barely remembered in the Paris art world and has only recently been accorded a place among the artists collectively known as the School of Pont-Aven. But for a time, his mystical medievalism, with its submerged homoerotic impulse, was part of a movement running through late nineteenth-century art, which often found expression in an escapist, reactionary, highly ceremonial Catholicism, as much devoted to aesthetics as to holiness. None of this would seem to have any bearing on Gauguin's work. Heterosexual, with an aversion to any sort of organized religion, the older man should have found little in Filiger's world that interested him. But as so often before, Gauguin's hunger for ideas and images often led him down strange paths and there is a portrait entitled *Nude Breton Boy*, which he made later that year, which shows all the signs of having been based on a source which only Filiger could have provided: Baron von Gloeden's photographs of Italian boys, some little more than children, vaguely costumed with Attic floral crowns, which had just been published. Gauguin may have seen a copy in Paris but it is more likely that Filiger brought one with him to Brittany, for there is a striking resemblance between some of Von Gloeden's youths and Gauguin's nude.

Despite their fake 'antique' settings and costumes, Von Gloeden seems to have wanted a degree of realism in his pictures – his boys were not chosen for their physical perfection, they were clearly poor peasants, with rickety-limbs and slightly swollen bellies, who were all too obviously standing there, dressed up in a few flowers, because they were going to be paid.

This finds an echo in Gauguin's painting, in the way the Breton boy, with his spavined chest, coarse red hands and sullen face, parodies the wary village rent-boys in Von Gloeden's photographs. But it was not merely a case of one isolated painting. Ideas of sexual dominance, of seduction and control, seem to have become part of Gauguin's thinking in the wake of his brief affair on Martinique. The 'hygienic practices' in Arles and the Mulatta from the Exhibition had simply reinforced this process. With Mette he had known a woman as independent as himself – if anything stronger-willed and less concerned to compromise than even he was. Before her, there had been his youthful experiences with harbour-front whores but behind everything had been his mother, Aline,

with her powerful will and her stinging hand. Now that there were no more strong-willed women to dominate him, he was free to savour the images of pubescent Javanese dancers and Filiger's angelic boys. And to excuse it all were the Symbolist theorists who said that such things were spiritually uplifting.

There can be little doubt that Gauguin's introduction to this languid effete world of half-whispered sensations, so different from the robust femininity of Mette, the Nordic goddess with her tailored clothes and cigars, unleashed hitherto suppressed emotions in him that would have far-reaching consequences. For the moment, Gauguin watched, and dabbled in imagery whose full import he may as yet have only vaguely comprehended.

## Bonjour Monsieur Gauguin

Laval came and went, exasperating Gauguin who decided that his one-time colleague was just too lazy, too much of a dilettante, ever to succeed as an artist. Sérusier arrived and slept in the little dining room and word began to spread back to Paris that Gauguin was setting up some sort of monastic community. This amused Gauguin, who wrote to Bernard to tell him that reports of him walking along the beach at Le Pouldu with the others trailing behind him, trying to hang onto his every word, were ridiculous. He insisted that each got on with his own work and that they only met up in the evenings when they relaxed. This was true, but it was also the case that Gauguin could not entirely resist playing the role of guru, letting drop such quasi-mystical pronouncements on art as: 'A square centimetre of green in the middle of a billiard cloth is more green than when isolated in space.' Even Van Gogh, alone in his southern asylum, heard about these goings on and referred to Gauguin in one of his letters as 'The Father Abbot'. And like any supportive, closely linked community, the group could appear very attractive to outsiders, a fact noted by a young writer who was travelling through Brittany and happened to stay at the Inn where he observed the 'Abbot' and his followers and was much taken with what he saw:

> A servant-girl showed me into a whitewashed room, and left me sitting with a glass of cider before me. A number of unframed canvases standing with their faces to the wall were all the more conspicuous because of the scarcity of furniture and the absence of wall-papers ... No sooner was I alone, than I ran up to the pictures, turned them round one after the other, and gazed at them with increasing amazement! I was under the impression they were mere childish daubs, but their colours were so bright, so individual and so gay that all desire to continue my walk left me. I wanted to see what kind of artists were capable of producing such amusing

freaks; I gave up my first plan of reaching Hennebon that evening, engaged a room and inquired what time dinner was.

'Do you wish to dine by yourself or in the same room as the other gentlemen?' asked the maidservant.

'The other gentlemen' were the painters of the canvases; there were three of them and they soon made their appearance with their easels and paintboxes. Needless to say I had asked to dine when they did – that is, if they had no objection. They soon made it very obvious they were not in the least put out by my presence, by showing not the least concern for it. They were all three barefooted, in brazen déshabillé, and with clarion voices. During the whole of dinner, I sat gasping with excitement, drinking in their words, longing to speak to them, to tell them who I was, to find out who they were and to tell the tall one with light eyes that the tune he was singing at the top of his voice and in which the others joined in chorus, was not Massenet, as he thought, but Bizet.

I met one of them later on at Mallarmé's – it was Gauguin. The other was Sérusier. I failed to identify the third – Filiger, I think.

The writer was André Gide, who recorded the encounter in his later memoir *Si le grain ne meurt*, in which he described his travels across Europe and North Africa aged twenty. These included a meeting with Oscar Wilde and Lord Alfred Douglas, and tales of Arab boy brothels and a first homosexual love affair, and while much milder in tone, his re-creation of life at the inn in Le Pouldu conveys vividly the lively atmosphere of the evenings when the trio met together after a day's solitary painting.

The group did at least collaborate on one artistic effort – the joint decoration of the dining room at the Inn. It seems to have begun as a distraction, probably when the weather kept them indoors. Gauguin and De Haan did most of the work with Sérusier and Filiger adding a few small sections – for they eventually covered the walls, the ceiling, the doors, and even painted over the window-panes, to create a curiously rich interior, not unlike the sort of Byzantine sanctuary Filiger so admired. De Haan seems to have been the prime mover behind the scheme – which is no doubt why Marie Henry went along with it – and his original intention was to create a rather serious set of murals depicting everyday life in Le Pouldu. The one mural that was completed showed two women working on the harvest, but it is clear that Gauguin consistently under-mined the whole thing by adding childish flourishes of his own. He painted a bunch of onions on the ceiling and added the inscription 'I like onions fried in oil', and seems to have painted whatever crossed his mind without any reference to De Haan's overall plan. He painted a Caribbean nude on the door inspired by the plaster fragment from the Angkor Wat pagoda which he had placed on the chimney piece – the same curved arm and genuflecting hand. But despite this sabotage, De

Haan did manage to achieve something noble with his portrait of Marie Henry sitting with her baby daughter Léa, in which he gave her such a gentle, caring expression that the painting has become one of the most moving images of motherhood in late nineteenth-century art, and certainly the finest piece of work De Haan ever produced. For all his apparent mockery, Gauguin was not entirely unserious. He covered one wall with his own version of *Bonjour Monsieur Courbet*, the painting he and Van Gogh had admired in the museum in Montpellier. In his version, *Bonjour Monsier Gauguin*, the artist is no longer the heroic Courbet being greeted respectfully by his dealer, but a somewhat rundown, depressed figure, who has arrived at a garden gate where he is being observed rather suspiciously by a distinctly unimpressed Breton peasant woman. There were several in-jokes of this sort – a still life painted in tiny dots was signed 'Ripipoint', the satirical name for a fictitious follower of Seurat that Gauguin and Bernard had invented in Pont-Aven. The only work that made any attempt at depth was Gauguin's self-portrait with a halo, which included some apples and a serpent as his, by now usual, symbols of temptation. It hardly added up to much, and if there is any conclusion to be drawn from all that effort it is only that Gauguin was wasting his time. The room was mainly done between October and the end of November 1889 and was a poor follow-up to the religious paintings he had done the previous summer. The fact that his thoughts were increasingly directed towards leaving only confirms that he was aware of how far things were drifting. He even wrote to the Ministry of the Colonies to see if there was any possibility of a post in Tonkin but, unsurprisingly, received no reply.

All the news was bad. Mette wrote that their youngest son Pola had fallen from a third-floor window of her apartment and had nearly died. Gauguin replied, castigating her for only writing when something so extreme had happened. When Theo van Gogh wrote it was to say that there had been some rather savage criticism of the latest paintings he had sent to Paris and even Degas, who had begun to show an interest in his work, was once again expressing his disapproval. The only conclusion was that it would be better for him to return rather than to go on wasting his time in Brittany. Back in Paris, he could go to the Ministry of the Colonies to plead his case and having begged Schuff for the fare, he left Le Pouldu in the first week of February.

## Illusions and Delusions

He might as well have stayed. Schuff had moved and was now living near Plaisance on the outer edge of the suburbs, a place of half-finished building sites. He had just sold his share in the gold-plating business

but when he announced that he would rather enlarge his house than help fund Gauguin's Studio of the Tropics, he brought down even more sarcasm on his bent head.

Dressed as ever, in a fisherman's jersey and painted clogs, Gauguin, unsurprisingly, failed to win over the interviewing officials at the Ministry of the Colonies. He found a little work tutoring in a studio in Montparnasse but it didn't last; the Master had no patience with the pupils. The only thing that pleased him were some new paintings by Vincent van Gogh at the Salon des Indépendants which Gauguin thought were the best things in the Exhibition.

Had he wanted adulation, Gauguin could have visited his young Nabi friends, who still considered him a sort of founding prophet. This was the year, 1890, when the brotherhood began to organize, holding a monthly dinner at which participants dressed in oriental costumes, each bringing an *icône*, a new painting for the others to discuss. But the principal gathering soon became a regular Saturday session at the studio of Paul Ranson, at 25 Boulevard du Montparnasse, which was eventually known as the Temple of the Nabis. Sérusier painted Ranson in full rig: embroidered cope, a massive crozier in his hand – though his goatee beard and pince-nez do not seem altogether appropriate to this image of prophet and patriarch. While they had originally been artists of the city, producing sharp, decorative, graphic images of street scenes and café life, the Nabis were placing increasing emphasis on mystery and ritual; this was gradually nudging some of them towards a revival of religious art with strong medieval and Byzantine elements. It was a perfect circle – they had started with Cloisonism, itself partially drawn from medieval enamels and stained-glass windows, and were now applying it to its original biblical subject matter. Here again, Gauguin had played a part, with his powerful religious paintings, which the Nabis took as yet another pointer towards the role of the sacred in art.

They were not alone; the mixing of esotericism with a reactionary, backward-looking Catholicism was very much the thing of the moment. That August of 1890 saw the setting up of the first Rosicrucian group that would attempt to link its rituals to Catholic dogma and try to give expression to this through art. The man behind it was an extremely strange figure, full-bearded, dressed in monastic robes who called himself the Sâr Péladan, preferring the ancient Chaldean title to his given name Joséphin. Péladan was a writer who, like so many before, was trying to make his mark through art criticism, though from the start he displayed a set of ringing convictions quite new in the narrow world of Parisian journalism. His first review of the Salon of 1883 opened with the statement: 'I believe in the Ideal, in Tradition, in Hierarchy.' It was a cocky attempt to position himself as far as possible from the humane,

democratic ethos of left-leaning Impressionists like Pissarro and when, the following year, Péladan published the first part of his twenty-volume fictional series, *Le Vice suprême*, his reputation as chief mystic amongst the clamorous voices of literary Paris was established. Throughout the 1880s Péladan immersed himself in Kabbalistic knowledge and was soon issuing occult tracts, some with unintentionally hilarious titles like 'How to be a fairy', and when de Guaita set up his Ordre Kabbalistique, Péladan joined him, but soon found it too tight-knit and uninfluential. Péladan had something of the Blavatsky about him; he was ambitious and capable of making quite astonishing assertions without blinking. Seeing him dressed in his medieval doublet and hose, with his full black 'Chaldean' beard, it was hard to tell where joke ended and reality began, where true belief merged into self-promotion – he had probably forgotten himself.

He broke away in 1890 to found his own order of the Rose+Croix and from the start he was determined to preside over an artistic movement which would promote his beliefs, defined in a typically forthright pronouncement: 'Artists who believe in Leonardo and *The Victory of Samothrace*, you will be the Rose+Croix. Our aim is to tear love out of the western soul and replace it with the love of Beauty, the love of the Idea, the love of Mystery. We will combine in harmonious ecstasy the emotions of literature, the Louvre and Bayreuth.'

Actually this was pretty standard by then – Wagner and literature and art, the Symbolists would have felt quite at home in such a temple, as would the Nabis, and when the Sâr began to organize his own exhibitions, two years later in 1892, with the first of the Salons of the Rose+Croix, there was a great deal of overlap between them. Though only as long as the participants were male, for while the Sâr permitted women into the very lowest ranks of the Order, he excluded them entirely from the inner rituals and from participation in his Salon. Such stuff was certainly not for Gauguin – though once again, it was probably the ritual mumbo jumbo and the dressing up which kept him apart from Péladan's movement, as much as anything it claimed to believe in. But there were aspects of Péladan's thought to which he was far from immune. In 1891, Péladan published another novel, *L'Androgyne*, for which he drew on one of the key themes of the literature of the period – the obsession with dual sexuality, with the hermaphrodite and, in turn, with suggestions of homosexuality. For some writers the androgyne was the epitome of lust – having two sexes, he/she would satisfy all possible desires within one body; for Péladan it was the opposite, the androgyne's dual sexuality cancelled desire, the androgyne was liberated from sex.

Péladan, and the others like him, were only reflecting a far broader feature of cultural life in the last half of the century, a preoccupation

with, and a fear of, women. Woman the seducer, the dangerous Sphinx, the seductive Eve, the murderous Salome, had been central to Symbolist imagery. The aesthetes and the decadents had joined them in elevating the effete solitary male who prefers the artificiality of Art to the crudeness of Nature of which woman is the most dangerous part. This opposition to women was as much philosophical as physical and arose from social and economic forces which were slowly, very slowly, unbinding the chains on women's lives. The things for which Flora Tristan had struggled were starting to become apparent and the New Woman, as she would be called, was beginning to make her presence felt, often, like Mette Gauguin, out of economic necessity. And this in turn sparked off what has been called a 'Crisis in masculinity'. For Péladan it came down to sex which had to be controlled and if possible suppressed or neutralized in the person of the androgyne. For the troubled, homosexual Filiger, it had to be subsumed into effete angels and willowy saints. Gauguin, by contrast, stood somewhat outside these movements, for while he was always close to the ideas of his time and touched on many of their beliefs and fears, he was never the simple adherent of a particular line. Most often he floated in the stream, his final direction unpredictable, his course uniquely his own.

## A Place of Pilgrimage

Ranson's Temple was not for Gauguin. Despite their admiration for him, he was never going to be a Nabi. Indeed, the crowding in of so many new ideas, new movements, new people, was beginning to depress him.

Given his natural cynicism and a disinclination to believe in anything, it is all the more surprising that Gauguin should have shown such complete faith in a strange character called Dr Charlopin to whom he was introduced by a colleague of Schuff's at the Lycée where he was then teaching art. The man's name, so near to charlatan, ought to have been a warning. Charlopin was – according to Charlopin – on the point of selling the patent to one of his inventions. No one seems to have asked just what this was, but no matter, he would shortly, so he claimed, be paid a great deal for it, whereupon he would buy 5000 francs' worth of Gauguin's paintings, enabling him to fulfil his dream of leaving for the Tropics. Charlopin felt sure he could give him the money by mid-July, thus Gauguin could leave France by mid-August at the latest.

Believing he had everything sewn up, Gauguin and De Haan returned to Le Pouldu that July and were soon joined by a summer crowd of admirers. From among the original Pont-Aven gang, Henry Moret came, renting a room in the Inn at nearby Bas-Pouldu, and a short time after, the engraver Paul-Emile Colin, a friend of Filiger's, moved into the

Buvette, though only Filiger had any direct influence on the Master himself. Most, however, were useful publicists for his genius and it was due to these visiting acolytes that Gauguin was able to acquire a reputation far greater than the limited exposure of his paintings could ever have brought him. Only the few who had visited the Café Volpini or who knew of Theo van Gogh's occasional presentations had ever seen his paintings and ceramics, and fewer still had bought any, yet here he was in a tiny hamlet on the west coast of France, the object of a significant artistic pilgrimage. Even more surprising was the extent of this word-of-mouth fame, for many of the students who trailed down from the Paris studios were originally from outside France and when they returned to their homes they spread the message even further.

Only one of these passing tourists, though certainly one of the oddest, need be singled out from the crowd, as he alone would have a role to play in Gauguin's later life. Staying at the Destais Hotel was a group of foreign students on holiday from Paris, who were almost caricatures of the French idea of the English. Most were public schoolboys from well-to-do families who could afford to indulge an interest in art by paying for them to study at one of the fashionable Paris academies. One of them, Alfred Thornton, left an account of their holiday in which he mentioned that they had come across the notorious Gauguin. He also noted that it was the shyest of the band, the 27-year-old Arthur Hay-thorne Studd, always known to his friends as Peter, who was most affected by the encounter. On the surface, this would have been far from predictable – ex-Eton and Cambridge, from a family more known for producing first-class cricketers than artists, Peter Studd seemed too gentle and withdrawn to be the sort who would be attracted to the swaggering swami of Le Pouldu. But Peter Studd deserves more careful attention than such a dismissive comment suggests. While it was true that one of his brothers would become Lord Mayor of London – as indeed would a nephew much later – and that the family would be linked by marriage to the Asquiths and were thus part of one of Britain's leading political dynasties, Peter was quite different. Born in 1863, he did all the conventional things – Eton, Cambridge, but then broke with tradition to study art under Legros at the Slade. From then on his friends were writers, musicians and painters and included Leslie Stephen and his daughters Vanessa and her sister the future novelist, best known by her married name, Virginia Woolf. But it was Studd's decision to go to Paris and enrol at the Académie Julian, in late 1888, that lifted him out of the normal rut of minor English painters. Peter Studd's talent may have been modest but his eye was good and he had soon latched on to where the most interesting things could be seen and had enough family money to back his hunches. Like Gauguin before him, Studd found that the

ability to buy offered easy access to the otherwise hidden world of art, and his circle soon included Maurice Denis and Forain and touched on Puvis de Chavannes and Bonnard. According to William Rothenstein, the future head of the Royal College of Art, who followed Studd from the Slade to Julian's, the French liked Peter because 'he appeared to be the traditional *Milord*, whose eccentricities, however extravagant, were to be accepted without surprise.' But there can be little doubt that it was the power of his purse that helped win friends and when Studd paid the then astonishing sum of 200 English pounds for one of Monet's haystack series, he earned himself considerable respect as a man of both taste and means.

Rothenstein's memoirs include Bracquemond among the people they encountered at the Académie and also mention a visit to the 1889 exhibition, either of which could have been the means by which Studd first heard of Gauguin, for it was his decision to go to Brittany in search of this intriguing figure, and while he was certainly never to be as close to Gauguin, in the way De Haan or Filiger were, his contacts with him were greater than has usually been acknowledged by the tiny group of historians who have come across their odd friendship.

Thornton has left us a graphic description of the sailors' *cabaret* where he and Studd and their other friends lodged – the bare floors, the grit, the fleas, the huntsmen who sometimes stayed and who sat up 'and roistered till late'. The formerly rigid English painters soon lapsed into Bohemian ways, wiping their brushes on their trousers, buying drinks for the local peasants so that their daughters would pose for them, going to the annual Pardons to experience local colour. They were still struggling to catch up with Impressionism but they were not unaware of what was happening down at Marie Henry's and were close enough to Gauguin for Thornton to have left an intimate portrait of the artist:

> As he often bathed in the inlet at Les Grandes-Sables we saw that his body was finely proportioned, and of a colour harmonizing well with the dull copper-green of the seaweed-covered rocks which formed a background as he splashed in the shallows at low tide. Gauguin was evidently possessed of great physical strength, of which he could, but rarely did, make use; his expression was severe and his movements were slow, giving him an imposing manner that kept strangers at a distance. Yet lurking behind was a fiery temperament leading at times to fierce outbursts of wrath. As his father was from Orleans and his mother Peruvian, such outbursts were not surprising.

But whatever Gauguin's temper, it is clear that the little band of Englishmen were not kept at a distance. Studd and the others must have been familiar visitors to Marie Henry's Buvette for Thornton has also left an exact description of some of the reproductions pinned up on the walls

of Gauguin's bedroom at the inn: including Manet's *Olympia*, Botticelli's *Triumph of Venus*, and Fra Angelico's *Annunciation*, as well as some reproductions of the work of Puvis de Chavannes and a print or two by Utamaro. Thornton and Studd must also have frequented the villa at Les Grandes-Sables, as Thornton reveals that the walls there had also been painted like the room at the inn and that in later years he met a Madame de Tailleur, the daughter-in-law of the owner of the house, who told him that what she called *les horreurs* had been whitewashed over. Thornton recalls that these had been fine big designs with peasants and cattle – 'lost for ever under the whitewash'.

As far as Gauguin's influence on the art of these young men was concerned there is less agreement. Thornton claimed that Gauguin's work was far ahead of anything the group had so far encountered – 'we felt his power, we did not really understand him, obsessed as we were by pure Impressionism'. But here, the otherwise objective recorder is really only speaking for himself – in Studd's case the influence was far more direct, indeed he was so impressed he returned to Le Pouldu for many years, renting what Thornton described as 'a charming little white-walled house with pale blue shutters, on the Laïta at the horse-ferry.' Sadly, none of Studd's Brittany oils have survived, but Gauguin's influence is clearly evident in his drawings and there is a painting produced in England entitled *Washing Day*, now in the City Art Gallery, York, in which there is something of the bold outlining that he must have garnered from Gauguin's Cloisonist work.

If that was all there was to the slight tale of Paul Gauguin and Peter Studd, it would hardly merit our attention. The minor artists whose lives Gauguin touched would occupy a book of their own, but Studd was different and the encounter in Le Pouldu would result in one of the more surprising and least known twists in Gauguin's life – seven years later and half a world away.

## The Inner Circle

Despite the pleasant existence at Marie Henry's, Gauguin could think of little else but the longed-for letter from Charlopin telling him that his money was ready and that he could prepare to leave. Madagascar was once more the favoured destination, but who should go with him? Not Laval, he was too much the dilettante. He settled on Bernard and was somewhat surprised when the young man, having just read *The Marriage of Loti*, wrote back to propose that they should go to Tahiti. This was too much, even for Gauguin, who rather tartly pointed out that Loti had written a novel, not a guidebook. Unabashed, Bernard sent him a handbook on what was then known as *Les Établissements français*

*de l'Océanie*, a collection of scattered islands which included Tahiti, Moorea, the Leeward and Windward Islands and the Marquesas; it was one of a series of promotional guides produced for the Ministry of the Colonies under the direction of a Monsieur Louis Henriques. Despite its official status and its authoritative air, only one of the authors had actually been to the islands and it is significant that Loti was one of the sources acknowledged in the bibliography, which may be why the brochure waxed so lyrical about the beauty of Tahitian women. Overwhelmed by this bounty, it was easy for the reader to ignore the counterbalancing statistics which set out the high cost of imported goods, and warned that land was not easily available.

Gauguin chose to ignore such quibbles. He was now won over and he wrote to Schuff to tell him of the marvellous country where he intended to end his days 'with all my children'. He would, so he explained, get a free passage out from the Société de Colonisation and hinted that De Haan and Bernard would be going with him, while his family would join him later.

This was no sooner written than De Haan was removed from the equation when his family in Holland summoned him home. They may have got word that he was planning some mad voyage with the disreputable Gauguin and were concerned to ensure that their money did not get squandered on such an adventure. Or it may simply have been that De Haan now knew that Marie Henry was pregnant and that it was time to get out before he was trapped.

Either way it left Gauguin in deep trouble. There was no one to settle his bill at the Inn, thus leaving him more dependent than ever on Charlopin. Unable to pay for the rented rooms at the Villa Mauduit, Gauguin had to abandon the studio, and the shack next to the inn, where Filiger slept, was converted into a work space. Fortunately, Gauguin was in one of his open-air moods, preferring to work out of doors whenever possible.

At the end of July, he received the appalling news that Vincent had died by his own hand. Gauguin already knew that the Dutchman had moved from Saint-Rémy to Auvers-sur-Oise, west of Paris, to be near Dr Gachet, an old friend of Gauguin's, an art collector who was thought to be, like the Blanches, an expert in the mental illnesses of creative people. Unaware that the two men had not really understood each other, Gauguin had assumed that this was a sign of progress. On 27 July, an increasingly tormented Vincent had gone out to paint in the wheat fields above the town. He had taken a revolver with him, supposedly to scare off the crows, but instead he had turned the gun on himself. He died two days later, on the 29th, in the arms of his brother.

Gauguin's initial reactions in a letter to Bernard, sound cold and unfeeling, especially his comment that Vincent's dying was 'a great deal

of luck for him . . . the final end to his sufferings.' Later, when Bernard
tried to organize a memorial exhibition, Gauguin was equally cool, advis-
ing against the idea on the grounds that it would harm them all to
promote the notion that the new art could be produced by a madman.
Such a reaction is only comprehensible if one remembers how similar
the two men were, both isolated by the nature of their art, by poverty
and emotional loneliness. For Van Gogh to surrender, to have taken his
own life, must have terrified Gauguin who could only respond with a
sort of defensive indifference.

It was probably at this confused moment that Gauguin decided to
anticipate his departure for the tropics by painting the sort of exotic
beauty he had read about in Bernard's brochure. Of course he had no
real idea what he was going to find, so he simply used his memories of
Martinique to paint a lush tropical setting and for his Tahitian maiden
he used one of the statues of a naked Buddha in a photograph of a
Borobudur temple frieze that he had been given by Gustave Arosa,
slightly exaggerating the breasts to transform it into a woman. There
would have been nothing especially odd about this, except that the face
he gave his nude is strangely familiar – he had used a surviving photo-
graph of his mother Aline, taken when she was young and under the
protection of George Sand. There is a look of ineffable sadness about
her, an expression which evokes all the suffering she had known at the
hands of her crazed father. It may well have been that Gauguin, so near
to his departure from Europe, was also thinking of her namesake, his
own daughter Aline, for in the aftermath of Van Gogh's suicide a whole
gamut of confused and disturbing emotions had begun to surface.

The shock, when one recognizes that familiar sad expression, is con-
siderable. The figure reaches to pluck fruit from a tree, around which
the tempting serpent has wound itself, thus making her the *Exotic Eve*
of his title. There is something worrying about the figure's aggressive
nakedness, the way the pubic area is so clearly delineated, leaving her
fully exposed, with all the shamelessness that would have preceded the
Fall. There is a thesis that the picture represents his dream of Tahiti,
that it would be like a return to the world of his childhood in Peru,
when his life had been cocooned within the love provided by Aline, his
mother. Such a feeling may have been allied to a deep longing to keep
her for ever young and beautiful, the opposite of the rictus-hunched
mummy in the Trocadéro museum. There are also hints of the cycle of
birth, death and rebirth that he may have attempted earlier in *The Green
Christ*. Here, the figure is both Eve who brings about the Fall, and Aline
his mother, who gave him life and launched him on the path of suffering,
until now both as Christ and artist, he can, through his art, bring her
back to life once more.

## Crisis in Paris

That October Theo van Gogh sent a telegram announcing: 'Departure for tropics assured, money follows – Theo, Director.' Gauguin had no sooner begun to celebrate than word came from Paris that the poor man was now as demented as his brother. The money had been a figment of his fevered imagination; Theo was insane, probably as a result of syphilis.

Gauguin was furious, convinced he had been duped. The poor man would die the following January, less than six months after his brother, leaving a large collection of paintings which his successor, Maurice Joyant, had little hope of selling. By then, all except Filiger had left Le Pouldu and the two of them spent quiet evenings, Gauguin strumming his mandolin, the younger man a guitar. Gauguin would have left but he was unable to settle his debt and Marie Henry was disinclined to be forgiving about money. Then came the final blow: De Haan had stumbled into a major dispute with his family who were threatening to cut off his allowance, so that there was no hope from that source. Gauguin was trapped, and it was 'little' Bernard who finally saved him, organizing the sale of five paintings at 100 francs each to the Belgian poet and painter Eugène Boch who had known Van Gogh in Arles. Part of the debt could be paid while Marie Henry agreed to keep all the paintings in the inn as a surety for future settlement. Leaving Filiger as sole remaining guardian of the painted shrine, Gauguin left Le Pouldu for Paris, arriving at the end of the first week in November.

## An Elected Genius

He had now reduced all his schemes and fantasies to one clear aim – to get to Tahiti by whatever means. In this he was no longer disposed to tolerate any indecision among his associates. When Schuff continued to refuse to underwrite the plan, they quarrelled, though this time the worm turned and Gauguin found himself without a roof over his head. It hardly bothered him. He now had Georges-Daniel de Monfreid to take Schuff's place and moving into a tiny hotel at 35 rue Delambre, he simply commandeered Monfreid's nearby studio as his new headquarters. Geographically, Gauguin was well placed for the campaign he was about to undertake: the Rue Delambre ran into the point where the Boulevard du Montparnasse crossed the Boulevard Raspail, around which were the little streets with cheap lodgings and large rooms for artists' studios, while on the main avenues were the cafés and restaurants where poets and painters could meet, drink and talk. This small circle of the fourteenth *arrondissement* was to constitute Gauguin's Paris from now on, replacing

his former stamping ground north of the river, in the area around his birthplace near Pigalle and the Bourse further south.

Once settled into his hotel, Gauguin continued the process of elimination. When it became clear that Bernard was dithering about leaving, he too was written out, and as De Haan in Amsterdam was claiming to be ill or pretending to be so, in order to avoid the perils of fatherhood, Gauguin at last accepted that he was on his own. He knew Monfreid would never travel with him but at least he was useful in his role as the new Schuff. Monfreid's marriage was as rocky as Schuff's – he was currently having an affair with a seamstress, Annette Belfis, and she obligingly introduced Gauguin to a colleague, Juliette Huet, from the same workshop. Juliette was in her early twenties and was the first woman in Gauguin's life since Mette for whom we have a name. He can hardly have been unaware that she was following the same trade his mother had practised when she had taken up with Gustave Arosa, which does suggest that at forty-two he had found himself a living embodiment of the maternal Eve of his Tahitian fantasy.

Not that he saw the relationship with Juliette as anything other than a temporary affair. All his energies were now concentrated on a programme of self-advancement, aimed at raising the money needed to get him to Polynesia. The free passage to Tahiti promised in the brochure had not been forthcoming: the Colonial Department wanted farmers and businessmen, not artists, and Gauguin had been forced to accept that only by selling his paintings could he hope to raise the necessary cash, and for that he would need promoting in the press, if he hoped to whip up sufficient interest and thus some sales.

He was quite single-minded about it, religiously visiting those cafés and restaurants where he knew the Symbolist poets gathered. He could be a good listener when he wanted and had his first success at La Côte d'Or restaurant when, within weeks of getting back, he was introduced to a young writer called Charles Morice. Twelve years Gauguin's junior, Morice had attracted attention to himself with his first book, *Littérature de tout à l'heure*, in which he had advocated ambiguity as the basis for poetry. The thesis itself was not especially original, indeed it owed more than a little to the theories which the young man had heard Stéphane Mallarmé, the acknowledged leader of the Symbolists, expounding at his Tuesday evening soirées, though that was of little concern to Gauguin who had no difficulty in persuading Morice that this theory related perfectly to his own painting. The essential factor here is that both men quickly realized that they needed each other.

Despite his current popularity, due in part to his romantic looks and his dashing performances at poetry readings, Morice may have already sensed that he was never again to achieve such a position of eminence

as that first book had brought him. For his part Gauguin certainly recognized that the younger man had an entrée to many of the most important figures in the literary world. Morice later recorded how the two began to meet regularly and how shortly afterwards, at the Café Voltaire, the Symbolists' headquarters, Gauguin revealed his desire to go to Tahiti. 'But oh,' he sighed, 'I would need tens of thousands of francs.' He then went on to explain that the only solution was for him to hold an exhibition of his work from Martinique, Brittany and Arles. 'But for that I can see nothing better than a ringing article in a major journal, an article which could also serve as the preface to the catalogue, but . . . .' one imagines Gauguin lowering his eyes at this delicate point before adding: 'but an article by whom?'

He need not have worried. There were to be several further discussions as a plan was fully worked out, after which, some time in late December/early January, Morice engineered a meeting with Stéphane Mallarmé. This encounter between the leading Symbolist poet and the already notorious painter was a clear success. From then on Gauguin began to attend the Tuesday night gatherings at Mallarmé's apartment in the Rue de Rome. With Morice's help, he had done it, broken through to the inner sanctum where the great man held court, his precious words occasionally drowned by the noise of trains rattling into the nearby Gare Saint-Lazare.

Once again, it is the young Gide in *Si le grain ne meurt*, who has left us a graphic description of the atmosphere in what was partly drawing room, partly dining room. Somewhat overawed by the august figure, Gide records how Mallarmé would stand by the stove, a shawl over his shoulders, to deliver a little talk, always ending his observations with 'Don't you think so?', a ploy intended to convince his listeners that they had somehow been participants in a discussion instead of mere students. Older guests, like Henri de Régnier, were less cowed than Gide and found the soirées charmingly informal. If there were not too many guests, Madame Mallarmé would continue with her needlework, her daughter beside her, though she would leave if the room filled with smoke. At about eleven o'clock, she would return with some glasses of grog – there were no servants – as a nightcap, before everyone trooped off into the night.

In his account, Gide recalls the many people, including Gauguin, he saw on those Tuesday evenings, but there is one name missing – one searches in vain, in Gide and elsewhere, for the name of the composer who Mallarmé and his colleagues had decided was to be their musical Symbolist, Claude Debussy, Gauguin's fellow adoptee, the one-time ward of Achille Arosa. Three years earlier, the 28-year-old Debussy had returned from Rome where he had been studying, and where he had already set one of Mallarmé's poems, *Apparition*, to music. That and the

evident Wagnerian influence and impeccable literary source for his recent *Cinq Poèmes de Baudelaire*, had assured him of the support of Symbolist critics, a position confirmed two years hence, with the closest union of Symbolist poetry with music, his transformation of Mallarmé's major verse-drama, *Prélude à l'Après-midi d'un faune*. Most accounts of the collaboration between the two men have the heavily bearded and already corpulent Debussy, climbing the stairs to Mallarmé's apartment for the Tuesday night soirées. This, however, seems to be wrong – Debussy was pathologically shy and aside from work was not especially close to the poet. This would explain why the two 'stepbrothers' never met, though he and Gauguin would have found much in common. Indeed, it is strange that they never bumped into each other at the Universal Exhibition where Debussy had frequented the Javanese village, entranced by the Gamelan orchestra that accompanied the little temple dancers. Yet search as one may, there is no record that artist and composer ever met, at Mallarmé's or elsewhere.

For Gauguin, being accepted by so revered a literary figure was a sort of apotheosis and he responded by making a magnificent etched portrait of the great man, noble featured, left eye quizzically raised, while behind him, emerging from the shadows, is a black raven, the eponymous subject of Poe's poem and Mallarmé's best-known translation. Marllarmé's angular nose seems at one with the beak of the bird at his shoulder but overall it was a clever piece of flattery, and one which ensured that the Symbolists would act on the artist's behalf. In January of 1891, Morice visited Mallarmé and coyly wondered aloud who might write an article on Gauguin which could provide useful publicity and serve as the preface to the catalogue for his exhibition and sale. He was no doubt hoping that the choice would fall on Octave Mirbeau, the only one of the group to have access to the popular press through his occasional articles in *Le Figaro*, and Mallarmé duly obliged, writing to the poet in terms fulsome enough to engage his interest:

> One of my young colleagues who is a talented and kind fellow and who is a friend of the ceramic artist, painter and sculptor, Gauguin, you know who he is! has begged me to put to you the following request, as the only person in Paris capable of achieving anything. That rare artist, who, I believe, is spared few mercies in Paris, feels the need to be able to concentrate in isolation and virtual savagery. He wants to set off for Tahiti, to build a hut and live amongst what he has left of himself over there, to work afresh and become truly himself. He needs 6,000 francs for a few years until he returns. The successful sale of his current works can provide him with that sum. Except that what is required is an article, not on the sale itself, we are not talking about anything commercial. Just something to draw attention to the strange case of this refugee from civilization.

An early lithograph of Gauguin's portrait of
Stéphane Mallarmé, used to illustrate
Charles Morice's biography, published in 1919

Mirbeau was a shrewd choice on two counts, firstly because this was the
same Mirbeau who had once worked at the Bourse at the same time as
Gauguin but primarily because he did not know enough about art to
have any damaging opinions, while being sufficiently in awe of Mallarmé
to ensure that he would perform the task of trumpet-blower to perfec-
tion. A week later Morice took Gauguin to be interviewed by Mirbeau,
and all was arranged. Unfortunately, François Magnard, the editor of *Le
Figaro*, did not share this admiration and saw no reason to promote a
little-known artist of mixed reputation, and in the end Mirbeau had to
be content with publishing his piece in *L'Echo de Paris* – but it was full
of praise and it did appear a week before the sale and was seen by just
the sort of people who might be persuaded to attend.

As the day approached, an intensive round of literary socializing began.
On top of the visits to the Café Voltaire and the Tuesday night soirées
*chez* Mallarmé, there was a 'Symbolist Banquet' for Jean Moréas on 2
February at which Moréas dutifully hailed Gauguin as the leader of the

new Symbolist school of painting and three nights later there was a dinner with the Têtes de Bois literary group. It was soon clear that Gauguin was prepared to plead or flatter wherever and whomsoever he thought might help, on occasions presenting himself as a sound invest-ment, on others as a sort of artistic charity in need of support – whichever was most likely to achieve the best results. There was nothing sneaky or underhand in any of this, his manœuvring was so transparent even Pis-sarro, stuck out in the countryside, could write to his son in London that Gauguin had been trying to 'get himself elected (that is the word) man of genius, and how skilfully he went about it'.

## Madame Charlotte's Crémerie

In January of the new year, 1891, Gauguin had left the hotel for a more congenial, furnished room at 10 rue de la Grande-Chaumière – a short walk though a significant change, as the street was the epicentre of the Montparnasse artists' quarter. Number 10 was actually the Académie Colarossi, a ramshackle set of studios where artists and students could pay to use the models and receive a little tutoring if they wished. The Colarossi was not an atelier in the accepted sense, with a single famous artist teaching his pupils, but was more of an open facility, useful because of the high cost of hiring an individual model, especially if he or she was required to pose in the nude. That Gauguin was now living at the Académie suggests that he had been offered a room in exchange for a little part-time teaching.

The narrow street bustled with activity – Monday was the jolliest day when a 'model-market' was held on the corner with the Boulevard du Montparnasse, where a crowd of hopeful men, women and children, mostly Italian immigrants, would hang around waiting to be selected by the passing artists. It was a convention that if someone was expected to pose nude, they could be taken to the Colarossi and asked to undress for a quick inspection before any deal was finally struck. Many were known for their speciality roles – this one as an old Jew or that one as a young saint and no doubt Gauguin heartily enjoyed the carnival atmosphere. Opposite the Colarossi was his favourite restaurant, Madame Charlotte Caron's famous Crémerie, immediately recognizable by the two painted-metal panels which flanked the doorway. One was a painting of fruit by a Polish artist Wladyslaw Slewinski, the other, a woman with flowers, by a young Czech painter Alphonse Mucha who lived in a room above the Crémerie, thanks to the kindness of Madame Caron, who had taken pity on the struggling artist when his stipend from Austria had been unexpectedly withdrawn. Mucha was delighted to find Gauguin living near by – he was already a follower, having

enrolled at the Académie Julian in 1888 just as Sérusier returned from Pont-Aven with the *Talisman*, and while Mucha had not joined the Nabis, he had adopted elements of the new Cloisonist style. This would eventually be transmuted into the sinuous Art Nouveau line and bold colours of his now famous posters, the swirling, dramatic images of Sarah Bernhardt, the intricate figures on the advertisements for JOB cigarette papers, the most immediately recognizable emblems of turn-of-the-century Paris.

These major commissions were then three years away, and when he and Gauguin first met, Mucha was struggling to survive, dogged by misfortune. When he had joined the Vienna opera as a set designer the theatre burned down, and the patron who had paid for him to get to Paris had cut off funds when he failed to keep in touch. With no money, he had moved from the Académie Julian to the Colarossi and was now surviving on Madame Caron's charity and lentils – a diet which had just begun to affect his health when he was saved by his first small commission from *Le Petit Français illustré*. But while he was glad of the money, he was less happy to be branded an illustrator. Mucha had ambitions to be a painter on an epic scale and was more than happy to have Gauguin on hand to remind him that it was fine art and not commercial art that was central to his life. It was an odd relationship – Mucha was rather prudish and disapproved of Gauguin's drinking and womanizing, but he could overlook these for the pleasure of joining the other students from the Colarossi in the little dining room of the Crémerie to listen to this 'violent savage' as he dubbed him, holding forth on art. No doubt Gauguin felt he had to oblige: he clearly drew a crowd to the restaurant and this was an easy way to pay back the somewhat portly Charlotte Caron, who presided over 'her' artists like a dowager, unsuitably dressed in brightly coloured floral gowns. The space for dining was tiny – no more than about ten people could sit down at one time – but the meals cost only a franc, or a franc fifty, coffee was included and the walls of the little room were covered with paintings, offered in repayment for meals. The atmosphere was jolly and anyone who shared the milieu would always recall the moment with affection. And nothing better illustrates the extraordinary breadth of Gauguin's influence than to see him, at table, the young students hanging on his every word, especially the young Alphonse Mucha, who would one day be the most famous of them all. Because of the success of his posters, we tend to overlook the fact that in his native land, to which he returned in the new century, Mucha is best known as the creator of the vast mural series *The Slav Epic*, the great work of Czech mythic and racial nationalism that Mucha believed had been the ultimate purpose of his life. After the First World War and the collapse of the Austro-Hungarian Empire, Mucha single-handedly

created an entire visual imagery for the new Czechoslovak state: every-
thing from banknotes, to stamps, to the interiors of Prague's leading civic
buildings. The grandeur of this national enterprise, with its muscular Slav
heroes and courageous peasant matrons, makes it easy to overlook how
much the bold powerful style in which they are represented owes to
the firm outlines and pure colours which Gauguin bequeathed to his
followers.

## The Loss of Virginity

With all this socializing and politicking, it is hardly surprising that
Gauguin had had little time for painting and it may have been more a
desire to keep his hand in than anything else which prompted him to
apply for permission to copy Manet's *Olympia* which was then hanging
in the Luxembourg. Whatever the initial reason, the choice of painting
was no accident. It was standard practice at the time to learn by copying,
but in this case there was as much a sense of challenge as emulation in
Gauguin's desire to come to terms with this key work. More than any
other, more even than *Le Déjeuner sur l'herbe*, *Olympia* was the one paint-
ing that had transformed the otherwise rather staid Manet into a hero-
figure of the avant-garde. The noise surrounding Seurat's *Grand Jatte*
had been a mere echo of that original scandal in 1865, since when it had
become a virtual necessity for young artists to attempt to surpass that
shocking moment. In his own eyes, Gauguin had never succeeded in
this. His quiet success, the way he had slowly entered the consciousness
of the avant-garde, until he gradually came to achieve the same sort of
notoriety, was lost on him. He still yearned for the big outrageous
moment, the fury and the combat, and with this in mind, Olympia,
reclining on her couch, impudently staring back at him, remained the
ultimate challenge.

   In the end he spent no more than a week working in the actual gallery,
completing his version, slightly smaller than the original, with the aid
of a photograph. The result was reasonably accurate, though without
the variety of tones in the colours which Manet managed to work even
into his blacks. Gauguin seems to have been more concerned with
Olympia herself, the representation of Victorine Meurent, Manet's
eighteen-year-old model, who from her first appearance had come to
embody those tens of thousands of Parisian girls hovering on the poverty-
line, the laundry-women and serving girls, the shop-assistants and seam-
stresses – like Juliette Huet and Aline Gauguin before her. The
connections were uncanny – Victorine Meurent's father had, like Aline's,
been an engraver, while the black maid in the painting could only have
reminded Gauguin of his childhood in Lima. But merely copying the

painting was hardly an adequate response to the challenge. To lay these demons Gauguin would have to make his own Olympia and, having finished the Manet, he immediately took another canvas, exactly the same size, and set to work.

Juliette was the obvious model, but she was reluctant to pose in the nude and was only persuaded with difficulty. Once work was under way, it was the similarities with the Manet which were most obvious – Juliette lies, stretched out full-length like Olympia, her feet crossed in an identical way – yet as work progressed it was the differences which came to matter most. While Olympia reclines in her boudoir, mistress of her confined world, dominating the space she occupies, Juliette was laid out on a grassy hillside overlooking a valley, somewhere in Brittany, exposed and vulnerable. Where Olympia stares back at us, assured and unblinking, Juliette has her eyes shut, presumably asleep, but with echoes of Bernard's painting, *Madeleine in the Bois d'Amour*, which in turn was based on the tomb sculptures in the nearby churches, and thus hinted at death.

No doubt eager to please his new associates, Gauguin decided to make this the most overtly Symbolist of all his paintings – though there would be nothing artificial about the inner meanings he added to the work, all of which reflected his relationship with the subject, some in quite disturbing ways. At Juliette's head he painted a fox, resting a paw on her exposed breast, its narrowed eyes studying her. Once again we have his 'Indian symbol of perversity', though in Brittany the fox was also thought to represent sexual power and renewal. Either will do, for there was no denying that even while Gauguin was making love to Juliette, he was planning to abandon her, while the original title of the painting, *The Loss of Virginity*, suggests that he was her first lover, an interpretation reinforced by the white flower, spotted with red, which she holds in her hand – a detail probably taken from Puvis de Chavannes's painting *Hope*, a reproduction of which Gauguin still kept with him – though where Puvis's flower symbolized something positive, Gauguin's blood-flecked blossom suggested only the loss that is proposed by the title. We can see this again in a group of figures wending their way along the valley path in the background, a wedding party processing towards the waiting figure, unaware that they will be too late to collect a virgin bride.

He must have known that Juliette was two months' pregnant when he painted her, though he would not have shown it in the painting, even if it had been more evident, for he was hardly painting a woman at all, only a girl slightly beyond the moment of ambiguity, but only just. The advent of their baby ought to have put an end to his plans to leave. He knew what had befallen the model for *Olympia*, for he could hardly have missed seeing the hunched form of the aged Victorine Meurent, her face

ravaged by alcohol and prostitution, sitting on the steps of the Palais des Beaux-Arts at the Exhibition of 1889, begging for coins from the visitors entering the show where the now celebrated portrait of her was on display. So what then of Juliette who would be left to have a baby with no one to care for her?

Perhaps that is why he changed the title of the painting to the more neutral *L'Eveil du Printemps* (*The Awakening of Spring*), unless he was being cruelly sarcastic, which was always a possibility. Though if he was worried that a suggestion of virginity and seduction might damage his reputation he needn't have been concerned – after only a single, brief public showing, the painting was bought by the homosexual Count Antoine de la Rochefoucauld, who was no doubt drawn to the thin, near-androgynous figure, much as he was to Filiger's delicate Breton boys and doe-eyed angels. Because the painting remained locked away in the Count's private collection until 1947, its importance in demonstrating the complexity of Gauguin's sexual make-up was not realized until recently – only a single preliminary sketch entitled *Bust of a Young Girl with a Fox* was known to exist, though this conveyed nothing of the pubescent eroticism of the full-length painting.

## Sexual Flowers with their Tempting Convolutions ...

Gauguin gave the sketch to Octave Mirbeau, in gratitude for his article, which appeared in *L'Echo de Paris* on 16 February. This was reprinted in the catalogue for the exhibition at the Hôtel Drouot auction house, on 22 February, prior to the sale which was held the following day. Even Gauguin must have been somewhat embarrassed by Mirbeau's gushing prose which described how, as a young man, Gauguin had signed up as a sailor in order to spare his impoverished mother the cost of his school fees. Later, amidst the tumult of the Stock Exchange, Gauguin had discovered a 'heart-rending love of Christ, a love that would later inspire his most beautiful canvases'. Of course there is the possibility that Mirbeau got all this from Gauguin himself, but even so, he had written it up in the most romanticized way imaginable and not content with one article, he followed it two days later with a second in *Le Figaro* which, though blessedly short at the editor's insistence, was if anything even more unctuous. 'And I also experience,' burbled Mirbeau, 'a profound joy in holding in my hands, turning this way and that, one of the miraculous pottery pieces, one of his surprising firings: tangible poems, with their unexpected oxidations, their rich and muted colorations blending into one another, in flows of tawny gold, mineral red, poisonous green; vases, goblets, symbolic groups, hallucinatory statuettes, sexual flowers

with their tempting convolutions, whose forms, so new, so bold, so harmoniously combined, bend to the whims of the imagination and dream of a poet who has seen everything, mourned everything.'

In later life, Mirbeau frankly admitted that he had not even liked Gauguin's work, and had only written the article to please Mallarmé. It had all been nothing but a public relations exercise, though Mirbeau was not alone: Morice even managed to persuade Roger Marx in *Le Voltaire* to review the works two days before the exhibition even opened. At the sale itself the Symbolists rallied round, with some of them bidding to keep prices up, while buyers included de la Rochefoucauld, Roger Marx and even Degas. Apart from one canvas, which Gauguin was forced to buy himself, having kept up the bidding to stop it selling too low, the paintings attracted bids of 250 to 900 francs. These were similar to the sums Theo van Gogh had been getting at Boussod et Valladon, and the total of 7,350 francs, after expenses, was better than any of them could have expected – though Gauguin cautiously informed Mette that the whole thing had been more of a 'moral success' than a financial one.

The only sour note in the whole affair was the appearance of Emile and Madeleine Bernard at the exhibition on the day before the sale, both of them livid with rage. Emile had been at the Moréas dinner on 2 February, and had heard the poet's speech heralding Gauguin's leadership of the Symbolist painters. To Bernard's fury there had been no reference to his role in creating the new art and now here was Gauguin exhibiting alone. Why, Bernard asked, had not he, the original inventor of Synthetism, been invited to share the glory? Madeleine was even more direct: 'Monsieur Gauguin,' she began coldly, 'you have broken your pledge and are doing the greatest harm to my brother, who has been the true originator of the art which you now claim for yourself.'

It was a quarrel which did not end there. Following the sale Albert Aurier published an article in the *Mercure de France* entitled 'Symbolism in Painting: Paul Gauguin' which publicly proclaimed what Mallarmé and the others had already decided in private, that Gauguin was now their chosen Symbolist painter. According to Aurier, the *Vision after the Sermon* was the Symbolist work par excellence and, while he was more aware than Mirbeau of what was happening in painting, his words were equally effusive: 'With this gift, complete, perfect, absolute art exists at last . . . and our idiotic society of bankers and polytechnicians refuses to give this rare artist the least palace, the meanest national hovel wherein the sumptuous mantles of his dreams may hang!'

One doubts anyone really understood what all this meant, let alone took it seriously, save the aggrieved Emile Bernard. Aurier was supposed to be a friend of his; it was after all Bernard who had introduced Aurier to Gauguin, yet here he was, treacherously setting down a description

of the birth of pictorial Symbolism, effectively an official record of it, without any mention of him or his painting, without which Gauguin could never have painted the *Vision* – or so Bernard argued. He was to go on doing so, in letters and articles, from that day forth. As his work slipped into obscurity, as he concerned himself more and more with a private Catholic medievalism, gradually disappearing from public view, he went on making ever more vehement claims that an art, which he had by then rejected, nevertheless owed its origins to him.

At first, Gauguin tried to appear indifferent. Bernard was no longer going to accompany him to Tahiti, and had ceased to exist. Gauguin had now accepted that he would have to go alone, but first there was the family in Copenhagen which he had not seen for six years.

## Bonjour Papa

Mette was waiting at the station with Emil and Aline. Gauguin was shocked by how tall the boy was, while Aline, although only thirteen, was already an elegant young woman, taller than her mother, who was now stout and grey-haired. The next revelation was less pleasant – he was to stay at the Dagmar Hotel in the Vestre Boulevard. Mette was taking no risks of a further pregnancy and while Gauguin may have felt this to be an affront to his conjugal rights, there was nothing he could do about it. After they had left his luggage they took a carriage to Mette's new apartment where it was immediately clear that despite her complaints, she was managing very well. On top of her work translating Zola, she still had several well-placed pupils, one of whom was the son of Reinholdt Jorck, a speculative builder who had bought up large tracts of central Copenhagen, and who had arranged for Mette to have a flat on the corner of Vimmelskaftet and Badstuestraede on 'The Stretch', the long winding highway which ran from the City Hall down to the Royal Danish Theatre, effectively the hub of the city. Part of its length contained some of the smartest shops and apartments, and Mette's block on Vimmelskaftet came at the point where the street was given over to cafés and amusements. Just near the entrance was a Freak Show featuring Ramasama the human dog, Count Vasiloff the Cossack giant and Count Dummerling the world's smallest man, while Viola the giantess competed for attention with the Half Lady (she had no bottom half) as well as a mermaid, a snake charmer and a Fakir.

Once past the door, it was a surprise to Gauguin to find a spacious hallway and a light wide stairway leading up to a large corner drawing room which looked out over what he could guess was one of the better parts of the city. Beyond the three-sided room was a large dining room and, as well as rooms for the children, a writing room for Mette and

accommodation for the maid. The place was decorated with the best of the things he had bought during the stockbroking years and the walls were hung with the art collection he had built up – works by Guillaumin, Pissarro, Cézanne as well as many of his own earliest Impressionist pieces. For all her complaining letters, there was now no denying that Mette was living in considerable style.

But this was only of fleeting concern to Gauguin, whose attention was entirely directed towards his offspring, as they lined up to meet him. He was appalled to discover just how great was the distance between them – they were now little Danes with few traces of any Frenchness left. The youngest, Pola, could barely say '*Bonjour Papa*' and must have been rehearsed to say even that, while Clovis was so shy of this odd-looking stranger, he could not say anything at all. Despite his sadness at such evidence of his long absence, Gauguin had to admit that they had been well brought up, Mette had used all her contacts to ensure that they had a better education than her limited means would normally have afforded them. Emil was still being sponsored by the Moltkes who had paid for him to attend the Soro Akademi, the oldest and most celebrated school in Denmark, and was now waiting to go to the Polytechnic. The three youngest had gone to an excellent private school run by Emil Sloman, a noted educationalist who much admired Mette. Only Clovis, the one who had been so close to his father, had had any problems at school. It may have been the bizarre life he had led in Paris with his father which lay at the root of his difficulties, though Gauguin also suspected that Mette's indifference was one of the main causes. Whatever the reasons, Clovis had been removed from school at eleven and apprenticed to the Titans Machine Factory. It upset Gauguin when the boy came back that evening as dirty as a blacksmith and he was hurt by Mette's not unreasonable request that he should sign papers relinquishing Jean-René's French citizenship so that the boy could join the Danish Navy. Despite the fact that his son was trying to follow in his footsteps, Gauguin was annoyed by this further proof that his family would now be com-pletely Danish, when he had continued to nurture the illusion that as soon as his finances were more stable, he would simply call them to him in France and restart his married life.

The only thing that truly pleased him was the beautiful Aline. She had been attending a school for upper-class girls run by Mette's cousin Elizabeth Gad and even as a teenager she had all the grace of a *soignée* young woman. Better, she was unaffectedly happy to see the father she had not known since she was eight. She slept in a room surrounded by his mysterious art, deeply hurt whenever she overheard her Gad relations criticizing the man she secretly worshipped. Gauguin revelled in her love, though he could see that it was hard on Mette to be the strict

parent when there was this absent figure forever claiming her daughter's affection.

It was obvious from the start that if he still hoped to preserve some semblance of a marriage, after so long an absence, he would have to come to an accord with Mette. Yet she now showed every sign of being entirely independent. 'She was not gracious,' their son Pola wrote. 'When she walked her feet were splayed out to either side so that she could easily have been taken for a man. She expressed herself forcefully in a Jutland accent with its open vowels and strong consonants, like a man, without any of the feminine modesty expected at the time.' He also noted that she drank very strong tea and that her cigars were larger than ever. Mette and her sister Emma had joined the Women's Reading Union, a proto-feminist group, though Pola insisted that his mother was not really interested in the political side of the organization and went more for the social life. He recounts how at one meeting, a member of the Royal Family, the Princess Maria, went up to Mette and said: 'It is obvious from your hairstyle that you are part of Denmark's Feminist movement.' To which the close-cropped Mette is said to have retorted: 'Your Royal Highness is mistaken, my hair is cut to display the shape of my beautiful head to advantage.'

There was, however, another side to Mette's life which might have brought her closer to Gauguin. Near the entrance to Mette's block was the Bernina Café, one of the main meeting-places for the city's artists and writers. After moving into her apartment, Mette had started frequenting the place, probably accompanied by her Brandes in-laws, though later by the poet Holger Drachman with whom she had a close friendship. As she got to know more and more people there, she occasionally invited them to visit her and this gradually progressed to the point where Mette was effectively running a major salon, with leading members of the Danish intelligentsia climbing the stairs to her drawing room, having first bought a bottle of something at the Bernina. Of course, the setting was perfect; her home was, after all, a gallery of avant-garde French art, a fact much appreciated by the young Danish painters who had little chance to see the sort of work they were hearing so much about. In this way, Mette-Sophie Gauguin came to play a distinct and important role in the evolution of Danish modernism, quite independently from her husband. Some of this grew out of her continuing French lessons which drew in young people who would later become prominent in Danish cultural life. Mogens Ballin, who did much to introduce progressive Parisian art to Copenhagen, was one such and he in turn introduced the nineteen-year-old Ludvig Find who was inspired to become a painter himself by his amazed encounter with the works hung so casually about the walls of Mette's apartment: Cézanne's *Zola's Villa*,

Guillaumin's *The Garden*, Gauguin's still shockingly realistic portrait *Nude Study, Suzanne Sewing*. As late as 1942, although by then an old man, the author Otto Rung vividly recalled the awe mingled with affection in which Mette was held in artistic circles. Everyone, Rung wrote, loved her high spirits and delighted in the fact that she always chose to sit in the smoking room with the men, 'entertaining everyone with her gay remarks', though all the ladies would 'shout for Mette to come back to their circle' only to be somewhat shocked by her bold language. Rung's conclusion is fascinating: 'She was,' he wrote, 'the universally adored *enfant terrible* of that snob-ridden, tight-laced era of tasselled curtains and bric-à-brac . . . one of the heroines of that over-decorous, over-decorated age, one who struggled to feather the nest where a fledgling generation would grow into fine, and free artists in the time to come.'

Mette was also close to the painter Theodor Philipsen whom Gauguin knew from his earlier visit and whom he had seen again in Paris at the time of the Volpini exhibition. Philipsen was invited in 1889 to tea at Vimmelskaftet, another shrewd move on Gauguin's part as the Danish artist was to become one of his principal supporters and the man largely responsible for Gauguin's first critical success outside France.

There has been a tendency to view Mette unsympathetically as something of a mannish harpy, utterly out of sympathy with her husband's ambitions, yet in her homeland she is remembered for having assiduously promoted him, caring for his works, framing them even though she had little money and approaching anyone who might be persuaded to display them. Of course she had a financial interest in getting them known and sold, and Gauguin was constantly accusing her of grabbing what he believed was rightfully his – conveniently overlooking the fact that it was she who had the unaided task of paying for the upkeep of their five children.

One would have thought that this unexpected side to his wife might have brought Gauguin closer to her during that brief week in Copenhagen and he certainly convinced himself that his dream of an eventual re-establishment of their marriage was still intact. But despite this community of interest, Mette was now too much her own person to be able to accept the role of dutiful wife again. Nor can he have been unaware of the difficulties involved in trying to relaunch a physical relationship with this strange, mannish figure. He did persist, but there can be little doubt that it was now mainly for Aline that he wished to preserve whatever links still remained. Aline had something of her grandmother and great-grandmother about her, which showed in her hatred of the strict religious atmosphere at her school and her longing for the sort of free life she imagined her father was leading. He was warm and emotional,

where her mother seemed cold and northern, and during that week she made such feelings clear, telling him that one day she would marry him.

Mette tried hard not to feel bitter at these somewhat unfair displays of affection towards a man who had done nothing for his children for eight years. She decided to look on these signs of tenderness between father and daughter as evidence that her marriage might still have a future. On the occasions when Gauguin talked about their joining him in Tahiti, she said nothing, thus leaving him with his illusions intact. When he boarded the train for Paris, they parted as friends.

## Paradise Beckons

Charles Morice, meanwhile, had been using his contacts to pressure the Ministry of Public Instruction and Fine Arts into issuing a letter stating that Gauguin would be in Tahiti on a *mission officielle*. There would be little financial benefit apart from a thirty per cent reduction on fares aboard government-sponsored shipping lines, but such a letter would ease any dealings with colonial officials, who would treat the bearer with more respect if they imagined that he had come with the backing of the government. Morice had again contacted Mirbeau who knew the politician and journalist Georges Clemenceau from meetings at the home of Edmond de Goncourt. Clemenceau had always had a wide circle of literary and artistic friends which had included Zola, Manet and Monet and was disposed to help progressive artists where possible. As the leader of the Radical block within the National Assembly, Clemenceau had no direct political position, but his ability to bring down governments was legendary and it would have been a foolish administrator who ignored a request from so difficult a source. Gauguin himself was not without useful connections. There were the well-placed associates of the Arosas, as well as the contacts he had made himself during a varied life. These included the painter Ary Renan, a follower of Gustave Moreau and an admirer of Gauguin's supposed Symbolism. Renan was trying to establish his own avant-garde group, yet another of the many post-Impressionist movements, and along with Jacques-Emile Blanche and Charles Angrand he had launched Le Groupe des 33 at the Galerie Petit. Of more use to Gauguin was Renan's ancestry, for he was of course the son of that same Ernest Renan who had been Plon-Plon's guest aboard the *Jérôme-Napoléon*, and also a great-nephew, on his mother's side, of the distinguished history painter Ary Scheffer, after whom he had been named. Both these forebears gave the younger Renan easy access to the cultural bureaucracy and when he too was persuaded to write to Gustave Larroumet, the acting director of Fine Arts within the Ministry of Public Instruction, this and Clemenceau's intervention were sufficient to stifle

the director's natural inclination to tear up the application. Gauguin and Morice were summoned, a dangerous moment given Gauguin's usual appearance and behaviour. Fortunately, it could not have escaped Larroumet that all he was being asked to do was help exile this scruffy Bohemian to an island on the other side of the planet. He swallowed his pride and agreed, and even added, unprompted, that he would recommend to the Minister that the government should buy a picture for 3,000 francs upon his return.

Outside on the street, Morice was overjoyed at their success, but he quickly saw that Gauguin was silent and morose. Worried, Morice hurried him into the back of a nearby café where Gauguin suddenly broke down and began crying. Worse, he suddenly exclaimed 'I have never been so unhappy' and proceeded to talk about Mette and the children and how he had failed to support them. Pulling himself together a little, he said he needed to be alone and got up to go, leaving the astonished Morice to reflect on the inner turmoil which Gauguin's apparent self-assurance and blunt arrogance had been trying to mask all along.

In the end he rewarded Morice with a loan of 500 francs and appointed him his business manager while he was away. He had to buy supplies of canvas and oil paint, and new clothes for the Tropics and then there was the pregnant Juliette to be taken care of. He decided to settle the matter with a straightforward lump sum, renting her a room in the Rue Bourgeois near to Monfreid and buying a sewing machine so that she could follow her trade while taking care of the child. All that, as well as the two-thirds price of the ticket from Marseilles to Tahiti, took up about half the proceeds of the sale, leaving him with something like 3,000 francs for what he hoped would be three years in Oceania. But at least he had got what he wanted and was free to go.

The Symbolists gave him a farewell banquet at the Café Voltaire on 23 March, at which Mallarmé presided, proposing a toast in which he declared his admiration for Gauguin's search 'for renewal in distant lands and deep down into his own soul'. There were poems and more toasts, and further speeches and more toasts, and a recitation of parts of Mallarmé's translation of Poe's *The Raven* and more toasts. So that all Gauguin was able to say, when his turn to reply came, was how much he liked them all and how he would like to propose a toast to them and to works to come.

A week later some of these same friends helped carry his baggage to the Gare de Lyon. There was a shotgun for hunting the plentiful game he had read about and a French horn, two mandolins and a guitar, so that he would be able to join in with the music-loving natives. As for his art, he was not leaving everything to chance but had also packed what he referred to as 'an entire little world of friends', the extensive

collection of photographs, postcards and reproductions he had built up over the years and a rich source of imagery if all else failed. Before the train pulled away, he handed Monfreid some photographs of himself, to be passed on to his friends. One was for Juliette.

The following day in Marseilles he boarded the *Océanien*, with a second-class ticket bought at the reduced rate allowed to those on official business, having first sent Mette a note promising that upon his return he would marry her again and ending with a 'betrothal kiss'. It was the ultimate delusion, greater even than the affair with Charlopin, about whom nothing more was ever heard, or any of the other schemes and dreams that had littered his journey through life. When he had been with her in Copenhagen, Mette had been unsure of her own mind. With him gone there was only the conviction that she had been wilfully abandoned yet again. When she eventually heard of the successful sale of his paintings she was furious that she had received nothing and that he had tried to hide the truth from her.

Watching the *Océanien* make ready to leave, Gauguin had no inkling of her change of heart. As he stood on deck 'staring stupidly at the horizon' he did not know that when he had kissed his wife and children goodbye that March, it was for the last time, and that he would never see any of them again.

# 9

♦

# Hina, Goddess of
# the Moon

On 7 April 1891, a week after leaving Marseilles, the *Océanien* steamed into the Suez Canal, docked briefly at Aden, then continued on to Mahe in the Seychelles where the passengers were allowed to disembark. For the most part these were government servants travelling with their families to the various colonial outposts in Oceania ruled by France, and while they were, in Gauguin's words, 'utter mediocrities', he balanced his judgement in his first letter to Mette by saying that they weren't so bad after all. His only real reaction was to grow his hair long, very long, presumably to emphasize his artistic otherness, and to irritate his respectable fellow travellers, a harmless enough sport.

That aside, he kept himself to himself, staring vacantly at the horizon, with nothing to break the tranquil monotony save the porpoises jumping out of the water as if to wish him good morning. The one irritation was that he felt he had wasted money on a second-class ticket when the third class appeared to be just as comfortable. There was also a nagging worry that he might get stuck in Noumea in New Caledonia, where he was due to change boats, for it was only after the *Océanien* had left Marseilles that he learned that there was no regular service between Noumea and Tahiti and that if he was unlucky, there might be a long wait before a boat appeared which would call at Papeete.

When the boat called in at Melbourne and Sydney he was struck by the fact that while barely fifty years old, both cities already had over half a million inhabitants, with twelve-storey houses, steam trams and cabs 'exactly as in London. The same smart clothes and abounding luxury.' He had to admit that 'the English people have truly extraordinary gifts for colonizing and running up great ports.' But having said that, he still concluded that it was all 'a burlesque of the grandiose'.

It was the same contradiction which struck him after he had disembarked at Noumea on 12 May. He noted how the officials and their wives were able to lord it in their carriages on their colonial salaries but

that the richest people were the ex-convicts who had been shipped out
to New Caledonia and who, after serving their sentences, had made
fortunes in commerce; an irony not lost on Gauguin who commented
to Mette that he was 'truly envious of the results of committing crimes'.
That said, Noumea was 'very pretty and amusing' – a blow to the notion,
often found in books about his first journey to the South Seas, that from
the outset he experienced nothing but disappointment. Even his fears
about being stranded were quickly allayed when his official letter
prompted the authorities to arrange passage for him aboard a naval
vessel, the *Vire*, which would take him to Tahiti almost at once, and for
only 60 francs. Even there he was lucky, as the *Vire*'s Commandant
Dupré allowed him to have one of the officers' cabins and invited him
to dine in the mess. The only drawback was that the *Vire* was old and
had to make a somewhat circuitous route to avoid the strong west winds,
which meant a further eighteen days before he saw Papeete, Tahiti's
capital and only town. Fortunately, the company was more agreeable
than that aboard the *Océanien* – two of the ship's officers had once sailed
with a Captain Gad, who Gauguin felt sure must be Mette's cousin. As
for his fellow passengers, they were mainly French military, a detachment
of thirty marines with three non-commissioned officers below decks with
three further soldiers on leave, a police officer and his wife, and a Miss
Fanny Faatauria, whom the notice of landing simply describes as a
Tahitian, a somewhat isolated position amongst all those French people.
The principal passenger was a marine captain, Swaton, travelling out to
take command of the garrison on Tahiti, who was able to overlook
Gauguin's extraordinary appearance, so that the two struck up a friend-
ship during that somewhat tedious fortnight in the southern seas. There
was nothing too surprising about this. Gauguin had been in the navy
and had seen active service. His friendship with the Zouave Milliet in
Arles shows how easily he got on with soldiers, and in any case Swaton
appears to have been a fairly open-minded person. When Gauguin
painted his portrait two months later, the captain let himself be dressed
up like a brigand wearing a large floppy Bohemian hat and wrapped in
a shawl – hardly the sort of thing appropriate to the military commander
of the island, but well suited to Gauguin's impression of him as a sort
of honorary fellow-artist.

   With New Caledonia behind them, Swaton and Gauguin were now
entering the vast emptiness of Oceania, a watery expanse as large as
Europe and Asia, barely dusted with pinprick islands occupied by people
of similar culture and – though there was still much debate as to where
it might have been – of the same origin, probably in South East Asia.
These seafaring nomads were now isolated within their island clusters,
but the similarities of language, art, religion and social structure still

seemed greater than the differences. In New Zealand the people called themselves *Maori*, in Tahiti *Maohi*, and their ancestral myths had too much in common to be ignored. For want of anything more precise the region was called Polynesia or 'Many Islands', occupying an ocean triangle with Hawaii at its peak and with sides an awesome 4,000 miles long, stretching westwards down past Fiji to New Zealand, then across the 4,000 miles to Easter Island then back north a further 4,000 miles to Hawaii again. Within this triangle was an area the size of Western Europe and at its heart were the Society Islands with Tahiti at their centre. Around this point were grouped Samoa, Tonga and the Cook, Austral and Marquesas Islands, each of which, before the coming of the Europeans, had been sealed off from its neighbours, its people convinced that their home was the limit of a universe of which they were the only inhabitants.

The European influx had done nothing to unify Polynesia, for the different powers had swooped on clusters of islands taking them for their own. Thus the *Vire* was streaming towards what was then known as *Les Établissements français de l'Océanie*, which at that time consisted of a firm base on Tahiti and its immediate neighbours, principally the island of Moorea with further claims, though less control, over the outer Leeward Islands such as Huahine, Raiatea and Bora-Bora. Added into this somewhat artificial collection were the distant Marquesas Islands, 750 miles north of Tahiti, a full five days' sea voyage at that time. Many of these outer islands were desolate places, French in little but name. Tahiti alone had any sort of European life based on its tiny capital Papeete, the one town in the entire group.

For someone planning to stay at least three years, Gauguin's ignorance of what he would find on Tahiti was almost total. He certainly had no idea about what constituted Polynesian culture and even after being on the island for some time, continued to refer to the Tahitians as Kanakas, a word picked up by whalers in Hawaii and spread, wrongly, around the other islands they visited. One suspects that even the most petty-minded colonial administrator, with little regard for the natives under his control, would have taken more trouble to find out about them than Gauguin did.

It is probable that Gauguin had his first sight of the outer islands on 7 June, the day of his forty-third birthday, which he can only have taken for a good omen. From then on it was only a short wait, glued to the deck-rail, before the first sighting of Mount Orohena, the long-dead volcano which dominates Tahiti Nui, the larger circle of the figure-of-eight-shaped island, linked to its smaller sister Tahiti Iti by the isthmus of Taravao. From the sea, things looked much as they had to the first European travellers in the eighteenth century: white surf on the coral

reef beyond which lay the glittering lagoon and thence the narrow coastal strip at the foot of the mountain, covered with palm, pandanus and hibiscus, amongst which nestled the traditional oval palm leaf and bamboo dwellings. The beauty of this view was legendary, prompting rugged seafarers to flights of poetry. The earliest French visitor, Bougainville, dubbed the island the New Cythera, in honour of the Goddess of Love and even the normally taciturn Captain Cook spoke of being 'imparadised' by what he saw. If Gauguin was reticent in his account of his first sight it was probably more because he was trying to restrain his enthusiasm, than from any true lack of appreciation for that vision of loveliness. Certainly, there was little to spoil the view on that morning of Tuesday 9 June, for when the *Vire* negotiated the danger-ously narrow gap in the reef and safely weighed anchor in the lagoon, Papeete was still hidden behind a screen of flame trees in full scarlet blossom. Having been rowed ashore and made his way up the beach, Gauguin was too distracted to make any judgement about his new home. For one thing all the people he passed on the beach were quite openly laughing at him. He knew his long hair, hanging below his cowboy stetson, made him look strange, but he had no idea why it should cause such wholehearted mirth among the groups of fishermen standing by their outrigger canoes or the women on the seafront dressed in their shapeless Mother Hubbard gowns. Perhaps appropriately, Gauguin's first encounter with the people he had travelled so far to meet, was marked by total, if hilarious, incomprehension.

The story of what was actually happening is best left to a young French marine officer, Lieutenant P. Jénot, who had come to welcome Captain Swaton and was thus the first person to greet Gauguin on Tahiti:

> I brought the captain and M. Gauguin to my quarters to tell them the indispensable things anyone new to the island should know right away, and that was how I first met Gauguin.
>
> Let us say right away that as soon as Gauguin disembarked he attracted the stares of the natives, provoked their surprise and also their jeers, above all from the women. Tall, erect, a forceful figure maintaining, despite his already awakened curiosity and, no doubt, anxiety about his future work, an air of profound disdain. He contrasted with his neighbour the captain, who was a little smaller with a slightly heavy figure, easy-going, and a little hunched over. They must have been about the same age, in their forties, but what focused attention on Gauguin above all was his long, salt and pepper hair falling in a sheet on his shoulders from beneath a vast, brown felt hat with a large brim, like a cowboy's. As far as the inhabitants could remember they had never seen a man with long hair on the island – except for the Chinese, who did not wear it the same way – also, that very day, Gauguin was renamed *taata vahine* (man-woman), which the

natives made up ironically, but which provoked such interest among the women and children that I had to chase them from the entrance to my cabin. At first, Gauguin laughed when told of this, but after a few weeks, with the help of the heat, he cut his hair in the same style as everyone else.

What Jénot was reluctant to tell Gauguin was that the Tahitians had assumed he was a *mahu*, a feature of Polynesian society which often caused considerable confusion amongst European visitors. Captain Bligh of the *Bounty*, who visited the island just before the legendary mutiny, commented on a 'Mahoo' that he saw, believing him to be a eunuch until he had, in the laudable spirit of eighteenth-century scientific enquiry, inspected the situation, and discovered that, while effeminate, the man had not been 'cut'. 'The women,' Bligh concluded, 'treat him as one of their sex, and he observed every restriction as they do, and is equally respected and esteemed.' It was only modern anthropologists who were able to see that every village had its own *mahu*, and that they had a near-sacred position, combining in a special way both male and female characteristics.

Walking up from the beach into the town, heading for Jénot's 'cabin', Gauguin was no doubt as intrigued by the Tahitians as they were with him. Despite their all-enveloping Mother Hubbards, the *vahines* were famous for their boldness while the *thane* or *tane* was often tall, supple and muscular. Gauguin certainly found them so, rather tartly writing to Mette to tell her that 'the handsome men you are so fond of are numerous here, much taller than I with limbs like Hercules.'

Such things were what Gauguin had come to see, though hidden under their missionary gowns, the *vahines* were hardly a vision from the New Cythera, while the men in cotton loincloths, white shirts and straw hats were too comic to be noble savages. In any case they did nothing but laugh at him, for despite the honoured role of the *mahu* in Tahitian society, the sight of what they took to be a French version was a little too much for the people Gauguin first encountered, hence their mirth. There was clearly a great deal Jénot was going to have to explain to the new arrival and he was the ideal person to take on the task, both sympathetic to the stranger, tolerant of his appearance and well placed to show him around. Despite having been in the colony less than a year, Jénot had made some good friends in the local community, and had also mastered the Tahitian language, not a common achievement among the average European bird-of-passage.

While there was a great deal Jénot needed to explain to both his new commander and the artist, there was little opportunity during that first day, when they both needed to go through the usual formalities, obligatory in the colonies. This was certainly the case with Swaton but it is a

little surprising to note the alacrity with which Gauguin assumed that such things were also part of his role as an 'official' artist. Thus, his first action was to make a formal call on the governor, the grandly named Dr Etienne-Théodore-Mondésir Lacascade, at his official residence at the rear of the town.

The short walk from Jénot's house near the military barracks was Gauguin's first real chance to see Papeete and here again it is usual for his biographers to seize on later remarks, when he was fed up with the place, to highlight how depressing he found it all. With a mere 3,000 inhabitants, it was not especially interesting. A devastating fire seven years earlier had wiped out most older buildings which had been replaced by unpainted brick shops or plank houses with corrugated iron roofs which had quickly rusted in the heat and rain. But photographs of the period hardly reveal a hell-hole on the scale of Panama. Rather, the main shopping street with its clapboard façades has a touch of the American West, while a view from the higher ground at the rear of the town shows little but trees with the occasional roof and the spire of the small cathedral peeping through the leaves, and beyond them some warehouses and thence the bay with the masts of the sailing ships riding at anchor. No better, but certainly no worse, than an experienced traveller would have expected, and far from wanting to cut and run, Gauguin quickly convinced himself that it was in this little capital that his destiny lay. Not to put too fine a point on it, the rather spurious 'Official Mission' which had been cooked up for him, went to his head, and nothing could better illustrate this than his attitude towards the inhabitant of the most imposing building he saw that day, the wooden palace next door to the governor's residence. This strange, square, two-storey building, surrounded on both floors by a colonnaded veranda and topped with a spired mirador, not unlike some of the older buildings which Gauguin had known in Lima, was the home of his majesty King Pomare v. The building had been prefabricated in France and shipped out to Tahiti to be the official seat of his mother Queen Pomare iv, the ruler who starred in Loti's novel. In 1847 the queen had finally given up her resistance to the annexation of her country and agreed to accept the role of titular monarch within a French protectorate. Her fairy-tale wooden palace was certainly the most imposing building in the town, which probably explains why Gauguin, much influenced by Loti, leapt to the conclusion that the king would be just the sort of local ruler who would prove, like an Indian maharajah, or an Arab potentate, a willing patron of the arts. Gauguin decided that he would arrange an audience as soon as possible, but first there was the governor.

Once again, the vitriolic abuse which Gauguin later heaped on Lacascade's head has led to the assumption that when they first met, at ten

that morning, there must have been at least some animosity between them. Appearances would certainly support such a view – Jénot has given us an accurate description of Gauguin's oddities of dress and coiffure, which would have been pointedly at variance with the standard formal garb usually worn when calling on the colony's highest official. Whatever the heat, Governor Lacascade always dressed in the obligatory black frock-coat, an outfit which tended to highlight a somewhat pompous and abrupt manner. At fifty, Lacascade was rather short, with receding hair counterbalanced by exaggerated mutton-chop side whiskers, a blustery appearance which made it all too easy to dismiss him as just another pompous administrator, lording it over a distant outpost of France. In fact Lacascade was significantly different from his predecessors in trying to make something of the post. Paris had not always shown much concern for its Polynesian possessions. Prior to the French, the first Europeans to settle had been members of the London Missionary Society, a particularly dour Calvinist bunch who with grim aptness had opened their first prayer meeting on Tahitian soil by singing 'O'er the gloomy hills of darkness' to a crowd of happy, smiling, bare-breasted natives. It was the missionaries who had helped the Pomare dynasty establish its rule over the island's other chiefs and in return they had been allowed to create a heavy-handed theocratic state, with laws based on Old Testament precepts which forbad everything which had formerly made the Tahitians so special – their guiltless innocence, their openness and generosity, especially with regard to sex. Even so, the islands, under the Pomares, had remained independent, and trouble began only when Queen Pomare IV expelled three Catholic missionaries, two of whom were French, an action which led the government in Paris to demand reparations, a common enough excuse for colonial intervention. What no one now admitted was that the subsequent seizure of Tahiti by a Captain Dupetit Thouars had been an entirely personal decision, only reluctantly accepted after much toing and froing by his government, which quite rightly saw little profit in such a move. It was only in 1847, after nearly a decade of destructive fighting, that Queen Pomare IV was finally convinced that Queen Victoria had no intention of granting her requests for help and was persuaded to return to Papeete and her new, ready-made palace. Although she retained a few residual powers, such as the right to be consulted over the appointment of chiefs, there was little for the queen to do save to amuse herself with fun and drink, in the manner so graphically described in Loti's novel.

Viewed from Paris, Tahiti and the other Society Islands were just too small to merit investment. There was insufficient land for the Society for the Promotion of the Colonies to be able to hand out farms to French citizens willing to settle in this faraway place and as a consequence

no French shipping line bothered to provide a direct link between the metropole and its lonely outpost at the other side of the globe. The result was that the French remained strangers in what they believed should be their land. Most of the business of the islands was in the hands of non-French families, most of whom were of English, American or German origin, who had arrived before the conquest and who had married into the upper reaches of Tahitian society, those chiefly families which had the largest areas of good land across the island. These immigrants combined European skills with access to capital which quickly gave them control of the economy and thus the leading positions in the island's social hierarchy. Those few French citizens who settled tended to be sailors of limited education who signed off from visiting ships when their contracts ended, married girls they found in Papeete and tried to set up businesses or to farm any morsels of land that they could buy. Most had little success and, unlike their predecessors, the English, Americans and Germans who lived in substantial villas and maintained a luxurious colonial lifestyle, these deracinated Frenchmen rapidly went 'native', or, as one Police Commissioner put it, *définitivement encanaqués*. The main ambition of these poor whites was to get off the land where they were forced to labour to produce cotton or copra, and later vanilla, with little hope of much profit. The dream was to open a bar near the harbour in Papeete, which was commonly believed to be an easy route to riches, though the few who did manage to penetrate the *petit commerce* of the town then found themselves in competition with the Chinese community, whose members were harder working and often more intelligent. About a thousand Chinese had been brought to Tahiti in 1864 to work on a short-lived cotton project and while many had gone back after the enterprise failed, about 300 had settled in or around Papeete where they opened restaurants and shops near the market area and soon had their own temple and cemetery, all signs of an enviable success. This inevitably aroused the racist resentment of the poor whites, who assumed that these 'yellow creatures' were conniving against them and that it was they and not their own ineptitude that was the hidden cause of their failure to become equally rich.

During the Second Empire, under Napoleon III, the colony stagnated, a situation little changed by the advent of the new Republic. It was only when a true believer in colonialism as a force for change, Jules Ferry, became Prime Minister in 1878, that things began to move forward. The appointment of Isidore Chessé as Tahiti's first civilian governor marked the start of the colony's transformation – though how that should be judged depends entirely on one's interpretation of the word 'progress'. By persuading King Pomare V to abdicate on behalf of himself and his descendants, retaining the right to only the most minor symbolic digni-

ties for the remainder of his own life, Chessé ensured that any lingering vestiges of Tahitian independence would soon vanish. But when he tried to counterbalance this by introducing a measure of local democracy, through the setting up of a *conseil colonial*, he merely succeeded in opening the whole gamut of rancorous divisions within the civilian population. The most powerful figure to emerge under the new dispensation was the first president of the council, François Cardella, who had come to Tahiti as a naval doctor, resigned and opened the first pharmacy in Papeete, before diversifying into other businesses. It was, however, the granting of a monopoly concession over the island's opium production, a drug much used in Europe in the form of laudanum, which made him rich enough to allow time to devote all his energies to politics. When Paris granted Papeete municipal status in 1890 Cardella assumed the leadership of the 'Catholic' party which promoted the interests of the French settlers, as opposed to the 'Protestant' party which was favoured by the older, non-French colonists. Cardella became the city's first mayor and leading opponent of the administrators sent out from France.

It was the arrival of Théodore Lacascade that brought matters to a head. Born on the island of Guadeloupe and thus attuned to petty-minded colonial politics, he made it clear from the moment he arrived that he was not going to vegetate as many of his predecessors had done. His first act was an ill-advised attempt to establish direct control over the islands in the Leeward group, including Bora-Bora and Huahine which were only nominally French. Unfortunately for Lacascade this adventure resulted in an outbreak of fighting and a local resistance that continued until after he had left the colony. No doubt the leading trades-men in Papeete hoped that this set-back would teach the newcomer a lesson and that he would now settle down and leave matters alone. But Lacascade also planned to reform Tahiti's administration while attempting to get its finances in order, moves which were bound to irritate the settlers.

It is clear from the records of the *conseil général* that its meetings were little more than an excuse to undermine whatever the governor was trying to do, an activity further advanced by the island's elected representative in Paris who saw it as his primary function to complain about the administration to the Under Secretary of State for the Colonies whenever an opportunity arose.

As yet, the newly arrived Gauguin was completely unaware of any of these complexities. Still under the spell of Loti's novel, he seems to have imagined that Tahiti was a kingdom, at the head of which was Pomare v, while Lacascade was, in some way, merely his chief administrator. Lacascade was perfectly welcoming, he had already received a message warning him of the arrival of an artist on an official mission and announced that

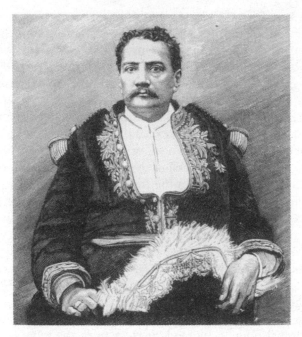

An engraving of King Pomare V of Tahiti,
from a photograph by Charles Spitz, published
in the magazine *L'Illustration* at the time of
the king's death in 1891.

he was willing to help, though his real reason, as Gauguin quickly
deduced, was less straightforward. It was not unknown for Paris to try
to keep an eye on its distant provinces by sending someone to report
back, unofficially, on the true state of affairs. After the débâcle in the
Leeward Islands, Lacascade had probably expected something of this
sort and what better cover for a spy could there be than an artist?

No doubt eager to make a good impression on this unknown quantity,
the governor offered Gauguin the use of a room in one of the guest
houses set aside for newly arrived government officials, until he could
rent a house of his own. This convinced Gauguin that his official status
was more real than it actually was, a misconception reinforced by an
invitation from the number two in the hierarchy, the Director of the
Interior, to lunch with his wife and family. Final confirmation came on
11 June when the *Journal Officiel* put him second, after Swaton, in order
of importance, amongst the recent arrivals, aboard the *Vire*, and even
though they did spell his name Goguin, they nevertheless noted that he
was an *Artiste-Peintre en Mission à Tahiti*, clear proof, so it seemed to
him, of his elevated role. His second letter to Mette reveals a new fantasy

in full flight: 'I think I shall soon have some well-paid commissions for portraits: I am bombarded with requests to do them. I am making the utmost difficulties about it at present (the surest way of getting good prices). In any event I think I can earn money here, a thing I was not expecting. Tomorrow I am going to see all the Royal Family. All of which is advertisement, however tiresome.'

If he had taken the trouble to ask Jénot, he would have learned how especially fragile such hopes were just then. King Pomare was ill, though it is true that most of those in Papeete who knew, thought it was just another hangover. Like several of his predecessors, and indeed like a good many of his subjects, Pomare v was a hopeless alcoholic. Drink was the curse of the islands and in that respect alone His Majesty was a suitable figurehead. He had perfected a lethal cocktail of rum, brandy, whisky and liqueur which had managed to keep him permanently sozzled and divorced from the fact that his life was pretty meaningless. Having been prevailed upon to abdicate in 1881, his sole remaining privileges were the right to fly the Tahitian flag over his palace and to go on using his title, though the French had made it quite clear that these were concessions granted for his lifetime only, and that with his death these last vestiges of royalty would be abolished. But while his former subjects may have imagined that the pathetic figure in his wooden palace had no more than a bad headache or an attack of the *grippe*, those near him knew otherwise – the cocktail had proved all too lethal, and as Gauguin prepared to set off for his audience on the morning of 12 June, his dreams of royal patronage, by a court similar to that described in Loti, were shattered by the boom of the town's guns, saluting the passing of the last Tahitian king.

Understandably curious to see what was happening, Gauguin decided to go ahead with his visit to the palace, and it says much about the comic-opera monarchy, as well as the way Europeans could do pretty much as they pleased on the island, that no one stopped him entering the building on such a day. He found the director of the Department of Public Works already there, supervising the preparation of the throne room, where the body of the late king was to lie in state and, seizing the opportunity offered by Gauguin's arrival, the man asked whether, as official artist, he would be prepared to take on the task. Prudently, Gauguin demurred, though for once he showed a degree of tact by suggesting that the King's estranged wife Queen Marau, who was already decorating the hall with flowers, would have a better feeling for local taste in the matter. That dealt with, Gauguin could take a look round, though he was disappointed at how European everything was, as if he had expected to find Pomare's palace stuffed with sculpted idols and traditional carved wooden furniture. Only the widowed queen offered

some of that old Tahiti which he still hoped to find and later he would
claim to have fallen under her 'Maori charm', though by then he must
have known that she was like many in the ruling elite, only partly
Tahitian; her father, Alexandre Salmon, was the son of a prominent
Jewish banking family, who had quit London after a business failure,
eventually drifting to Tahiti where he married a princess and became a
key figure in the power-struggle between Queen Pomare IV and the first
French administration.

## Settling in

Jénot now helped Gauguin find his own cabin, a small wooden building
with the usual veranda, near the foot of the mountain at the rear of the
town, not far from the cathedral.

At first, he was too busy getting himself set up to contemplate work.
Houses in Papeete did not come furnished and while his needs were
simple, he still had to arrange to rent a bed, a table and some chairs.
There was also much to see with the preparations for Pomare's funeral
in full swing. The king now lay in state, on his double bed, spruced up
in his admiral's uniform, bemedalled and sashed, his corpulent stomach
almost obscuring his face. In the bay, outrigger canoes were already
arriving with mourners from all over the archipelago, come to witness
the last rites of their final monarch. It was not lost on Gauguin that
their sadness was not shared by the French, who went on with their lives
as if nothing had happened. The centre of colonial society was the Cercle
Militaire, the military club, where the expatriates drank, gossiped and
played dominoes. Jénot had taken Swaton and Gauguin there on their
first evening. It was a pleasant enough place, set in a park in front of
Pomare's palace with a wooden balcony, ten foot above ground, built
among the branches of a giant banyan tree. Jénot seems to have organized
a reception party, with Tahitian girls waiting outside to greet them with
flower garlands, much as if they were modern tourists. Inside, things
were less jolly. The domino players sipped their absinthe and dreamed
of the grey skies of home, for as a former Secretary of the Interior, a
Monsieur Méthivet, had put it, Tahiti had 'too much sun, too much
blue . . . one is mortally bored with such beauty. . . .' Government offices
opened at seven, there was a break from ten to one in the afternoon to
avoid the greatest heat, then after the siesta came the long haul until
liberation at five in the afternoon when the men could gather at the club
and the women could call on each other to gossip and generally stir
up trouble. The colonial archives contain the pathetic reports which
Lacascade was obliged to make to his minister in Paris whenever one of
these petty feuds got out of hand and relations broke down. On one

occasion, a Madame Féline had sent word that she was unavailable when her husband's *chef de service* and his wife had made a courtesy call to her house – apparently an insult so dire, the minister had to be consulted about the appropriate disciplinary measures to be applied to poor Monsieur Féline.

Faced with such people, one might have expected Gauguin to have taken one look and fled. Instead, he accepted it all as part of his new 'official' life. He had his hair cut and put on a respectable linen suit and settled down to await the commissions he felt sure would now flood in.

Lacascade decided that the funeral of Pomare v would take place on 16 June, four days after his death, to allow those on the farthest islands to get to Papeete. Pomare's nephew, and recently adopted son, Prince Hinoi, was on a visit to the neighbouring island of Moorea, and Lacascade, who had no wish to alienate the family and their supporters, dispatched a warship to bring him back. French hold on the islands was less secure than it appeared from the standpoint of the Cercle Militaire and the colonial archives in Paris contain a secret report from Lacascade which shows that the governor was concerned that there might be some move to proclaim an heir and thus continue the dynasty. A military ceremony had been planned for the day after the funeral, at which Pomare's flag was to be publicly hauled down and the French *tricolore* raised in its place. With nearly all the Tahitian chiefs in Papeete, the governor had no wish to see anything happen which might prevent this taking place and to that end he had put Swaton and his men on alert and had ordered the police to be ready to dig a ditch in the palace grounds in the event that something might delay the ceremonies and thus oblige them to dump the corpse before it finally putrefied. In such a climate, delaying a funeral by four days was a tricky business and the Service de Santé had had to work hard to ensure that the bloated corpse was in a fit state for the ceremony.

In the event, all went as planned. The king's coffin, surmounted by his sword, was borne on a bier panoplied with black swagged velvet fringed with gold braid. Lacascade hoped to show as much respect as possible and thus dampen any criticism at the way the Tahitian monarchy had been treated. A surviving photograph shows the bier drawn by a team of six horses, behind which stand the French officials in their white sola topees. Gauguin joined the long procession which followed the swaying hearse on the three-mile walk to the east of the town, to Arue, to a spit of land reaching into the sea, where the royal family had built their mausoleum. It was now a week since he had arrived on the island, though he still had little idea of the political undercurrents that were bothering his fellow Frenchmen as they kept a wary eye on the milling crowds.

The mausoleum was a plain rectangular tower, crudely built of rough coral, surmounted by what was meant to be a Grecian urn, except that the workmen who built it had not been up to the task and had created a curiously squat object which local wits compared to an outsize liqueur bottle – a fitting memorial for the pickled corpse which was now laid to rest beneath it. That done, Lacascade attempted to pacify the crowd with a stirring oration full of pointed messages: '. . . in Pomare you have lost a father, therefore draw closer to your mother, France, the mother of us all.' When he had finished he was disturbed to see that one of the local leaders, Chief Teriinoharai of Mahaena, had stepped forward and launched on a rambling speech which seemed to suggest that Prince Hinoi be recognized as Pomare's successor. This was just what Lacascade had not wanted to happen, and when the speech was over and the crowd began to amble back to town, he quickly issued orders to Swaton and the others as to what they should do if any trouble were to break out that night.

Gauguin, no doubt bored and mystified by the long speeches, yet fascinated by the fact that he was surrounded for the first time with so many Tahitian faces, took out his sketchpad and began to draw. These funeral figures are the first works he did on the island, all with that now-familiar oval face with its centre-parted 'curtain' of hair, broad nose and lips and heavy-lidded almond eyes, the face which he established as the classic image of Polynesia, his ideal of non-European beauty. Despite his ignorance of the political struggle going on behind the façade of the funeral, Gauguin seems to have quickly realized that the Tahitians were not as Europeanized as they at first appeared, that beneath the formless Mother Hubbard gowns something of the old Tahiti still breathed. His brief account of the funeral notes how the returning crowd began to laugh and talk, how the women went into a river, lifted their skirts and washed themselves and how, as they walked back, he could smell the fragrant mix of body odour and sandalwood. The missionaries may have tried to suppress the sensuality of the people but, in the forty years since they were replaced by the French, many of the old ways had begun to creep back. The defeated Queen Pomare IV was said to have led 'a rollicking, sportive life surrounded by troupes of frolicsome attendants' while much of her money had gone on 'decking her dark-eyed favourites with trinkets'. So much for 'the gloomy hills of darkness'! But one thing that was lost was the will to resist French rule. On his return to Papeete, Lacascade managed to convince the head of one of the island's most respected families, Adolphe Poroi, a man firmly loyal to France, that he should dissuade the chiefs from any action which might impede the next day's military ceremony. He succeeded. One flag came down, the other went up. Prince Hinoi was bought off with the presidency of the High

Court which brought with it a substantial income, Poroi was given the cross of a Chevalier of the Legion of Honour and Lacascade and his cohorts could relax once more.

## Joining the Dance

Gauguin now decided to learn the language and anything he could about Tahitian lore and customs, and Jénot introduced him to friends and neighbours, such as Jean-Marie Cadousteau, one of the government interpreters, who had a French father and Tahitian mother and who was the perfect bridge between the two worlds, and a Dr Charles Chassaniol, who, at 47, had just retired as head of the island's medical services and was a friend of Queen Marau.

Some of those living near by knew the language and could help. The nearest was Jean-Jacques Suhas, who had also come out to Tahiti with the naval medical service and had decided to settle in Papeete. Suhas was now chief nurse at the nearby military hospital; while across the road was the house of Sosthène Drollet who had a business specializing in the production of Guava jam, with a two-storey brick shop on a corner of the Rue de la Petite Pologne (today the Rue Paul Gauguin). Drollet had a twenty-year-old son Alexandre who was a government interpreter and it was arranged that he should give Gauguin lessons in Tahitian. Jénot too tried to help by explaining any difficulties with the language whenever they met, usually at the end of the afternoon at Jénot's 'cabin'. But it was soon accepted that the painter was making no headway, for as Jénot put it: '. . . he had an infuriating propensity to forget, to mix up syllables or to invent them – after a certain age it is difficult for some tongues to learn a new language – even when it is simple, like Tahitian: still one at least needs a memory. This is why Gauguin, even when he saw my name written many times, mostly by myself, was never able to spell it correctly and usually called me Gino, the sound that must have struck his ear when we first met.'

Inevitably the lessons were abandoned, leaving Gauguin with a smattering of ungrammatical phrases, some of which would survive as the titles of his paintings. By then Gauguin had already found another, far more pleasurable way of making contact with the local population. Every Wednesday and Saturday evening, a dance was held in the park beside the Cercle Militaire – the drinkers up in the banyan tree could actually look down on the festivities, an open event, attended by Tahitians of both sexes and by any passing French sailors and soldiers and even the occasional higher ranking official, drawn to what was, by all accounts, quite an extraordinary spectacle. Starting at eight o'clock an amateur group would take up position in the little wrought-iron bandstand at the

centre of the park, they would sound their horns, whereupon some 200 Tahitian girls would begin to caper round in a circle. Anyone could join in, and of course Gauguin did, throwing himself into the excited mêlée, tearing about amidst the rising dust. It was a great social occasion, stalls sold cheap tobacco and drinks and even Pomare's widow, Queen Marau, would sometimes attend and everyone would make a great effort to dress up, the women in long white dresses with white gardenias in their raven black hair. The evening officially ended with the band dutifully playing the Marseillaise, but couples could go on to the Chinese quarter to drink tea. Even on those nights when there was not a dance a visit to the market place could achieve the same result, for it was soon clear to Gauguin that the years of missionary rule had failed to change that free and easy attitude to sex which had most astonished the earliest visitors to Tahiti. By Gauguin's day it was effectively prostitution. He quickly discovered that the up-country girls who drifted into Papeete to see the sights were more than happy to accommodate visitors, just as their ancestors had done, though now they knew precisely the going rate for what they did. In one way they were the beautiful exotic Eves that he had imagined when he first read Loti's book, but now he also knew that the serpent had done its work and that he had arrived in Eden a century after the Fall.

   Not that such high-flown thoughts prevented him from making full use of what the local people, with utter bluntness, called 'the meat market'. For once he had money, and in any case the girls were hardly demanding European prices, despite their youth and beauty. And just as Gauguin was getting into his stride with a heady round of dancing and visits to the market square, the whole thing became even more like one long wild party when the entire island surrendered itself to what was in effect the national fiesta, centred on 14 July, Bastille Day. While the French officials and their wives were celebrating their national day, the Tahitians were simply having an extended holiday, a prolonged carnival of drinking, dancing and general merry-making. Gauguin realized that something important was going to happen when he saw the edition of the *Journal Officiel* which announced his arrival, for the thin broadsheet contained several pages outlining the programme of activities which would be sponsored by the authorities. These began on 13 July at three in the afternoon with the opening of a funfair and ended at ten that evening with a torchlight parade led by the municipal band. The next three days were filled with various competitions: swimming, sailing, horse racing out at Fautaua, ending on the 16th with a tombola. But the main event was the *Concours des himene* with a first prize of a substantial 600 francs for the winning choir. The word *himene* was one of the many Tahitian borrowings from English, though the islands' choral hymn

singing had moved a long way from the 'gloomy hills' and was a marvel of descant and counterpoint and improvised plunges and swoops of sound which all visitors to the island found bewitching.

For the small French community in Papeete, the heart of the festivity was the government reception on the 14th, though that year, with fighting still continuing on the Leeward Islands, the Governor had decided to show the flag by attending a ceremony on the Tuamotu islands, where he had sailed ten days earlier aboard the battleship *Volage*. His place at the reception was taken by the *chef de service administratif*, Monsieur Mathis, who made the usual speech lauding the Republic, then presented medals and diplomas to those who had won prizes at the *Exposition universelle* in 1889. It was probably then that Gauguin had his first contact with the photographer Charles Spitz, the local jeweller, whose photographs for French magazines such as *Illustration* helped create the image of Tahiti as an unspoiled rustic paradise. Much of this was completely artificial – many of Spitz's supposedly exotic images were shot in his studio in Papeete – and was geared to the nascent tourist trade, turning out pictures of bare-breasted *vahines* for visiting sailors to take home with them. But there is another side to Spitz, one that is shown in the clear division between his 'town' and his 'country' photographs. One of these town pictures is entitled *July 14* and shows a Bastille Day procession with a line of women swathed in their white missionary gowns, marching beside a line of men dressed in trousers and shirts who are waving rather pathetic wooden guns above their heads, a poignant image which seems to highlight the emasculation of these one-time warriors under colonial rule. In direct contrast, one of Spitz's country scenes shows a clearing in a forest glade beside a river where a solitary *tane*, dressed only in a breech-cloth, is posed on a fallen log, his head resting on his hand. Here, Spitz seems to say, is the handsome Noble Savage, a philosopher in his unspoiled, natural habitat. Of course, to Gauguin, it was obvious that the pose of this 'natural' figure was taken directly from Rodin's *Thinker* and that Spitz was simply imposing another, albeit more generous, European concept onto the Tahitians. The two photographs embody a classic schizophrenic attitude to the 'natives' who were either corrupted and slightly comic, or noble and untouched – all of which must have added to Gauguin's increasing doubts about his decision to settle in the town and lead a colonial life.

When Spitz and the others had received their awards the official section of the festivities was over, but Gauguin now learned that they were only a tiny part of what was almost a fortnight of jollity. Having barely returned home from the funeral, many of the out-islanders were back in Papeete once more and most would stay until their money ran out and they could no longer indulge their appetite for candy-floss, or amuse

themselves at the shooting galleries and the gambling and medicine booths and, of course, at the makeshift bars where prodigious quantities of local booze were consumed.

The main interest for Gauguin was the sight of so many village people, more freely dressed and natural looking than the townsfolk in their missionary clothing. He wandered about, asking anyone who caught his fancy if they would pose for him, and being Tahitians and thus generous and curious, they agreed. There is a charming spontaneity about these hastily pencilled portraits – a head tilted to one side, a lock of hair blowing free – but because each usually fills an entire sheet, they have the monumental quality of sculpted idols, and as he often left the eyes blank, they also become masks, as if he wanted to show that he had not yet been able to get behind the surface beauty of the Tahitian face.

Because he was happy and barely able to suppress his contentment, his next letter to Mette bordered on the indiscreet:

> Such a beautiful night it is. Thousands of persons are doing the same as I do this night; abandon themselves to sheer living, leaving their children to grow up quite alone. All these people roam about everywhere, no matter into what village, no matter by what road, sleeping in any house, eating etc, without even returning thanks, being equally ready to reciprocate. And these people are called savages! . . . They sing; they never steal; my door is never closed; they do not kill . . .

It would have been impossible for Mette not to have guessed what was going on and it was hardly surprising that she decided not to reply. Discretion was hardly his forte, even though he must have known that in a place as small as Papeete, being seen so often with beautiful *vahines*, especially disporting himself so publicly at the twice-weekly dances, would do him no good with the tight-knit expatriate community. Having a discreet Tahitian mistress was one thing, openly picking up girls in the market square quite another. Not surprisingly, the invitations to dine soon dried up as official society began to shun this salacious Bohemian, a move which ended any hopes of his getting portrait commissions. Not that there had ever been any great likelihood that the poorly paid administrators would have wanted to spend money on art.

At this point Gauguin ought to have abandoned his fantasy of leading a colonial existence and begun to think of experiencing something of the island he had travelled so far to see. Instead, he stubbornly persisted, asking Jénot to try to find patrons from among his friends in the business community. Normally the settlers and the administrators, which included the military, did not mix socially, but Jénot's willingness to learn Tahitian had helped him bridge the divide and so the lieutenant set about introducing Gauguin to some of the more prosperous *colons*, the

most prominent being Cardella, president of the *conseil colonial* and mayor of Papeete. Here, however, a sort of reverse opposition came into play: in the eyes of a settler like Cardella, Gauguin was still an official artist and as such was firmly in the enemy camp, and while he was perfectly polite to Gauguin, he never invited him to his home or showed any intention of hiring his services.

Gauguin's best hope was another Jénot introduction, this time to the island's leading lawyer, Auguste Goupil, a fascinating character, then in his mid-forties, who had studied law in France and England, after which he had done a little travelling before settling in Papeete in 1869. He had quickly established himself as Tahiti's most successful advocate, willing to defend the local Chinese traders against punitive taxes and able, through his knowledge of English, to make a substantial income from advising foreign businesses. Goupil had used this money to make himself the island's leading business magnate, acquiring the local newspaper *Océanie Française*, and buying a large coconut plantation on the west coast where he produced copra and exported grated coconut for cake-making to the United States. Within the convoluted world of Tahitian politics, Goupil was in some respects Cardella's main opponent; not only did he support the Protestant faction but he had agreed to join the three-man privy council which advised the governor and which thus made Goupil something of an *éminence-grise*. Furthermore, with his wealth and his overseas connections, Goupil was well outside the circle of small tradesmen with their Tahitian *vahines* – Goupil had married the daughter of an English businessman and maintained a way of life some-what on a par with a provincial gentleman in Europe. He was mildly interested in the arts – his daughters were encouraged to paint and draw – so there was reason to hope that he might look sympathetically on Gauguin, though there was no sign that he was about to rush into a commission, until he had had a chance to assess the newcomer.

In the end the only commission came from an Englishman, Thomas Bambridge, who had married a Tahitian and set himself up as a black-smith and cabinet-maker in Papeete. Hearing about this official artist, Bambridge decided that he would like a portrait of Susannah, one of his twenty-two children, who had married a Tahitian chief and assumed the name Tutana. Because the late king had been estranged from his wife, Susannah/Tutana had been given the role of official hostess for the various banquets and receptions held at the palace, a task which had no doubt contributed to her bulk, for Susannah/Tutana was a very large lady indeed. Her official role, however, meant that this was just the sort of commission Gauguin needed if he was to become the society portraitist to Papeete's upper crust and, realizing this might be his last chance, he decided to avoid anything adventurous, preferring to work

in a simple naturalistic style. This was a bad move – Susannah was in her forties and looked even bulkier in the loose-fitting Mother Hubbard she chose to wear for their sessions together. Naturalism was not the best way to tackle such a problem and poor Susannah Bambridge ended up looking fat and middle-aged with a somewhat vacant, moronic expression and a complexion realistically flushed with touches of not very attractive pink. Gauguin got his 200-franc fee but the picture went into her father's old tool-shed where it remained for nearly fifteen years. There were no further commissions.

## A Change of Direction

Gauguin was lucky to have found a devoted friend like Jénot, and the younger man showed refreshing maturity in his assessment of his friend's character, rightly judging that the air of disdain and haughtiness which Gauguin assumed with strangers was no more than a protective shield.

Jénot also noted that Gauguin was concerned to find wood suitable for carving. Making wooden vessels was one of the last crafts still practised by the Tahitians and Jénot had a large *umete*, a wooden bowl originally used for the preparation of *poipoi*, a paste made from breadfruit, a staple of the traditional Tahitian diet, though the 'bowl' was most likely used for soup by expatriates like Jénot. The *umete* had a handle at each end, and one had a canal chiselled through it so that liquid could be poured away. One day at Jénot's, Gauguin took up the *umete* and asked if he might carve it, then set to 'without saying anything, for when he was working Gauguin was mute and even deaf'.

When he broke for lunch, conversation resumed and Gauguin asked where he could see Tahitian figures carved in wood and stone. Jénot was forced to disillusion him, there simply weren't any. The old crafts were still practised on Easter Island, New Caledonia and New Zealand but not on Tahiti. The Catholic bishop of Papeete, Etienne Jaussen, a student of local culture who had compiled a French–Tahitian diction-ary, had set up a small museum of Polynesian art and artifacts, mainly Marquesan and Easter Island objects. The Head of the Gendarmerie had a personal collection of Marquesan stone statues, ornaments, battle-clubs and wooden bowls which Gauguin eventually saw, but that was the limit of what could still be seen on the island.

Neither the French authorities nor the settlers had ever taken much interest in local art. As recently as 1882 an English visitor, Lady Brassey, had seen a collection of 'idols, paddles, masks and other curiosities' from all over Polynesia, which had been amassed by a Mr Flockton, a guano dealer, and noted that he intended to send them to Hamburg where Gustave Godeffroy, the retired head of the Godeffroy de Hambourg

company, one of the most important commercial enterprises in Oceania, was exhibiting the collection he had made while in the Pacific region.

Since Lady Brassey's day, most of the objects offered to visitors were effectively tourist trash, specially churned out for the passengers from passing ships who wanted a souvenir of the savage life they had singularly failed to see. Gauguin would have seen such things during the Bastille Day festivities, when a market was set up along the short street leading from the quay to the late king's palace, with all manner of booths offering these debased local crafts along with cheap imported goods and foreign knick-knacks. Only ten years earlier Lady Brassey had been able to find 'handsome cloaks, of a kind worn by chiefs at feasts. They were of tapa cloth, trimmed with a fringe and ornamented with knots of the graceful reva-reva.' What Gauguin saw a decade later were mainly the cheap European and American goods that the Tahitians now coveted: brightly coloured printed floral material instead of the traditional bark cloth wraps, and factory-made tools instead of stone axes and bamboo knives.

Until Jénot disillusioned him, Gauguin had gone on imagining that out in the villages native art would still survive. But as he now learned, Tahiti had never been one of the great centres of Polynesian art. Tahiti and the other Society Islands, in common with other Polynesian groups, had been rigidly stratified, with a chiefly class in a supreme, indeed hallowed, position. Art was made not for this 'upper' class by 'lower' class craftsmen, but was usually a by-product of the leisure the chiefly families enjoyed. Art was to a large extent a recreation of those who had others to work for them. Many of the forms this art took were decorative: the production of elaborate headwear and delicate feathered cloaks for the supreme chiefs, fine bark cloth and most important of all, the complex body tattoos which were a form of genealogy, whose swirling designs represented ancestors, and linked the living tattooed person to his fore-bears in an unbroken line. Inevitably, such delicate things were not made to survive and, following the arrival of the first British ship in 1767, decline was rapid. On the one hand, the ruling élite wanted the things which the sailors had to offer and ceased to esteem their own craftwork, on the other, the social disruption following the influx of European visitors threw the hierarchical system into disarray, replacing traditional chiefly families with new leaders and removing the traditional patrons for the fine decorative things which had charmed and astonished the first outsiders.

Gauguin seems to have held to a mistaken belief that the Tahitians must have made religious artefacts – the sort of things he knew from pictures of the monumental Easter Island heads and from Loti's description of Marquesan idols. It was true that the Tahitians had once made *ti'i* or *tiki*, figures of lesser spirits in their religious hierarchy, but even

before the coming of the Europeans, the islands had undergone a religious revival which had led to the dominance of a single god Oro as supreme deity whose images were 'elementary', stubby cigar-shaped cylinders of sennit (plaited palm fibre) with no more than simple circles for eyes and mouth, and lines for arms. Such objects were not meant to be the god nor even to represent him, rather it was thought that in some way his essence had passed into them, making them sacred and venerable. In any case, the coming of Christianity had led to the total destruction of such 'pagan' things. Most were destroyed by the first converts to Christianity trying to please their missionary masters. Any work that survived had already been carried off by the earliest visitors, with some pieces being sent to European museums by the missionaries themselves as evidence of their triumph over the heathen. In his book *Missionary Enterprises*, published in 1837, the Rev John Williams included an engraving of the people of the island of Rarotonga, where the religious art seems to have been more representational than on Tahiti itself, delivering their god-images to two seated European couples, the men in top hats, the women in bonnets and shawls, much as if they were royalty receiving tribute.

But Gauguin was nothing if not persistent and he showed Jénot some photographs he had bought of Marquesan men with their bodies covered in tattoos, then he returned to the *poipoi* bowl and began to carve swirling lines along its sides, similar to the patterns on the men in the photographs. This was probably the first tentative move in what was to become the prime obsession of his first visit to Tahiti, an attempt to re-create the art that he was unable to find. So thoroughly had the missionaries swept away the old crafts that neither he nor Jénot could find anyone in Papeete who could tell them what sort of wood was used for the *umete*, presumably because they were made outside in the villages and brought in to the market for sale. It was clearly hard and durable and Jénot thought it might be guava and got some pieces which Gauguin worked on with the gouges and chisels he had brought from France. It was only after several pieces had been finished that he realized that the wood attracted local insects and was soon riddled with wormholes and began to crumble into dust. The only early carvings which survived were those he carved on the bowls which he bought and which were somehow resistant to insect attack.

Obviously, there was a limit to what could be carved on a bowl, and finding a more durable material than guava wood became a major preoccupation of those early months. At some point Jénot took him out of Papeete, up onto the mountain, to see an old man called Terea, a farmer and local healer, who Jénot thought might be able to help him. Terea suggested something, probably rosewood, though Jénot doesn't say, and Gauguin and he took some blocks back with them. Unfortu-

nately the pieces they chose were not thoroughly dry, and after Gauguin finished working on them they split irreparably.

But if the wood was a failure, the trip had given him his first glimpse of life beyond the town and had brought home what he ought to have realized from the start, that if he was going to attempt to re-create something of the old Tahiti, then he was going to have to move. In any case there was little to keep him in Papeete any longer – in the space of two months he had descended from semi-official artist to social outcast, and while this was definitely a more familiar role, it hardly amounted to a reason for staying in the town. Even at Tahitian prices, so many *vahines* added up to money he could not afford on top of paying rent on the house and furniture, plus his meals at Renvoyé's, his preferred restaurant, two doors along the Rue de la Petite Pologne from Drollet's shop. Not that all these girls were quite so anonymous or transient. Some he saw more often. We know from an unpublished letter to Jénot that he was attached to a girl called Tehura (with his usual sloppiness he spelled this Tehora) his version of the Tahitian Te'ahura. And there was a remark-ably bubbly character called Titi (for obvious reasons) who was of mixed English/Tahitian blood and whose flightiness seems to have amused him. But if he was seeing some of these market women on a fairly regular basis then we can be sure that he was paying for the privilege, which was another good reason why he should resurrect his original plan of getting away from it all, to a place where he could live off the land.

Had Gauguin bothered to ask, he would certainly have learned that while the southern route round to Taravao, where Tahiti Nui joined Tahiti Iti, was the easiest, with a regular coach service, it was still an ordeal. The dirt road was narrow and bumpy, and most of the tiny rivers which ran out of the mountains had to be forded, which was a real struggle in the rainy season. But at least the coach could get through, which meant that the southern rim of the island was the most settled and the least wild. The north was probably too unspoiled. Along parts of the coastline the cliffs dropped sheer to the sea, narrowing the road into little more than a track. Large stretches of the region were hardly visited and had discreetly been abandoned by the administrators in Papeete who contemptuously referred to anywhere outside the town as 'the zone' as if it were an outstation on another planet. Yet, amazing as it seems, Gauguin made little attempt to seek out what alternatives the island might offer. As far as can be inferred, he simply packed a few basic things, caught the coach in the direction of Taravao and set off to see where luck and fancy might lead him.

## Between the Mountain and the Sea

So it was that some time in late July 1891 Paul Gauguin finally carried
out his much-heralded plan and set off from civilization, riding south
from Papeete in the notoriously uncomfortable horse-drawn public
coach which ambled daily between Papeete and Taravao and back.
Despite the discomfort, the journey must have pleased him, for the views
are stunning even today when one has to negotiate an unending stream
of motor cars along a burning tarmac highway. But the traveller has only
to lift his eyes to see what Gauguin saw: the high hills dropping to the
sea, split by vertiginous clefts worn away by the narrow streams which
have forced their way out of the green heights, down to the palm-fringed
beaches. There is a belt of flatter land, only about two kilometres wide,
between the sea and the foothills, on which people may live and farm –
mainly coconut plantations on the outskirts of Papeete. Look out to sea
and there are the calm waters of the lagoon with the white foam breaking
on the coral reef.

But the coach was hellish, and after little more than an hour and a
half, a mere twenty-five kilometres along the road, Gauguin got off and
let it go on without him. He was in the district of Paea, today a residential
suburb of Papeete and even then barely outside the urban area. The
usual explanation is that he had been invited to stay by a local school-
teacher, Gaston Pia, but official records show that Gaston and his brother
Edmond did not arrive on Tahiti until 1898, seven years later, and were
in any case posted to Moorea, not Paea. The truth seems to be much
simpler: Gauguin just abandoned his journey on a whim. Perhaps the
coach was too much for him or it may be that he had heard that there
was a rare surviving *marae*, one of the old religious meeting places, in
the area and wanted to visit it before moving on. Even without an invi-
tation, it would not have been hard to find somewhere to make a short
stay – Tahitian hospitality was justly renowned and he would quickly
have been invited to share a hut and a meal.

Whatever his reasons, he certainly found the place attractive, especially
as night fell:

> I went, that evening, to smoke a cigarette on the sands by the sea-shore.
> The sun was rapidly approaching the horizon, was beginning to hide
> behind the isle of Moorea, which I had on my right. Against its light the
> mountains stood out in strong black upon the blazing sky, all those crests
> like ancient battlemented castles.

We do not know how long he stayed in Paea. He began to make what
he called 'studies' for future paintings but without a settled place of his
own he was severely restricted in what he could do. Nor would the sort

of subjects he wanted have been readily available – Paea was too near to Papeete and too much given over to plantation farming to offer the sort of untouched sites he wanted to see. Nor is it likely that the *marae* in the valley of Arahurahu would have offered him much. Today, it is quite impressive, having been heavily restored and used now for folklore and other cultural spectacles but in the 1890s there was little more than a few overgrown stepped banks to indicate where the pyramidal platform must have been, on which the religious ceremonies were performed.

Paea was just too near to Papeete. Land was seldom for sale, accommodation was hard to rent, the girls drifted off to the meat market and there was a terrible air of indolence which spread back from the town to its hinterland. Drink and imported diseases had taken their toll – typhoid in 1890; dysentery in 1892, the year after Gauguin arrived. Syphilis he knew about, and all together they added up to a perfectly sensible set of reasons for choosing to put more distance between himself and the spreading tentacles of urban squalor.

He could have caught the daily coach and continued south to Taravao, but instead he returned to Papeete in order to prepare for a longer journey. The usual explanation, that he had had an invitation from a local chief to visit his district, is probably true, given the nature of these preparations. Gauguin is said to have met his host at the 14 July reception – the chief had been sent to the international exhibition in Paris as a reward for his loyalty to France and would certainly have been amongst those, like Spitz, who were being fêted for their participation in that event. The chief's district, Mataiea, was some forty-five kilometres from Papeete, less than ten kilometres short of Taravao and the isthmus, just far enough to be a serious proposition. We can tell that Gauguin intended to make this more than a brief visit from the careful way he prepared himself for hardships to come. These involved more than just packing his paints and chisels; his main concern was to avoid any possible privation by finding a woman willing to go with him. His choice fell on the chirpy, none-too-bright Titi, who was rootless and keen to attach herself to anyone happy to keep her. She certainly seems to have looked on the trip as an extended picnic, turning up on the day of their departure in her best dress, her woven hat bedecked with artificial flowers and orange-coloured shells. She was clearly thrilled to be riding along in the carriage Gauguin had borrowed from a friend in the police, though he might well have had second thoughts once he had gathered from her chatter that she believed him to be far richer than he was and that she was looking forward to leading a very grand life indeed.

Still, when she let her hair fall loose, she was very pretty and even if she was mercenary, he could still see some trace of love in her. Fortunately, her 'insignificant conversation' could not spoil the view of the

sea and the coral reefs, against which the breaking waves sent up spray like rising smoke. The journey took all morning and the encounter between eccentric Bohemian artist, with Titi in all her finery and their equally larger than life host must have made quite a spectacle.

Tavana Ariioehau a Moeroa – always knows as Chief Tetuanui – was one of the local leaders who had sided with the French against the Pomare dynasty. He had fought for the colonists at the final battle and always wore his campaign medal on his vest as proof of his valour. This makes Gauguin's decision to stay in Tetuanui's district somewhat puzzling, if one believes that he was really looking for somewhere wild and unspoiled. Thanks to Tetuanui's collaboration, the French had made Mataiea the most developed spot outside Papeete. Administrative buildings had been put up for the chief, French nuns ran the local school, there was a Protestant chapel and a nearby rum distillery at Vairia run by some white settlers. Even Tetuanui's home showed that Mataiea was no longer untouched. There was a fashion amongst the wealthier Tahitians for fanciful colonial buildings and though we have no exact record of Tetuanui's home, there is a photograph, probably by Spitz, of the country house of the magnate Auguste Goupil who had a plantation at Punaauia, about twelve kilometres from Papeete, which gives some idea of the style. This amazing construction was bedecked with gingerbread fretwork along its verandas and gables, not unlike a Victorian-Gothic railway station. The photograph also reveals the sort of gentility to which such people aspired: Goupil's daughters are posed before his mansion in long white gowns with mutton-chop sleeves, grouped about an easel where one of them has been doing a little painting. With the manicured lawn and the neat clusters of palms and bamboo, safely trimmed and controlled, we are offered the perfect image of colonial propriety and if Tetuanui's residence was even slightly like this, then Gauguin ought to have seen at once that Mataiea was a very long way from his unspoiled Eden. Yet after only the briefest glance, he decided to go no further. The place was certainly beautiful – the coastal plain was wider than at other points on the journey so that one could get far enough away to have the sort of majestic views of the mountains, otherwise only possible from out at sea. The lagoon was especially lovely and the way the Tahitian dwellings were not clustered into one village but scattered under the trees, did give an illusion of a pre-colonial world. Perhaps more to the point, Tetuanui could help organize matters, for Gauguin had now accepted that his inability to speak the language would have him floundering about, were he to continue his journey beyond the isthmus.

Keen to see his new friend suitably housed, the chief introduced Gauguin to a wealthy farmer called Anani, the Tahitian word for orange,

the fruit he successfully cultivated and exported. Anani, too, had built himself a European-style house which was not yet occupied but, to the surprise of both men, Gauguin rejected this modern affair of wood and corrugated iron and asked instead if he could rent the nearby bamboo hut where Anani was still living. The setting was ideal, in one direction the open plain led to the first slopes of the mountain range, in the other it ran down to the sea. There was a stream near by, the Vaitara, good for drinking and bathing, while the hut itself, with its single room roofed with pandanus leaves and an earthen floor covered with dried grass, was simple yet cool and just as Gauguin had imagined it would be. We, however, may imagine Titi's reactions when she realized that her new man was rejecting the offer of a fine colonial mansion in favour of a miserable native hut. There was a kitchen-hut for cooking over an open fire and that was that, simplicity itself. No doubt, equally mystified, Anani agreed to move into the European dwelling and to let Gauguin rent his modest home. The great adventure had begun, but first Gauguin decided to return to Papeete to collect the small amount of furniture he would need and to stock up with any other goods that would be difficult to find near by. He and Titi spent that night in Mataiea and set off back the following day. There was, however, another reason for the journey. Titi was, in Gauguin's words 'glossy from contact with all those Europeans' and he was no longer keen to have her with him. He would have to take his chances with the local girls and when they arrived in the town and Titi asked if he would be taking her back, he lied, saying that he would send for her once he had settled in.

At first, he was happy in his solitude. 'Only the beating of my heart could be heard. The reeds of my hut in their spaced rows were visible from my bed with the moonlight filtering through them like an instrument of music . . . In my sleep I could imagine space above my head, the vault of heaven, not a prison in which one stifles. My hut was Space, Freedom.'

Gauguin was to know this freedom for nearly eighteen months, from late September 1891, throughout 1892, until March 1893, though he would not always enjoy it. His decision to cut himself off from the European life of the town, and his attempt to share what he thought of as the real Tahiti, were bound to induce cultural schizophrenia. With Gauguin this manifested itself in breathtaking lurches between states of blissful happiness, swiftly followed by a plunge into gloom and introspection. Sometimes he would swing back and forth between the two within a matter of weeks, in a manner akin to Van Gogh's terrible manic changes. One shudders to think what might have happened had they travelled out together, to the 'Studio of the Tropics' – as they originally planned.

Fortunately for his sanity, Gauguin was basically an optimist, hence his use of fantasy, to help him ride out the bad periods. But even someone as tough as Gauguin was to be sorely tried by the coming year and a half, for he was now faced with the greatest test anyone can be asked to take: the unforgiving challenge of living out a dream of one's own devising. He had wanted to be a savage from Peru and to return to what he imagined must be his natural state, he had got his wish and now he would have to live with it.

Initially it was bliss. He began by turning his back to the sea and painting the open plain stretching to the lower slopes of the mountains, returning to the same scene over and over again, making it his own, always the same: the large mango tree dominating the background, a glimpse of huts, the occasional tiny figure passing along the coast road which crossed the land in front of his own cabin where the local black pigs snuffled in the undergrowth. Only gradually did he move closer to the people, though not too close as yet, just a group of women sitting talking in the shade, perhaps talking about him, hence the title *Parau Parau*, which he eventually gave to the finished painting, and by which he meant something like *Words, Words* or perhaps *Whispered* – one can never be entirely sure given his weak grasp of the language, allied to his usual desire to be ambiguous. However, the people were not unfriendly, just reserved. When the supplies he had brought ran out after only two days, one of his neighbours asked him to come and eat but he was too embarrassed to accept, and they sent over a child with some food 'cleanly done up on fresh picked leaves'. A little later the man went by and called out *'Paia?'* which Gauguin imagined must mean something like, 'Are you satisfied?' Clearly there was no animosity to this stranger in their midst, but Gauguin quickly discovered the impossibility of living off the land as he had planned – fishing was a skilled art and any game lived high on the inaccessible slopes of the mountain. Even collecting the famous wild red mountain bananas involved a long journey and a steep and dangerous climb which none but the experienced undertook with any ease. This left only a local store run by a Chinaman called Aoni, though this sold no fresh food as his usual customers had their own supplies. The simple solution of buying fruit and vegetables from the villagers was not open to Gauguin, as selling it would have been against their principles, and were he to ask they would have assumed he was begging, an intolerable position for someone as proud as Gauguin. He preferred to live on tins of corned beef and bottles of French claret or absinthe – all of which were staggeringly expensive in so remote a place and any lingering notion that he could live a natural existence, disporting himself among bare-breasted *vahines*, was finally dispelled when he had the first of many run-ins with authority. Away from Papeete, the local

gendarme was a tin-god, applying the law and, in the remoter districts, administering justice and acting for the administration in almost everything. Some were decent enough, some were swaggering dictators, and Jean-Pierre Claverie in Mataiea seems to have been one of the latter. The missionaries were already suspicious of this peculiar newcomer and they seemed to have provoked the gendarme into taking action, spying on Gauguin to see what he was up to. Thus when Claverie saw that Gauguin was in the habit of bathing naked in the nearby stream, he pounced, threatening him with arrest if he didn't desist. It was the start of a long drawn-out battle which could only end badly.

It is hardly surprising that Gauguin, caught between the unsympathetic French and the distant Tahitians, initially produced paintings which are those of an outsider looking in, painting a fruit gatherer just coming into view as he returns from the mountain with his stem of red bananas; standing beyond the clearing where the young people are dancing round a bonfire; trying to get down a quick portrait of a young man with a white horse, some way away, as if he was somehow unapproachable.

Gauguin was clearly intrigued by this handsome youth. His first attempt to portray him close-to shows the boy, stripped down to his breech-cloth, standing beside his horse, holding the bridle in a pose taken from one of Gustave Arosa's photolithographs of the Parthenon frieze. One of Gauguin's first acts had been to decorate his hut with his 'little friends', pinning up the postcards and photographs of the temple friezes from Borobudur, Manet's *Olympia*, the mural from the Theban tomb he had seen in the British Museum. Gauguin could turn to them when, as now, he could not get close enough to the original. The boy and his horse may have been imaginary characters, but it seems unlikely, for he is very similar to another figure Gauguin drew, who was apparently employed as a wood-cutter. There was a diseased coconut palm near the kitchen-hut, which had bent into the shape of a huge parrot and Gauguin had watched intrigued as the nearly naked man went to work on it, wielding a heavy axe with both hands. It was a sight which Gauguin later recorded with a touch of poetry, noting how, at the top of its stroke the axe left 'its blue imprint on the silvery sky and, as it came down, its incision on the dead tree, which would instantly live once more a moment of flames . . .'

It is impossible to be sure when Gauguin first decided that this poetic symbol should be his model. He certainly wanted, as he put it, to initiate himself properly into the character of a Tahitian face. He had seen a woman living near by who seemed to be of pure Tahitian descent and he eventually managed to persuade her to come into his hut. As she was examining the photographs and cards he had pinned up, he tried to

sketch her but when she realized what he was up to she 'made a nasty grimace' and left. This was not, however, the end of the matter: just as he was about to give up, she came back, having only slipped away in order to put a flower behind her ear, a necessary touch for a Tahitian beauty. Once again she studied the photographs while he tried to hastily finish sketching her before she changed her mind. When she got to the reproduction of Manet's *Olympia* he tried to ask her what she thought of it and she said she thought the woman was beautiful then asked if she was his wife.

'Yes,' Gauguin lied, then seizing the opportunity this seemed to offer, he asked if he could paint her portrait.

Realizing what he wanted she said 'Aita – no', clearly outraged at the idea of posing naked like 'his wife' and again she left.

This time, Gauguin was truly depressed and all the more surprised when she again returned, an hour later, though safely covered in her Sunday-best Mother Hubbard. Thus protected she allowed him to paint her and *Vahine no te tiare* (*Woman with a flower*), is his first portrait of a true Tahitian model and one which gives the lie to the assumptions that he was solely interested in young, conventionally pretty girls. The face in this painting is mature and full of character, as Gauguin put it: she was not in fact pretty by European standards but was 'beautiful all the same – all her features had a Raphaelesque harmony in their meeting curves, while her mouth, modelled by a sculptor, spoke all the tongues of speech and of the kiss, of joy and of suffering; that melancholy of the bitterness that mingles with pleasure, of passivity dwelling within domination. An entire fear of the unknown.'

This reveals much about the way his mind was turning. It is easy to assume that his desire to travel to the Pacific had been partially aroused by a belief that he would find adoring young native women happy to oblige any passing white man. For someone who had spent almost all his life with dominant women, from his mother to Mette, it is easy to assume that what he really longed for were passive village girls, willing to become his exotic sex slaves, yet here we have the first sign that his true feelings were much more complex than that conventional image of him allows.

We know he made a sincere effort to merge into the world around him, dressing like the villagers in a simple Tahitian *pareu*, a flower-printed sarong, and going to what was called 'The House of Hymns' where an old man would lead the prayers and the people would sing the beautiful choral *himene*. And, gradually, they did accept him – he painted a gathering in the Protestant meeting hall and over time the figures in the painting get closer until they and not the surrounding landscape dominate the scene. They had already sensed his loneliness and in true

Tahitian fashion one of the old men pointed out a woman who might join him. '*Mau tera*,' he said. 'Take this one.' But Gauguin was secretly afraid, having heard that many of the villagers had 'the sickness which the civilized Europeans have brought with them in return for their generous hospitality.'

He did eventually find a friend, though not from amongst the women. He wrote:

> I have a natural friend who has come to see me every day naturally, without any interested motive. My paints in colour (and) my wood carvings astonished him and my answers to his questions taught him something. Not a day when I work but he comes to watch me. One day when, handing him my tools, I asked him to try a sculpture, he gazed at me in amazement and said to me simply, with sincerity, that I was not like other men; and he was perhaps the first of my fellows to tell me that I was useful to others. A child . . . One has to be, to think that an artist is something useful.
>
> The young man was faultlessly handsome and we were great friends. Sometimes in the evening, when I was resting from my day's work, he would ask me the questions of a young savage who wants to know a lot of things about love in Europe, questions which often embarrassed me.

His friend was the young wood-cutter, the youth with the white horse. In his account of their friendship, Gauguin sometimes refers to him as Totefa but most often as Jotefa, a version of Joseph. Of course, the name may simply have been a later invention, given Gauguin's indifference to hard facts in all his writings. But whatever he was called, the young man was clearly a key feature of the artist's life in Mataiea. Gauguin painted him, his axe raised above his head in the way so poetically described, though the pose, with the left hip slightly turned, is again taken from one of the details on the Parthenon frieze. Once again, we are witnessing Gauguin's merging of cultures – the handsome Polynesian figure seen as an Attic sculpture, an ephebe by Phidias. This may well have been the first of the Tahitian paintings to depart from everyday village life, the first to re-enter the imaginative world which Gauguin believed to be his true vocation. The posed youth is set against a stylized beach, with a dugout canoe in which a woman is arranging a fishing net. She is bare-breasted, which shows that the scene could not have been taken directly from life – such sights were no longer available to him, as he now accepted. Rather, the whole picture is an evocation of a golden age, of the innocent Tahiti before the missionaries with their Mother Hubbards and their talk of sin.

The figure of Jotefa, as it is convenient to call him, reappears throughout the early Tahitian paintings. Sometimes he is the dominant character, either as the man with the horse or as the wood-cutter, occasionally he is simply a small background figure, watching the main action from a

distance. But his presence is always significant and usually indicates an important change in Gauguin's thinking, as if the wood-cutter/horseman were a sort of spirit or genie pulling him in a new direction. But this was the only male character: women remained Gauguin's primary interest and while he seems to have used a number of models – anyone who would pose for him, one suspects – there is some similarity about their appearance. At a guess, most were in their early twenties, strong with square shoulders and powerful legs that give them that touch of manliness which Gauguin had remarked on from his first arrival. Most have the oval face, with strong nose and full mouth that he had already established as the very archetype of his vision of Polynesian beauty. One has to remember that before him, European artists had seen other races only as oddly dressed Europeans. If they wanted to be charitable, they depicted an exotic beauty as a classical Venus with a few local embellishments. By contrast, Gauguin found the Tahitians beautiful in themselves and pictured that beauty with an original honesty. Not that everyone was willing to be painted. The paintings seem to suggest that it took him some time to persuade the local women to pose in the nude. Tahitian women were by then a curious mix of their former 'wantonness' and of the 'gloomy' prudishness which the missionaries had inflicted on the islands. Sitting about being stared at, without your best Mother Hubbard on, was apparently a step for which some cajoling was needed. In one of the early portraits, the sitter is completely covered in a long red gown, posed in a rocking-chair which Gauguin may have brought out from Papeete. Slowly, over the following weeks and months, this Europeanness is literally stripped away. More often, he had to content himself with painting them clothed, going about their normal village activities, though some still show a charming degree of intimacy – in the painting he called *Tahitian Women*, a woman in her pink Mother Hubbard, while half-heartedly plaiting a straw hat, glances up out of the corner of her eye, as if trying to see what he is doing.

Persuading the local women to pose for him was one thing; finding one willing to share his bed was quite another, and in desperation he sent word to Papeete for Titi to come out and join him – a foolish idea as she was far too citified ever to accept the quiet life of a village *vahine*. From the moment she was back he found it hard to put up with her chatter. She was never willing to leave him alone to get on with his work, nor can she have approved of his attempts to merge with his surroundings.

Gauguin tried to shut out the talk and to make the best of their life together, but reality was never far away. Despite the way his work was progressing, there were still worries. By the end of the year, only seven months after his arrival on the island, the last of his savings from the

Drouot sale were almost gone. It had been painfully expensive to live off imported food even before Titi returned; with two of them to feed he was rapidly running out of cash. There was no sign of any help coming from France. Not long after his departure for Tahiti, Morice and the other Symbolists had organized a joint benefit evening for Gauguin and Verlaine at the Théâtre d'Art, but *Cherubim*, the play Charles Morice wrote as the centrepiece for the evening, had been a hopeless flop. The critic Pierre Quillard had so savaged the piece in the *Mercure de France* that he effectively demolished Morice's budding reputation. Not surprisingly, the 'benefit' had failed to show a profit, since when Morice showed no sign of being willing or able to repay the 500-franc loan. The silence from Paris and Copenhagen was deafening. Only Monfreid had written and then only to tell him that Juliette had given birth to a daughter, news which produced a somewhat unpleasant display of self-justification in Gauguin's next letter back: 'Poor Juliette with a child, and now I can't help her. I am not surprised that the little one is feeling ill. It happened in spite of everything; God knows the conditions under which I did it. However . . .'

The letter goes on to reveal a surprising lack of confidence on Gauguin's part, mainly his doubts about his work, doubts that were to increase as time went by.

> You ask what I am doing. It's rather difficult to say, for I myself hardly know what it amounts to.
>
> Sometimes it seems to me to be good and yet there is something horrible about it. As yet I have done nothing striking. I am content to dig into myself, not into nature, and to learn a little drawing; that's the important thing. And then I am getting together subjects to paint in Paris – if this tells anything, so much the better; I cannot say more without inventing stories and filling you with illusions that you would lose on my return . . .

The letter was dated 7 November 1891, and would have taken two months to reach France via America. Shortly after sending it, Gauguin had ample justification for his bout of depressive introspection for he suddenly began coughing blood. Worse, he had chest pains as if his heart was giving out. There was no obvious reason for something so dramatic. His diet was meagre, but adequate, he had his worries but he was hardly suffering the sort of pressure he had known in the past, yet here he was bringing up blood.

He wrote a hasty note to Jénot outlining the situation: 'This poor Captain is sick, I trust it isn't serious,' then added that Titi would be back in Papeete soon as he had kicked her out: 'She never wanted to do anything, she whined about everything . . .' And he ends with his regards to Tehora, who was no doubt again on his mind now that he had ejected Titi from his life.

## A Lavender Angel

Despite his illness, Gauguin was determined to break with the drifting lethargy that had even seeped into his work. Christmas was approaching, always a time of change in his life, a fact brought home by the hymns pouring out of the Protestant chapel on one side, and the sounds of the mass from the Catholic church on the other. It is easy to assume that the Bohemian Gauguin must have been forever at odds with his devout neighbours, so that it is surprising to discover from the sketchbook he kept at the time that he was on good terms with at least one of them, a Sister Louise, a nun of the Order of Saint-Joseph de Cluny, who taught at the Mission School. Of course there is always the possibility that Gauguin was only sketching her portrait as a means of getting closer to the young *vahines* in her charge – but actually the drawing reveals that the 38-year-old nun was beautiful enough to engage his interest, her eyes modestly cast down, her profile framed by the full black robe that the Sisters wore, unlike other orders who had changed to tropical white.

What Gauguin seems to have liked most about the Catholic ceremony was its curious mix of these Western traditions, with other, Polynesian, touches that had crept into the services. As the sounds of the mass drifted across to his hut, he could hear the Tahitian responses chanted by the converts. The 'Hail Mary' opened with one of the few Tahitian phrases he had mastered: *Ia orana* – 'We Greet Thee', and the idea of this familiar prayer being so easily transformed into a mysterious otherness intrigued him. He knew little of the old Tahitian religion which the missionaries seemed to have so thoroughly repressed, yet he could imagine how Christianity might look to the Tahitians, much as he had seen the story of Jacob wrestling with the Angel through the eyes of simple Breton peasants. Thus when he painted his tall, imposing Tahitian Madonna with the Christ-child balanced on her shoulder, he placed them in an exotic jungle of fantastically coloured plants, as if the Nativity, which will redeem mankind, were taking place in the Garden of Eden, the setting for the original Fall. He called the painting *Ia orana Maria*, and we know that he had great difficulty finishing it and that there were several radical changes of plan before it was finally completed.

The painting we know today is very different from his first attempt. He began with a large horizontal canvas but eventually turned it on its side and completely repainted it, only completing the work in the following year, 1892. The setting of *Ia orana Maria* is Gauguin's lush, richly hued, imaginary Tahitian Eden with Maria as a Tahitian Eve in her vivid red *pareu*. The baby on her shoulder is both a golden islander and a Renaissance Christ-child with a gilded nimbus. The two worshipping women are based on figures in the temple frieze from Borobudur, their

hands clasped not in Western prayer but in the Hindu manner denoting respect and adoration. Strangest of all is the archangel, rushing in behind the foliage, a little late for an Annunciation, given that the Baby is already with us. The Archangel's awkward pose, crammed in at the left-hand side of the picture, does give the distinct impression that this was an afterthought and that its gaily coloured outfit – a lavender robe with wings in purple, blue and yellow, is there to heighten an already lush colour scheme more than for any specifically theological reason. Another late addition is the wooden altar painted over the bottom of the canvas on which are laid offerings of tropical fruits: a stem of wild red bananas, some breadfruit and yellow bananas in a *poipoi* bowl, all contributing to the transformation of the Western religious story into a rich Tahitian folk-tale.

To modern eyes the painting seems no more than a superb, and perfectly legitimate attempt to transpose the Biblical story to another part of the world and to integrate it into the local culture. But the fact that we can see it in such a way is itself part of Gauguin's triumph, for at the time it was painted *Ia orana Maria* was considered blasphemous. Where today the painting would be welcomed by any priest keen to encourage his congregation's identification with the familiar tale, in the last century such a resetting of the holy story was formally forbidden by the Church. Even a religious scene set in Brittany had proved completely unacceptable to the priest at Nizon and it is surprising to learn that it was only as recently as 1951 that a Papal Encyclical permitted the representation of 'native' figures as Biblical characters, in local costumes and settings. And Gauguin had gone much further, drawing on other beliefs, Hindu and Buddhist, and merging them into the Christian story.

Perhaps the painting's real success lies not so much in the religious sentiments it expresses but in the richness of the colours through which such feelings are transmitted. We know from his notes that he was worried that he was going too far, that the vividness of Tahiti might be forcing him into excesses he might later regret:

> Everything in the landscape blinded me, dazzled me. Coming from Europe I was constantly uncertain of some colour (and kept) beating about the bush: and yet it was so simple to put naturally onto my canvas a red and a blue. In the brooks, forms of gold enchanted me – Why did I hesitate to pour that gold and all the rejoicing of the sunshine on to my canvas? Old habits from Europe, probably, all this timidity of expression (characteristic) of our bastardized races.

There is a continuing supposition that Gauguin completely invented his own Tahiti, particularly in respect of his colours, but one could only hold to such a view if one had never visited Tahiti and seen the amazing

effects of light and tone that are created by the spectacular sunsets. As
the great red orb descends into the Pacific, it ignites a dazzling array of
seemingly impossible hues: purple and saffron, cerulean and lilac. What
worried Gauguin was that no one would believe that what he was setting
down on his canvas was no more than the truth, and of course he was
right. Even though he is no longer criticized for offering such a vivid
palette, he is still assumed to have dreamed it up.

## An Affair of the Heart

Any satisfaction the work may have brought was dispelled by his declin-
ing health. He was now coughing up a quarter litre of blood a day and
it may have been at the point when *Ia orana Maria* was completed at its
first, horizontal stage, that he decided to abandon everything and return
to Papeete, the only place where he could get medical help.

Early in the new year, 1892, he took the uncomfortable public coach
to the town where he was able to get admission to the military hospital,
where one presumes that his friend Dr Chassaniol, by then a consultant,
would have supervised his treatment – though whoever was involved
seems to have accepted Gauguin's own diagnosis that heart trouble was
the root cause of his illness. As a consequence his chest was cupped,
while mustard plasters were applied to his legs and when he stopped
vomiting blood, he was given digitalis, the homoeopathic specific for
heart disease. None of these would have done him any actual harm,
though they were little use as a cure for what really ailed him – while
there can never be a complete diagnosis without a patient to test it
against, most experts have concluded that the blood-letting and the chest
pains were manifestations of syphilis. The one alternative, that he had
contracted yaws, either in Panama or Martinique, needs to be considered,
though as the symptoms are virtually identical to those of syphilis and
as neither could then be cured, the difference is academic. Assuming
that it was syphilis, then the signs are that it was by then entering its
secondary stage, though had not yet got to the point where the desper-
ately painful skin infections, the unsightly lesions and rashes accom-
panied by debilitating fevers, finally begin to wear down the sufferer,
leading to the tertiary phase which brings with it the terrifying mental
breakdown known by its bleak medical title GPI, a euphemism for Gen-
eral Paralysis of the Insane. Anyone who has ever glanced at an old
medical textbook, with those appalling photographs of syphilitic sores
and tortured bodies with faces and limbs eaten away by the disease, can
only give heartfelt thanks for the discovery of the modern treatments so
sadly lacking in Gauguin's day. The strange thing is that he must eventu-
ally have known what was wrong with him, for while seldom openly

discussed, the disease was common enough and much feared, yet in none of his letters or other writings does he ever acknowledge it to be the source of his sufferings, as if he simply could not face the truth of what was happening to him.

If it was venereal syphilis, then it is unlikely that it had anything to do with Titi or the other denizens of the 'meat market' – the disease was so far advanced he must have caught it before his arrival on the island. He might even have been infected way back in Rio de Janeiro at the time of his first sexual encounters. But even if the doctor had diagnosed syphilis, there would still have been no cure, though there were a number of treatments which might have helped check the progress of the symptoms. At the very least, Gauguin should have taken the opportunity to rest under medical supervision, a respite which would have helped build up his strength and his resistance. But the 12 francs a day it cost to stay in the hospital was just too much and as soon as the first treatments were over, he discharged himself, even though he was far from fully recovered.

It was a low moment. His money was nearly gone and he was lucky to have Jénot and his settler friends, Sosthène Drollet and Jean-Jacques Suhas who tried to help with small loans. This was generous of Suhas who had to keep a wife, daughter and baby son on little more than his salary from the military hospital. One assumes that Gauguin was such an entertaining figure in an otherwise drab situation that these friends were prepared to make considerable sacrifices for him, and he certainly attracted a motley crew of the island's more colourful, not to say disreputable, characters. Drollet introduced him to a Captain Charles Arnaud, another ex-Navy man, who had built up a substantial business with his schooner the *Mateata*, trading amongst the hundred or so Polynesian Islands and indulging in a little smuggling. His goods were said to be of such poor quality and the prices he offered for the copra and mother-of-pearl which he took in exchange were so low, that it was little wonder the natives of the Tuamotu Islands, where he did much of his business, nicknamed him 'The White Wolf'. Despite this reputation, Arnaud's name crops up amongst those managing the various consultative councils on Tahiti where he was a major nuisance for the governor. Gauguin could hardly complain. Since he was now shunned by the French administrators and their wives, he needed any friends he could get.

Back in Mataiea, his landlord Anani was equally generous, insisting that Gauguin move into the European-style villa so that he could convalesce in comfort. It was now well into the rainy season and the draughty hut offered little protection against the winds coming off the sea. We know something of Gauguin's stay at the house from a fascinating source – the British author Somerset Maugham who visited Tahiti in February

1917. Although this was fourteen years after Gauguin's death, Maugham was still able to find some traces of the artist's time there. On a visit to Paris in 1904, Maugham had heard a great deal about the recently dead Gauguin and had spoken with several of those who had known and worked with him. It was at this point that he hit on the idea of writing a novel loosely based on Gauguin's life, a book which was eventually published as *The Moon and Sixpence*. It was thirteen years before Maugham was able to travel out to Tahiti, and even then he could only spend a few days on the island, staying at a hotel in Papeete and travelling out by car to visit places associated with the artist. It was while he was visiting the house of a female chief about thirty-five miles from Papeete that he was told that there were some 'Gauguins' in a house near by. What Maugham found was 'a very shabby frame house, grey and dilapidated', which he approached by a swampy grass path. The veranda was 'swarming with dirty children' but the owner was 'a flat-nosed smiling native' who invited him in. This was Anani's son and when he showed the visitor into one of the two main rooms, Maugham found that:

> There were three doors; the lower part of each was of wooden panels and the upper of panes of glass held together by strips of wood. The man told me that Gauguin had painted three pictures on the glass panes. The children had scratched away the painting on two of the doors and were just starting on the third. It represented Eve, nude, with the apple in her hand . . . . I asked the man if he would sell it. 'I should have to buy a new door,' he said. 'How much would that cost?' I asked him. 'Two hundred francs,' he answered. I said I would give him that and he took it with pleasure. We unscrewed the door and with my companion carried it to the car and drove back to Papeete. In the evening another man came to see me and said the door was half his. He asked me for two hundred francs more, which I gladly gave him. I had the wooden panel sawn off the frame and, taking all possible precautions, brought the panelled glass panes to New York and finally to France.
>
> I have it in my writing room.

That was written in 1962, shortly before Maugham sold the door for 17,000 dollars, a huge sum at the time and a reflection of the rarity of Gauguin's Tahitian work. Maugham had in fact discovered one of the last of the 'lost' Gauguins and thus preserved a fragment of what had once been a large and complex work made to thank Anani for his hospitality. It is a pity that Maugham did not attempt a fuller description of those fragments which were still visible but which he did not think worth saving. The door Maugham took was probably a minor element in the overall scheme but it is still fascinating as it shows what must have been one of the earliest bare-breasted representations of a Tahitian Eve who has just plucked a breadfruit from the exotic plant curling up beside her.

We can even piece together something of what it was like inside Anani's house as Gauguin worked on the scheme, for he also painted a portrait of a woman sitting on the floor, perhaps Anani's wife, in her white shift patiently waiting for him to finish. The title of that picture: *Te faaturuma* has been variously translated as Silence, Dejection, Melancholia – even 'The Sulky Woman' or 'The Brooding Woman', but all Gauguin shows us is a *vahine* in a typically pensive mood, her head resting on her hand, her mind far away. We know this is Anani's house, from the elaborate fretwork balustrade on the veranda seen through the open door. Beyond that we can see a figure, who could be Jotefa, who has ridden up on his horse, and who is looking into the open house, intrigued by the sight of the Frenchman at work – 'the Man who makes men' as the Tahitians called him.

It was probably at this point that Gauguin returned to *Ia orana Maria*, turning the canvas vertically and completely repainting it, forcing himself to use the colours he knew were there but which would seem so strange to European eyes. As the work progressed, he seems to have finally liberated his palette. But while the colours were Tahitian, the subject was still half-way between two cultures. *Ia orana Maria* was a significant achievement but a long way from his ultimate aim of entering the pre-Christian world of the Maori. He might well have left Tahiti with his dream unrealized, and it was only an accident which finally opened the door to that other world that he was beginning to believe was lost for ever.

## The Seed of the Areois

When not painting he could think of little except money and by February he was forced to accept that he could not go on without getting some from somewhere. He had heard that there was a vacancy for a magistrate out on the distant Marquesas Islands and he quickly convinced himself that he was just the man for the job. It would be easy enough to do and would leave him ample time for painting. The Marquesas would be far less Europeanized than Tahiti and he confidently expected to find the sort of native art which the missionaries had wiped out elsewhere. The photographs of tattooed Marquesan men that he had seen were some proof that the old traditions still survived out there. All he needed to do was convince the governor to grant him the post, and in February he took the coach back to Papeete to see Lacascade at his residence.

The commissionaire took his card and instructed him to go up the stairs to the governor's office; but as he climbed, Lacascade, dressed in his usual black frockcoat, came out and stood at the top of the stairs looking down. He was polite enough at first, asking Gauguin why he

had come, but when he heard this scruffy painter, who he knew had gone native, ask to be made a *juge de paix*, his manner became less accommodating. It is impossible to tell from Gauguin's record exactly what passed between them. We don't even know whether the governor was angry at his presumption or amused at his folly. Either way, he gave Gauguin a dour lecture on the qualifications and experience necessary for so delicate a post, none of which Gauguin had any wish to hear. 'I bowed and withdrew, like the fox, swearing that . . . .'

He never ceased to vilify Lacascade from then on, playing on his dark looks and his Caribbean origins by referring to him as 'the negro Lacascade' and openly suggesting that he took bribes or could be swayed in his judgements if sexual favours were on offer. He even drew a caricature of him as a monkey in a frock-coat and another as a monkeyish buffoon in top hat and tails.

Of course the governor was quite right in his assumption that Gauguin would have made a disastrous magistrate, had be bothered to turn up in court, once the post had been secured. For his part, Gauguin was playing a dangerous game in so publicly attacking the man who was, after all, the supreme authority on the island and thus quite capable of making his life a misery. Nor had any of this improved his finances, which is why he was forced to call on Tahiti's leading lawyer and businessman, Auguste Goupil, at the imposing Victorian mansion on his plantation at Punaauia, about twelve kilometres along the road between Papeete and Mataica.

Goupil was sympathetic and agreed to buy the hunting gun for which Gauguin had no possible use, a deal which would relieve his financial problems, temporarily at least. But Goupil was more than just a useful source of money – he was genuinely interested in what the painter was doing and thinking and listened attentively to his ideas about trying to re-create the missing art of the Tahitians. Keen to help, Goupil produced a book, or rather two books, for it was a double-volumed work, which he was willing to lend Gauguin as he felt sure it would provide him with the information he so clearly lacked. He was quite right, for seldom can so appropriate a study have fallen into the right hands at so precisely the right moment.

The two-volume *Voyage aux îles du Grand Océan* by Jacques-Antoine Moerenhout was by any standard an ambitious work, an attempt to record the entire pre-European culture of the three groups of islands which were then known as the Iles Pélagiennes, the Archipel Dangereux and the Archipel des Iles de la Société – roughly today's French Polynesia plus those islands, including Pitcairn and Easter Island, which are scattered along the East Pacific Ridge. Finished in 1835, and published in Paris in 1837, the book was the work of a French businessman of Flemish

origin, who had done a good deal of travelling around the islands before
settling on Tahiti, where he acquired a sugar cane plantation near
Papeete. Moerenhout acted first as consul for the United States then for
France, in which capacity he was involved in the incident of the expelled
Catholic missionaries and the subsequent attempted annexation of the
island by Captain Dupetit Thouars. After several posts in the adminis-
tration of the new protectorate, Moerenhout moved to California where
he became French consul, dying in Los Angeles in 1879. The two vol-
umes are certainly long, some 520 pages in total, and give the appearance
of being thorough. Part one covers the geography of the islands, part
two the ethnography, divided into language, religion, customs and
origins while the third part gives a detailed history of each island group.
In its day the book was accepted as the definitive account of the region
in French and for a time it exercised the sort of imaginative hold on
the minds of some French authors, such as the poet Leconte de Lisle,
that Loti's fiction had with a much wider public – though, unlike Loti,
Moerenhout was trying to offer a scientific record of the dying societies
he had visited.

Today, Moerenhout's reliability is more open to question, and anthro-
pologists now emphasize the errors in the reconstruction of Tahiti's
pre-European culture which Moerenhout based on interviews with a few
elderly Tahitians which he subsequently wrote up in a rather self-
consciously literary manner. Moerenhout seems to have accepted what-
ever he was told and made the best tale he could out of the material.
More seriously, he appears to have viewed Tahitian mythology through
the perspective of those European models with which he was most
familiar, an approach which led him to construct a pantheon of gods
and goddesses, reducing the complex Polynesian vision of interrelated
spirits to a pattern similar to the religion of ancient Greece. Yet it was
precisely this linking of cultures which appealed to Gauguin, who was
more interested in ideas of universal mythology than in a uniquely Poly-
nesian philosophy. Jénot had already suggested that there were still sur-
vivors on the island old enough to remember the old ways with more
precision than could be found in Moerenhout but Gauguin had neither
the Tahitian to understand them nor the inclination to delve any deeper
than the easily absorbed tales set down in *Voyages aux îles du Grand Océan*.
He believed that he had found just the account of Tahitian lore and
legend that he needed if he were to imaginatively re-create the lost art
of the island.

And concentrate he certainly did. He not only read the book but
copied out those passages that especially appealed to him. He had a small
sketchbook in which he wrote down chunks of Moerenhout word for
word, apart from his own spelling mistakes, in his large childish hand.

He eventually transformed these notes into an illustrated book which he called *L'Ancien Culte Mahorie*, by which he meant the Ancient Maori Cult. As the text was little more than a straight copy of a few pieces of Moerenhout's book with only the occasional side comment by Gauguin, he may not have had publication in mind when he first began. He probably looked on it as a personal reference work, to be used as source material for paintings or as notes for some future book that he might write.

It is clear that at a mere fifty-four pages of large handwriting, Gauguin barely touched on more than the tiniest fragment of Moerenhout's 520 pages and there is no disguising that what interested him most were primarily those stories connected with sex; almost the entire first half of the notebook, twenty-one pages, is given over to the coupling of gods and goddesses in the Tahitian creation myth, eight pages are then given over to the Ariois Society (sometimes Areois), a phenomenon that has been described as 'The Apostles of Free Love', while the final twenty-five pages offer selected folk-tales and legends, clearly picked because they are romantic or shocking and are thus highly suitable as dramatic material for future paintings. For Gauguin, it was a question of eye-catching headlines and his enthusiasm for what he had found bursts through in a postscript to a letter he wrote to Sérusier that March: 'What a religion the ancient oceanic religion is! What a marvel! My brain is buzzing with it and all the ideas it suggests to me are really going to scare people off. If people were worried about my old work in a domestic setting, what will they say about the new ones?'

With this in mind it is easy to see why he gave so much space to the Ariois Society and why part of their story became the basis for the first paintings he did, using Moerenhout and the *Ancien Culte Mahorie* as his source. Because the missionaries were determined to stamp out the Ariois, and did in the end succeed in doing so, their prejudiced accounts of this religious phenemonon convey the impression that it was little more than a band of marauding prostitutes. Modern anthropologists have tried to rectify this by describing a genuine religious group, which practised free-love and whose members travelled around the islands putting on performances of music and drama, as well as sexual demonstrations, as part of their proselytizing mission. If we separate Tahitian myth and missionary calumny from historical fact, we learn that the Ariois began in the middle of the fifteenth century on Raiatea, the sacred island within the Polynesian group whose priests created the society to act as roving apostles of the god Oro, whom they saw as a superior deity within the Polynesian pantheon. The Ariois had a strict hierarchy moving up from novice status to full membership by examinations in the faith. Members were forbidden to marry, were permitted free love and were

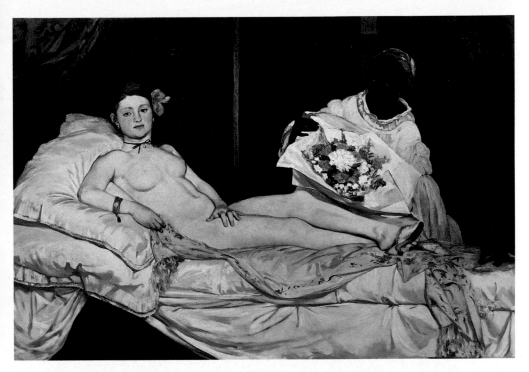

*Olympia* (1863) by Edouard Manet. Gauguin made a copy in 1890–91 and used many elements from the work in other paintings over the following decade. BELOW *The Little Dreamer: Study.* Gauguin's portrait of his daugher Aline asleep, painted in 1881 when she was four.

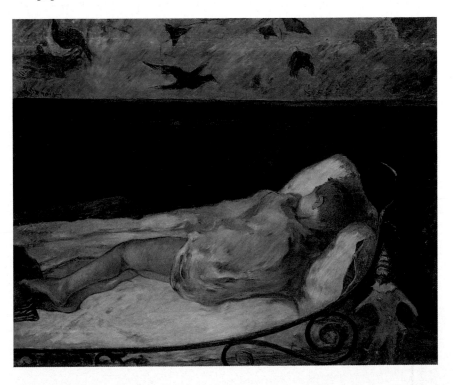

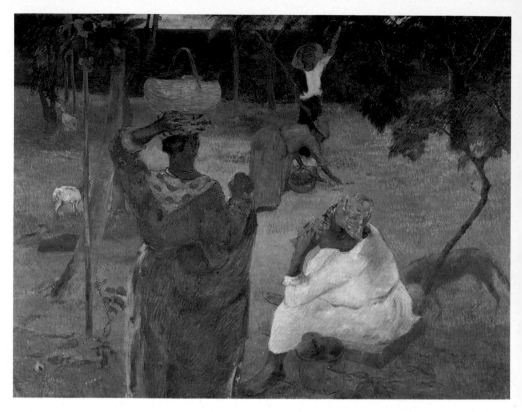

*Under the Mangoes* (1887). One of Gauguin's major works from his brief time on Martinique, which marks the beginning of his own unique style.

BELOW *The Vision after the Sermon: Jacob Wrestling with the Angel* (1888). The complex painting that united Gauguin's experiments in Brittany with the new ideas being put forward by the Symbolist movement.

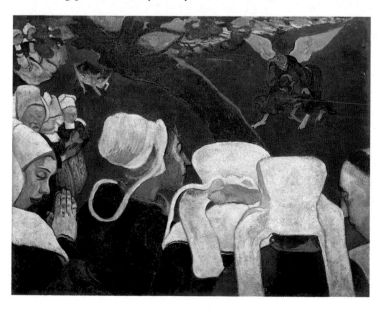

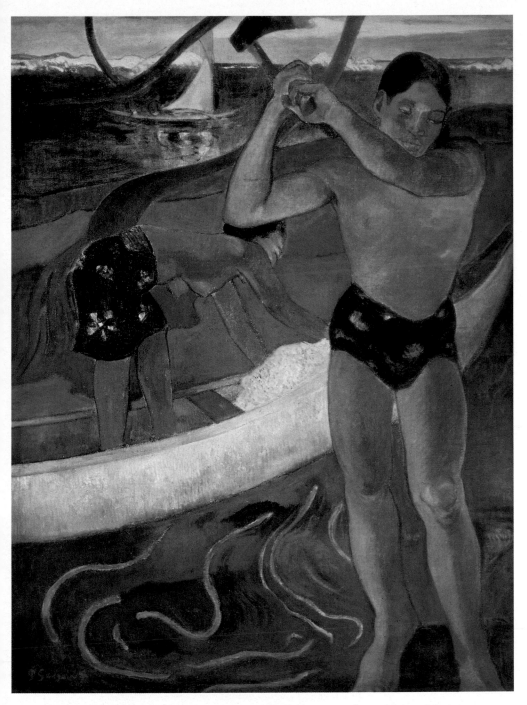

*The Man with the Axe* (1891). A painting which illustrates the incident with the Tahitian wood-cutter Jotefa from *Noa Noa*, Gauguin's book about his Polynesian experiences.

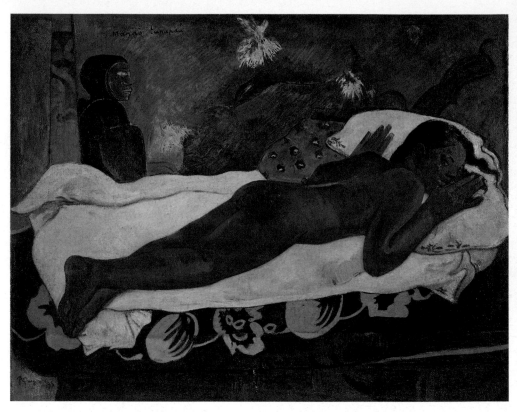

*Manao tupapau* (*The Spirit of the Dead Keeping Watch*) (1892). The most controversial of Gauguin's Tahitian works, following his claim that the girl on the bed was his thirteen-year-old child-bride Teha'amana.

An etching by
the Dutch artist
Humbert de
Superville, which
may have been one
of the sources for
*Manao tupapau.*

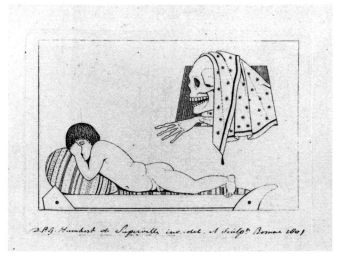

Page 57 of the exercise book in which Gauguin copied out *Noa Noa*, the fictionalized account of his first stay on Tahiti. He used wood-block prints, photographs and water-colours to tell a parallel story to that provided by the text.

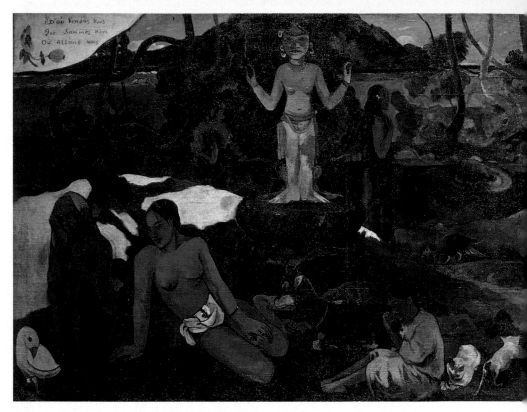

*Where Do We Come from? What Are We? Where Are We Going?* (1897).
The vast canvas on which Gauguin tried to summarize the thoughts
and feelings of his mature years.

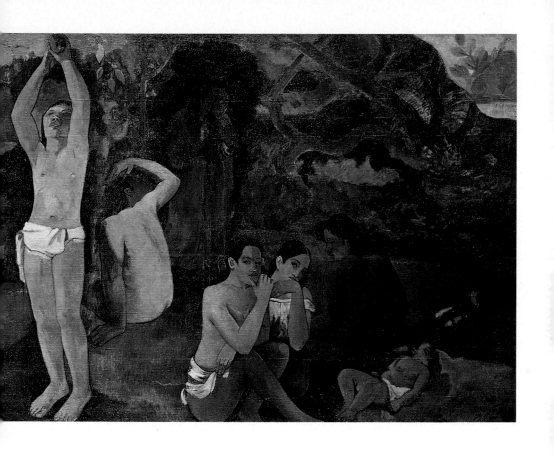

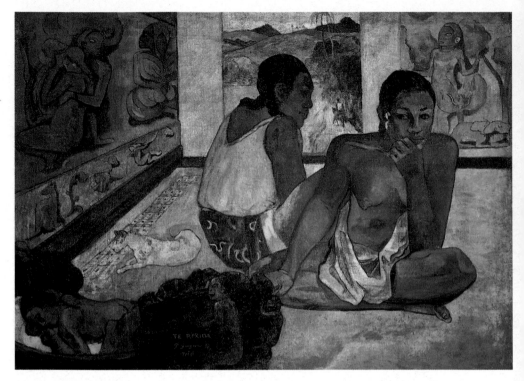

*Te Rerioa* (*The Dream*) (1897). One of the most sumptuous works of Gauguin's final Tahitian period in which he pays homage to the Maori art he had seen in New Zealand two years earlier.

obliged to practise infanticide to deter permanent relationships. And just as revivalist Christians use mass gatherings and music to promote their message, so the Ariois put on hugely entertaining spectacles of erotic dancing and sexual displays. It was, of course, these which so incensed the missionaries and it was undoubtedly just such an Ariois display which Captain Cook recorded with commendably dry Yorkshire wit:

> A young man, nearly six feet high, performed the rites of Venus with a little girl about eleven or twelve years of age, before several of our people, and a great number of the natives, without the least sense of its being indecent or improper, but, as it appeared, in perfect conformity to the custom of the place. Among the spectators were several women of superior rank, who may properly be said to have assisted at the ceremony; for they gave instructions to the girl how to perform her part, which, young as she was, she did not seem much to stand in need of.

It was the undeniable popularity of such spectacles which for a long time prevented the missionaries from making any headway on the islands. Only when these English preachers were accepted by Pomare III, who needed their help to gain supreme power, could these dour men begin the process of ensuring that the Ariois were suppressed. In Gauguin's time, it had been nearly a hundred years since one of the great flotillas had arrived on Tahiti, but none of this historical detail was of much concern to him as he was only interested in the legends surrounding the society, which Moerenhout had recorded.

According to these myths, the society had been founded by the god Oro, who, having dispensed with his shrewish wife, had taken to visiting earth to make love with the beautiful Vairaumati by whom he had a son. Aggrieved at this ungodly behaviour, Oro's brothers descended the rainbow to spy on him but, dazzled by Vairaumati's beauty, they decided they must present the couple with gifts of a pig and a bunch of red feathers. Oro then declared that these would be the symbols of a new society, which he would call Arioi, whose members would be childless and who would spend their days in dance, song and worship and whose first leader would be chief Tamatoa of Raiatea.

The best-known student of Tahitian anthropology, Bengt Danielsson, has shown that such a story was intended to legitimize the descendants of Tamatoa as heads of the cult and thus give to the chiefs of Raiatea a role as spiritual leaders of the islands. But Gauguin, knowing nothing of this, was only interested in what he saw as a beautiful tale of love between exotic beings in a setting full of colour and strange details. Two years later, he wrote up the story, using Moerenhout as his starting point, but enriching it with all the poetic embellishments he could dream up:

Then Oro, placing the rainbow again as at first, came down to Vaitape.

Vairaumati had prepared for his reception a table weighed down with the most beautiful fruit, and a couch of the rarest of stuffs and finest of mats.

And divine in their grace and strength they offered service to love under the tamaris and pandanus, in the forest and on the edge of the sea. Every morning the god reascended the summit of Paia; every evening he came down again to sleep with Vairaumati.

No other daughter of men henceforth was permitted to see him in human form.

It is this enhanced version which he used for the paintings based on the Vairaumati story, each one adding a slight twist to the basic tale. In *The Seed of the Areois*, he seems, at first glance, to be telling the story 'straight': Vairaumati is seated in a clearing, on her open palm sprouts the seed or germ of a plant, symbol of the son she will have by the god, who will in turn be the seed of the Ariois cult.

The painting is certainly beautiful and utterly strange. To see it alone, without any knowledge of its mythological sources, is like stumbling upon a surviving 'morsel' of an ancient culture, a tomb-painting buried deep inside a pyramid and glimpsed by candlelight. A feeling enhanced by the way the figure of Vairaumati, stiffly posed, her sideways posture taken directly from one of the women in the Theban frieze which Gauguin probably saw first in the British Museum – the torso flat to the picture plane, the legs turned sharply to one side.

Such cultural synthesis, mixing Polynesia and Ancient Egypt, and the prevailing air of mystery and otherness which the work conveys, makes it the Symbolist work *par excellence*. From this standpoint, one can say that with the aid of Moerenhout, Gauguin had achieved everything that he had set out to do, though recent criticism has tended to emphasize how far both Moerenhout and Gauguin depart from a true understanding of the ancient Polynesian religion. It has been pointed out that Gauguin could have made a greater effort to learn more about Tahiti's past had he really wanted to. This is unarguable, but misses the point. Gauguin's aim was not anthropological research but the imaginative re-creation of a lost past in a way that could be meaningful to the present.

In *The Seed of the Areois*, Vairaumati is not sitting in some lost antique world, but in a recognizable place, the familiar scene before Gauguin's hut which we know from earlier paintings. In this way, the fantastic story is situated in the everyday – a feeling reinforced in a second painting: *Vairaumati tepi oa (Her Name is Vairaumati)*, in which the seated figure is smoking a local cigarette, made from a rolled pandanus leaf, as if she were one of the girls in the 'meat market', only in this case she is not waiting for an ordinary lover to chance along and pick her up, but a

god. It was probably to balance this 'realism' that Gauguin gave her an Egyptian pose that would help remind us of her mythic role. In a sense, we are watching a play, a modern re-enactment of the myth. Gauguin makes no claims to have discovered a true Tahitian past, rather he invites us to share an evidently fictional experience with him. By using an obvious Egyptian pose, he takes a local myth and universalizes it, much as he had with the biblical roots of *Ia orana Maria* and before that with *The Vision after the Sermon*. In all these works, the charge comes from the interplay between his wry observations of contemporary life and an imaginative vision of a lost past. Just as the original tale of Vairaumati, as retold by Moerenhout, is a simple love story raised to poetic heights, so Gauguin reverses the process, making Vairaumati 'real', with echoes of the *vahines* he had known, casually puffing on a cigarette, waiting for a lover to arrive. Just as the Madonna could be a Tahitian mother, just as Gauguin himself could be the suffering Christ, so Titi or Tehura could be Vairaumati, and thus could the spiritual be reintegrated into the everyday.

## The Desire for the Unknown

In the midst of the Ariois series, Gauguin returned to the single most persistent figure of the Mataiea period, the young wood-cutter. We are again at the foot of the mountain, in the clearing before his hut – perfectly recognizable from former paintings – but instead of the mythical Vairaumati we again have Jotefa, taken from the earlier work, his axe swung above his head, chopping wood. By then, Gauguin had gone too far to return to simple reportage; the very lushness, the gorgeous colours and sumptuous foliage make the painting too rich for mere realism and in any case the strolling peacocks in the foreground lift it firmly into the realm of fantasy.

This is probably all that Gauguin expected us to see – a richly operatic scene, a land of heady delights of colour and beauty. But it is equally obvious that this is not the whole story, that beneath the surface beauty there is another work, hidden from us, known only to its creator. Some hint of this is discernible in the title Gauguin painted on the canvas: *Matamoe*, probably his least helpful Tahitian name. A compound of two words, it can be broken down into *mata* – face or eyes, and *moe* – sleep, which means nothing. Nor does Gauguin's French translation *mort* or death get us much further, unless we think back to the first painting of the wood-cutter and Gauguin's description of the axe making its incision on the dead tree which would instantly 'live for a moment of flames'. With this in mind, it might be argued that what Gauguin is really offering is a symbolical re-enactment of the cycle of life, death and rebirth –

though no one could possibly come to such a conclusion if the painting were approached 'cold' with no prior knowledge of his thinking.

One wonders if Gauguin was fully aware of the historical significance of the imagery associated with the youth? The axe had been introduced to Tahiti by Captain Cook, who had given hatchets as presents to chiefs only to discover that this useful tool enabled the favoured recipients to produce war canoes faster than their neighbours and thus made them increasingly dominant. The axe became a symbol of the destructive gifts of the Europeans – even more so when the original hatchets wore out and the Tahitians, who had not been taught iron-working, were unable to replace them, but had in the meantime lost the old skills of making tools of wood and stone. Horses too were originally brought by Cook as a gift from King George III of England to the man they mistakenly thought was paramount chief of the entire island and though this original equine strain eventually died out, the animals were from the first associated with power, or more exactly, foreign power.

Consciously or not, everything surrounding Jotefa is resonant with such meanings and it is certain that the concept of death and rebirth that Gauguin indicates as being present must have a much more profound source than a simple metaphor of wood and fire. In fact, it can be traced to an event which finally explains the persistence of the wood-cutter/horseman in the art of that first year, an episode which provides the deepest and most unexpected insight into the true nature of the changes which Gauguin personally underwent while he was on the island, and which has come down to us in his own words, untouched by any later hand. In his highly charged account, Gauguin describes a journey he made with Jotefa, one that was to prove as much spiritual as physical, a journey that was to transform his perception of Tahiti and its people:

> One day I wished to have for sculpture a tree of rosewood, a piece of considerable size and not hollow. 'For that,' he told me, 'you must go up the mountain to a certain place where I know several fine trees that might satisfy you. If you like, I'll take you there and we'll carry it back, the two of us.'
>
> We left in the early morning.
>
> The Indian paths in Tahiti are quite difficult for a European: between two unscalable mountains there is a cleft where the water purifies itself by twisting between detached boulders, rolled down, left at rest, then caught up again on a torrent day to be rolled down further, and so on to the sea. On either side of the stream there cascades a semblance of a path: trees pell-mell, monster ferns, all sorts of vegetation growing wilder, more and more impenetrable as you climb towards the centre of the island.
>
> We went naked, both of us, except for the loincloth, and axe in hand, crossing the river many a time to take advantage of a bit of track which

my companion seemed to smell out, so little visible (it was), so deeply shaded. – Complete silence – only the noise of water crying against rock, monotonous as the silence. And two we certainly were, two friends, he a quite young man and I almost an old man in body and soul, in civilized vices: in lost illusions. His lithe animal body had graceful contours, he walked in front of me sexless . . . .

From all this youth, from this perfect harmony with the nature which surrounded us, there emanated a beauty, a fragrance (noa noa) that enchanted my artist soul. From this friendship so well cemented by the mutual attraction between simple and composite, love took power to blossom in me.

And we were only . . . the two of us –

I had a sort of presentiment of crime, the desire for the unknown, the awakening of evil – Then weariness of the male role, having always to be strong, protective; shoulders that are a heavy load. To be for a minute the weak being who loves and obeys.

I drew close, without fear of laws, my temples throbbing.

The path had come to an end . . . we had to cross the river; my companion turned at that moment, so that his chest was towards me. The hermaphrodite had vanished; it was a young man, after all; his innocent eyes resembled the limpidity of the water. Calm suddenly came back into my soul, and this time I enjoyed the coolness of the stream deliciously, plunging into it with delight – 'Toe toe,' he said to me ('it's cold'). 'Oh no,' I answered, and this denial, answering my previous desire, drove in among the cliffs like an echo. Fiercely I thrust my way with energy into the thicket, (which had) become more and more wild; the boy went on his way, still limpid-eyed. He had not understood. I alone carried the burden of an evil thought, a whole civilization had been before me in evil and had educated me.

We were reaching our destination – At that point the crags of the mountain drew apart, and behind a curtain of tangled trees a semblance of a plateau (lay) hidden but not unknown. There several trees (rose-wood) extended their huge branches. Savage both of us, we attacked with the axe a magnificent tree which had to be destroyed to get a branch suitable to my desires. I struck furiously and, my hands covered with blood, hacked away with the pleasure of sating one's brutality and of destroying something. In time with the noise of the axe I sang:

> *Cut down by the foot the whole forest (of desires)*
> *Cut down in yourself the love of yourself, as a man*
> *would cut down with his hand in autumn the Lotus.*

Well and truly destroyed indeed, all the old remnant of civilized man in me. I returned at peace, feeling myself thenceforward a different man, a Maori. The two of us carried our heavy load cheerfully, and I could again admire, in front of me, the graceful curves of my young friend – and calmly: curves robust like the tree we were carrying. The tree smelt

of roses, *Noa Noa*. We got back in the afternoon, tired. He said to me:
'Are you pleased?' 'Yes' – and inside myself I repeated: 'Yes'.

I was definitely at peace from then on.

I gave not a single blow of the chisel to that piece of wood without
having memories of a sweet quietude, a fragrance, a victory and a reju-
venation.

When Gauguin wrote this down he added two notes in the margin beside
the passage:

1. The androgynous aspect of the savage, the slight difference of sex
   amongst animals –
2. The purity of thought associated with the sight of naked bodies and
   the relaxed behaviour between the two sexes.
3. Vice unknown among the savages –
   Desire to be for a moment, weak, a woman . . .

These were probably ideas which were to be further developed during
the course of rewriting, which he did not in the end complete.

Inevitably, the question arises as to whether Gauguin was really
describing an actual event. Many of the details are symbolic elements
presumably worked in to enhance the deeper meaning of the tale. The
lotus he mentions is both a Hindu and Buddhist symbol of regeneration
and rebirth, the underlying theme of the story. The blood on Gauguin's
hands represents this new birth: when the young males on the island
came of age they were in the habit of supercising themselves by the
painful operation of closing the end of the foreskin with their fingers
when urinating, forcing the skin to balloon away from the gland. When
frequently repeated, this caused the end of the foreskin to rip free, 'cir-
cumcising' the tip of the penis, just as Gauguin mutilated the tree,
bloodying his hands in the process. At another level, by entering the
world of the hermaphrodite, the androgyne, Gauguin has returned to
Eden where, as he expressed it in a letter to de Monfreid: 'before the
separation of Eve, Adam was both male and female.' Then came the
intimations of the Fall, of the knowledge of Good and Evil, of Gauguin's
lust for Jotefa, where the androgyne is not a symbol of sexless purity but
of all possible sexual pleasures, male and female in one body. This Gaug-
uin conquers, plunging into the cool river water, a baptism which pre-
cedes the ascent of the mountain, a climb to Nirvana, to that higher
state of enlightenment, to the point where he is at peace with himself,
a Maori at last.

Before he discovered Moerenhout, Gauguin had had to use Christian
symbols, as in *Ia orana Maria*, revivifying them by placing them in
Tahitian settings, with the occasional 'primitive' reference drawn from
the little Marquesan art he had managed to see. But even when he had

digested Moerenhout he still lacked an underlying unifying theme for the art he would create, but from now on, this was provided by the tale of the voyage into the mountains and its metaphor of the conflicting elements of male and female being reunited in a prelapsarian Eden, Gauguin's vision of a paradise regained, a state accessible to those who have sloughed off the cloying poisons of so-called civilization, who are reborn, savage, Maori, androgyne.

This is the missing element which makes sense of what before was merely random. Whether there was a real event behind this carefully woven symbolic narration we cannot know. On the evidence of the paintings, Jotefa was not a *mahu*, but they were not the only Tahitians to indulge in homosexual practices – a degree of bisexuality being perfectly acceptable among the islanders, who in any case seem to have found it impossible to disapprove of anything pleasurable which the human body might offer. Polynesian culture celebrates love between those of the same sex whether men or gods and the Polynesian word '*aikane*' indicates an idealized homosexual state expressed in the *upa-upa*, or *hupa-hupa*, which was passed into English as the Hawaiian hula-hula – which has openly homoerotic elements, with the male dancers twisting and thrusting their bodies, knees bent outwards, while stamping and grunting, in a frank evocation of sexual coupling. Gauguin was especially fond of the *upa-upa* and would embark on his own amateur version whenever the occasion arose. But whether he and Jotefa actually made love is hardly important, when what matters is Gauguin's willingness to unveil such unexpected thoughts and feelings. Given that most of his writings were intended to maintain the image of a macho traveller, raunchily acquiring nubile native girls, this admission of feelings of passivity, of the desire to be dominated, of a willingness to submit, is truly unprecedented and transcends any question of whether it was based on a real event or not.

One final mystery – or more correctly, confusion, surrounds the work: Gauguin listed it in his inventory as *Le bûcheron de Pia* (the wood-cutter of Pia), which has led to the assumption that Jotefa was employed by the schoolteacher Gaston Pia with whom Gauguin was supposed to have stayed when he stopped off in Paea, or that at the least, the painting was a gift to him. This is unlikely as there is no trace of the Pia brothers having taught in Paea, but there are other possible explanations for the listing. Gauguin may well have found the word Pia in Moerenhout – the meaning of the Tahitian is arrowroot which was used for making poisoned arrows, and Moerenhout mistakenly thought it was a kind of tree. It is possible that Gauguin may have been associating his wood-cutter with this ancient warlike craft. On the other hand there is another painting which Gauguin entitled *Landscape Paia Evening*, which most

biographers have assumed must be a misspelling of Paea. However, there is no reason why he could not have meant Paia, rather than Paea, in both cases, for this was the name of the mountain in the Oro/Vairaumati story. In which case, calling Jotefa the wood-cutter of Paia would have been part of the mythologizing process, associating him, and thus their joint journey into the mountains, with the story of the God and his earthly love.

That these feelings were the main driving force behind his work at this time cannot be doubted. The figure of the wood-cutter can be found at each point during his first year on the island when there was a major change in his art. The portrait of *The Man with the Axe* marked his break with the simple depiction of everyday scenes around Mataiea and his re-entry into an imaginative symbolic world. Now *Matamoe* would be followed by what are surely the most profoundly 'Tahitian' works which he would produce, the wood-carvings through which he tried to revive the lost art of the islands.

## Cut Down by the Foot the Whole Forest

It must be remembered that Gauguin's original reason for making the mountain journey with Jotefa had been to look for suitable wood for carving. At a time – spring 1892 – which would correspond to his return from the outing, Gauguin began to carve in what he calls rosewood and later as iron-wood, but which experts now refer to as 'Tamanu' wood. More importantly, all the pieces which can be ascribed to this time have as their primary figure an androgynous divinity. A possible first carving, the *Idol with a Pearl*, has a Buddha figure seated in a curved niche, though the long hair and evident breasts transform 'him' into both a *mahu* and a *vahine*. On the opposite side of the carving are two figures drawn from Moerenhout's account of the Tahitian creation myth, which tells how Taaroa, the supreme god, coupled with Hina to produce Tefatu or Fatu, god of the earth. Gauguin wrote out, word for word, Moerenhout's account of the conversation between mother and son which encapsulated the Polynesian concept of death and rebirth:

> Hina said to Fatu: 'Bring man back to life or resuscitate him after his death.'
>     Fatu replies: 'No, I will not bring him back to life. The earth will die; the plants will die; they will die just like the men that they nourish; the soil that makes them will die. The earth will die; the earth will come to an end; it will come to an end never to be reborn.'
>     Hina replies: 'Do as you wish: for my part I will bring the moon back to life. And that which belonged to Hina will continue to exist: that which belonged to Fatu perishes, and man must die.'

Given the limited space in his small notebook Gauguin gave far more prominence to Hina than is merited by the account in Moerenhout, though it is not hard to see why he identified with her, even making her, in some senses, his personal Tahitian goddess. Hina's position as the deity responsible for regeneration was seen by Gauguin as a symbol of his own self-appointed role in the rebirth of the Tahitian past. The wood-carvings are a direct attempt at emulating that lost art and everything about them is imbued with a symbolism of natural creation. Some have the rough wood left untouched at the base, a memory of the living tree within which the figures were 'found' by the sculptor. Several of the Hina carvings are cylindrical, a deliberately phallic shape, meant to highlight the interplay of masculine and feminine that Gauguin read into the Hina story. As the goddess of rebirth, of the ever-renewing moon, Hina embodied both the masculine force of generation and the female force of conception and thus represented Gauguin's desire to reunite the divided self which he saw as the ultimate failure of Western 'progress'. Understanding this is the key that unlocks the otherwise sealed world of these first truly Tahitian works. Such ideas can be sensed in the Vairaumati paintings but are most fully realized in the Hina carvings which follow from the story of Jotefa and the journey into the mountain in search of wood to carve. Only with all this in mind is it possible to appreciate fully the poetry implicit in the muscled form of the young wood-cutter, his axe raised, hacking away at the dead wood which will be reborn as fire, intense and purifying.

# 10

◆

# *The Spirit of the Dead Keeping Watch*

By March 1892, three months before his forty-fourth birthday, and nearly a year since he had set sail for Tahiti, Paul Gauguin had finished almost thirty paintings and a number of carvings. In many ways his life was not too different from his original dream: he had moved to a simpler village existence where his neighbours appeared to like him and were willing to help when necessary. Best of all, his art had progressed along lines which could be construed as a pre-ordained plan. He had stumbled on Moerenhout and had thus been able to create the symbolic and imaginative world which he had theorized about as long ago as 1885, when he had begun to set down his 'Notes synthétiques'. True, his health still troubled him: he wrote to tell Mette that he had gone completely grey and in a later letter to Monfreid he revealed that cutting down on alcohol was giving him the 'waist of a young girl', an understatement as he was alarmingly thin, owing less to his Spartan régime, an over-reliance on tinned food from the Chinese store, than to the continuing effects of syphilis. But he was not entirely without resources – Lieutenant Jénot would borrow a horse whenever he was free and ride out to stay for a few days, always bringing a supply of fresh meat and imported French foodstuffs from the army commissary to help vary his friend's diet.

Gauguin could hardly have expected more and if he had accepted a situation little different from that which he had always claimed he wanted, then he might well have settled down and gone on producing more works along the lines of the Ariois and Hina paintings and carvings. Had he been able to free himself completely from his last connections with the European world, he might have been able to live out the theory of oneness, both within himself as a sexual being, and outwardly in his relations with the village and the land, that he was groping to express in his art.

Yet somehow, he found it impossible to finally let go. Even in his simple hut under the spreading mango tree, with the sounds of hymn-

singing wafting over the fragrant land, Paris still beckoned. His letters are full of demands for information about the minutiae of artistic politics, he longs to know how his reputation stands and who has said what and to whom about him. He just cannot let it drop. Of course there was the eternal agonizing over money, the one inescapable reality, the unbreakable bond that tied him to France and forced him to travel into Papeete whenever a mail ship was due to dock, interrupting his work and shattering the fragile sense of isolation which, despite everything, he still believed he wanted to maintain.

Almost as bad as the interruption was the expense of the public coach he was forced to use. This rickety conveyance loomed large in his life. It cost 9 francs for the five-and-a-half hours it took to bump its way from Mataiea to Papeete, and another 9 francs back. As the rainy season would not end until April, the journey was made infinitely worse by the inclement weather and its effects on the already miserable coastal track.

At least there was a welcome when he reached the town: either Jénot or Drollet or Suhas would put him up or ask him to dinner, though their liking for him did not extend to his art, as none of them appreciated his work any better than the Bambridges had done, and while they were willing to help him out with small loans, there was still no sign of a longed-for commission. Of course Gauguin refused to accept that this was final and went on trying to persuade them to sit for him. A bizarre opportunity did seem to present itself when he arrived in Papeete on 5 March and discovered that the Suhas's eighteen-month-old son Aristide had just died of some sort of gastritis. When he saw the distraught mother by her son's deathbed, Gauguin gruesomely seized the opportunity, and offered to paint the boy's portrait. Hardly in a position to refuse, the poor woman could only watch as Gauguin rapidly produced a canvas and paints and set to work on an image of her child, eyes closed, hands clasping a rosary. Predictably, the result was as unsatisfactory as ever – the boy's skin had an unpleasant yellowish tinge which, Gauguin explained, was the result of the drawn curtains which filtered the light falling on the bed. A distraught Madame Suhas insisted that he had made her beloved Aristide look like one of the despised Chinese traders and refused to accept the gift, though her husband tried to calm the situation by taking the portrait and hiding it away. Today, like many of Gauguin's Tahitian works, the deathbed image of Aristide Suhas has taken on a life of its own – it now hangs in the Kröller-Müller Museum in Holland under the title *Portrait of Prince Atiti*, an invention not entirely out of line with Gauguin's own imaginative names for his paintings.

It would be wrong to conclude from this that Gauguin was indifferent to the death of the child. Despite having effectively abandoned them, Gauguin remained profoundly attached to his children and still insisted

that everything he did was motivated by a desire to be reunited with them and Mette one day. In Jénot's later memoir, he records how, wherever he stayed, Gauguin always placed photographs of his children on the walls of his room, arranged in strict order of age and height. Even allowing for self-deception, there can be no doubt that he was often pained at the separation, especially in the case of Aline who, since their last meeting in Copenhagen, was frequently in his thoughts. When he did write to Mette, those rare letters nearly always contain urgent instructions on his daughter's education, along with expressions of concern about her upbringing – remarks which seem curiously at odds with his own rakish life. Mette's letters to him were not preserved, but we can glean from his responses that he was deeply unhappy about his wife's attitude to the girl. One reproach makes it abundantly clear that he did not believe Mette loved their daughter sufficiently, though Mette always complained that it was the other way round – that Aline loved only her father and not her – a remark which made Gauguin blame himself for not being there to give Aline the affection he knew she wanted.

## The Meat Market and the Art Market

This inability to turn his mind away from Europe along with the visits to Papeete inevitably affected his art. There was still that unbreakable chain to that tiny area around the Rue Laffitte in Paris, linking his thoughts to the world of galleries, and *vernissages* and critics and newspaper reviews. He was plagued by doubts over what he had been doing – was it challenging enough? Would it have the sort of effect Seurat's *Grande Jatte* had had? Would the exhibition of his Tahitian works that he would one day hold finally confirm him as the leading avant-garde painter? Had he finally challenged Manet's *Olympia* and won?

At a distance of a century, such questions seem foolish. The Ariois paintings are beyond anything that was then being done in Europe – but to Gauguin these were crucial questions and they and the doubts they embodied were to provoke him into actions which have seriously distorted later opinion on the nature of his achievement. As before, it was the baleful influence of *Olympia* which was to act as the main provocation – that and the other great 'challenge', Loti's book, whose success represented everything Gauguin wished to achieve from his visit. Indeed, it was probably an attempt to combine both elements – Manet and Loti – which lay behind a painting he began, most likely near the end of March 1892, a work which has proved the single most controversial act of his entire career.

In his *Olympia* Manet had presented his model Victorine in the conventional display of the nude female available to the male gaze, but he had

also broken the convention by portraying her as a young woman of her time, who, although obliged to pose naked for a fee, still shows those signs of confidence and independence which challenged the orthodoxies of the available odalisque, and which marked her out as someone modern, in spirit at least. By contrast, Loti had given the world Rarahu, his child-bride, fourteen when he first met her, offering her as a simple, passionate 'natural' creature in a distant exotic world teetering on the brink of collapse. At first sight these two females are at opposite poles on a spectrum of enslaved and independent womanhood. There is no doubting that the opposition to Manet's *Olympia* had come from the discomfort many male critics felt in the presence of that assured gaze, looking back at them, in unblinking self-confidence. Equally, Loti's success came from his male readers' pleasure at the idea of an erotic world free of the confusions and threats surrounding sexual relations in the West. But Loti had also touched on something deeper – the desire for simple affection, for an innocent love, thought to be possible only with the very young, a desire which is a strong under-current in nineteenth-century life. Edgar Allan Poe had married his cousin on the very day of her thirteenth birthday – then the age of consent in America. Many more were unconcerned with such legal niceties, as witness the appalling statistics on child-prostitution in most Western capitals. Sometimes this manifested itself as a reverence for innocence and purity as in Lewis Carroll's photographs of the naked children of his friends, but as often it was simply a question of lust for passivity, for those obliged to accept without needing or demanding anything in return. It was surely this which Loti had clearly seized on, and which, set in an exotic 'savage' place, ensured that he attracted none of the criticism which might have arisen, had his fourteen-year-old 'bride' been French. Indeed, until then, literature and art had carefully avoided this obsession with children – naked ladies were exactly that and usually quite substantial. But thin, bony, hairless girls had become the province of the new photography, either 'aesthetically' in the case of Carroll, or erotically, with the mass of paedophile pornography which was such a feature of the age. It was into these murky waters that Gauguin now stepped.

Of course he needed a context, a situation which would justify the representation of a naked girl, and this he found in Loti, who had written about the universal belief on Tahiti in the existence of ghosts or malign spirits called *tupapaus*, terrifying spectres, roaming the night, ever ready to seize the unwary. The belief in *tupapaus*, in spirits, was one of the last surviving elements of the ancient Tahitian religion – indeed in some ways it had been exaggerated by the implantation of Christian notions of sin and guilt and by the collapse of the old social and family structures, which had been the most terrible consequence of the struggle for power

in the archipelago that the missionaries had provoked through their
support for the Pomare family, a disintegration continued under the
French with their war of conquest. As David Howarth succinctly
expressed it in *Tahiti, A Paradise Lost*:

> Tahitians in the 1840s did not want to 'continue to be'. They had often
> been afraid, *matau*, but seldom much afraid of death, and now after the
> slaughter and among the diseases raging more fiercely than ever, the living
> were far outnumbered by the recent dead. It was an island of ghosts.
> Every valley, every grove and stream and ruined house was haunted: the
> survivors, sleeping or waking, were always aware of living among the dead.
> Of course, some obstinately clung to life, the ardent Christians and the
> youngest; but many simply wanted to make the easy crossing they had
> always conceived death to be, to surrender and 'go into the night' and be
> absorbed by gods and join the pressing multitude of spirits.

Since then, things had stabilized. In the half-century since the old order
had collapsed, some of the former *joie de vivre* had crept back into
Tahitian life. But it was still true that the spirit world had a powerful grip
on the minds of the people. Because the dark was considered especially
dangerous, it was common to sleep with a night-light and what Gauguin
chose to represent is a scene in a hut where the oil has run out, the light
is extinguished and alone in the dark a young girl – Rarahu? – lies on
her bed, her thoughts filled with wild imaginings of the *tupapau*, which
we can see, lurking behind her. Gauguin called the painting *Manao
tupapau*, which is variously translated as '*The Spirit of the Dead Keeping
Watch*' or '*The Spectre Watches over Her*', and if taken at face value, such
a painting could represent Gauguin trying to get as close as possible to
what still survived of the old Tahiti. The *marae*, the temple sites, were
ruins, the religious carvings had been destroyed or carried off, the gods
were no longer worshipped, only the ghosts, the spirits of the dead,
survived in the superstitious fears of the people and here, we see it
made flesh: the frightened child, the strange spectral figure sitting in the
background, watching over her, though as with *The Vision after the Sermon*, we may be seeing what is imagined rather than what was actually
there.

All this is to put the painting in the best possible light. But there is
surely more to it than just a charming anecdote based on local folklore.
In blunt terms what we actually see is the interior of a hut at night, with
a large couch, covered in a boldly flowered cloth, partially overlaid by a
plain white sheet on which lies a naked girl, face down, another of
the child-like, yet distinctly erotic figures who have appeared before in
Gauguin's work – pert buttocks offered invitingly to the spectator. There
is even something disturbing about the way the face is half-turned
towards the viewer, or rather towards the artist, Gauguin, as if he and

not the figure in the background is the spirit of which she is afraid.

All of which obliges us to make comparisons with *Olympia*. The similarities between the couch on which the child lies and the attendant black figure behind – Victorine Meurent and the black model Laure in Manet's painting, the young girl and the *tupapau* in Gauguin's – are clearly intended. But where Manet offers a mature woman, self-confident and in control, staring back at the spectator with an insouciance which has always challenged any charge that the artist had created a clichéd image of woman as prostitute, Gauguin presents nothing less than an available and frightened child. Nor was Gauguin unaware of what he had done – the painting is not the subconscious expression of otherwise suppressed desires; there can be no doubt that he intended the work to shock and thus attract attention. Given the sensuality of the figure on the couch, there seems no reason to doubt that Gauguin was attracted to images of passivity and ambiguity. There is little difference between a girl-child and boy-child face downwards, paedophilia is often bi-sexual, and research has unearthed an etching by a little-known Dutch painter, Humbert de Superville, which Gauguin may have drawn on as a source for *Manao tupapau*. We know that Seurat used de Superville's theoretical studies to formulate his own colour theories and there are indications that Gauguin too was aware of the Dutchman's writings and thus, by extension, could have come across the curious little etching which shows a similarly posed child and a ghost, though, interestingly, in the de Superville, the figure on the bed is a little boy and the Death's head spectre hovering above him extends a skeletal hand to seize his plump buttocks.

It is as if the battle Gauguin had fought and supposedly won on the mountainside with Jotefa, when he wrestled against the feelings of androgynous sexuality, that terrifying sense that the boy's ambiguous body offered all sexual possibilities, had now been lost. Where the Ariois paintings elevate the idea of the female as the prime creative, life-giving source, *Manao tupapau* offers no more than a titillating image of easy under-age sex. Remove the *tupapau* and the attendant explanation, and such a painting would be branded as no more than child-pornography.

There are curious similarities between this painting and two of his earliest works, both portraits of his daughter Aline. The background of *Manao tupapau* has much in common with the wallpaper behind Aline in the *Sleeping Child* of 1884, but the most intriguing connections are with the earlier *The Little Dreamer: Study*, his portrait of the sleeping Aline made in 1881. There too, Aline has strange phantoms in her room, not least the vague image of her father staring out from the wall beside her bed and while there is nothing in Gauguin's writings to suggest a direct connection between his daughter and *Manao tupapau*, the fact that

the last time he had seen Aline she had been thirteen years old and thus about the same age as Loti's Rarahu and the exact age he would later claim for the girl in the painting, is worth noting. If one compares the two pictures, there is a sense in which the sleeping Aline, aged four when her portrait was painted in 1881, has now become the fantasy figure lying on a Tahitian couch.

That the painting was intended for a European public is best shown by the *tupapau* who has nothing whatsoever to do with Tahitian beliefs. According to the anthropologist Bengt Danielsson, *tupapaus* were hideous bestial creatures, with large, bright eyes and fangs that stretched from their upper jaws to their chins, whereas Gauguin offers what he later described as a *'petite bonne femme'*, a squat female figure wearing what looks like a tight Breton cap, the sort of thing commonly worn in Le Pouldu, placing the spectre firmly in the European folk tradition of witches and other evil spirits in the form of female crones.

## I Have to Explain This Fright

Many biographers and critics have assumed that *Manao tupapau* portrays a real person, and some of Gauguin's later writings encourage such a view. As a result, it is now firmly entrenched in the conventional story of his life, that he was living with a thirteen-year-old child-bride and that the figure on the couch is she, spread out in the painting, fearfully glancing up at him.

Yet there seems to be just as much to indicate that this was really a work of fiction. The girl in the painting is almost unique in his Tahitian works; most of his female figures are much older. The key to the work is surely his desire to out-shock Manet and Loti, a fact borne out by his subsequent attempts to play down what he had done, for, having made his challenge, he was immediately concerned that he might have gone too far. No one in Europe, save those who had kept Loti at the forefront of their minds, was likely to know much about *tupapaus*, so that despite the title and the funny old crone in the background, the painting was likely to appear as no more than a lascivious study of a naked girl. His concern is evident in his subsequent attempts to present the picture in the best possible light, though even in a letter to Mette, in which he set out detailed instructions on the way adverse comment was to be countered, his underlying motives kept breaking through:

> Naturally many of the pictures will be incomprehensible and you're going to have work on your hands. So that you will understand and be able to show off, as they say, I am going to give you an explanation of the most difficult one, which in fact, is the one I want to keep – or sell for a very good price: *Manao tupapau*. I did a nude of a young girl. In that position,

a mere hint, and it is indecent. Yet that is the way I want it, the lines and movement interest me. So when I do the head I put in a little fear. For this fear I have to give a pretext, if not an explanation, and it has to be in keeping with the character of the person, a Maori girl. The Maoris have a very great, traditional fear of the spirit of the dead. A girl from our own part of the world would be afraid of being caught in that position (women here not at all). I have to explain this fright with the fewest possible literary devices, as in olden times. So this is what I do. Dark, sad, terrifying general harmony that rings in the eye like a funeral bell. Purple, dark blue, and orangey yellow. I make the cloth greenish yellow (1) because the linen of these savages is different from our linen (beaten treebark), (2) because it creates, suggests artificial light (a Kanaka woman never sleeps in the dark) and yet I do not want any suggestion of lamplight (that's ordinary), and (3) because this yellow linking the orangey yellow and the blue completes the musical chord. There are a few flowers in the background but they mustn't be real, since they are imagined. I make them look like sparks. The Kanakas think that the phosphorescences of the night are the souls of the dead and they believe in this and are afraid. To finish up, I do the ghost very simple, a small figure of a woman; because the girl, not being familiar with the French spiritist theatres, can't help seeing the actual dead person, that is, a person like herself, linked to the spirit of the dead. This little text will make you look very scholarly when the critics start to fire their mischievous questions at you. And finally, the painting has to be done very simply since the subject matter is primitive, childlike.

And this must be very boring, but I am sure it is necessary for you over there.

Kisses for you and children.

As an exercise in damage limitation this was a complete failure. From the first time it was exhibited, the painting attracted unfavourable comparison with *Olympia* and this criticism has continued down to our own time, where *Manao tupapau* has been seized on by feminist art-historians as an arch example of the white male artist as a sexual tourist, living out fantasies difficult to satisfy except amongst poor Third World peoples.

Even accepting it as the work of fiction which I believe it to be, does not clear Gauguin entirely of such charges. But perhaps the raw self-revelation of the work is its own best justification – we are at least spared the simpering 'purity' of Lewis Carroll, the girl's position clearly demonstrates the artist's lust. But at the same time he also shows us her terror and it is hard to disagree with the sympathetic critic who wrote that, ultimately, '*Manao tupapau* remains marvellously ambiguous.'

At least the child-figure was an aberration, a unique sortie into forbidden territory, immediately abandoned in succeeding works as he returned to his former adult Tahitians. But the painting did mark a shift

of direction away from the tranquillity and harmony of the Vairaumati and Hina works, and a move into something darker and more troubled. Loneliness and the depressive effects of his illness may both have played a part, but for whatever reason he found himself returning to the figure of the *tupapau* and to the theme of fear and uncertainty. In *Words of the Devil*, he even took his own emblem of exotic pleasure, his Eve in the Garden of Eden, and turned it full circle, showing us Eve after the Fall, her hand attempting to cover herself, trying to hide the shame of her nudity, spied on by the same *tupapau*, who plays the role of the serpent, mocking the trembling Eve by wearing a formal gown with a plunging neckline.

## A Commission at Last

No matter what his physical or mental state, he still felt obliged to make the coach journey into Papeete whenever a mail boat was due, hoping that Morice or Mette would have sent him some money at last. He was in the town on 18 March, awaiting the arrival of the ship from San Francisco due the next day, when he met up with his friend, the swash-buckling privateer Captain Arnaud. They must have gone out drinking for at some point the Captain commissioned Gauguin to paint a portrait of his wife and offered him the extraordinary sum of 2,500 francs for it. They were probably drunk as Gauguin later gave confused accounts of the sum he had been promised. In any case, Arnaud left on another trading voyage almost immediately, prudently taking his pretty wife with him, so that the commission, if such it was, was put into abeyance until they returned, which would be anything up to two months hence. On top of that, the mail boat brought no news from Morice nor money from any other source. Furious, he dashed off a letter to Sérusier, ruefully complaining about Morice's silence:

> To state my case briefly, I am broke, all because of Morice's perfidy, and the only thing I can do is to return home. But how to do so *without money*? Moreover, I want to stay. My work isn't finished yet; it has just begun and I am sure I can achieve something good. Yes, Morice has let me down; for if he has written twice by registered mail, as he says he has, I should have received the letters – all yours have arrived. And if I had another 500 francs (the 500 Morice owes me) I could manage. I have been promised a woman's portrait in May for 2,500 francs, though unfortunately I can't rely on the promise. But I shall do everything, including the impossible, to hold out till May. If I do get this commission – and the portrait will have to be a flattering one à la Bonnat – and get paid for it, I think I can get one or two more commissions, which would make me a free man again.

It was a frustrating exercise – the letter would take over a month to reach its destination and even assuming a prompt reply, there would be a further month or more before anyone could get an answer back to him. He returned to Mataiea but was back in Papeete towards the end of April only to find that his few letters contained no money and that Captain Arnaud had still not returned with his wife. There was nothing to be done except call on Goupil again, to see if he could offer any help and as it turned out, the lawyer had been handling the bankruptcy of a Chinese shopkeeper, Ah-Kong, out at Paea, where Gauguin had first stayed, and as liquidator, Goupil needed a caretaker to guard the man's property until the proceedings were over. The fee was only a miserable 36 francs 75 centimes, but Gauguin had no choice, and at least it was only for eleven days starting on 7 May, ending on the 18th. There may have been one positive side to this second stay in Paea, for it was probably after he finished the job that Gauguin made the second voyage into the interior, walking up the valley of the Punaruu, which he later wrote about as an adventure undertaken alone despite being warned of the dangers, both physical and emotional from the *tupapaus* which he was told might attack him at night.

On his return to Mataiea he began to reflect seriously on the choices that lay before him. Whatever happened, no money from France could now arrive in time for the key date which loomed ahead of him – 9 June, the first anniversary of his arrival. It was a rule, rigidly adhered to, that indigent French citizens could ask to be repatriated to France at any time during their first year in a colony, but that after twelve months had passed they were to be regarded as permanent settlers and not eligible for a free ticket. While Gauguin still had much that he wanted to do, the number of paintings he had so far completed would be enough to organize an impressive exhibition. He also reckoned that he had enough material in the form of sketches and notes to enable him to go on working once he was back in Europe. On balance, it seemed better to avoid the risk of being stranded and to throw himself at the mercy of Lacascade. He waited until the last possible moment – the arrival of the mail boat on 1 June, but when this docked and there was again no money nor any sign that a remittance was on its way, he gave up and headed for the governor's residence. Just as he was mounting the steps of Lacascade's office he found himself face to face with the newly returned Arnaud, who was covered with embarrassment when he heard the reason for his friend's visit and who promptly thrust 400 francs into Gauguin's hands, muttering something about being given a picture in return for it. Having got over his first delight, Gauguin hastily tried to get confirmation that this was not just a way of wriggling out of the portrait commission and managed to get Arnaud to agree that that could still go ahead – though

the wily captain skilfully reduced the price by half. Under any other circumstances Gauguin would certainly have argued, but with the 400 francs in his hand and the promise of more to come and the simple fact that he did not have to have another humiliating encounter with the governor, he let it pass. He was, however, still nervous about losing his chance of repatriation and took the wise precaution of writing to the Director of Fine Arts in Paris to ask for a ticket home. By writing to Paris before the end of June, Gauguin hoped to preserve his right to repatriation, while at the same time buying himself two or three months or more – the time it would take for his letter to reach France and for any reply to get back.

## The Giver of Strength

Gauguin was overjoyed at having been so unexpectedly thwarted in his plan to leave the island. As he wrote to Monfreid: 'It has been like this all my life: I get to the edge of the abyss but never fall in ... I have gained a respite till my next disaster, and shall start working again.'

To judge by the paintings, this sense of relief did much to drive out the moody depression of the earlier part of the year, though the paintings do become so filled with a sort of lighthearted joy that there must surely have been something else which had lifted him to such heights. It could well be at this point that the woman he called Tehemana or Tehamana enters the story. Since Titi, there does not appear to have been anyone permanent in his life – he may have found the occasional local woman willing to share his bed, or he may have been confined to the 'meat market', on his visits to Papeete. The paintings are not much use here, as they depict a range of models about whom we know nothing, save for the incident with the woman who was reluctant to pose for him. It was common practice for unattached foreigners to take a local 'bride' while on the island, a practice which hardly conflicted with pre-colonial custom and which had economic advantages for the families of the *vahine*. Now that Gauguin had a little money, this would have been the logical moment for him to find a 'wife'. He knew that there was little point in looking around Mataiea, which was probably too Westernized for his purposes, and according to his own later account, he decided to make a tour of the island to search for the sort of simple, unspoiled girl he had dreamed about before he left France.

Because of his deliberate mixing of fact and fiction, it is always difficult to extract the complete truth from his writings but we know that Tehemana, his corruption of the Tahitian Teha'amana, did exist, because as late as the mid-1950s the Swedish anthropologist Bengt Danielsson met people who had known her, including her subsequent husband, and also

managed to discover her death certificate. Nor is there any reason to doubt Gauguin's story of how he found her, which is detailed enough to be a first-hand account.

He first took the local coach the final part of its journey to Taravao on the isthmus at the point where Tahiti Nui joins Tahiti Iti, and where the local gendarme lent him a horse so that he could continue along the more difficult track around the northern coast, which eventually ended up in Papeete again. This was far worse than the uncomfortable southern road: the cliffs were steep, the strip of coastal land narrow, the fords unbridged, so it is hardly surprising that the less than adventurous Gauguin should have rapidly tired of the whole business and stopped at Faaone, hardly more than four kilometres from the isthmus.

Inevitably he was invited to share a meal with a local family and was 'quizzed by a fine Maori woman of about forty' as to why he was travelling so far. 'To look for a wife,' was Gauguin's spontaneous reply, whereupon the woman promptly offered him her daughter.

'Is she young?'
'ae —'
'Is she pretty?'
'ae —'
'Is she in good health?'
'ae —'
'Good, go and fetch her for me.'

In Gauguin's original notes the passage that follows shows that blend of observation with sexual fantasy which is simply too intertwined to unpick:

> She went away for a quarter of an hour; and as they brought the Maori meal of wild bananas and some crayfish, the old woman returned, followed by a tall young girl carrying a small parcel. Through her excessively transparent dress of pink muslin the golden skin of her shoulders and arms could be seen. Two nipples thrust out firmly from her chest. Her charming face appeared to me different from the others I had seen on the island up to the present, and her bushy hair was slightly crinkled. In the sunshine an orgy of chrome yellows. I found out that she was of Tongan origin.
> When she had sat down beside me I asked her some questions:
> 'You aren't afraid of me?'
> 'Aita (no).'
> 'Would you like to live always in my hut?'
> 'Eha.'
> 'You've never been ill?'
> 'Aita.'

On the one hand she was a vision of Polynesian grace, on the other he wanted to be prudently reassured that she had not caught one of the

diseases his predecessors had inflicted on the island. It is such 'real'
sounding details which have prevented biographers from entirely dis-
missing the tale as no more than a middle-aged white man's erotic fan-
tasy. As for her 'Tongan' origins, this is obviously unlikely and was
probably a mis-hearing of 'Rarotonga', one of the Cook Islands, within
reasonable boat distance of Tahiti. Gauguin's account goes on to tell
how, on the way back to Mataiea, they stopped at a village about nine
kilometres from Faaone where they visited the girl's 'mother', an encoun-
ter which confused Gauguin until he realized that sharing children was
a common enough practice and that the girl accepted several people as
her parents. And there is certainly a ring of truth about his account of
how, on his return to Taravao, the gendarme's wife tactlessly exclaimed:
'What! have you brought back a trollop with you?'

So he had found his child-bride, and a model, though his aversion to
strict portraiture makes it difficult to state with any certainty exactly
which of the *vahines* in his subsequent paintings is really she. She may
well have posed for most of them, but he may also have varied the faces
as it suited him. One of the first paintings after his return shows two
voluptuously beautiful women, naked and indolently relaxing on an
impossibly rose-coloured strand, washed by bands of blue, black and red.
He was certainly well-pleased with it, for that August he wrote to Mon-
freid to tell him that he had just painted 'two women at the water's edge
– which I think is the best of what I've done so far'. Perhaps seeking to
add a little spice, he painted *Aha oe feii?* at the bottom of the canvas, a
phrase which he thought meant something like 'What, Are You Jealous?',
though it is closer to 'What, have you got a grudge against me?' Later,
he tried to wrap an anecdote around the title, though it does sound
rather like an afterthought: On the shore, two sisters are lying after
bathing, in the graceful poses of resting animals; they speak of yesterday's
love and the morrow's victories: 'What! are you jealous?' But though he
speaks of 'two sisters', Teha'amana could well have modelled for both
of them. More to the point is the obvious happiness which she brought
him and which shines out of the picture. Her name in Tahitian means
'Giver of Strength' and she undoubtedly gave him the force to paint
with renewed vigour. He only named one painting directly after her,
and that at the very end of their time together, but there is an earlier
painting which is more likely to be a direct portrait than any other,
owing to a peculiar detail which seems just too realistic to have been
invented. He called the piece *Te nave nave fenua* and translated it as 'The
Delightful Land', though he must have been aware that the real meaning
of *nave nave* was closer to what might be called 'sexual pleasure' or 'erotic
satisfaction' rather than something as bland as mere delight. At first sight
the painting seems to be just another reworking of an earlier Eve in the

Garden of Eden – it is not dissimilar to *Words of the Devil* in which Eve is watched over by the old crone as she tries to shield her sexual parts with a cloth held in her left hand. But now, in *Te nave nave fenua*, there is no crone and the nude figure openly displays her nakedness. This Garden of Eden is indeed delightful. Eve is about to pluck a flower – there were no apples on Tahiti – and is tempted by a lizard, the creature that the early missionaries substituted for the snake, which is absent from the island's fauna, when they tried to explain the Book of Genesis to their bemused converts. Just such a tale was told by Rarahu in *The Marriage of Loti*, which was probably Gauguin's source for the imagery in his painting. At one level, the whole thing is a wonderfully surreal dreamworld – the peacock's feather flowers are entirely imaginary, while the lizard has impossible wings as if it were a tiny dragon. The colours are a child's fantasy of cerulean and cerise, of lime and sage, but there is one very precise detail – the second toe on the left foot of the naked figure sprouts two little embryonic toes, a sign that we are probably looking at the real Teha'amana, for despite all the technicolour fantasy, this is a recognizable person with a small physical defect, so that here at least dream and reality are one.

There is also something familiar about the way Teha'amana stands, a pose which takes us back to the curious little painting Gauguin had done just before he left for Tahiti, and which he entitled: *Exotic Eve*. In both cases, the figure is based on a slim-waisted Buddha from the Borobudur friezes, but in the first painting he gave her the features of Aline his mother, where now she is Teha'amana, and it is no great leap to conclude from this that his Tahitian *vahine* has now replaced his mother-figure, which can only mean that the Delightful Land, with all its suggestions of sexual pleasure, has finally taken the place of Peru as Gauguin's imaginary Eden.

## A Moment's Happiness

As if to confirm this happy mood, the news he received was suddenly very reassuring. Mette wrote to say that another article by Albert Aurier had again singled him out as the leading Symbolist painter, with special reference to *The Vision after the Sermon*. Mette also described moves which were under way in Copenhagen to hold a special showing of his and Van Gogh's work, the first major exhibition of its kind so far. This was largely due to Theodor Philipsen, who was keenly promoting Gauguin whenever an opportunity arose. He and the author Otto Rung had been in Paris just before Gauguin's departure and had been invited to the farewell banquet at the Café Voltaire, an event which had given them a first-hand view of the high esteem in which Gauguin was held

by the leaders of the avant-garde literary world. Back in Copenhagen, Philipsen lost no time in communicating this news to his friend, the artist Johan Rohde, who was the leader in moves to break with the traditional academic salon held annually at the Charlottenborg Exhibition Hall. In 1891, Rohde had launched *Den frei Udstilling*, the Free or Open Exhibition, as a rival to that official show, and had repeated the success the following year at the Gallery Kleis. For a third attempt, Rohde wanted to enhance the credentials of his local artists by including works by leading members of the foreign avant-garde, and Philipsen and Mette eagerly put forward the name of Gauguin as the most likely candidate, emphasizing that many of his works were already in Copenhagen. Rohde decided to visit Paris to study what was going on and Mette gave him a letter of introduction to Schuffenecker, so that he could see other works by her husband which were still stored in his studio. By the time he returned, Rohde had conceived the idea of a joint show – a room for Gauguin and another for Van Gogh – and though some of the organizing group were not enthusiastic, perhaps recalling Gauguin's previous failure in their city, Philipsen supported him and helped win them round. Rohde wrote to Theo van Gogh's widow, to ask for a loan of works by Vincent, while Mette wrote to Gauguin asking him to send new work from Tahiti as soon as possible. In the meantime, Philipsen bought the early portrait of the nude sewing which had once scandalized the critics, paying 900 kroner, a generous sum, given that Mette was getting only 100 to 200 kroner on the rare occasions when she managed to find buyers for Gauguin's work – and they were mainly sympathetic friends trying to support her.

It is probable that Gauguin was more pleased by the news of Aurier's article than anything else. To be praised in the Paris press was what he most desired. But he was aware that even in a city as remote as Copenhagen, it was still a coup to be accorded so much space and he wrote to Mette in cordial terms promising her 'good' canvases by the end of the year, in readiness for the exhibition the following spring. What he omitted to tell her was his growing desire to take the paintings back himself, for it was tempting to try and be there for so prestigious an event. However, he did write to tell Mette that he approved of her wish to send Aline to a boarding school, a rare occasion when he supported one of her decisions regarding their daughter.

## The Women in White

As far as his work was concerned, 1892 proved to be Gauguin's best year out of the two he spent on the island. Some would argue that it was the best of his entire artistic career, that the blending of myth and realism

which he achieved in the Vairaumati and Hina works was superior to anything else in his oeuvre, including the religious paintings he had done in Brittany. In fact the two are closely linked, the archaic Christian images and the mysterious Hina figures being obvious products of the same imagination. But just as in Brittany, this burst of creative activity was fairly short-lived. By the end of 1892, the rapid succession of major works was already drying up and it was the mid-year period, around July/August, which saw the peak of his ecstatic feelings for the island and for Teha'amana, feelings easily discernible in his art. The reason for this is not hard to find: we can catch a hint of what had happened in *Vahine no te vi* (*Woman with a Mango*), another portrait of a woman in a shapeless Mother Hubbard. It is that garment which sends out conflicting messages; the woman, who we can assume was based on Teha'amana, holds up a mango as if she is still playing Eve with the tempting fruit, but an Eve in a billowing missionary gown that swells over her stomach?

Gauguin offered an explanation, in an off-hand way, in a letter to Monfreid, otherwise taken up with the sort of artistic gossip both of them clearly found irresistible:

> I shall soon be a father again in Oceania. Good heavens, I seem to sow everywhere! But here it does no harm, for children are welcome and are spoken for in advance by all the relatives. It's a struggle as to who should be the foster father and mother. For you know that in Tahiti a child is the most beautiful present one can give. So I do not worry as to its fate. . . .

Teha'amana's pregnancy must have seemed the final stage on his journey of integration into the Maori world, for with their child he would truly become part of the delightful land. He painted a water-colour of her, naked, showing the full roundness, for by the time he wrote to Monfreid, she may well have been four to five months into her term. If so then she would be due to give birth around Christmas, yet, strangely, this does not seem to have stopped Gauguin from continuing his moves to get himself repatriated. As so often in the past, his behaviour was puzzlingly contradictory. On the one hand, he was overjoyed at the prospect of fatherhood and was painting pictures which glow with pleasure. On the other, he was doing everything possible to get away – moves which he could hardly have kept hidden from Teha'amana, who must have realized that she was likely to become a mother just as her child's father walked out of her life.

It was money which drove him to actions he might otherwise have shunned. Captain Arnaud's 400 francs had not lasted long and by October he had run out of canvas and had no funds to buy more. He went back to wood carving and did manage to sell two pieces, presumably

to someone looking for local curios. What finally became of them will probably never be known, and there may well be a shelf in some quiet suburban home, somewhere in Europe, on which a Gauguin idol is even now silently gathering dust. When he had had money, he had bought some local curios himself, some spears and Australian boomerangs. He had even carved some of his own, a walking stick and some carved ear-plugs with Marquesan designs. He had already done a realistic, highly polished head of Teha'amana which was a useful prop now that she was too big to pose for him though he seems to have been content to go back to his original subjects – the old familiar view outside his hut, with the spreading mango tree at the foot of the mountain, the place where he had first painted Jotefa chopping wood for his fire. The tree and the hut are the same, but the vivid colours show how far he had progressed in the eighteen months since he first began work in Mataiea. He called one of these late paintings *Noa Noa*, the name most associated with his journey into the mountains. It is a pyrotechnic display of seemingly impossible hues, a riot of vegetation, a happy jungle with nothing poison-ous in the undergrowth, neither lizard nor *tupapau*, though this was to be one of the last of the joyful works.

Early in November he learned that his request to the Director of Fine Arts for repatriation had been granted, while at the same time a letter from Monfreid contained 300 francs from the sale of one of his Brittany paintings to a British collector, Archibald Aspol. This awakened his hopes that he might still be able to raise sufficient funds for a return ticket to the Marquesas Islands. The next boat for Noumea was not due until January, so he decided not to see Lacascade about his passage home until December, by which time something else might have turned up which would enable him to get to the Marquesas, before he was obliged to go back to France.

This did mean that he would not be able to take back the paintings he wanted to show at the exhibition in Copenhagen, though this was resolved when the ever-loyal Jénot arranged for a colleague, an officer called Audoye, to take eight, out of the fifty or so which had been completed, when he returned to France at the end of his service. Gauguin carefully selected those he considered most important and priced them accordingly, putting *Manao tupapau*, at 2,000 francs, way above the others. The next down was a mere 800 francs.

But all this packing and parcelling can only have proved to Teha'amana that it would soon be over, and though what exactly happened is nowhere recorded, some signs of conflict are discernible in the paintings. One of the landscapes, *Fatata te mouà* (*At the Foot of the Mountain*), while appear-ing to be just another view of the foothills, the spreading mango tree and the hut, has two tiny figures travelling along the coast road in front

of Gauguin's dwelling – one is the man on the white horse galloping out of the picture to the left, while the other figure, perhaps the wood-cutter, walks off to the right. Nothing is accidental in Gauguin and it does look as if both these familiar figures are quitting the scene, aban-doning the familiar homely setting. And if they are supposed to represent Jotefa in his two roles as horseman and wood-cutter, what interpretation are we meant to place on this revelation of his departure? In the end, the picture remains indecipherable, but from then on, a sort of sour irony starts to creep into the titles. Gauguin paints a landscape illuminated by ghostly moonlight and calls it *Arearea* (*Amusement*), though it is clear that the eerie glow is a reference to Hina in her manifestation as the goddess of the moon, whose statue can be seen in the background being worshipped by a group of distant women. The most immediately striking thing about the picture is the strange short-haired dog in the foreground, not unlike a whippet, though coloured an alarming saffron/orange, simi-lar to the colour of the robes worn by Buddhist monks. There had been a tiny red dog in one of the harvest paintings in Le Pouldu but this creature is centre stage, a major player in the action. The early Polynesian navigators had had dogs as trusted companions on their epic voyages and they were important in the new lands they found both as food and hunting companions. By Gauguin's time the pure, short-haired Poly-nesian dog had crossbred with other breeds escaped from passing ships and was now a lost race, not unlike the human companions with which it had once crossed the Pacific. For Gauguin, this symbiosis may well have given the dog a poignant role as the representative of a lost, pre-European order.

*Amusement* is unsettling in other ways largely because of the figure in the foreground dressed in white. A white costume is a dominant feature of this group of canvases, it is worn by a ghostly woman who stares out from behind a tree over a frozen landscape in a second ironically titled work: *Tahitian Pastoral*. Here the land is still fragrant – an overhanging frangipane has opened its blossom and another dog in the foreground lifts its snout to sniff the perfumed air. But most disturbing of all are the white-robed figures in a third painting *Matamua* – which could be translated as 'Formerly' or 'Once Upon a Time' or perhaps more exactly as 'In Olden Times'. The women in white could all be Teha'amana and yet white was traditionally the Tahitian colour of mourning. But who has died? The child? And if so, how and why? There is no answer, but after that letter to Manfreid nothing more is recorded of the child Gau-guin had predicted.

## For Aline

When Gauguin finally called on Lacascade in late December, he received a very unpleasant shock. The new Director of Fine Arts, Henri Roujon, had not been best pleased to find his predecessor's unwanted protégé dumped in his lap and had written to Lacascade to say that while repatriation was granted, it was up to the colonial authorities to pay for it. This Lacascade was not prepared to do. He was well aware that Gauguin had been saying scurrilous things about him and knew that a cruel caricature, made by this troublesome artist, was being passed around the French community in Papeete. For once, the settlers were more than happy to see one of Gauguin's works. They were furious with the governor for raising duties on imported goods in order to pay for public works. Since the death of Pomare v there had been a running battle with Cardella over the royal palace which the mayor wanted for his new town hall but which Lacascade was determined to fill with his own people. Now the local newspapers were demanding the governor's recall and in such an atmosphere he saw even less reason to spend public funds on a ticket for someone he so heartily despised. This left Gauguin with no option but to reapply to Paris for the money. That done, he could only slouch back to Mataiea to sit out the four months minimum it would take for a response to arrive. It was an impossible situation; by the time he had an answer he would be finally and completely broke, and if the news was only another refusal, what was he then to do? The only prudent course of action was to assume that the answer would be negative and to write at once to France in a last desperate attempt to get money sent out from whomsoever might be prepared to help him.

March of 1893 saw a barrage of begging letters despatched to Mette and to Schuffenecker and to Maurice Joyant, Theo van Gogh's successor at Boussod et Valadon, as well as to Alphonse Portier, the other art dealer who had once handled his work. He would have asked Charles Morice to start pulling strings in the hope of getting the new Director of Fine Arts to change his mind, but he now knew that his supposed 'agent' was playing a devious game – Morice had written a disingenuous letter complaining that he had received no word from Gauguin, who did not believe him. While it was true that the post was slow, it had proved remarkably reliable. As everyone else had received their mail, Gauguin assumed that Morice was lying. In desperation, he wrote to Sérusier to see if he could intervene with Roujon, though he knew that the young man had no political clout whatsoever.

With all this weighing him down, Gauguin's return to Mataiea lacked the sense of relief he had experienced the last time he had been reprieved and allowed to stay on. This time he longed to leave and one can imagine

his confusion when the usually barren mail boat suddenly disgorged a letter from Juliette Huet, giving her new address and recounting all the news of their baby girl. Now his hut, with the dated photographs of his children staring down at him, was no longer the refuge from civilization it had once seemed. Stacked against the walls were the succession of paintings not yet despatched to Monfreid or Mette, unfolding like a visual diary of his life on the island, from the first pictures with Teha'amana to the final ghostly figures in their funereal white. It must have been then that he decided to write a book for Aline, a sort of collection of thoughts and advice for the most precious of his offspring, as if he could somehow replace all the lost moments when he ought to have been there to talk with her. That all he had to write in was another of his children's exercise books makes the resulting effort all the more poignant. He wrote out the title: *Cahier pour Aline* (*Notebook for Aline*) and followed it with a dedication in his now familiar scrawling handwriting, which seems to make a reference to the child he had just lost:

> To my daughter Aline, this notebook is dedicated. These meditations are a reflection of myself. She, too, is a savage, she will understand men . . . Will my thoughts be useful to Her? I know she loves her father, whom she respects. I give her a remembrance. The death that I have to accept today is an insult to my fate. Who is right, my words or myself? Who knows. In any event, Aline has, thank God, a heart and mind lofty enough not to be frightened and corrupted by contact with the demonic brain that nature gave me. Faith and Love are Oxygen. They alone sustain life.

Despite such a bold beginning, what follows was hardly suitable for a girl approaching her fifteenth birthday. Apart from a print of a Corot, glued inside the front cover, and a Delacroix in the back (both from the Arosa collection), the only illustration was a rough, hand-coloured sketch of *Manao tupapau*, which shows the naked girl on the bed and which was followed by yet another lengthy defence of the painting, intended to forestall any criticism of its difficult subject matter. Indeed, the whole tone of the little book becomes distinctly defensive as it progresses:

> Is it not a miscalculation to sacrifice everything for the children, and doesn't that deprive the nation of the genius of its most active members? You sacrifice yourself for your child who, in turn, becomes an adult, and will sacrifice himself. And so on. There will be nothing but sacrificed people. And this stupidity will go on for a long time.

He seems to have wanted to offer Aline some snippets of good advice, the sort of things any father might have passed on to a daughter during childhood but which had been omitted as a result of his absence. Yet rather sadly, all he could find to offer her were his usual ruminations on art, the sort of things which fill out his letters to his cronies:

It is said that God took a little clay in his hands and made every known thing. An artist, in turn (if he really wants to produce a divine creative work), must not copy nature but take the natural elements and create a new element.

Why he thought a teenage girl needed such lofty coaching, it is hard to imagine, and in any case the notes soon veer off into rambling thoughts on Edgar Allan Poe and the music of Wagner, neither of whom would have much interested Aline, had she ever been sent the book. He was, however, touchingly keen that she should admire her father, and most of the remaining pages are a scrapbook, in which he pasted all the reviews and printed comments on his work that he had carefully snipped out of the newspapers – Mirbeau's and Huysmans's articles prominent amongst them. Sadly, the last impression left by the *Cahier pour Aline* is of a man desperate to have his daughter's affection yet unable to drag himself away from his own obsessions. Had he been able to keep his family with him, he might not, on the evidence of these notes, have proved such a good father after all. Aline was able to worship him because he was not there. He was the untouched perfect being, unlike her mother who was the day-to-day figure of authority. Had she been confronted with her libertarian father she might well have thought again, for there are notes in the book which would not have sat well with her dreamy romantic nature.

Freedom of the flesh should exist, otherwise it is revolting slavery. In Europe, the coupling of two human beings is a consequence of Love; in Oceania, Love is the consequence of copulation.

In the end the little book was never sent to her, and was probably no more than a way of passing the time as he waited for news, isolated and impatient, increasingly bitter over the way he was being ignored.

## Mysterious Water

There is some, albeit slight, evidence, that by the end of 1892, Gauguin and Teha'amana were less close – she may even have left him for a time as he seems to have turned away from painting live models and returned to his former practice of working from photographs. He was familiar with one of Charles Spitz's best-known Tahitian images: a scene in the mountains set among richly exuberant foliage, where a young man wearing nothing but a wrap-around cloth leans forward to drink from a thin jet of water, cascading from a hidden stream. Of course when Gauguin incorporated the painting into the book he eventually wrote about his experiences, he made it his own, appropriating Spitz's photograph just as he had Loti's novel. In Gauguin's account the meeting with the drink-

ing figure occurs on his climb up the valley of the Punaruu, though it is interesting to note that the same sexual ambivalence persists, and that Spitz's boy is transformed into a girl:

> I had made no sound. When she had finished drinking she took water in her hands and poured it over her breasts, then, as an uneasy antelope instinctively senses a stranger, she gazed hard at the thicket where I was hidden. Violently she dived, crying out the word *tachae* (fierce) . . . I rushed to look down into the water – vanished – Only a huge eel writhed between the small stones of the bottom . . .

Despite this later story, Gauguin seems to have begun the painting with the intention of making little more than a fairly exact copy of the photograph but as he worked he 'found' something, much as the later Surrealist painters found accidental faces in the shapes of trees or clouds. Gauguin had already done this sort of thing in Arles, when he had turned a garden chair into a malign insect and a bush into a face. What he 'found' now was a fish's head, at the point where the figure leans to drink, as if the water is spurting from one mouth into the other. The discovery may well have been accidental, but once made, Gauguin was no doubt happy with all the echoes it set off. The fish was important in Tahitian mythology – the island itself was believed to be a fish which had swum away from the other islands in the Leeward group. And having started down this path, Gauguin used his old device of adding meaning to the painting through its title. He called it *Pape moe* (*Mysterious Water*) and the way the liquid shines and sparkles does draw comparison with a shaft of light and could thus be another reference to Hina the moon goddess, who, through the mouth of the fish, ejaculates her luminous fluid into the eager mouth of the figure, which in Gauguin's painted version, and despite the later story, is neither boy nor girl. While the long hair indicates that it is female there are no evident breasts and Gauguin may well have intended just such an ambiguity.

*Pape moe* is more richly coloured and darker than the works produced earlier in 1892. As the title suggests, the atmosphere is sombre, more mysterious, and one has to strain to make out the fish head in among the deep tones of the claustrophobically embracing plants. And as well as Spitz's photograph there were a number of paintings which may have contributed to the pose of the drinking figure: Courbet has a similar nude, back-view, catching water in her hands, while Ingres's *La Source* may also have been on Gauguin's mind. All of which would indicate a shift away from his total preoccupation with Tahiti itself, and an imperceptible easing back into his own world, into the culture which he had almost succeeded in escaping.

The coming of the new year, 1893, brought no change in his circum-

stances. Life had become a matter of waiting upon the mail boats – as ever a distressing experience. In February he learned that several of his paintings had been sold, as long ago as May 1892, but that Morice had never sent him the proceeds. Gauguin wrote an explosive letter to Mette, complaining bitterly about the wretched man's dishonesty. He also asked her to use whatever contacts she still had in Paris to see if he could obtain a post as a school inspector for drawing, yet another forlorn hope.

Now all the news was bad. He was appalled to learn from Mette that the young critic Albert Aurier had suddenly died of typhoid fever and he wrote at once to Monfreid bemoaning his bad luck at having lost one of his few supporters: '. . . Van Gogh and then Aurier, the only critic who has ever understood us and who might have been useful some day.'

On 5 March his hopes were dashed yet again when the first mail boat, which could just have been able to bring a response to his request for repatriation, failed him. At least there was another 300 francs from Monfreid who had sold a second Breton scene to the same British collector but he would rather have had his ticket home. This perplexing mix of good and bad was repeated on the next mail boat of 21 March. Again there was no news regarding his ticket but this time there was an unexpected 700 francs from Mette, from the sale of paintings prior to the opening of the Copenhagen exhibition. But it was no use – despite this windfall Gauguin still managed to be irritated that she had not sent something earlier, which might have enabled him to make his longed-for visit to the Marquesas. There was no justification for any of this – unknown to him, Mette had been working very hard on his behalf, and had had difficult decisions to make over the organization of the promised exhibition. Rohde and the others had decided to build their own exhibition hall and when Kleis, the director of the gallery which had previously housed the annual show, tried to persuade Mette to go on showing with him, it took courage on her part to break with someone who had proved he could sell and throw in her lot with the untried Rohde and his new building. At least with Kleis, she would have been assured of some sales, while to exhibit with the *Frei Udstilling* was a complete gamble. The new centre, designed by Thorvald Bindesboll, stood in the old Haymarket, now the City Hall Square, right beside the municipal offices. Mette had by now amassed some forty-seven of Gauguin's works and at Philipsen's suggestion she tried to create a balance between early and more recent canvases. In the end she chose nineteen paintings from Brittany and ten from Tahiti, as well as a number of ceramics and carvings, making what amounted to the first full-scale retrospective of Gauguin's art. As these included his portraits of various naked figures, as well as *Manao tupapau*, the disturbing image of the naked child on the bed, one has to suppose that it took considerable self-control on Mette's part to act as agent for

what was explicit evidence of her husband's intimacy with other women – an intimacy made all the more obvious through his desperate attempts to offer explanations of what he had painted, explanations which did little more than confirm his guilt. One thing was not in doubt: when all the paintings were hung, their impact was extraordinary, and even today, when we are used to violent colours and shocking images, a single room filled with those same works would still be utterly breathtaking.

Some of the impact might have been modified had the promised Van Goghs been hung in the adjoining room, but the boat bringing the canvases from Holland was delayed by a few days and there was nothing to deaden the searing blast of Gauguin's uncompromising vision, when it was unveiled alone, to the invited guests at the private view on 26 March. That same day saw the opening of a rival exhibition of Symbolist Art and works by the Nabis at the Gallery Kleis which included seven paintings and six ceramics by Gauguin which the aggrieved director had already acquired. Thus it seemed that in a single day, everything in the Copenhagen art world was suddenly concentrated on that isolated figure on opposite side of the globe.

Although he had no way of knowing it, Copenhagen could not ignore him a second time. All the daily papers covered the two openings. The most important, *Berlingske*, took such a strong line against the work at the Free Exhibition that it raised it to a far higher status than might have been the case had the writer been more moderate in his opinions:

> We are exposed to a kind of hieroglyphic painting which throws overboard years of stored artistic capital, scoffs at any technical skill and hopes to find a new beginning by going back to nature. The cultivators of this style of art place a dummy in their mouths and a rattle in their hands, to convince people that they are immensely spontaneous and one can almost hear them speak when one reads the titles in the catalogue: Ari Pari, Manau Tupapauii, etc.

Even allowing for the not unamusing sarcasm, the writer had inadvertently hit on one of the underlying themes of Gauguin's work, its almost childlike vision which attempted to see the world afresh, without the barriers thrown up by supposed sophistication.

As expected the liberal daily *Politiken* had a long, sympathetic article by Emil Hanover, explaining Symbolism and emphasizing the importance of Gauguin's role within the movement, but there can be little doubt that it was the attack in *Berlingske* that gave Gauguin a revolutionary reputation in Denmark, making him a key figure in the growing split between the Academy and those moving towards the new.

Strange as it now seems, there was far less agreement about the recent works from Tahiti, which were so new they left even the avant-garde

gasping. The progressive poet Johannes Jorgensen devoted an entire article to Symbolism and Synthetism but while he acknowledged Gauguin's leading role within both movements he also opined that the Tahiti works were failures.

None of this would have bothered Gauguin had he known how much his children were enjoying the whole thing. The ten-year-old Pola revelled in his new-found status as the son of the mad painter and would use his free pass to take his young friends in to see the nudes, especially *Manao tupapau*. But it was Mette's reaction which was strangest of all. She had long resisted Gauguin's art, claiming not to fully appreciate it, now she was forced to accept that it was capable of attracting a great deal of attention, and with that realization came another, that she would never again be able to look on his painting as just a passing aberration, a thing he would one day get over. Standing in the crowded room in the Free Exhibition, she was forced to confess to her closest friends that she now knew her husband was lost for ever and that, despite everything, this still saddened her.

## My Heart Belongs to Two Women

What exactly Gauguin felt, half-way around the globe, is less clear cut. If Teha'amana had been away, she was certainly back with him at this point, though there was never any sign that he thought of her other than as a temporary lover. As before, his feelings for Mette were ambiguous, or perhaps more precisely self-deluding. He went on insisting that his ultimate goal was to reunite his family once he had established his reputation and made some money, but how much he really believed such a thing cannot be said. He was certainly very fond of a Tahitian popular song in which Oviri, the savage, roams the forest bemoaning his love for two women:

> *I think of those clear moonlit nights*
> *When the beams shine through the crevices*
> *And both are here in my heart.*
> *My heart sings in tune with the flute,*
> *Now very near, and now far away.*

His thoughts were now firmly on departure. There are signs that since finishing his notes for Aline, he had started planning the book he would write about his time on the island and had even jotted down the occasional note, trying to recapture his experiences – the arrival, Pomare's funeral, the story of how he acquired Teha'amana. He may also have been thinking of how he would illustrate such a book, for he was planning something out of the ordinary, a book where word and image

would both play a part. All of which may explain the one painting to which he attached Teha'amana's name. He called it *Merahi metua no Tehamana* – a title which has launched a long saga of confusions. This was originally translated as 'Tehamana has Many Ancestors', which on the surface is not very meaningful but thanks to the work of anthropologist Bengt Danielsson, one of the few with a knowledge of the Tahitian language to have studied Gauguin, we now know that a more correct translation should be: 'Tehamana Has Many Parents'. This can be seen as a reference to the incident on the way back from Faaone, when Gauguin found himself confused over just who were the real parents of his new wife. But there is a sense in which Danielsson may have approached the title from the wrong angle. It may well be that it was not the French translation which was wrong but rather Gauguin's attempt at creating a Tahitian version of it. Perhaps Gauguin really did mean ancestors rather than parents, for this actually conforms to the painting, which has a most extraordinary background decoration, along the wall above Teha'amana's head. These are invented hieroglyphs which Gauguin based on examples of the still indecipherable Easter Island script, while below, to her right (our left), is a representation of his statue of Hina. Taken together, these decorations seem to add up to a representation of the forgotten culture of the Polynesians, a culture quite lost on Teha'amana who would have known little of the old ways save for a persistent belief in *tupapaus*. In this sense the reference to her many ancestors takes on the sort of ironic note Gauguin had favoured in several of his Tahitian titles.

The business of the title does not end there, however. For a long time the work was known in France as *Les Adieux de Tehamana* implying that it was a farewell piece, painted on the eve of his departure from the island. This ties in well with the assumption that we are looking on some sort of definitive comment about the Tahitians and their relationship with their past, a sort of final melancholy comment on all that had been irretrievably lost.

As this is the one painting to which he attached Teha'amana's name, one might have expected the figure to bear some resemblance to the standing nude in *Te nave nave fenua*. Instead she is another of the much younger girls, closer to the figure in *Manao tupapau*. Of course this may just be another case of Gauguin adapting Teha'amana to suit the purposes of a particular painting, but it may also show that Gauguin was already trying to draw together a group of works which could serve as illustrations for the book he was planning. It is likely that he had already conceived some sort of story, similar to Loti's, in which he, Gauguin, would have a Tahitian child-bride. If so, then both *Manao tupapau* and *Merahi metua no Tehamana* would fit the tale far better than his adult Eves.

## Bound for Home

The money he had recently received meant that he could get home at his own expense and when he learned that a troop transport ship, the *Durance*, would leave for Noumea on 1 May, he decided that if his request for a ticket was again refused, he would pay for his own passage and thus put an end to all the waiting.

Once this had been decided, the only sensible thing to do was to pack up and move back to Papeete, where he would have easy access to the mail ships and be ready to go when the *Durance* sailed, but before that there would be one last painting, which really does seem to have been a final farewell to Teha'amana. He entitled it *E Haere oe I hia? (Where Are You Going?)* which in Tahitian was a greeting rather than a literal question, though there seems little doubt that Gauguin meant it as both. The foreground is dominated by a barebreasted figure, for which Teha'amana would probably have posed. She is holding a gourd level with and covering her right breast – for this Eve the forbidden fruit has become part of her. A second figure watches from the background, and perhaps she too may well be another representation of Teha'amana, dressed in white and carrying a baby, a ghost figure, the mother who failed to live out her role, who did not finally replace his own mother Aline, the first exotic Eve.

At the other side of the painting, two girls watch from behind a tree. The nearest is sketchily brushed in, but her features could well be those of the young girl in *Manao tupapau* and *Merahi metua no Tehamana*. She is smiling, while the central figure with the gourd is sad, for it is perhaps she who poses the question in the title: 'Where Are You Going?' to which there was only one answer.

While he waited in Papeete for the *Durance*, Gauguin rented a house in the suburb of Paofai, on the western edge of the town but still within easy reach of Jénot and his other friends. His landlady, Madame Charbonnier, despite an outward image of black-draped respectability, had had a colourful career. She had been deported from Paris by the Vice Squad and despatched to a penal colony on New Caledonia with other young ladies of the night. Blessed with a forceful and persuasive personality, she had prevailed upon her jailors to let her disembark at Papeete where she had gradually established herself as a considerable business-woman and property owner. By the time Gauguin rented one of her houses, she had been living on the island for thirty years and few knew the real origins of her wealth and the true cause of her arrival on the island. Outward appearances were somewhat deceptive, however, for when Gauguin found a model, and began to do some life drawing, he quickly realized that the figure of Madame Charbonnier in her long

black dress was spying on him through the window of the veranda door. His solution was to do as he had in Anani's house and paint over the glass, though the somewhat rough image of a *vahine* with animals and flowers was more practical than artistic. As if to confirm the ephemeral nature of the work, Gauguin entitled it *Rupe Tahiti*, the opening words of a popular song 'Beautiful Tahiti'.

In the end, Gauguin's prudent determination to leave on 1 May aboard the *Durance* began to waver. What if he paid for his own ticket and word came on the next mail boat that he was to be repatriated at government expense? He agonized throughout April and in the end let the warship sail without him. It was a risk, though he was probably aware that the cruiser *Duchaffault* would call at Papeete in June, en route from San Francisco to Noumea. If the news from Paris was bad, then he could still buy a ticket and sail with her as far as New Caledonia. For once, his luck was good and the 25 May mail boat brought word that his request had finally been granted. The case had been passed from the Department of Fine Arts to the Ministry of Colonies, who had referred it to the Ministry of Foreign Affairs, who had shuffled it on to the Ministry of the Interior, as this was the department that was supposed to deal with the repatriation of destitute French citizens who needed help getting home. They had reluctantly decided that he was to be given a lowest-class ticket and when Lacascade broke this news to him, Gauguin was furious. Was he not on an official mission and had he not been given officer-class accommodation on the way out? Why then should he be made to suffer in this way? But the governor was implacable, for he too had had bad news by the latest mail. Through the conniving of their supporters in France, the local settlers had succeeded in getting him removed from Papeete. The quarrel with Cardella had descended into farce when elections to the municipal council had produced a stalemate between the Catholic and Protestant factions, which left the mayor unable to govern. Seeing a chance to humiliate his enemy, Lacascade had refused to dissolve the assembly and thus permit a second election, an action which Paris could no longer ignore. Now Lacascade was being despatched to another, inferior post, on the island of Mayotte in the Indian Ocean. For someone who had tried harder than his predecessors to improve the administration of the colony and to get a number of public works under way, this was a bitter humiliation and one which hardly predisposed him to make any particular concessions towards the well-being of a man who had only contributed to his troubles with his nasty little drawings. It was galling for Gauguin to have to accept the ruling but at least he had the satisfaction of witnessing Lacascade's final humiliation: rather than wait for the *Duchaffault*, the governor took the first boat out, a British steamer, the *Richmond*, bound for New Zealand

and as he left he was treated to a cruel parting gesture by the settlers, who gathered on the quay to whistle and jeer as the vessel pulled away.

By contrast Gauguin had a handsome send off. He left on 14 June, just over two years since he had first set foot on the beach at Papeete. In his own words, he was two years older but 'younger by twenty years'. He was taking some sixty-six paintings and several sculptures with him, no mean achievement for only twenty-four months' work and with certainly many quite remarkable canvases among them. But he was not as confident about this as his later writings would claim. His letters, especially those to Monfreid, were full of doubts and uncertainties. He had certainly gone further than any of the other artists who were moving away from Impressionism but that left him extremely isolated. As yet, he had had no word of the exhibition in Copenhagen which had opened on 26 March and so had no way of knowing how the first major presentation of his Tahitian works had been received. He seems to have imagined that he was leaving Polynesia for good and that he was taking back enough shockingly new works to ensure his reputation and bring him a decent income which would allow him to live with his family again. By and large, he had enjoyed his Tahitian experience but looked on it as a passing interlude. Now he was going home and, even before the island had disappeared from view, he was already erasing the unpleasant memories and improving his better stories, ready to amuse his old friends when they would all be together again in a few weeks' time. Even something as simple as the quayside adieu to his friends in Papeete would later take on all the glow of a transcendental experience. When he wrote it up, it was garnished and gilded into the artist-hero's farewell to the island, as if he were Odysseus bound for home:

> As I left the quay, at the moment of going on board, I saw Tehemana for the last time.
>
> She had wept through many nights. Now she sat worn-out and sad, but calm, on a stone with her legs hanging down and her strong, little feet touching the salt water.
>
> The flower which she had put behind the ear in the morning had fallen wilted upon her knee.
>
> Here and there were others like her, tired, silent, gloomy, watching without a thought the thick smoke of the ship which was bearing all of us – lovers of a day – far away, for ever.
>
> From the bridge of the ship as we were moving farther and farther away, it seemed to us that with the telescope we could still read on their lips these ancient Maori verses,
>
> > *Ye gentle breezes of the south and east*
> > *That join in tender play above my head,*
> > *Hasten to the neighbouring isle.*

*There you will find in the shadow of his favourite tree,*
*Him who has abandoned me.*
*Tell him that you have seen me weep.*

It is significant that in Loti's account of his hero's departure, on which Gauguin certainly based his own touching little scene, it was not the girl Rarahu who wept but her lover, the English captain Harry Grant, who wept for *her*!

As he climbed the gangplank, the captain who, in Gauguin's account, 'had heard of me as an artist', welcomed him on board and invited him to join the officers in the ward room. Gauguin was so grateful he eventually listed all their names in his book, referring to them as the gentlemen who 'did everything possible to make life for me pleasant'.

It had proved surprisingly easy for Gauguin the savage, the reborn Maori, to slip back into the role of a French colonial official, bound for home.

# 11

◆

# *With a Fixed Smile*

### A Colonial Returns

Despite the welcome from her crew, the voyage aboard the *Duchaffault* turned out to be the first of a series of disasters. The ship was simply too good – her powerful engines meant that the crossing to Noumea took only seven days, leaving Gauguin with three weeks to wait before he could board the steamer *Armand Béhic* for France, three weeks in which he was obliged to pay for room and board. He might yet have arrived back with sufficient funds to see him through, if his touchy pride had not finally reduced him to penury. The third class on the *Béhic* was pretty bad, but he might have been able to tolerate it if he hadn't noticed that his arch-enemy Lacascade was happily ensconced, above decks, in the first-class accommodation. The ex-governor had crossed from New Zealand to New Caledonia to join the *Béhic*, and the thought that Lacascade might see him was too much for Gauguin, who paid the difference and had himself transferred to second class, thus depriving the 'negro' of any satisfaction he might have had at watching him stuck amongst the soldiers and other poor whites crowded into steerage. The voyage was certainly made more comfortable by this move but it meant that when the boat docked at Marseilles, on 30 August 1893, Gauguin had only 4 francs left and was effectively destitute.

Despite having warned his friends that he would need help, he found no letters awaiting him. He was not allowed to stay on board and when he moved into a small hotel he was in the uncomfortable position of having insufficient funds to cover the bill. He sent an urgent telegram to Maurice Joyant at Boussod et Valadon, asking for help, then went round to the General Post Office where he was relieved to find a letter from Monfreid with an address for Sérusier who was apparently willing to lend him 250 francs. A second telegram, no doubt using up the last of the 4 francs, asked Sérusier to send this as quickly as possible. The

young man was as good as his word, for the money came the very next day, allowing Gauguin to settle his hotel bill and get something to eat before boarding the train for Paris, arriving that same evening with his enormous bundle of paintings. There was now only one thing on his mind – an exhibition, *the* exhibition.

It being August, everyone was out of town on holiday and there was no one to meet him at the station and no one to offer him the expected hospitality. Gritting his teeth, Gauguin took a cab to Monfreid's studio and bullied the concierge into letting him and his paintings in. The next day he hurried round to Boussod et Valadon only to find that Maurice Joyant had left six months earlier and that the gallery had sent back to Monfreid the paintings which Gauguin had left on consignment before his departure to Tahiti. The other dealer with whom Gauguin had left works, Portier, had also given up the hopeless task of trying to sell paintings that no one wanted.

While this double rejection was a blow, it at least left him free to choose where he would hold the exhibition. Before finally deciding, he had to get lodgings, and his next call was on Madame Charlotte at the Crémerie in the Rue de la Grande-Chaumière to see whether she and any of his other former contacts at the restaurant were still prepared to help him. When he met up with Alphonse Mucha he found that the once-hungry artist was now making a good living from his commercial work, providing highly detailed illustrations for *Le Figaro illustré* and *L'Illustration*.

Mucha had moved across the road to number 8, next door to Gauguin's old address, the Académie Colarossi at number 10. The building was owned by an artist and engraver, Emile Delaune, who had another smaller apartment available, which Mucha suggested that Gauguin should take, offering to share his studio space with him. Charlotte Caron promptly lent Gauguin the advance quarter's rent he would need, and gave him renewed credit in her restaurant.

While these acts of kindness went some way towards counterbalancing the rejection by his dealers, nothing could soften his anger at what he took to be Mette's indifference and a series of unfortunate accidents now took place which succeeded in souring relations between them to a point where they could no longer be repaired. Most of this can be put down to the simple problem of keeping in contact with someone who drifted about so much. Gauguin had written to Copenhagen from Marseilles as soon as the boat docked. When no reply came, he sent her a tetchy letter demanding to know what was going on. This crossed with a telegram from Mette informing him that his Uncle Zizi in Orléans had died at the age of seventy-five. As Zizi had been a bachelor, Gauguin realized that he stood every chance of benefiting from the situation and hastened

to Orléans on 3 September for the funeral. Before leaving, he despatched a particularly bitter letter to Mette, accusing her of never answering his questions and of failing in her wifely duty in not having come to France, or sent Emil at least, to greet him on his return.

When he returned to Paris briefly, he took up this theme again, urging her to come, then returned to Orléans on 12 September, staying for three days for the reading of the Will, an event which produced mixed reactions. Uncle Zizi had left something in the order of 22,000 to 25,000 francs – it was difficult to say precisely, for while some was in cash, the rest was in securities which would have to be sold. While this might seem like wonderful news, there were a number of complications. Uncle Zizi had left 4,000 francs to his housekeeper and Gauguin thought he knew why so large an amount should have gone to a servant. The remainder was to be divided between himself and his sister Marie, but as she was now living with her husband in Colombia, the lawyer required a signed agreement before he would sell the securities or hand over the cash. As Gauguin, the ex-stockbroker, ruefully noted, some of his uncle's investments were in Italian bonds which were currently slipping in value and the longer all this dragged on the less there would be for any of them. Still, there was no doubt that around 9,000 to 10,000 francs would be his and he would now be able to borrow against the certainty of the impending settlement.

In Paris once again, he was somewhat chastened to find that Mette had replied promptly to his original letter from Marseilles but having had no address for him then, she had sent her letter to Schuffenecker. As Schuff was on holiday in Dieppe the letter had been sent on and, unsure what to do for the best, he had in turn despatched it to Monfreid's country house in the Pyrenees, where it had languished until the receipt of Gauguin's new address in the Rue de la Grande-Chaumière, where it was duly sent, and where Gauguin now found it. Thus Mette was sitting in Copenhagen steaming with righteous indignation, while her husband mixed wounded pride with humiliation and then had salt rubbed in when the next letter from Mette informed him that while the Free Exhibition had been a critical success, with everyone paying more attention to him than to anything else, sales had, as ever, been poor. What little she had collected had already been spent on clothes for the children and as far as she was concerned, that was that.

It was this matter of the sales of his work and of the other paintings which he had collected when he was working in Paris, which now caused the worst misunderstandings between them. Gauguin had no idea how much Mette had been doing on his behalf, nor did he ever accept that she had any right to keep back money from the sales, even if she put it towards the upkeep of their children. When she first arrived back in

Denmark, Mette had been heavily dependent on the kindness of her new brother-in-law, Edvard Brandes, and because he was one of the few to appreciate the pictures in Gauguin's collection, it had seemed perfectly reasonable to let him have some in exchange for money, on the understanding that Gauguin would be permitted to buy them back later, if he so wished. This compromise ought to have satisfied everyone, allowing her to survive and educate the children, while not finally depriving Gauguin of his collection. Indeed so sensible did this arrangement seem to her, that she repeated it with a friend, the family doctor, Kristian Carøe, to whom she offered some of the Impressionists, including two landscapes by Sisley, under the same buy-back arrangement. Unfortunately, nowhere was it precisely specified as to what method would one day be used to value the paintings should Gauguin decide to repurchase them. It could hardly be expected that Brandes would simply hand them over for the same amount he had originally paid, but in the absence of a clear agreement, there was ample room for the sort of unpleasantness which did in the end arise. At first Gauguin offered Brandes some of his own works in exchange for paintings by Cézanne and Pissarro and when this was refused, he then offered to pay Brandes back his money with interest – though without saying how much that would be. In the end Brandes rather deviously decided to assume that the pictures actually belonged to Mette and was thus able to refuse to sell them back to anyone but her. Inevitably, this ploy only exacerbated Gauguin's anger towards his wife, as it fuelled his belief that she was somehow trafficking in his pictures, while offering him only a fraction of the profits she was making.

He again wrote, telling her to come to Paris and join him, insisting that on top of Uncle Zizi's money there would soon be his exhibition which would change everything. It was a hopeless attempt. Mette wrote secretly to Schuffenecker listing a catalogue of earlier betrayals, principally Gauguin's refusal to share the proceeds from the Drouot sale before his departure for Tahiti and the way he had tried to hide from her just how much he had actually made. Husband and wife were no longer communicating, stalemate had been reached.

From then on any contact with the family in Denmark was minimal, save for an apparently charming letter he wrote to Aline in December in honour of her sixteenth birthday:

> Very dear Aline, how grown up you are. . . . You don't remember it, of course, but I saw you when you were very small, very calm, you opened your beautiful light eyes. So you have remained, I believe, for ever. Mademoiselle is off to the ball. Do you dance well? I hope the answer is a graceful Yes, and that young men talk to you a great deal about me, your father. That's an indirect way of courting you. Do you remember,

three years ago, when you said you would be my wife? I sometimes smile when I recall your naïve idea . . .

This wish that her future suitors would talk about him and his wish that he might thus be a participant in her courtship, is redolent of those barely suppressed emotions which had already spilled over into his art. The letter was so frank, one wonders why he hesitated to send Aline the notebook he had supposedly written for her? Perhaps he intended to, at some further point, when she was older, though it was not to be. In the end, that letter would come back to haunt him, like a terrible curse he had inflicted on himself.

## The Gallery

There was less problem over where he should exhibit. Durand-Ruel had already sold the occasional Gauguin among other Impressionist works, so he was not unknown to the gallery and felt fairly confident that an approach would be welcomed. However, this was not as clear-cut as Gauguin may have thought. Now aged sixty-two, and after thirty-eight years as a dealer, Paul Durand-Ruel was no longer the bright young adventurer who had been among the earliest to realize the brilliance of the Impressionists. In fact he was rather settled in his ways, with little time for any art which strayed too far from the light airy work of his two main stars: Monet and Renoir. His thoughts were increasingly directed towards America, where he had started to resolve the problem of what to do with the vast cache of Impressionist works which he had been adding to over the long years when there was never much hope of achieving significant sales. As recently as 1884, he had been in debt to the colossal sum of one million gold francs. Three years later he opened a gallery in Manhattan and rented an apartment on Fifth Avenue – a stroke of the purest luck, for the owner of the building, H.O. Havemeyer, a sugar millionaire whose wife Louisine had already been won over to the Impressionists through her friendship with Mary Cassatt, was so smitten by the paintings on the walls of Durand-Ruel's salon that he promptly began to buy them, eventually ending up with forty in all. Durand-Ruel's worries were over and by the time of Gauguin's return from Tahiti, the gallery in the Rue Laffitte could sell out of Monet's works, many to American visitors, even before an exhibition opened. What had once been unsaleable at 30 francs was now being seized upon at a hundred times that price.

None of which inclined Durand-Ruel to advance his tastes – he disliked the recent Pissarros because they were influenced by Seurat whose work he loathed and he was hardly predisposed to like the new Gauguins,

which were by then even further removed from the Impressionist ideal. Fortunately, there were two things in Gauguin's favour. Durand-Ruel was about to leave for America for the first time in four years, and there is every likelihood that the elder man did not see Gauguin's work but left matters to his two surviving sons Joseph and George, who were less committed to the earlier style than the founder of the gallery. In any case there were other elements working for Gauguin, the support of Degas, who had again changed his stance, and the fact that two of the rare younger artists which the gallery deigned to handle, Henri Moret and Maxime Maufra, were followers of Gauguin from his Brittany days. To take on the pupils while rejecting the master, could only seem perverse. On balance, Joseph and George were inclined to let Gauguin have his show, though they were not willing to be as generous as their father had once been with *his* discoveries, when he purchased work which at the time seemed to have little commercial potential. While they agreed to let Gauguin have his exhibition without having to pay any fee to the gallery, as was sometimes the case, they nevertheless insisted that he pay for framing, advertising and all the printing of the posters, catalogues and invitation cards. As this might cost anything up to 1,000 francs, he could hardly count his visit an unqualified success. The opening was set for 4 November, with the exhibition to run for a month.

At least with the holidays ending, most of Gauguin's friends were now returning to Paris and could be asked to lend him money, confident that he would be able to repay them once his inheritance was cleared. Thus he was able to raise an astonishing 2,000 francs, though he was to need it all, as framing the paintings was even more expensive than he had imagined. The canvases were all of different sizes, which meant that mass-production was impossible as each had to be individually worked on and, given the other expenses he was obliged to meet, it is hardly surprising that he began to realize that his hoped-for success might well descend into yet another financial catastrophe. He could hardly overlook the fact that his sale of work at the Hotel Drouot had succeeded because of all the advance publicity and while forking out huge sums of money for framing and printing, Gauguin ruminated on who now might engineer just such a public relations exercise. The man he really needed, Albert Aurier, was dead, and reactivating his other Symbolist supporters would take the sort of time and effort he could hardly afford while fully employed setting up the actual show. It was the increasing fear that his precious works might sink without trace that led him to accept back into his life the reviled figure of Charles Morice.

## Words and Pictures

It was on Morice's initiative that they met again – he wrote a letter begging for a meeting and Gauguin probably thought there might be some chance of getting back at least part of his loan. He was quickly disabused. Morice was broke. His literary reputation had taken a serious downturn after his disastrous sortie into drama and the young man was now reduced to ill-paid jobbing journalism. Here at least, Gauguin saw some means of recouping his losses, for if Morice were to assume his former role as chief promoter of Gauguin and his art, he might yet rally support for the exhibition. Morice was delighted to get off so easily, and there can be no doubt that in the task he was set, he proved both energetic and effective. Throughout that October articles on the forthcoming exhibition appeared in every leading journal concerned with the arts, while Morice himself wrote a first-rate foreword for the catalogue and undertook to see that anyone who mattered was sent an invitation to the private view.

At some point, while all this was under way, Gauguin mentioned his idea of producing a book of his experiences on Tahiti and tentatively hinted that he was looking for someone to help finish it. Unsure of his literary abilities, he hoped to find a professional writer who would put a final gloss on his prose, a suggestion obviously directed at Morice, who indicated that he would be happy to take on such a task, though as Gauguin had still not decided on the final format of the work, the business was left hanging for the time being.

Initially, Gauguin linked the project very closely to his art – in a letter to Mette written some time that October, he told her that he was 'preparing a book on Tahiti, which will facilitate the understanding of my painting', which suggests that he was contemplating some sort of adjunct to the catalogue, a work which would set out the mythological and visual sources that underpinned the canvases. This assumption is reinforced by the fact that some time about then, Gauguin lent Morice *L'Ancien Culte Mahorie*, along with some of his other notes. What exactly these consisted of we do not know, but his first commission for the poet could well have been to tidy up his borrowings from Moerenhout in a manner suitable for publication, even though there was by then little chance that this could be ready in time for the opening of the exhibition, now only a few weeks away.

Whatever the poet and the painter were up to, they were at least friends again. It is worth noting that in his occasional letter Gauguin always addressed Morice with the familiar *tu*, a rare sign of friendship from a man who would seldom *tutoyer* anyone. Morice's poverty no doubt helped; Gauguin was not the sort to bear a grudge against a

struggling artist – it was the bureaucrats of this world, like the hapless Lacascade, who earned his undying hatred. In addition, Morice was happily in love with a countess who had touchingly chosen to share his miserable existence, while Gauguin, after some effort on his part, had resumed relations with Juliette.

He had tried to contact her as soon as he got back, wanting to see their daughter as much as anything, but had been unable to find her at the address she had sent, and had had to write to Monfreid in the country to see if he knew where she was. Monfreid was very much in contact with her as he was now living with her friend Annette Belfis, a relationship which had caused the breakdown of his marriage. His wife and son Henry had moved to the south of France, while Monfreid was presently travelling with Annette and about to leave for North Africa. When Gauguin did eventually get an address, Juliette came to the Rue de la Grande-Chaumière with their daughter Germaine, now two years old, and an affair of sorts was relaunched, though on a somewhat tentative basis – Juliette seems not to have wanted to move in with him, perhaps concerned that he would get too involved with the child, then simply up and leave as he had before.

Despite all this activity, there must have been some moment when he could have made time to see the sort of Polynesian art no longer on view on Tahiti, though in one important instance he was unlucky: the Oceanic collection of the Musée d'Ethnographie de Paris was inaccessible – for several years it had been displayed on a cramped staircase but when it was eventually moved to a larger hall no curator was appointed and it remained locked from view until 1910, depriving Gauguin of the chance to see France's finest assemblage of Polynesian art. However, there were other means, generally private dealers who displayed objects in their galleries; there was currently quite a vogue for Pacific carvings – Sarah Bernhardt had had a buffet made from the Maori sculptures presented to her in New Zealand during her 1891 world tour. But again Gauguin seemed to have shunned any possibility of following up his avowed desire and to have sunk back into a Parisian existence, content to recycle his own Polynesian imaginings rather than to make any effort to seek out anything more genuine.

Much of this can be explained by his confused state of mind. A number of things were undermining his self-confidence. Emile Bernard had organized the editing and publishing of his correspondence with Van Gogh, much of which referred to Gauguin and the tragic incident in Arles. It was obvious that young Bernard was not averse to the world learning that Gauguin had not behaved with noticeable sympathy towards their late colleague. Nor was his position as the leader of the avant-garde as unassailable as he would have liked. Even the Nabis, who

had looked on themselves as his disciples, were now as well known as he was and working on their own ideas.

Of course, as the honoured father-figure, Gauguin was still welcome to visit Ranson's studio, the Temple of the Nabis, but the increasingly religious nature of some Nabi art meant that they were hardly disposed to like Gauguin's primitive idols and in any case watching grown men dressed up like rabbinical ancients, reciting kabbalistic mumbo jumbo was not for Gauguin, though he had every reason to try to keep these newly successful artists on his side. He was far more interested in the fact that they had found a promoter in a new art dealer who rejoiced in the unusual name of Le Barc de Boutteville, whose basic business was said by some to be what is politely known as 'furbishing up' old pictures, but who wanted to get what one rather tart observer called, 'a little fresh air' into his shop by showing new work by younger painters. Whatever his reasons, it was bold of Le Barc de Bouteville to take on the Nabis and no doubt to his surprise, as much as theirs, the richly coloured, flatly decorative paintings with their aura of languid mystical spirituality struck a chord and were favourably received, especially in those parts of the press where the Symbolists published their criticism and which saw them as falling in with the broad outline of their movement.

The previous year, while he was in Tahiti, a number of the works which Gauguin had left behind in Paris had been loaned to Le Barc de Bouteville for an annual presentation he held of the artists associated with his gallery, and that November, a few days before his own one-man show opened, Gauguin allowed some newer works to be displayed at that year's exhibition. He was keen to ensure that no one should forget his role as chief prophet of the Nabis, though he sent only works done before Tahiti, including his copy of Manet's *Olympia*, in order to preserve the impact that he hoped his more recent pieces would have when the Parisian public could see them for the first time at Durand-Ruel's in the Rue Laffitte.

Oddly enough, Gauguin did not slip back into his former round of café-going and socializing with the Symbolist crowd. Part of this was undoubtedly due to the fact that Mallarmé had taken an extended summer holiday, and it was not until 3 November, only six days before the Durand-Ruel opening, that Gauguin wrote to him tentatively enquiring whether he was again holding his weekly soirées and suggesting he might call round the following Tuesday when he would tell him all about his journey. There is an entry in Henri de Régnier's unpublished diary which confirms Gauguin's presence at the *Mardi* of 7 November, along with Charles Morice, who looked thin and dejected, while Gauguin looked robust and '*marin*', by which Régnier probably meant 'up from the sea', perhaps a reference to Mallarmé's poem 'Air marin. Brise

marine'. According to Régnier, Mallarmé's little talk that evening was about certain châteaux in the forest of Fontainebleau, hardly a subject that Gauguin would have found very gripping. He was now too divorced from Parisian life to find these soirées as impressive as formerly, though his real reason for staying away may have been as much to do with a once-suppressed dislike of all the politicking he had been forced to do, a feeling he was no longer prepared to disguise.

Whatever his reasons, his isolation hardly affected matters, for Morice really was labouring long and hard on his behalf. The popular press was already speculating about the return of this strange artist with his Tahitian 'negresses', a line which hovered dangerously close to the sort of publicity you might expect for a circus. This idea that something wild and barbarous was about to open was played on by Morice whose introduction to the catalogue deliberately emphasized the way Gauguin had gone native, and implied criticism of earlier, more sentimental travellers, especially Loti with his romantic view of the island and its people. By contrast, Gauguin would be offering something more real, more earthy. To back this up, Gauguin produced an especially 'savage'-looking illustration for the catalogue, showing the heads of Hina and Tefatu as they debate the mortality of mankind, two brutally simplified figures, made even more crude by the medium he chose – a wood-block print with the outlines gouged out like the wild marks left by an animal clawing at a door-post. As the opening day approached things began to get frantic. Gauguin wanted only plain white frames, already the accepted method of showing modern art as they deliberately distanced the work from the heavily scrolled and gilded Salon presentations, but completing forty-two of them was proving endless. As October ran on, and the task was still not complete, the decision was taken to delay the opening by five days, until 9 November. At the same time, Gauguin was forced to accept that he would never finish his explanatory book which he had hoped would help people come to terms with the complexities of his canvases. As he had not allowed Morice to put French translations alongside the Tahitian titles in the catalogue, which was already being printed, there was now a real risk that both critics and public would be totally mystified by what they saw.

It may have been this which prompted Morice to dream up what looks like a classic publicity stunt, whereby Gauguin offered to donate his Tahitian religious work, *Ia orana Maria*, to the national contemporary art collection at the Musée du Luxembourg, only to have it, predictably, refused by the curator Léonce Bénédicte, who was about to make himself infamous as the man who turned down the Caillebotte Collection and thus lost France one of the greatest assemblages of Impressionist art imaginable. As Gauguin and Morice no doubt hoped, Bénédicte's refusal

provoked the sort of newsworthy fuss which served to enhance Gauguin's avant-garde credentials.

This, as well as Morice's final spurt of activity, personally contacting all the leading figures in the art world to ensure that they had received their invitations and were planning to come, induced the desired result. Well before the opening time of two o'clock on the afternoon of 9 November, people had already begun to arrive at the gallery in the Rue Laffitte.

## With a Fixed Smile

The sight which greeted them would today be an object of mass pilgrimage. There were forty-two of the sixty-six Tahitian paintings, among them *Ia orana Maria*, *Manao tupapau*, and *Vahine no te tiare*, along with three of the earlier Breton canvases and one of the main woodcarvings, with some of his lesser 'local' pieces dotted about to add to the exotic atmosphere. Not that Gauguin, with his highly individual taste in interior decoration, was entirely satisfied with the overall effect. He had been able to control the colour of his frames, mainly white with the occasional dark-blue or yellow, but had been unable to do anything about the walls of the gallery itself. The strange thing was that, while Durand-Ruel was deeply involved in contemporary art, he had little concern over the interior decoration of his gallery or even his home – his apartment in the Rue de Rome, not far from Mallarmé's, was covered, floor to ceiling, with what are now priceless Impressionist masterworks, yet the setting was typical period bourgeois, the sort of thing Zola had mocked in *The Scramble*. So too the gallery, with its heavy drapes and potted plants, which looked much like the foyer of a moderately grand hotel. Nor were all the spaces particularly well lit: some were inner rooms away from the windows overlooking the street and were illuminated by strange clusters of functional, oil-burning arc-lights, under which Gauguin's already vibrantly coloured works must have shone with a garish intensity.

Most shocking of all, were what were now dubbed the *ti'is*, a variant of the more usual *tikis* or carved wooden figures. There is a photograph, believed to have been taken in the gallery during the exhibition, showing three of them (two must have been added after the opening) – the *Idol with a Shell*, the *Idol with a Pearl*, and one of the Hina and Fatu cylinders – clustered together in a way which still looks brutal and unsettling. What it must have seemed like then, as the elite of the Parisian art world left their carriages in the Rue Laffitte and entered the calm, draped sanctum, to be confronted by these squat barbaric monsters, one can only imagine.

Gauguin stood where he could see and be seen, with Morice at his

side for support – Monfreid, who might otherwise have assumed this role, was still on his travels, thus the only accounts we have of the opening are Gauguin's and Morice's. With two such emotional witnesses, it is hard to arrive at a balanced view of what actually took place. Gauguin was exaggeratedly disappointed and Morice took his cue from this, thus adding to the general feeling that all had gone wrong. That Gauguin was dressed even more aggressively than usual, in a dark blue flowing cape with flamboyant metal clasp, over loudly checked trousers and with a pleated astrakhan hat on his head, would imply that he was out to face down the world with his boldness. If so, then it was a pose calculated to provoke confrontation. He nurtured such high expectations for the show that anything short of total adulation was bound to disappoint him. By any objective judgement reactions were excellent, certainly from among the Symbolist writers and critics who rallied as before – Octave Mirbeau in *L'Echo de Paris* and Félix Fénéon in *La Revue Anarchiste*. And if controversy is any guide, then he could hardly complain when the anti-Semitic journal *La Libre Parole* attacked the work and referred to Morice as an 'Israelite', its worst insult.

The problem was that Gauguin had expected the writers to support him, while what he really wanted most was the wholehearted approval of his fellow artists. One must remember that this was what had always eluded him. He had been the latecomer to Impressionism, the wealthy collector who had bought his way into the charmed circle. With rumours about his shabby treatment of Van Gogh circulating within the art world, Gauguin felt more an outsider than ever. As he watched the first arrivals enter the gallery, he was in fact feeling raw and vulnerable.

He might have expected some opposition, especially from the older generation – Monet and Renoir were never going to like what he was doing, though he seems to have been hurt when the ever kindly Pissarro came up and started telling him that such subjects did not belong to him and that as a civilized man his function was to show harmonious things. However, this was hardly the general reaction and there was little cause for Gauguin's comment that 'the critics howled before my canvases, saying they were too dense, too non-dimensional,' when in truth they did no such thing. It was not the flatness nor the vivid and unusual colour combinations which shocked the reviewers – the exhibitions of the Nabis at Le Barc de Bouteville's gallery had proved very popular and Gauguin's work was far less two-dimensional than theirs. What did irritate the more thoughtful writers was the suspicion that Gauguin had been using Tahiti, its people and their culture, to buck up his work with a little sex and exoticism. The most thoughtful expression of these doubts was given in an article by the writer Thadée Natanson in *La Revue Blanche*, in which he pointed out that despite the exotic settings, the

Tahitian paintings were often based on easily traceable Western sources. Natanson gently suggested that Gauguin had best do away with these if he really wanted to achieve something new. This seems to have been the basis for most of the informed criticism of the exhibition, and left the impression that the Tahitian titles and Gauguin's explanations were a smokescreen, which should be abandoned, so that one might judge the works purely by what one could see. This view took its strongest, least forgiving form, in Pissarro's hurtful remark that Gauguin was now 'stealing from the savages of Oceania', implying, by extension, that he was no longer stealing from Pissarro himself.

Standing in the gallery with Morice, Gauguin quickly saw that he was not going to enjoy the unalloyed adulation of his peers and the pain of that realization must have been hard to bear. Morice, who was watching his every move, wrote: 'The fear which clutched his heart at that moment can easily be imagined.' But he was not the man to show it and, as Morice rather proudly noted, 'as soon as he realized that they were judging him without troubling to study and discuss his art, he adopted an air of supreme indifference, smiling without betraying the effort which it cost him, quietly asking his friends their impressions and discussing their replies coolly and dispassionately without a trace of bitterness.'

This image of Gauguin, with a fixed smile on his face, is one we should retain, for there can be no doubting the effort involved. It was true that his motives in Tahiti had been confused – how could they have been otherwise – he was a child of his time, born into an age that had barely begun to analyze its reactions to other peoples and cultures. There was also a degree of self-serving about his exploitation of Tahitian themes and a good dollop of self-publicity about the way he knowingly chose the shocking and the outrageous. But even Pissarro must have been able to sense that that was not all there was and that one of the most fascinating things about Gauguin's new paintings was the way such 'Western' obsessions existed in tension with the more profound things which he had experienced on the island. Gauguin had gone to Polynesia uniquely equipped to embrace it; he was not fully Western in outlook, yet he had enough of so-called civilization about him to be able to act as a litmus when confronted with the 'Delicious Land'. What he had brought back was the result of one man's not entirely successful struggle to purge himself of the vices of sophistication and his equally confused attempt to plunge into another culture, which was itself terribly damaged by those same vices. In this sense, Gauguin was not the artist-hero bravely facing new challenges as his supporters tended to depict him, rather he was Everyman, stumbling on his pilgrimage, yet still striving to reach his battered, imperfect vision. By contrast, it was Pissarro who was stuck in the past. His last adventure had been to dabble in Seurat's dots, since

when he had returned to his former Impressionist style and would devote his final years to the patient but repetitious reworking of the same scenes in Paris and Rouen. One is left with the thought that if he had had enough verve left in him to see the positive side of what Gauguin had done his own work might have benefited. For all Gauguin's confusions, his ungrammatical and confusing titles, his invented mythology based on a half-understood fantasy, he had still succeeded in adding a dimension to European art which had never been so fully expressed before. Those Western artists who had visited other cultures had imposed their own classical vision on them. Only rarely had there been an example like Delacroix in North Africa, but even then one can hardly claim that Delacroix drew much from Arab culture save for his vivid colours and backgrounds. Gauguin alone had attempted to penetrate what he imagined might be the inner world of those amongst whom he was living. One has to emphasize 'imagined', for how else was such a thing to be achieved, if not through art and its fictions? An anthropologist or ethnographer might have been more exact about the details but could never have communicated the sensation of how such things might really have been. Of course Gauguin's motives were impure and his results patchy but then he was doing that most difficult of all things – not learning, but unlearning! And while he could be criticized for failing to fully create a Tahitian culture, he was surely to be praised for the extent to which he had cast off the shackles of a European past.

Only one person cheered him up, and he the least likely of all. While he might have expected Pissarro to be at least superficially supportive and had been hurt when he was not, Gauguin could hardly have expected kindness from the sharp-tongued Degas. Surprisingly, on this occasion, he got it. Degas was never totally sure of Gauguin but he knew there was something there and backed up his hunch by occasionally buying his work. He had not been much struck by the first arrivals from Tahiti, which had been briefly displayed by Maurice Joyant, before his departure from Boussod et Valadon, but now, confronted with the full range of what Gauguin had been doing, Degas saw much more reason for support and gave it and said so. He then backed this up by purchasing two of the major paintings: *Hina Tefatou* and *Te faaturuma*. Charles Morice noted that Gauguin showed no emotion as he accompanied Degas to the door and listened to his final words of praise, but that as the older man was leaving, Gauguin suddenly reached for the carved 'Marquesan' walking stick hanging near the entrance and, in a spontaneous display of gratitude, handed it to him with the words: 'Monsieur Degas you have forgotten your cane.'

## Picking up the Pieces

Over the following months, articles and reviews continued to appear, several of them exceptionally sympathetic and perceptive, most notably Achille Delaroche in *L'Ermitage*, who dismissed the business of whether Gauguin had or had not accurately represented Tahiti and its inhabitants and concentrated instead on the inner mystery of the works, commenting on how they seemed to exist at 'the wavering threshold of the conscious and the unconscious', and could be seen as 'resolving the paradox of the sensory and intellectual worlds'.

This was just what Gauguin wanted to read, and despite his grumbles, he went on snipping out the more favourable reviews and pasting them into his *Cahier pour Aline*, against the day when he would present her with this evidence of her father's success. Even sales were not as bad as Gauguin maintained. A quarter of the works on offer were eventually bought, which compares well with similar exhibitions of progressive work at the time. But that cannot alter the fact that Gauguin believed he had failed and that his failure was due mainly to a general incomprehension of what the paintings were all about. As a result, two ideas began to take shape – first, that he still needed to make more money and second, that he would have to find some means of educating the public about his Tahitian adventure. It was at this point that Charles Morice played his most crucial role. The two men often met during the month-long run of the exhibition. Gauguin would turn up at the gallery to talk with reviewers or potential patrons while Morice would be there to offer support. There seems little reason to doubt Morice's claim that it was at one of these gallery encounters that he suggested to Gauguin that they should make the book they were planning more than just a diary of his Tahitian travels with a few notes on the paintings. They should produce something as startling as *The Marriage of Loti*, and, it went without saying, something equally profitable, a book that would be both a work of art and a best-seller.

Confusion was built into the project from that moment on. They seem to have vaguely dreamed up the idea of writing a work of fiction, a sort of novel, without admitting this to themselves. Though in doing so, they were actually close to Gauguin's normal working method with his paintings: he was to try to use his real experiences, for which he already had a few notes, but he was then to expand them as his imagination saw fit. Precisely what Morice was expected to do seems never to have been defined, except for a role as a sort of sub-editor, tidying up Gauguin's final manuscript.

We can tell that when Gauguin began this new set of notes he was determined that they should be as full as possible – the earlier parts are

completely fleshed out and required little intervention by Morice. These first sections are a re-run of his actual early experiences which he probably began noting down on Tahiti – his arrival, the death and funeral of Pomare v, his move to Mataiea and the episode with Titi. But from then on he begins to follow what was probably Morice's scheme of loosening up on fact and adding in elements of Tahitian mythology and folklore, and romanticizing his adventures, especially the sexual ones, in order to make the book more appealing.

Despite this, he still appears at this early stage to be drawing on his own experiences. The encounter with Jotefa and the episode in the mountains is recounted early on and its detail and frankness indicate that it is a revelation, if not of an actual event, then at least of true emotions experienced by Gauguin and clearly of great significance to him. Indeed, it was a phrase from this episode which gave the book its name: 'From all this youth, from this perfect harmony with the nature which surrounded us, there emanated a beauty, a fragrance (*noa noa*) that enchanted my artist soul.'

Thus Noa Noa – scented or fragrant or even perfumed – it became and he may well have shown the manuscript to Morice at this point, for the very next episode has all the hallmarks of having been put in to counterbalance the rather discomforting homoeroticism of the Jotefa experience. This is an account of Gauguin's solitary journey up the valley of the Punaruu, where he encounters a semi-naked woman, drinking at the waterfall – a far more 'macho' adventure and one in line with the theme of Gauguin the hero-artist bravely going where no man had gone before, which Morice may have wanted the book to portray.

Gauguin might have resisted this dubious line had he not wearied of the task. As November passed into December, and the work failed to make much progress, Gauguin gradually pushed more and more of the writing Morice's way. At the same time the poet began to see the possibility of a joint work in which he would share equal billing with the increasingly famous, or at least notorious artist, a collaboration which might help restore a reputation badly damaged by his theatrical flop.

After the Jotefa episode, the writing becomes noticeably less complete, on occasions nothing more than a few loose notes or the title of one of the paintings meant to guide Morice in a certain direction, but leaving the actual description of the event to him. At the same time, urged to be romantic and less factual, Gauguin began to lean more and more on the only model he had, *The Marriage of Loti*, the very book they were supposed to be surpassing. This becomes most apparent in the main core of Gauguin's notes which concentrate on his love affair with Teha'amana and which now merges fact and Loti-esque fantasy in a way which finally leaves reality aside.

In Loti, Rarahu comes from the island of Bora-Bora, Teha'amana according to Gauguin came from Tonga, or, as we may assume, Rarotonga. Loti's novel contains long, languid descriptions of Rarahu's physical charms – especially her skin and her bosom, as now does Gauguin's account. Grant's marriage was arranged at the prompting of older women, precisely what happens to Teha'amana and Gauguin. When Grant marries Rarahu his name is changed to Loti, in Gauguin's case the natives rename him Koke, the nearest they can get to Gauguin. Loti spends much time contemplating the differences between his culture and that of his little savage until the day comes when he has to sail away leaving his child-bride on the shore – Gauguin, in his story, does much the same.

None of this might have mattered, except that Gauguin already possessed an ideal illustration for this by now fictional love affair – *Manao tupapau*, with its provocatively posed girl who could well have been thirteen, and whom he now worked into his story as if she were Teha'amana and as if the painting were a real episode from his life on the island. Thus Gauguin ensured that his future readers would believe that he had gone one better than his predecessor Loti, that he had succeeded in conducting a love-affair with a simple thirteen-year-old child-bride.

To the contemporary mind, it seems barely credible that anyone would wish to saddle himself with such a reputation, but to the male public of the late nineteenth century, this was heroic stuff.

Gauguin had certainly fulfilled his side of the bargain in jazzing up his manuscript and after the *Manao tupapau* episode, his interest seems to have waned. He added two further anecdotes and an intemperate attack on 'the negro Lacascade' which Morice dropped when he got down to rewriting the notes and adding in his poems. All this has simply served to confuse succeeding generations of art historians. Even today, books appear in which criticism of *Manao tupapau* is largely based on the assumption that it is a real account of an actual event, instead of being a confused mixture of fiction and sexual fantasy. Even the previously cavalier Morice seems to have had second thoughts when he finally received the notes, perhaps realizing that the sources Gauguin had drawn on were a trifle too visible for comfort, laying them open to a charge of plagiarism. To deflect this, Gauguin included a section in which he claims that it was Teha'amana who told him the stories of the old Tahitian religion: 'She learns from me, I learn from her . . . . In bed, at nightfall, conversations.'

Of course, this was nonsense. By then, only a handful of very old Tahitians had any knowledge of the former religion. A young woman like Teha'amana would have known little more than folk-tales about

*tupapaus*, but this was clearly meant to stay any accusation that Gauguin had simply copied Moerenhout.

Similarly with Loti, it may well have been Morice who suggested they should change the name of Gauguin's 'bride' as there is a minor character called Tehemana in Loti's book, and while she only appears briefly, Morice may have feared that that was yet one more connection they had best avoid. Whatever the reason, Gauguin agreed to change the name of his *vahine* for the final book from Tehamana to Tehura, presumably after the girl he called Tehora that he and Jénot had known in Papeete. This slight change has caused extraordinary problems for Gauguin scholars who have tried to use both the book and the paintings as sources of information on his life. If you study the paintings and Gauguin's notes you have Tehamana, if you turn to the final *Noa Noa* you have Tehura. The result has been that no two books on Gauguin quite agree as to what he was doing or who he was with during that first stay on Tahiti. If mystery was what he had hoped to achieve, then he has certainly succeeded.

As if this was not bad enough, the situation was compounded by the division which opened between Gauguin and Morice as the work progressed. Gauguin finished his expanded notes quite quickly, though he seems to have written three more folk-tales over the coming year which he passed on to Morice, to be fitted into the text where appropriate. But Morice, burdened with the need to earn money from journalism, took for ever to produce even a fraction of what was needed to complete a book and in the end Gauguin had to leave Paris with only a first draft from Morice and the promise that he would get the final version as soon as possible. He never did, and a long and acrimonious correspondence ensued, which ended with Morice publishing a version of the book which Gauguin had never seen nor approved. Gauguin saw part of it when it was serialized in a magazine but he was not to know that Morice produced yet another version and published that too, all without any further input from the supposed author. After Gauguin's death, his friends took the work out of Morice's hands and attempts were made to publish 'cleaned-up' versions, usually by dropping Morice's verse, no great loss, but still not really the book that Gauguin had once imagined. In fact there is good reason to believe that he would not have disapproved entirely of what the poet had done, for it was in essence what had been asked of him.

In the light of all this, it would be reasonable to assume that if one went back to Gauguin's notes – not the first Tahitian jottings, if they did exist they are lost, but the worked-up version he gave to Morice – then one would be as near as possible to the truth of what happened on the island. But here too, things proved difficult. When Morice realized

that he was being expunged from *Noa Noa*, he kept quiet about the original notes lest they be resurrected as the genuine article, and all his labours finally discarded. He hung on to them until 1908, when poverty forced him to sell them to a print dealer Edmond Sagot, who, perhaps as a condition of sale, hid them away for the rest of his life. They only resurfaced in 1954, when Sagot's heirs published them in a facsimile edition, though even then there were several missing pages which Morice had either lost or disposed of in other ways. Of course by 1954, much of the damage had been done, with Gauguin's life-story written and copied and rewritten dozens of times, on the basis of the various Morice versions. But since the notes have appeared the situation has only marginally improved. True, they are clearer and more readable than anything Morice produced – proving if nothing else that Gauguin was wrong in believing that he needed a ghost writer. But no, they are not a spotless version of the truth, there are still the borrowings from Moerenhout and Loti, still Gauguin's boastings about his sexual exploits, and in addition there is the fascinating afterthought when he launches into his totally gratuitous attack on Governor Lacascade, a petty act of spite, quite out of tune with what had gone before. What is important are marvellous details which the nervous Morice clearly censored, in particular the episode with Jotefa on the mountainside, where the removal of a few key sentences was enough to completely expunge the true extent of Gauguin's admission of homoerotic feelings.

By returning to the original notes, we do not totally rewrite the story of Gauguin's first stay on the island, but there is a subtle and important change of emphasis away from the bragging paedolphile with his child-bride and his White explorer mentality. What emerges is in some ways less clear-cut, more confusing but certainly far more intriguing. It also liberates the paintings from being mere narrative sign-posts and allows us to see them in new ways.

Overall, *Noa Noa* has probably done Gauguin's posthumous reputation more harm than good. He certainly knew it would be taken as a record of his life on Tahiti but thought that such myth-making could only add lustre to his art. He was not to know that later generations would find this behaviour less amusing. Which is sad, both for him and the book.

Nevertheless, what has survived somehow transcends its confused origins. Despite the borrowings from Moerenhout and Loti, the book does not plagiarize them, for in the end Gauguin used these sources much as he drew on photographs and other paintings in order to create a new art of his own. More than that, his original intention was to create something beyond a simple book, by working into the text visual material that would not exactly illustrate but would complement and

move beyond the narrative framework, something ultimately, entirely original. This, however, he was to do later, while Morice was left to complete the text.

## The Rue Vercingétorix

In the wake of the exhibition, the time-consuming and apparently unrewarding business of framing, hanging and selling his pictures remained very much at the forefront of Gauguin's thinking. It was clear that he had been only reluctantly accepted by Durand-Ruel and that he needed some way to both show and explain his paintings, which was impossible at the gallery even though he often turned up to see if anyone wanted to talk to him.

A new dealer, Ambroise Vollard, had opened a gallery at 6 rue Laffitte, ten doors from Durand-Ruel, and was sniffing around for new artists but Gauguin was not hopeful, despite Vollard's overtures and the fact that both men had much in common. Vollard had been born on the Indian Ocean island of La Réunion, and had, though he denied them, similarly mixed racial origins to Gauguin – Gertrude Stein later described him as a 'great tall black man with a melancholy expression.' The familiar portraits show a slim, bearded aesthete where photographs reveal a stocky bull-like figure, much more in character with the wheeler-dealer tradesman who was to build one of the most successful contemporary art businesses in France out of virtually nothing. At home on La Réunion he had been destined for medicine but having fainted at the sight of his first blood-stained surgeon, he was allowed to go to Paris to see what might suit him better. Drifting about, ostensibly studying Law, the young man began to collect cheap prints and engravings from stalls and shops and was soon absorbing the rudiments of buying and selling art. A brief period as an unpaid assistant in what was fancifully called the Union Artistique, a gallery owned and run by the painter Alphonse Dumas, largely as a means of selling his own work, led to the backing of a small investor and the opening of Vollard's own modest little gallery, that December of 1893. But the tall dark man was not yet ready to become the most adventurous dealer in the Paris art world, the legendary figure who would back Cézanne then, later, Picasso and Matisse. Desperately in need of money himself, all that the new gallery owner could hope to do was poach from longer-established dealers like Durand-Ruel, by exhibiting those of his artists who were beginning to be in demand. His opening show was a safe selection of Impressionists, and while he was happy to include several by Gauguin, those Vollard chose were from the acceptable early period when he was under the influence of Pissarro. While Gauguin was happy to be exhibited, and not averse to Vollard

acting as his dealer if he so wished, this did little to resolve the problem
of how best to present and explain his most recent paintings and at some
point he conceived the idea that he might well undertake the task himself,
by finding a space where he could both work and show his paintings
while being on hand to discuss them with anyone who was interested
enough to visit. The opportunity to realize the plan came when his
landlord Delaune offered him the use of a much larger studio he had
built in an open courtyard at 6 rue Vercingétorix, back across the
Boulevard du Montparnasse, past the cemetery, not far from where
Gauguin had lived before. This area, south of the Gare Montparnasse,
was already a thriving artists' colony. There were studios in the neigh-
bouring Rue Vandamme and several had been built along the Rue Ver-
cingétorix, then a somewhat seedy working-class area. Number six was
on the corner with the Avenue, then called the Chaussée du Maine, on
a piece of land Delaune had acquired which lay behind a high wall beside
an abattoir. There was an unprepossessing yard with a sickly tree and
stacks of stone abandoned by a sculptor, at the far end of which Delaune
had built a large, two-storey shed out of sections of the pavilions sold
off after the closure of the Exposition Universelle of 1889. This inevi-
tably meant that the spaces were somewhat ramshackle, ranging from a
high one-room workshop on the ground floor with smaller rooms along-
side, with an upper floor reached by an external wooden staircase which
went up from the yard to an outside veranda which ran the length of
this second level. It was this eyrie which was offered to Gauguin, who
moved in, early in the new year 1894.

Within a week he transformed the place into a glowing exotic fantasy,
covering most of the walls with cheap plain chrome yellow paper with
a saffron border at 4 sous a roll, then painting over the high west-facing
window with the same yellow, so that the vast space seemed to glow
with an intense, sunny light. This was enhanced by paintings like *The
Yellow Christ* and *The Loss of Virginity* and others which he retrieved from
the various caches he had left with Monfreid and Schuffenecker. When
he finally received the remaining Tahitian paintings from the Durand-
Ruel exhibition, he decided that the plain white frames were one of
the reasons for the lack of sales and brightened them up with bands of
jollier colours, before they too went up on the yellow walls, along with
surviving pieces from his former collection, principal amongst which was
Cézanne's *Still Life with Apples*.

The furniture, including a battered Louis-Philippe sofa and an upright
piano, was hastily acquired from flea-markets, while the newly-returned
Monfreid lent some rugs. The bedroom, a small space to the left of the
entrance, was dominated by a fireplace and furnished with an iron bed.
Aside from the paintings there was the usual clutter of photographs and

postcards and all the curios he had collected on Tahiti – boomerangs
and carved sticks – now joined by an odd selection of things he had
inherited from Uncle Zizi, who seems to have shared the family's mania
for acquisition, including a collection of shells displayed in a cabinet and
a bell-jar under which was a miniature tree with a tiny humming bird
on each branch. As in Tahiti, Gauguin painted the glass panel of the
main door from the exterior veranda, and on it he placed the words *Te
faruru* (here one makes love.) To step through was to move into a wash
of yellow light emanating from the walls and paintings. Once inside, the
visitor was transported away from the grey city below into the exotic
paradise of Gauguin's imagination – or so it seemed to one of the more
frequent callers, Judith, the teenage daughter of a sculptress who lived
in the studio below, and who later described the impression of art and
magic which that room and its creator seemed to radiate 'like a source
of interior light'.

## The Little Girl and the Tupapau

Even those few words are enough to convey that their author was in
love with the 45-year-old artist. Just approaching thirteen when Gauguin
came into her life, Judith was at that point when a great passion, à la
Flora Tristan, was bound to happen – she had only recently become
aware that her bust was now attracting attention. It was a fateful encoun-
ter, though it is probable that Gauguin was, initially at least, more inter-
ested in her family in the studio below. The Molards kept what was
effectively a salon, mainly for composers, and the atmosphere in the
Rue Vercingétorix was friendly and amusing from the moment Gauguin
arrived.

Judith's mother, Ida Ericson-Molard, was Swedish, a sculptor, then
aged forty. Hers had been a difficult life, having been born into a poor
family, and she had had to struggle to maintain herself at the Academy
of Arts in Stockholm, working as a maid in a theatre to pay her way.
This was how she came to have an affair with Fritz Arlberg, by then
more a great drinker than a great opera singer, but she was happy to bear
his child, Judith, even when the scandal led to the loss of a scholarship to
Paris. She went anyway and eventually settled there, marrying the much
younger William Molard who agreed to adopt Judith and become her
father. Molard's mother was Norwegian, his father French. He was a
composer, though lack of sponsorship obliged him to work as a clerk in
the Ministry of Agriculture. His operatic version of *Hamlet* had already
had a performance in Paris, but today his entire output has disappeared
and it is impossible to judge his work save to note that some of the most
interesting people in contemporary music – Ravel, Grieg, even the shy

Debussy – were happy to come to his Saturday reunions at the studio in the Rue Vercingétorix.

The Molards had decided on the studio even before Delaune had finished assembling the structure, so that Ida was able to specify that no interior partitions be put into the large downstairs space, allowing her to have a studio, kitchen and salon all in one and was thus never forced to be absent when there were guests. Inevitably, this was less satisfactory for a teenage girl, who had to sleep behind a screen and who hated this lack of privacy at a time when she wished to have secrets of her own. Judith's account of life in the studio bristles with details of a somewhat claustrophobic existence, describing the rows initiated by the jealous Ida, who was ever watchful where her handsome young husband was concerned. According to Judith, her mother had a passion for helping strays – she was often accused of stealing their pets by angry owners – so it was hardly surprising that she immediately latched on to Gauguin and began inviting him downstairs for meals. It was also perfectly predictable that Judith would fall hopelessly in love with him. We know all about it from her touching, biased, yet beautifully written account, which she set down some fifty-six years later, when she was sixty-eight, and able to look back on those days with a wry honesty that even allowed her to reveal her own adolescent harshness towards her mother and stepfather.

Where others described Ida as small, blonde and plump, Judith writes of her as being lively and coquettish; claiming that Gauguin was unable to make a portrait of her, as there can have been nothing to inspire him in her hair: 'the colour of a washcloth, curled with a curling iron and ruffled into a cloud around a nondescript little face, where only the square nose like that of Madame de Sévigné provided some solidity.'

Molard fares even worse in her memoirs, being depicted as little more than a cringing lap-dog in the presence of the all-commanding God-like Gauguin. 'I could not do anything but gather up my store of admiration, devotion and tenderness and carry it to someone before whose feet I deposited it. I was prepared. Gauguin would come. And Gauguin came.'

This paragon was invited down one night with Monfreid, a few days later the Molards with their daughter were invited up for the first of what were to be regular Thursday night soirées, Gauguin's version of Mallarmé's Tuesdays but certainly far jollier and less self-consciously intellectual. There were cakes and tea and Judith drank in the exotic decoration which had been so hastily assembled and tried to figure out who was who amongst the artists and 'scribblers' who made up the guests.

It was the first of many such evenings but they were only the formal side of her encounters with the new beloved, for whenever she was able

to escape the watchful eye of her mother, Judith would hang about on the staircase, reciting love poems to herself, waiting until Gauguin appeared to let her into his studio where she would sit, in total silence so that he could get on with his work. Of course, in Judith's eyes his way of working was utterly perfect, his 'beautiful ... sensitive, sensual hands ... did not abuse the material, when he was carving, nor did he appear to be in the throes of inspiration when he was painting. His mouth would be slightly open, his eyes steadily focused as he applied his paint quietly and slowly.'

Judith leaves her readers in no doubt that Gauguin had only to reach out and she would have given herself to him. She happily let him take her into his arms and was delirious whenever he chose to touch her: even though she loathed her stepfather for trying to do the same thing when her mother was not looking. Gauguin, however, was no dirty old man, he was love itself:

> Without the slightest surprise I let his beautiful plump hands caress the recent roundness as if they were caressing a clay pot or a wooden sculpture.
> 'These, these are mine?'
> Of course they were his, but I could only remain silent.

But that was all. Gauguin was perfectly content with the knowledge of his power and went no further, despite every invitation to do so. And Judith was no fool; even for one so young, she was able to perceive what she must really mean to him, guessing that he saw in her 'a surrogate daughter on whom he could lavish his excess tenderness'.

Judith was as Aline had been when he last saw her and he gave this surrogate daughter a portrait of Clovis, who was by then the same age as she was and with the same blond hair. There is no doubt that he was thinking of Aline when he looked at her and the temptation must have been exquisite – the pubescent Judith at the same magical age of thirteen as Aline had been when he had last seen her; this openly loving desirable nymph forever trying to snatch a kiss. Judith would look at him adoringly when he came to her bed with herb tea when she was sick. That bed, behind a screen in the large downstairs room, was so placed that she was obliged to hear the man she refused to call father, arguing with her mother, both of them suspicious of what Gauguin was up to, little knowing that the temptation was resisted because she was as precious as Aline to him.

On the surface they were all friends – Molard posed for Gauguin while he in turn posed for Ida. But if Molard lingered too long upstairs, his wife would be consumed with jealousy, convinced that he was listening to Gauguin's tales of his 'negresses,' his dusky Tahitian women. Who can wonder that the girl could only wait for the moment when

she could tiptoe up the balcony and into the yellow room to be alone with him, always hoping that he would relent a little and cuddle her and stroke her as she so desired:

> I walk quietly to Gauguin, his arm steals around my waist, and he puts his hand like a shell on my budding breast. His husky voice, barely audible repeats, 'These are mine . . . .'
> Of course they are his, his tenderness, my young feelings which have not yet been aroused, my whole soul. Standing on my tiptoes, I search for his cheek. It is his mouth that I meet. My whole soul is on my lips, he can take it away.

So pure, so generous was this passion, that even when Gauguin entertained other women, the angelic Judith saw nothing to criticize. Juliette Huet called from time to time but Judith's feelings for Gauguin were so divorced from reality she barely noticed. Years later, when she wrote up her memoir of their life in the Rue Vercingétorix, she entitled it *The Young Girl and the Tupapau* – as if she were the trembling figure on the bed in the darkened hut and he were the watching ghost.

This account by Judith has become the accepted record of Gauguin's life in the Rue Vercingétorix studio but in 1993 the Swedish historian Thomas Millroth published his research into the Molard circle which gives a more balanced impression of these fascinating characters. According to Millroth, Ida was far less hidebound than her daughter allows, for when Gauguin asked if he might paint Judith's portrait, Ida agreed, even though the girl would be alone with the older man for a considerable amount of time. It was only when she called in on the upstairs studio that Ida changed her mind – her daughter was posed naked for a full-length portrait and while there seemed to be nothing more to this than art, the woman was understandably angry that her goodwill had been pushed to the limit and the sessions were terminated. However, they were soon friends again and Ida even allowed Judith to go up and have painting lessons. But there were to be no more thoughts of nude portraits.

## Annah the Javanese

It was not long before Gauguin had a new mistress, found for him by his new dealer, Ambroise Vollard, who later claimed to have offered her to the artist as a model – probably to mask the fact that he had not been above acting as a pander in order to ingratiate himself with someone whose work he wished to handle. Vollard's account of the girl's background may be somewhat fanciful, but the arrogant tone of the piece sounds correct. Annah, as they called her, seems to have been little more

than an object to those who possessed her. According to Vollard, an opera singer called Nina Pack had a friend who was a rich banker with contacts in Malaya, to one of whom the singer happened to let drop that she would love to have a little negro girl. A few months later a policeman turned up at her door with 'a young half-breed, half-Indian, half-Malayan' who had been found wandering about the Gare de Lyon with a label hung round her neck reading *Mme Nina Pack, rue de la Rochefoucauld, à Paris. Envoi de Java.* According to Vollard she was given the name 'Annah the Javanese', after the place she was said to have been sent from. Even if one doubts the details, it is still quite clear that Annah was not unlike many Third World women today in being sent off for unpaid domestic service – or other services – with little say in the matter. Something, however, went wrong. Annah was turned out by Mme Pack and went to ask Vollard's help, because she had met him at the singer's house. According to Vollard, he decided that she would have more chance as a model than as a housemaid and proposed her to Gauguin, who, in Vollard's damning words, 'decided to keep her'.

Annah was very dark and very small with prominent eyes which look out fiercely from her photographs. She seems to have been good fun – dressing up for party games in a Breton coif and showing off in elegant dresses with fashionable mutton-chop sleeves. Her vivacity was probably a manifestation of an inherent wildness, for Annah, despite her difficult position, was nobody's slave, she had a mind of her own and was potentially dangerous – all of which must have made her very attractive to her new 'owner'. She arrived with a monkey called Taoa, whose provenance is unknown, but who along with his mistress added immensely to the general carnival atmosphere at 6 rue Vercingétorix. Certainly the adoring, infatuated Judith accepted these new arrivals in that light, being as uncritical of Annah as she was of the monkey; they were simply something new which her beloved had added to his collection – which in an awful way was not far from the truth. At school one of Judith's friends tried to explain that Annah was Gauguin's mistress but the infatuated girl was not sure – when she found Annah in Gauguin's bed one day, she assumed that it was because the poor woman was sick and it was all so that 'the doctor doesn't have to climb the stairs to the balcony. And besides, *it was during the day.*'

Gauguin, of course, claimed that Annah was thirteen – the mystical age which seems to have represented for him the hallowed point when a girl became a woman, rather than any very precise chronological moment. Certainly, in common with many South East Asians, Annah had the good fortune to look ageless: judging from her face alone, she could have been anything from twelve to twenty-eight, but in the nude portrait of her which Gauguin painted, the fullness of her breasts and

the spread of her pubic hair suggest someone far older than thirteen – more like twenty, at a rough guess.

According to Thomas Millroth, the true story of the portrait unveils a series of double meanings. Millroth had access to the private archive of a friend of Judith, which revealed how Gauguin had taken the half-finished canvas that had been abandoned on Ida Molard's insistence, and how he painted over it and began another nude, this time Annah. He posed her, front-on, seated in a large arm-chair with a rounded back and with carved figures, like Polynesian *tikis*, for arms. She is supremely self-confident, staring back at the viewer with total assurance, and in this regard, the painting is much more Gauguin's *Olympia* than his copy of Manet's original. Just as Victorine Meurent in her role as Olympia refuses to act the role of the cowed and submissive *fille de joie* awaiting her lover or her next client, so Annah, despite her nakedness, has all the bearing of a queen on a throne. The similarities between the two paintings are reinforced by the presence of the monkey at Annah's feet, which corresponds to the black cat in the Manet. The monkey Taoa also stares indifferently away, out of the side of the canvas, confirming the impression that the real subject of the work is poise and insouciance. Given Vollard's arrogant description of Annah's provenance, it says much about Gauguin's ability to see beyond the usual cultural and racial stereotypes to a truer perception of the individual he had before him.

At the same time, the work is also highly imaginative – the pink wall behind Anna is invented, the walls of the studio being chrome yellow, while the skirting-board has a curious pattern of white on black squares that look like stylized letters. The chair is similarly invented, with some suggestions of the sort of furniture made for visitors to 'primitive' cultures – one thinks of Sarah Bernhardt's Maori buffet. The final effect is of a placeless, timeless scene, neither East nor West, North nor South, not a bad metaphor for Gauguin's curiously suspended existence in the Rue Vercingétorix.

It is also true that Annah is not quite Annah – she does not quite resemble her photographs and there is good cause to believe that Gauguin slightly modified her appearance so as to work in some resemblance to his original model Judith. This notion is reinforced by the title he eventually gave the painting: *Aita tamari vahine Judith te parari*, this time using the Tahitian to deliberately ensure that no one, especially the Molards, would understand the meaning, which can be translated as: 'The Child-woman Judith is not yet breached.' If nothing else, this at least confirms Judith's assertion that he did no more than kiss and fondle her. Though the strangest thing of all, according to Thomas Millroth, is the way the vague forms of the original portrait of the nude

girl can still be discerned under the pink wall to the right of the canvas, as if Annah is being watched over by the ghostly presence of the obliterated Judith.

## Party Time

So Annah the Javanese became a regular feature at meal times at the Crémerie and at Gauguin's soirées in the studio. And very wild she must have seemed, with her penchant for staring back at anyone she presumed was staring at her, and for pulling faces and sticking out her tongue at those who displeased her. The main guests at Gauguin's evenings were initially his usual supporters – Monfreid with Annette, Morice and his Countess and the Schuffeneckers who, Judith notes, embarrassed everyone with their marital squabbles. Louise Schuffenecker would exclaim in her shrill voice that her husband was an imbecile and Judith noted that while nobody doubted this, it was still painful to hear it repeated in his presence.

This first group were soon joined by younger disciples and then by a long list of names which begins to read like one of those confusing and slightly irritating social reports in fashionable magazines – names one has heard of but which conjure up no image of the person or his or her work. Many seem simply to have been there but to have had little effect on anything. Later, they would write their memoirs and recall their evenings with Gauguin, as if it had all been very important, yet only a handful made any impression on his life. One who did, was the odd-ball Paco Durrio, who looked at first as if he would be no more than just another amusing hanger-on, but who later would play an important role in Gauguin's story. 'Small, plump and inquisitive', as someone described him, Durrio had come to Paris from Bilbao in 1892 to study sculpture, with the help of a rich Spanish family who wanted him to create a mausoleum for them. For a time the young man produced sketches and models for this grandiose project, much influenced by ancient Egyptian temples and the sculptures of Angkor Wat, but after meeting up with Gauguin he abandoned monumental ideas in favour of ceramics and jewellery. Durrio was probably living at the Crémerie when they met and from the start Gauguin seems to have treated him like a faithful puppy. He seems always to have worn the same clothes: a labourer's blue outfit with high-heeled yellow boots and as time went by his moustaches grew and grew until they became a pronounced feature on one so small. His strengths were personal – he was exceptionally generous, as a new generation of struggling artists, amongst them Picasso, was later to find. Best of all, he was fanatically loyal, a trait which was to do much for the future fame of his so-called teacher, Paul Gauguin.

While Durrio played his guitar and sang plaintive Spanish songs, a more serious role fell to another newcomer, Julien Leclercq, a young poet who was hardly out of Gauguin's presence during the early months of 1894. We can see him taking part in the charades and other games that were a feature of evenings in the studio, some of which were recorded with a large box camera on a tall tripod, which Gauguin had acquired. Like Molard, Leclercq had the sort of raffish Bohemian good looks which enabled him to play the role of lady's man, though, as with her stepfather, Judith disliked Leclercq intensely. She was not alone in this, as many thought he was manipulative, always using his charm to advance himself. Although he had been on the fringes of the Gauguin circle since before the first departure for Tahiti little is known about him save that he was born in Armentières near Lille in northern France in 1865 and that he was one of the countless young hopefuls who drifted to Paris to churn out a string of poems, novels, plays and reviews, few of which ever got published. When he met Gauguin, Leclercq had published a slim volume of verse: *Strophes d'Amant*, which had appeared in 1891 to a less than enthusiastic reception from the few critics who noticed it. Even if he had not died young, in 1901, aged only thirty-six, it is unlikely that Leclercq would ever have been more than a friend of the famous. He is sometimes wrongly assumed to have been one of the two Leclercq brothers who founded the famous symbolist journal *La Revue Blanche*, presumably because he hung around Symbolist circles and because his friend Gauguin sometimes appeared in the magazine. We can safely assume that Gauguin supported him because he was poor and struggling to make his way – he was also useful on occasions, publishing an article on Gauguin: 'La lutte pour les peintres' in the *Mercure de France* in November 1894. To most people, Leclercq's slim physique, Byronic curly hair and intense eyes did not make up for his tendency to borrow money then forget to repay it. To Judith he was just another pest trying to seduce her, when all she wanted was to be with Gauguin. When Leclercq declared that he had wept all night over her, the unmoved girl told him to weep on: 'You'll piss less.'

Photography was very much a feature of life in this group. Using his recent earnings, Mucha had bought a camera for his studio in the Rue de la Grande-Chaumière, where he used it to photograph models in poses he needed for his illustrations. He had also bought a harmonium and took a photograph of Gauguin – seated at the instrument – minus his trousers – and after Gauguin acquired a large box-camera himself there was similar fun and games at the Rue Vercingétorix. In one shot we can see Gauguin in a Moravian peasant's hat and a friend of Mucha's called Marold dressed in medieval costume, next is the blurred image of Mucha himself who must have rushed to his place after starting the

camera, and beside him is Annah, mysteriously dressed in biblical robes and over-acting strenuously. One day Leclercq brought a professional photographer to the studio to photograph Gauguin as a Tahitian chief in a tight blue sarong decorated with yellow leaves, bare chested with his arms painted blue and white in imitation of Marquesan tattoos. Judith crept in to watch spellbound.

> He had assumed a terrible look – half Inca half cannibal. They didn't pay any attention to me so I stayed, dumbfounded before the milky complexion, the curve of his torso like a Japanese wrestler.

## Of Music and Musicians

One of the more intriguing figures in the Molard circle was the English composer Frederick Delius who had been living in France for nearly seven years. Although British of German descent, and brought up in the northern English manufacturing town of Bradford, Delius had become an honorary Scandinavian through his association with Grieg and his frequent visits to Norway, a country to which he was deeply attached. It says much about the openness of the group which gathered at the Rue Vercingétorix, that the 33-year-old Delius could so easily become a part of it while still in effect a learner – the works for which he is best remembered would not be written until the early years of the next century.

That April, there was a party at the Molards, undoubtedly engineered by Delius, and attended by Grieg and Maurice Ravel at which the latter played some of Grieg's folksongs, while the little composer dashed about the room urging him to play faster and faster. Usually, Molard's Saturday salon was more serious than the parties Gauguin gave but the artist seems to have been intrigued by the musicians, even if they were very involved with theoretical debate about the new music. This is surely the reason why the only painting of this time that can equal the portrait of the naked Annah was a striking study of a cellist in full flow, entitled *Upaupa Schneklud*, by which Gauguin meant something like 'The Player Schneklud' or more straight-forwardly: 'Schneklud the Musician'. The Swedish cellist Fritz Schneklud was another friend of the Molards, and Gauguin shows him bowing his instrument whose prominent red colour gives it as much importance in the composition as the blue-suited musician himself and thus completely integrates man and means, in one of the boldest representations of music-making in Western art. The peculiar thing is that if one examines closely any of the rare photographs of Schneklud, one sees that there are marked differences between this face and that of the musician in Gauguin's painting. One suggestion has been that Gauguin added some of his own features to that of the cellist,

though why he should have done so is nowhere made clear. Perhaps he felt a need to identify with a fellow creator, for he seems to have tried to convey visually the sensation of hearing him play, surrounding the seated figure and the cello with lines which seem to vibrate as if the canvas is shaking from the waves of melodious sound broadcasting outwards from the monumental red instrument.

## With his Bedstead as a Press

Painting, however, was not his primary concern. His real effort was concentrated on the illustrations for *Noa Noa*. It was no accident that Gauguin's launch into wood-block printing happened just as the long-prepared revival of artist print-making finally got into full stride. Gauguin had, after all, been watching the process for the past two decades. He had seen just how far this interest in print-making had spread in 1886, when Durand-Ruel had put on an Exposition de Peintres-Graveurs, with thirty-nine artists from France, including Bracquemond, Degas and Pissarro, but also from other parts of Europe. The preferred methods were engraving, which was close to drawing, and lithography which was close to painting. Wood-block engraving required other skills. It was this which appealed to Gauguin, who had abilities his other colleagues lacked. He was not interested in producing the usual polished image, emulating the precision of ink drawing, which had always been the pride of the professional newspaper engravers. Just as he had plunged into the earthiness of pottery, teasing and moulding his ceramics, reinventing the medium with his own hands and, just as he used washes of ink to transform the zinc plates of the Volpini Suite, so he now intended to play on the fact that wood-block engraving was more a branch of sculpture than of drawing or painting.

We are now so used to seeing others do what Gauguin first did, that it is impossible to recapture the revolution he launched with his aggressive gouging and scoring of the wood, deliberately leaving every sign that he had done so. After Gauguin the smooth surface previously considered essential would look merely bland and anonymous. Gauguin put the mark of individual personality into the craft and made it an art.

Gauguin had bought ten box-wood blocks from which he made three vertical and seven horizontal prints, in a large format – 355 × 205 mm to be laid on pages measuring 400 × 260 mm – a scale comparable to Manet's illustrations for Mallarmé's translation of *The Raven*, which were clearly the starting-point for Gauguin's own production. As there would be eleven chapters in Morice's completed book, the intention may have been to have a woodcut between each of them, starting between chapters one and two.

While it is safe to assume that the *Noa Noa* print was meant as a title page, it is better to abandon the idea that the remaining prints were simply illustrations and to accept that Gauguin had a much more creative end in view and was proposing a series of images which would run parallel to the text – with the exception of *Manao tupapau*, all the events in *Noa Noa* take place in daylight and are essentially autobiographical, whereas all the prints take place in darkness and are essentially fanciful and imaginative – one print, *L'Univers est créé*, has a bizarre monster, part insect, part animal, part fish, in the foreground, leaving the impression that Gauguin was creating a wild and fanciful universe of his own.

That we can no longer fully comprehend his ultimate intentions with the Noa Noa Suite, as the ten prints are now known, does not alter their value as independent works of art of astonishing range and emotion, for it is clear that as the work progressed his ambition grew to the point where he was embarked on nothing less than the total transformation of print-making as an artistic medium.

From this perspective, the key print in the series is *Te atua*, a reworking of three of the Tahitian carvings, *Hina and Fatu*, the seated Buddha from *Idol with a Pearl*, and the solitary standing *Hina* figure, which he almost recarves in bas-relief – the lines are so deeply gouged the effect is three-dimensional. Gauguin deliberately emphasized this when he began to pull prints from the block, for instead of trying to avoid the gouged-out areas he actually used his fingers to force the paper into the spaces, thus printing the rims of the tiny gulleys where his gouging tool, an ordinary carpenter's chisel, had been at work. The effect of this is both sculptural and kinetic, creating swirling lines around each solid area, leaving an impression that the figures and objects radiate energy. It was with this manner of inking the blocks that Gauguin provoked a second revolution, for he was not only a great wood-block carver, he was also a printer of genius – not necessarily the same thing.

Looking at the ten prints, one has a vivid sense of someone pushing the medium to its limits and enjoying himself while doing so. Sometimes he printed areas of pure colour first before printing the carved block on top of them, thus achieving varieties of tone and depth. On other occasions, he printed the same block twice on the same sheet, slightly shifting the position to leave an out-of-focus image which sometimes produces extraordinary resonances. In the print of *Manao tupapau*, the figure of the girl was already changed into a huddled foetal bundle but then, with this double printing, she seems visibly to tremble with fear.

There can be no doubt that Gauguin abandoned the original plan for a unified series of illustrations in favour of an exercise in pure creativity. The print version of *Te nave nave fenua* (*The Delightful Land*), which shows his Tahitian Eve in her fantastic Eden, was probably begun with

the intention of disseminating one of his key works to a wider audience, yet once he had made the block he played with numerous variations, printing it on differently woven papers, in a selection of inks and even cutting down some prints, either to eliminate unsuccessful segments or to highlight those parts which had worked especially well.

The revival of artists' print-making was linked to the quasi-socialist, rural-based handicraft philosophy of the Europe-wide Arts and Crafts Movement. Prints were democratic, the opposite of the single painting. If enough were printed they could be sold cheaply, providing art for all. Print-making, according to the theorists, would break down the barrier between high and low art, penetrating and reforming the decorative arts in everyday use and there is little doubt that Gauguin subscribed to such ideas yet, as with his ceramics, whenever he set to work, his own unique and complex vision led him towards images which were un-reproducible. All his prints are different – each is a highly individual work of art, the antithesis of what the theorists wanted. He even began to make mono-types, which are only technically a branch of printing. In Gauguin's case, even the term monotype may be inexact; 'colour-transfer' might better describe the technique he preferred. He would first create an image in water-soluble colours – water-colour, gouache, pastel – then he would lay on top of this a sheet of dampened paper which was then 'counter-printed' with the original image. Thus a monotype or a colour-transfer print is a single image as unique as the original design. Other artists had occasionally used the method, not to produce multiple copies, but to leave an image which has all the anonymity of a print with none of the hand-crafted marks of the original painting from which it has been pulled. Gauguin, of course, simply stood this on its head, by pulling up to three prints of the wet original, each one 'weaker' than the one before. In one sense he may just have been trying to see how far he could go, but in another, he was surely fascinated by the effects of vagueness and mystery, which no other method would have permitted.

Because his prints were overlooked in the past, there is a tendency now towards excessive praise, as if each were an unalloyed masterpiece. But with such experimental work, it was inevitable that the quality would vary enormously. Sometimes his individual way of printing and his double image-making succeeds in producing wonderfully mysterious effects: but equally there are times when this delicate balance is lost among the smudge and blur which clouds the final image. More so with the monotypes, or 'colour-transfers', where it was always impossible for him to predict what would happen when he lifted away the damp paper. Some work beautifully, leaving a delicate, dream-like scene, others are a mess.

He seems to have been pretty easy-going about it all – he did not,

after all, destroy his failures, which suggests that he was more interested in the experiment than in producing a consistent body of finished work. The Hungarian painter, József Rippl-Rónai, who had come to Paris and drifted into the circle of the Nabis round about 1892, recorded a visit to the Rue Vercingétorix where he watched Gauguin seated on his bed, working on one of his wood-blocks. Rippl-Rónai described the dimly lit room with Leclercq playing the piano, Annah sitting on the floor with her monkey chasing up and down a rope suspended from the ceiling, while through all this, Gauguin calmly got down to printing one of his blocks. When he had finished he began to chat with the Hungarian, the usual litany of complaints about dealers and sales and before he left, Rippl-Rónai was presented with three of the prints, which, he observed with some amazement, had been 'printed in a primitive way by using the foot of his bedstead as a press'.

A number of the prints were given to friends in just this off-hand fashion, though one still wonders why he was not more concerned to destroy those prints which clearly had not worked and why he did not try to assemble those which had into a more comprehensible order. This may be the reason why he decided to work with an experienced printer, Louis Roy, one of the friends of Schuffenecker whom Gauguin had allowed to exhibit at the Café Volpini after Guillaumin had decided not to take part. Gauguin began by working closely with him but after a time Roy was left to complete the work on his own, a thankless task as it is not the identical, 'professional' sets which catch the imagination but the rough variable versions which Gauguin produced in his own eccentric fashion with the foot of his bedstead.

In the end, many of the prints were left with Ida Molard who gradually sold them, but before they were dispersed, they were kept on permanent view at the studio where they were seen by the Norwegian painter Edvard Munch. One does not have to search far to find the connection between Munch's swirling expressionist lines in paintings like *The Scream* and the kinetic marks which Gauguin's fingers had sought out in the ridges and gulleys of his wooden blocks.

## The Harem

Somehow, while working hard on his prints and his writing, Gauguin had managed to keep the three women in his life at arm's length. The 'child-woman' Judith was treated as if she were a mix of daughter and doll, while she in turn accepted Annah as a sort of plaything, so that it was inevitable that poor Juliette Huet would be left outside this agreeable ménage. This could go on because Juliette usually contrived to visit the studio while Annah was out, but one day in April she arrived while the

other woman was there and the inevitable explosion occurred. Finding herself face to face with what she took to be an ignorant 'negress', Juliette let fly with a string of insults in French, which she assumed the small dark woman would not understand. She was quickly disabused, for when she paused to draw breath, Annah coolly asked: '*Alors, Madame a fini?*' There was nothing for Juliette to do but to make a final, humiliating exit, but as she recorded later, she left bitterly regretting that she had not brought her seamstress's scissors with her.

At least violence was avoided and life at the studio was easier now that she was gone. To Judith, it seemed like one long party and she records how the group set off to attend the opening of the Salon des Indépendants on 26 April, a cluster of tall men including Monfreid and Morice with a bunch of small women which included Judith and her mother and Annah, so that the group averaged out, by her calculation, at a metre and a half. Once inside, everyone set about their own business, some to look at the art, others to find useful contacts, but it was the diminutive Annah who most fascinated the young girl: 'Marching to conquer the world. She drew herself up to her full height, her nose in the air, her small pointed chin rising over her starched collar with its border of English embroidery. The stiff straw hat was perched at a 45-degree angle over her small nose, flat as a baby chimpanzee's, held up at the back by a high bun of her blue-black hair. She was wearing a silk-checked bodice with deep pleats and large leg-of-mutton sleeves and a skirt with a train which she held on her hip with her hand, gloved in filoselle. She thought of herself as a lady and shamelessly stared at everyone. She completely ignored me and I had only one worry: not to lose the others.'

Not everyone accepted Gauguin's new mistress nor his new, flamboyant lifestyle as the enchanting Judith had done. In the days when he was poor, Gauguin had been somewhat restrained, with his inheritance, he was a theatrical performance in full cry. Older friends like Schuff preferred to withdraw, leaving him to newcomers like Morice, Leclercq and Durrio. Several old friends absented themselves for one reason or another: Emile Bernard was then totally alienated, Meyer de Haan was back in Holland, sick and with only a short time left to live and, though Gauguin would not hear of it till later, the very day after that jolly outing to the exhibition, his first and once most devoted disciple Charles Laval died in Egypt. Laval had gone on trying to recapture some of the excitement of Martinique, when for a brief moment it had seemed that he too was at the forefront of the new art. He had gone to Egypt but the climate worsened his incipient pulmonary tuberculosis. Madeleine Bernard travelled out to nurse him and may even have married him when she realized that he was not going to survive, though that has never been absolutely confirmed. Either way, it sealed her own fate, for a year later

she too succumbed to the then incurable disease and died. Today, Laval's slight immortality rests on Gauguin. When his brother Nino auctioned off his works later in 1894, most were irretrievably scattered and the few which survive may well be those scenes from Martinique which unscrupulous dealers later passed off as being by Gauguin.

With the end of April, the winter seemed to be over and it was time to think of returning to Brittany. Leclercq moved in to take care of the studio, for Annah and the monkey were to go with him. It was a foolish decision. The last thing the little 'Javanese' wanted, after so much fun in Paris parading about in her fine new clothes, was a return to the simple life.

## The Fight at Concarneau

Gauguin ought to have gone to Denmark to sort out matters with Mette, but given the bad feeling between them it was easy to persuade himself that he should leave it until the weather was better, and they could rent a cottage somewhere, probably on the Norwegian coast, and have a holiday with the children. In any case, he needed to go to Brittany to recover the paintings he had left with Marie Henry at the Buvette in Le Pouldu, a task made easier when Mucha's friend, the Polish painter Wladyslaw Slewinski, who had painted the other panel outside Madame Charlotte's crémerie, invited Gauguin and Annah to stay in a house he had rented in the village.

It was because of Gauguin that Slewinski had decided to become a professional painter, having spent a good deal of time rather aimlessly pondering his future. His problem was his rather relaxed approach to life which made it unlikely that he would ever achieve much. At home in Poland, his aristocratic father had given him one of the family estates to manage, only to find that the young man quickly let it sink into debt. Thrown out, Slewinski eventually drifted to Paris where he managed to get a place at the Académie Julian but soon moved to the more easy-going and congenial Colarossi, where he met Mucha and later Gauguin. They got on remarkably well, and Slewinski and his Russian-born wife Eugenie Schevzoff, also a painter, began to spend their summers in Brittany. Somehow the two managed to live reasonably comfortably, moving between Paris and the Atlantic coast, with Slewinski painting in what is now called the Pont-Aven style, using firm Cloisonist outlines, though with colours less flat, more naturalistically shaded than in the overtly decorative work of the Nabis.

Slewinski was delighted to have the master to stay but the visit was not a success. The only other person Gauguin knew was Filiger, but he was ever more preoccupied with his androgynous shepherds and choir-

boys and adolescent angels. Marie Henry had married and sold the inn
and had moved away. When Gauguin tracked her down to a nearby
village, he was appalled to discover that she was no longer the friendly
hostess he had once known. She was no doubt furious with De Haan
for having abandoned her and her baby but the real trouble came from
her new husband who had a little more education than she – just sufficient
for him to be both suspicious and grasping. He seems to have reckoned
that if this fine gentleman was so keen to have these funny pictures back
then they had to be worth quite a bit. Prompted by her spouse, Marie
Henry prevaricated and said she would have to think a bit before handing
them over. Puzzled and alarmed, Gauguin decided to move to Pont-Aven
while she made up her mind.

Much had changed in Pont-Aven too. Marie-Jeanne Gloanec had
opened a new establishment, the Hôtel Ajoncs d'Or, at the town's main
crossroads (today, 1 place de l'Hôtel de Ville), only a short walk from
the Gloanec, and while she was delighted to see her old customer, it was
all very unsettling. One hardly imagines that Annah was much company,
suffering the ennui of small-town life, then to cap it all word came from
Marie Henry that she was definitely not going to give back the paintings
and he knew he would have to begin a court case to attempt their
recovery.

It was a miserable moment. The old place was overrun with new-
comers, youngsters searching for the spirit of Pont-Aven which was by
then being whispered about in their academies and ateliers. The list of
artists who are now considered to be members of either the Pont-Aven
School or the Nabis, begins to seem endless. They all owed some allegi-
ance to Gauguin, as the father figure of both groups, though many barely
knew him, and some not at all. Two young painters, the Parisian Armand
Seguin and an Irishman Roderic O'Conor, had visited Pont-Aven and
Le Pouldu and fallen under his influence without meeting him until that
spring of 1894. The 25-year-old Seguin had been a follower while a
student at the Ecole des Arts Décoratifs in Paris when he visited the
Volpini exhibition. Now he made up for lost time by becoming virtually
inseparable from the man he so admired. It was the same with O'Conor,
who may have been visiting Brittany since 1887, after studying in Dublin
and Antwerp, but who had also missed the passage of the master. Perhaps
because he was older, at thirty-four, O'Conor was less bowled over than
the younger Seguin by his encounter with so forceful a personality.
Although he is often put into the Pont-Aven School, the Irishman
never really accepted even the broad limits which define the style. Most
Pont-Aven paintings are marked by their calm placidity – the gentle,
untroubled landscape is a typical subject – but O'Conor was inclined
towards movement and action and his paintings eschew the flattened

patches of colours typical of the school, preferring sharp, active brush-strokes. His etchings too are made up of swirling emotive lines, and were often done entirely in the open air, in direct defiance of Gauguin's rule that work was best completed, from memory, back at the studio.

Seguin was much more obedient. One story, presumably apocryphal, has Gauguin pulling out a pistol and threatening him if he didn't stop using complementary colours. But there was little need for force – Seguin was happy to accept orders. Whatever their differences, both he and O'Conor were more successful as printmakers than painters – a tragedy in Seguin's case, as he would come to believe himself a failure. Part of the problem may well have been that both were fairly comfortably off and able to lead a pleasant Bohemian existence, with studios in Paris and holidays in Brittany. It was a life without too many worries but also without that drive to succeed which had always propelled Gauguin, enabling him to struggle on, even when sick and hungry. Seguin is remembered less as an artist than as the chronicler of the Pont-Aven School, having published his memoirs just before his untimely death from tuberculosis in 1903. O'Conor lived on until 1937 though for much of his later life he was an isolated figure, living in Paris, but working in a conventional academic style having abandoned the adventurousness of his early days. Back in 1894, however, both men were still full of hope and convinced that they were right at the heart of things, strolling about Pont-Aven with the most notorious figure in the avant-garde, with his diminutive black mistress and her capering monkey.

Even for a place well used to artists' eccentricities, this ménage must have seemed quite extraordinary. The younger art students were notori-ous for their high jinks – one year a group had painted some chickens in various colours, got them drunk and let them loose. But that was fairly tame beside Annah with her haughty ways, one minute, and her blunt rudeness the next – pulling faces and sticking out her tongue when she was being stared at, which was more often than not. Set that beside Gauguin's flamboyant appearance and add in O'Conor, who was tall and rambling with a mass of black hair and a prominent black moustache, and you have a very noticeable group indeed. This was just about tolerable in Pont-Aven but far less so in other spots, where the old traditional Brit-tany still lived on, limited in its horizons and unsure of outsiders. So that it was a little unwise for them to visit the fishing port of Concarneau, on 25 May, for while it was only about eight miles west of Pont-Aven, it was very different in terms of its tolerance of Bohemian behaviour. The port was a mix of old and new, on the one hand it was the third or fourth most important centre for the French fishing industry, with up-to-date canning and processing businesses, on the other its pictur-esque old town and harbour were still intact and attracted a number of

painters, though mostly of the highly respectable Salon variety. The wilder sort kept to Pont-Aven.

In her memoirs Judith made it clear that she believed Annah must have been responsible for what happened – her cheekiness was bound to have stirred up trouble, though Judith also adds that Seguin's mistress, a model notorious in Montmartre for her bad language, may well have worsened an already difficult situation. There were eight of them on that fateful outing: Seguin and O'Conor, joined now by the painter Emile Jourdan who had known Gauguin from back in the early days at Pont-Aven. These three had brought their girlfriends, and there was, of course, Gauguin, Annah and the monkey.

Concarneau is built round a semi-circular harbour divided into the *avant-port*, which is more exposed to the sea than the narrower *port de pêche*, where, as its name implies, the mass of fishing-boats were sheltered and where the famous spectacle of unloading the catch took place. The two ports were separated by a spit of land on which stood the historic *Ville Close*, the ancient fortified town with its ramparts and old dwellings, so beloved by visiting artists. At the end of the century, Achille Granchi-Taylor would be one of those who led the campaign to have the site classified, when it looked as if the old walls might be pulled down. It was to this already famous monument that Gauguin and his party were headed when the trouble began.

They were strolling along the Quai Pénéroff, which ran along the front of the *avant-port*, when a group of children began to follow after them, no doubt drawn by the extraordinary spectacle of Annah and the monkey. But what began as childish badinage quickly progressed to insults. A somewhat nervous Jourdan suggested they leave but this only provoked Gauguin, who pointed down a narrow alley and bellowed at him to go that way if he was so afraid. At this point some of the boys, led by a particularly rough and insufferable brat called Sauban, started to throw stones. This was far more serious and Seguin went over and pulled the boy's ear hoping to frighten him off. Unfortunately Sauban *père* was sitting with a group of friends drinking at a nearby tavern, and seeing this attack on his child, ran forward and punched the already terrified Seguin, who leapt fully clothed into the harbour. Hoping to save his friend, Gauguin rushed up and felled Sauban with a well-aimed blow. They ought really to have hurried away at this point, as the people of the port were clearly on the side of the local children and the insults were flying thick and fast. But before anyone could think what to do, three of Sauban's friends appeared and a full-scale battle began. With René Sauban back on his feet, Gauguin, O'Conor and Jourdan were outnumbered though the odds were slightly lessened when a group of drunks began to attack Annah, and this provoked some of the local women to rush out of their houses to defend her. By then, the whole

thing was out of control, the three artists and their women were being pushed towards the entrance to the old town. Gauguin put up a heroic fight and managed to send two of his assailants flying over the edge of the quay into a bank of mud left by the receding tide, but at one moment he suddenly turned and by his own account had the terrible sensation of putting his foot into a hole. In fact he had had a kick in the shin from one of the hefty clogs his assailants wore and his ankle had suddenly shattered. He was no sooner on the ground than a group of thugs were on him, kicking at him mercilessly, with Gauguin barely able to do more than protect his face with his hands. It was some time before his assailants realized they risked killing him and pulled back. Just then the local police ran up and the men fled, leaving his battered companions to try to help the badly wounded Gauguin.

Apart from the wet Seguin they were all in a bad way. Even Seguin's mistress had a damaged rib, but none was as bad as their leader whose shinbone had pierced the skin just above the ankle. He was barely conscious as they lifted him into a cart which would get them back to Pont-Aven. There, he was taken to the local hospital, his wounds dressed and the leg treated and bound though he hardly needed a doctor to tell him how serious the situation was and that he would have to rest for a long time in order to let the fracture heal.

After a few days, he was allowed to move into the Hôtel Gloanec but it was clear that he would be able to do little more than lie in bed, a grim prospect for one so active. The pain was terrible, and the local doctor prescribed morphine, to which Gauguin added his own palliative, alcohol, thus drugging himself into a reasonably soporific state. Some of the effects of this can be seen in the only work he felt able to do over the two months in which he was virtually immobile. Confined to his room, he could do no more than work on his prints and it is easy to see in the colour-transfers, and their vague and watery images, an echo of that dreaminess induced by drugs and alcohol.

He had barely been working before the catastrophe, now he was filling time. While Seguin and O'Conor did what they could to cheer him up, one doubts that Annah was much use. There was definitely no chance of his getting to Denmark to see his family now and there was the prospect of two disagreeable court cases, one against Marie Henry for the recovery of his paintings and a second against Sauban and one of his friends, Pierre-Joseph Monfort, whom the police had charged with assault.

Nothing was going his way. An auction of paintings owned by the late 'Père' Tanguy, the Parisian colour merchant who had amassed a collection of modern work, mostly in settlement of debts for paint and canvas, had resulted in very low prices being paid for the Gauguins on offer. The one thing which might have bucked him up, the completion

of *Noa Noa*, seemed to be getting nowhere, as Morice never managed to finish anything. Gauguin fretted and began to remember when things were better, when the nights were warm and the *vahines* beautiful. He felt misunderstood, unwanted and in pain; he felt sorry for himself and the shadowy images in the colour-transfers he made were most often Tahitian girls or the familiar view of the hut at Mataiea with the mango tree at the foot of the mountain.

    This obsession with Tahiti was further intensified towards the end of June, by the arrival in Pont-Aven of the 21-year-old Alfred Jarry who had deliberately travelled down to visit Gauguin, whose work he much admired. Although Jarry had been working on his most famous play *Ubu Roi* since he was a schoolboy in Rennes, it would be another two years before the first public performance at the Théâtre de l'Œuvre would establish his reputation as the most shocking of all the new adherents to Symbolism. At the time of his visit to the Gloanec, Jarry was just beginning to make a name as a highly precocious art-critic with a gift of picking out the new and exciting. Having first seen Gauguin's work at the Le Barc de Bouteville gallery, Jarry had been further entranced by the exhibition at Durand-Ruel, which he had written about as part of a series of articles entitled *Minutes d'Art* published in the magazine *Les Essais d'Art Libre* that spring. Jarry had met Gauguin briefly at the magazine's offices just before the painter left for his ill-fated trip to Brittany, and the young man had become yet another convert – arriving at the Gloanec with three poems inspired by works in the Durand-Ruel show: *Ia Orana Maria*, *Manao tupapau*, and most significantly, *The Man with the Axe*. Jarry was not trying to describe these works but to imagina-tively re-create his own sensations on seeing them. Gauguin's portrait of Jotefa had clearly struck a deep chord – Jarry's barely suppressed homosexuality was certainly a reason for his interest; he was still very close to his schoolboy companion, the writer and critic Léon-Paul Fargue, a relationship which had scandalized Fargue's mother when they were fellow pupils at the Lycée Henry IV in Rennes. Jarry would now forge a close friendship with Filiger, lending him money on occasions and trying to offer support in the few years before alcoholism wrecked Jarry's life and led to his early death in 1907, aged only thirty-four. Given these predilections, it is not surprising that the poem based on the Jotefa painting should be the most forceful of the three, building on the splendour of the young man's physique, dwelling sensuously on the feelings of strength and power which emanate from it:

> *Or on a marble column, he*
> *Carves a boat out of a tree,*
> *Astride in it will give us chase*

*To where the leagues' green limits lie.*
*From shore his copper arms in space*
*Upraise the blue axe to the sky.*

It is noticeable that Jarry ignores the figure of the woman in the boat, an important element in the original painting, and one assumes that it was after reading this homage that Gauguin made his own reworking of the scene in ink and gouache, in which he too leaves out the female figure and concentrates solely on the foreground Jotefa. He may well have intended this to be an illustration for the poem though the two were never published together. Jarry had probably returned to Paris before the drawing was completed, for it was folded into quarters at some point, perhaps to be posted to him, though in the end it was never sent and was later inscribed to Monfreid and given to him as a gift.

Once the young writer had gone, there was nothing to keep Gauguin distracted. He wrote to Morice's wife urging her to encourage her husband to finish the work on *Noa Noa*, the first letter in what was to become a long, acrimonious correspondence on the subject. There was little more that Gauguin could do. As Morice was forced to scrape a living out of jobbing journalism, he did not have *Noa Noa* high on his list of priorities.

To Gauguin, stuck in the Hôtel Gloanec, it must have seemed that life was passing him by. The Paris art world was in uproar following a series of alarming events which had begun on 24 June, when a young Italian jumped onto the running-board of the carriage taking Sadi Carnot, the popular French president, through the city of Lyons, and plunged a knife into his chest. The death of the Head of State had resulted in a witch-hunt against all those suspected of radical sympathies, which included many of those in the artistic community. Some, including Pissarro, had never made any secret of their anarchist sentiments, and judged it wise to leave for a while. Pissarro chose Belgium. Mirbeau fled too, frightened off by emergency laws which allowed concierges to open mail and virtually encouraged a man's enemies to denounce him.

Obliged to miss all this excitement, Gauguin could only feel trapped, like a wounded beast with no outlet for his energies. It is surprising that Annah put up with it for as long as she did. Life at the Gloanec can hardly have matched her ideal and her loneliness became acute after Taoa ate a white yukka flower and died of its poison. Gauguin was equally upset; the little creature had been a happy companion, running about freely – it had even followed him into the water when he went swimming before the attack; he cannot then have been surprised when

Annah announced that she was going to return to Paris, supposedly to find work. She went some time around the end of August or the beginning of September, leaving Gauguin with nothing to look forward to but the two court cases.

On 23 August he travelled the twenty-five miles to Quimper where the case against his attackers was to be heard. He had every reason to believe he would be awarded some recompense for his suffering and his subsequent expenses. Even the local newspaper *L'Union Agricole et Maritime* had described the assault as an act of brutality and spoke of the need to support the visiting artists who did so much for the reputation of the town. But in the end the journey was as pointless as it was painful. He was putting his damaged ankle at risk by such exertion, yet as soon as the process began he knew he had been duped. Despite all the evidence, the police claimed that they had only been able to identify two of the attackers, the ship's pilot Sauban and the fisherman Monfort. It was clear that the court was utterly unsympathetic to so bizarre an outsider and that there was little inclination to punish two local men, despite the seriousness of Gauguin's injuries. He had asked for 10,000 francs damages but was awarded a paltry 600 – insufficient for his medical and hotel bills. The final humiliation came when the fisherman Monfort was acquitted and Sauban was sentenced to a mere eight days' imprisonment. Not surprisingly Gauguin dashed off a letter to Molard complaining about political manipulation – the accused had had contacts with local officials and Gauguin asked Molard to try to get Leclercq to use his journalist contacts to expose the injustice. However, it was his final remarks which were the most revealing: he had, he told Molard, decided to return to the South Seas and this time his new friends Seguin and O'Conor would be going with him. He wrote a similar letter to Monfreid but there he says he will be going with an Englishman and a Frenchman. This is the second reference to an Englishman and while he may simply have confused English and Irish, and really meant O'Conor, it could just be that he had again met up with the painter Peter Studd who had been coming to Le Pouldu since their first encounter in 1890. Studd had been planning a trip to the South Seas since hearing of Gauguin's original departure and Gauguin would certainly have encouraged anyone who wanted to go with him, happy to have any support in setting up what he now thought of as his 'Studio of the South Seas'. That speculation aside, the most fascinating thing about his letter to Monfreid was his insistence that once back in the Pacific painting would be for amusement only, as he was going to concentrate on wood-carving from then on.

His desire to leave received another boost when the second court case was heard in Quimper on 14 November and proved even more dispiriting

and unreasonable than the first. Because he had not obtained a written receipt for the paintings when he left them with Marie Henry, the court ruled that he had shown that he was not really interested in them and that his former landlady had every right to deduce that they were hers. At a stroke he had lost a good part of the work he had produced during 1888 and 1890 and was even more out of pocket, with no possible chance of compensation. He left the court, went straight to the station and took the first train back to Paris only to be confronted with the worst shock of all: Annah had been to the Rue Vercingétorix and emptied the studio of everything she could carry, his furniture and his souvenirs though, unlike Marie Henry, she had at least left him his paintings, hanging on the bright yellow walls, sole survivors of the past ten years.

## My House Will Be of Carved Wood

There was a general rallying round. A week after his return Charles Morice and a group of friends held a banquet in his honour at the Café des Variétés but he made it quite clear that he meant to leave France as soon as he could, preferably for Samoa which he believed to be reasonably unspoiled and which could thus still offer all the things that no longer existed on Tahiti. This time, however, he insisted that he was going for good. He would, as he had told Molard in his letter, be going in February and would end his days 'a free man, peacefully, with no concern for the morrow, and no more battling all the time with imbeciles'. Moreover, he repeated that he would only paint for his own pleasure and added prophetically: 'My house will be of carved wood.'

It is difficult to explain his growing dissatisfaction with painting. Part of it may be due to his feelings of rejection since the Durand-Ruel show, yet there were no signs that his carvings or his prints were any better understood. One imagines that he allied himself with carving because it was somehow more true to the culture he had tried to re-create. All of which was no doubt on his mind when he decided to make what he called a 'ceramic sculpture', a large fired clay figure, though the subject was less a question of the medium he was working in than a reflection of his troubled state of mind. The incident in Concarneau had created a feeling of revulsion for Europe that went far deeper than his friends may have realized, reawakening his sense of being an alienated savage – the Maori he had felt himself to be after the journey into the mountains with Jotefa. The clay figure was to be just that, a savage, a naked woman with wide-blank hyper-thyroid eyes and a cascade of hair falling behind her. The pose is familiar, she stands as Teha'amana had in that final painting *Where Are You Going?* but she is no placid village girl – the

savage stands astride an animal, a wolf dying in a pool of its own blood, and she clutches a young cub to her, so closely she may be trying to crush the life out of it or perhaps to smother it with love. Gauguin called his creation *Oviri*, the folk-tale figure he knew from the popular song in which the savage bemoans his love for two women. Gauguin had probably learned that this was only a modern version of a far older myth about Oviri-moe-aihere, one of the ancient Tahitian gods who, with the collapse of the old religion, had been gradually transformed into a malign spirit, a sort of *tupapau*, 'the savage who sleeps in the forest'. By making him a woman, and by showing her as simultaneously giver and destroyer of life, loving and crushing her whelp, forcing it against her womb, Gauguin offers a dramatic symbol of birth and death, his personal belief that the old ways, the civilized side of his dual nature needed to be killed off before he could be reborn again as a savage. The pose of the figure, as that of Teha'amana before, was taken from one of the Borobudur frieze figures, which was itself a symbol of fecundity, thus amplifying the ambiguities of birth and death and rebirth. On one occasion, in a letter to Vollard, Gauguin referred to 'her' as *La Tueuse*, the 'Murderess' but on a later drawing of the sculpture he wrote: 'And the monster, embracing its creation, filled her generous womb with seed and fathered Seraphitus/Seraphita' – a reference to Balzac's novel *Seraphita* with its androgynous hero/heroine, implying that Oviri is both mother and father of the androgyne, the perfect asexual being which she clutches to her. Indeed both readings are valid and complementary – Oviri is murderess and mother, destroying the old to give life to the new, and in the same moment birth and death become one.

In its ambiguity and complexity, this is Gauguin's most ambitious sculpture and he would never again attempt another model or carving so profound or so personal. It was also the summation of his skills as a ceramicist and while he again turned to Chaplet for technical assistance with the firing, the use of varied glazing was very much the product of Gauguin's love of experiment that pushed the process to limits seldom tried before. Because there are signs of wood grain imprinted on the base, it has been suggested that the statue was first carved then cast in plaster and that the final clay figure was taken from this mould, but this seems unlikely, as there would have been little reason to fire a ceramic if a durable wooden statue already existed. It is far more likely that Gauguin moulded the tall figure – at 74 centimetres the biggest ceramic he ever made – directly in clay, so that it could be fired then partially glazed. The greater part of the figure remains in coarse stoneware which, after firing, became a slightly purplish brown, the hair was protected with a transparent glaze which meant that it remained a lighter sandy colour. He glazed the two wolf heads with a red so dark they appear

almost black, to which he added some green touches. On the front of the base he formed the word OVIRI and along the side of the dead wolf he added his usual mark, the letters P G O, which can be read phonetically in French as the first part of his name. This was a joke he often used, for if the first letter is pronounced in French and the second two are run together you get PEGO – French naval slang for the male organ, equivalent to the contemporary English 'prick'. If one reads all this literally then Oviri standing astride the dead wolf, represents the female womb conquering the male penis. Woman the destroyer was a common image in *fin de siècle* art and literature, often represented as Salome ogling the severed head of John the Baptist. It is usually interpreted as one of the nightmares of the syphilitic age and it is perhaps significant that as Gauguin worked on *Oviri*, he again showed signs of the disease he still refused to name.

Whatever its gruesome provenance, Gauguin knew that *Oviri* was one of his most important works, though its subsequent history would be a miserable tale of misunderstanding and rejection which continued long after his death. During all that time, the savage she-devil seemed to live under a curse of her own creating. She made her first public appearance shortly after completion – for Gauguin had now decided to hold a studio showing of his most recent works, hoping to repeat the success of the Drouot auction while side-stepping the gallery system, which he still believed had served him badly. If he were to survive on Samoa he would need money, his inheritance would not last for ever and there would be no subsidized travel as before.

Since Annah had looted the place, carrying off his collection of oddities and much of the flea-market furniture, the empty studio now made an ideal exhibition space. As before he worked hard at the framing and hanging, mounting the prints on mottled blue paper so that they could be passed around or pinned up as needed – the essential premise behind the event being that he, the artist, would be on hand to explain the work in a more intimate atmosphere than was possible at Durand-Ruel's. He announced the opening, on 2 December, in various art journals and both Morice and Leclercq published reviews timed to coincide with that week. There is no authoritative list of those who accepted his invitations but it is safe to assume that Mallarmé, Degas and Vollard were among those who climbed the wooden staircase to the balcony and the yellow room in the Rue Vercingétorix.

What they found was clearly an improvement on the confusing anonymity of the Durand-Ruel exhibition. Gauguin was there, eager to talk and willing to pass around his prints or to hold one up against the other to demonstrate connections and developments, a performance which helped generate more interest in the woodcuts and monotypes

than might normally have been the case, had they been on show in an anonymous gallery. But sales were no better than they had been at the Rue Laffitte. Gauguin's greatest admirers were the younger generation of struggling artists, most as poor as he was, and in no position to purchase the works they so manifestly loved. Once again he was admired for having broken new ground and was praised for it – but of money there was none. Five days after the opening he was given yet another celebratory dinner, again by the Têtes de Bois group, but it was a rather chastened Gauguin who mournfully declared that it was Tahiti that he had decided to go back to after all. He added ruefully that, given the choice between 'the savages here or the ones over there,' he would leave without a moment's hesitation.

As he still needed money he now accepted that he would have to risk all on a repeat of his former strategy and hold a public auction of his work at the Hôtel Drouot, even though the Père Tanguy sale, only seven months earlier, had revealed little enthusiasm for his paintings amongst the general sale-room public. Having decided to go ahead, his time was then taken up with canvassing his journalist contacts to drum up more advance publicity. There was hardly time for work, though it would be wrong to assume that this was an entirely empty period in his life – thanks to the Molards he again found himself the centre of another group of new arrivals, an extraordinarily talented crowd, though this time the leading figure would not be a painter or musician but a dramatist.

## Like a Family

The man in question has left us a description of a typical evening with the group that gathered at the Rue Vercingétorix, and while some of the details are initially puzzling, they can be opened out to give an intriguing picture of what life was like for Gauguin during his last six months on French soil.

> I pursued my studies in chemistry all winter, staying in the sparsely fur-nished apartment which I had rented until the evening when I would go to eat in a Crémerie where artists of every nationality had formed a group. After dinner, I went to visit a family that I'd rejected in a moment of severity. The entire circle of anarchist artists meets there and I find myself condemned to suffer all those things I would have preferred not to see or hear: dissolute manners, loose morals, cold-blooded irreligion. There is much talent assembled there, an infinity of wit, one of them has a true natural genius and has made a great name for himself. Despite everything it is like a family. I'm liked there and this makes me close my eyes and deafen my ears to their little affairs which are no concern of mine.

The author of that revealing memoir was the Swedish playwright August

Strindberg who enjoyed considerable success in Paris during the winter of 1894–95. Although famous in his homeland for a string of highly acclaimed plays: *The Father*, *Miss Julie*, *The Creditors*, the dramatist gives enough clues in that short paragraph to indicate that he was far from happy with his lot. The acrimonious collapse of his second marriage had succeeded in dampening the warmth of his reception in Paris, driving him almost paranoid with jealousy and suspicion. Julien Leclercq, who became very close to Strindberg at this time, visited him on Christmas Eve and found him sitting alone in an enormous winter coat, facing a desk 'bare save for a photograph of his children and a revolver'. While Strindberg forbore to blow his brains out, he did take solace in strange scientific experiments – a sort of alchemy – which almost succeeded in achieving the same result. An attempt to heat sulphur on the stove in his hotel room resulted in horrendous burns seriously exacerbating an already bad case of eczema which may have been syphilitic in origin. As it was, Strindberg was twice hospitalized during his stay in Paris, though he continued to insist that he was making revolutionary advances in scientific research, discoveries which he believed would bring him the immortality which his paranoid mind was convinced was being denied him as a playwright.

The rest of his description of the evening is fairly easy to unpick. The Crémerie he mentions was of course the restaurant of our old friend Madame Caron with whom the dramatist was having an affair of sorts – she would mother him and he would play the little boy hiding his head in her apron. Strindberg was staying in a small hotel opposite but had free run of the Crémerie, and one morning Madame Caron came down to find that he had piled all the pots and pans in the middle of the room and was dancing round them, dressed only in his shirt and underpants, apparently trying to exorcize the evil spirits he believed were trying to poison his food. Despite all this, the kindly woman went on believing right up to the turn of the century that he genuinely loved her. Only some time around 1900, when she heard that he had married another, did she finally give up, selling the restaurant and moving back to her native Alsace.

The family which Strindberg visited in his description was of course the Molards, downstairs in the Rue Vercingétorix. He had known Ida Ericson-Molard from her earlier life in Stockholm and she and William remained his closest friends in Paris, despite the temporary falling out which he refers to, which had been due to his feeling humiliated when they had tried to raise money from among the Scandinavian community, to pay for the treatment of his hands, damaged by his imprudent experiments. Now they were friends again and were once more the central figures in his social life.

Easiest to recognize, in the anecdote, is the man with true natural genius. Strindberg had been aware of Gauguin even before he arrived in France, having been introduced to Mette in Copenhagen, though he disliked her mannishness. There were other connections: Strindberg knew Edvard Brandes and would have seen Gauguin's paintings in his collection, though they were not to his taste. Aside from chemistry, Strindberg also saw himself as a painter and had exhibited several of his large Expressionist canvases in Sweden before his departure. Like his plays, the paintings were an intense and dramatic heightening of reality, far removed from Gauguin's careful cerebral myth-making. But Strindberg also knew the Thaulows and had recently stayed with them in Dieppe, so that it was inevitable that he and Gauguin should be brought together when Strindberg arrived in Paris in the autumn of 1894 to prepare for the opening of *The Father* at the Nouveau Théâtre. They met during rehearsals, shortly after Gauguin's return from the second trial in Quimper, when Strindberg was still living in the Latin Quarter and attempting to change modern chemistry They were almost of an age – Strindberg was forty-six – and despite their artistic differences they recognized similar qualities in each other and became as friendly as it was possible for two such egoists to be.

*The Father* had been due to open on Friday 14 December but this was moved back a day so as to avoid clashing with the 1000th performance of *Faust* at the Paris Opera. Why Strindberg's première should have become the big social occasion it did is hard to say. Since Ibsen there had been something of a cult for Nordic theatre which, despite its naturalism, seemed to chime with Symbolist aspirations. In any event the smart crowd turned up though it was the increasingly lionized Gauguin in his astrakhan hat and flamboyant cape who was acknowledged to be the centre of attention. Not that Strindberg was there to see it, as it was his habit to sit nervously at home during his opening nights. In any case, Gauguin had probably come to see the sets and costumes by the Nabi painter Félix Vallotton as much as anything, though he soon learned that the play's author was a figure worth knowing. The critics were mixed, but Strindberg became an overnight sensation. *Le Figaro* gushed about his 'majestic forehead crowned by anarchic locks; pale blue eyes, taciturn, tall, and lanky; acts as if he were on an apostolic mission; completes the Nordic Trinity, in which Ibsen is the Father and Bjornson the Son'.

After the play was launched, Gauguin introduced the playwright to Charlotte Caron and the crowd at the Crémerie and invited him to the regular Thursday evenings at the Rue Vercingétorix. Despite his disapproval of the loose morals he found there, Strindberg was happy to attend, though he does not appear to have been an especially amusing

addition to the group with his tendency to drone on, in bad French, about alternative science. However, he was the brightest playwright of the season and he did join in the crazy games. Judith remembers him putting on a play, *The Burial of the Russian*, and how he set about 'howling in his out-of-tune and cavernous voice a funeral march, which only he found amusing'. As with her parents, Judith was hopelessly biased. She drew a sharp contrast between the Swede whom she clearly thought ridiculous and the urbane Gauguin, who stood in front of the fireplace, his thumbs in the armholes of his waistcoat, looking on the performers as if on 'the great unwashed'.

She noted sharply that when Strindberg talked of chemistry, 'they listened to him with boredom, deference, and with lack of knowledge', and she remembered one occasion when he took a flask from his pocket and held it up to show something black which he explained proved that sulphur was not a single-element – 'as if any of his listeners cared one way or the other'.

Along with Strindberg the other regular Thursday-night attenders were Delius, Leclercq and Slewinski, and, rather less frequently, Mucha. Older acquaintances like Schuff and Monfreid had dropped away, probably out of a dislike for such raucous young company and the inevitably childish games. On one occasion Delius and Leclercq set up the gullible Strindberg, inviting him to Delius's room for a seance where they all sat, hands on the table, while Leclercq asked what message there was for them. At this point the table began to shake and rap out the letters: M ... E ... R ... It was some time before the humourless Strindberg realized that they were tapping out MERDE (shit). As Delius put it: 'I do not think he ever quite forgave us for this.'

It was unusual for Delius and Leclercq to act together in this way, for Delius shared Judith's opinion of the poet that he was selfish and untrustworthy. Indeed Gauguin and Molard were the only common denominators within the group, several of whose members found each other antipathetic. Delius was fond of Monfreid and, despite his games, tolerated Strindberg with whom he took long walks around the Luxembourg Gardens and the Latin Quarter, even though the playwright's conversation frequently bordered on the insane.

Gauguin put up with Strindberg's increasingly bizarre behaviour because he thought he might prove useful. Shortly after the success of his opening night, the dramatist had begun to publish some exceptionally outrageous magazine articles which only added to his status as the Scandinavian of the moment. One preposterously misogynistic piece was entitled 'The Inferiority of Women' and was no doubt sparked by his running battle with his second wife whom he once described as 'the filthiest beast I have ever known'. The article caused an understandable

stir and prompted Gauguin to send a letter to Strindberg asking if he would consider writing the catalogue preface for his forthcoming sale. All accounts of what happened relate how Gauguin wrote to ask for Strindberg's help only to receive a long refusal which was so closely argued that Gauguin decided to use it as his preface. However, a moment's thought suggests that the two of them cooked up this scenario to add a little drama to their efforts. In effect, the playwright deliberately wrote an encomium, thinly disguised as a refusal, as a means of praising the artist without sounding sycophantic. Strindberg's 'refusal' was in reality an extended survey of Gauguin's art in the context of a general essay on contemporary painting. He began by apologizing for his inability to write the preface and defended himself by evoking his love of the early Impressionists which led him to reject what Gauguin had done with art since those now distant days: '. . . you have created a new earth and a new heaven, but I don't feel at home in this world of yours. It's too sunny for someone like me, who loves *le clair-obscur*. And your paradise contains an Eve who isn't my ideal, for I really do, even I, have an ideal or two of women.'

All of which seems unequivocal, except that as one reads on, it is clear that Strindberg was effectively playing devil's advocate with himself and that by the time the letter approaches its end, he has virtually talked himself round.

> Having gotten myself warmed up, I now begin to have a clearer under-standing of Gauguin's art.
>
> A certain contemporary author has been reproached for not having portrayed real human beings but having simply constructed his own beings. Simply!!
>
> Bon voyage, maître. But do come back to us, and look me up again. Possibly by that time I shall have learned to understand your art more, and that will put me in a position to write a real preface to a new catalogue for a new Hôtel Drouot exhibit. For now I too begin to feel an irresistible drive to become a primitive and to create a new world.

Gauguin was hardly taking a risk when he used this carefully argued change of heart as his preface, and the fact that he was involved in its production is borne out by the way he offered it to the magazine *L'Eclair* along with his own closely reasoned response.

Despite this little ruse, the effect was not what he and Strindberg would have wished. The sale on 18 February was sparsely attended, and only nine of the forty-seven works were sold. Degas bought two paintings and six drawings, including the copy of *Olympia*, and though the official receipts came to 2,200 francs, this included 830 francs that Gauguin paid himself when he was forced to buy in some of the works, under a variety of pseudonyms, in a desperate attempt to keep up the bidding. Even the

money taken was not all his, as there were expenses to be settled, and in the end the result came down to a paltry 464 francs and 80 centimes. He was obliged to concede that he would not be able to leave for Tahiti just yet and that his departure would have to wait until he had found some other means of raising money. To cap it all, he was ill again, and though he would never admit it he must surely have accepted at last that he was suffering from syphilis.

## Upa-Upa Tahiti

It was impossible to confuse the disease with heart trouble any longer – the skin around his legs had broken out in a form of weeping eczema similar to Strindberg's damaged hands. Such treatment as was available could only tackle the symptoms, not the underlying disease, which remained incurable, and Strindberg's account of his own enforced stay in a Paris hospital where he was surrounded by what he called 'a company of spectres . . . a nose missing here, an eye there, a third with a dangling lip, another with a crumbling cheek' – graphically evokes the terror which the disease provoked in its sufferers.

It was probably this, as much as anything, which finally convinced Gauguin that he should definitely go to Tahiti where there were some medical services, rather than the far more primitive Samoa which had virtually none. He now knew that no one would go with him – both Seguin and O'Conor had the sense to realize that they would be crushed by such a powerful personality and that in any case Tahiti was his, he had claimed it, and there was no room for a disciple to do anything there other than live in his shadow. If the obscure Englishman Studd had been in on the affair, then he too must have dropped out at this point.

The strangest thing about Gauguin's arrangements was his refusal to tell Mette that he intended to leave. He had sent her a tart little missive back in January complaining that he had had no Christmas or New Year greetings but she did not reply until she saw a press report of the Hôtel Drouot sale, whereupon she wrote to enquire whether he intended to send her some of the profits. His response was to send her a balance sheet to show how little he had made. He then accused her of abandoning him – a fine twist – and of being negligent in dealing with family matters. There is no record that she replied, though none of this really explains why he chose not to tell her he was going. She only found out after he had sailed, and was understandably aggrieved.

February drifted into March then into April. He had nothing much to do except wait for the disease to abate and a suitable boat to present itself. He would have only the residue of his inheritance and the slight

profit on his sales to sustain him and he knew that he would have to get
some sort of employment on Tahiti in order to survive. Jénot had now
been posted elsewhere, they had met briefly in Paris when the lieutenant
passed through, so life on the island was bound to be even more lonely
and difficult. Nevertheless, Gauguin's disgust with metropolitan life was
by then so total that nothing could deter him. Despite all the evidence
to the contrary, despite his undoubted role as the key figure in the new
art, he felt misunderstood and spurned. His paintings ought to have sold
and the money should have brought with it the visible status symbols
that attached to the famous Salon stars: large studios and country houses,
official positions at the Beaux-Arts and on the Salon jury. It wasn't
enough to be the unquestioned leader of several different groups of
artists, many of whom were far younger than he was. Perhaps that was
the trouble – they *were* so young, half his age in most cases. They had
flocked round him, taken what they needed from him, then gone off in
pursuit of their own fame. Even those acquaintances who were older
and of similar stature to himself seemed to take without offering much
in return. Strindberg learned a great deal from Gauguin's ability to cut
himself free in order to create. There is no doubt that it was Gauguin's
example which helped him get through his unpleasant divorce, as Strind-
berg took careful note of the way the painter had been willing to abandon
himself to new experiences, leaving for Tahiti to relaunch his art, to see
everything as if it were new, to surrender family, country, everything
for his work. But while Gauguin's example was part of the process which
enabled Strindberg to emerge from the period of despair and sterility
which followed the collapse of his marriage, one would be hard put to
say what, if anything, Strindberg offered to Gauguin. Likewise with
Delius, whose belief that the first duty of an artist was to find ways in
which his own personality could be forcefully expressed, was partially
drawn from his association with that powerful figure in the Rue Vercin-
gétorix. It is easy to draw a direct parallel between Gauguin's bold colours
and exotic subjects and the work that Delius would do. But yet again,
what could Delius offer Gauguin? On the contrary, these bright, creative
folk were exhausting, they took but did not give, leaving Gauguin little
time for reflection, let alone work.

The pace of change in the Paris art world in the 1880s and 1890s had
been wearying. It was a young world, most of these fledgling artists came
up with one idea, exploited it, made a name and went on developing it.
Gauguin had been throwing off ideas at a profligate rate for over ten
years now and he had had enough. As he said in his letter to Molard,
he wanted to paint for himself at last.

Perhaps more than any single irritation, the main reason for his decid-
ing to leave France for ever was because he had become the victim of

his own myth. Having set himself up as the wild savage, willing to go to the ends of the earth for his art, it was impossible for him to settle into the routines of the Paris art world, to become just another struggling figure desperate for exhibition space and the attentions of ever younger reviewers. Familiarity would only breed contempt; better to disappear. And if he had any lingering doubts about his decision, they were dispelled that June, when Emile Bernard launched his most vicious attack yet in the literary magazine the *Mercure de France*. Like a scorned lover, the increasingly obsessed Bernard was determined to show that Gauguin was no more than a plagiarist who had appropriated the ideas of others. Wisely Gauguin decided to let his supporters refute the charges in what became an exceedingly rancorous correspondence, but as it continued it can only have seemed to Gauguin that he would make a far better impression if he simply walked away from the debate by leaving the country, a sure way of proving that the petty squabbles of the Paris art world were beneath him and that he had far better things to be getting on with. He did, however, ensure that he would keep himself informed by using some of his remaining inheritance to buy shares in the *Mercure de France* and by arranging for his subscription copies to be sent out to Papeete. In addition, having decided to settle permanently in Polynesia, he went to some lengths to ensure that he would have everything he needed, both for work and comfort: packing those furnishings in the Rue Vercingétorix which Annah had not carried away, in order to set up a home and a studio wherever he would finally be. He also began to assemble an ever greater number of photographs and postcards, aware of just how little visual stimulus he could rely on once he settled on the island.

Despite these preparations, Gauguin might yet have backed away from so final a move, but the last straw came when he submitted his magnificent *Oviri* ceramic sculpture to that year's Salon, an act which provoked a confusing fuss. According to Charles Morice the piece was simply and categorically rejected. However, Vollard's memoirs suggest that it was included by Chaplet amongst the other work in his display cases but removed on the orders of the organizing committee. At this point, Chaplet threatened to withdraw all his own pieces, an unthinkable act by the country's leading ceramicist, forcing the committee to retract, allowing *Oviri* to be put back on display, though it is interesting that Vollard cites the failure of the Salon to accept Gauguin as the main reason why he went 'to the ends of the earth'.

Whatever happened, the incident with *Oviri* only served to confirm Gauguin's deep-seated sense of public rejection and hasten his preparations to leave. He finally decided to sail from Marseilles on 3 July and once that was fixed, a flurry of activity ensued as he attempted to

set his affairs in order. It has been suggested that he could have come to some sort of contractual arrangement with a gallery whereby he would have received a fixed income in return for work sent back from Oceania, but it is hard to see who would have taken him on. Durand-Ruel were not interested, and as Gauguin's later problems with Vollard show, the new dealer would never have been reliable enough for the task. It is easy to criticize the loose arrangements which Gauguin set up but difficult to see what else he could have done. He trusted people. That they later let him down was as much bad luck as bad judgement.

He managed to interest a few potential purchasers in some of his works but they were not well off and he was forced to let them have the paintings on credit, against the promise of future payment. This was not a prudent arrangement, as he would not be around to collect the money and the only people he could find to act as agents were hardly of the first rank. There was a man called Lévy in the Rue Saint-Lazare and an aspiring artist called Georges Chaudet who did a little dealing on the side, though neither was an especially brilliant choice and all Gauguin could do was hope that they would show willing. If everyone who owed him money paid up, he might get by for a time. It was all based on hope, there was nothing else now.

The worst situation of all was the confused state *Noa Noa* was in. Morice had been unable to finish it, though some sections had been reworked and under pressure a version could be shuffled together, though Morice insisted he would need more time to add-in further material before final publication could be attempted. Gauguin accepted this, carefully copying out what Morice had finished so far in a large format exercise book, big enough for him to eventually paste in his woodblock prints. He left pages blank both for these and for the remaining material Morice promised to send as soon as it was ready. He appears to have left Morice with the reworked and illustrated version of *L'Ancien Culte Mahorie* and to have let him hang on to the notes for *Noa Noa*, which Morice would later sell and which have only resurfaced in recent years. Gauguin did, however, give William Molard a special power-of-attorney to supervise the publication of *Noa Noa*, a sure sign that he no longer had complete faith in Morice. But even with that wise precaution, there can be no denying that as Gauguin prepared to leave for Tahiti, his affairs were in a mess, with so many complications that the potential for disaster was overwhelming.

The infatuated Judith observed all this through a veil of melancholy, awaiting the departure of the beloved as of the ending of life itself. There can be no doubt that he was leaving for ever – he was even taking the harmonium which he must have bought from Mucha, and had packed a number of things which were clearly meant to sustain him now that he

would never see Europe again. There was his guitar of course, but also a little painting of Brittany, a snow scene, as if he knew he would need to be reminded of a place and a season so far removed from the tropical island that was to be his home from then on.

Judith continued to have her painting lessons – he even let her help him restore the self-portrait by Van Gogh which the artist had sent from Arles. But as the dread day drew nearer, it seemed to her that he held her just a little tighter, with a little more passion. She asked him for a keepsake and he gave her a lock of his hair, vaguely gold coloured, in a malachite pendant, then asked for a lock of hers – but not from her head – 'the beard' as he delicately put it, telling her he would keep it under his pillow to bring him beautiful dreams.

Her parents gave a farewell party and . . . 'with death in my soul' . . . she served tea for the last time and watched entranced as Gauguin, who had managed to drink something stronger, danced the *upa-upa*. Little Paco Durrio wore a dress and make-up and sang languorous *malagueñas* and looked to Judith as if he was longing for Gauguin to kiss him, which was probably the case. Judith kissed him instead, as Durrio left with the others. They all went downstairs but when Judith tried to creep back up for a solitary adieu, her mother caught her and refused to let her leave.

Gauguin sensed her distress and on the day before he left, he took her alone to the local theatre and let her hold his right hand in both of hers. She didn't see much of the play, concentrating instead on his profile: 'to fill my eyes with the sight for ever. I would have liked to put my fingers through the bronze hairs, turning silver, which curl on his neck, but I couldn't do it in public . . .'

As they walked back he tried to tease her out of it, stopping to piss in the courtyard – a ritual, so Judith tells us – while she waited on the stairs, one step up, so that she could lean on his chest when he embraced her. Instead he took her straight inside and returned her to her waiting parents. She was bitterly disappointed. Everything about the departure turned to ashes – she had been saving the *sous* from her breakfast croissant to buy him some farewell flowers but when she went for them the next morning the colours seemed nondescript and she threw them away. As they rode in the bus to the Gare de Lyon, Paco started to weep, which made her start to cry too, yet somehow she sensed that she would survive – she had woken up that morning knowing that she was no longer a little girl; his leaving was the start of her maturity. Years later, she decided to replace the hair in the pendant with a lock of hair from her new love, the man she was about to marry, but when she opened it she found that an insect had got in and the little gold curl was nothing but dust and 'the spell was broken'. Judith went on to become a painter

herself and ten years after Gauguin's departure she met up with Annah
the Javanese who was still modelling – an ideal occupation, as Judith put
it, as it meant she had to do nothing but lie around. Fascinated to see
her again after all that time, Judith hired Annah to pose for her, intrigued
to listen to the incessant chatter about their mutual past. Annah revealed
how Gauguin had given her one of his portraits of her but that she had
been angry when they parted and had poked out the eyes and then
burned it. Now she was truly furious because she had been told it would
be worth a lot of money. There is a curious twist to this story, for the
nude portrait of her that Gauguin had made disappeared from the public
view for many years until it turned up with Vollard, so it may be that it
was the one picture which Annah took when she looted his studio, a fact
that she was now trying to hide by claiming it had been destroyed when
she was in fact planning to sell it to the dealer.

As her new portrait took shape, Annah chattered on and on until
Judith told her servant to let the poor thing sit in the kitchen and drink
herself to sleep so that there could be some peace at last.

Growing up amongst such wild characters did not help Judith settle
into anything like a conventional existence. The Swedish historian
Thomas Millroth has described how she upset people by showing them
how much cleverer she was, and how she defied convention by smoking
cigars and appearing in public in a man's hat, walking around with one
of Gauguin's carved walking sticks in a manner surprisingly reminiscent
of Mette. According to Millroth she made a prestigious marriage but
turned out to be a 'social catastrophe' for her husband Edouard Gérard
when he was governor of Algeria. On their return to France, after only
two years in the colony, they decided to live apart. Judith continued to
paint, though aside from being appreciated within the narrow circle of
expatriate Swedes in Paris, success eluded her. In later life her income
was much reduced though she always kept up appearances with some
style, even when drunk. As she grew older, Gauguin would sometimes
return to her in dreams. On occasions he was old himself, eighty, with
white hair; on others he was as she had known him 'in the splendid
maturity of his forty-seven years'. One thing which shines out from the
touching and passionate memoir which she wrote in 1949 is that whatever
his faults, Paul Gauguin was able to inspire others to heights of creativity
they seldom achieved elsewhere.

Equally sad was the most faithful of all the group, the little Spaniard
Paco Durrio. He was one of those chosen to act as an unpaid agent and
was left with about thirty of the works, among them the *Yellow Christ*
and the portrait of the artist's mother. What Gauguin could not have
foreseen was that the devoted little man was to be his wisest choice, for
Durrio hung on to his works, only parting with them years later when

extreme poverty obliged him to sell to survive. Before that, he had made them the link which connected the absent Gauguin to a whole new generation of young artists, including Durrio's fellow countryman, Pablo Picasso, who would ensure that the reputation of the lost Savage in faraway Polynesia was not entirely forgotten.

With wild abandon, Gauguin left for Marseilles in a first-class compartment. It was a final gesture, a last act of bravado meant to impress the grieving friends whom he knew he would never see again.

# Part Three

◆

# WHERE ARE WE GOING?

# 12

◆

# *The Translation of a Dream*

When the steamer *L'Australien* called in at Port Said before entering the Suez Canal, Paul Gauguin bought 45 pornographic photographs. There are several eye-witness accounts of the shock or amusement they aroused when finally hung on the walls of his last home, though the authors of these reports modestly forbore to leave details of what they had seen, perhaps unwilling to reveal that they had shown too great an interest in them. By today's raucous standards most nineteenth-century obscenity was pretty tame stuff: buxom ladies, a hint of amazing underwear, seldom what a connoisseur might call the real thing. Much of it was produced in France anyway, a great deal for export – lesbians for Spain, little girls for England – so that one wonders why Paul Gauguin should have wanted it, except as a joke, a talking point, or perhaps as evidence of the hypocritical moral code he was leaving behind?

The *Australien* had sailed on 3 July 1895, and by changing boats at various points, and by using ships of other nationalities, he hoped to avoid the long delays which were likely to occur if one travelled exclusively aboard French vessels. That he did not take the quicker and more certain trans-Atlantic route by boat, then train across America can only be explained by a desire to lose himself peacefully at sea for several weeks. He was tired, emotionally drained, and still suffering from the after-effects of the beating he had received in Concarneau, and the two-month cruise was no doubt intended to do him good. The *Australien* went as far as Sydney, there he changed to the *Tarawera* for the voyage to New Zealand, where he was to join the *Richmond*, which made the round trip: Auckland, Rarotonga, Tahiti, Rarotonga, Auckland, with a clockwork timetable, or so Gauguin believed. Unfortunately, when he arrived in Auckland on Monday 19 August, in the very middle of the wet New Zealand winter, he discovered that the boat was for once seriously delayed. On her last outward journey to Tahiti, high seas and a strong westerly wind had broken her crank shaft and while she carried a spare,

it would take time for it to be fitted and even after her arrival in Auckland she would then need a further period in dock for a final refit. As things stood, she was not expected for another ten days, with no guarantees on how long it might be before repairs were complete. Gauguin was stuck indefinitely, in a cold, damp, British-style city, a prospect he viewed without relish.

## Among the Maori

He moved into the Albert Hotel, a large three-storey building on Queen Street, then as now the city's main commercial thoroughfare, which ran up from the quayside where the *Tarawera* had docked. The Albert (later the Coburg Hotel and now the Mid-City Centre) advertised itself as having 'the most central position in the city' with 'private suites for families'. Given that there were smaller hotels near by, or even seamen's lodgings on the harbour, one wonders why Gauguin chose somewhere so stuffily bourgeois, and so unnecessarily expensive. His total indifference to New Zealand is also a little puzzling. Even allowing for his desire to escape from the modernity of Europe, it is hard to accept that he could show no interest at all in a city which had made such obvious progress. From the imposing offices along the harbour front, to the horse-drawn trams which ran up and down Queen Street past the elaborate clock-tower atop the New Zealand Insurance Company, everything offered a vision of organization when compared with the rough-and-ready frontier feel of Tahiti's only town. Had he glanced at the *New Zealand Herald* of Tuesday 20 August, which listed him amongst the passengers who had arrived the previous day, the lone 'foreigner' amongst all those British names, he would have seen that the country was enjoying an economic boom. Entire pages were given over to advertisements for agricultural equipment and for all those important products so essential to Anglo-Saxon life: Beecham's Pills 'for Biliousness and Nervous Disorders' and Ayer's Sarsaparilla, 'a renowned restorative'. He would also have discovered that Auckland had just beaten Wairoa at rugby with over 3,000 spectators cheering them on, though this was no doubt what he most disliked – the sheer Britishness of the place. But this does not explain why he was so blind to the equally obvious fact that no matter how British Auckland might seem, New Zealand was still the largest of all the Polynesian island groups and home to the Maori, ethnically linked to the Tahitians, and the one Polynesian people to have kept their cultural identity reasonably intact. Of course, Auckland was not visibly a Polynesian city. In the nineteenth century the Maori lived on their tribal lands, in areas distinct from those formed by the Pakehas – the whites. But it was not beyond Gauguin's wit to have learned that

these were places where Polynesian art still flourished and to have made some effort to see something of it. But no, he stayed close to his hotel waiting for news of the *Richmond* and sulked, rather like a modern-day traveller forced to hang around an airport, constantly on the look-out for word of a long-delayed flight. Bored and listless, he poured out his dissatisfaction in a letter to William Molard written a few days after his arrival:

My dear William, my dear Ida, my dear Judith,

I embrace you all and am writing to you from here, that is to say Auckland, New Zealand, where I have already been for eight days and for eight days the steamer for Tahiti has been supposed to arrive but has not. And it is cold, and I am bored, and I am spending money stupidly, to no purpose.

And how dirty I am; impossible to get any laundering done because of the uncertainty about departure and my trunks are in the customs. I am managing with the little English that I know, but it's hard and long – travel by America – it will be cheaper and quicker. There's always an element of uncertainty in this route.

When this letter arrives you will probably be in Brittany, at the end of your holidays. I hope the three of you have enjoyed yourselves.

I'm not going to write you four pages, I'm travelling and so in a lethargic state.

I embrace you. Write to me by the next mail.

P. Gauguin

As usual, he was exaggerating his miseries. He had not been in Auckland eight days as he claimed: the *Richmond* berthed at the Queen Street Jetty on 25 August, only six days after his arrival, and was floated into the nearby dry dock for final repairs the following day, all of which Gauguin would have known. She was expected to sail on Wednesday the 28th and this seems to have jolted Gauguin out of his avowed lethargy and goaded him into seeing something of the city before it was too late.

On Monday 26 August, as the *Richmond* was beginning its refit, he walked a few blocks up Queen Street, climbed the steep little incline to the corner of what were then Coburg and Wellesley Streets and entered the ornate Victorian building on the edge of the Albert Park which housed the city's library and art gallery. Having signed the visitors' book in the lobby, he sauntered round the mixed bag of works, mostly assembled by two benefactors: an ex-governor, Sir George Grey, who had donated his personal collection, and a businessman, James Mackelvie, who had sent back from Europe a number of purchases, including two paintings by Guido Reni: *The Christ Child Asleep* and *Saint Sebastian*.

One cannot imagine Gauguin being much impressed with these nor with the sweetly romantic landscapes painted by early visitors to New

Zealand who had seen this new world very much as if it were the old one they had left behind. But Sir George Grey had also donated his collection of small Maori artefacts, and these may have been on display in a room on the ground floor which was then called the Old Colonists' Museum. This could have been Gauguin's first sight of Maori art, but if it was he left no recorded reaction to it, nor to anything else he saw in the gallery. By contrast, when he climbed Coburg Street, to its summit where it crossed Princes Street, he had another of those epiphanies that punctuate his creative life. At this vantage point, overlooking the town and the harbour, stood the Auckland Institute and Museum. Far less imposing than the ornate City Art Gallery, the simple classical façade of this modest two-storey building was more reminiscent of a provincial bank than a major cultural institution – though that was deceptive, for what Gauguin was about to see was precisely what he had been longing for since he first arrived in Polynesia.

Even before he walked up the few steps to the main entrance, he was confronted by a wealth of Maori imagery, lying about on the street in front of a shop, near to the Institute. This two-storey wooden building had a sign: CRAIG'S MUSEUM over its portico and spread before it was an intriguing collection of Maori wood-carvings. This was not exactly a rival, but a business which advertised itself as a 'Fern and Curiosity Shop'. Although Craig had rather grandly called his emporium a 'museum' he actually sold souvenirs, from pressed botanical specimens, especially the famous giant New Zealand ferns which were immensely popular in the Victorian era, to all manner of 'Maori Carvings and Curios'. Laid out on the narrow strip of land in front of the shop they must have attracted Gauguin's eye as soon as he approached the official museum.

Although lumped together as 'curios', what Craig actually offered was a mix of traditional carvings along with specially commissioned pieces from Maori centres such as Rotorua, pieces made with the tourist market in mind and thus carefully avoiding anything that might offend European sensibilities over the depiction of male and female sexual organs. But despite their newness, they must have convinced Gauguin that these were far from the pathetic tourist trifles produced on Tahiti. Curios they may have been but some of them were art for all that. Had he taken the trouble to find out, Gauguin might have realized that this was part of a fascinating process of adaptation which had helped save Maori culture from the total extinction experienced by their fellow Polynesians on the Society Islands. New Zealand's Maori art had a far stronger and more refined tradition of carving then elsewhere in Polynesia: finely worked greenstone *tiki* figures to be worn as pendants, colossal sculpted wooden figures that bestrode entrances to tribal compounds, and intricately inter-woven figure friezes in deep bas-relief on the façades of important build-

ings – chief's dwellings or communal store-houses.Not only were they far superior to anything the Tahitians had ever produced; such art was still a living tradition.

Gauguin had arrived in New Zealand fourteen years after the end of the land wars by which the Maori had unsuccessfully attempted to hold back the settlers. Yet even as further waves of white farmers were moving onto what had once been Maori land, a form of cultural resistance was being set up. Much of this was based on the exceptional tradition of wood carving which helped provide social cohesion through the establishment of communal meeting houses. These were elaborately decorated by the finest surviving wood carvers who in turn trained a new generation of artists to carry on the tradition.

By 1895, this wave of construction was largely complete and many of the carvers who had learned their craft in this way were now happy to earn a living producing curios on demand. But this ensured that the art form continued and it was a fascinating situation which could have had some bearing on Gauguin's desire to reinvigorate Tahitian art. Sadly, he made no effort to go any deeper than the average visitor, content to see only the surface qualities of the carvings, to admire the skill of those who had produced them, without making any moves to learn who had produced them or why.

When Gauguin entered the real museum he found a curious mix of European and Maori art, largely made up of donations presented over the previous thirty years, set out in two large galleries, the second running at a right angle to the first. The Annual Report of the Museum's Council covering the year of Gauguin's visit gives some idea of this cultural jumble:

> At present the centre of the main hall is chiefly occupied by the collection of plaster casts of Greek statues presented by Mr T. Russell CMG. This collection, in many respects an admirable one, is altogether out of place in its present situation, surrounded by stuffed birds and animals, and of necessity arranged in such a manner that its use by art students is greatly limited.

A photograph taken some time after 1885 shows a skeleton of a by-then extinct giant Moa, staring sightlessly at the Apollo Belvedere, while the Discobolos seems poised to cast his discus at an elaborately carved *pataka* or Maori ceremonial store house. By Gauguin's day, the ethnographical collection, including a second *pataka*, had been placed in the new hall, added in 1892, primarily to house the great east coast Maori war canoe: *Te Toki a Tapiri* which, at eighty feet, was the largest exhibit in the collection. Yet despite this greater spaciousness, the disposition of the two halls, the one opening into the other, meant that the overall effect

was still of an explosive mix of cultures – statues of Maori ancestor figures glimpsed through the white limbs of a Greek goddess, the whole thing presided over by the terracotta busts of their Royal Highnesses, Edward and Alexandra, the Prince and Princess of Wales on their plinths under the ledge of the upper gallery.

Of course, in some ways, it was Gauguin's fantasy world made, if not flesh, then at least bone, wood and plaster-of-Paris – a mix of cultures, faiths, styles and histories, all brought together in two silent rooms, a *musée imaginaire* he might well have dreamed up to pass the weary days of waiting. It certainly pleased him, for he took out a small sketch pad and began to scribble down some of the images which caught his fancy: parts of the figures of the fascia boards that fronted the steeply sloping roof of one of the *patakas* and a carved bowl made slightly comic, like a squat figure in a bowler hat. There may well have been a great deal of similar stuff but only six pages of the pad have survived and only four have recognizably Maori elements. But we know that this encounter with Polynesian art went much further than just a passing amusement. He had found what he had long been searching for and we know that he was much taken with some of the more imposing pieces in the collection – the reclining figure on the carved stern-board of the war canoe, and the monumental statue of Pukaki and his Children, a *tiki* of one of the main ancestors of the Te Arawa tribe, which had once stood over a gateway in Rotorua, the tattooed face sternly threatening any who approached the compound with evil intent while the two children Pukaki clutches to his breast symbolized the continuity of the tribe. Probably carved in the 1830s, this stunning image still dominates the vast hall where it is now exhibited, in the present museum which was opened in 1929, but in the narrow confines of the old museum, in Gauguin's day, it must have seemed truly awesome.

Both the war canoe and Pukaki were undoubted masterpieces of Maori traditional art, but Gauguin was equally drawn to the newer curio pieces that were then mixed in with the collection. He was especially taken with a large carved wooden bowl based on a *kumete*, a traditional cooking bowl similar to the Tahitian *umete*, but obviously far too ornate to have any practical use. Its side handles were carved figures with two other forming an arched handle over the lid, all safely bereft of any of the anatomical details that so offended Pakeha sensibilities – understandably as the bowl had been intended as a gift for Sir George Grey, the governor, and had been commissioned from Patoromu Tamatea, a famous carver working in the Rotorua area, though for some reason the gift was never made and the museum had been given the piece on permanent loan.

Other pieces which caught his attention have been identified from the

surviving pages of his sketchbook – a smaller round bowl, an elaborately decorated egg-shaped container held by two figures standing on the back of a dog, and a carved oblong box. Such work differed from traditional sculpture largely as a result of the exchange of stone and bone tools for forged metal knives and chisels which allowed more complex figures to be teased out of the wood. Where before a carver had been obliged to work with his material, to go with the grain as it were, producing work which had a natural organic truth, the new sharper tools replaced this elegant light simplicity with audaciously twisted and intertwined elements. The results were clearly pleasing to Victorian taste, though one might have expected Gauguin, the ceramicist who loved simple stoneware, to have been less easily won over. The main attraction was probably the sheer audacity of the work, the strange and inventive ways in which figures and animals were juxtaposed, with no reference to the conventions of Western art.

What remains puzzling is why, having discovered and admired these things, Gauguin made no effort to find out more about them. Why, having discovered the greatest collection of Polynesian art then in existence, did he not try to find out more about it, before his boat sailed? He could have found someone at the museum with a knowledge of the subject, even the people in Craig's 'museum' would probably have helped him visit at least one of their Maori carvers before his ship sailed in two days' time. Even when travel was still difficult, there were Maori settlements within a day's ride of Auckland where he could have met someone like Patoromu Tamatea, had he truly wished to see what he had always claimed to miss on Tahiti. One is left with the conclusion that Gauguin was less concerned with the inherent meanings of the works he admired than with his own reactions to them. What the Maori episode makes clear is that Gauguin had left Europe not to find a new art but to free himself from the claustrophobic pressure of the old, to enter a void which he could fill with himself. With the Auckland sketchbook and whatever photographs he had managed to purchase at the museum he again had the sort of images – suitably free of any restricting knowledge of what the things might actually mean – that would enable him to begin again the imaginative work he had been doing before his return to France. Without this accidental New Zealand interlude Paul Gauguin's time in Oceania would have passed with only the vaguest imaginings of what it was he was attempting to reinvent. Now he had a collection of real Polynesian images to set beside those of other cultures – the Buddhas and Egyptian figures, the Parthenon friezes and the Breton calvaries and the Peruvian vases. None was understood in the way its makers had conceived it, but all were given equal value. Where before, all things Polynesian had had to be entirely invented, now there was an

authentic visual vocabulary which he could draw on as he saw fit.

And there was one other, equally important effect of that brief stay: his encounter with Maori art had finally convinced him that he should go to the Marquesas Islands. It was easy to draw a comparison between the photograph of the tattooed Marquesan he had once shown to Jénot, and the incised face of the monumental statue of Pukaki. Why then should he not find something similar to that wonderful sculpture on those distant islands? When he boarded the *Richmond*, on Thursday 29 August, Gauguin had already decided that he would stay on Tahiti just long enough to arrange his onward passage.

## Treading Water

From the moment the *Richmond* docked at Papeete's little passenger jetty, everything Gauguin saw convinced him of the rightness of this decision. In a mere two years, progress had struck – the mayor, Cardella, and his settler friends might not like the governor spending their money, but they were quite happy to plough funds into improvements which they thought would be good for business. Under an energetic head of Public Works, Jules Agostini, like Cardella a Corsican in origin, street lighting with Parisian lamp standards had gone up, unhealthy dwellings were being pulled down, roads resurfaced and the open parks where animals had been corralled before going to the slaughterhouse were being closed and replaced by a proper abattoir. To Gauguin, this union of Cardella and Agostini was just a colonial version of Napoleon III and Haussmann, the same disruption, the same mad scramble for an illusion of modernity.

There was change at every level. After Lacascade's ignominious departure, Paris had hastily ordered the Director of the Interior, Adolphe Granier de Chassagnac, to step in as acting governor. He had prudently allowed Cardella his second election but this had produced another deeply divided municipal council which spent so much time on in-fighting they were hardly able to find a moment to pursue their usual task of trying to undermine the governor. Despite his malleability, Chassagnac had lasted less than five months and there were two further short-lived stand-ins before the arrival of the extremely likeable Clovis Papinaud, a professional politician from the south of France who changed places with Lacascade as Governor of Mayotte, and who knew just how to win over any potential enemies. Soon after their arrival, Papinaud and his wife toured the island, talking to everyone and handing out gifts as if he were running for local office in his native Charente-Maritime, rather than making the usual arrogant gubernatorial progress. Papinaud was less concerned with social status than some of his predecessors such

as Lacascade. As a result the newly returned Gauguin was to find his plans radically altered with the unexpected arrival of an invitation to join the governor and a large party of officials and notables, leaving Papeete on 26 September, on a visit to the outer islands.

Raiatea-Tahaa, Huahine and Bora-Bora had continued to resist French hegemony since Lacascade's unfortunate attempt to annex them seven years earlier and since that failure, the colonial authorities had chosen reticence rather than bluster. Now it was felt that the time had come to risk another formal encounter. To facilitate the process, Paris had despatched Isidore Chessé, who had been the first civilian governor of Tahiti and the man who had successfully persuaded the drink-sodden Pomare v to abdicate his throne. Glorified with the title of Commissioner-General of the French Republic in Oceania, and kitted out in a splendid gold-braid uniform, Chessé was thought to be the ideal person to deal with Teraupo, Chief of Raiatea-Tahaa, who had set up what was virtually an independent state, able to exact payment from ships and to permit a commerce in contraband which gravely undermined Papeete's businessmen, who were obliged to pay Lacascade's import duties, only to find cheaper goods being smuggled in via this rebel enclave. In reality, many of those businessmen had now come to terms with the situation and simply used Teraupo's island as a duty-free staging post from where they moved goods to Papeete, thus depriving the colony of considerable revenue.

The party set sail aboard the battleship *Aube* on 26 September. The crossing to Huahine took only a night and the following morning, Chessé in his braided uniform and plumed tricorn hat stepped onto the beach where he was greeted by the 'little' Queen, Taahapape II, and by interminable speeches from her court orators. After the official replies were made, the party, including a fascinated Gauguin, trooped up to the queen's residence where her official submission was accepted, her flag taken down and the French *tricolore* formally raised. Champagne was drunk and the rest of the day was taken up with perusing and signing official documents while the fellow-travellers were free to see the sights.

The following day, 28 September, a long and copious banquet was held, with singing and dancing. The visitors were offered the traditional garlands and Agostini, the Director of Public Works, took an unintentionally amusing photograph of a line of portly French officials in their tropical whites looking rather sheepish under the crowns of exotic flowers which had been placed on their heads. Before boarding the *Aube* that night the ceremonies ended with fireworks, much to the delight of the queen and her people.

This entire scenario was repeated on 30 September when they weighed anchor before Bora-Bora, famously the most beautiful of all the islands.

This was traditionally the site where Oro descended the rainbow to find Vairaumati, one of the stories which Agostini would recount in his later collection of folk-tales. In his report of the voyage, in his book *Tahiti* published in 1905, the Director of Public Works makes it clear that he admired Gauguin for the 'undoubted talent' with which he had painted the same subject, a remark which suggests that it may have been Agostini who had arranged for him to join the party.

According to Gauguin, in a letter to Molard, the local queen not only offered her submission to French rule but also temporarily annulled all marriages on the island so that the visitors could enjoy a traditional Polynesian welcome. This, so Gauguin claimed, led a number of husbands to lock away their wives for the duration.

There was no joyous welcome, no pompous speeches, no lavish banquet and no annulled marriages on Raiatea and its sister-island Tahaa. Worst of all they found a home-made British flag, albeit upside down, flying from a pole stuck in the sand. The only greeting was a sullen encounter on the beach with the queen of Avera, a sub-district on the island, the only person of consequence to turn up, as the real rebel leader Teraupo had wisely hidden himself away while the *Aube*'s guns were trained on his stronghold.

Despite the weakness of her position, the queen stubbornly refused to allow the flag to be taken down, or to accept that the French flag should be raised in its stead. Chessé argued all day but she remained implacable, though this had nothing to do with the usual rumours about Protestant missionaries and English plots – the commissioner-general had been out-manœuvred by the business community in Papeete who liked the present situation and knew that Paris wanted to avoid the use of force at all costs. On their own, the rebels would surely have been cowed, but the real enemy back in Papeete had seen through the whole thing and had advised them to resist, sure that Chessé would have to withdraw. Hoping that further persuasion might work, Chessé decided that the somewhat unmanageable bunch of hangers-on would best be sent back to Papeete.

In the end the negotiations dragged on for nearly three months before Chessé steamed back to Tahiti on Christmas day, to prepare for his return to France. The two islands remained an irritant to the administration for another two years, until a landing party occupied them by force and put an end to the last resistance to French rule in the region, though one suspects that Gauguin was far from sorry to see these representatives of so-called civilization held at bay by a handful of determined natives.

## A Change of Plan

Gauguin and his new friends had already returned to Papeete on 6 October, having enjoyed the journey and the chance it had brought him to meet some of the more sympathetic people who were now employed in the colony – Agostini of course, but also another keen photographer, the 25-year-old Henry Lemasson who had come out to Tahiti the previous year on secondment from France and who was now working in the main Post Office in Papeete. Young and energetic Lemasson had already won praise for his initial improvements and in later years he would completely restructure and modernize the island's postal services. He eventually abandoned photography save for a famous series of postage stamps which he issued, using his most popular plates, some of which are still reproduced today, blown-up as postcards for sale to tourists. In Gauguin's time, the young Lemasson was interested as much in art as in parcel deliveries and mail-ship timetables and as such he was immediately drawn to Gauguin whose arrival was a welcome addition to the limited cultural life of the colony. Nor were the two photographers alone; aboard the *Aube* had been two magistrates who had arrived the previous year and who both had artistic leanings: Edouard Charlier, who painted, and Maurice Olivaint, who wrote melancholy poetry in a Symbolist vein.

Charlier in particular was a most sympathetic character, despite a calling which was usually the province of the harsh and the intolerant. He had been a colonial magistrate since 1887, first in Indochina, then La Réunion, before becoming a senior judge in Papeete in 1894. In his first year, he had already gained a reputation for fairness in his dealings with the local population and an unwillingness to favour the settlers in any dispute. Originally he and Gauguin got on very well, with the artist making gifts of paintings to the judge, probably as thanks for loans. The other new magistrate, Maurice Olivaint, had already had some of his poetry published before he came to Tahiti. His collection of verse written on the island, *Les Fleurs de Corail*, would come out in 1900, with a central section based on Polynesian legends, surely drawn from Moerenhout, but probably much influenced by Gauguin's paintings as well. The inevitable consequence of finding such interesting companions was the decision to delay, indefinitely, his departure for the Marquesas. He had now settled into one of Madame Charbonnier's 'cabins' and it was easy to find excuses – the only available boats were uncomfortable tubs and if he waited a little longer something better might be on offer. In any case, with his health rickety and his leg still giving him trouble, it might be wise to stay close to the hospital in Papeete, the only one in the colony. Though not *too* close, for the old problem of money remained. The town was

still expensive and if he was to eke out his days on the island, he would have to get back to the countryside once more.

## By the Side of the Road

This time there was to be no delusion about finding some wild abandoned place – he knew that that was impossible on Tahiti itself and saw little reason to make long uncomfortable journeys every time he needed to collect his mail. The problem was that land near to the town was much sought after. Out along the southern road, the plantations were often communally owned and not for sale or rent, so that he was fortunate to find a Frenchman living in the village of Punaauia, a mere twelve and a half kilometres from Papeete, who owned a vacant plot near his own home, which he was willing to let out. The situation was superb, only two kilometres further on from the valley of the Punaruu, which he had climbed three years earlier, and one of the rare places where the seemingly impenetrable mountain range opened up to allow a wide view of the interior. Punaauia was the site of the great battle which had brought Pomare I to power and where he burned a vast array of idols and other art objects to show his gratitude to the Christian God, who he believed had brought his victory. Gauguin's plot lay between the Catholic and Protestant churches, though at least he had the advantage of a Chinese store on the other side of the road. Best of all was the view across the lagoon to the island of Moorea, especially at sunset.

It was a small matter to hire local people to run up a dwelling using the traditional bamboo canes for the walls and plaited palm leaves to make a thatched roof. There is a surviving photograph by Jules Agostini which shows a construction in two sections: the living quarters, which have a slightly rounded gable like a local *case ovale*, though with a row of very untraditional windows, and an adjoining, larger section with a latticed veranda which was his studio. Despite its simplicity he was touchingly proud of his first effort at architecture and described it in glowing terms in his first letter to Monfreid that November:

> It's beautifully located, I must say, in the shade, by the side of the road, and behind me there is a gorgeous view of the mountain. Just picture a large sparrow cage made of bamboo grillwork and having a coconut-thatch roof, divided in two by the curtains from my old studio. One of the two parts makes a bedroom, with very little light, so as to keep it cool. The other part, with a large window up high is my studio. On the floor, some mats and my old Persian rug; and I've decorated the rest with fabrics, trinkets and drawings.

The letter also indicates that he was finding it hard to get any work done. He told Monfreid that he had finished some 'stained-glass' by which he probably meant that he'd painted over his windows yet again. That aside, he seems to have kept to his decision to be a wood carver, rather than a painter, still under the influence of the Maori sculpture that he'd seen in Auckland. The only known work from those last months of 1895 is a carved wooden cylinder on which he again brought together disparate cultural and religious sources – on one side a crucifixion above which are decorations taken from a Marquesan ceremonial war club, while on the opposite side is a *tiki* figure not dissimilar to the standing statue of Hina which Gauguin had devised on his previous visit. With its mixture of elements: signs based on Easter Island script, grinning *tiki* faces, a possible self-portrait, the cylinder was probably an attempt to bridge his passage from Paris to Tahiti while paying homage to the intensely decorated pieces he had seen on the Maori store-houses in Auckland.

The oddest element of all is near the top of the cylinder, between the crucified Christ and the *tiki* figure, where Gauguin carved a disembodied foot with a hand grasping its ankle. An explanation for this can be found in an account written later by the post-master Lemasson, who was one of the first to notice that something was wrong with the artist. Gauguin was in the habit of putting on his version of European clothes, a white vest and trousers, canvas shoes and straw hat, and going into Papeete to the post office whenever a mail boat was due. Lemasson soon noticed that his new friend had begun to hobble and soon needed a stick to help him get around. As yet, only Gauguin was aware that a particularly nasty form of weeping eczema had broken out on his lower leg, due as much to the persistent effects of syphilis as to the shattered ankle and damaged shin. He omitted to mention this in his letter to Monfreid, though he did give some indication that all was not well when he described how he had sent for a former lover but that she had not been prepared to stay with him:

> The woman I lived with before has got married in my absence and I've been obliged to make a cuckold of her husband, but she can't live with me, although she did run away for a week.

Again it was the anthropologist Bengst Danielsson who in the 1950s came across a man called Ma'ari who had married Teha'amana after Gauguin's departure for France in 1893. She had stayed in Mataiea where she had been working as a servant for Chief Tetuanui. Ma'ari told Danielsson that his wife had gone back to Gauguin but the discovery that he was sick, and for reasons that she could well imagine, drove her back to Mataiea and her young husband. It was a sorry end to what had

once been an ecstatic love affair, though Gauguin tried to shrug it off. As he told Monfreid:

> Every night frenzied young girls invade my bed; last night I had three of them to keep me company. I'm going to stop leading this wild life and install a more responsible woman in the house and work like mad, especially as I feel in tiptop shape and I think I'm going to do better work than before.

There was a good deal of bravado in this. With the unpleasant sores on his leg it is unlikely that bevies of young girls were throwing themselves at him, nor was he feeling as good as he claimed. But it was certainly true that he wanted to get his domestic affairs sorted out and early in the new year 1896, one of the local girls was persuaded to move in with him. He called her Pahura, his version of Pau'ura, and claimed that she was thirteen, though her birth certificate in the *Etat civil central de la Polynésie Française* shows that she was born on 27 June 1881, which made her fourteen and a half when Gauguin met her. However, she was still very young, almost young enough to fulfil his long-held fantasy, and because of her youth and the fact that she accepted to share a bed with someone who was increasingly physically repellent, it has been easy to assume that she only tolerated the situation because of his money and the easy life it gave her. It is true that what little we know of Pau'ura hardly adds up to a tale of great love. Gauguin's occasional comments in his letters are dismissive to the point of disparagement. Later accounts say that she was more often with friends and family than at Gauguin's hut, but there are other signs that it was a little more complex than that. Years after his death, when a visitor to Tahiti tracked her down, by then an old woman, still living in Punaauia, breeding guinea pigs for a local Chinese trader, Pau'ura referred affectionately to her one-time lover as *Coquin*, her version of Gauguin, but also French slang for 'rascal' – which would seem to indicate that she had got his measure, and had been content. As for money, he rarely had any, and though he was, by her account, generous if any came, most of the time it was Pau'ura who went off in search of food – mainly fruit – for them to survive on.

He was certainly squandering his savings on a fine old scale, having acquired a horse and cart to ease his journeys into Papeete and playing host to whoever happened to drop by – there was a 200-litre cask of claret just inside the door of his hut which was dispensed to visitors and replenished as soon as empty, an expensive habit on an island so far from the vineyards of France. But even if he did not have a burning passion for Pau'ura, nor she for him, she nevertheless inspired a portrait which he was convinced was the best thing he had so far done, better even than his portraits of Teha'amana.

## A Voice from the Past

There is no single reason why Gauguin suddenly abandoned his plan to make wood carving his primary activity and took up painting again. He had certainly believed that he had done enough in Brittany and on that first Tahitian visit to ensure his reputation and that he no longer needed to struggle so hard to establish himself. But that was shattered with the monthly arrivals of his subscription copies of the *Mercure de France*, which he devoured avidly, though rarely to his satisfaction. Even before his departure he had sensed that the sections of the magazine devoted to art were not leaning his way. The resident gallery reviewer, Camille Mauclair, seemed to be actively opposed to him and sympathetic to those he considered his enemies. The fact that the *Mercure* was willing to offer a forum to Emile Bernard worried Gauguin. It was Bernard's 'Lettre ouverte à M. Camille de Mauclair', published in the June 1895 edition, with its intemperate assault on Gauguin's reputation and its ridiculous assertions that he owed everything to Bernard's ideas, which had been one of the deciding factors in Gauguin's final departure from France. It marked the start of a conflict with the magazine, of which he was, ironically, a shareholder. Gauguin knew that Leclercq intended to reply on his behalf, in the July edition, though he may not have seen it before he sailed, and there was more than a month's gap before the post could get it to him by the sea and land route across America. Infuriatingly the August edition, which he probably received in late September or early October, contained a further response from Bernard who was then living in Cairo but still within easy postal reach of Paris. As succeeding copies of the magazine caught up with Gauguin, his own views seemed to be decreasingly on offer but it was not until the last edition of 1895, in December, that Mauclair finally made his own position abundantly clear. In a favourable review of Cézanne's latest work at Vollard's gallery, Mauclair listed his influences: Whistler, Gustave Moreau, Monet; but then, for no reason at all, he threw in a last paragraph which was nothing less than a snide attack on Gauguin, stating that he owed everything to Cézanne and Pissarro, and finishing with the damaging claim that whereas Gauguin had merely fiddled with his sources in order to sell his canvases, Cézanne had created something new and that he, Mauclair, much preferred that.

Gauguin must have been devastated. Cézanne had influenced him years ago but had quickly been left behind and even Pissarro would not have claimed any credit for Gauguin's work after the *Vision*, which was the very antithesis of everything the older man believed in. But truth had no part in it. Mauclair seemed to be saying pretty much what Bernard had been shouting from the rooftops: that Gauguin was a plagiarist with

no originality of his own. It was a challenge someone of Gauguin's combative temperament could hardly ignore.

His response was two-fold, in the first instance he began to bombard the editor of the *Mercure* with complaints about his shabby treatment, both as an artist and a shareholder, but his second line was to take up his brush intending to show these newcomers and critics just who they were dealing with.

## The Noblewoman

In a letter to Monfreid, some time around April 1896, Gauguin provided a sketch and a description of the portrait of Pau'ura which he had recently completed:

> I have just finished a canvas of 1.30 by 1 metre that I believe to be much better than anything I've done previously: A naked queen, reclining on a green rug, a female servant gathering fruit, two old men, near the big tree, discussing the tree of science; a shore in the background: this light trembling sketch only gives a vague idea. I think that I have never made anything of such deep sonorous colours. The trees are in blossom, the dog is on guard, the two doves at the right are cooing.

We may add that the figure holds a large red fan, a sort of personal nimbus, behind her head, its colour echoed in the clusters of mangoes scattered on the grassy slope before her.

There is no dispute about the art-historical sources – the pose of the reclining Pau'ura is taken from works by the German artist Lucas Cranach the Elder, reproductions of which were part of Gauguin's 'little friends'. But it has also been universally recognized that the queen on her grassy couch is another challenge to Manet's *Olympia*. This time there is no attempt to shock, as there had been with *Manao tupapau*, when Olympia's self-confident independence had been replaced by the terrified girl on the bed. In this new painting, which he called *Te arii vahine* (*The Noblewoman*), all of Olympia's assurance has been preserved, even enhanced. Just like the original, Victorine, Pau'ura returns the gaze of the curious with a look of commanding assurance – hence her status as a noblewoman, or queen as Gauguin sometimes referred to her. Why else the title, why else the saintly nimbus around her head, or the fan, symbol of Polynesian aristocracy? We are once again in the Tahitian Eden with Pau'ura as Eve, and the mangoes on the ground before her as the forbidden fruit, already plucked. Far from showing shame or fear, this Eve has no cares at all, she is liberated from the consequences of the Fall, it has passed without notice. The rich decorative detail and the 'deep sonorous colours' show that this is a joyous work which celebrates

its subject's freedom, rather than manifests her bondage. If this is Pau'ura, then she is not some renegade slut, but a young woman with a will of her own, like Victorine Meurent.

## Why Are You Angry?

The challenge to *Olympia* may well have been Gauguin's attempt to refute the Bernard/Mauclair charge that he was a mere plagiarist. *The Noblewoman* was a means of showing that he could start with another's work and completely transform it, and this was probably what lay behind a group of paintings of a fisherman and his family which clearly have Puvis de Chavannes as their starting-point. Gauguin probably saw Puvis's *Le Pauvre Pêcheur* at the Salon of 1881 and we know from one of his letters to the art critic André Fontainas that at about that time Gauguin met a rather disillusioned Puvis who was complaining that no one seemed to understand the painting, the inference being that they were looking for hidden meanings in a work that was essentially simple and sentimental.

It may well have been the memory of that conversation, and the resonance it now had with his own sense of rejection, that decided Gauguin to adopt the subject, making three versions in all.

With Manet and Puvis disposed of, Gauguin might well have turned to Degas, the other 'master' he most admired, but something happened which succeeded in redirecting his thoughts, leading him towards a way of working that was completely new. By April, or at the latest early May of 1896, Gauguin knew that Pau'ura was pregnant but this time his reactions were radically different from those which had greeted the expectation of Teha'amana's child. Far from producing another image of 'motherhood' he reworked a painting he had made in 1891 of a simple village scene but this time he peopled the compound before a hut with groups of women and called it *No te aha oe riri* (*Why Are You Angry?*). The title is essential to our understanding, because it is clearly the question being put by a seated woman to her companion who is certainly displeased with her lot. Her hanging breasts and extended nipples show the effect of child rearing and her anger comes from having to watch a woman stroll by, elegantly attired in a brightly coloured *pareu*, a purse dangling at her side, a flower at her ear, whose pose and manner proclaims the liberty that the exhausted mother has surrendered. To drive home the point, Gauguin has added two groups of hens, those near the mother are obliged to watch over their chicks, while a second group – childless as it were –are free to forage at will.

The painting is extraordinary in that it completely by-passes the air of joyful anticipation that male artists usually ascribe to childbirth and attempts to unveil some of the confusions which must have been going

through Pau'ura's mind. Indeed the painting is the exact counterpoint to *The Noblewoman* which had offered an image of Pau'ura as a free and independent spirit, her own mistress. The two canvases are exactly the same size, 96 centimetres high by 130 centimetres long, far longer than usual, which adds to the suspicion that they are in fact a diptych, each side a mirror-image of the other. Interestingly, one of the Fisherman paintings was the same size, which raises the possibility that Gauguin was contemplating a series of related works, perhaps a unified exhibition that would completely dominate the viewer, obliging him or her to surrender totally to his unique vision, and thus remove any possibility of a repeat of the Durand-Ruel experience where the strolling Parisian dandies had been able to single out and scoff at any stray details that caught their savage humour. Reading Mauclair, it must have seemed to Gauguin that these scoffers were still refusing to see his art as anything but an eccentric off-shoot of Impressionism. What could be more understandable than that he should now find a way to make them change?

If he had a sequence in mind, there was never any question of his working it out in advance, of knowing precisely what he would do on each of the large canvases before he began. It was more a case of working on one canvas after another, each leading into the next. It must also be said at the outset that if there was a scheme, it has always remained an unfulfilled dream. Because he despatched groups of canvases to Europe as they were finished, Gauguin himself never saw them all together and because they were sold separately as they arrived, they could never be shown in the same room. Now that they are scattered between Russia, America, France, Germany and Britain, it is possible that they never will be.

There would eventually be six paintings measuring 96 × 130 centimetres, painted throughout 1896 and over into 1897, though the task did not take up all of his time and there were occasional diversions into smaller, unrelated works. And of the six canvases, not all can be included in a scheme that makes any sort of sense. One, *The Fisherman*, seems not to fit, for the five that do are all concerned with Pau'ura and her experience of motherhood.

## Near Golgotha

By early April the last of Uncle Zizi's money was almost gone but the pain in his damaged leg was so severe he needed to buy morphine in Papeete to try to dull the agony. To his intense fury, all his arrangements for the sale of his paintings in Paris had quickly unravelled. Lévy had written to resign from the arrangement, Chaudet was getting nowhere, Schuffenecker, instead of trying to sell his work and send him the money,

had obeyed a request from Mette and despatched a set of paintings to Copenhagen. Once again, his correspondence is weighed down with angry outbursts against all this treachery and laden with fruitless demands for help. Yet somehow he carried on working and none of this misery seeps into the art. Even when he was in despair about the lack of sales, he could still write to Monfreid, describing his home in glowing terms:

> And if you could see my place! A thatched house with a studio window. The trunks of two coconut trees, carved into figures of Kanaka gods, some flowering shrubs, a little shed for my horse and carriage. It's true I went to some expense to settle myself here, so I won't have to rent anything, and can always be sure of sleeping under my own roof; but who wouldn't have done the same, considering the money due to me, that I await in vain?

Elsewhere in the letter he rather touchingly describes his modest pleasures: a little tobacco and soap, the occasional dress for Pau'ura and his guitar – for which he asks Monfreid to send him some new strings. We know from a neighbour, Fortune Teissier, a retired income tax officer who had left the service and gone into business in 1894, that Gauguin still kept open house, with the cask of claret by the door and a delicious *omelette baveuse* for those who stayed for meals. Many of course kept away – some of the local people forbade their children to go near the hut, terrified by tales of this weird Frenchman walking about, painting or whatever he did, *without any clothes on!* And as for the strange unholy images he had carved on the trees, who could doubt that he consorted with *tupapaus*?

But such rumours had no practical effect on Gauguin's life. For once he was not entirely deprived of the sort of intellectual stimulus he had known in France. Another of his French neighbours, Jean Souvy, although approaching eighty, maintained a keen interest in the sort of intellectual matters then in vogue. Souvy had run the government printers until his retirement eight years earlier and when he had moved out to Punaauia he had decided to build a school for the local children – though he had so little faith in the efficacy of the French education they were to receive that he arranged for a sign to be put above the main entrance which read: $2+2=4$, as an assurance that the pupils would at least learn one thing of value. The main interest Souvy held for Gauguin lay in his personal studies, he was a Theosophist, part of the spreading network launched by Madame Blavatsky, furnished with publications through the San Francisco branch of the Society. Throughout his retirement Souvy worked on a collection of thoughts on various philosophical and Theosophist topics which he entitled *Cogitations* and which, though

unpublished, is today conserved by the Papeete Museum. They reveal a mind running on lines close to Gauguin's, especially then, when his thoughts were once again turning to religious topics. The *Mercure de France*, apart from its disagreeable articles about art, had begun serializing the first French translation of Thomas Carlyle's *Sartor Resartus*, so that Gauguin was at last able to read for himself the complex and challenging work which De Haan had enthused about when they were in Le Pouldu together. Just as Carlyle's huge reputation in Victorian England was beginning to recede, as people grew weary of his hectoring tone and his constant harping on the need for strong leaders who were to be admired and followed, so his reputation began to increase in France, the one country that might have been expected to find his bleak Calvinism distinctly unappetizing. What French readers, amongst them Gauguin, seemed to have liked was Carlyle's weightiness, his way of tackling mighty issues with Scottish *gravitas*. Gauguin certainly thought so, lingering over the ponderous dialectic of *Sartor Resartus* with its philosophic profundities: 'What am I? a voice, a movement, an appearance – some idea incarnate, visualised at the heart of the eternal Spirit. *Cogito ergo sum*, alas, poor cogitant, this does not get one far. Of course I am, but latterly I was not. But from where? how? where?'

One imagines Gauguin and Souvy discussing these matters, a glass of absinthe to hand, as the sun sank behind Moorea, throwing into the conversation the other admired thinkers: his grandmother's friend Eliphas Lévi, Edouard Schuré whom Sérusier had so admired, and with Souvy no doubt adding in Lady Caithness, the English Theosophist whose writings on the Buddha were much studied by adherents.

These were no doubt the best of times, but not all his neighbours were as amiable as Teissier and Souvy. The greatest potential for trouble was the local Catholic priest, Father Michel Bechu, a former sergeant, who had come to Tahiti with the army and stayed on, studying for the priesthood and perfectly combining in his person the contradictions of colonial life: on the one hand he clearly saw it as his duty to serve the local people and was an acknowledged expert on the Tahitian language, while at the same time he remained an almost comically devoted patriot, raising the French flag over his house on special occasions and firing a volley of twenty-one rifle shots in honour of the occasion. He certainly looked formidable, with what was described as a 'fantastic beard', a large square block of hair, and rather tender blue eyes, at odds with what could be an irritatingly imperious manner. Given that Gauguin was neither a credit to the mother-country nor a devoted son of the Church, the two men were destined to come into conflict at some point. It was really only a question of what would provoke it and when it would happen.

For the moment, all that concerned Gauguin was money. By June his health was so bad a further letter to Monfreid was virtually a howl of anguish.

> My strength is gone, utterly exhausted by days and sleepless nights of suffering with my foot. The whole ankle is one great wound, and it has been that way for five months.
>
> When I work I am distracted and gain strength; but without work, almost without food and without money, what will become of me? No matter how strong one is there are walls one cannot scale.

His only solution was a desperate plea to Monfreid, repeated in a separate letter to Maxime Maufra, that they should try to get together a group of collectors who would each pay a fixed annual sum in return for regular supplies of his paintings, a scheme which would provide him with a small but certain income – so small in fact that he emphasizes that at 200 francs a month it would be less than the wage for a labourer. He suggested a list of possible participants, including Portier the art dealer and the wealthy Comte de la Rochefoucauld, the patron of Sérusier and Filiger, and he added a rather pathetic *Agreement*, in quasi-legal language, by which he promised to provide, say, fifteen sponsors with a canvas each year 'conscientiously executed according to my artistic faith'.

Of course it was a hopeless pipe-dream and in any case he was too sick even to wait for the refusals. He entered the hospital in Papeete on 6 July and stayed eight days. He was fortunate to be treated by a Dr Buisson with whom he became friendly, though there was an argument on the 14th, the day he left, because he could not pay his bill for 118.80 francs and he was entered in the hospital's register as 'Indigent', a designation that was to cause him much trouble later.

Back in Punaauia, he was far from recovered and his spirits were lower than ever, so that it is hardly surprising that his decision to paint himself resulted in a harrowing image of mental and physical anguish. There is little need of the title – *Self-portrait near Golgotha* – to make out that this is the place of Christ's final suffering: the blasted tree on the hill with its crossed branch like a crucifix, the two spectral faces perhaps carved, perhaps real, vaguely there in the background, faces which seem to be Tahitian and thus show that Golgotha has been transported to Polynesia. Such things deepen the central message, which is concentrated on the solitary figure of Gauguin, haunted and tortured, humiliatingly clothed in his faded blue/white hospital shift. It is the image of a man obsessed with his own death and it is surely significant that he never considered selling it, keeping it near him for the remainder of his life.

## Desperate Moves

Gauguin was now so broke he was offering drawings to the local Chinese trader in exchange for food. The man only took them out of pity, and used them as wrapping paper. So bad was the artist's relations with the tradesmen in Papeete that long after his death visitors could easily induce a litany of complaint from surviving shopkeepers. One anonymous example, interviewed in the early 1940s, spoke of his dislike for Gauguin: 'If he wanted anything from you he was servile in manner; if he did not want anything he was a bully and a braggart – just as it suited him.' The speaker recounted how Gauguin had brought in a stove for repair but when he called to collect it he had no money and offered one of his pictures as payment. 'I told him to take the stove and get out of the shop. I had seen his daubs and did not care for them and neither did anyone else.'

Even if the story is apocryphal it still conveys the deep animosity that was beginning to spread throughout the expatriate community, towards someone who so openly flaunted his dislike of them and their ways. In such a climate Gauguin was driven to take desperate measures to keep himself alive. One of the few people he could still turn to was the wealthy lawyer and businessman Auguste Goupil, whose country house was near by. Goupil had helped him before, with the low-paid commission to guard the effects of the Chinese bankrupt Ah-Kong, and Gauguin now revived his old idea of getting a commission for a portrait and presented himself at the imposing mansion, in its well-tended grounds dotted with reproductions of classical statues, in the hope that the lawyer would look kindly on his proposal. It is likely that Goupil was unwilling to seem uncultured – he approved of the arts as a social grace and encouraged his daughters to draw and paint – but on the other hand he well knew his visitor's doubtful reputation and was probably equally aware that most people could make neither head nor tail of his art. In the end, he judiciously decided to let Gauguin make a portrait of his youngest daughter Jeanne, usually known by her Tahitian name Vaïte, probably reckoning that he would look less stupid if the artist made a botch of painting a child of ten. The only truly strange thing was that he allowed her to go to Gauguin's studio to sit for him, which, given all the rumours about his behaviour, was fairly bold on Goupil's part.

Vaïte arrived in a long orange-brown Mother Hubbard with severe pleats, a flower in her hair and a nervous expression on her face. Gauguin made her sit, hands crossed in her lap, rather stiffly, in a high-backed, carved dining chair, a typical piece of colonial furniture, matched by the locally made woven bag that dangled from her arm. As he worked she took in the bizarre surroundings, noticing that he lacked a lot of the

things she regarded as necessities and that there were drawings on the floor in place of the pieces of furniture he presumably could not afford. One imagines that to someone brought up in a genteel colonial atmosphere, it was the sight of a white man wearing nothing more than a traditional wrap which shocked her most. Then there was his leg with its distasteful wound, and his total, rather frightening, self-absorption as he jabbed at the canvas. Not surprisingly, she sat as still as she could until he finished, then hurried back home glad to get back to where, in her own words, 'the orderliness, the polished furniture and the large armchairs were a comforting contrast'.

Vaïte's account of her alarming adventure with the extraordinary painter implies that she sat for him only once, but we can tell from the overworking on the finished canvas, especially in her smooth white face, that Gauguin spent a long time trying to get it right. There was clearly a struggle between the free-wheeling artist, and the hungry outcast, determined not to irritate yet another patron, and in the end the portrait reflects all this, with the girl frozen and still and slightly hieratic, her face more like an Egyptian death mask than a living creature of flesh and blood, while for a background he put the same neutral flowers on a coloured field that he had used in previous portraits, rather than painting a specifically Tahitian scene, as if trying to 'Europeanize' the picture even further.

Inevitably all this effort was wasted. According to Vaïte, her father found the portrait so ugly and so unlike her, he immediately consigned it to the attic. But, unlike many others on Tahiti who foolishly destroyed what they were given, the family did keep it, eventually selling it to a French dealer. It finally ended up with the title: *Portrait of Miss Schuffenecker* which rather irritated Vaïte when she heard of the change in later life, by which time she had realized that there was considerable kudos in having been painted by the peculiar man who had terrified her as a young girl.

Despite his dislike of the portrait, Auguste Goupil was still willing to help Gauguin and agreed to let him give his daughters drawing lessons at the villa. Initially Gauguin seems to have tried to make himself agreeable – he rather liked Madame Goupil and gave her a painted fan made back in 1892, which he had decorated with figures based on the Theban tomb painting, though the youngest daughter scribbled all over it. Somehow, he managed to behave himself for it was over two months before something happened to cause a rift, we do not know what, though as he and Goupil both held strong opinions, particularly on local issues, it was inevitable that a quarrel of some sort would occur. By October his post had been annulled and the small fees stopped and in revenge he carved a deliberately crude statue of a naked woman and set it up, outside his

studio, as a way of aping the copies of antique statuary so beloved by
Goupil. One doubts whether the lawyer was much bothered but it was
precisely the sort of gesture guaranteed to infuriate Father Michel, being
at once a display of moral turpitude and an insult to the cultural traditions
of the mother country. Angry on both counts, the priest insisted that
the statue's naked loins be covered or he would come into Gauguin's
garden himself and tear the thing down with his bare hands. We may
imagine the delight with which Gauguin thwarted this plan by going
to see the local gendarme and getting him to warn the priest that this
would be trespassing, in which case he risked arrest for breaking the
law.

Made to look foolish, there was nothing for Father Michel to do except
rant against the artist from his pulpit and to ensure that as far as possible
his congregation kept away from this dangerous anarchist. It was a small
matter, a joke really, but it was also the beginning of Gauguin's quarrel
with the church, a dispute that would presently be transformed into
open warfare.

## The Child of God

Pau'ura's child was due around Christmas, a period charged with mem-
ories – the birth of his daughter Aline, Van Gogh's madness and self-
mutilation. He had marked it before with significant paintings. *Ia orana
Maria*, his first major work on Tahiti, had been a Christmas painting.
Now that he was to become a father at this time it was impossible for
someone who had long identified himself with Christ – most recently
in that ghostly self-portrait before Golgotha – to let the event pass
unnoticed. His solution was a Nativity scene, though one charged with
his own personal concerns. He called it *Te tamari no atua* (*The Child of
God*) which again borders on the blasphemous given that the Madonna
here is clearly Pau'ura, reclining on a large couch which fills the lower
half of the picture space, at rest after her labour. To show that this is
indeed a nativity the upper right of the canvas has a scene of cattle in a
stable taken from a work in the Arosa collection by the nineteenth-
century animal painter Octave Tassaert. But there the traditional
imagery ends. In all other respects this is a reworking of the earlier
*Manao tupapau*, only now the image of the terrified girl on the bed is
reversed – here she is at peace while, seated beside her, the *tupapau* has
been transformed into a nurse holding the newborn child and beside her
is the angel who could have stepped out from behind the bush in *Ia
orana Maria*. Again there is a mix of cultures and places: Pau'ura has a
vague halo, just enough to show that she is 'playing' the part of Mary,
as does the child, but neither has a nimbus prominent enough to divorce

them totally from their human selves. The pillar behind the bed with its 'Marquesan' markings indicates that this is both the manger and Gauguin's home in Punaauia, and the white cat at Pau'ura/Mary's feet tells us that we are witnessing yet another transposition of Manet's *Olympia*. We know from the amount of overworking in the painting that it took a considerable time to produce and that, allied to the date when we know it was sent to France, makes it certain that it was painted before the actual birth of Pau'ura's child and is thus a prediction, rather than a fulfilment, a looking forward to this key event in Gauguin's life on the island which he had failed to achieve with Teha'amana.

*The Child of God* could be the third in this possible series of paintings revolving round Pau'ura's experience of motherhood – first her independence in *Te arii vahine*, second her confused reactions to her pregnancy in *No te aha oe riri*, and now the joyous moment of fulfilment. But things are seldom so simple and clear cut with Gauguin and this latest work has several contradictions which are worth exploring. For what ought to be a joyful scene, the background seems ominously gloomy and a *tupapau* is hardly a suitable figure for a nurse, especially as she appears to be sitting in a chair, the back of which closely resembles a headstone in a grave yard. In fact the chair turns out to be the same piece of furniture on which Annah had been enthroned for her nude portrait in the Rue Vercingétorix, while Pau'ura's couch is fringed with the same design as the skirting board in the Annah painting. This is typical Gauguin, making surprising links between otherwise disparate works, perhaps suggesting a theme running from *Olympia* to Annah to Pau'ura. And there are other subtleties – the carved bedpost is surely a reflection of the work he had seen in the Auckland Museum, so that in the end such richness of imagery precludes any one interpretation from being absolute and final.

It may be that Gauguin was simply attempting to show the proximity of death to birth, the way the infant Christ is often depicted with a lamb, the symbol of his ultimate sacrifice. But these elements of doom and foreboding could just have a more personal connotation, for in the end they turned out to be a premonition of the tragedy that was about to overwhelm him.

The story is much easier to trace in the last major canvas of that year. Again, this is a work ostensibly concerned with pure joy. Even the title: *Nave nave mahana* (*Delightful Day*) makes that clear. Six large figures stand in a grove by a rivulet, surrounding and protecting a seventh, younger woman, presumably Pau'ura wearing a red *pareu* with a white flower design and a garland of white flowers around her head. There is no male figure, the women are self-sufficient, harmonious and protective. The mother-to-be, the beautiful Pau'ura stares out at the spectator, or,

in the original, at Gauguin the artist, the only man involved with their private, timeless, feminine world.

Gauguin began *Nave nave mahana* in 1896 but did not complete it till the following year, by which time the tragedy had occurred. We can see the effect of this in the bottom left hand corner of the canvas where there is a curious child clothed in a dark green/brown outfit, sucking on a piece of fruit, an unsettling isolated spectral creature, quite at odds with everything else, though easy to explain. Some time about Christmas Pau'ura gave birth to a daughter. Given all we know about Gauguin's thoughts on these occasions, he might well have named her Aline in order to link her to his beloved child in Denmark. It was not to be – a few days later, the baby died. It was some time before he felt able to paint again and when he did he reworked *Nave nave mahana*, adding the strange little imp-like figure sucking on its fruit, as if to show the pain that lurks in the corner of even the most idyllic dream of heaven.

## Nevermore

The loss of a child at birth is a dreadful thing, but the death of a baby which has survived for a time is surely worse. We can experience something of the emptiness, the drifting loss which Pau'ura must have felt from Gauguin's deeply moving portrait of her, made after they had buried their tiny daughter. He may have wanted to complete the sequence – an X-ray examination of the painting he eventually made has revealed a large figure composition, which included a child. But for whatever reasons, this dissatisfied him, for he covered it with a layer of white, cut away a section of the canvas, turned it on its side, and began to paint Pau'ura, again lying on her bed – there is a glimpse of the same yellow material from the now painfully optimistic nativity painting. Then she had been at rest, now she seems melancholy. We know that painting it was not easy. Gauguin wrote to Monfreid in mid-February of the new year, 1897, saying that he was hoping to send it with a new batch of paintings he was putting together, but as he did not, we can assume that he had to go on with it after the ship had sailed. Much of this was due to the extraordinarily rich, vividly coloured detail in the background, a deliberate contrast to Pau'ura's languid pose and to the blank, dazed expression on her face, a clash between colourful busy opulence and still, tragic plainness. He painted the word 'Nevermore' in English, on the top left-hand corner of the canvas, a reference to the word which makes up the chorus of *The Raven* by Edgar Allan Poe that Mallarmé had translated. Because the poem and the painting seem so different: the student's room in the poem is dark and gloomy, whereas Gauguin described his scene as one of 'long-lost barbaric luxury' – some have

concluded that he was again trying to add a dash of Symbolist mystery to what was otherwise a rather straight-forward, personal work. There is a bird in the painting, but Gauguin's somewhat plump creation seems, at first, to be more like a cartoon seagull than the menacing black creature that Poe conjured up. A close examination, however, shows that the supposedly comic bird is far more frightening than it looks at a distance – it has no eyes and yet it 'looks' sightlessly in on the reclining form and this sense of blindness, of incomprehension is reinforced by the presence of two women in the background, who stand half-glancing towards Pau'ura, presumably gossiping about her, though about what we cannot tell.

Despite what remains an essentially private, even enigmatic, work, *Nevermore* went on to become one of Gauguin's most influential paintings. When it arrived in France, Monfreid showed it to Delius who bought it for 500 francs, spending a further 50 francs to have it properly framed. When the composer loaned it to the Gauguin exhibition at the Salon d'Automne in 1906, three years after the artist's death, it achieved the status of an avant-garde icon on a par with Seurat's *Grande Jatte*, the very thing Gauguin had always dreamed of. It was seen by Picasso and Matisse, provoking them into a lifetime's attempt to absorb and challenge the masterwork, in the same way that Gauguin had spent years trying to come to terms with Manet's *Olympia*, which itself had sources stretching back into the roots of European art.

## A Book of Beginnings

At this point, around late February 1897, a reasonable chronology of Gauguin's work is even harder to maintain than usual. He seems to have been trying to work out his ideas in words as if to clear his mind before starting to paint again. He had already begun to use some of the pages left in the exercise book into which he had copied the existing parts of *Noa Noa*, to jot down various thoughts on art or on topical matters, under the general heading *Diverses choses* (*Miscellaneous Things*), a catch-all for quite short ruminations on some of his hobby-horses. The various sections have a sort of unity, being mainly concerned with his hero figures: Delacroix, Giotto, Raphael, Puvis de Chavannes, mostly as part of a fragmented discourse on colour. That is until page 267 of the exercise book, when he suddenly begins to write in praise of someone called Gerald Massey who is described as the author of the *Nouvelle Genèse* or *New Genesis*, and who, according to Gauguin, had proved that 'the Christ of the Gospels is not an historical personage, but an Egyptian myth.'

So gripped was Gauguin by whatever it was that he had been reading that he continued for a further twelve pages to outline Massey's theories

on the myth of Christianity. We now know that he had not then read Massey himself, but had been given, undoubtedly by his neighbour Jean Souvy who must have obtained it through his Theosophist connections, a little pamphlet by a French author, Jules Soury, entitled *Le Jésus Historique*, a highly edited selection of translations from works by the English author Gauguin was quoting. The pamphlet was a limited edition meant to be signed by Soury and gave as publisher: M. V. Lacaze, rue (sic) Montgomery, San Francisco, with the date 1895. This was not as strange as it now seems – there was a flourishing French community in the city and an export trade in French language books to France's territories in the Pacific, especially amongst members of the Theosophical society with which Gerald Massey and Jules Soury were connected. Both Massey and Soury were published in England by Annie Besant who would later succeed Madame Blavatsky as head of the Theosophist movement while the founder herself was a great admirer of Massey's studies in comparative mythology.

Virtually forgotten today, Massey had a brief moment of fame in the mid-nineteenth century as a radical poet admired for having risen from the appalling rural poverty into which he had been born in 1828. It is sometimes said, even today, that Massey was the model for Felix Holt the Radical, the eponymous hero of George Eliot's novel, published in 1866, but the few references to him in Eliot's letters tell a different story, and if anything it is more likely that Massey was one of the sources for the arid and querulous amateur scholar Mr Casaubon in *Middlemarch*, who wasted his life attempting to produce the *Key to all Mythologies*, a work which so neatly parodies *The Book of the Beginnings* which Massey was writing just at the point in the early 1870s when Eliot was beginning her novel, that it is impossible to ignore the connection. From 1869 onwards, Massey virtually gave up poetry for mythological studies of an incredibly detailed kind, using his formidable self-trained intellect to master Egyptian hieroglyphs, the Hebrew kabbala, even Maori religious beliefs. It is significant, in the context of Gauguin, that Massey visited New Zealand some time between 1883 and 1885 as part of a long tour across America and Australasia, lecturing on mesmerism and spiritualism.

The first of his mammoth studies of world mythologies was published in 1881 and the preface is such pure Casaubon it could well have been written by Eliot herself: 'In a *Book of the Beginnings*, I have endeavoured to trace the Egyptian *Origenes* in Words, Symbols and Divinities, in Britain, Israel, Akkad and New Zealand, and connected much of the Typology with Inner Africa as the birthplace of all.'

Whatever the unconscious humour, Massey's aims were not unserious, his principal motivation was the contemporary obsession with evolution – he seems to have seen his work as offering a cultural parallel to Darwin's

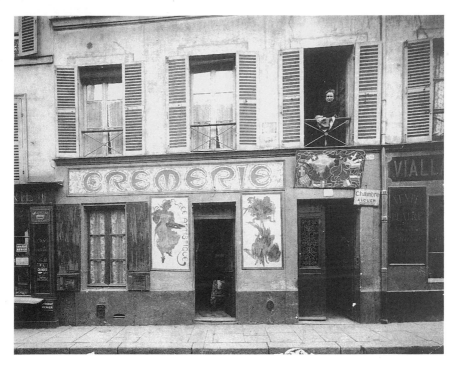

The Crémerie in the Rue de la Grande-Chaumière with Madame Charlotte Caron at the window. The paintings by Alphonse Mucha and Wladyslaw Slewinski are on either side of the entrance.

6 rue Vercingétorix; Gauguin's studio above, the Molards' below.

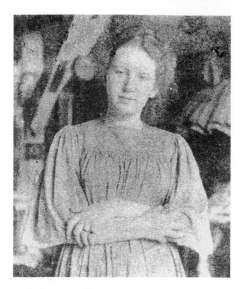

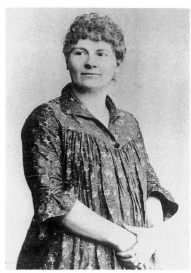

Judith around 1896.

Ida Ericson in 1880.

The Molards' studio in the Rue
Vercingétorix; Ida in the background,
William at the piano.

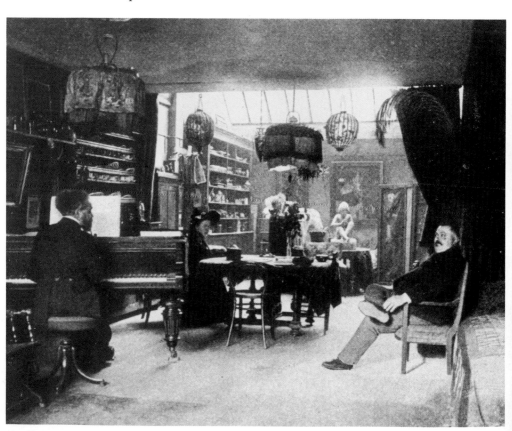

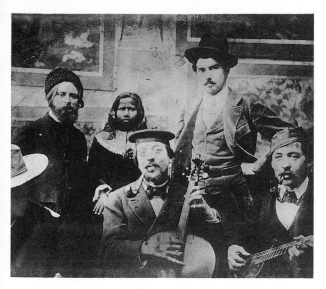

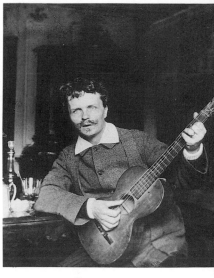

Photograph taken by Gauguin in the Rue Vercingétorix studio. The cellist Fritz Schneklud is seated centre, behind him are Paul Sérusier, Annah la Javanaise and Georges Lacombe.

August Strindberg playing the guitar, 1886.

BELOW *The Harbour at Concarneau* by the realist painter Alfred Guillou – the scene of Gauguin's disastrous encounter with the local fishermen.

BELOW Early photograph of the *Oviri* ceramic sculpture.

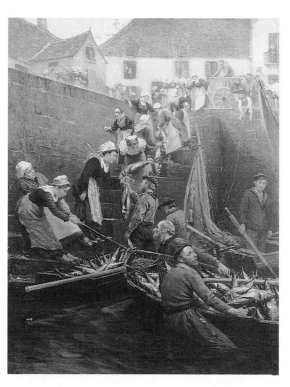

The Auckland Museum and caretaker's cottage as Gauguin would have seen them; photograph taken some time after 1876.

The 'new' south wing of the Auckland Museum as it was during Gauguin's visit.

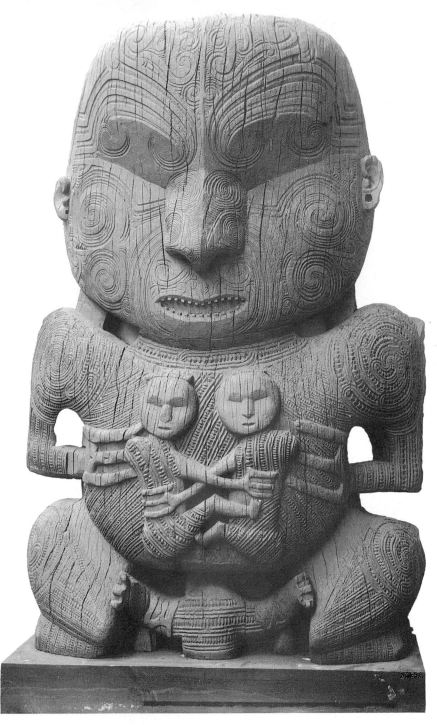

*Pukaki, chief of the Ngati Whakaue tribe* – one of the most important of the Maori sculptures that Gauguin saw during his visit to Auckland – an image which was to resurface in his later work.

Gauguin's first house in Punaauia, built in 1897 and photographed by his friend Jules Agostini.

*Pacific Island Study* by Arthur Haythorne (Peter) Studd 1898, the only artist to follow Gauguin out to Tahiti. The central figure is probably a self-portrait.

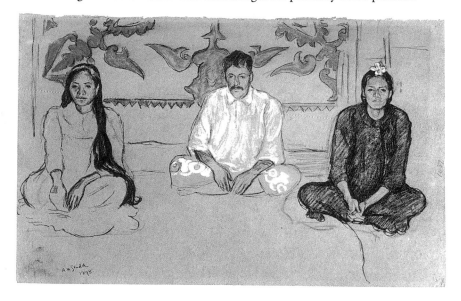

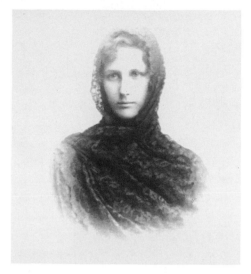

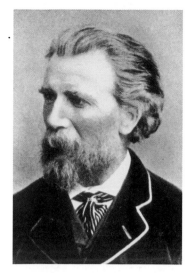

Aline Gauguin, photographed around 1895, just two years before her tragic death at the age of nineteen.

The English author Gerald Massey, one-time radical poet, later student of world mythologies whose writings stimulated some of Gauguin's most important works.

BELOW  Tohotaua 1902; a photograph posed by Gauguin and taken by his friend Louis Grelet, then used as the basis for one of the artist's most successful portraits.

BELOW  Gauguin's implacable enemy, Bishop Martin.

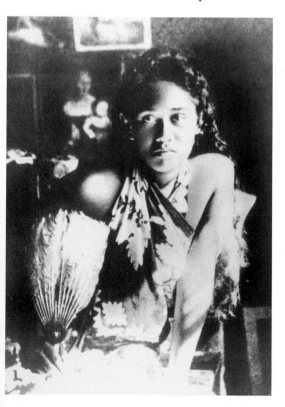

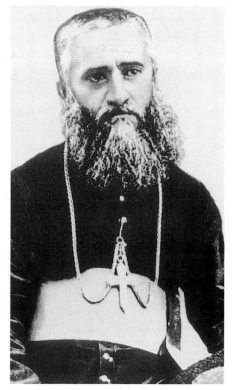

Gauguin's tomb in the Marquesas before the statue of *Oviri* was placed there. Standing centre is the artist's granddaughter with her three daughters.

A Gauguin family reunion, Copenhagen 1987. The English Mette is standing at the very centre of the photograph. There are two Mettes, three Alines, one Clovis but no Paul.

zoological evidence, attempting to prove that all human culture had spread outwards from one point in a seamless wave across the continents, always retaining a deep inner, subconscious memory of its origins. Just as all languages, wherever they were spoken, retained an inner 'memory' of their roots in prehistoric Africa, so all world myths and religions drew on basic proto-myths most of which found their fullest expression in the Egypt of the pharaohs, only to be subsequently adapted and added to as they spread and were transformed en route to the remotest atoll in the furthest ocean. Thus the puberty rites of the New Zealand Maori were re-traceable to similar practices on the banks of the Nile, or to the Roman Mysteries in certain early Christian practices. To Massey, Christ was simply another manifestation of Horus or Pan or of a whole range of similar symbolic sacrificial figures; it was 'Christolatry' which had treated the myths as the story of a real person, imbued with Divine powers. It was thus the Church which had broken the great flow of spiritual knowledge that ought to link humanity in one great all-embracing universal truth.

It is not hard to see why Madame Blavatsky was such an admirer of his work and while Massey was certainly more rational than she was in *The Secret Doctrine*, he too achieves the same miasma of arcane information by using excessive amounts of research to confirm rather than challenge a previously assumed conviction. Gauguin, however, had only a much edited-down summary in Soury's little pamphlet and was totally gripped by a theory of universal culture that chimed very well with his own gropings in this field. Added to that were the not displeasing attacks on the official Church, its entire basis and structure which according to Massey/Soury amounted to a fraud. As with Moerenhout earlier, so Massey now – in a simple hut under a palm tree, an obsessed English poet found the perfect disciple.

## The Great Buddha

As Soury had provided the address of Williams and Norgate, Massey's London publishers, Gauguin set about ordering the original, but in the meantime he began to copy out those parts of Soury's pamphlet which most appealed to him. To these he added his own theories of biblical study which drew on his memories of those far-off days when he had sat at the feet of Félix Dupanloup, the Bishop of Orléans, as he conducted his Bible classes at the Little Seminary of La Chapelle-Saint-Mesmin. As Gauguin noted in his final memoirs:

> Remembering certain theological studies of my youth, and certain later reflections on these subjects, certain discussions also, I took it into my

head to establish a sort of parallel between the Gospel and the modern scientific spirit, and upon this the confusion between the Gospel and the dogmatic and absurd interpretation of it in the Catholic Church, an interpretation that has made it the victim of hatred and scepticism.

As with Moerenhout so with Massey. What began as a literary interest quickly crossed over into painting. In Section XVII of Soury's selected texts, we find Massey's anecdote about how, when the Christian faith was first brought to New Zealand, both the missionaries and Maoris were surprised at the similarity between Jesus and Tawhaki, a Maori deity, and how there was even a form of Mass or religious feast associated with the latter's cult. If nothing else this was clear proof of Massey's incredibly detailed research – Tawhaki by any standards was an obscure figure, a minor, tribal god of the Tuhoe in the Ureweras, associated with thunder and storms – but to Massey this was again proof of the existence of a single universal religious truth, embodied in even the remotest practices. Significantly, Section XVIII, following immediately after, offered Massey's interpretation of Buddhist philosophy, a conjunction which clearly struck a chord with Gauguin.

The result was a painting Gauguin called *The Great Buddha*, in which he attempted to draw together these various ideas. The scene is a large hall. At the rear, through an open archway, we can see the moon, symbol of Hina, representing the ancient faith of Polynesia. In the background to the left the Last Supper is taking place with Christ at its centre, but dominating the room is a giant statue, ostensibly the Buddha of the title but in fact instantly recognizable as our old friend Pukaki, the monumental *tiki* last seen in the Auckland Museum, clutching his children to his breast. A Tahitian woman sits on the ground at the foot of the statue, another memory, for this is the foreground figure from the painting *What! Are You Jealous?* which Gauguin had painted back in 1892. Now, five years later, she is literally reborn in this painting, which can be interpreted as a wheel of life, revolving around the Buddha. If we begin at the top right with Hina we have Birth, then round to the foreground where the seated woman represents Life, over to the figure of Christ in whom we have Death leading to Rebirth, the belief incarnated in the story of the Buddha and made visible in Pukaki, clutching his children, the living proof that he will live on through them.

## The Translation of a Dream

For once Gauguin's financial situation had slightly improved. He even had news from Paris which showed that he was not as overlooked as he had believed. Vollard had put on an exhibition of his work the previous November and the ever-loyal Schuff had been bustling about on his

behalf, lending *The Yellow Christ* to an exhibition entitled *L'Art Mystique* at the Petit Théâtre Français, in the Faubourg Poissonnière, and petitioning the Ministry of Fine Arts to give Gauguin a grant. Why the long-suffering Roujon, who had had to endure Gauguin's sarcasm on previous occasions, agreed to this request is a mystery, though he can hardly have expected Gauguin's response to his gift. When 200 francs arrived in December of 1896, Gauguin was furious at what he considered a miserable and humiliating act of charity and promptly sent it back. Fortunately the Christmas boat brought a totally unexpected cheque for 1,200 francs from Chaudet who had managed to sell three canvases to Vollard, with the promise of a further 1,600 francs to come. All of which makes it somewhat confusing as to why he refused to pay for another bout of hospital treatment that January when he clearly could have afforded it. Instead he chose to let them classify him as indigent once more and to rail about the indignity of being put in a ward with soldiers and servants.

His mood swings were becoming increasingly manic. On the one hand he was convinced that he was being abandoned and ignored in Europe when all the evidence is that his closest friends were doing their best to see that his work was exhibited whenever an opportunity arose. Even though Leclercq, with Molard's help, was arranging for him to be represented in an exhibition in Stockholm, Gauguin did nothing but complain while at the same time writing an almost ecstatic letter to Sérusier early in the new year, to tell him how good things were and how he wanted no other life but this. His letters are of little use in judging his state of mind. By turns ranting with fury at supposed injustices then just as quickly offering an elegiacal description of the pleasures of life in his tropical paradise.

It was in this confused frame of mind that he at last began work on the painting which seems to conclude the 'maternity' sequence. He entitled it *Te rerioa*, by which he meant 'The Dream', though it has since been pointed out that a clear translation would be something more akin to nightmare. But dream is definitely what Gauguin intended to convey, for this was to be Pau'ura as she might have been had the child not died, a situation which only fantasy could now conjure up.

He worked quickly, completing the work in ten days at the end of February, hoping to send it to France with a Dr Gouzer, a naval surgeon who had agreed to take a parcel of work to Monfreid and whose vessel was delayed in Papeete harbour for repairs. The fact that this ship, the *Duguay-Trouin*, had been sent from France to help the new governor, Gustave Gallet, in the final pacification of the recalcitrant outer islands was not lost on Gauguin, as the work he was rushing to finish before the cruiser sailed is in many ways his subtlest fictional re-creation of a

Polynesian culture whose final vestiges of independence had just been crushed.

The setting is a square, box-like room, based on the sparse Japanese interiors in the much-admired prints, with echoes of Delacroix's *Les Femmes d'Alger*. Pau'ura and a friend sit on the floor, to the left is a sleeping baby and Pau'ura's breasts now hang in a way which recalls the woman in *Why Are You Angry?* clearly demonstrating that she is the mother. The decoration of the room is the most 'Maori' of all Gauguin's paintings. The baby is lying in a cradle, with carved figures on its head-board based on the handles of the large Maori *kumete* in the Auckland Museum. Carved panels around the walls offer a message of creation, birth and life. On the left wall, two figures are shown in the act of coupling, on the far wall is the familiar standing Hina figure, goddess of Life. At the rear of the picture is what could be either a picture, hanging on the wall, or an open space looking out into the landscape. Either way, it shows a track leading off towards the mountains, and riding away from us, the once-familiar figure of the boy on horseback in his white singlet, the Jotefa figure from the works of the first Tahitian period. That he is riding away, leaving, presumably indicates ending and completion. The only discordant note is the same white cat from *The Child of God* stretched out beside the cradle in much the same pose as the sleeping child, as if it is a ghostly doppelganger, the one reminder that this is not the truth and only a vision of what might have been.

He had now completed five identically shaped canvases, a celebration of motherhood, with an intensity and profundity unexpected from a male artist: *Te arii vahine* (*The Noblewoman*), the confident innocence of a young woman on the threshold of maturity; *No te aha oe riri*, (*Why Are You Angry?*), that sudden fearful moment when the transformation towards motherhood begins; *Te tamari no atua* (*The Child of God*), the allegorical image of birth as a divine occurrence; *Nave nave mahana* (*Delightful Day*), the perfect female Eden with the hint of tragedy in the spectral child, and finally *Te rerioa* (*The Dream*), the state of bliss now that the child has come, with the fulfilled mother, at peace, surrounded and succoured by the antique symbols of her culture.

The first part of the sequence was already with Monfreid in France, these last works were hastily packed and handed over to Dr Gouzer, aboard the *Duguay-Trouin*, which up-anchored on 3 March carrying home news of the great colonial victory, along with Gauguin's poignant images of an unspoiled pre-colonial Polynesia that had finally ceased to exist.

It is sad that the artist never saw his creation assembled in one place, and a continuing irritation that the sequence has never been brought together since. London is fortunate in having both *Nevermore* and *The*

*Dream* in the Courtauld Institute Galleries, which allows visitors to see both the final work in the sequence and the haunting confessional work which prefigured it. But without all five canvases, we can never truly experience the full force of Gauguin's vision. Despite that, he must have felt reasonably satisfied as he watched the *Duguay-Trouin* sail away. He even allowed himself to relax – there are descriptions of him sitting outside his hut, contentedly puffing on his pipe, and there are lyrical paintings of bathing women, probably made that March after the boat sailed, which are like the sort of easy-going, light-hearted painting he had promised himself he would do before he left France, art that was not work but relaxation, akin to the sort of things he had done when he was a Sunday painter, twenty-five years earlier. He even allowed himself the indulgence of sending a heavily sarcastic reply to Vollard who had written to request some drawings, wood-block prints and sculptures. This provoked the comment that as quite a lot of his work had been hanging about in Paris for four years without achieving any sales, Gauguin saw no reason to add to them.

Of course his leg still hurt dreadfully, but he could now afford the morphine along with tiny doses of arsenic to rub on the wounds which further eased the pain. Father Michel was a nuisance but there were Teissier and Souvy near by if he needed company. Although his scheme to get a group of sponsors to pay him a yearly subvention had come to nothing, Vollard went on trying to get him to send work – commercial stuff it was true, but at least it proved he wasn't entirely forgotten.

By April, four months after the loss of the child, the pain must have been at least dulled, and life must have returned to something approaching normal. It was the lull before the storm. That April he received a brief note from Mette informing him that back in January their daughter Aline had contracted pneumonia and died. The letter was blunt to the point of brutality, without affection or sympathy, though it is hard to imagine what Mette could have added that might in any way have eased such devastating news. The solitary detail, that Aline had caught the fatal chill while coming home late from a dance, only added to his grief – had his last letter to her not expressed his hope that she could dance well? Had he not wanted to take part, vicariously, at some ball when her suitors paid court? Had he not brought this curse on himself?

He told no one, and, as far as we can gather, spoke to no one. There was no longer anything to be said; *Te rerioa* had found its true translation, dream had turned to nightmare.

## Her Tomb Is Here Beside Me

It is doubtful whether Gauguin ever learned the full story of his daughter's death. Aline had been a vivacious young woman, just turned nineteen, often invited to parties. She had come home late, on the morning of 1 January 1897, after a New Year's ball, happy but cold from the carriage ride. The following day she was feverish and that night Mette sent for the family physician Dr Caröe who decided that it was serious – probably pneumonia – and asked a Professor Sextorp to call. For two days both doctors fought to save her, to no avail. Mette was shattered, which may explain why she waited so long before letting her husband know of their daughter's death. As her letter only reached Tahiti in April, she must have left it until late February before sending off the brief note which may well have had to pass from Copenhagen to Paris to Polynesia via America.

If Mette's reaction was one of stunned confusion, Gauguin's was little better, demonstrating the classic symptoms of 'denial'. Far from trying to contact his wife to discover what had happened and so lay to rest the intense agony through a knowledge which would unleash the grieving he so clearly needed, he foolishly attempted to suppress his emotions, passing off his beloved daughter's death as if it was no more than just another blow to one who, like Christ, had already suffered so much. Of course, such a ludicrous attempt at bravado could not last, and grief quite soon overwhelmed him and as ever, there was only Daniel de Monfreid to whom he could explain so tortuous and complex a catastrophe.

Tahiti, April 1897

> Your letter arrived at the same time as a short but dreadful letter from my wife. She informed me bluntly of the death of my daughter, who was snatched from us in just a few days by a fatal attack of pneumonia. This news did not distress me at all, hardened as I have been for a long time to suffering; and then each day, as thought kept piling in, the wound opened up, becoming deeper and deeper, until now I am completely overwhelmed . . . .

As with so many in similar situations, the vestiges of his sanity were probably saved by the utterly mundane business of coping with day-to-day matters. Close on the news of Aline's death came a second, far lesser blow, but one capable of distracting him sufficiently to drive out any thoughts of suicide. The owner of the land on which he had built his hut and studio suddenly died and the heirs immediately sold off the inheritance, forcing Gauguin to move out. What with the need to rehouse himself and Pau'ura, the next three months were entirely taken

up with acquiring another plot of land and building a home – in some ways the best possible thing that could have happened to him.

Luckily, he managed to find a plot only 500 metres further south along the coast road next to the local school that Souvy had endowed, with its 2+2=4 sign over the gate. That sign, or at least a new version of it, is there to this day and Gauguin's house survived until fairly recently, largely because he spent so much money on the materials for it that it lasted far longer than any local construction of bamboo and pandanus could ever have done. In truth, the whole thing was a product of a mind deranged by grief. He still had most of the money Chaudet had sent just before Christmas and he ought to have found an inexpensive plot where he could have run up a modest local hut until further money arrived. Instead he embarked on an act of sheer folly. The land next to the school was being sold by a Madame Gatien who had inherited it after her husband's death. Because Punaauia was near to Papeete and within the 'zone' favoured by Europeans, the cost was consequently above the odds. To raise the money, Gauguin presented himself at the Caisse Agricole in Papeete, then the only bank on the island, in order to get a loan for his project. His friend Sosthène Drollet had been a member of the board, and though he had recently died, it is likely that Gauguin knew enough of the other members to get a hearing. This, however, was not enough as the bank's policy was only to lend money for farming projects, backed by land deeds. Here Gauguin seems to have been fairly economical with the truth – there were palm trees on the Gatiens' land and the region round Punaauia was certainly where many of the most flourishing plantations could be found, so it was on this basis that Gauguin suggested himself as a future farmer and was, amazingly, granted an advance of 1,000 francs at ten per cent interest, repayable in a year.

As if that were not enough, he then proceeded to run up two buildings which in the end proved so expensive he had to get credit from the builders and was thus doubly in debt. Despite that, there were mixed reactions over the quality of what he had built. We know from the Postmaster Lemasson, who cycled out to see him on occasions, that this new affair was different from the single building he had put up on the previous site. This time the house and the studio were separate with the latter being built perpendicular to the road, while the living quarters were some way away, not far from the homes of the other Frenchmen and local people which were dotted about in a fairly haphazard fashion among the palms. The English author Robert Keable, once famous for his best-selling religious novels, and another keen photographer, rented the house in 1923 and left a sharp black and white image of the view:

Taken where Gauguin must have sat hundreds of times as the sun went down, Moorea is bathed in the day's last ruddy light, which flowing across the water, turns to blood the mouth of the little stream that runs past the house and the slim palm trunks to pillars of night. All that earth has to offer of beauty cannot exceed such a scene as this. And this the master found night after night in the home of his adoption, supremely and nobly discontent.

Of course by Keable's time, everything that had belonged to Gauguin had long since gone, though some of the friends left descriptions, according to their personal inclinations. Jules Agostini was lyrical:

The walls of the little room were carpeted with canvases which had nothing of the classical or conventional, where the master had captured, without missing a single detail, all the beauty which a prodigious nature had scattered beneath the radiant sky of that unforgettable isle.

Lemasson by contrast makes it quite clear that the house and the studio were a mass of objects with things so cluttered you had to be careful where you walked. According to the postmaster the walls of the studio were made of unplaned wood, with a wall that Gauguin could slide open to let in the light. There was even greater disorder there than in the living quarters and we know that Gauguin had brought over the carvings from the previous hut and that he carved most of the new posts both inside and out on the veranda. Once the space was ready, he tried to start painting again – he even had a title: *Te rohutu* (*The Dwelling-place of Souls*), undoubtedly intended as a memorial to Aline. But it was not to be. Unlike earlier occasions when tragedy had stimulated art, when some terrible moment had been exorcized through creation – the loss of Teha'amana's baby, the death of Pau'ura's child – this time, there was to be no easy catharsis. The death of Aline had overwhelmed him and the painting was never made.

Through all this, he did not write back to Mette but when he received no word from any of his children on his forty-ninth birthday on 7 June, he could bear it no longer. As far as he was concerned there was only one person to blame for this miserable silence, his wife. She knew he longed to hear from them, yet she had failed to provide even that little comfort. He was ill again, so ill he had to get a friend to write for him, but that August he finally dictated the note which contained all the bitterness that had been consuming him since April.

I'm reading over the shoulder of a friend who is writing . . . . 'I have just lost my daughter, I no longer love God. Like my mother, her name was Aline. We all love in our own way: for some, love is kindled at the coffin, for others . . . I don't know. Her tomb over there, the flowers, that's all pretence. Her tomb is here beside me; my tears are living flowers.'

He was a man suffering beyond pain and his final barb, aimed directly at Mette, was effectively a curse: 'May your conscience sleep to prevent you welcoming death as a deliverance.'

Needless to say she did not reply, nor ever wrote directly to him again, nor he to her. It was over, his family would have no contact with him from then on. He was dead to them and they to him. He made a few carved panels in a desultory sort of way. His illness flared up again and he found it hard to get about. When the eruptions on his leg got worse he rubbed the wounds with powdered arsenic and thought about suicide.

This then was his 'Studio of the Tropics', the little bit of paradise he and Van Gogh and the others had dreamed about: a wooden hut under the palms, a nubile native mistress, cheap food, and best of all a place to work. Yet here was the reality: an incurable disease, impossible debts, an unfinished canvas and no inclination to start again. There was no sign that any of those who had once considered joining him were ever likely to turn up – except, that is, for one. He was hardly the man Gauguin would have chosen or even expected to make the effort, but strange as it was and still seems, the only person out of all those who had ever known Gauguin to make the journey to Tahiti was the languid Englishman Peter Studd, who had first met him briefly in Le Pouldu eight years earlier. Now on 22 May 1897 just as Gauguin was at his lowest point, Studd suddenly turned up in Papeete, hoping to find the man whose work he had formerly admired and attempted to emulate.

## Sea Pieces and Night Nocturnes

Like Gauguin, Peter Studd had taken the eastern route round the world, travelling first to Sydney then on to Auckland, arriving on 13 May 1897 and staying three days. He does not seem to have bothered with the Art Gallery as there is no signature in its visitors book. We cannot tell whether he visited the Museum or not. He left on 16 May aboard the *Upolu* calling in at Rarotonga and Raiatea, arriving in Papeete on the 22nd. If he had come expressly to see Gauguin, he could not have arrived at a worse time. Gauguin was still frantically rehousing himself, in a mental state fluctuating between abject grief and an insane refusal to accept the situation, his health was rapidly deteriorating and his notorious temper can only have been stretched to breaking point. Studd appears to have stayed in Papeete but there can be little doubt that he visited Gauguin – Studd clearly entitled one of his paintings, *The View from Gauguin's House*, a scene so similar to Keable's photograph of the view across the lagoon to Moorea that there is no reason to doubt that he had been there. There are other links – a reclining figure, in a crayon and pastel work by Studd entitled *Tahitian Interior*, is clearly based on

a drawing of a sleeping Tahitian girl in the sketchbook Gauguin made during his first stay on the island (the *Carnet de Tahiti*) and a Studd drawing in the Tate Gallery, London entitled *Pacific Island Subject* shows three figures at a table which has echoes of Gauguin's painting of three children with an Umete bowl – though in the case of the Studd, the middle figure of a European in native dress is probably Studd himself wearing a *pareu* – evidently the dapper Englishman, with his brushed-out moustaches and his narrow epicene features, had also tried to go native.

But Studd's visit was too late for both men. Gauguin was ill and Studd himself was no longer as impressed by 'the Savage' as he had been in Le Pouldu. Two years before this Pacific journey, Studd had met Whistler and had become one of the American artist's closest disciples. The strong outlines and bold effects which Studd had tried in Brittany after his encounter with Gauguin in 1890 had begun to give way to Whistler's soft, wispy impressionism, the nocturnes and mood pieces that many other than Studd had found dangerously seductive. Had Gauguin been in any state to offer this impressionable character an example to follow, Studd might well have fallen under his spell again. He might even have stayed on the island, which in turn might have helped Gauguin who was in dire need of someone to lean on, being always at his best as the leader of an adoring group, for ever pushing himself forward as he tried to impress his followers. Gauguin needed disciples and challengers, on his own he withered and became prey to paranoia. The peculiar Englishman was no great disciple but he was there and he had money, and the sad thing is that these two men, who needed each other for such different reasons, failed to connect. In the end Whistler won out in this curious little battle between the effete Europeanized aesthete and the hard, self-created savage. For a brief moment, Studd tried hard to absorb something of Gauguin's boldness and out of the twenty-odd surviving works from Studd's stay on Tahiti some display a vague leaning back towards the savage in Punaauia, away from the lyrical softness of the absent master. But the Englishman probably realized quite early on that Gauguin was too absorbed and ill to be able to offer any real guidance and on 22 June, a month after his arrival, Studd took the unusual step of writing to Whistler to suggest he should come out and join him:

> There are amazing things to paint. Women who walk like goddesses. Splendidly proportioned youths sitting in the moonlight, crowned with garlands, where palms wave in the background like huge black plumes against the sky, or struggling, naked, two or three abreast with great cases of oranges to carry them down to the water by the light of a bonfire, boats laden with fruit and adorned with flowers – we have had beautiful cloudy weather ever since my arrival a month ago and the day would be for you

full of sea pieces and the night nocturnes. Here, too, you would still be under the government of the only country you consider enlightened.

Significantly, the letter omits any reference to Gauguin, but given Whistler's aversion to any hint of a rival, and perhaps remembering the unpleasantness in Dieppe all those years ago, Studd was probably wise to play down the fact that there was already another 'genius' in residence on the island. In any event, there was never any likelihood of the urbane Whistler travelling so far from the sophisticated haunts of London and Paris – though the thought of two such *monstres sacrés* as Gauguin and Whistler meeting up on that tiny outcrop in the Pacific does provoke a smile.

## The Catholic Church and Modern Times

It is unlikely that Studd saw much of Gauguin after his first months on the island. By July Gauguin's illness had advanced to the point where fever had him bedridden and unable to take anything more than a little rice and water. Over the coming month he had an eye infection, probably conjunctivitis, and the eruptions on his skin were so vile the rumour began to spread that he had somehow contracted leprosy.

He was not, however, completely inactive, having decided to expand the notes he had made from the Soury pamphlet into an essay of his own, with religion as its theme. He wrote the title across the *Noa Noa* exercise book: *L'Eglise catholique et les temps modernes* and he was to work at it, off and on, for the remainder of the year and through into 1898. But despite its lofty title, much of what he wrote was merely a continuation of Soury's attack on Catholicism, which in Gauguin's case was probably as much inspired by his immediate anger at Father Michel's interference in his daily life, than with any heartfelt desire to reform Christian belief. As he continued writing – bedridden, ill and depressed – what may have begun as a philosophical exercise was soon reduced to little more than a vitriolic attack on the canting, hypocritical, pharisaical Catholic Church, though Protestants get an occasional venomous paragraph. The problem is that Soury/Massey had unleashed something within Gauguin which he was unable to expound adequately in words. Massey's work is literally a 'Book of the Dead', in fearsome imitation of that sacred Egyptian text to which he so often referred. But as with Casaubon in *Middlemarch*, Massey demonstrates no imaginative feelings for the people whose myths he scatters about his studies; all is reduced to the level of lifeless statistics, plucked flowers which have quickly withered. Reading Gauguin's attempts to emulate such dusty stuff, we can see behind the words a sick man struggling to formulate some earthly philosophy which will allow

him to make some sense of the bleak impasse into which his life has turned:

> Given this ever present riddle: *Where do we come from? What are we? Where are we going?* what is our ideal, natural, rational destiny? and under what conditions can it be accomplished? or what is the law, what are the rules for accomplishing it in its individual and humanitarian meaning? A riddle which, in these modern times, the human mind does need to solve in order to see the way before it clearly, in order to stride firmly towards its future without stumbling, deviating, or taking a step backward; and this must be done without wavering from the wise principle which consists of making a tabula rasa of all earlier tradition, of subjecting everything to a comprehensive, scientific, philosophical supervision . . . So that we do not overlook any portion of what this problem of nature and ourselves implies, we must seriously (even if only as an indication) consider this doctrine of Christ in its natural and rational meaning which, once freed of the veils that concealed and denatured it, emerges in its true simplicity but at the same time full of grandeur and shedding the intensest light on the solution to the riddle of our nature and our destiny.

It was there, submerged inside the clotted prose, but it needed form, living form, which he as the supreme visual artist was capable of doing but not, surely not, in words. Yet he was too tired, too sick to do more than scribble and even that was denied him, when he suffered a heart attack in the second week of October and began coughing blood again. He was now convinced it was only a matter of time, and that he would, in the very near future, die.

## The Futility of Words

There were few to help him save Pau'ura. Peter Studd had already left – having only stayed on because his brother Reginald had decided to come out to New Zealand so that they could make the trip back, via Samoa. While Gauguin lay in bed, that July, Studd had enjoyed all the fun of the Bastille celebrations which every year seemed to get bigger and last longer. The one final mystery about his visit is why he bought none of Gauguin's paintings, which he could have had for next to nothing. One can only assume that he really had decided that he was Whistler's man after all and that he saw no reason to waste his money on the eccentric daubings of this sad diseased exile.

On his return Studd would move to a house next door to Whistler in Chelsea and would follow him to Venice to paint the misty lagoons and churches, in a similar ethereal vein. He was a devoted disciple and collected the master's work, while doing little to promote his own, and since his death in 1919 only four exhibitions have featured his work, the

most ironic being 'The English Friends of Paul Gauguin' at the Anthony d'Offay Gallery, London in May 1967. If Peter Studd is remembered at all, it is for his munificent gift to the nation of three of Whistler's greatest works, most notably *The Little White Girl* which now hangs in the Tate Gallery, London.

Peter Studd left Papeete in early September 1897 and was back in Auckland on the 28th and with his brother Reginald he sailed for Samoa the following Saturday, 2 October, a departure which finally put an end to the persistent dream of the 'Studio of the Tropics' and to any lingering hope that Gauguin might have had that he would find a kindred spirit to sustain him. He might well have carried out his threat to put an end to himself if it had not been for a totally unexpected gift in mid-October – 126 francs sent by Monfreid's mistress, Annette Belfis, the friend of Juliette Huet, mother of Germaine, who was now Gauguin's only surviving daughter. Annette must have been shown Gauguin's letters and been moved to pity by his situation. It was a tiny sum but enough to help him survive for a while. The main part of his diet was now whatever Pau'ura could find – mainly freshwater shrimps and mangoes and gauvas. He appears to have been so weakened as to be virtually immobile and in this state of drifting inactivity, October slipped into November and on into December with nothing to mark their passing. It was now six months since he had done any painting. He wrote to Charles Morice to say that he had given up hope of seeing *Noa Noa* printed but added that he would try to get up the energy to make him a copy of his essay on 'Art, The Catholic Church and the Modern Spirit' and added a long postscript on Ernest Renan, whose *Life of Jesus* was again on his mind, finding in the history of Renan's treatment by the Church echoes of his own struggles and sympathizing with the way Renan retained his belief in Christ while ceasing to believe in the Church's interpretation of His life.

Early in December, he had another heart attack and it looked as if his longed-for death was now a certainty – the appalling condition of his damaged leg was hampering circulation and weakening the heart. He ought to have returned to the hospital but he now wanted to die sooner rather than later. Death, however, was not prepared to oblige and again the crisis passed, leaving him weaker but still breathing, for the moment. At this point, Gauguin decided that in the little time left to him, he would make one last painting – last in every sense, for it would be the summary of all that he had done before. A final creative act. As befitted such a plan, it would be the largest painting he had ever attempted, both in physical scale and in the ambitious nature of its subject. He would later give it a title which would make it evident to even the densest critic that this was nothing less than the testament of a man who had roamed continents and cultures, whose thinking embraced many philosophies

and religions, who had experienced the contradictions of a revolutionary age, who had been rich and poor, lived in mansions and hovels, who had known sexual ecstasy and humiliating failure. His title was nothing less than the ultimate, impossible riddle all sentient beings at some point ask themselves, but from which most recoil in confused despair: *D'où venons-nous? Que sommes-nous? Où allons-nous?* (*Where Do We Come from? What Are We? Where Are We Going?*).

The title came last – painted on when the picture was complete – but it is wrong to suggest, as some have done, that it was a mere afterthought, intended to give a spurious unified resonance to an otherwise unconnected series of images. We know from the writings which preceded the making of the picture that these questions were the essence of the religious debate that had been swirling around his fevered brain since he had learned of the death of Aline. They had arisen out of his readings from Massey, but the attempt to explain a cosmic theology in his essay had proved too difficult. Now he intended to bring his ideas to life, on canvas.

Most biographies of Gauguin tell the same story: that having decided to make the work, he dashed it off at high speed during December 1897, without any prior studies, straight onto a vast canvas he had strung up in his studio. By all accounts it was a race against time, for he had definitely decided that if the last mail boat of the year brought him no money he would finally put an end to himself, using the arsenic he had stored up from the amounts he obtained to treat the eczema on his leg. Like a demented Michelangelo covering the Sistine ceiling in fast-forward, Gauguin got it all down in an unstoppable, heroic outpouring. Unfortunately, this anecdote, while exciting and dramatic, does not fit the few facts that have begun to emerge. These reveal a far from simple genesis, though one which is surely more apt for so complex a painting than the theatrics usually offered up.

The main evidence against what might be described as the 'Impetuous Production' theory is the fact that Gauguin had been planning a large work for some time before December. Almost as soon as he had finished building the studio, he measured it to see what was the largest-sized canvas he could fit inside and he even made some notes in his Miscellaneous Things, on the sort of large-scale painting he had in mind:

> The main figure will be a woman turning into a statue, still remaining alive yet becoming an idol. The figure will stand out against a clump of trees such as do not grow on earth but only in Paradise. You see what I mean, don't you? This is not Pygmalion's statue coming alive and becoming human, but woman becoming idol. Nor is this Lot's wife being turned into a pillar of salt: great God, no.

Like his projected memorial to Aline, *The Dwelling-place of Souls*, this ambitious work was never begun – in that period of sick lethargy that overwhelmed him, he was too ill to undertake such a strenuous task. But his mind had clearly been on it long before December. However, the main proof that he did not, as he later suggested, simply hang a canvas and set to work, making it up as he went along, is found in a coloured drawing in the Musée des Arts Africains et Océaniens in Paris, which shows most of the main elements of the final painting already in position. The drawing is on tracing paper, which presumably means it was copied from a previous study. This copy was then over-ruled with vertical and horizontal pencil lines so that the image could be transferred, in effect blown up onto the vast length of material which he had stretched along the length of the room. Far from dashing off this work in an impromptu fashion, Gauguin was still working on the canvas six months later, in the middle of the year, when he asked the postmaster Henry Lemasson to photograph it for him. Lemasson clearly remembered bicycling out to Punaauia on 2 June 1898, along with a friend, a Monsieur Vermeersch from the tax and registry office, and the photograph Lemasson took shows the long picture raised on a box or table which is covered with a tattered striped cloth, while all around the earth floor is scattered with dried rushes of some sort. Minute examination of Lemasson's photograph reveals that the painting was not quite in its finished state, and must have been completed in the latter part of June before being despatched by boat to France. All of this adds up to an exceptionally long gestation, almost seven months in all, from first sketch to final brushstroke.

That said, Gauguin's report, in a letter to Monfreid dated February 1898, that the work was finished and had been done rapidly and without prior preparation, offers considerable insight into his thinking. He was obviously trying to distance himself from the muralists of the academic tradition with their preparatory studies and their squared-off transfers – precisely the method he had used but wished now to deny. While it is likely that the work was largely in place when he wrote to Monfreid and that what came later were no more than small adjustments, the 'Impetuous Production' theory remains a gross exaggeration. This was a precisely worked out and carefully balanced scheme, methodically put in place then rapidly executed, after which there was a long period of reflection and adjustment, until the canvas was taken down and rolled up for shipment.

The word canvas is used loosely – in fact, he had to stitch together a long strip of rough sacking material whose knotted grain is clearly visible through the thin washes of paint. The final surface was enormous, one metre seventy high, a staggering four metres fifty long – truly a mural, a feeling deliberately induced by two chrome-yellow 'patches', at the top

left and top right hand corners, which were, as Gauguin explained to Monfreid, meant to leave the impression that one was looking at a fresco whose corners had worn with age.

Once he saw the 'canvas' in place Gauguin realized that his preparatory sketch would have to be adapted – the squared-off drawing in the Musée des Arts Africains et Océaniens is shorter than the finished painting, and we can see that Gauguin added a section to the right-hand side, in order to balance the composition and bring the principal figure into a more central position – a further blow to the fanciful notion that he just started at one end and worked his way to the other, making it up as he went along.

The basic background setting is fairly naturalistic, a sylvan glade of the sort Puvis de Chavannes specialized in – though where Puvis would have created a dreamlike evocation of a timeless Parnassian vale, Gauguin offers us a fanciful rendition of his surroundings in Punaauia. As he described it: 'It is all on the bank of a river in the woods. In the background the ocean, then the mountains of a neighbouring island. Despite changes of tone, the colouring of the landscape is constant, either blue or Veronese green.' But that is the only concession to the traditional 'through a window' technique of conventional Western easel painting, the events taking place in this landscape are more like an unfolding strip-cartoon, though in this case it is one that is meant to be read backwards from right to left. As before, the painting works at a great number of levels with Gauguin using elements from several previous paintings which bring with them the added meaning of earlier ideas, all of which can be worked into this story, subtly leading the spectator down new avenues of meaning and feeling. But for once, no one need feel in any sense intimidated by this – there is a perfectly clear surface meaning to the work, which in turn holds the key to all the others. Gauguin explained it to Lemasson and Vermeersch when they came for the photography session in June, presumably in a way he thought someone like the tax inspector would understand: 'On the right, a newborn child; on the left an old woman with a bird, symbolic portent of approaching death. Between these extremes of life is mankind, loving and active. And in this terrestrial space, a statue symbolizing the Divinity that is inherent in humanity.'

We can even reduce it further: Birth, Life, Death – 'Where do we come from? What are we? Where are we going?'

To Daniel de Monfreid, a man more versed in Symbolist meanings, Gauguin gave the first indications of the subtler interpretations which lay behind that simple outline:

To the right at the lower end, a sleeping child and three crouching women. Two figures dressed in purple confide their thoughts to one another. An

enormous crouching figure, out of all proportion, and intentionally so, raises its arms and stares in astonishment upon these two, who dare to think of their destiny. A figure in the centre is picking fruit. Two cats near a child. A white goat. An idol, its arms mysteriously raised in a sort of rhythm, seems to indicate the Beyond. Then lastly, an old woman nearing death appears to accept everything, to resign herself to her thoughts. She completes the story! At her feet a strange white bird, holding a lizard in its claws, represents the futility of words.

Perhaps we can assume that the words which were so futile, were those he had used for his notes based on Massey. When he had tried to write about such complex ideas he had failed – now in paint, he would succeed.

Beginning at the right, with the section concerned with Birth, we have a reenactment of *The Dream*, with Pau'ura and the sleeping child; move across to the extreme left and we have the opposite, a woman awaiting death, based on the now familiar Peruvian mummy, sitting in a crouched foetal position, similar to the sad-eyed girl in *Misères humaines* (*Human Anguish*). To reinforce the idea of loss, this left-hand section is filled with those symbols that Gauguin had created for the Tahitian past: a statue of Hina, a figure based on Vairaumati, the Polynesian dog, but also within the death sphere, as if to unify it and link it to Pau'ura and the imaginary baby on the far side, is a curious girl-child sucking on a fruit, an echo of the spectral figure added into *Nave nave mahana*, (*Delightful Day*) after the death of their baby just over a year earlier. Now the figure is slightly older, as of course the child would have been had she lived.

Both right and left, birth and death, are in some ways merely supporters of the central section Life, which lies literally and metaphorically at the heart of the work. Not quite at the centre, just to the right, a little more on the Birth side than on that of Death, a figure reaches up to pluck fruit from a branch. A Tahitian Eve? Pau'ura taking on Teha'amana's former role? Tahiti as the Garden of Eden once more? A last resurrection of the lost paradise?

Even today this stretching figure causes more confusion than anything else in the entire painting. There are still writers who refer to a Tahitian Eve gathering the forbidden fruit and there can be little doubt that Gauguin wanted echoes of his earlier works to resonate across the great canvas and that by giving the figure the long hair and oval face of a *vahine*, he may have deliberately aimed at a sense of ambiguity, and androgyny. Yet there is no suggestion of breasts, or any other sure signs of womanhood and the figure is as much a man as a woman, as much Jotefa as Pau'ura or Teha'amana. We now know he based the pose on a *Study of a Nude* attributed to the School of Rembrandt – a male nude, but even without that knowledge, the folds of the loin cloth suggest a

prominent erection, a covered phallus which is so central, it is almost the focal point of the entire canvas.

Here, in his self-conscious masterwork, the one painting he saw as the summation of his philosophical and religious thinking, Gauguin seems to be saying that if there was an innocent paradise then it was as much Man as Woman who brought about the Fall. The answer to the central question of the triple enigma 'What are we?' is that we are what inquisitive man in his thirst for knowledge has made us. This is what lies between the innocent dream into which we are born and the lost culture into which we pass and die.

There is only one other male figure in the entire work, a strange ghostly presence in a sepulchral shroud who walks in the background with a young girl similarly garbed. Gauguin and Aline? It is impossible to be sure. Two shadowy figures strolling in this imagined glade, walking from left to right and thus symbolically from Death to Birth – an interpretation which is only made clear if one first understands *The Great Buddha* with its cycle of birth, death and rebirth, which once more seems to be the true inner meaning of this work. Did he believe that in making it he had somehow released his daughter's spirit – both daughters, perhaps? If this interpretation is correct then the three figures which represent them – the sleeping child, the fruit-eating girl, the spectral Aline, can be linked by a circle, with the erect figure of Adam/Jotefa as its centre – a circle of life, turning around that potent emblem of Gauguin's sexual epiphany.

Any complete answer to the triple question of the title cannot be deduced by reason alone. The picture must be experienced, both intellectually and sensually, or as Gauguin put it, in the jottings in the *Noa Noa* exercise book:

> Today, for our modern minds, the problem *Where do we come from? What are we? Where are we going?* has been greatly clarified, by the torch of reason alone. Let the fable and the legend continue as they are, of utmost beauty (that is undeniable); they had nothing to do with scientific reasoning.

Three years later, in 1901, still obsessed by what he had created, he tried again to get at the inner meaning of the work in a letter to Charles Morice in which he spoke of the 'two sinister figures, shrouded in garments of sombre colour, recording near the tree of science their note of anguish caused by this science itself, in comparison with the simple beings in a virgin nature, which might be the human idea of paradise, allowing everybody happiness of living'.

Here then is the man who had spanned the latter half of the great century of change, ranging from the antique world of the crumbling

Spanish Empire to the thrusting Europe of railways and factories and colonial power. Who had enjoyed the great circus of progress and technology and wealth only to turn away from it in disgust. Gauguin never truly abandoned his origins, never really entered the non-European world which was all around him, never truly lived the myth of his own escape from civilization. Rather, he existed in the fissures that were opening between the certainties of his age. As the nineteenth-century belief in progress, in the scientific and the rational fractured, and people looked to the irrational and the spiritual and thence to nihilism and utter disbelief, Gauguin yet hoped that there might be another way, some path we had missed, somewhere back along the road, and that there might still be time to return and find it and thus move forward in an entirely different direction from the commercial squalor and the spiritual emptiness which progress left in its wake. Sixteen years before the First World War would prove him right, Gauguin offered us his vision of the other. Not a paradise – there is too much decay and death in this arcadia, but nor is this the expression of despair that some have chosen to see. 'Where are we going?' is the final question, and the answer, albeit tentative, which Gauguin seems to offer, lies in the concept of eternal renewal, of rebirth and continuity and, ultimately, of hope.

## I Shall Never Do Anything Better

By the end of December, the bulk of the work was complete, at which point despair took hold. The Christmas mail boat brought mixed news. It included a copy of the October edition of *La Revue Blanche* which contained a first instalment of Morice's rewritten *Noa Noa*, with the promise of a second the following month. Far from being overjoyed at this long-awaited event Gauguin was confused. According to Morice, no fee had been paid for the work and in any case Gauguin had only a passing acquaintance with the *Revue* which seemed to him to be a hopelessly inadequate vehicle for his major testament. This was a misjudgement on Gauguin's part, for under the editorship of Félix Fénéon the *Revue* was by then the most influential of all the literary/artistic periodicals, whereas the *Mercure de France*, which was all Gauguin ever saw, had slipped in the estimation of the Paris art world, which was no more pleased with Mauclair's reviews than Gauguin was. But in the isolation of Tahiti, it looked as if the ever untrustworthy Morice had thrown away all their work on a no-account publication, for no reward whatsoever. To add to his despair, the mail contained no money from Chaudet, the very thing which he had said would be the end of him.

It was at this point, Gauguin claimed, that he decided to carry out his promise to kill himself. Leaving the largely completed canvas, he took

the arsenic which he had been hoarding from the treatments for his eczema, and on 30 December, a week after what would have been Aline's birthday, he went up into the mountains, presumably via the nearby valley of the Punaruu, which he had climbed before, going as high as he could, in order that he would not be found and his body be devoured by ants. Having chosen his spot he lay down and swallowed all the arsenic and waited for the end.

# 13

◆

# *Strange Occupation for an Artist*

It was not to be. As he told Monfreid in a letter that February: 'Whether the dose was too strong, or whether the vomiting counteracted the poison, I don't know; but after a night of terrible suffering I returned home.'

It must be said that there has always been some doubt about the truth of this episode. In the February letter, he claims that the great painting was finished, and implies that after the heroic struggle with his master-piece, he was at last able to lay down his burden, whereas we now know that while the canvas was largely complete, it would be several months before he was finally satisfied. Almost everything he said about the way the work was made was a direct lie. He told Monfreid that he had *not* done it 'like a Puvis de Chavannes, sketch after nature, preparatory cartoon etc. It is all done straight from the brush . . . .' When in fact it was precisely the other way round. As for the suicide story, that may well have been part of this deliberate myth-making, a way of enhancing the stature of the great work by emphasizing the desperate agony of its creator. There may also have been an element of self-defence in the story, arising out of his continuing obsession with Van Gogh and his conviction that the world held him responsible for the attempted suicide in Arles. What better way to purge himself of blame, than to show that he too had reached the point of utter despair and had only been spared by forces beyond his control.

Whether or not he did climb into the mountains and try to do away with himself on that December night, we shall never know, but by January he was certainly back at work again, making adjustments to the great canvas, but also embarking on another attempt to create a sequence of large, related paintings, that could be hung together, around the central masterwork, and thus create the total environment which he still believed was the only way he could persuade a resistant public to enter fully his imaginative world.

This time he would be more successful than with the earlier group of works which seem to make up a 'Maternity Sequence' – this second group was kept together and exhibited by Vollard at the end of that year and a sympathetic article in *La Revue Blanche* by Thadée Natanson enables us to reconstruct the paintings that were shown. Natanson wrote of '. . . eight motifs inspired by the decor where the painter lives and by the large decorative, mysterious panel that brings them together, but they can also represent fragmentary replicas rather than studies.'

Despite the eight which Natanson gives, nine works are suggested by his piece, but as two of them are similar studies of the same male figure, Natanson may well have counted them as one. What his account reveals is that Gauguin saw these eight or nine canvases as extending, or adding to, the effect of the central work. Unlike the possible 'Maternity Sequence' whose canvases had evolved over a year's work, each painting leading on from its predecessor, most of this group were painted as a set, after the great central canvas, whose themes they were meant to explain or extend in some way. Two earlier works were included, as they were in effect preparatory paintings – one of them, a painting of Vairaumati, was the basis of a figure which appears in the great canvas itself. The rest were mainly extensions of individual elements within the complex work – in one the ambiguous figure picking fruit becomes more definitely a woman, while in another he adds the familiar figure of Teha'amana as Eve, in the pose from the Borobudur frieze, as if trying to bring together all his cultural icons. Amazingly, it was Natanson in Paris who came closest to understanding what he was doing, when he wrote that the works should be collectively seen as 'fragmentary relics'. This sits very well with Gauguin's own explanations, especially his comment that the golden edges at both corners of the large canvas were intended to create the illusion that the painting was an ancient fresco, damaged by time. This takes us back to the first Tahitian visit and the Ariois paintings, and all those works where understanding cannot come from rational analysis alone. It has been well said that because so many students of Gauguin's art are obliged to work from photographic reproductions, there has been a tendency to concentrate on analyzing Gauguin's sources both visual and literary, whereas to experience the works themselves, with all the emotion of colour and scale, offers an entirely different sensation. To follow Natanson's lead, the great painting and its eight or nine supporting works are like the surviving vestiges of a lost culture, the 'fragmentary relics' whose meaning may never be fully understood by the contemporary spectator, but which still convey a powerful, non-literary emotive force, similar to that which Gauguin himself had experienced in the plaster pagoda from Angkor Wat.

## Six Francs a Day

As most of the work for the planned exhibition was not completed until the end of March, he was obliged to survive on a combination of Pau'ura's food sorties and by begging loans from friends. But there was an inevitable limit to that sort of charity and when he heard that the post of Secretary-Treasurer was available at his bank the Caisse Agricole he thought he would try his luck. There was little chance that so scruffy and disreputable a figure would get it, but by the time the refusal came, he had accepted the inevitability of surrendering his freedom in order to survive. He tried writing to the governor's office to ask for an administrative position but his letter went unanswered and in the end his only solution was to take a job no one else wanted, a post in the Public Works Department in Papeete, presumably through the Agostini connection and the fact that his artistic skills would enable him to work as a draughtsman, laboriously copying out the minor drawings needed for small-scale projects. That was tedious enough, but it was only half of the task, for once the plans were completed and the work under way, Gauguin was expected to act as a sort of foreman or works inspector, going out to supervise the sites, to see that all was progressing as intended. For this he would be paid a meagre six francs a day, six days a week, with nothing for the unworked Sunday. It was hardly worth it, particularly as he was expected to dress properly, as a European, in jacket and trousers, for his daily inspections. On top of that, he could hardly commute between Punaauia and Papeete every day and would have to close up the house and studio and move back into town. But whatever the drawbacks, he was in no position to refuse and some time in late March or early April he moved with Pau'ura to Paofai, the district around the cathedral, not far from the market, and just the sort of rundown area Cardella and Agostini were trying to clean up. His fellow countrymen may not have cared for him before, but at least he had appeared to be a man of independent means with his own property and while they certainly didn't like the results, they had to accept that he was a professional artist who had once been on a *mission officielle*. Now he was the lowest sort of public servant, barely higher in status than the labourers he supervised and he soon had visible evidence of what this meant when he began visiting the building sites and found himself snubbed by any passing Frenchmen, including some who had formerly been quite friendly, who would look the other way rather than be seen greeting someone so far down the social scale.

Of course he still had some friends, those who were a bit more intelligent or creative like Lemasson. And he still had the power to make new ones like a colleague in the Public Works Department, Pierre Levergos,

who had been given a sinecure after being wounded in the hand during Gallet's expedition to Raiatea and Tahaa. But in essence the only whites willing to befriend him were those who were in some way at odds with the system. One of these was a government clerk, François Picquenot, whom he had met during his first stay on the island, but who had not really made any impression. Now he had to accept his friendship, as he was one of the few who were willing to associate with him, largely because Picquenot himself was unable to play the humble functionary in the way his superiors demanded.

For five months he did no new painting, merely tidying up work begun earlier, if he managed to travel out to Punaauia on his free Sundays. There seemed to be no hurry. As he explained to Monfreid, he liked sitting contemplating the large canvas, it pleased him and he felt no particular compunction to do much else. It was only after he had met yet another naval officer who was willing to take work back to France when his boat sailed in July that Gauguin decided he must finally conclude the project. In June he got Lemasson to cycle out to take the photograph, after which he added a few finishing touches before rolling all the canvases and getting them to the ship in Papeete harbour.

And that was that – he had little left in the way of paints, certainly no canvas, and not much inclination to do anything anyway. There were some moments of relief in this year of humiliation and gloom – the rare letter with which the ever-loyal Monfreid was able to pass on a little money from the occasional sale, usually just enough to keep up the repayments on his bank debt, but those aside the situation seemed to worsen remorselessly. By August Pau'ura had had enough of living in penury amongst strangers in Papeete and had returned to her family in Punaauia. Inevitably, she considered the things in the house and the studio to be partly hers and took to breaking in and taking what she needed or what she could sell. When Gauguin discovered this he tried to stop her but when the losses continued he seems to have lost all sense of balance and set about trying to recover the stuff through the courts. The consequences were little short of ludicrous. He accused her of stealing a ring, a coffee grinder and a copra sack. At the first hearing, she was found guilty and could have ended up in jail for a week if she hadn't been persuaded to appeal, thus moving the case upwards into the court of the Procureur de la République, Edouard Charlier, the one-time friend of Gauguin, who had travelled out with him on the famous expedition to the islands three years earlier. As an amateur painter, Charlier had initially been charmed by Gauguin and had somehow acquired three of his works – we do not know which or how, though they were probably repayment for loans rather than straightforward purchases, as the magistrate does not seem to have appreciated them any

more than his fellow Frenchmen did. That he was now to re-hear the case was not necessarily to Gauguin's advantage, as Charlier was only too well aware of the real relationship between the accused and the plaintiff, and decided to set aside the former judgment and dismiss the case.

Gauguin was furious. His loathing for Charlier was allied to an irrational sense of injustice. Alone in his shack in Paofai and unsure what state his house and studio were now in, he was as isolated as he had ever been. Once again his illness flared up and he was forced to spend much of his pathetic income on medicines.

At some point, probably to cover credit for morphine and arsenic, he offered a painting of horses to Ambroise Millaud, another retired functionary who now looked after Cardella's pharmacy. The painting may have been done as part of the sequence now en route for France but either was not completed in time or had been kept back as it did not quite fit in with the others. This large canvas shows a stream flowing down through a forest glade with two naked, barebacked riders in the background and a riderless horse gambolling in the foreground pool, a simple Arcadian dream, which is probably why Gauguin thought the pharmacist might like it – just a nice pretty picture to hang on his wall. Predictably, Millaud refused, though half a century later his daughter, by then a Madame Marcelle Peltier, told the anthropologist Bengt Danielsson that there had been an acrimonious interchange about the colour of the foreground horse which her father claimed was an impossible green, and which Gauguin defended on the grounds that green was the true colour of the island and that the pharmacist had only to half-close his eyes whereupon everything would be green. The indignant Millaud had dismissed this, saying that he could hardly be expected to sit down with half-closed eyes every time he felt like looking at his picture.

In the end Gauguin sent the painting to Monfreid who, in the absence of a title, named it *Le Cheval Blanc* (*The White Horse*), because of the light overpainting on the green hide. Perhaps because of its simplicity, its rich colouring, and the lack of more profound inner meanings, this has become another of those pictures which Gauguin probably considered quite minor, but which, over time, has been transformed into one of his most popular works, much loved and endlessly reproduced on book-covers and post-cards. Small wonder Millaud's descendants chose to dramatize their loss.

## Reasons for Living

As if he did not have enough troubles, a colonial quarrel, way across the oceans in Africa, succeeded in adding considerably to his difficulties. The confrontation between British and French forces in the Sudan had led to talk of an all-out war between the great powers – one of history's more ridiculous disputes – but one which was taken very seriously at the time and which led to a disruption in international shipping as dispositions for some unforeseen naval encounter took place. In faraway Tahiti, this meant even more uncertainty over the mail boats, ever a subject to infuriate Gauguin who lived for the post. Under normal circumstances a letter might take a month to six weeks to travel between France and Tahiti, depending on the connections; now there was no telling at all. Dependent entirely on the small sums that Monfreid could occasionally despatch, Gauguin grew ever more desperate as the weeks passed with no sign of a ship and no news of when one might arrive.

By September 1898, his foot was again so bad that he was forced to go back into hospital, this time staying for a full three weeks, so that he was hugely relieved when a boat appeared just after his release, bringing 1,300 francs which Chaudet had passed on to Monfreid from some sales. When Gauguin wrote to thank them in October, he rather touchingly asked Monfreid to send him some seeds: 'Simple dahlias, nasturtiums and sunflowers of various sorts, flowers that can stand a hot climate – whatever you can think of. I want to decorate my little plantation, and as you know, I adore flowers.' Though, as yet, it was not possible for him to move back to Punaauia. Paid daily, he had lost much by his twenty-three days in hospital, and the money from Chaudet did little but cover his debts. He returned to work – half the time bent over a drawing board copying plans, half limping out to inspect road works and ditch-digging. It was a dismal existence, made worse by the most profound silence from France so far – Monfreid's mother had died so that his closest friend had been totally distracted by his own personal tragedy. When he heard the news in December, Gauguin sent a letter of condolence full of reflections on death and the collapse of his own life. 'If I can no longer paint, I who love only that – neither wife nor children – my heart is empty. Am I a criminal? I don't know. I seem condemned to live when I have lost all moral reasons for living . . . .'

This was sadly wrong. Unbeknown to him, he now had every reason to live. The July shipment of paintings had arrived on 11 November and within six days Vollard had given over his gallery to the great canvas with its supporting pictures. For a month it was the most important exhibition of the Paris winter season and for once the critics were fulsome in their praise. Even as he wrote that letter of despair, the art and literary

journals were carrying long articles lauding his achievement. Thadée Natanson in *La Revue Blanche* was the most perceptive in his understanding of the interplay of the various pieces in the sequence, but in some ways Gustave Geffroy in *Le Journal* went even further in writing of his regret that Gauguin had never been given a major commission for some great public scheme, say a tapestry or, better still, stained glass. Even the *Mercure de France* changed its tune – though this was largely due to the fact that Gauguin, a shareholder, had so vehemently and frequently complained about Mauclair that the editor, in the interests of balance, had decided to ask André Fontainas to write the review. The resulting essay was everything Gauguin had hoped such a unified exhibition might achieve. Fontainas began by saying that he had never much cared for Gauguin's work but now declared his conversion. The great canvas – *Where Do We Come from? What Are We? Where Are We Going?* – that self-conscious masterpiece, conceived as an assault on the citadel of art criticism, had done its work. And Fontainas, too, ended his piece with a call for Gauguin to be given some major public commission, a mural that would be worthy of his undoubted skill at major decorative schemes.

If there was ever a time for Gauguin to go back to France it was then, but he had no way of knowing it. In December he wrote to Monfreid to say how he was longing for the next mail boat in the hope that it would bring news of how the paintings had been received. '. . . it seems to me that my large canvas must be very good or very bad, and I know that you are too masculine and too frank to tell me other than the truth about it . . . .' He was somewhat less humble, later in the same letter, when he mentioned reading about the death of Stéphane Mallarmé in *Le Mercure*, noting that 'he is another who died a martyr for his art', no doubt seeing similarities with his own condition, though adding more respectfully: 'His life was at least as beautiful as his work' – which was only fitting, given how the poet had once done all he could to help him.

Early in January, the much-delayed mail brought 1,000 francs from Monfreid which included the 500 from the sale of *Nevermore* to Delius – but this had been sent so long ago, it contained no news of the exhibition and thus nothing of his success. Far from heading back to Paris, Gauguin decided that this money was just about enough to liberate him from his tedious job and, quitting the Department of Public Works, he returned to Punaauia, only to find his home in ruins – rats had eaten part of the roof and rain had caused severe damage, while insects – he suspected cockroaches – had eaten several drawings, and destroyed an unfinished painting. He ought to have been furious with Pau'ura, who could have kept the place in order while he was away, but as soon as he saw her he realized that there was no point in quarrelling – she was five months' pregnant; he was going to be a father again.

Gauguin repaired his house and his studio and planted the seeds which Monfreid had dutifully sent and which had finally arrived with news of the great success. Gauguin promptly sent one of his etchings of Mallarmé to André Fontainas to thank him for his effusive article, the beginning of a correspondence between artist and critic. To set against this was the depressing news that Vollard had decided to buy all the paintings in the exhibition but had paid only 1,000 francs for the entire group, a sum so niggardly it was breathtaking. Gauguin did not blame Monfreid who thought he was acting for the best, given the continuing difficulty he had in finding buyers and given the way the canvases continued to mount up after every shipment. But Gauguin certainly blamed Vollard: '. . . a crocodile of the worst sort . . . .' But what could he do?

Despite his return to his own home and studio he was still unable to paint. He told Monfreid that if he ever managed to start again and found he had no ideas he would make some flower studies once the seeds had grown; he would, so he said, 'have paradise at hand'.

On 19 April, Pau'ura gave birth to a boy whom Gauguin named Emile after his and Mette's first child, though this time spelled with the French 'e'. At about the same time Annette, Monfreid's mistress, gave birth to a daughter, and the two friends wrote to congratulate each other in a rather self-regarding way. The flowers began to bloom. His leg worsened but a new man at the hospital was friendlier than his previous doctors, which made his visits easier. But still he could not paint.

In a way his life was a parody of domesticity – Pau'ura's family fussed about, she breastfed the child, who looked 'completely white' to Gauguin. He even went into Papeete to try to legitimize his new offspring but was bluntly informed that as he was still married to his Danish wife, there was no way under French law that he could disinherit his legitimate family by becoming the legal parent of his mistress's bastard. Gauguin's name appears on the certificate as a witness but the father is listed as 'not known' and the boy is given the name Marae, which means 'temple' and a Tai, his mother's name, with Emile added for good measure. It was all very confused but one thing was clear: Emile, despite his French name, would remain Pau'ura's and Tahitian.

It was just one more pinprick from the official world which seemed to Gauguin to come on top of a succession of slights. He had not forgotten the insults he had suffered while working in the town, nor the reversal of the judgment in his court case against Pau'ura, for which he still held Charlier responsible. As each new thing had punctured his pride, so the anger had built up inside him and it is possible to see in his bouts of fury what ought perhaps to have been obvious earlier, that the ravages of syphilis were not confined to his suppurating body alone, but were also taking their toll on his sanity. So far he had been content to void

this fury in his increasingly intemperate letters to Monfreid, and might well have done no more, had he remained hidden away in Punaauia, with only a few neighbours to grumble at and the occasional local enemy like Father Michel upon whom he could vent his spleen and exercise his penchant for childishly rude jokes. But it was just at this dangerously low moment in his life that someone decided to prod the sleeping beast, to goad him into action, by offering him a way to exact his revenge on all those he believed had wronged him.

## Preparing for War

Unaware that the crisis in the Sudan had ended in November the authorities in Papeete went on preparing for a British invasion. The Navy mounted its guns to defend the entrance to Papeete harbour, a blockhouse was built in the valley of the Fautaua, where Loti had once dallied with Rarahu, and where now the governor could retreat if the redcoats landed. A bridge, built to allow him to get there, is still called the Pont de Fashoda, a lingering sign of how seriously it was all taken at the time.

But if war had passed from the international scene, there was another battle raging in Papeete, one which was to prove very vicious and into which Gauguin would find himself drawn as a principal combatant.

The new governor, Gustave Gallet, was proving a tough, indeed a ruthless fighter. He had first made his name through a bloody repression of an uprising in New Caledonia back in 1878 when he was only an officer in the Land Survey. Awarded the Legion of Honour for his personal bravery he had been rapidly promoted within the colonial service. Now aged forty-nine, with a splendid walrus moustache and a mind of considerable subtlety, Gallet was hardly the sort of man to be worried by a bunch of gossiping businessmen.

No sooner appointed governor, Gallet decided to change the rules in his favour. Since the establishment of the Conseil Général in 1885, the limited franchise had ensured that Cardella's 'Catholic party' always won and as every governor had found to his cost, they were the main opponents of any move the administration tried to make that might involve greater expenditure and thus any form of taxation or duty. Although the governor theoretically had the last word, being able to veto the decisions of the Conseil and to initiate action on his own, the ability of the settlers to manipulate events through direct contact with Paris created a situation of near-perpetual strife within the colony's administration. It was this which had brought down Lacascade; Gallet, however, had no intention of going the same way. To avoid his predecessor's fate, he decided to play the game according to the settlers' rules. Thus, in March 1899, he left for Paris to consult with his minister and managed to persuade him

to permit a major restructuring of the Conseil Général. Gallet's argument was that the outer islands were poorly represented under the present electoral system, while it was largely their taxes which paid for public works in and around Papeete. The justice of this was clear and Gallet returned with an authority, announced in Papeete on 12 October, to change the electoral system, providing for new representatives other than from Tahiti and Moorea who would be appointed directly by the governor himself. Of course, what Gallet knew, and what quickly dawned on Cardella, was that these new seats were not going to go to the Catholic party. There were to be new elections on 19 November, and any fool could see that Goupil and the Protestants were bound to benefit from the redrawn boundaries. Cardella went into a paroxysm of activity, in his determination to prevent the inevitable or if not then at least to damage the man he now considered his major enemy, Governor Gallet.

At one time Cardella could have counted on the support of his newspaper *Le Messager de Tahiti*, but this had fallen into the hands of a local lawyer and printer, Léonce Brault, who was a member of Goupil's Protestant party in the Conseil Général and thus a supporter of the enemy. Cardella now decided to launch a campaigning journal called *Les Guêpes* (The Wasps), the first edition appearing on 9 March to coincide with Gallet's departure for Paris on the mission which Cardella knew was bound to bring trouble. By subtitling *Les Guêpes* 'The Organ of French Interests' the mayor was clearly signalling its role as the mouthpiece of the Catholic party and its opposition to Goupil and Brault.

Despite the paucity of news in the colony, *Les Guêpes* appeared monthly, though the early editions had only four pages. While nominally under the editorship of the head of one of the local printing works, Germain Coulon, everyone knew that he was simply the frontman for the Cardella clan. Unfortunately for the clan, he was no journalist and *Les Guêpes* was remarkable more for the endless repetition of its editor's grievances than for the style or authority with which they were expressed. Nevertheless, it was all that Cardella now had with which to confront the devious Gallet, though what no one expected was that into this curious scrap would step none other than the scruffy artist, Paul Gauguin. Of course, none of them knew that Gauguin was the son of a radical journalist and grandson of a campaigning feminist/socialist author, but what they did discover was that he was now a man burning with rage, and keen to share his seething anger with the world.

## A Challenge to a Duel

In a way, Pau'ura was responsible for the initial outburst. It seemed that her former habit of breaking into the house to retrieve whatever she fancied had not gone unnoticed. Since his return, Gauguin had dis-covered that there were more things missing, and began to believe that others in the neighbourhood were following her example. Or course it may simply have been Pau'ura who had gone on pilfering, or it may all have been a product of Gauguin's fevered imagination. This latter does seem likely given that his main ground for complaint was that he had woken one night and caught a woman in his compound 'going about with an ordinary house broom sweeping'. He never explained why he thought she was doing this, and at best the incident sounds distinctly unlikely. But he was convinced it was a crime and set off to complain to the local Tahitian policeman, who naturally enough did nothing, likewise the nearest French gendarme who listened to the complaint but took no action. Thoroughly incensed, Gauguin rode into Papeete to put his complaint to Charlier the Procurator, who must have told him that he too was not prepared to take up the case, even though Gauguin was determined to make a major issue out of so trivial an incident. Undaunted, Gauguin went back to Punaauia and started the whole pro-cess again, and again got nowhere. Infuriated, he decided to report the matter but what began as a letter of complaint to the procurator soon turned into a full-scale attack on the way members of the administration sided with the local people to the detriment of the French settlers, amongst whom, significantly, Gauguin chose to place himself. 'How can settlers continue to feel safe in this district, subject as they are to the obvious bias of native chiefs and your arbitrary and autocratic rulings' – and this from the man who had once hoped to revive the dead Tahitian past! His 'letter' concluded with a threat to 'request the Government to recall you to France' and even included a lightly veiled challenge to a duel: '. . . I can handle both pen and sword, and I demand that everyone, including the procurator, should pay me due respect.'

Having got it down on paper, it must have seemed to Gauguin a shame to waste it on Charlier alone, and instead of simply posting it to the procurator, he sent it as an open letter to *Les Guêpes*, and attached a paragraph encouraging other readers to join him in a protest to the governor, along with a ready-made formula for the letter they should send.

Needless to say Cardella and Coulon were delighted at this assault on a member of the administration from such an unexpected source. The strange artist might be many things, God knew, but no one could claim that he was an automatic supporter of the Catholic party. He had a

curiously ambiguous position on the island, an oddity which for once gave his pronouncements a certain force. Although they covered themselves by printing the letter under a proviso that the editors took no responsibility for its contents, there can be no doubt that they considered the essay quite a coup.

Gauguin, meanwhile, was awaiting the procurator's response and wrote a seven-page defence of his position in readiness for the court case he was certain would ensue. Charlier, however, wisely refused to rise to the bait, neither replying in kind nor sending his seconds to accept the challenge to a duel, though years later, when in retirement, he told one interviewer that he had burned the three paintings by Gauguin which he had acquired and that he still considered him to be a second-rate artist despite the news of his increasing fame which was by then seeping back to Tahiti from France.

Gauguin was disappointed at this failure but was cheered when Cardella and Coulon asked if he would care to make further contributions to *Les Guêpes*, unaware that this was like giving a gun to a child. Gauguin immediately obliged with a long piece libelling the governor and his administration as 'the enemy of colonization' – the very thing one might have supposed Gauguin would have favoured. In fact he quickly established that he was quite willing to say whatever anybody wanted him to, as long as he could be as disagreeable, indeed as downright nasty as possible. And as if one outlet were not enough, come August he decided to launch his own journal of abuse, *Le Sourire* (*The Smile*), which would not only provide him with a forum for his opinions but also produce, hopefully, an income. The first issue was subtitled *Journal sérieux*, but this was quickly changed to *Journal méchant*, meaning naughty or cheeky for, as its name implies, *The Smile* was to be more wickedly humorous than the more openly savage *Les Guêpes*. The first issue of *Le Sourire* was largely given over to satirizing a project, supported by Goupil, that a rail link should be built from Papeete along the southern coast to Mataiea. It was not lost on Gauguin that such a track would be very useful to the lawyer's business interests, especially to his more distant plantations where he produced desiccated coconut for export to America. Thus Gauguin's article took the form of an imaginary journey, the opening trip on the new line, every stop along which turns out to be a desiccated coconut factory. The principal station is right beside Goupil's mansion where selected travellers are given a sumptuous banquet, but where the *hoi polloi*, including the author, remain behind at the station buffet where they are forced to dine off desiccated coconut!

## The New Century

Although it appeared only monthly and had no more than four pages, *Le Sourire* could have absorbed all his energies. He had to write and illustrate all of it – the cartoons and caricatures were obviously important to him. Then he had to distribute it, fully aware that every copy he managed to sell would be passed around at no profit to himself. Yet despite these difficulties, having something positive to do seems to have jolted him out of his lethargy. His illness was clearly cyclical and he was now in one of his periods of remission when he found himself filled with renewed energy. He had written to Monfreid in July asking for paints and canvas and now that the boats were running normally these arrived promptly that September, just at the time when his mind had again fixed on another large-scale project. To celebrate the new century the following year, another Universal Exhibition was to be held in Paris and even in faraway Tahiti, word had got round that this was to be gigantic. Again, art was also to have a huge role, and the old Palais de l'Industrie on the Champ-de-Mars, which had for so long housed the Salon and the art section of the Universal Exhibitions, was deemed inadequate, pulled down, and replaced by two vast spaces on the right bank of the Seine, the Grand Palais and the Petit Palais, one to house the exhibition of the Decade, the other of the Century – immodest ambitions but in keeping with the grandiose spirit of the entire event. This time, however, the organizers could hardly leave out the once despised Impressionism, but where would that leave Gauguin, who had barely been part of the movement? Maurice Denis had written to suggest that they hold a reunion exhibition of the participants in the Volpini Café Exhibition a decade earlier, but Gauguin turned that down, afraid that he would be lost as part of a group show and maybe even accused of plagiarism again. What he wanted was something similar to the previous year's show at Vollard, a complete cycle of his work revolving around a single theme, another total Gauguin environment where he was the complete ringmaster – no comparisons, no escape for the visitor. The problem was that it was already well into September and the Universal Exhibition would open in January. Even if he completed the work he would have to find a means of shipping it and even with the best of connections, it was bound to be en route for at least a month. But while this left him no more than two and half months to finish his scheme, he was feeling surprisingly healthy and confident and wrote at once to Monfreid announcing his intention of completing a dozen paintings in time for the great event.

Once again, these were to revolve round a large central canvas, which he entitled *Rupe Rupe*, by which he meant something like 'Luxury', and which is clearly a reverse image to the heavily symbolic *Where Do We Come from?*

Looking at *Rupe Rupe*, one is struck by the thought that the pallid pastel classicism of Puvis de Chavannes has somehow encountered the sumptuous glowing richness of a Byzantine icon. Like an icon, the background of the painting is a field of gold, upon which is picked out a sylvan glade with three female figures, one picking fruit, and beside them a naked rider whose horse has paused to drink. The colours: black, terracotta, slate, are subservient to the luminous gilded background, as if one were looking at a slide placed on a light-box. Allied to this sumptuousness is an absence of deeper symbolic meanings – even the woman reaching into the tree in *Rupe Rupe* is only performing a simple, everyday task and is not about to provoke the Fall of Man or some other apocalyptic event. The fact that the faces echo drawings which Gauguin made during his first visit to Tahiti, by then nearly a decade earlier, reinforces this sense of someone trying to recapture a lost world of innocence. It is as if his scurrilous journalism had lanced a boil and drawn off all the toxins, leaving him free to produce an art untouched by doubt.

Of the associated paintings, the most famous is *Two Tahitian Women*, now in New York's Metropolitan Museum of Art, which is exactly what its title says – against a background of abstract patches of colour, two graceful *Vahines* are posed as if the spectator has just encountered them while out walking. They are not Gauguin's contemporaries, swathed in Mother Hubbards, but dream figures out of the imagined Edenic past, barebreasted, bearing gifts. The woman to our right holds a posy, the other carries a tray on which one can make out flower petals or chopped fruit, though the way she holds it just below her breasts, implies that *they* are the fruit being offered. Such an image would not have been out of place in any of the nineteenth-century Salons, where representations of women as yielding and available to the overwhelmingly male purchasers of pictures were a staple commodity of the Fine Art business. Connection has also been made between the figure with the tray and the sort of saucy illustrations common in popular French magazines – one such shows a semi-naked teaser with a tray of apples under her bosom and has the tempting title *Achetez des pommes* (Buy Some Apples). It is hardly necessary to point out that this in turn was a transformation of the long Fine Art tradition of representing Eve offering Adam an apple held near her breast, as a symbol of the sensuality associated with the Temptation and the Fall.

But any attempt to denigrate the Metropolitan's *Two Tahitian Women* as a mere representation of sex objects, offered for the titillation of a predominantly male audience, must fail. If Gauguin had wished to paint an overtly erotic work he could have placed mangoes, the 'apples' of Tahiti, on the tray and not the curiously ambiguous pink scumbling, which could be mashed fruit or maybe even flower petals, but which is

certainly not large and round and breast-like. That we are being offered
something, and that there is a connection between the gift and the
woman's breasts is obvious, but whatever it is, it is not automatically
lascivious and is more a symbol of bounty and giving than of fetishistic
lust. As the American art historian Wayne Anderson put it: 'The lushness
of the presentation causes the breasts to appear as cornucopias from
which all good things flow.'

This seems especially true of a group within the group, a set of new
'maternity' paintings which show a woman (Pau'ura), feeding a child
(Emile), watched by two other figures who seem to hover protectively
beside them. In the various versions, they seem similar to the women in
the Metropolitan's painting, offering fruit and flowers, monumental and
secure, a sculpted group in a glowing polychrome dreamworld: Van
Gogh's yellow/orange, a sharp lime green with an orange tending to
blood, colours which indicate a return to earlier attempts to create sen-
sation and emotion through abstraction, an echo of those distant Synthe-
tist days in Pont-Aven.

But it would be wrong to think of the group as being merely pleasure-
giving, or in some way simplistic. While Gauguin chose to avoid deeper
symbolic meanings he nevertheless worked hard to replace them with sen-
sations of contentment and happiness which were not easily achieved. As
the American art historian Richard Brettell has pointed out: 'at 128×200
centimetres *Rupe Rupe*'s sheer size alone means that it must be considered
in the same league as *Where Do We Come from?* As Brettell put it:

> *Rupe Rupe* . . . is utterly paradisiacal, placing the fruitpicker, the traditional
> figure of temptation, in the centre of a landscape abounding in luxuriant
> beauty. Here, fruits have already been picked and will be picked again,
> and there is no necessity for the fall of man. As viewers, we are placed in
> front of what might be called the ultimate decoration, the painting that,
> even more than anything by Matisse, embodies Baudelaire's ideal, 'luxe,
> calme, et volupté' (enchantment, pleasure and serenity).

## A Distorted View

Whatever these new paintings were intended to convey, they were not
destined to celebrate the new century. Gauguin had been over-ambitious
and left it far too late. By the time they reached France, the exhibition
would already be under way and all the independent galleries would
almost certainly be taken up with their own shows. A small Breton
painting, a landscape, was slipped in amongst the Impressionists in the
centennial exhibition in the Grand Palais, but apart from that Gauguin
had no other official representation. It was not until January that he was
able to despatch the work to Monfreid but even then he put the wrong

address on the wrapping, and the entire collection went missing for nine months, eventually being sent back to Marseilles where they languished in a warehouse while the customs tried to figure out what should be done. Thus Gauguin failed to mark that turning point between the old century, which both his life and his work had embodied to so remarkable a degree, and the new century, which his creations would so signally influence. It is tempting to wonder what difference his participation in the Universal Exhibition might have had, though one suspects that in the end he did not lose too much by his failure to take part. The Fine Art establishment may have felt constrained to include the Impressionists but they certainly made the works they selected seem as thin and as unexciting as possible. As for the private galleries away from the exhibition proper, it was the more obvious Symbolists who dominated, though none of the names seem especially front-rank today. With Van Gogh dead and Gauguin lost in Tahiti, the last decade of the nineteenth century seems strangely devoid of the sort of towering monumental figures who had been such a feature of former years. With the sole exception of Toulouse-Lautrec, the nineties had been a decade of minor artists, short-lived groups and small-scale theories. The real interest of the Exhibition lay in the decorative arts, with the undoubted dominance of the Art Nouveau style in both architecture and furnishings. The Pavillon Bleu restaurant became the prototype for countless future shops and cafés, Eliel Saarinen's Finnish Pavilion caused tremendous excitement in architectural circles, while the decoration of the Viennese pavilion altered the whole course of interior design in the early years of the new century. Despite the size of the two main exhibitions, art did not dominate as it had at earlier World's Fairs. As Gauguin had long advocated, it was the nature and appearance of everyday objects that had come to matter most, and he was perhaps better out of it.

This tale of missed opportunities does not end there. If, when the series eventually arrived, it had been put on exhibition as Vollard had done, with the large canvas and its supporting works, all might have been for the best. Unfortunately, as before, individual paintings were sold off and the group scattered, never to be reassembled again, and the effect of this has been a serious distortion of Gauguin's overall achievement. As Richard Brettell has pointed out, the easy access to *Where Do We Come from?* in Boston has meant that American and European art historians have written about it 'almost excessively'. While *Rupe Rupe*, tucked away in the Pushkin State Museum of Fine Arts in Moscow, has been largely ignored. Thus the usual assumption that Gauguin's deeply profound study of Birth, Life and Death is his ultimate statement, has not been counterbalanced by a full recognition of his vision of a feminine paradise, caring and generous.

Gauguin's 'use' of women has been the subject of much recent criticism, which suggests that his Tahitian paintings were merely a continuation of the erotic themes of nineteenth-century Salon art in an exotic setting. But such a view is only plausible if we drag Gauguin out of the context of his age in order to isolate his work under the spotlight of twentieth-century sensitivities. It is essential to remember that he was working at a time of rising gynaephobia, when the Symbolist aversion to the feminine was transformed into outright disgust. Thus the *femme fatale* of Gustave Moreau's *Salomé* was seen by Huysmans, in *À Rebours*, as a phantasmagoria of evil:

> She had become, as it were, the symbolic incarnation of undying Lust, the Goddess of immortal Hysteria, the accursed Beauty exalted above all other beauties by the catalepsy that hardens her flesh and steels her muscles, the monstrous Beast, indifferent, irresponsible, insensible, poisoning, like the Helen of ancient myth, everything that approaches her, everything that sees her, everything that she touches.

No one should think that this was mere fictional fancy with no effect on the real world. Some of the practical manifestations of this fear of women were merely misogynistic and silly – even as Gauguin was painting his *Rupe Rupe* series, the Sâr Péladan, the mystic magus, was holding his annual salons of his Order of the Rose+Croix, for which he had ordained a set of rigid rules, amongst which no. 17, headed 'Women', stated categorically that 'in accordance with magic law no work of any woman could every be exhibited'. Others were even more deadly, as seen in the growing literary mode in which women were killed, mutilated or dissected: most notably the English novels *Dracula* and *Dr Jekyll and Mr Hyde* which became, and remain, widely read classics of world literature despite the lightly hidden subtext of male violence against women which they present.

It hardly needs saying that Gauguin is part of that world and that his life reflects aspects of it. His desire for young women – girls in effect – demonstrates this, especially those brought up in the obedient ethos of non-European cultures, showing none of the independence of mind encouraged by even a limited Western education. But this is not the message of his paintings, which time and again create a uniquely feminine universe in which women dominate, both as subject and in meaning, the scene which he presents. Of course it would be ridiculous to carry this too far. In terms of actual feminism he would never approach his own grandmother whose thinking was in advance of his, a decade before he was born. One could even argue that he got no further than accepting the reverse of the *femme fatale* view of women, seeing them instead as mother-figures, essentially passive and nourishing, a concept which had

spread in the wake of Darwinian evolutionism which seemed to reinforce the role-images of man the hunter and woman the home-maker. Certainly the 'maternity' pictures can be slotted into such a category with ease, for while Gauguin's treatment of the family was cavalier to say the least, his representations of motherhood are tender to the point of sentimentality. But while a reverence for maternity is clearly preferable to the desire to commit vivisection on the female body, or any of the other obscenities available in late nineteenth-century literature, it hardly constitutes a liberated view of woman. Yet given his own limitations and the context of his time, Gauguin does go further than that. It has to be significant that in his series for the Universal Exhibition, works which he believed would herald the transition into the new millennium, Gauguin once again created a set of canvases in which male figures are barely discernible. Yet these are not tableaux of women offered like odalisques in a *bain turc*, but independent beings in a universe which is entirely theirs – light-years away from the reality of Gaugin's life among his male friends with a young *vahine* somewhere in the background, to cook, clean and come to his bed in exchange for her food and a few gifts.

It is the classic division between artist and art, the life surpassed in the creation, yet it is all too often the Gauguin, dying of syphilis and tortured with religious and philosophical brooding, who fills the frame for those who study his paintings and his writings – while it is the average gallery-goer, the ordinary member of the public, standing in enchanted innocence before *Two Tahitian Women*, who may well have a broader appreciation of Gauguin's legacy.

## A Descent into Limbo

There is not a single painting in existence ascribed to Gauguin for the year 1900. He may have made works which have not survived but if so there cannot have been enough of them to alter the claim that he had for all intents and purposes given up. There is an important group of wood-block prints and a handful of colour transfers but in the main his efforts were now concentrated on journalism – if that is the correct term for his increasingly contentious pamphleteering.

He didn't plan it that way. At the start of the new year he wrote to Vollard proposing a contract, which surely implies that he still believed he would go on painting – though by March, when the dealer's acceptance arrived, Gauguin must have known that he could not fulfil the terms he had suggested three months earlier. Nevertheless, he agreed to provide twenty-four paintings a year in exchange for a monthly salary of 300 francs, though he must have guessed that this would be impossible as he had not produced a single canvas in the interim!

The main reason for his absence from his easel was a tempting offer from the mayor. Gauguin had been careful to send Cardella copies of *Le Sourire* from its first appearance and had been happy to provide further articles for *Les Guêpes*. Cardella needed them; the copy produced by his friends was pretty feeble and he was losing the battle with the governor at every turn. In the November election, the Catholic party had salvaged only four seats – the remaining seven 'village' seats had gone automatically to Goupil and the Protestants. As if that were not enough, Gallet had proceeded to fill his nominated 'island' seats with Cardella's enemies, even making Goupil's adjutant, Léonce Brault, the representative for the entire Marquesas Islands. This was a rout, and Cardella was more determined than ever to fight back with the only means left to him, *Les Guêpes*. In February of 1899 he enlarged the journal from four to six pages and in order to fill them with something worth reading he asked Gauguin if he would become full-time editor. Not only would he ensure a magazine far more entertaining than anything the clan itself could produce, but he also had the advantage of appearing to be a disinterested party, being neither a small businessman nor an aspiring politician. He could also draw and was cheap. Cardella proposed, Gauguin accepted, art went out of the window.

A further reason for Cardella's anxiety was that Gallet was once more on the offensive. Satisfied with his reform of the Conseil Général, he was now proposing to carry out the same structural change in the Chambre de Commerce, reducing the number of elected members from ten to four, with the rest to be nominated by himself. Prompted by Cardella, the first issue of *Les Guêpes* under Gauguin's editorship led with the headline: 'Dissolution of the Chamber of Commerce', over an article which savaged the Governor's proposals. That was relatively mild compared to another article in the same issue entitled *Croquemitaine administratif* (*The Administrative Bogey-man*), which was near-libellous and which was openly signed by Gauguin himself, as if to show who was now at the helm and leading the battle against the enemy.

Of course much of the journal was given over to reports of meetings of the various elected bodies but as these were highly selective and favoured those participants who were members of the clan, they amounted to little more than a back-up for the more evidently scurrilous pieces. But even this rather mechanical stuff was very time consuming. It had to be written up then typeset and printed using the somewhat limited facilities at Coulon's works – a wooden, two-storey stilt house on the opposite side of town from the Punaauia road, and by April Gauguin had decided to abandon *Le Sourire*, to concentrate all his energies on what had by then become a full-time job.

The one thing neither Cardella nor Gauguin thought to do, was to com-

ply with the law which obliged them to deposit copies of the magazine with
the Bibliothèque Nationale in Paris – an oversight which meant that until
recently there was no complete set of *Les Guêpes* either in France or Tahiti.
This absence meant that most writers on Gauguin assumed, understand-
ably, that he must have given up art and gone into journalism in order
to defend his beloved Tahitians against the depredations of the wicked
colonialists. The few copies of *Les Guêpes* that were available in France,
with their outright attacks on the governor and his administration, seemed
to bear this out. Here, surely, was Gauguin, proud grandson of Flora Tris-
tan, defending the weak against the powerful.

It was only as recently as 1966 that his assumption was challenged by
the Société des Océanistes, which published the results of research in
Gauguin's journalism made by a Father P. O'Reilly, a Frenchman despite
his name and a Catholic priest who had devoted his life to Tahiti and
its history, and who had been working with the anthropologist Bengt
Danielsson, whose life of Gauguin had been published in Sweden two
years earlier and was just about to appear in English. This demolished
any argument that Gauguin had been campaigning on behalf of the
native population, which only merited four mentions in the whole of the
two years that Gauguin was associated with the journal and even those
were distinctly ambiguous. One piece criticized the educational system
for being badly attuned to local needs – but that was only because Gaug-
uin wanted to point out that it was largely in the hands of local Protestant
teachers and ought to be handed over to the French Catholic mission-
aries. On a second occasion, Gauguin called for the appointment of
French gendarmes in every district, not to protect the local people, but
to stop them robbing the settlers. On another, he attacked a proposal
by Protestant pastors to control the sale of alcohol – a grave problem
on the island – on the grounds that this would drive more natives into
Papeete in search of drink, carefully omitting the fact that the production
of alcohol was one of the areas where the settlers made good money.
Indeed the only time he really tried to defend local interests was a passing
mention that the 'invasion' of Chinese immigrants might be damaging
to the Tahitians, but even here, he was clearly less concerned with pro-
tecting the indigenous population than in defending the economic inter-
ests of his paymasters, the French business community, who loathed the
Chinese shopkeepers, their principal rivals.

As O'Reilly and Danielsson concluded, far from Gauguin caring about
the Tahitians and using his editorship to defend them, he was nothing
but a totally passive mouthpiece for Cardella and the Catholic party.
One could try to defend him, by claiming that this was only another
manifestation of his total disregard for politics. In his *Cahier pour Aline*,
which he had written during his first stay on the island, he had set out

for her his views on politics, writing, self-mockingly, that he believed absolutely in Democracy and Republicanism then turning the whole argument round so that he ends up believing in neither. This was standard anarchist sarcasm, and Gauguin had been an avowed anarchist since his days with Pissarro. But to see his activities with *Les Guêpes* as just another piece of amoral play-acting won't do. The truth is that it was the very people whom Gauguin attacked in *Les Guêpes*, men like the procurator Edouard Charlier, who were the true friends of the indigenous population. Charlier always used the law justly on behalf of the Tahitians throughout a long career on the island, including a stint as acting governor. Unlike Gauguin, who made no provision for his Polynesian off-spring, Charlier thoughtfully adopted his son by his *vahine* and saw to his welfare. Of course, the procurator's real offence in the eyes of the clan went beyond his place in the administration – the real reason so much vitriolic abuse was heaped on this good man by Gauguin was simply that he was a Protestant and thus a part of the clan's detested enemy.

There was far less reason behind his treatment of some of the other figures pilloried in *Les Guêpes*. A few were even quite friendly to Gauguin, though this proved insufficient protection if the clan had them in its sights. One such was Victor Rey, the island's Secretary General, and thus adjutant to the governor, who had stood in for Gallet while he was in France. Gauguin satirized Rey as 'Man Friday' to Gallet's 'Robinson Crusoe' though his most vicious assaults were reserved for the marvellously drawn caricatures which graced the cover of the journal and which often represented Gallet as a bear (symbol of Protestantism) with Rey as a monkey riding along on his back. In fact the Secretary General was one of the few truly cultured men on the island. As a writer in Paris before joining the colonial service, he had contributed to the cabaret at the artistic night-club the Chat Noir and had thus moved in the same circles as Gauguin. Ironically, Rey probably enjoyed the ribaldry in *Les Guêpes*, and may well have been the only person on Tahiti to have any concept of how important an artist Gauguin was. During one of his periods of illness, Rey went to some lengths to ensure that he was being properly looked after, but none of this spared him the abusive mockery ordained by Cardella and his friends.

Some of their targets seem frankly irrational, unless one accepts the sheer blind fury of settler opposition towards what they believed was a Protestant plot against their interests. They attacked the *Croix du Sud*, the only regular boat to carry passengers and goods between Papeete and the Marquesas Islands, simply because it was New Zealand-owned and was therefore a humiliating reminder of the islands' dependence on the dreaded Protestant Anglo-Saxons. They even had Gauguin attack a

Pastor Vernier, a Protestant missionary on the Marquesas Islands, who was rumoured to be having considerable success winning over converts from the Catholic missions. Gauguin even worked Vernier's wife into what was surely one of his nastier articles, which proved doubly unpleasant when the poor woman died shortly afterwards, guiltless as her husband of the sort of paranoid accusations of hypocrisy which Gauguin levelled at them and which can only have sullied the closing moments of their marriage.

Not that there was any consistency about the journal's choice of targets – if the clan were not bothered, and the person was a friend of Gauguin, then he was safe. Thus Maurice Olivaint, despite being a magistrate and a member of the administration, had one of his poems published in *Les Guêpes* along with a shameless eulogy, praising his capacities as a judge. But there was no such concession possible for the one man who had actually helped Gauguin both morally and materially, Auguste Goupil. He was the devil incarnate, leader of the Protestants, friend of the governor and ally of the Chinese, whom the journal increasingly saw as an enemy on a par with the hated English.

In his dealings with the Chinese, Goupil emerges with considerable honour. Contrary to his own best interests he defended them against the settlers, helping organize the successful petition to President Loubet in France against a monstrously unjust tax aimed at Chinese businesses which the unreformed Conseil Général had tried to impose in 1898, a tax intended to hamper the commercial success of the oriental immigrants and thus benefit Cardella and his cronies. The leader of the anti-Chinese faction was the mayor's associate Victor Raoulx who lost his seat as President of the Chamber of Commerce when Gallet's reforms came into effect. Left with nothing to do, Raoulx devoted himself to campaigning against the Yellow Peril, the hordes of Chinese who were said to be circulating around the Pacific in search of lands to plunder – a campaign in which Gauguin proved surprisingly eager to lend a hand.

The Cardella clan had given Gauguin some status again, along with a steady income for which he was grateful. With money to spend, he took to holding little parties out at Punaauia, to which his new friends were invited, along with any of the older ones like Pierre Levergos of the Public Works Department who had moved near by. As Raoulx was also a wine and spirits importer, he provided the drink while Gauguin laid on a Tahitian feast, usually lunch on a Sunday for which he occasionally produced an illustrated menu. The meal over, the party often continued on through the night until Monday morning. At some point things would get a little rough – according to one witness any women who had been brought along would be persuaded to undress – though it was noticed

that Gauguin himself always stayed sober, which leaves an unpleasant image of him, slyly watching the vulgar antics of his new associates, without quite joining in. It makes him sound pitifully lonely – neither one thing nor the other.

## Lines and Shadows

He wrote to Monfreid that May to say that he was sick again, and that he had done no painting for six months. Some time in June or July, he received the first supply of canvas and paint that was part of his agreement with Vollard, though in his present state, there was clearly no way that he could fulfil his side of the bargain. At the time this did not worry him, as he assumed that the paintings he had despatched for the Universal Exhibition would turn up before long and that they would provide the dealer with more than enough work for the time being. He had also sent Monfreid the prints he had done late the previous year with instructions to give them to Vollard – a traveller had agreed to take them that February and again Gauguin assumed that they would help satisfy his obligations under their contract. However, both Monfreid and Vollard were less than overjoyed when they first saw the package which contained nearly 500 wood-block prints, each on a tissue paper sheet, whisper thin. When they looked closer, it must have dawned on them that there must be some key as to how they related to each other, and thus how they were meant to be displayed, but Gauguin appears never to have explained his thinking, nor were any instructions sought by Vollard, who clearly thought them not worth the effort. As a consequence the fifteen or so different prints, with about thirty copies of each, have remained an unresolved enigma. Vollard did not rush to exhibit them, a source of much friction, given that Gauguin, as ever, believed that he was bound to have a commercial success if only someone would offer them to the public.

We know, because there was no one else who could have done it, that this time he printed the blocks himself and that he must have gone to some trouble to improve his skills – the papers show signs of having been correctly dampened before being laid. He was also less bothered with the sort of fine subtleties of shading that had characterized the *Noa Noa* suite – this group were bolder and simpler, with deliberately folksy outlines, rather like medieval illustrations or the *images d'Epinal*, the popular wood-block illustrations of the seventeenth and eighteenth century which Emile Bernard had been among the first to promote as part of the basis for Cloisonism. As before, these prints can be seen as a sort of catalogue of Gauguin's interests in the preceeding years. Just as the *Volpini* and the *Noa Noa* suites had drawn on the paintings of the years

immediately before they were made, so these thin tissue paper sheets contained scenes from the years 1896 to 1900. But there was evidently more to it than that, though what exactly cannot now be said with any certainty. The organizers of the mammoth Gauguin exhibition in America and France in 1988–89 did come up with an ingenious and convincing notion that they were meant to be put together in sets, almost like strip cartoons. The evidence for this is the way some do seem to run into each other – say a continuous horizon that flows across two different prints, which join up when you set them side by side. Such a way of working ties in well with Gauguin's desire to make paintings in series, and put together in this way, sometimes in twos or threes or fours, the sets can be read as manifestations of Gauguin's religious preoccupations, his search for a unified faith à la Massey, his other readings in Theosophy, and his ideas about Buddhism and the search for enlightenment.

These themes were continued in the only work Gauguin appears to have done in early 1900, a set of transfer prints for which he had devised a new technique. For his earlier monotypes he had followed the conventional method of painting a water-colour or ink picture, laying a sheet of paper over it, pressing down and thus 'printing' the reversed image. Obviously, this was not to create multiple reproductions, being at best a 'one-off' method, though Gauguin did occasionally try to pull a second and third sheet – but rather it was the somewhat accidentally blurred effect that he had been eager to achieve and which he felt added a further air of mystery to his already mysterious subjects. But in 1900 he devised an entirely different method – covering a sheet with ink washes, laying the second sheet on top and drawing on the back of it thus causing the ink to 'print' only where this pressure was applied. If we look at the backs of the surviving transfers we can still see the pencil drawing, while the 'front' has a much sharper image than the earlier monotypes, though still retaining something of that intriguingly haphazard quality which has led to them being compared to ancient cave art or worn frescoes.

Gauguin used large sheets of paper for these new transfers, clearly to enhance the impression that we are looking at an old mural, but Vollard was still not impressed, and again the prints languished and as the year progressed their relationship soured. As the dealer had not received the paintings, he felt disinclined to pay the advances. Some time after the event, Gauguin discovered that his previous supporter, the young artist Chaudet, had died, still owing him money. Eventually Chaudet's brother did pay some of what was due, but the early part of 1900 was very difficult for Gauguin, which may go some way to explain, if not excuse, his unquestioning fidelity to his paymasters at Les Guêpes, who at least provided him with a regular income.

## Leader of the Pack

Even allowing for his material difficulties it is hard to find anything that can really excuse the virulent anti-Chinese attitude which was to become such a dominant feature of his activities in the latter part of the year. There was a precedent for hating the Chinese in Tahiti, which had been set by Julian Viaud in *The Marriage of Loti* in a nasty little scene in which the merchant Tsin Lee tries to buy what he desires from the sweet innocent Rarahu by bribing her with cheap trinkets. Viaud/Loti left his readers in no doubt about the nature of such men and how they were viewed on the island:

> Now, the Chinese merchants of Papeete are an object of disgust and horror to the Tahitian women; there is no greater disgrace for any girl than to be found out in listening to the addresses of one of these men. But they are sly, and they are rich, and it is a well-known fact that by dint of gifts and silver coin many of them win favours which amply compensate them for the scorn of the public.

Gauguin, Loti reborn as Koke, seems to have adopted his predecessor's prejudice wholesale, though for no particular reason. It could be argued that any sort of mass immigration would not have been wise for such a tiny island with so small an amount of arable land. Today's problems on Fiji where the Indian population now outnumbers the indigenous islanders has already exploded and remains unresolved. Even a country the size of Malaya, today's Malaysia, had difficulties when the Malays found themselves economically marginalized and the country's economy almost entirely in Chinese hands. It is possible to take a perfectly clear line on such matters without descending to racial hatred – if there had been countless Chinese waiting to pounce on little Tahiti, then laws could have been devised to regulate the flow – though as they would have been made and carried out by the very people who had themselves taken the island away from its original inhabitants, such laws would, of necessity, have lacked any moral authority.

But the anti-Chinese sentiments were only loosely based on these rumours of a potential invasion. Every society has its scapegoats; in Papeete it was the Chinese. In fact, originally, they had been deliberately brought to Tahiti as cheap coolie labour, by white plantation owners, at a time when the happy-go-lucky Tahitians saw no reason to work for money when there was fruit on the trees and fish in the sea and when new activities like growing cotton made no sense at all. Decrees dating back to 1852, after the abolition of slavery in the French colonies, actually set aside public funds to pay for the importation of such workers. Initially it was thought that Indians might be suitable, being in the eyes of the

French racially more like the Tahitians! But this proposal was refused by the Imperial Government in India which saw no reason to lose some of their best and fittest men to a rival Empire. The British administration in Hong Kong proved more accommodating and so, from 1865, the Chinese began to arrive, brought in largely by the island's main business families, the Salmons and Branders and by a strange, and not altogether honest Scotsman, William Stewart, who imported nearly 1,000 Chinese labourers and their families to work on a wildly over-ambitious scheme to produce cotton which went spectacularly bankrupt. Not all these imported labourers returned to their native land and some turned out to be first-rate businessmen, saving what little money they earned to open trading posts around the island, and shops and restaurants in Papeete, which, in less than a decade, had a Chinese quarter with its own temple, pagoda and hospital. The area around the market became, and largely still is, a sort of Chinatown, with restaurants and shops selling Chinese goods. And soon there were all the usual difficulties – often to do with opium, which it was all right for Cardella to export for medicines such as laudanum, which was only a thinly-disguised drug, but which was deemed horrendous when two old Chinamen were found smoking the stuff at the back of a store.

Of course it was the competition between the French businessmen in the town and their Chinese opposite numbers that turned a mild dislike into an obsession motivated by hate. That the Chinese had bought leprosy to the island was universally believed – it wasn't true but no matter. From 1883 the debates in the Conseil Général show an increasing obsession with the matter, but the honour of bringing things to a head was to fall to Gauguin. Victor Raoulx was the local politician most convinced of the Chinese threat and he was the prime motivator of the eventual protest, but it was Gauguin who acted as his mouthpiece. In September of 1900 a poster printed by Coulon appeared in the town:

<div align="center">

TAIIITI FOR THE FRENCH

NOTICE

</div>

We wish to inform our non-Chinesified fellow countrymen that a meeting will be held on Sunday 23 of this month at 8.30 in the morning in the Town Hall, in order to decide what measures should be taken to halt the Chinese invasion.

<div align="center">

Paul Gauguin

</div>

A vast crowd gathered. Victor Raoulx spoke and was elected Chairman. Gauguin spoke next and was elected Vice-chairman. We know what he said because he proudly printed his discourse in *Les Guêpes* and as it is his only known public speech it is fascinating on many counts. He began

by claiming to speak as 'a Frenchman – a name very dear to my heart' – and went on to raise the spectre of the 'twelve million Chinese circulating the Pacific and gradually obtaining control over the trade of the South Seas', a possibility he mildly compared to the barbarian invasion of Europe by Attila. Worse, in Gauguin's opinion, was the possibility of a mixed race of Chinese-Tahitians who would all be able to claim French nationality and who would be, as he delicately expressed it, a 'yellow blot on our country's flag'. After blaming the administration for letting things get to this pass, he called on his hearers to sign a petition that would bring to the attention of people in France 'that there is a French colony in a far-off part of the earth where there are Frenchmen worthy of that name who do not want to become Chinese and who, for that reason, can no longer be ignored without the acceptance of a dreadful responsibility'.

This was rabble-rousing stuff and it may only have been the usual heat-induced lethargy which ensured that no one got sufficiently worked up and set off and attacked one of the neighbouring Chinese stores. But the meeting and the petition and the subsequent campaign in *Les Guêpes* were not without noticeably harmful effects on racial harmony. Until quite recent times the Chinese population of the French Pacific territories have been viewed as aliens and treated as second-class citizens subject to special legislation. Today, all that has happily ended, custom and inter-marriage has led to a remarkable assimilation of the Chinese into the life of Tahiti. But one reason that the hatred and misunderstanding endured for so long was the actions of those who chose to stir up the envy and fear of little people, greedy men who thought they had something to lose, men like Cardella and Raoulx, but also one man who had nothing whatsoever to gain from the whole squalid business, Paul Gauguin.

## Art by Mail-order

At least Gauguin had succeeded in one thing – as the new year 1901 began he was a total pariah. His grandmother had thought of herself as such but only as an honourable political outcast, and while her grandson had once had a rather romantic view of that isolated state, it is certain that he found the reality far less pleasant. He had ceased to be an artist and was only technically a journalist – a cheap propagandist would be more accurate. Apart from his somewhat basic relationship with Pau'ura his contacts with the Tahitians were virtually nil. The island's élite – whether rich families such as the Goupils or those in the French administration such as Charlier – had been transformed into implacable opponents, while any Chinese who knew of his activities must have loathed

the very sight of him. At the same time, it is likely that those to whose defence he had dedicated himself regarded him as nothing more than a useful fool, as most would make abundantly clear after he was gone. To add to his miseries, the new year saw the cycle of his illness return once more and during February and March he was in and out of hospital three times. Worse, the sympathetic Dr Buisson was no longer there, having been transferred to the Marquesas Islands.

If nothing else, these periods of enforced rest at least offered an opportunity to reflect calmly on what he was doing with himself. He now had a little money. The paintings had finally turned up in Paris and after much argument Vollard had honoured his side of the bargain. Even better was a totally unexpected payment, passed on by Monfreid, from the sale of two paintings, one of them the *Two Tahitian Women* with the tray of fruit or flowers, to Gustave Fayet, a businessman from Béziers in the south of France, the beginning of a relationship that would have a profound effect on Gauguin's future fame. Fayet would gradually acquire the first full-blown collection of Gauguin's work, among which would be many of his most important canvases, and in so doing would generate interest among other collectors while helping to drive up prices from the miserable levels that Vollard maintained. It is just possible that Gauguin knew of the Fayets. Their money came from vineyards and from the sudden boom in profits from *vin ordinaire*, once the new railways could carry it swiftly to the northern cities, but since his grandfather's day, Fayet's family had used their wealth to indulge their passion for art, becoming founder members of the Béziers Société des Beaux-Arts, which had been responsible for setting up the local museum and organizing an annual art exhibition. When Gustave inherited the family business in 1899, he was made curator of the museum and could use the annual show to promote his personal preferences, which included Gauguin. Part of this was personal – Gustave had become a frequent visitor to Paris and those few galleries that supported avant-garde art, and in 1894 he just happened to see Gauguin out with Annah the Javanese and was immediately struck by the sight of these two beings 'as magnificent as they were strange', Gauguin in his 'Bolivar' hat, Annah 'sculptural, dressed in a canary yellow robe'. Having met Monfreid, Fayet visited his studios in Paris and his country house in the south, where he saw Gauguin's work and where the first purchases were made; at the same time he decided that Gauguin should figure prominently in the next annual exhibition in April of 1901, and he began to write to Tahiti, sending fan-letters to the isolated artist and eventually offering him the leading role in the 1903 exhibition.

The prospect of exhibiting in the provinces was extraordinary in itself, but to be sent money in advance was staggering. Gauguin's financial

woes were, temporarily at least, over, and he was free to make a move if he so wished. Despite all the anger it had stirred up, *Les Guêpes* was having only a limited effect on the island's political life; Cardella and the others might not choose to go on supporting it for much longer. On top of that his art was in abeyance and seemed unlikely to find fresh stimulation in Punaauia. Since the *Rupe Rupe* paintings and the wood-block prints his desire to create anything out of the life around him had evaporated. If he was to start painting again he would have to find new inspiration. Now, if ever, it was time to leave for the Marquesas Islands, where he might yet find a flourishing Polynesian culture and, with it, the stimulus he so clearly needed.

He had not heard from Schuff in over a year and could only assume that he had succeeded in finally offending a friend he had always treated so shabbily. Perhaps it was just as well that Gauguin never learned the real reason for Schuffenecker's silence. It would have been too painful. It dated back to June of the previous year 1900, when Mette wrote to tell Schuff that her second son, Clovis, had died at the age of 21 as a result of an operation to rectify the effects of a riding accident three years earlier. Blood poisoning had set in and the young man had not survived. The tone of Mette's letter reveals considerable anguish – she was alone with Jean and Paul, the eldest son Emil having thrown up his studies to follow in his errant father's footsteps by setting off for Bogota in Colombia, presumably in search of his Spanish-American family, the Uribes. This reminder of her husband's fecklessness had opened old wounds for Mette. As she told Schuff, the death of two of her children and the flight of a third had left a void in her heart and life and she begged him to give her Paul's address – 'It seems to me he must be written to although it goes much against the grain, for his ferocious egoism revolts me every time I think of it. I have borne heavy burdens, I have suffered all these distresses, all these worries alone. Or would you send him this letter?'

In the end Schuff did neither and never wrote to Gauguin again, thus sparing him the dreadful news of his son's death, but also the story of how his eldest boy had inherited his wild, irresponsible longings for adventure.

There was a silence on all fronts. He had only the haziest notion of what Morice was up to since the arrival of the first extracts of *Noa Noa* in *La Revue Blanche*. It is likely that Gauguin was unaware that further fragments were to appear in a Belgian magazine *L'Action humaine* that January and that the only full version would be published in the French journal *La Plume* in May, paid for by Morice with his name alongside Gauguin's as joint author. The lack of communication between the two men is puzzling. Daniel de Monfreid's letters arrived regularly, yet from

Morice there was only silence. He would later claim to have sent Gauguin 100 copies of the complete *La Plume* edition, but if so, they never arrived. Worse from Gauguin's point of view, the only thing he had seen, the first excerpt in *La Revue Blanche*, has not been illustrated, in complete contradiction to his wish that the work should be both literary and visual. In order to see the thing as he had originally intended, he took the *Noa Noa* exercise book, the one into which he had now added *Diverses choses* and onto the pages which he had left blank, planning to fill them with Morice's poems if and when they were sent, he now pasted a selection of drawings and prints which he thought most appropriate to the text. It is this version which has most often been taken as the true *Noa Noa* and has indeed been reproduced as such. However, it must be said that Morice's *La Plume* edition is probably textually nearer to what they had both planned. In effect there was not, nor could there now be, a final, perfect *Noa Noa*. It has been suggested that if the text of the *La Plume* edition could be married to the illustrations in Gauguin's exercise book then something like his overall intention would be fulfilled, but as he never saw Morice's later additions, this cannot be confirmed.

Poor Morice – history has damned him for destroying a masterpiece, when he only did what was asked of him and when it cannot have been easy to get something so unusual published at all. True, he was less than straightforward with Gauguin and failed to keep him informed of what he was doing – but these were charges that could as easily be laid at Gauguin's door. Morice had no more money than Gauguin; he was struggling to survive and his career was dying around him. In the end he would be remembered only as the man who failed Gauguin, and must have bitterly regretted ever agreeing to try to help. Oddly enough, the one person who seems to have understood all this was Gauguin himself, who, aside from a few sharp comments in his letters to Monfreid over the poet's dilatory behaviour, remained touchingly loyal to one of the few people he considered a true friend.

The variety of visual material Gauguin pasted into the exercise book – photographs, wood-block prints, colour transfers, original water-colours – shows him trying to fulfil his original aim of having a second, visual text, running parallel to the written matter. An official photograph of King Pomare v is pasted above a cut-down section from the wood-block print *Maruru*, which shows a woman worshipping a monumental *tiki*, both symbols of the lost Tahitian past, the one recent, the other ancient. Another page has a water-colour which shows a woman spied on by Hiro, god of thieves, whose hand is clasping a phallic branch of the Tree of Knowledge, making it clear that it is her innocence he intends to steal. On the same page is a daguerreotype portrait of a naked *vahine*, whom many have assumed to be Teha'amana because of her

frizzy hair. However, it is more likely that this was just an anonymous *carte de visite* type image, chosen because the girl is wearing a string of traditional jewellery and a choker from which dangles a Christian cross, making her a symbol of transition between the old days, when nakedness was natural, and the modern world, where she must cope with the concepts of shame and repression brought by the missionaries. While much has been done to analyze the written *Noa Noa*, little effort has gone into understanding its visual counterpart. Certain themes are discernible, as witness that page which treats with the change from past to present, with ideas of innocence and shame, spirit and substance, which to Gauguin were at least as important as the text of the book.

Unaware of what Morice was doing in France and Belgium, Gauguin published his own fragments of *Noa Noa* in *Les Guêpes* when he came out of hospital in April. Heaven knows what his settler friends made of them, other than to hasten the day when they shut down the paper, which was obviously getting more and more eccentric in the hands of this unreliable artist.

However, it was one thing to decide to leave, but it was proving quite another to achieve it. He found a buyer for his house quite quickly. A Swede, Axel Nordman, an ex-sailor who had been working as a salesman in Papeete and wanted to retire to somewhere quiet like Punaauia, and was happy to pay the asking price. Unfortunately Nordman's lawyer discovered that Gauguin was still legally married and insisted that his wife in Denmark approve the transaction – standard practice under French law but a difficult undertaking for one who had been so long out of touch with his family. Gauguin wrote to Monfreid asking him to get Mette's written agreement and she did eventually reply as requested, showing a singular absence of rancour on her part, but by the time this was sent Gauguin had found a way round the problem and had gone, and it is probable that he never discovered this act of selflessness on the part of the woman he had once loved.

While all this was dragging on, Gauguin attempted to keep up his contractual obligation to Vollard, a commercial animal, keen on sales, who had already written to Gauguin asking him to do some flower studies, only to receive a characteristically sarcastic rebuff. Now, bereft of any other ideas, Gauguin was less inclined to be so dismissive. In any case the house was by then surrounded with Monfreid's European blossoms, especially the dramatic sunflowers which flourished in the warm climate. But while Gauguin may have returned to painting for quite cynical reasons, he was incapable of leaving it at that. In two of the works, the sunflowers are arranged in carved wooden bowls, one of which is obviously the same *kumete* by Patorumu Tamatea that he had sketched in the Auckland museum. The symbolism is simple enough –

the bringing together of Europe via the flowers, with Polynesia, via the receptacles. But in two of the paintings he placed a bold staring eye at the centre of one of the sunflowers, the trademark of the painter Odilon Redon, yet not one that has much relevance in a Polynesian context. While he may just have been cocking a snook at Vollard, there are similar signs in other paintings of the period which have figures whispering together in the background, and which suggest that he was concerned with being watched or spied upon. Equally disquieting images appear in what may be the final painting from this brief period of production to order. Variously entitled *Riders*, *The Flight*, or *The Ford*, it shows two figures, sharing a horse, about to cross a river. The first bears a strong resemblance to the hooded *tupapau* of earlier paintings, and has led some writers to make a connection with Albrecht Dürer's famous engraving *Knight, Death and Devil* of 1513, a copy of which Gauguin later pasted into the back cover of his final memoirs. This shows Death as a ghostly figure leading a young warrior across a stream to the land of the dead. This subject, too, was much in Gauguin's thoughts. In October 1900, as part of his dispute over money with Vollard, he had asked Monfreid to recover all his sculptures from the dealer and to send him his ceramic *Oviri* so that it could be placed on his tomb – so close did the end appear to be. And while this was never done, the request, and the message of parting and farewell implied by the *Riders*, all suggest someone with his mind on departure, especially that journey to the place where he must have known he would end his days.

## Crossing the Stream

The legal barrier to the sale of Gauguin's house and land was easily overcome when he learned that the law allowed him to post a notice of sale at the Papeete registry office for a month, and that if this produced no objection from any quarter, then the exchange could take place. Nordman seems to have taken advantage of the delay by beating down the price to 4,500 francs but at least Gauguin could pay off the loan at the bank and was free to go. He was even able to leave in something approaching a blaze of glory as Governor Gallet suddenly resigned and left for France. The truth was that he had been ill for some time and had applied for early retirement, but to the triumphant settlers it seemed as if Gauguin had succeeded in driving away the enemy and it was announced that his final edition of *Les Guêpes* would be the last of all – without the talents of its editor the journal was to close down and would only reappear 'when the special need for it arises'.

Gauguin packed everything – the harmonium, the pornographic pictures, his portrait as Christ before Golgotha, the little Breton snow

scene. He even shipped enough good timber, a rare commodity in the Marquesas, to build himself a new home. It would have been more sensible to have visited the islands first, but that was not his way. He left on 10 September 1901 and though his original idea was to go to Hivaoa, second largest of the Marquesas, when he learned that the ship would continue to Fatuiva, smaller and supposedly even less marked by 'civilization', he decided to go all the way with her. The fact that he was travelling aboard the very boat, *La Croix du Sud*, that he had attacked in *Les Guêpes*, merely added a final irony to his last glimpse of Tahiti.

Few seem to have regretted his departure. He had been something of a joke to most people, as their stories of him would later attest. Few of these are reliable and most fulfilled the expectations of the visitors who recorded them, by describing the artist's bizarre behaviour and recalling the numerous works of art which were destroyed before it was realized just how valuable they would become. Axel Nordman's son Oscar was especially prominent in this regard. Before the Second World War, and by then a butcher, Oscar told a visiting French writer, Renée Hamon, that he was nine when his father bought the house in Punaauia and that he had found it full of wood-carvings like *tupapaus*, which scared him. Hiring some sailors from a British ship, Oscar had the sculptures rowed out across the lagoon and dumped in the sea, adding: 'If I had not been such a blockhead, today I should be a millionaire.' It's fair to note here that Oscar had already served a prison sentence for fraud and was hardly the most reliable witness. Indeed after the war he slightly varied his tale to Bengt Danielsson, recalling how he found the house full of lumber along with drawings, rolled up paintings and carvings and that everything was destroyed except one carving which they managed to sell and which is now in the Swedish National Museum in Stockholm.

Only two people remained constant to Gauguin's memory. His French neighbour Fortune Teissier always spoke kindly of him and the other was Pau'ura, who seems never to have reproached her 'coquin' for leaving her and Emile behind. Their separation had been amicable. She had not wanted to leave her family to live on the faraway Marquesas, and she knew that her baby would always be well taken care of by relatives. When the author Robert Keable tracked her down in the twenties, the once sylph-like Pau'ura was stout and poor but apparently happy, except when irritated by too many people traipsing up the track to her hut to pester her with questions about the two years she had spent with her eccentric artist. Whatever else, her life with Paul Gauguin had been far from boring – she was nearly jailed and for a time life became one long party, which, for a teenager, doomed to the dull routine of a peasant community, must have seemed like a wondrous distraction; for a time at least.

For Gauguin, his second stay on the island had been a mixed blessing
– part a replay of the earlier visit, with some wonderful paintings, perhaps
his best, to show for it. But there was also the rather sour taste left by
his other activities. As he probably realized, he had overstayed his wel-
come. He did not belong on Tahiti, which had been more a subject for
his art than the complete way of life he had once hoped it would be.
When the subject tired, and the art ran out, he should have left, and not
attempted to integrate himself with the sort of people he otherwise
despised. In the end the best summary of his final time on the island
was a scathing comment from a schoolteacher, Georges Dormoy, who
had suffered an abusive attack in *Les Guêpes*, purely because he was a
Protestant. Dormoy wrote to protest at what he called Gauguin's lies
and calumny about innocent people. Gauguin published the letter with
a response intended to show just how liberal he was for letting the
teacher have his say. But he cannot have been entirely untouched by
one comment, which aptly summarized what anyone must feel about
Gauguin's two years as a muck-raking satirist. As Dormoy put it: 'To
exploit the good faith of his fellow-men and shamefully abuse the public
trust is a strange occupation for an artist'.

# 14

◆

# *The Right to Dare All*

A single, fragile thread linked Paul Gauguin to the place where he was destined to end his days – the first European to discover the archipelago was a Spanish American, Alvaro de Mendana, whose voyage had been ordered by the then Viceroy in Peru, the Marqués de Mendoza. On landing, the captain dutifully named the islands after his patron, though only the viceroy's title survived and they became known as the Marquesas. Tragically, the crew massacred over 200 of the inhabitants before sailing away, a bloody dénouement that was to act as a model for the future – death and disease on a scale which far overshadows the sufferings of Tahiti and the other Society Islands.

There is a grim aptness about this, for the Marquesas are in many ways an exaggeration of everything found on Tahiti – more rugged and less generous, with steep volcanic cones rising up to a thousand metres, impressive but offering few pleasant beaches or navigable bays. These outcrops are dramatic, a brilliant emerald green on the lower slopes, but lacking the abundant natural produce of other islands, and not even much use for fishing, given their poor harbourage. As a result, the Marquesans, while of the same ethnic origins and cultural background as their fellow Polynesians, became, in their isolation, hardier and less pacific than the Tahitians; more warlike, similar to the Maori of New Zealand.

Because fishing was limited they relied heavily on breadfruit, but frequent famine made this a valuable commodity and one which was often fought over. As in New Zealand the islands were divided into competing tribes, often one for each narrow valley, constantly juggling for advantage, and as with the Maori, this constant warfare was a stimulus to creation – somehow on those high, rugged outcrops a fascinating culture flourished before the Europeans wrecked it totally. A recent visitor, the American novelist Paul Theroux, writing in 1992, described his amazement at what still survived:

Except for the jungles of Belize and Guatemala, I had never been in a place where the foundations of so many stone structures existed, covered with moss and ferns. All around them were petroglyphs, of birds and fishes, and canoes, and turtles, finely incised in the rock. In the damp shadows of the tall trees, and teeming with mosquitoes, the sites had all the melancholy of lost cities. It was exciting to see them sprawled in the gloom, on those muddy slopes – the immense terraces, the altars, the scowling, castrated tikis. To anyone who believes that all the great ruins of the world have been hackneyed and picked over I would say that the altars and temples of the Marquesas await discovery.

But they are by now ancient ruins. Cook merely called in, though his rediscovery literally put the islands on the map, which in turn brought the flotsam of the sea lanes – prison ships and passing whalers, the crudest and most violent of the scum that came to ply the South Seas, diseased vagrants who used the islands as rest and recreation points to restock their vessels and provide them with women. If the syphilis was too bad, a sailor might be left behind on one of the islands to recover, before another boat picked him up, leaving him to spread his infection unchecked while dabbling in local politics by teaching his preferred chiefs to use firearms and thus gain an advantage in the unending tribal wars. Thus did a population, believed to have been around 80,000, sink to 20,000, raddled with the effects of drink and disease and said to indulge in bouts of cannibalism. This is often hard to prove or disprove – the evidence being literally consumed – but in the case of the Marquesans, so many and so varied are the stories of human flesh-eating amongst a population driven to squalor and despair, that for once it seems hard to doubt.

Unlike the Society Islands, where missionary influence was inappropriately harsh and damaging, on the Marquesas, both Protestants and Catholics were the only half-way decent elements in the midst of the havoc wrought by passing seamen. The French annexed the islands in 1842, merely to keep the British out – they were of no value economically and never have been. Some traders settled there, dealing in copra, exported to produce coconut oil for cosmetics, but no proper administrative system was set up until this century. A number of French gendarmes policed the islands and carried out all the legal administrative functions required by the governor in distant Papeete. Magistrates visited from time to time, the governor appointed a representative to the Conseil Général – in the first instance the Protestant lawyer and newspaper proprietor Léonce Brault – but that aside the Marquesas stagnated. By the time Gauguin arrived, the decline was nearly terminal. The population had sunk to a mere 3,500 and seemed destined to be completely wiped out. The Marquesas were dramatically beautiful, seemingly blessed

with the intriguing remains of a former culture but in reality a sewer. Generally, it was only the Chinese who had much stomach for the place, the French avoided it and the only whites who would settle tended to be English, Germans or Americans of dubious origins who cheated the natives, who thought only of drinking themselves into stupefaction. When imported wines were forbidden to them, they took to distilling fierce spirits from the oranges growing in the remoter valleys. Even the supposed authorities were no more than a sorry reflection of this miserable state of affairs – the law was in the hands of poorly educated French policemen who had more power than judgement, while morality was in the hands of the rival Catholic and Protestant missionaries who spent most of their time exchanging abuse, and attempting to snatch converts from each other. In every way, the archipelago was the end of the Earth, the drain down which all the polluted streams of nineteenth-century life flowed. This was to be Eugène Henri Paul Gauguin's final home.

## The Loves of an Old Painter on the Marquesas Islands

On 15 September, the *Croix du Sud* called briefly at Nukuhiva, the largest of the islands, before sailing on to Hivaoa, where she docked at the little settlement of Atuona the following day. We know from photographs of the time what such an arrival meant: everyone crowded onto the jetty to see who and what had come and generally to enjoy the one brief spectacle in an otherwise eventless life. Such grainy prints usually show the local gendarme in his white uniform, a missionary or two in long white gowns and white sola topees, cloth-wrapped locals and traders in trousers and wide-brimmed straw hats. Nothing special, though on that morning there was one unusual element – watching Gauguin disembark was a slim, elegant oriental gentleman, not at all like the usual Chinese merchants, but a neat figure, smartly dressed in European style, who showed a keen interest in the new arrival.

As Gauguin reached dry land, the man approached and introduced himself as Ky Dong, an Annamite, or Vietnamese as it would be today. Gauguin learned later that his full name was Nguyen Van Cam and that in his native land he had been a prince, though to judge from his photograph, even at twenty-six he must have seemed little more than a boy. It was intriguing to Gauguin to be welcomed by this elegant oriental who spoke such impeccable French, but Ky Dong was not the only one interested in him – the tiny white community of Atuona had been avid readers of *Les Guêpes*, and when they heard that Gauguin was one of the passengers they hurried out to see the hero of the day, the man who had defended settler interests against the wicked machinations of the Parisian functionaries. Little wonder that Gauguin was overwhelmed by

this unexpected popularity and instantly decided to go no further. Why travel on when everything he needed was there, not least a branch of the Société Commerciale, the Hamburg-based company through which it had been arranged for Vollard to transmit his payments.

The captain was informed and his boxes and bundles were quickly unloaded – carvings and household goods, his easel and camera, the harmonium and the Breton winter scene which had travelled with him from the Rue Vercingétorix. The heavier boxes along with the supply of timber were simply stacked on the beach and left there. It must have been quite a sight, and no doubt a further enhancement of his already inflated reputation.

Having parked Gauguin's property, Ky Dong took the newcomer in hand, taking him to be introduced formally to the island's principal personalities, amongst whom was the same Dr Buisson who had treated Gauguin in Papeete and who was now the official military physician on the island and clearly of acute importance for his future well-being. Next, his new friend suggested that they walk to the other side of the little settlement, out to the road which led into the valley where a Chinese-Tahitian called Matikaua had rooms to let, after which they could find somewhere to eat.

Atuona itself was no more than a ramshackle settlement which had grown up around the two missions, Catholic and Protestant, that had established themselves on the narrow piece of land between the valley and the sea. The principal building was the Catholic church in front of which was a girls' school with 200 pupils, run by six nuns of the Order of the Sisters of Cluny, and, a hundred metres away, a boys' school, with 100 pupils, run by three monks of the order of the Frères de Ploërmel. To the west of the settlement was the Protestant mission which ran a small day school.

It was probably on this walk that Gauguin learned something of Ky Dong's intriguing story. As a prince, Nguyen Van Cam had received a first-rate education in his native Thai Binh province, before obtaining a grant to continue his studies in Algiers, where he took a double degree in literature and science. Seasickness prevented a planned career in the Navy and at twenty-one he returned to Annam where he joined the colonial administration, a move which was radically to alter his view of life. Faced with the inherent injustice of the system, and reborn as Ky Dong, he quickly assumed the role of agitator and opponent of the foreign régime. After a year, he married and moved to the countryside where he had some land, but continued to pursue his political activities, somehow getting involved in what was described as 'a matter of terrorism'. Early in 1898 he was arrested, tried and imprisoned in Saigon before being sentenced to deportation to the infamous Devil's Island in

Guyana. Fortunately for him, the boat called in at Tahiti where Governor Gallet's attention was drawn to this unusual traveller. Sympathetic as usual, Gallet arranged for Ky Dong to be released into his care and had him appointed a male nurse in government service – a task for which he had no especial qualifications, which was probably why he was posted to the Marquesas, where any sort of medical help, even from someone totally untrained, was appreciated. No doubt realizing that he had little chance of ever getting away, the young man contracted a local marriage with a Marquesan woman and settled down to a life in exile. With the thought of Devil's Island ever before him, he no doubt counted himself lucky, though what he missed most was intelligent conversation – he was far better educated and had far wider interests than any of the simple settlers and low-level administrators who were his only contacts – that is until the arrival of Gauguin, for the arrival of this worldly artist must have seemed to Ky Dong like a gift from heaven.

For his part, Gauguin certainly played up to expectations. His impetuous decision to offload his goods and chattels, his willingness to plunge into whatever was proposed, must have been highly entertaining in so sultry and lethargic a backwater. Then there were the obvious signs of past adventures – Ky Dong had just enough nursing experience to know what the wounds on Gauguin's legs implied, and as if that were not enough, there was Gauguin's evident fascination with the local women as they strolled along.

This was hardly surprising. Since the first European arrivals, visitors had extolled the remarkable physical perfection of the Marquesans, though in the past half-century elephantiasis, leprosy, consumption and syphilis and other imported diseases had wreaked havoc. The people were still stunningly beautiful but often with some attendant disability or deformation caused by disease or the effects of rough alcohol.

Not that Gauguin seemed aware of this. As he crossed the village with Ky Dong the local women came out to indulge in the teasing banter common throughout the islands. Gauguin evidently enjoyed all this, but as his companion began to suspect, the newcomer did not seem to be quite sure who he was chatting to. It was eventually revealed that Gauguin's eyes were by then so weak, he had acquired some little round spectacles but that like many others, he preferred trying to get by without them and was as likely to indulge in a little sexy chit-chat with an old grandmother as with her nubile granddaughter.

When Matikaua, the Chinese-Tahitian, had found Gauguin a room, Ky Dong suggested they go back into the village to Ayu's restaurant where they could get a meal. It was probably on their way there that they called at the *gendarmerie*, the centre of the local administration where the French policeman acted as mayor, solicitor, magistrate,

surveyor, virtually everything, except on the rare occasion when a visiting functionary came out from Papeete. For once Gauguin was lucky – he knew the current gendarme, Désiré Charpillet, who had been stationed in Mataiea in 1894 while Gauguin was back in France, and where he had seen the decorations in Anani's house and heard some of the rumours about this notorious character. Two years later, in 1896, Charpillet had seen Gauguin during one of his stays at the Papeete hospital and had subsequently visited him, out at Punaauia. From Gauguin's letters and other accounts, it is easy to get the impression that his contacts with the police were always fraught and that he was forever at odds with them, but the truth is that a man like Charpillet seems to have looked on Gauguin as a source of free entertainment – always provided he didn't go too far. On Tahiti he had heard both good and bad reports of the artist, and was inclined to be sympathetic and let things take their course. The main reason for Gauguin's call was to see if there was a piece of land available where he could build a permanent home, but all that Charpillet could do was to point out the obvious, that almost all available plots in and around the settlement were in the hands of the Catholic mission and that he had best become, at least temporarily, a devoted son of the Church if he hoped to persuade the bishop to part with one.

No doubt Ky Dong would have taken him to the centre of the village and shown him the best available plot, a surprisingly large tract of land which no one had yet built on. Given Gauguin's health, and the way the increasingly frequent attacks made it difficult for him to walk very far, this looked ideal, especially since the best stocked shop, run by a young American, Ben Varney, was close by. All that remained was to persuade the Bishop to agree to sell.

That decided it was off to eat, still joking with the inquisitive women and generally enjoying all the attention he was getting. As well as running a restaurant Ayu also had a pâtisserie and being now surrounded by what he took to be a bevy of local beauties, Gauguin invited them all along to join him for tea and cakes. He was not wearing his spectacles at that time and clearly favoured a girl called Fetohonu, a sight which drew a good deal of cruel laughter, for not only was he staggering along on his bad leg but she, poor woman, limped along beside him on her club foot. Even the more sophisticated Ky Dong could not entirely control his laughter – Fetohonu meant 'Star of the Tortoises' but Gauguin seems not to have noticed and to have plodded on happy in his ignorance. After they had eaten, Ky Dong ushered them back to Gauguin's lodgings and left them to it, returning to his own home where he sat down and began to write a little play which he entitled 'The Loves of an old painter on the Marquesas', a scurrilous comedy, written in rhyming Alexandrines, in which the main character, an artist, arrives on the *Croix*

*du Sud* and quickly finds three Marquesan beauties, Marguerite, Fran-çoise and Germaine, with whom he plunges into a rapid seduction, joined by a Female Hunchback, who seems to be there just to add to the excessive brutality of the piece. Ky Dong claimed to have shown the play to Gauguin after it was completed four days later, but if that was the case, the surviving manuscript must have been heavily rewritten later. However, one can imagine the young author reading a more judicious version, out loud, as Gauguin and his friends enjoyed an early evening absinthe, laughing at the interplay of saucy local colour with erudite classical allusions, all in the strictest metre and rhyme.

## A Son of the Church

As if this were not enough, Gauguin now completed the air of unreality by going to mass every morning, along with Doctor Buisson and the gendarme Charpillet. The fathers had acquired all this land by persuad-ing their converts to bequeath their property to the Church and as the Marquesan death rate was high, so the mission prospered. But as Gaug-uin knew, any sale of Church land had to be approved by the Bishop, the formidable Joseph Martin, who was temporarily absent from Atuona. A heavily bearded, somewhat intolerant figure, Martin had come out to Tahiti as a priest in 1878 and made his entire career in the islands. No one could doubt his dedication to the task – he had been largely respon-sible for the publication of a new translation of the Bible in Tahitian and since becoming the apostolic vicar to the Marquesas Islands he had used all his considerable powers to try to halt the rapid disintegration of life on the archipelago. Faced with the drunkenness and disease which looked set to wipe out the entire population, the bishop behaved like a stern Victorian paterfamilias, making rigid rules and using any means to enforce them. His aim was to get as many of the local children into the mission schools as possible and to this end he enlisted the help of the gendarmes in convincing the people that they were legally obliged to make their offspring attend, and while there was no doubt an element of personal aggrandisement about the way the missionaries attempted to grab as many converts as possible, one has to admit that in an appalling situation, they represented one of the few organizations trying, by what-ever means, to do something to reverse the slide into self-destruction that was killing off the islanders. On the one hand drunken lethargy, on the other a rigid code of behaviour – not a pleasant choice to the contemporary mind, but there was nothing else available.

In such a difficult situation, the last thing the bishop needed was a parishioner like Paul Gauguin, though what he saw on his return was a man who went to mass every day and who came with the reputation of

a loyal defender of the Catholic party on Tahiti, a cause dear to Joseph Martin's heart, for if the bishop had one enemy above all others it was the Protestant missionaries, whom Gauguin had so flamboyantly attacked in *Les Guêpes.* In any event the bishop quickly agreed, and the plot was sold for 650 francs and Gauguin stopped going to mass.

So preoccupied had Gauguin been with all this, that he clearly forgot that his original reason for coming to the Marquesas was the search for a true Polynesian art. Once settled in Atuona he made no attempt to get beyond the town, to see what the island had to offer. Along the north-east coast, about a half hour's walk from the village of Puamau were the largest stone sculptures in the archipelago, which some consider to be linked to the great stone heads of Easter Island, and enough reason for Gauguin to have made every effort to get there. But no. As before, he acquired a photograph of one of the monumental *tikis* and was content. As for the carvings he hoped to find, he quickly learned that the situation was only marginally better than on Tahiti, with little more than a few minor curios such as carved walking sticks available in the local stores, and that, under pressure from the missionaries, even tattooing was dying out. From a cultural point of view the move from Tahiti had been hardly worth it, but by then he had accepted the inevitable and was content to build a house and settle down where fate had put him.

His nearest neighbour was a Marquesan called Tioka who appears from a photograph, perhaps taken by Gauguin, to have been small but sturdy, with a wonderfully fluffy white beard that sprouted to left and right in two pointed wings. In the picture, he stands beside one of his nephews, a handsome fifteen-year-old called Timo, with some French blood, who would later provide much of the information that we have about Gauguin at this time.

Aside from his sexual relationships and the possible, though brief, association with the wood-cutter Jotefa, Gauguin had never had a Polynesian friend of any importance. Making himself an outcast from French society had not integrated him into the indigenous world and in his last year on Tahiti he had deliberately rejected Tahitian life for the company of white settlers, the very people who represented everything he had once affected to despise. All this ended with Tioka, who from the start took to Gauguin as if he were part of his extended family. Some of this may be due to his religion – Tioka was a deacon at the nearby Protestant church and the way Gauguin had duped the bishop into selling him the land, followed by his abrupt cessation of churchgoing, can only have amused the older man. Soon after their first meeting he proposed to this 'maker of images' that they follow the old Marquesan custom and exchange names as a sign of abiding friendship. Thus Koke became Tioka, and Tioka became Koke.

From then on a form of brotherhood existed between them, which both were to respect entirely. As Gauguin needed to build his new home, Tioka offered to help – unpaid – along with a friend called Kekela, another deacon, named after a former pastor from Hawaii who had established the Protestant mission. It was a situation new to Gauguin, one that would radically alter his attitudes, reversing the somewhat dubious behaviour of recent years. As soon as the cases and the supply of timber could be brought up from the beach, work began.

## The House of Orgasm

Gauguin quickly outlined the building he had in mind – a unique construction unlike anything Tioka or Kekela had seen before. We know from photographs that there had been only two buildings over one storey high in the entire settlement – the Catholic Church and Varney's store. Gauguin's house and studio would be the third.

At ground level, he built two cube-like rooms, one to be the kitchen, the other a wood carving studio separated by an open space which would benefit from any breeze and act as a cool dining area. Over this, resting on the cubes, Tioka and Kekela constructed a long first floor room, roofed with thatch, which was to be both living space and the main studio. This was approached up a ladder leant against an opening on the gable end. Gauguin surrounded this entrance with a set of carved panels, in fulfilment of his promise to himself, before he finally quit France, that he would live in a house of carved wood. The panels on either side of the doorway contained standing female nudes, while the panel which ran off to the left was carved with the words: *Soyez mystérieuses* and that running off to the right: *Soyez amoureuses et vous serez heureuses*. And if that were not enough to spread alarm amongst the suspicious missionaries, Gauguin capped the whole thing with a panel running along the top of the entrance, on which was emblazoned the title: *Maison du Jouir*, usually rather tactfully translated as 'The House of Pleasure', though the French word *Jouir* also implies a more specific form of enjoyment – that associated with ejaculation and orgasm.

Louis Grelet, a 22-year-old Swiss national, who was then a commercial traveller calling on Atuona's tradesmen with supplies of brandy and liqueurs, often visited the newly completed house and half a century later was able to give Bengt Danielsson an accurate description of the interior:

> The staircase led to a small anteroom, containing only a single piece of furniture, a rickety wooden bed, which he had decorated with carved figures and scrolls . . . A thin wall separated this room from the studio, which gave the impression of being rather large and was an absolute lumber-room, without any sort of order. A small harmonium stood in the

middle of the floor, the easels being placed in front of a large window at
the far end of the room. Although Gauguin had two chests of drawers,
they were too small to hold all his belongings, so he had had shelves made
from ordinary wooden planks put up round the walls. In native fashion
he kept all his valuables in strong chests, which were padlocked. On the
walls were some reproductions of paintings and forty-five pornographic
photographs which he had bought at Port Said on the way out from
France. Besides the harmonium, Gauguin had a mandolin and a guitar,
but could not play any of the instruments properly. His favourite tunes
were Schumann's *Lullaby* and Handel's *Reverie*.

Although the building would not be completed till the new year, 1902,
by early November, after six weeks' work, Gauguin was able to move
in. Another nephew of Tioka, a boy called Kahui, half Chinese, was to
be the cook and a man called Matahava was hired to work on the garden.
They were not paid much, Kahui got 20 Chilean francs a month – that
being an acceptable currency on the islands. But as Kahui's cousin, the
young Timo, later noted, Gauguin was hardly very demanding, and his
'servants' were more often seen strolling about than labouring on his
behalf. All the artist insisted on was that his meals were ready on time.
Gauguin would tell Kahui what he wanted early in the morning and the
young man would have it ready by eleven. We know from the accounts
at Varney's store that he bought a good deal of expensive imported food
and drink which implies that he was living like a typical French settler,
though quite often this was varied by whatever Tioka sent over for them,
as his new friend always shared any fish or fruit that came his way. When
the food was on the table under the house, Gauguin would divide it into
three, one part for the two servants who ate in the kitchen, one part for
himself if he was eating alone, and the third for his new pets, an unnamed
cat and a dog he called Pegau, another version of Pego, his usual way
of signing himself. Timo recalled that Gauguin took a little wine with
his meals, not much, though he drank a good deal of absinthe (a quarter-
litre per day, according to his accounts with Varney – and absinthe was
100% proof alcohol!) and had a fishing line hung out of the upstairs
studio window at the end of which was a bottle of water cooling in a
pond below, which could be hauled up at need. The dog and the cat ate
with Gauguin in the open-sided dining room, but he seems seldom to
have been alone. Ky Dong was a frequent visitor, as was another neigh-
bour with a property on the beach, Emile Frébault who ran a general
store in competition with Ben Varney. Having married the daughter of
an Englishman who had run the plantation of the Société Commerciale,
the Hamburg-based company who were Gauguin's bankers, Frébault
stood slightly outside the normal Catholic settler society. As did another
drinking companion, an old Basque called Guilletoue who spoke

Marquesan and who lived something of a wild existence, most often out hunting in the valleys. The one exception was the actual leader of the Catholic party in the settlement, a former gendarme called Reiner, who had abandoned his earlier allegiance and was now the arch-enemy of the administration. Reiner had lost his seat as the Marquesan representative to the Conseil Général as a result of Gallet's reforms and was thus a keen admirer of Gauguin the campaigning editor. But in a way, Reiner was now something of an anomaly in Gauguin's new circle, for this was not to be a re-run of Punaauia, this time the local 'natives' were welcome visitors to the House of Pleasure.

## Cloth to the Value of 200 Francs

Inevitably, the local people would come to stare at the naked women in the carvings and to try to catch a glimpse of the pornographic pictures from Port Said, some of which had now been unpacked and pinned up around the studio room. Being Polynesian, they brought gifts of fruit and chicken and eggs and fish, and were invited in for a glass of rum so that at any hour of the day or night a party might begin. Tioka, despite his duties as a verger, was a great drinker and the bills at Varney's were soon considerable – though Gauguin's allowance from Vollard meant that by Marquesan standards he was a wealthy man. The drink flowed, the visitors came and Gauguin was soon speaking a little Marquesan, quite different from Tahitian, and if it was daylight he would persuade his visitors to go down to the garden where he would pose them in front of his large camera, disappear under the black cloth and capture their likenesses, dashing back upstairs to develop the plate in the studio. The room was soon a mass of images, his photographs strewn everywhere, the walls covered with his 'little friends' alongside the obscene pictures. Any woman caught staring at them was inevitably encouraged to go further – one witness described how Gauguin would caress the watching women, running his hands under her wrap while whispering: 'I must paint you'. Though when he did, the results were far removed from these sleazy approaches, for as in Tahiti the separation of life and art was near total – he may have treated his women like whores but on canvas they were sanctified. One double portrait, made about then, illustrates this perfectly. Two women stand at one of the windows in the upper room which offers a view over a neighbouring roof and the surrounding plantation; the woman on our right suckles her baby, her companion, head reverently inclined, proffers a gift of flowers. Entitled *The Offering*, the suggestions that this is a Polynesian Nativity are obvious enough, making it difficult to accept that that may have been the window from which he hung the bottle of water for the absinthe, and that prior

to starting work on the canvas Gauguin might have given both these saintly figures a lecherous grope.

Gauguin reworked the painting and re-signed and dated it the following year, 1902, but it was most probably begun during this interlude of parties and play. Aside from painting, sex was once again a dominant part of life. The window in the painting had a precise role to play here, for with his spectacles on Gauguin could enjoy a daily performance of acute interest. On the other side of the small square facing the Catholic church was the boarding school for girls, run by the Sisters of Cluny who looked after their charges till the age of fifteen, hoping to separate them for a time from the easy-going ways of their parents. Occasionally, a little procession of girls under the watchful eyes of the nuns, dressed, as in France, in their black robes, would wend its way through the settlement, allowing the pupils a little exercise. We may guess the effect of this on Gauguin and need not be surprised at what happened once he realized that most of the girls' families had only sent them to school out of fear of their legal obligations as interpreted by the bishop. What Gauguin now learned was that French law was actually quite reasonable on this score – anyone living within four kilometres of a school was obliged to send their children to be educated, but those without a nearby establishment were excused. Thus the bishop had deliberately exaggerated the rules, telling people far from the town that they had to bring their daughters to the mission, even though there was no such law to compel them. Armed with this information, it was not hard for Gauguin to follow some of the girls when they returned home for holiday visits and thus to discover which came from families well outside the four-kilometre limit.

He eventually settled on a local chief in the Hekeani valley, a suitable ten kilometres out of town, with a very suitable fourteen-year-old daughter Vaeoho, whom the nuns had named Marie-Rose. The chief was happy to accept Gauguin's interpretation of the law, a foreign education counted for little, especially for a girl who was only useful on the land or for a profitable marriage. Thus Vaeoho became Gauguin's new 'bride', in exchange for a 'gift' of cloths and ribbons to the value of 200 francs from Ben Varney's store. Varney duly noted the transaction in his account book and dated it 18 November 1901 – the closest thing there was to a marriage certificate.

With Vaeoho for company, Kahui and Matahava to look after him and a mixed bag of errant Frenchmen and loyal Marquesans for his friends, Gauguin was better set up than at any time in his ten years in Polynesia. Even the gendarme Charpillet would stop by for an aperitif on occasions, so the frictions of former days seemed happily in abeyance. His illness was once more manageable. He was still in pain and his

wounds were ever worsening, but the cyclical nature of the attacks meant that he felt a little better than before and was surprisingly contented. As the new year 1902 opened, everything was in place and he felt able to start work again.

## The Woman with Red Hair

Given that Vaeoho, at fourteen, was the nearest of all his *vahines* to the mystic age that he had long lusted after, one would have imagined that she would have instantly become his model, just as Teha'amana and Pau'ura had done. In fact there is no extant representation of her, photograph or portrait, though why this should be so is not clear. What we do know is that Gauguin settled instead on a couple, a man and wife who were among his new friends and who, independently, became his main models. She was called Tohotaua and her husband was named Haapuani, and it is not hard to see why Gauguin found them both fascinating. Tohotaua came from the nearby island of Tahuata where there was a unique strain of red-headed Polynesians –Tohotaua's hair cascaded behind her back in rich copper locks. We know how extraordinarily beautiful she was from a surviving photograph taken in Gauguin's studio, by the travelling salesman Louis Grelet, who was clearly acting under close instructions from Gauguin. Tohotaua was posed in a way that makes a clear reference to earlier images – she is seated in a chair, looking straight at the camera, holding a fan in her right hand, in a way reminiscent of the last portrait of Teha'amana and with echoes of the portrait of Pau'ura as the *Noblewoman*. It seems clear from this, and from Grelet's later accounts to Bengt Danielsson, that Gauguin and Tohotaua were briefly lovers – a thing that would not have bothered either Haapuani or Vaeoho, both of whom accepted polyandry as quite normal among friends.

Grelet's photograph offers us an intriguing glimpse of the room behind Tohotaua, where we can see a wall of woven grass on which are displayed a jumble of 'little friends': Holbein's *Woman and Child*, Puvis de Chavannes's *Hope*, Degas's *Harlequin* and, importantly as we shall see, a photograph of a sculpture of a seated Buddha.

Gauguin used Grelet's photograph as the basis for a portrait of Tohotaua, though he made several important changes during the painting. In the photograph she is modestly covered, on canvas she is barebreasted, her lower body wrapped in a vivid white cloth which contrasts strongly with the plain mustard-coloured background. There was nothing prurient about this – to Gauguin the clothed body symbolized those feelings of shame the missionaries had induced in a people who had once rejoiced

in their nakedness. He himself wore nothing but a simple *pareu* wrapped round his waist and in showing Tohotaua barebreasted he was returning her to a former state of physical and spiritual freedom. This was also why she holds a fan, symbol of Polynesian aristocracy and thus a sign of her cultural independence – yet there is something strange here, for on its handle he painted a tricolore rosette, bright blue, white and red, and obviously French, which attracts the eye more than anything else in the painting. At the same time, Tohotaua looks away to our right, whereas in the photograph she stares straight at the camera – so that the effect in the painting is curiously unnerving, as if subject and observer are avoiding each other's gaze – we stare at her fan, she looks away from us, so that we do not quite meet.

It is doubly strange that this sense of separateness, of alienation between subject and artist, should have crept into his work at a time when he was growing closer to the people amongst whom he lived. Perhaps it was only as he started to know them as individuals that he could begin to comprehend their uniqueness and thus their true independence. In some ways, this portrait, more than all his former attempts, comes closest to that sense of proud indifference we see in Manet's *Olympia*, staring out boldly at her judges. Tohotaua's sideways glance, although quite different from Olympia's direct gaze, achieves the same sense of self-confident immunity.

Gauguin used this technique in another painting which featured Tohotaua, *Contes Barbares*, which again offers that curious sense of displacement. This time there are three figures, set in a flowery glade, with Tohotaua seated in the foreground, sideways to the spectator, looking out of the picture to the left. Behind her is a second figure, based on the photograph of the seated Buddha we have already picked out from the glimpse of the wall in Gauguin's room in Grelet's print, while behind the Buddha, the third figure is unmistakably Gauguin's old friend Meyer de Haan from Le Pouldu.

It would be easy to assume that it was Tohotaua's coppery hair which had called to mind the red-headed Dutchman but there were clearly far more profound reasons for his presence. Although de Haan had died in 1895, after four years of fruitless treatment for a kidney complaint, he was still Gauguin's symbolic figure for demonic knowledge. In *Contes Barbares* this role is exaggerated: he is dressed in a long Mother Hubbard and his one exposed foot has elongated animal claws in place of human toes. In the foreground is the innocent figure of Tohotaua but she is protected from this fallen angel by the intervening figure of the Buddha. The key to the picture has to be Carlyle's *Sartor Resartus* with its philosophy of covering and revelation – De Haan in the Christian gown of shame, the Buddha and Tohotaua with their innocent nakedness. One

thinks of Carlyle, comparing the beauty of an uncovered horse with a man 'thatched over with the dead fleeces of sheep'.

## The Man in the Red Cape

In an early letter to Monfreid, written just after he had moved into his new home, Gauguin tried to claim that he was doing something entirely different, moving away from Symbolism which he depicted as just another form of sentimentalism. This was an exaggeration, but there was certainly justice in his later assertion that he had 'The right to dare all', which better explains his restless search for new ideas. Now, as his flesh decayed under the ravages of an incurable disease, his mind was turning towards thoughts of free bodies, to the union of the spiritual and the physical through untrammelled nakedness. The key to his thinking was long thought to be Haapuani, Tohotaua's husband, who was assumed to be the subject of several of the Marquesan paintings. This was perfectly reasonable, Haapuani was an intriguing character and just the sort of figure Gauguin would have wanted to paint. A native of Atuona, he had been a traditional priest before the coming of the missionaries, but since losing this function he had taken on the role of an organizer of festivals and celebrations. With this in mind it was logical to assume that one of Gauguin's more unusual paintings, a portrait of a man in a long red cloak, was a representation of Haapuani in his priestly vestments. There are a number of other elements in the picture which seem to back this up, the man in the red cloak seems to be offering a leaf which he holds up in his right hand – presumably a reference to traditional healing or magical potions. Behind him, in the forest, two women look on, as if fascinated by his behaviour – again this sense of the watchers on the sidelines, commenting on the central action.

Because of all this, the painting has come to be known as *The Enchanter* or even *The Sorcerer of Hivaoa*, two charming titles though somewhat unfortunate, as they suggest that what we are looking at is simply a pleasant, local folk-tale. In fact, the painting is far more interesting than such titles suggest and has nothing to do with Haapuani or sorcerers at all. If one looks carefully one sees at once that the figure is not the husband of Tohotaua, nor anyone else's husband for that matter. What we are actually looking at is a tall willowy figure with very long hair and a flower behind the left ear, wearing a short, skirt-like shift with the red cloak draped over his shoulders. The immediate effect is of femininity, for while Gauguin may have embarked on a portrait of Haapuani, what he finished up painting was a *mahu*. An interest in ambiguous or shared sexuality had surfaced all through his work in Polynesia. Most often this had taken the form of a muscular or male-like women until, with the

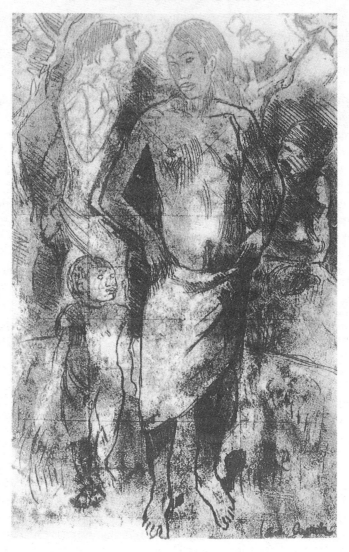

Monotype by Gauguin of the bathing *mahu* figure,
squared-off for transfer to a canvas

central figure reaching to pluck fruit in *Where Do We Come from?*, the
situation was reversed and we were given a representation of a man
who looks momentarily female, but is in essence more masculine than
feminine. With *Marquesan Man in a Red Cape*, the title now preferred
for the painting, Gauguin finally goes the whole way and represents an
unequivocally feminine man.

Once again, there are hints that Gauguin was planning something

more than a single painting, that he had some sort of scheme in mind. *Marquesan Man in a Red Cape* measures 92 × 73 centimetres, and there is an identically sized canvas which he may have seen as the other side of a diptych. This shows a bather, stripped down to a simple wrap, though his long hair indicates that he too is a *mahu*. Thus, on one side of the diptych we have the *mahu* completely dressed, smock and cloak, while on the other, usually entitled *Bathers*, the *mahu* wears nothing but the wrap, which he holds with his hands as if it might fall away. On the 'clothed' side, the *mahu*'s gesture with the leaf suggests magic and the supernatural; on the 'unclothed' side, the presence of a goat and a child convey the more earthy notions of lechery and procreation.

In another painting, *The Lovers*, (which could have been part of an intended series), the sexual ambiguity of the *mahu* is shown in the way he drapes his arm round a beautiful naked woman, while in another, the curious desirability of the sexually ambivalent is brought out from the way a cloaked and covered *mahu*, standing in his dark forest glade, is watched by a nude woman, whose pose echoes the Tahitian Eves of earlier works. All three speak of revelation and concealment and highlight issues of male sexuality, the eroticism of dress, the nature of sexual identity and masking, and are unlike anything Gauguin had so far attempted.

Apart from Jotefa, Gauguin had rarely dealt with the male figure, and why he should have taken up the subject at this late stage is unclear. Perhaps the acquisition of Polynesian friends after the rather sour settler period in Punaauia had resurrected some of the feelings he had experienced earlier and which he had encapsulated in the episode of the journey into the mountains with the wood-cutter. But if this was a second rejuvenation, a rebirth of his sense of being a Maori, it appears to have come too late. As his illness flared up, then retreated, then returned again, he found it increasingly hard to work, other than in short bursts. In April he alerted Monfreid that he was sending him twelve paintings with a further twenty for Vollard, but most of these must have been done earlier, on Tahiti, for after an initial burst of energy the finished canvases had begun to trail away, so that by the middle of the year he had abandoned any hope of making another major series. Whatever his ideas on male sexuality, homoeroticism and ambiguity may have been, they were not realized, he was too ill, too tired and possibly by then too mentally unstable for consistent work. He did not formally cease to paint, the occasional work was turned out, but the wider view, the bigger picture was no longer attainable, leaving the *mahu* in his red cape and its opposite, the near-naked bather, stranded on the fringes of his work, oddities which few have ever bothered to try to understand.

## I Am Indeed a Savage

Thoughts of sickness and death had again begun to crowd in on him. It was during March that word reached him that his loyal friend and advocate the young poet Julien Leclercq had died, poor and forgotten, the previous October. It must have seemed to Gauguin that there was no one but Monfreid left to support him. The only good news came from Molard who wrote to say that Judith, now a young woman of twenty-one, had become an artist and was already exhibiting with the Salon des Indépendants on the Champ-de-Mars, which perhaps showed that she at least still carried some trace of his presence in her life.

That aside, his letters are full of bitter complaints about minor treacheries and persistent failures, no doubt a reflection of an increasingly unstable mental state, the inevitable by-product of his disease. Once again, this was to be aggravated by the sort of wild political activity it would have been better for him to have avoided. In the middle of March the new governor, Edouard Petit, and an entourage of senior officials sailed out from Papeete to pay an official visit to Atuona, whereupon the settlers invited Gauguin, the famed journalist, to offer a petition listing their grievances. As most of those were various objections to paying taxes which were then spent on public works in and around Papeete – they amounted to the exact opposite of the argument Gauguin had once made for the Catholic Party in *Les Guêpes*. It had been precisely the aim of Gallet's reforms to create a more equitable distribution of the islands' revenues, reforms which Gauguin had volubly opposed when he was in Punaauia but which he now advocated with an equally intemperate zeal, stirred up by his new friends, just as he had been provoked into action by Cardella. He even requested a personal interview with the governor but as Edouard Charlier, by then the colony's chief judicial officer, was amongst the advisers aboard the cruiser, this was hastily, and no doubt wisely, refused.

It says much about these colonial functionaries that they knew so little about the people they ruled over – Rey, the Secretary General, had had some idea of Gauguin's connections back in France but he seems to have kept the knowledge to himself. Only occasionally did anyone get a hint of the fact that Gauguin was more than just a scruffy vagrant – Frébault once saw some letters lying around in the studio and realized that two of them were from Georges Clemenceau, which surprised him greatly. But Petit learned nothing of this and before leaving the island he made a tour of the settlement on horseback accompanied by Charpillet the gendarme, who pointed out the various sights and when he indicated Gauguin's home, Petit surprised the policeman by suddenly saying: 'Ah!

You know he's a scoundrel.' To which the sympathetic Charpillet replied, that he had 'no grounds for complaint against him'.

Gauguin, however, was infuriated by the governor's rebuff and determined to continue the fight, even after the visitors had sailed away. Thus when his annual tax bill, of 44 francs, arrived, he wrote to the official responsible for Marquesan affairs on the island of Nukuhiva, the impressively named Maurice de la Loge de Saint-Brisson, announcing his refusal to pay and naturally enough, received in return a brief, polite but firm note telling him he had to. If Gauguin had confined himself to this personal protest the whole thing might have drifted away into a to-and-fro correspondence which could have been dragged on through eternity, but when the intemperate artist began to suggest to his Marquesan friends that they too should ignore their tax bills, and when he personally refused to pay the 65-franc tax bill of his cook Kahui, the matter took on a far more serious aspect. This sort of seditious rabble-rousing was just what the authorities feared most – native taxes were always a contentious subject as they were clearly the means by which the French settlers were able to oblige the local people to work for them. If they had no need to pay taxes, most would have lived off the land and never have subjected themselves to low-paid labour. By stirring up this hornet's nest Gauguin was embarking on his first serious challenge to the colonial authorities.

None of this might have mattered if an accident had not fuelled local discontent – on 27 May the *Croix de Sud*, the islands' lifeline, ran aground on a coral reef in the Tuamotu Islands. The boat was a total wreck and all communications with the Marquesas were disrupted while a replacement was sought. Where before Gauguin and the settlers had complained about the boat's 'English' ownership they now bemoaned its loss and blamed the administration for failing to find an instant substitute, carefully ignoring the fact that if they had been taxed to provide a local vessel they would have whined even more. As the weeks passed, with no mail and no supplies, the matter festered and Gauguin was happy to be the voice of growing discontent, much stirred up whenever he had a visit from his friend Guilletoue who was notorious for getting the local people to claim their rights and who had been jailed by the vengeful authorities on a charge of accepting money in exchange for explaining the mysteries of French law to the confused natives – a fact which ought to have acted as a warning to Gauguin, though, of course, it didn't.

Inevitably, the cycle of illness turned again and by June he could only walk with difficulty. One neighbour later recalled that by this time, both his legs were giving him trouble and both had weeping sores which he attempted to cover with bandages which he was somewhat lax about changing: '. . . they were very dirty . . . . He was very dirty . . . .' Grelet, the Swiss salesman, once saw him out walking and noticed that his right

leg was literally gnawed away and was buzzing with green flies – by staring at the wound he made Gauguin angry as if he had no wish to be reminded of it. He walked, leaning on a walking stick he had carved with an erect penis for a handle but it was by then so painful to move about that he asked Ben Varney to order him a small trap from Tahiti, along with one of the plentiful Marquesan ponies so that he could ride out at least once a day. According to Haapuani, this ride was as regular as clockwork – each afternoon, wearing his green shirt and beret with his blue *pareu* pulled up high to keep his legs free, Gauguin would slowly canter round the settlement, never stopping to talk to anyone, though he would wave to friends as he passed. But while the pony and trap solved one of his problems, the underlying cause of his difficulties, his illness, was never going to improve, and he was now without access to proper medical treatment – Dr Buisson had been recalled to Papeete in February and had not been replaced. While Ky Dong was jolly good company, he was not much use as a nurse, and the only possible hope of help came from an unexpected quarter, the nearby Protestant pastor, Paul Vernier, who had briefly studied medicine in France and Edinburgh and had some experience of doctoring his flock, with a supply of medicaments at his mission. Unfortunately for Gauguin this was the self-same Vernier he had so maliciously attacked in *Les Guêpes* and whose wife had died shortly afterwards. Luckily, Vernier was a good man and bore no grudge. Indeed, of all the ministers in the region, he seems to have been the most sympathetic and in many ways the most Christian.

Vernier was born to his role – his father Frédéric had been sent out to Tahiti by the Société des Missions Évangéliques de Paris in 1867, when it was decided that French Protestants should replace their English predecessors from the London Missionary Society. Paul, the second son, was born in Papeete in 1870 and was raised amidst the factionalism both religious and political of the colony. Deciding, despite all that, to continue his father's work, he had prepared himself both as a minister and a medical practitioner and on his return from studying abroad, it was decided that he should try to build up the tiny Protestant mission on the Marquesas, where the London Missionary Society had had a long history of failure. In recent years a Catholic mission had been set up and had gained a dominant position, though the Hawaiian pastor Kekela, sent out by the Board of Missions in Honolulu, had had some success in winning a handful of converts such as Tioka. After Vernier's arrival in April 1899, a combination of good humour and practical medical help quickly established the young missionary as a force on Hivaoa, to the extent that his success began to concern the Catholic bishop who seems to have preferred heathens to Protestants. The problem was that few Marquesans were much taken by the new religion and those that did

accept the available sects were susceptible to an approach from another. As it was not uncommon for conversion to be encouraged by some sort of practical benefit, a baptismal gift of some sort, it can only have seemed perfectly reasonable to the new convert to exploit this happy situation by seeing what the other side had to offer. With his ability to provide a free medical service, Vernier clearly had a trump card, but when in 1900 he managed to enrol five recent Catholic converts living in the Hanaiapa valley on the northern coast of the island, Bishop Martin could stomach it no longer and rode out to personally reconvert his wavering flock. In this he appeared to be successful, though on the way back his horse stumbled and the bishop fell, dislocating his shoulder and paralyzing his arm – severely enough for him to have to travel to Papeete for treatment. On his return, the now furious bishop presided over a large open-air gathering, ostensibly a late celebration of the Jubilee ordered by the Pope, but in fact a near-hysterical rally against Protestant heresies, with a sermon protesting against those who denied the presence of Christ at the Eucharist. Heaven knows what his Marquesan audience made of this theological nit-picking – not a great deal one must assume. However, in such a climate, it was hardly viewed with favour that the apostate Gauguin should consort with the perfidious Vernier, even if it was only to obtain medical advice.

In fact the relationship between the two men went deeper than that. Both had lacked intellectual stimulus and thus found considerable pleasure in passing the odd moment talking about art and books, both willing to overlook the other's role – man of the cloth, dissolute artist – in the relief at having someone intelligent and well-read to talk to. By the time Vernier got to know Gauguin, the artist was so ill he seldom left his house. If they did meet on the rare occasions when Gauguin went walking in the valley, Vernier noticed how polite and kind Gauguin was to the local people and how they returned his kindness. 'He had a real cult for the country here,' Vernier later wrote, 'for this nature so wild and beautiful in itself, where his soul found its natural frame. He was able to discover almost instantly the poetry of these regions, blest by the sun, parts of which are still inviolate ... The Maori soul was not mysterious for him, though Gauguin felt that our islands were daily losing a part of their originality.'

That his two enemies met together from time to time was surely reported back to the bishop, who was far from best pleased. Matters came to a head at the annual 14 July celebrations, as important on the Marquesas as in Papeete. For reasons never made clear, the gendarme Charpillet invited Gauguin to preside over the Festival Committee, which in effect meant acting as a judge for the various competitions which were the main focus of the fête. Perhaps the policeman hoped

that this strange artist would be reasonably independent, in what was by then a traditionally acrimonious battle between the Protestant and Catholic schools. Charpillet assumed that while Gauguin was nominally a Catholic, as witness his brief flurry of churchgoing, he had now changed and was willing to welcome the Protestant pastor to his house. To the gendarme, this must have looked like something approaching balance and, if nothing else, shows that this agent of law and order was not the automatic enemy of the Bohemian artist that has often been portrayed.

However, Charpillet was to be less satisfied with his choice of judge once the main singing competition got under way. In a hopeless attempt to extricate himself from what he by then realized was an impossible choice, Gauguin split the prize between the Catholic school which had sung a *Hymne à Jeanne d'Arc*, both Catholic and patriotic, and the Protestants who cunningly sang the *Marseillaise*, thus allying themselves to Republican and anti-clerical sentiments. Such Solomonic balance might have worked, had not it been obvious that the Catholic pupils were on this occasion far better and had thus been robbed of their prize by a Protestant-loving apostate. In fact no one was happy, least of all the bishop, whose opposition to Gauguin now passed from a state of passive irritation to one of active loathing.

## A Solitary Dialogue

Only Gauguin's absorption with his own sufferings can explain his apparent indifference to Vaeoho. She was now pregnant and must have conceived shortly after moving in with him, but unlike the three earlier pregnancies in his Polynesian life, this one found no expression in Gauguin's art. Over the months that she grew larger, no *Maternity*, no *Mother and Child* appeared, just the mysterious *mahu*, clothed and naked, a puzzling preoccupation for one who had formerly relished his role as a prospective father. Sometime in mid-August, Vaeoho decided to go back to her family for the birth. Whether because of his indifference or her revulsion at his physical degeneration, she never returned. Their child, a daughter, whom she called Tahiatikaomata, was born on 14 September but whether Gauguin ever bothered to ride out to Hekeani valley to see her is uncertain – probably not, as he was by then increasingly trapped in a world of his own obsessions.

In his loneliness, Gauguin returned to writing and the screeds of paper he covered read like a conversation with himself – a solitary dialogue, the sound of a man alone, talking in his room.

He took up and finished a piece he had begun just before his departure from Tahiti, an essay on the nature of art, which he probably saw as a counterblast to the sort of reactionary stuff Emile Bernard had been

sending the *Mercure de France* from Cairo. This was posted to Fontainas in September, but the editors refused to publish it and it only saw the light of day in 1951 when it appeared under the title *Racontars de Rapin*, which can be paraphrased as 'Dauber's Gossip', a fair enough indication of its intimate, ruminative, conversational style.

It is difficult to be entirely critical of the *Mercure*'s decision. The essay was hardly a well-reasoned unified piece, it broke down too easily into three seemingly disconnected sections. The first section is a rambling defence of his artistic position as defined in his phrase 'the right to dare all'. He begins by asserting that he will talk about art as a painter, not as a man of letters and goes on to draw up battle-lines between those that do and are inevitably concerned with the future, and those who criticize and whose viewpoint is, equally inevitably, backwards, with the past.

The third section is an historical analysis of the artistic establishment in France since the Revolution, or more exactly since Napoleon 1 had set up the rigid state system of artistic control via the Academy and the Beaux-Arts. This is a stirring tale well told, comparing the collapse of the Salon to the Fall of the Bastille and ending with a note of victory, now that artists had freed themselves: 'All obstacles put up by ridicule have been hurdled. When they want to exhibit their work, the painters choose the day, the hour, the hall that suits them. They are free. There are no juries.'

Unfortunately, the effect is somewhat blunted by two curious and apparently unrelated anecdotes which Gauguin inserted between the two main sections. Both are fascinating, especially the second which tells how an old, blind, mummy-like native woman stumbled onto his property one night, walked up and began to examine him with her hand, eventually reaching under his *pareu* to feel his sex – the pego or 'prick' that he had adopted as his signature, so much did he think of it as representing his essential self. The woman, however, realizes that unlike a Polynesian man, he is not supercised and withdraws her hand in disgust, exclaiming the word *pupa* or European, making it clear that, whatever he might like to think, at his most essential point, he remained what he had always been – a white man, an outsider.

In isolation, the story is very revealing; as part of his discourse on art and criticism it is out of place, though it would not have taken much to put this right. Sadly, the editors on the *Mercure* were not up to the task – sad, because properly handled there was marvellous material lurking within those rambling pages. What Gauguin needed above all was a sympathetic editor, and it is irritating that there was no one on the *Mercure*, not even Fontainas, willing to take on the task. If Gauguin could have entered into a dialogue with a strong but concerned literary

figure, able to iron out his obsessions and digressions while leaving the force of his argument intact, he might well have enjoyed a second career as an author, as he seems to have wanted.

Confident the *Mercure* would publish it, Gauguin despatched *Racontars* in September, though by this time he was already well into a far more aggressive work, one that has never been published in its entirety – the reworking of his essay on the Catholic Church, in the *Noa Noa* exercise book, which he had begun in Punaauia. As before, there can be little doubt that the motivation for this was his continuing battle with the Church and as before the reason for this was simply sex. With his 'bride' back at her parents', Gauguin was once more in search of companions – which could only mean one thing, a return to ogling the procession of schoolgirls wending its way through the town under the watchful eyes of the nuns. Bishop Martin clearly expected something of this sort, and although the girls were then on holiday, dire warnings of damnation to come were issued towards anyone who dared associate with the godless artist, the friend of Protestants. The result was that Gauguin's desires were severely thwarted. He did get some girls to come round – he wrote to Monfreid about the chickens that called at his door – but they crept in and out under cover of darkness and refused to stay. Haapuani recalled how he liked to take the young women up to the obscene photographs and to point out just how 'dirty they were, laughing the while'. But this was not enough. He wanted the girls around as often as need be and, infuriated by the bishop's interference, repeated his taunts from Punaauia, by putting up a statue, or in this case two, before his house to convey his views to all who passed by. One was a tall wooden cylinder carved in the form of a man with devil's horns but with hands clasped in prayer. The face was identifiably that of Bishop Martin, while the inscription on the base read: *Père Paillard* or Father Lechery. More telling was the second carving, a woman, barebreasted, her loins scantily clad, with the word *Thérèse*, on its base, a reference to a common piece of gossip about one of Martin's former servants, who was said to have been his mistress, until she was married off to one of the catechists, thus giving a second meaning to the horns on the male statue.

It must be said that Gauguin had hit upon a well-known and widely believed story. Even a former gendarme, Charpillet's predecessor François Guillot, would later claim to have been summoned to the Catholic church where the bishop was struggling to evict a woman called Henriette who had started a shouting match at the Easter mass when she discovered that the bishop had given Thérèse a silk gown, while she had received only a cotton shift.

Of course such gossip was the life blood of the tiny white community in Atuona, riven as it was by competing factions. But the bishop cannot

have been unaware of what was being said about him, true or false, and would have seen that with his sculpture Gauguin was deliberately prodding a sensitive area. As before, there was not much the offended party could do about this calumny, nor was it clear what action they could take when Gauguin greeted the new school term by riding down to the beach in his trap, as the parents brought their daughters in by boat, in order to point out to them that they had been misled about the law and had no need to send their children to school, adding for good measure that they need not pay their taxes either. The effect of this intervention was dramatic. School attendance dropped by half, with even the children of the town, who *were* obliged to attend, also staying away.

As soon as he heard, the bishop asked Charpillet the gendarme to put a stop to it but he knew that this would not be easy. Charpillet attempted to warn Gauguin off by summoning him and threatening him that as his carriage was without lights he was committing an offence for which he could be punished. It was a hopeless ruse and one which had no effect on Gauguin's behaviour, leaving Charpillet little choice but to send a report to Nukuhiva to see what the administrator could suggest. Fortunately for Gauguin, Maurice de la Loge de Saint-Brisson had just been replaced by his old friend François Picquenot who had been despatched from Papeete as punishment for 'insubordination' which in that tight little colonial world could have meant something as infinitesimal as daring to question one of his senior's wishes. Picquenot was thus in no mood to listen to all this quibbling from Atuona and informed Charpillet that there was nothing anyone could do to stop Gauguin as he was quite right in pointing out that the Mission had been deceiving the parents. However, the question of the unpaid taxes was more delicate – the revenue had dropped from 20,000 francs to 13,000 francs and here Picquenot had to concede that action might have to be taken if Gauguin persisted and so he advised the gendarme to threaten him once more and then, if he refused to desist, to seize his property.

Of course Gauguin refused and in the end, the gendarme was forced to go to the House of Pleasure to collect goods to the value of Kahui's unpaid tax – he took Gauguin's gun and, hoping to solve two problems in one go, he also seized the two statues which had caused so much offence at the mission. Unfortunately for Charpillet, when he returned to the house to auction these items, as he was legally obliged to do, he found Gauguin holding a noisy party for his Marquesan and French friends – champagne and rum were on offer. The goods were offered at 65 francs, Gauguin bid the amount asked but refused to get up from the table where he was sitting and imperiously ordered his cook to 'pay that man and tell him to go'. Then he went back to drinking and ignored

Charpillet who had been publicly humiliated and forced to put back the statues.

The situation reached stalemate when Gauguin's illness flared up so violently he was barely able to hobble about, let alone ride around stirring up trouble. Pastor Vernier was able to supply him with morphine but he now realized that this was a mixed blessing – he was becoming addicted and using ever increasing doses to less and less effect. Haapuani remembered seeing him inject himself and noticed how his backside was a mass of red marks where the needle had been. In desperation he asked Ben Varney to take and hide the syringe and the bottles of the drug but when the American suggested destroying them, Gauguin panicked and told him not to, just in case the pain became absolutely unbearable. To replace the morphine, he bought the opium derivative laudanum, which was generally available, and tried to control the pain by drinking it in watered down measures. For a brief moment he even considered leaving and wrote to Monfreid to say that he was thinking of trying to get to Spain – the climate would be congenial and would remind him of his childhood. But by the time his friend's reply arrived, firmly pointing out that he was now incapable of living in Europe, so much had he adapted to his strange, remote existence, the desire had passed and he had accepted that he had reached the end of his journeys.

He was no longer encouraging anyone to drop by for a drink as he had done at first. Ky Dong sometimes looked in, hoping to cheer him up. On one occasion, the young man put a blank canvas on the easel and started to paint Gauguin's portrait but it was not long before he came across and took over, holding a mirror to study his face. The final result was unlike any of his former likenesses – no hint of the suffering Christ in the 'Golgotha' painting, which he had brought with him – just a rather dazed, melancholy figure, peering through his tiny oval glasses, so undramatic it could be a cheap portrait photograph, a snapshot record, empty of other meanings.

If alone of an evening, he would sit at the harmonium and play to himself – Emile Frébault sometimes overheard him and remembered later how he could 'make one cry with his music'. If things got too bad or too lonely, there was always absinthe to bring reverie then oblivion, though the excessive amounts of alcohol and the low-vitamin diet from the tinned foods he bought at Varney's store only weakened him further.

It was in this state – lonely, sick and in pain, yet still combative and unstable – that he worked on his second longest literary effort after *Noa Noa*. Not surprisingly, given his physical and mental state, his aims were far from clear – he seems to have wanted to set down his philosophical ruminations on life and the future, no mean aim, while at the same time he hoped to continue his warfare with the Church by other means. On

the one hand, a broad laudable ambition, on the other the same old petty-minded squabbling.

## In a Contrary Spirit

Back in Punaauia he had promised both Monfreid and Morice that he would send them his treatise on Christianity and the Church and now seemed as good a time as any to copy out the passages he had written in the *Noa Noa* exercise book – though being Gauguin he could not stick to so repetitive a task and proceeded to rewrite and greatly enlarge the whole thing. Much of this was due to his having acquired his own copy of Massey's books, *The New Genesis*, which Soury had drawn on for his pamphlet and from which Gauguin now copied a little illustration, a gnostic image of Christ/Horus, and also Massey's first *magnum opus*, *A Book of the Beginning*. This proved even more interesting, perhaps because the sections on New Zealand were more relevant to his own experiences. Certainly the chapter comparing the Maori language to Ancient Egyptian was exactly what Gauguin wanted – Massey claims that *Atua*, the Maori for 'first God', is derived from the Egyptian *Ati*, the title of Osiris as the sovereign, and *Tiki* is derived from *Tekhn*, an obelisk or memorial sign.

Even if one disputes such links, it is significant that at a time when most Western scholars could happily talk of inferior languages or degenerate peoples with their debased speech and culture, Massey accorded the remotest tribes on the earth the respect of equal attention and a place in his great scheme of things. And so by extension did his follower Gauguin. To Massey the Maori pantheon of gods and spirits was as valid as the Old Testament Jehova or the crucified Christ, because they were all branches of the same tree – which in turn was the underpinning of much of Gauguin's art from the Ariois paintings onwards.

Given Gauguin's resistance to all things English and his self-admitted weakness in the language, it says much about his early training at the Petit Séminaire de la Chapelle-Saint-Mesmin that he persisted in translating Massey's wearisomely turgid prose, huge chunks of which are reproduced in his own manuscript. He gave the work a new title: *L'Esprit moderne et le catholicisme*, (Modern Thought and Catholicism), which sounds brisk and to the point and there are some early parts of the script which offer the hope that his dementia may lead to a sort of manic poetry:

> *Whence do we come, what are we, where do we go?*
> *The eternal problem which chastens our pride . . .*
> *O! Sorrow, thou art my master!*
> *Destiny, how cruel thou art, and vanquished always I revolt.*
>    *Reason remains, distracted no doubt but animate.*
> *And it is then that the bursting into leaf begins.*

Unfortunately this heady, shamanistic, declamatory style quickly gives way to a sort of plodding exegesis clearly derived from Massey's pedantic explications of esoteric knowledge.

> In the Book of Enoch also, the Son of Man takes his seat on the last of the days at the end of the great year, and he is the manifestor of Messiah of the cycle of 25868 years; for it was the Book of the Revolutions (sic) of the celestial luminaries following each year of the world, until the new work was accomplished, which will be everlasting. From that time it is said that in the new heavens one does not enter upon the enumeration of time. In the same way here the manifestor, the *Cronian Christ*, assumes the lineaments of the Eternal Being in a psychotheistic phase.

Unsurprisingly, what was supposed to be his testimony has never been published, except in a limited private edition. The only person to have studied the manuscript in depth was an American naval surgeon, Dr Frank Pleadwell, who in the 1930s made an English translation, though not without considerable difficulties. Pleadwell wrote:

> It is apparent that this work, his last considerable labour, has no pretension to literary excellence. Its different sections are but loosely connected together; its philosophic presentations are disconnected and fragmentary; it is marred by obscurity; it lacks a literary style and balance; and its tautologies and redundancies of words and expressions have at times almost driven the translator to relinquish his task.

Pleadwell went on to raise the spectre of Gauguin's sickness and its effect on his mental state and quotes the artist's own admission that the writing seemed 'something of a Chinese puzzle'. But, as before, it would be wrong to dismiss this long essay as a mere by-product of obsession or lunacy. Despite his anti-clericalism, Gauguin was far less anti-Christian that one might have supposed. At one point he suggested that if organized religion were purged of its faults it might be possible for it to return to its original vocation, and he even goes so far as to affirm his own 'religious spirit', thus confirming the opinions of some, such as Pissarro, who believed that Gauguin was far from being the convinced revolutionary he sometimes claimed to be. In common with many people who rant and rave against religion and the Church, Gauguin seems at heart to have remained a confused believer, for ever castigating the thing he could not quite reject. That, and the astonishing depth of his biblical scholarship, are testimony enough to the thorough handiwork of Bishop Dupanloup all those years ago in the Petit Séminaire, for if this long, sad, document conveys anything, then it has to be this sense of struggle, of Jacob wrestling with an Angel or with God or, as some maintain, with himself, his very being.

## Sister of Charity

He sent the essay to the bishop, who refused to be drawn and simply returned it with a copy of a triumphalist account of the Church's colonial successes entitled *Les Missions catholiques françaises au XIXe siècle*, which contained a laudatory section on his own work in the Marquesas. One might have anticipated that Gauguin would have ignored this, but assumptions are never wise with so unique a personality and, against all expectations, he was quite intrigued by the book, mainly because of the photographs used to illustrate the rather dreary text – sombre images of clergymen and nuns. These were just the sort of thing most people would have flicked through without a backward glance, but which Gauguin now used to make a painting he called *The Sister of Charity*. This shows a room at the Atuona mission with a seated nun confronting the half-naked *mahu* from the beach scene. Again covering and repression confront nakedness and freedom, though there is nothing remotely critical about his representation of the nun who has the features of the Sister Louise he had sketched in Mataiea during his first visit to Tahiti. Perhaps in the end he identified with her, a representative of the West in her constricting raiment, with its emphasis on sin and shame, rendered meaningless in the presence of such proud physicality. Like the old woman who had felt Gauguin's sex in the garden and who made it clear that he did not belong, so this painting dismisses, without rancour, the claims of the Church to have any relevance to the people it sought to convert.

*The Sister of Charity* was Gauguin's final attempt to finish the *mahu* paintings. Once again the series was abandoned and there was to be only one further group of paintings, light airy scenes of horseback riders, gathering on beaches near the town. They owe much to Degas's race-course paintings of jockeys and mounts waiting for the 'off', but in Gauguin's case, his half-naked riders wheel about aimlessly, some heading away from us, some circling in ways that suggest they have nowhere particular to go, that they are simply there, without reason or purpose at the water's edge. It is as if he were extending the story of the rider crossing the ford, which he had painted just before sailing from Tahiti – as if his riders have now come to the limit of all journeys, to the end of the land beyond which they cannot go. One of the series is entitled *Women and White Horse* and is set on the beach near the town, looking in from out at sea in the Bay of Traitors – named after an incident when the Hivaoans treacherously murdered a party of Tuamotuans who were their guests. In the painting two women and a horse and rider meet on the beach but the most telling element in the scene is up on the hillside behind them, the high white cross which was the most prominent feature of the Catholic cemetery at Hueakihi – an image so striking and

unusual that no biographer could resist assuming that this was surely Gauguin's very last painting, a final act of clairvoyance, the foreshadowing of his resting place, overlooking the sea from whence he had come. Alas, there is no way of knowing for certain that this was so – though one is, of course, allowed to imagine.

## Before and After

Whatever he may have wanted to paint was by then largely irrelevant, as he no longer had the strength of will to do so. By December of 1902 the eczema on his leg had become so aggravated he was unable to stand at his easel. With time on his hands there was nothing to do but make trouble. He sent an open letter complaining about Governor Petit to Cardella's new journal in Papeete; he followed this with a letter to the Conseil Général, calling for the preservation of wild pigs, and finished with a complaint about the gendarme Charpillet, whom he accused of using prisoners to work in his garden. Fortunately the policeman was replaced before he could hear of this, though his successor was that same Jean-Pierre Claverie from Mataiea who had once forbidden Gauguin to bathe naked in the river near his hut. Even before his arrival at Atuona on 4 December, Claverie had heard about Gauguin's trouble-making and knew that he had recently complained about his predecessor. When the town turned out to greet his arrival, the policeman deliberately snubbed the artist by turning his back on him and refusing to shake hands. It was a declaration of war.

In the meantime, Gauguin continued with his writing, now working on his memoirs, a loose collection of reminiscences, anecdotes and stray opinions, another sign that he may have been preparing for his end. If so, there is nothing doom-laden about the book – gone are the long-winded biblical sermons and back comes the light story-teller's style that he had used for *Noa Noa*. It is not surprising that the result, which he entitled *Avant et après (Before and After)*, should be the only one of his books to have been consistently in print since it first appeared in the 1920s and the only one to have achieved a wide audience. This is not entirely without its problems, as many readers, unfamiliar with Gauguin's creative way with dull facts, have either concluded that the book is the true story of an extraordinary life, or that it is a pack of lies, larded with arrogance and deception. Of course, neither extreme suffices and Gauguin's opening statement that: 'This is not a book . . .' ought to have been sufficient indication that what follows would be neither truth nor falsehood but rather '. . . scattered notes, unconnected, like dreams, like life, made of bits and pieces . . . .' In fact the book is fairly consistent chronologically, starting with his grandmother, his mother and his memories of Peru,

continuing on through his schooldays in Orléans and his naval career before launching on his life as a painter, all of which are the '*Before*' part of the book, the second half being '*After*' – when he first left for Tahiti and his rebirth as a savage. This time his digressions and obsessions, his little treatises on art or his political homilies seem less the by-product of an unstable mind lurching from topic to topic in an unrestrained way, than fascinating side routes that weave in and out of the main text. As he put it himself: '. . . I'm not a professional. I would like to write the way I do my paintings, that is as fantasy takes me, as the moon dictates, and I come up with a title long afterward.'

Appropriately, the book has no ending, it closes on an anecdote, a fanciful story about cannibalism, presumably the point where he ceased writing. There could have been another, just as there was no ultimate final painting, just the one he happened to do last, whichever it may have been.

> At my window here in the Marquesas, in Atuona, everything grows dark, the dances are over, the soft melodies have died away. But they are not replaced by silence, Crescendo, the wind zigzags in the branches, the great dance begins; the cyclone is in full swing. Olympus enters the game; Jupiter sends us all his thunderbolts, the Titans roll the rocks, the river overflows.

## An Act of God

Thus did Gauguin describe the dramatic events which overwhelmed the island, for the beginning of the end was appropriately Wagnerian – the *Twilight of the Gods* – a cataclysm. Starting on 2 January of the new year 1903, the skies darkened and the rain began. Over the course of a week, the wind and the storms built to a peak until during the night of the 13th, a cyclone struck the Marquesas with a vehemence unknown in living memory.

The shock was still so vivid that over half a century later, the anthropologist Bengt Danielsson was able to piece together eye-witness accounts of the disaster. Old people told how Atuona was at first protected from the northerly winds by the sheltering mountains though there was no escaping the howling, torrential deluge on the 13th which flooded the two rivers running through the valley and swamped the tiny settlement. Blocked with boulders, the Western river overflowed and joined with the Makemake, near Gauguin's house, leaving him stranded on the upper floor, an island in the middle of a raging flood. When the bridge across the river, which connected his land to the centre of the town, was washed away, he was completely isolated as the tempest buffeted the thin walls of his home, uprooting the trees and whipping up the waters.

When it was over, Gauguin reported the experience in *Avant et après*, in a way which vividly conveys the nightmare he had lived through:

> The day before yesterday, in the afternoon, the nasty weather that had been building up for several days took on threatening proportions. By eight in the evening the storm broke. Alone in my hut, I expected it to collapse at any moment. In the tropics the enormous trees have few roots, and the soil loses all consistency once it is soaked. Now, all around me, those trees were splitting and crashing to the ground with a heavy thud. Especially the *maiore* (breadfruit trees have very brittle wood). The gusts of wind shook my light roof of coconut leaves and blew in from all sides, so that I could not keep the lamp lighted. If my house were demolished, along with all my drawings – all the material I have been accumulating for twenty years – it would be my ruination.
>
> At about ten o'clock a continuous noise, as if a stone building were collapsing, caught my attention. I had to go and see, and I went out of my hut. Immediately my feet were in water. The moon had just risen; in its pale light I saw that I was quite simply in the midst of a rushing torrent, carrying with it rocks that came slamming into the wooden pillars of my house. All I could do was await the decisions of Providence, and I resigned myself to do so. It was a long night.
>
> As soon as dawn came I looked outside. What a strange sight – the sheet of water, those blocks of granite, those enormous trees from heavens knows where. The road that went by my land had been cut in two, which meant that I was hemmed in on an island, less pleasantly than the devil in a basin of holy water.

Hivaoa was relatively lucky, the disaster was even greater as the cyclone gathered force in its passage across the Pacific, striking the Tuamotu Islands on the 14th and 15th with murderous effect. Many of the coral atolls in the group were barely above sea level but their tiny populations had just been swollen by the opening of the annual mother-of-pearl season which had brought hundreds of divers from the surrounding islands. Overall, 517 people were swept away as the raging waters covered the outcrops, the only survivors being those young and strong enough to cling to the few coconut palms that did not splinter under the constant pummelling of gale and tide.

The whole of French Polynesia was caught up in the tragedy. In Papeete the governor despatched his functionaries by whatever boats could be commandeered to succour the survivors and survey the appalling damage. Governor Petit himself left aboard the *Durance* for the Tuamotus, while in France appeals were launched to aid the blighted colony.

In Atuona, as the wind and rain abated and the waters began to subside, Gauguin and his neighbours could start to assess the damage. He had been fortunate that the unique construction of his house had weathered

the gale, as had Ben Varney's Store and the Mission. But many of the local huts had simply collapsed, including Tioka's home which was irreparable. In an act of generosity which goes some way to ameliorate his former indifference to the native population, Gauguin promptly gave Tioka part of his land so that he could build a new hut in a safer position, then set about seeing what could be done to make life easier for the other unfortunates. Atuona, while not as badly hit as other settlements, had suffered nevertheless – one child had been killed – but the problem facing many people was that time and resources were needed to rebuild their homes and gather supplies of food. As soon as Gauguin could get out and across the still swollen river, he went to see Claverie to ask him to cancel or delay the ten days of annual road work the local people were obliged to do, a perfectly sensible request in the circumstances. But the gendarme was in no mood to listen. Not all the European dwellings had proved as solid as Gauguin's – the Gendarmerie had collapsed in the rain and while Claverie himself had been away when the cyclone struck, his wife had only just escaped with her life before the building crumbled around her. Irritated beyond measure at being told what to do by someone he thoroughly despised, Claverie refused to consider the request, a ridiculous and indeed harsh decision that left Gauguin fuming with impotent rage.

Given the chaos, it did not prove especially difficult to find a way of getting his own back. The gendarme, in common with his colleagues elsewhere in the colonies, was obliged to perform tasks for which he was intellectually and educationally ill-prepared. Being policeman, public prosecutor and occasional judge, all in one, was asking too much of even the most decent man and with someone like Claverie, who was arrogant and uncaring, miscarriages of justice were inevitable. Bent on revenge, Gauguin summoned up what last reserves of energy he could muster and assumed the mantle of Guardian of the People – taking up the cases of anyone who had fallen foul of the gendarme with an energy that belied his feeble physical state.

Even someone half-way decent like Charpillet had made serious errors of judgement and one of these had been passed on to his successor – a case involving a runaway negro sailor who had settled on the island and taken a local wife. This woman had been found brutally murdered and Charpillet had arrested the husband, despite the fact that there was considerable evidence to show that it was one of the local people, the woman's lover, who had done the deed. This man had scared all the other inhabitants of their valley into silence but when Gauguin heard about the case he got all his friends – Tioka, Reiner, Varney – to help amass any evidence they could, all of which Gauguin now offered to Claverie, with the request that he rectify his predecessor's mistake.

Inevitably, Claverie refused to listen, insisting that the negro go for trial before a visiting magistrate who was due out from Papeete on 5 February. This turned out to be a young man called Horville, who, in common with most of his colleagues, preferred to accept the advice of the local gendarme, the only colonial agent on the spot, who usually acted as host to anyone sent out from Tahiti. Gauguin had prepared a long report on the case but Horville showed no inclination to take action on it and proceeded to refer the prisoner to the court in Papeete, the only one capable of trying a murder case, while he got down to clearing the backlog of minor cases which had built up since the last magistrate had visited. One of these involved a group of twenty-nine local people from the Hanaiapa valley, on the north coast, who had been accused of drunkenness, largely on the evidence of a half-caste called Maurice, who was himself a well-known drunk and proven liar. Gauguin promptly offered to defend all twenty-nine when the case came to trial, though it was not particularly to their advantage that when the day came, Gauguin should have led them into the court, wearing his usual *pareu* and scruffy singlet, nor that he should have chosen to sit on the floor native-style, obliging Horville to suspend the session, ordering Gauguin to go home and change into European dress.

Claverie meanwhile had not been inactive and had persuaded the chief of the Hanaiapa valley to testify that he had heard the drunks, even if he hadn't actually seen them. When Gauguin returned, with a pair of trousers on, and was confronted with this unexpected witness, he protested volubly but Horville accepted the evidence and sentenced the men to five days in prison and a 100-franc fine. Gauguin objected, demanding to know under what law the men were being judged and pointing out that as he understood the law they ought to have been caught in the act and not judged purely on hearsay evidence. This provoked a flaming row which ended with the magistrate ordering the police to evict him. At this point Gauguin waved his fist under the young man's nose and warned him that his men had better not lay a finger on him, after which he left, quietly but under his own steam.

Outside, in the square, he told the men he would appeal on their behalf to the court in Papeete and they all went off, no doubt mystified by the way the whole thing had gone. That might well have been the end of the matter, except that that very afternoon Gauguin's friend, the hunter, Guilletoue, came to see him with the news that he had seen the chief in another valley at the time of the alleged incident. Gauguin asked him to report this to Claverie, but when the gendarme still refused to act an argument broke out, so violent that when Gauguin got back to the Maison du Jouir he began to cough blood.

## An Angel with White Wings

As if to exacerbate his woes, he now decided to widen the scope of his activities, writing to the administrator Picquenot on Nukuhiva to complain that Etienne Guichenay, the gendarme on the neighbouring island of Tahuata, had been accepting bribes to turn a blind eye to foreign ships illegally trading with the natives – facts probably brought to his attention by his friend Reiner who had most to lose if people could get goods cheaper than from his store.

Picquenot tried to check these claims, leaving a copy of Gauguin's accusations for Guichenay to answer. Moving on to Atuona, the administrator reminded Gauguin of the undoubted powers of the police in these remote areas, and persuaded him to retract the charge.

It hardly mattered as Gauguin was now writing a detailed report about the trial of the allegedly drunken villagers, and about Claverie's refusal to carry out a proper inquiry, which he gave to two inspectors from Paris who arrived on 10 March. They stayed only two days, meeting with Claverie and attending a reception in their honour given by the bishop, who had much to say on the subject of Gauguin as evidenced by the subsequent report in which the inspectors referred to 'the painter Gauguin who defends all the native vices'. It was a shame so little attention was paid to Gauguin's report, because aside from the details of the specific case in question, he went on to give one of the most lucid criticisms of the absurdities of so-called Colonial Justice, wittily pointing out how the natural diffidence of the natives and the inadequacies of the court translators, allied to the prejudices of magistrates, who were only too willing to believe that anyone brought before them was bound to be a dangerous ruffian who would undertake any violence if given half a chance, made it impossible for a fair trial to be held. This report marked the exact opposite pole on the pendulum swing which Gauguin had made from his days as the editor of *Les Guêpes*, at the time when he was the mouth-piece of the white settlers. In conclusion, Gauguin offered some sensible suggestions that would have radically improved matters: that visiting magistrates should not stay with the local gendarmes and should attempt to make their own, independent inquiries about cases brought before them, and that if a native was found guilty, any fines imposed should be proportionate to the low incomes of local people.

To the inspectors, this would have seemed seditious stuff and it was hardly surprising that their report contained a sharp paragraph accusing Gauguin of undoing the good work of the mission by dissuading local parents from sending their children to school and worse by encouraging the population not to pay their taxes.

Small wonder then that the authorities in Papeete let Claverie know

that he would have their support in any moves to silence this troublesome artist. When he learned this, the policeman realized that he had just the means to hand. His associate Guichenay had sent him Gauguin's original letter with its accusations of bribe-taking and Claverie consulted his superiors in Papeete and obtained permission to sue Gauguin on the serious charge of defamation of a government official. Gauguin was summoned to appear in court on 31 March and as soon as the proceedings began, he realized that he had little chance of defending himself. The same magistrate, Horville, promptly dismissed his request for a full investigation of Guichenay's actions, the only means Gauguin might have had to show that what he had written was not a libel but the simple truth. Horville then refused more time for Gauguin to prepare his case. Claverie's statement was accepted without question and Gauguin was ordered to pay a fine of 500 francs and sentenced to three months' imprisonment.

It was a complete disaster. He had been shabbily treated – the law only applied to a printed libel and had nothing to do with a private letter. In a flurry of activity Gauguin wrote to request an urgent retrial by the Court of Appeal in Papeete, though he was by then in debt to the German company that handled his allowances, because Vollard was behind in his payments, and there was little likelihood that he would be able to raise the boat fare, if an appeal were to be granted. As so many times in the past, he fired off letters, to Vollard, to Morice, to Monfreid and via him to Fayet explaining the danger he was in and begging for money. To Monfreid, he made it clear that the trial and the subsequent worry had exhausted him: 'It will be said that all my life I have been fated to fall, only to pull myself up and to fall again . . . each day some of my old strength forsakes me.' And he ended: 'All these worries are *killing* me.'

It was the last letter Monfreid received. Two days after the trial, on 2 April, a messenger handed Pastor Vernier the following note:

Dear Monsieur Vernier
    Would it be troubling you too much to ask you to come to see me. My eyesight seems to be going and I cannot walk. I am very ill.
    P G

Vernier went at once and found him on the bed, his legs red and swollen and covered with eczema. He offered to dress them and recommended a medicine but Gauguin thanked him and said he would do it himself. Then they talked a little, of this and that. They spoke about art and Gauguin told Vernier that he was a misunderstood genius, then went on to talk about his quarrel with the police. He offered Vernier the loan of some books including the copy of *L'Après-midi d'un faune* which

Mallarmé himself had given him and as this seemed to please the pastor, he pulled out one of the prints of the poet that he had made in Paris – the one with Mallarmé and the Raven and he signed it: 'To Monsieur Vernier . . . a piece of art. PG'.

Ten days later, on 12 April, Tioka came to see Vernier and told him 'the white' was not well and again the pastor called by and spent a little time talking – for by then both men must have known there was nothing to be done.

In mid-April Gauguin found a last reserve of strength and parcelled up some paintings for Vollard with a letter imploring him urgently to despatch some money for the upcoming appeal. In desperation he wrote to Léonce Brault, the lawyer in Papeete and the man he had once attacked in *Les Guêpes* for his support of the Protestant party. Brault was now the Marquesas' official representative, under the reformed system set up by Gallet, and Gauguin asked him to take up his case with the administration, though even such a high level of intervention was unlikely to do much good now that Governor Petit wanted to deport him, were he legally able to do so. At the same time, Gauguin wrote and rewrote a long appeal to the Head of the Gendarmerie in Papeete, setting out the facts of the case, angrily attacking Claverie for his malicious behaviour and demanding that action be taken. Despite this, there are indications in the letter that Gauguin knew he had little chance – that with the passage of time the likelihood of a successful appeal was receding, thus bringing closer the certainty of prison, a prospect he viewed with an unexpected sense of shame: 'It is a thing unknown in my family,' he told the head of the gendarmerie as if some echo of the aristocratic pretensions of his Moscoso forebears, those Borgias from Aragon, still resonated within him, savage though he was.

The most interesting thing about this final appeal is what it reveals of Gauguin's image of himself in those last days. As he explained to the head of the gendarmerie: 'The natives are lucky to have me as their protector, for so far the settlers, who are all poor, earning their living as traders, have always been afraid to antagonize the gendarmes and so have been kept silent. Therefore, the gendarmes, being free from control (you are so far away and unlikely to be correctly informed), are absolute masters. . . . I am condemned for defending these poor defenceless people. Animals at least have a society to protect them.'

It was a theme he maintained in what was to be his last letter to Charles Morice, begging him to take up his case in France to try and expose the situation in the Marquesas in the Parisian press. Again he made it clear that he was now at one with the local people, telling Morice that he was 'wrong to say I was mistaken when I called myself a savage. And every civilized person knows that this is true; for what astonishes

and baffles them in my art is this very fact – that I am a savage in spite of myself.'

But this last conversion, this transformation into the defender of the Polynesians against their French oppressors had come too late. He was now in so much pain he was forced to ask Ben Varney to return his syringe so that he could once again inject himself with morphine. At first the American loyally refused to hand the thing over, but Gauguin insisted with all the weary repetition of a drug addict, which of course he was.

As the last weeks drifted by, there was nothing more for him to do except wait for the court or the Gendarmerie in Papeete to decide his fate. They might even have done so already but their decision had not yet reached Atuona. There was no way of knowing. It would also be months before any of his letters to France could produce any response, one way or the other. The sense of isolation was total.

He was now afloat between the harsh edge of acute pain and morphine-induced torpor where there was nothing and no one. At some point he pasted his reproduction of Dürer's *Knight, Death and the Devil* onto the back cover of *Avant et après* and arranged for it to be posted to Fontainas, in Paris. He stood the Breton snow scene on the easel where he could see it from his bed – a last yearning for Europe? – for Marie-Jeanne and the inn, when he had been surrounded by friends and admirers? Perhaps. The images pinned on the walls were hardly a full account of so varied a life. His children were there – his *official* children. He knew they would not remember his birthday – fifty-five in a month's time. It was years since Mette had made them send greetings but it had always hurt him whenever June had passed with no letter from any of them. Mette was there, in a group photograph with the four boys and Aline ... frozen in time, little beings captured before death could tear her out of the frame., There seems to have been no photograph of Juliette's daughter Germaine, nor of the second Emile, left behind on Tahiti, nor any contact with his new daughter. Perhaps he accepted that they would never really be his – or perhaps it was simple indifference?

If he looked about him, the 'Little Friends' told the other story of his life – partially. The Parthenon reproductions could call to mind Arosa and his enthusiasm for his new photographic process, the prints of the paintings in the older man's collection ensured that he could never quite forget what he owed to the man who had given him a start in life. Was there anything of Peru, an 'Inca' vase, a souvenir of Lima and the large house, the warm nights, the mulatta servants – there was the photograph of his mother when young, with that look that had haunted him all his life, but what of the grandmother whose character he had so clearly inherited – had any of her books survived his travels?

As April drifted into May, only the morphine had any reality. The paintings stacked against the studio walls were an odd lot, whatever he had not thought to send to Monfreid or Vollard. What remained must have been mainly the images of men: the red-caped *mahu*, the near-naked bathers, himself before Golgotha, his preferred self-image as the suffering Christ which he had refused to send away, and the peculiar last portrait begun by Ky Dong – far less heroic, more a befuddled professor, a figure buffeted by fate, who has somehow lost his way, like the riders on the beach, wheeling about, with nowhere left to go.

The first week of May he was barely aware of anything. Most of the time the two servants went off, they were lazy and he was often asleep. Tioka would call in to see what he needed but most of the time there was nothing, except for the morphine and his syringe.

By then, the pictures from Port Said must have seemed a good deal less amusing than before. Grelet's photograph of Tohotaua was there amongst them but whether the others, the 'brides', his Tahitian 'Eves', were recorded in any way is not known. There was the tiny daguerreotype of the frizzy-haired girl that he had stuck into his copy of *Noa Noa*, but she could have been anyone. The portraits had all gone – Teha'amana and Pau'ura – why had he never painted Vaeoho? Most of his pictures had been despatched almost as soon as they were finished so that he had never had a chance to see them together, no opportunity to make a final judgement and by then he had little idea what had become of them. It was strange that Mette was still there, among the children, her presence, even in black and white, must have been a harsh reminder of all his broken promises. She remains the most enigmatic of all the characters in his long and tortuous story. Mette with her love of mannish clothes, yet with her love of little luxuries. Mette who had fallen in love with him because he was unlike anything she had known, and who yet remained inflexible in her determination to lead her life in her own way. Now she hung there among the pornography and the last remaining paintings, in strange but not entirely inappropriate company – the mannish Mette Gad, with the *mahu* and the half-naked bathers. Perhaps Gauguin really had gone to the remotest ends of the earth not so much to escape Western civilization as to flee from those strong women who had shaped him: Flora Tristan, the grandmother he had never known but whose life set the pattern for his own, Aline his mother, with her firm sharp hand, and Mette, so like them in many ways . . . .

Early on the morning of 8 May, at the urging of Tioka, Pastor Vernier called round and found Gauguin on the bed as usual, though by then unsure whether it was day or night. His servants had wandered off and he was worried – he had had two fainting fits and was now in pain 'all over'. The pastor tried to cheer him up, they talked briefly about books,

about Flaubert's *Salammbô*, another beautiful woman, dominated by her emotions, and doomed to act out male fantasies of seduction, power and death. But Vernier could only stay briefly before going to teach at the little mission school. He left him lying on his back, looking calm and rested.

Alone again, Gauguin drifted in and out of sleep. Living in dreams – the recorded one near the end of *Avant et après*, a prophetic vision of that 'instant when everything was absorbed', that moment when he would pass into 'the Empire of Death':

> And in my dream an angel with white wings came to me, smiling. Behind him, an old man holding an hourglass in his hand:
>
> 'It's no use questioning me,' the angel said, 'I know what you are think-ing . . . Ask the old man to lead you later to infinity and you will see what God wants to do with you and you will feel that today you are remarkably incomplete. What would the Creator's work be if it were done in but one day? God never rests.'
>
> The old man disappeared and, awaking, I raised my eyes to the heavens and saw the angel with the white wings ascending towards the stars. His long blond hair seemed to leave a trail of light in the firmament.

Some time mid-morning he woke in pain, turned to the morphine bottle and realized that he had taken it all. He swung one leg off the bed and tried to get up but the effort was too much. He fell back and did not move again.

# 15

◆

# *The Empire of Death*

Shortly after eleven o'clock that same morning, Gauguin's servant Kahui ran up to the Protestant Mission shouting: 'Come, come, the White is dead.'

Vernier came out and hurried through the settlement to the House of Pleasure, clambered up the ladder, past the carved portals and found himself face to face with his opponent the bishop and two of the fathers from the Catholic school. Tioka, who was standing by the bed, began to explain how he had come back to see his friend and had called out 'Koke! Koke!' and rushed in when he got no answer. Greatly distressed, Tioka suddenly leant over the body and bit fiercely into Gauguin's scalp – a gesture which did not surprise the pastor as this was the traditional Marquesan way of calling the dead back to life. When Gauguin did not move, Vernier tried his own magic, wiggling Gauguin's tongue and attempting artificial respiration – which no doubt looked as bizarre to Tioka and the other local people who had begun to assemble, as their method had seemed to the white missionaries. It was no use, the body was still warm but to Vernier everything pointed to heart failure, though the empty morphine bottle had no doubt played its part. Eugène Henri Paul Gauguin was pronounced dead, with the time estimated at eleven, on the morning of 8 May, 1893.

Emile Frébault had arrived just after Tioka and when Claverie turned up to supervise the legal formalities, the two friends signed the death certificate. The gendarme could not resist adding a tart little phrase at the bottom of the form: 'He was married and a father, but the name of his wife is unknown.'

Frébault behaved best of all, arranging for the body to be cleaned and dressed and staying to keep vigil with some of the local people. It is commonly assumed that Bishop Martin behaved badly, hijacking the corpse and burying it in the mission cemetery, to win points over Vernier and the Protestants by showing the natives that the Catholic Church

always triumphs in the end. It certainly looked that way to the pastor, who returned to the House of Pleasure the next afternoon expecting to join the funeral procession, only to find that Gauguin had already been interred. But Frébault, who had no especial reason to like the bishop, always maintained otherwise, insisting that Bishop Martin had sent round a catechist that evening to keep him company while he watched over his friend and that it was only when the body began rapidly to decompose in the heat that he went to see Claverie and the Mission, to suggest that they bring forward the time of the funeral, before things got any worse.

Vernier had been untypically angry when he heard that *ces messieurs*, as he referred to the Catholic fathers, had decided to give the errant artist the last offices of their church. But as there was nothing he could do and wishing to pay his last respects to a man he admired, despite all his manifest faults, he set off for the House of Pleasure just before two o'clock, the time agreed for the ceremony, only to find the body gone, the church service complete and the hastily made coffin en route for the Catholic cemetery outside the town.

So it was that only Frébault and a young priest, sent by the bishop, and four local pall-bearers accompanied Gauguin on his last journey, along the quarter-mile track up the hillside of Hueakihi, to the burial ground under the high white cross, overlooking the Bay of Famine. It was hot, they were tired, there was no oration.

## All Creditors of the Deceased

Whatever his motives in bringing forward the funeral, the bishop's subsequent behaviour was more vengeful than Christian. Three weeks later, in a report to the Mission headquarters in France he commented: 'The only noteworthy event here has been the sudden death of a contemptible individual named Gauguin, a reputed artist but an enemy of God and everything that is decent.' Words were one thing, but the attempt to purify the House of Pleasure by destroying those images the Fathers considered immoral was more serious. Burning the pornographic pictures that had been hung up, was of little importance but there was a real risk that the paintings and drawings as well as the manuscripts might be consigned to the flames and it was here that the gendarme Claverie's petty-mindedness for once saved the day. The man who had once stopped Gauguin from bathing naked in the river at Mataiea because it was against the rules, was suddenly smitten with doubt about the legality of laying hands on the painter's effects. Gauguin had debts, most notably to the Société Commerciale for advances on the allowance that Vollard had been so tardy in paying. As far as anyone knew, Gauguin had left no Will, and under French law his property ought to be auctioned and

the proceeds given to his creditors. Aware that everything associated with this dangerous vagabond had so far proved troublesome, Claverie took the line of all embattled petty-bureaucrats and passed the buck, writing to Picquenot on Nukuhiva to ask what he should do.

The administrator was not entirely happy with the way things had gone – he may well have known by then that the court in Papeete had rejected Gauguin's appeal and he was furious with Claverie for having brought a case against the painter when he had been trying to calm things down and had succeeded in persuading Gauguin to withdraw his charges. Worse, he now knew that Gauguin had been correct in his allegations that the gendarme Guichenay had taken bribes. Gauguin's death aroused all the old rebelliousness in Picquenot, who wrote to Governor Petit in Papeete urging him to recall Claverie. In the meantime he enquired in Atuona whether there were any known contacts of Gauguin in France, and on receiving the name of Georges-Daniel de Monfreid, wrote at once to inform him of the death. Next, despite his doubts about Gauguin's art, he ordered Claverie to despatch all the paintings, carvings, drawings, books and manuscripts along with the more valuable belongings such as the harmonium and the large pieces of furniture to Papeete where they might be sold for a higher price – only the smaller, less important items were to be auctioned by Claverie himself. Picquenot then wrote to the office that dealt with the intestate to inform them that he had '. . . requested all creditors of the deceased to submit duplicate statements of their accounts, but I am already convinced that the liabilities will considerably exceed the assets, as the few pictures left by the painter, who belonged to the decadent school, have little prospect of finding purchasers.'

Whatever his personal feelings, Picquenot's decision was probably the single most important act in saving Paul Gauguin's last work from destruction. It was weeks before the goods were packed and put on a suitable boat and it was to be all of five months after Gauguin's death before they were finally auctioned in Papeete, a breathing space that was little short of miraculous.

Picquenot himself was not so lucky. Governor Petit recalled Claverie but his successor restored and promoted him and when Picquenot threatened to resign if his wishes were not respected, he was summarily dismissed.

Claverie was even more devious than Picquenot reckoned and before conducting the auction of the lesser goods he carefully pilfered some of the smaller carvings, just in case they might prove valuable one day. The sale, conducted by Claverie himself, in one of his many administrative roles, took place at the House of Pleasure on 20 July, five weeks after the funeral. It was a farce, everyone turning up to witness a rare piece

of public entertainment, with the gendarme playing to the crowd, like
a fairground huckster. At one point he held up Gauguin's carved walking
stick with its erection handle, called out 'What's this filth?', then, grab-
bing a hammer, smashed it. This was too much for Pastor Vernier who,
despite his undoubted dislike of the object in question, called out: 'You
have no right to break that stick, you don't understand that it is a work
of art, and not the filth you said it was.'

Some personal documents were withheld from the sale and were
despatched to the Official Registrar, including Gauguin's *livret militaire*,
the record of his military service aboard the *Jérôme-Napoléon*, later the
*Desaix*, which reveals how he simply discharged himself, as so many did
after the disastrous Franco-Prussian War. Some of his photographs were
kept but others, presumably at the whim of the policeman, were sold.
Friends bought what they could: Tioka acquired two pairs of cotton
trousers, Varney a mosquito net, Ky Dong some enamel plates – even
the Catholic Mission bid for his tobacco and cigarette papers and
Claverie himself bought in some tinned meat in the absence of any
other purchasers. Looking at the record of the sale, some acquisitions
seem quite touching: Haapuani, the supposed sorcerer of Hivaoa, bought
Gauguin's compass, a truly magical object; while the ever-practical Pas-
tor Vernier bought his wood-working tools. It is strange to think of
these things dispersed around the little colony, where some may yet
survive. As late as 1972, Vernier's son recorded how a magnifying glass
and a wrench which had belonged to the artist were still in the possession
of one of his sisters. By then, the pastor had been dead for fifteen years
but throughout a long life he had kept odd little souvenirs of those
strange days – Claverie had given him Gauguin's green beret and a piece
of this had been cut up and stitched to make a tray cloth which the son
still kept like a relic, all part of the sanctification of the dead painter.

The sale in Atuona raised 1,077 francs and 15 centimes. One tale has it
that a friend of Gauguin's, a half-caste from Hanaiapa called Louis-Otto
bought two litres of absinthe and invited any who had liked the painter
to join him in drinking to his memory – a nice story, true or not. The
House of Pleasure did not last long. Varney bought the land and sold
the building materials, though for some years the well and the place
where he had dug an open-air bath were still visible, until eventually
they too caved in and all trace of Gauguin's home was finally erased.
All, save for the five carved panels, which had been taken down and sent
to Papeete for the second auction.

While the house still stood, stripped and empty, it was visited by the
man who would then do most to save what remained of the paintings
and carvings and begin the process of mythologizing their creator – a
naval doctor and writer – Victor Segalen.

This dapper 25-year-old, who combined a spruce, upright military bearing with a more rakish pince-nez and up-swung moustaches, was to be the first of many who would build a career out of Gauguin's memory. He must surely have heard something about the artist when he received his first posting in 1902, as he had been befriended by Dr Gouzer who was then at the Hôpital Maritime de Brest, and who would certainly have told him all about the interesting characters he would meet. As soon as he joined the *Durance* in Papeete on 23 January 1903, Segalen began to hear a great deal more about this fascinating individual, who was by then in the Marquesas – the usual things: how he worshipped the sun and painted horses pink, but enough to capture Segalen's imagination. The *Durance* might well have arrived before Gauguin's death if it hadn't been for the cyclone, which meant that the boat and Segalen were despatched to aid the distressed. When he did get to Nukuhiva on 3 August, he was told by Picquenot that Gauguin was already buried, and that one of his tasks was to take on board a self-portrait and a case of belongings which Claverie had sent to the administrator and which were now to go to Papeete for the second auction. The *Durance* was to collect the rest of the goods in Hivaoa and while on route, Segalen opened the case and read with great delight the *Noa Noa* exercise book and whiled away the hours at sea by making a copy of the *Cahier pour Aline*.

The *Durance* reached Hivaoa on 10 August and Segalen made his pilgrimage to the now abandoned House of Pleasure. It had been stripped bare, but he did what any budding author would, he talked to the artist's friends then imagined what it must have been like. He met Tioka and Ky Dong through whom he distributed some much-needed medicines, and he talked with Vernier, who was wearing the green beret, and who introduced him to an old woman who was a repository of the history of the islands, which the pastor translated while Segalen made notes, having quickly decided that this could form the basis for a novel which might show the sort of world Gauguin had dreamt of re-creating. Segalen even talked to Claverie, so that in the end he had a fair idea of the artist's life in the House of Pleasure, though his account of it was to be rather more fanciful than factual. Having heard about the Breton snow scene on the easel, Segalen promptly decided it had been the artist's last work, a clear sign that at the end of his tortured existence his thoughts had turned again to his beloved Brittany – it was no doubt significant that Segalen himself hailed from Brest.

In a sense, Segalen was a worthy disciple in the way that his account of Gauguin's life in Atuona merges truth and fiction, launching the myth of the solitary artist-hero of the Pacific, the tortured genius.

More to his credit was the art he managed to salvage at the auction,

after the *Durance* arrived back in Papeete with fifteen cases of goods on 20 August. By one of those wonderful connections, these were stored in the now abandoned palace of the Pomares where Gauguin had seen the last king laid in state all those years ago.

Picquenot's decision to have the paintings and carvings auctioned in the town certainly saved them from Claverie but they were not entirely home and dry. The person charged with organizing the sale was the Receiver of Registry Fees, Emile Vermeersch who had accompanied Lemasson on his trip out to Punaauia to photograph the great canvas *Where Do We Come From?*, and who might have been sympathetic to Gauguin's work. Unfortunately he lacked confidence and consulted the only expert he could find, a painter called Charles Alfred Le Moine who had recently come out to Oceania where he was to remain, working in the administration to finance his painting. Le Moine had studied at the Beaux-Arts in Paris and had perfected a conventional compromise style, producing realistic scenes of Tahitian life – markets and farms and portraits of ordinary people – with the light quasi-impressionist palette that was then considered acceptable by the academic world. When Le Moine sifted through Gauguin's work he loftily decided that some of the drawings and carvings were either unfinished or 'unhealthy' and that many were in such poor condition they would have to be discarded.

Unfortunately, by the time Segalen heard about this it was too late to stop them, nor was he able simply to buy up everything on offer, despite the low bidding – he was very young, this was his first posting and he had precious little money with him. The sale opened on 2 September, in the Place du Roi Albert facing the governor's palace, and was another public spectacle with cat-calls and jeers and a general carnival air. In the main the Europeans were only interested in the furniture and other useful stuff and Segalen did manage to buy seven of the ten canvases on offer, including the *Self-portrait near Golgotha*, probably because it really was in a poor state of repair – so much so that Segalen had to have it professionally restored when he got back to France. He also bought a large number of prints and drawings, including the little sketchbook Gauguin had used in the Auckland Museum; and some carvings, though unfortunately he only acquired four of the five sections of the doorway to the House of Pleasure, having been outbid for the left-hand panel *Soyez Mystérieuses*, though by whom is not clear.

Despite Segalen's efforts much was scattered and subsequently lost. Buyers having acquired works of art or a manuscript in lots along with the goods they were really after, had no interest whatsoever in preserving the unwanted extra items. Significantly, the catalogue of the sale lists thirteen manuscripts, though only five have survived to this day. Again, it was a miracle that the most complete, the illustrated *Noa Noa* exercise

book, with the additional essays on art and religion, was not lost too. When the goods arrived in Papeete, the governor Edouard Petit asked the Registrar if he could see the manuscript but as soon as it arrived, he fell ill and was forced to resign his post and leave the island, dying in Australia on the way home. By a stroke of extraordinary good fortune, *Noa Noa* was parcelled up with the rest of his belongings and despatched to France, otherwise it might well have been burned.

The most touching thing Segalen acquired was the artist's palette – for 40 sous – and the collection of 'Little Friends', the photographs and reproductions he had drawn on for his art. Had the young doctor not been there, much of what we know of Gauguin's intentions would have been lost. Until his premature death in 1919, Segalen combined the life of a traveller and author with his self-appointed role as passionate advocate of Gauguin's work, expressed in articles, books and novels.

## In the Land of his Birth

It was only on 23 August, well over three months after Gauguin's death, that Picquenot's letter finally reached Monfreid, though it only gave the date of the funeral, so that a card was issued, informing the world that the painter had died on 9 May. There was a slight flurry of interest in the art journals and even some attention by the popular press, including one assertion that he had died of leprosy.

Monfreid immediately wrote to Mette, who had already learned from Schuffenecker that Gauguin had been seriously ill, but had not expected the end to be so sudden. One senses from her subsequent actions that the whole thing was by then beyond her. Whereas some widows of great artists devote their remaining years to collecting and promoting their husband's work, Mette merely wanted what she felt were her rights, money as ever being her greatest problem, and to that end she left everything in the hands of the loyal Monfreid who from then on dedicated himself to promoting his late friend's interests. His immediate acts were to write to Vollard, who typically tried to see if there were any paintings he could buy, while trying to wriggle out of the fact that his less than upright behaviour over the advances had been a contributory factor in the misery of Gauguin's final months. Monfreid also wrote to Fayet, who had promptly sent money when Gauguin had issued his desperate plea for help after the trial. It had arrived too late, but it and the outstanding balance from the two sales were recovered by Monfreid on Mette's behalf, while at the same time he appealed to the Ministry of the Colonies against the injustice of what had been done to the artist's inheritance, asking them to intervene to see if any remaining paintings could be sent to France.

It was in fact the much-reviled Charles Morice who initially did most to promote Gauguin's posthumous reputation, arranging for a special room to be set aside at that October's Salon d'Automne, at the Petit Palais, in which five paintings, including *Self-portrait with Yellow Christ*, were hung as a memorial to an artist who was no longer the butt of journalistic humour but was now launched on an unstoppable trajectory to a fame which he could never have begun to imagine. In 1919 Morice published his first full biography of Gauguin, in which he tried to divide the life from the art but it was no use, people wanted that idealized figure who had given up everything for the right to create, who had lived out the fantasy of many in the industrial age, of travelling to the very opposite point on the globe, to become a savage, free and independent. In 1906 it was decided to hold the first major retrospective, of over 200 works, at the Salon d'Automne, even though Morice expressed grave doubts about showing them before the myths had died down and they could be looked at objectively. But it was no use, by then the interest was too great and it was this show which was to draw Gauguin into the twentieth century, making him the first great influence on the new art that was struggling to be born. The list of those who came to wonder at the glowing, mysterious canvases, reads like a roll-call of the new century's leading artists. Matisse was overwhelmed by the colours and would one day travel to Tahiti in search of the sensations which had inspired them. André Derain and Raoul Dufy were there, also stunned by the freedom of form with colour, so that out of this would come first Fauvism, then Expressionism, and later the almost universal spread of Abstract art. But it is also clear that Morice had been right in fearing that the exhibition would lead to a distortion of what Gauguin intended. By concentrating on the abstract and emotive qualities of his colours, his new admirers were extracting only half of what was there. Gauguin had always resisted the final lurch into abstraction, trying to teach Sérusier in Le Pouldu that no matter how far the artist might try to move towards musical values his work should always remain grounded in reality, a fact increasingly lost as the emotive impact of his canvases spread and obliterated the difficult, philosophical and religious structure on which the apparently imaginary forms and hues were built.

Poor Morice, his loyalty and perspicacity were not to be remembered, while what was seen as his disastrous failure with *Noa Noa* would live on after him. When Monfreid published extracts of Gauguin's text in 1910, he deliberately omitted the poems, though Morice, who died in 1919, was at least spared the full edition which Monfreid finally brought out in 1924 and which as far as was possible erased his contribution to the book.

Monfreid died in 1929, after falling from a tree, but his daughter by

Annette the seamstress, Agnes Huc de Monfreid, continued to maintain her father's home as a gallery, archive and shrine to Gauguin, keeping important carvings like *Idol with a Pearl* or the self-portrait signed *A l'ami Daniel* until 1951 when she donated the entire collection to the Louvre.

The other figure from that long-ago period, Annette's fellow seam-stress Juliette, was more touched by Gauguin's death than might have been imagined. She took to drink, and in a moment of fury destroyed all his letters and other souvenirs, dying in 1935. Their daughter Germaine, who was said to have her father's 'Inca' profile, became a painter, exhibiting under the name Chardon, eventually marrying a Monsieur Bizet by whom she had a son Jean, and through him a grandson Laurent. Germaine had a long life, dying quite recently, on 18 October 1980, and the announcement of her funeral in *Le Monde* listed her as 'Mme Germaine Bizet-Gauguin, daughter of the painter Paul Gauguin', as was her right.

Not everyone was proud to acknowledge him; Pissarro, who died later in the same year as Gauguin, 1903, never forgave him for departing from the humanist and progressive tradition that he saw in Impressionism, exchanging it for what the older man saw as mere decorative primitivism. Others, like the one-time opponent Camille Mauclair, became cloyingly unctuous in their praise, once Gauguin was safely dead. Emile Bernard continued his increasingly self-destructive attacks through a long life of ever-diminishing work, until his death, aged seventy-three, in 1941. When a plaque was unveiled outside the Hôtel Gloanec in 1939, Bernard felt obliged to attend, no doubt pointing out to anyone who would listen, that it was he and not Gauguin who had started the whole thing.

Maurice Denis was also present, and one line of Gauguin's influence lived on in his religious work and that of the other Christian Nabis, a collection of which is now gathered together at the Musée Départmental du Prieuré, in Denis's old house with its private chapel at Saint-Germain-en-Laye, just outside Paris. While it is true that they built on the deep religious thread that exists in Gauguin's art, this has not proved an unmitigated blessing. Much modern religious art has developed out of the Nabi tradition, but one cannot help thinking that the sort of decorat-ive, bland, pallid, pastel friezes often seen in modern concrete churches are an affront to the passion and boldness of Gauguin's biblical sym-bolism.

Pont-Aven continued to attract late adherents to the sub-Gauguin style for years after his death and today both it and Le Pouldu are sites of artistic pilgrimage. In 1924 Marie Henry's old Buvette de la Plage in Le Pouldu was redecorated and when the layers of wallpaper were stripped away in the main room it was suddenly realized that sections

of the decorative scheme carried out by Gauguin, De Haan and the others were still there. What could be salvaged was carefully removed and parts of the walls and doors are now in museums around the world. But so great is the desire for cultural icons, that in 1990 a house some metres further up from the beach, but built to a similar plan, was transformed into a copy of the Buvette, with blown-up photographs stuck to the walls, doors and ceilings to simulate the paintings and thus re-create the atmosphere Gauguin and his friends had shared back in 1889. For those who do not mind the artificiality of it all, there are flippant pleasures – it is possible to sit on a copy of the narrow bed at the back of the house that Gauguin used, and imagine him fuming with envy at the thought of De Haan and Marie 'Poupée' enjoying the more spacious pleasures of the best bedroom across the landing.

This is not, however, the most eccentric museum in Gauguin's story. That honour must go to the wretched gendarme Claverie, who late in life discovered an unexpected admiration for the man he had destroyed. When Claverie retired, he opened a tobacconist's in the village of Montgaillard in the Hautes-Pyrénées, and there, in a little glass case, were displayed the small wood carvings he had purloined before the sale in Atuona. One report describes him 'religiously' showing them to visitors while he spoke fondly of his acquaintance with the great artist.

Some found it increasingly galling to have been surpassed by a man they had despised. All his life Jacques-Emile Blanche continued to snipe at Gauguin whenever the opportunity arose – in one book he gloatingly recounts an incident at an exhibition in 1937 when Emile Bernard, who was not included, was able to point out that one of his pictures had been hung as a Gauguin. Blanche concluded that the false Gauguin 'was in reality better than any genuine one'. In some ways the worst affected was the one who merited least to be hurt by his one-time friendship, Emile Schuffenecker. The Good Schuff lived on until 1934, increasingly disillusioned with his modest art and shattered by the collapse of his marriage. An embittered man, he was obliged to sell his Gauguins and go on teaching at the Lycée Michelet in Vanves where his hunched melancholy appearance earned him the nickname 'Buddha' from increasingly sarcastic pupils, who would occasionally shower him with bread balls when his back was turned. In his book on Gauguin and Monfreid, Dr René Puig recounts the painful incident when one such student, a future member of the Beaux-Arts, Robert Rey, asked 'Buddha' if it wasn't just fine to be a drawing master in a big Lycée? It was a joke too far. Pale and furious, Schuffenecker rounded on his tormentor: 'Little imbecile, filthy little bourgeois, do you think it's a fine thing when one had hoped to be a Cézanne, a Van Gogh or a Gauguin, only to be reduced to correcting this trash!'

The extraordinary thing about the incident, as far as Rey and his fellow tormentors were concerned, was that their teacher envied the fame of people who, at the time, they had never even heard of.

## The Collectors

That same cheeky adolescent, Robert Rey, was later to make up for his ignorance by becoming a leading expert on Gauguin. By one of the more impossible coincidences in a story already packed with bizarre events, Robert was the son of Victor Rey, the colonial Secretary-General under Governor Gallet whom Gauguin had caricatured as a monkey in *Les Guêpes*. Despite that, Victor's son went on to do much to promote his father's persecutor. Rey collected and published eleven of the menus Gauguin had made for his Sunday lunch parties, and was largely responsible for the plaque which was placed outside the building in the Rue Notre-Dame-de-Lorette, where the artist had been born. Perhaps Rey's greatest achievement was to convince Vollard that he should donate to the Louvre the painting of Angélique Satre, *La Belle Angèle*, which had caused Gauguin so much trouble in Pont-Aven in the summer of 1889.

Today, Vollard's gift has joined the far more substantial donation of the Monfreid family to make up the bulk of the twenty-one paintings now housed in the Musée d'Orsay, which has also acquired an impressive selection of ceramics and carvings.

Of course it is easy to take a strict line about the nefarious Vollard, but it is equally true that without his buying and selling the paintings, Gauguin's reputation would not have climbed in the way it did. It was Gustave Fayet, the collector from Béziers, who first set things moving by buying many of the works sent to Vollard from the Marquesas. There can be no doubt that Fayet loved his collection as much as Monfreid but Fayet was willing to sell when the price was right – an attitude which forced up prices and succeeded in making a Gauguin painting a desirable commodity. Fayet first acquired the important *Te arii vahine* (*The Noble-woman*), Gauguin's portrait of Pau'ura with a fan, for a few thousand francs but was soon turning down an offer of 15,000 francs only to find the potential purchaser offering double, and all this within a few years of the artist's death. After 1908 Fayet began to be interested in younger artists like Matisse, and started to sell off his increasingly valuable Gauguins to an increasingly eager band of collectors, many of them German, who in the years prior to the outbreak of the First World War came to Paris on what were effectively shopping sprees. Many of their purchases would make their way into state and city museums across Germany. Some were sold off when Hitler branded Gauguin one of the decadent artists who were to be swept out of the national culture.

*Marquesan Man in a Red Cape* went to Liège in Belgium, while the Frankfurt collector Baron von Hirsch escaped from the Nazis by negotiating Swiss citizenship in exchange for *Ta Matete* (*The Marketplace*), which went to the Kunstmuseum, Basle.

But of the early collectors, it was two Russians who easily outstripped all others, eagerly raking in Gauguins on a large scale. Sergei Shchukin and Ivan Morozov were *kupets* (grand bourgeois industrialists), as the Bolsheviks would dub them and banishing their icons to the attics of their mansions they took to the new art with alacrity. Shchukin had inherited the family textile business and began modestly with Whistler and Fritz Thaulow, which may have led him onto Gauguin himself. By whatever route, he had acquired two very cheap paintings before 1900, though initially he kept them from public view in a darkened room downstairs in his mansion. The artist Leonid Pasternak – father of the author Boris – remembered visiting Shchukin who drew aside a heavy curtain and pulled out his first Gauguin, laughing and stuttering, 'Here it is, a m ... m ... m ... madman painted it and a m ... mad man bought it!' No record exists of precisely which paintings these were, though it is possible that one of them was *Her Name is Vairaumati*, and thus one of the key works of the Ariois period. Certainly Shchukin, in all his Gauguin purchases, showed a marked preference for those with the richest, most glowing colours and by 1914 he had bought sixteen Gauguins including *Te arii vahine* – for it was Shchukin who had offered Fayet thirty times what he had originally paid for Gauguin's stunning portrait of Pau'ura. Ivan Morozov and his brother also owned some sixteen paintings between them, most of which were displayed in Morozov's mother-of-pearl covered castle near the Kremlin, but the outbreak of the First World War and the Bolshevik Revolution in 1917 put an end to the Paris visits and wholesale collecting. Curiously, neither of them was initially opposed to the uprising – Morozov was a friend of Lenin and let his house be used as a hideout during the street fighting, while Shchukin declared his intention to donate his collection to the new 'super-museum' that was part of Lenin's plan to transform the Kremlin into an 'acropolis of the fine arts'. Neither gesture spared them from the ensuing tyranny.

In 1918, Lenin personally signed the order nationalizing Shchukin's and Morozov's collections. Later that year Shchukin managed to escape to France but his and Morozov's Gauguins were to be lost to the world for nearly forty years.

# My Poor Paul

Gauguin's earlier works were inevitably more scattered, though as the room devoted to Gauguin in the Ny Carlsberg Glyptotek, Denmark, reveals, the finest collection of the pre-Tahitian art is in his wife's homeland. Mette, however, had little part to play in this. The largest part of Gauguin's Impressionist pieces as well as his own important collection of works by Pissarro and Degas and the others had gone long before his death when she allowed Edvard Brandes to purchase it with the condition that Gauguin could buy it back if he wished to do so at some future time. As we know, Gauguin did, but Brandes prevaricated – the agreement was informal and imprecise and he argued that his dealings had been with Mette and not with her husband, though Brandes's future behaviour proves that he was less concerned with the legality of the situation and more with the ever-increasing value of the works he had so cheaply acquired. In 1905 Mette received an inheritance from the mother of her friend Marie Heegaard, with whom she had made that first fateful visit to Paris back in 1872, but when she attempted to use this to recover the collection, Brandes continued to refuse, thus casting aside any pretence that he would only deal with her. Eventually Brandes stopped showing the paintings and did his best to keep as quiet as possible about them, as he tried to evade the ever-stricter Danish regulations governing the export of works of art. No one is quite sure how, but over the years Brandes manages to dispose of the collection at foreign sales and after his death in 1931 the Galérie Zac in Paris was somehow able to dispose of what remained. Thus, one of the best collections of Impressionist art, personally assembled by a late member of the movement, and including some of Gauguin's own earliest pieces, was irretrievably scattered – a sad record for a man like Brandes who had been at the forefront of the Danish liberal avant-garde.

Fortunately, Mette's other friend, Dr Caröe, who had also helped her by buying part of the collection when she was in desperate need of money, behaved more honourably. His collection included works by Gauguin, Guillaumin, Pissarro and Jongkind and following his death in 1921 this eventually passed to the Ny Carlsberg Glyptotek, who used it as the basis for the splendid assembly of French Impressionist paintings to which they have added over the years. A second collection, of a Mrs Wilhelm Hansen, was presented to the Danish State in 1951 and housed in what is now the Ordrupgaard Museum, and includes seven works by Gauguin including *Misères Humaines* and the portrait of Vaïte Goupil.

The various manœuvres made during Mette's lifetime were of concern to her only in as much as they touched on money. She was not being callous about this, she had never truly appreciated her husband's art and

saw no reason to hypocritically jump on the band-wagon of his success. She was, however, entitled to his inheritance, given the way she and the children had been treated and to that end she fought for her rights. The result was a further demonization of her role in Gauguin's story by the new devotees who looked askance at what they saw as a lack of reverence for their idol. In the new books and studies which began to appear, she came to be portrayed first as the domineering spendthrift who along with her family had cast out the struggling painter, forcing him to go alone into his tropical exile, and then after his death, as a grasping harridan, greedily trying to get her hands on work she had once despised. All of this was very painful to her, especially the portrayal of the artist's wife in Somerset Maugham's *The Moon and Sixpence* which he made clear was based on Gauguin's story. It was published in 1919, and caused Mette considerable distress when she read it. In 1907 she travelled to Paris to arrange for the sale, through Vollard, of those works which Monfreid had managed to salvage from Tahiti as well as several canvases which she had brought from Denmark. In most things she relied heavily on Monfreid, though she always looked on him as her husband's friend rather than hers and once the various sales were concluded their correspondence stopped abruptly. In one area only did Mette show an unusual interest – Gauguin's surviving manuscripts. During that visit in 1907 she persuaded Fontainas at the *Mercure de France* to hand over the manuscript of *Avant et après*, which she sold to a German, Kurt Wolff, in Munich, who in 1914 brought out a beautiful facsimile edition, limited to 100 examples, which included the black and white monotypes. Evidence of the extraordinary interest in Gauguin in the English-speaking world is shown by the fact that the earliest popular edition of the text was published in America in 1921, with a Paris publisher following five years later, since when Gauguin's quasi-autobiography has remained in print and widely read in several languages.

Mette was equally determined to get her hands on the *Noa Noa* exercise book, once Monfreid had retrieved it from the family of Governor Petit, being as convinced as everyone else that the version which Morice had had privately published in 1901 was a travesty of her husband's intentions and that only the exercise book with its copious illustrations could be considered valid. She too seems to have been unaware of the draft manuscript which Morice sold to the dealer Sagot in 1908. Here, however, she met resistance, as Monfreid was determined that the exercise book should stay in France. Although he was able to arrange for extracts from it to be published in the journal *Les Marges* in 1910, as long as Mette continued to insist that the book was hers, it was difficult for him to proceed to a complete edition. The tug of war went on, even after her death, and was only resolved in 1921 when the eldest son Emil, by

then working as an engineer in America, wrote to Monfreid, graciously conceding his rights to the book: 'I consider that you would be failing in your friendship for Paul Gauguin if you gave *Noa Noa* to the only people to whom he intended not to leave it ... since his death, I have often denied, in the presence of strangers, that I was the son of the great Gauguin. I have never tried to get money, and never asked for anything because I was Gauguin's son, and I have always looked upon it as a curse, for, measured by his standards, my own insignificance can only be the more apparent.'

Three years later, in 1924, Monfreid published the full text of the exercise book, though even he could not resist putting his mark on it, by having it illustrated with his own woodcuts based on Gauguin's paintings. The following year, he donated the exercise book to the Louvre, since when it has been known as the Louvre Manuscript, and in 1926 the museum published it in a facsimile edition, so that finally, Gauguin's own prints and colour transfers could be seen alongside his own handwritten text. It is significant, however, that the Louvre chose only to issue the *Noa Noa* section from the exercise book, and not *Diverses choses* nor the first version of his religious essay: *L'Eglise catholique et les temps modernes*, omissions that were to add to the imbalance in the overall understanding of Gauguin's thought.

Without doubt, the strangest tale is that of the bound manuscript of the rewritten essay which he had entitled: *L'Esprit moderne et le catholicisme*. As far as we can guess, this was bought by Alexandre Drollet, son of Gauguin's friend Sosthène, at the Papeete auction. Around 1923 it was acquired by a Madame Claude Rivière, a Frenchwoman living on Tahiti who wrote articles about art and who in turn sold it to a doctor in Los Angeles, Arthur B. Cecil. At some point it came into the possession of the actor Vincent Price, who played the lead in the series of films drawn from the work of Edgar Allan Poe: *The Fall of the House of Usher*, *The Pit and the Pendulum* and – strange to recount – one based on *The Raven*, the poem so admired by the French Symbolists and, of course, Gauguin. In fact Price was a serious and well-informed collector of modern art. Originally from Saint Louis, Missouri, he donated *L'Esprit moderne et le catholicisme*, to the Saint Louis City Art Museum in the late 1940s in memory of his mother and father, where it remains to this day.

With only *Avant et après* and *Noa Noa* as a guide, the public's knowledge of Gauguin has been reduced to a series of more or less scandalous anecdotes which have found their way into films in which the character of Gauguin has been represented in such hilariously extreme ways as to leave the cinema-goer totally confused. In 1942 he was played as an urbane Englishman by George Sanders, in a Hollywood version of *The Moon and Sixpence*, while in 1956, as portrayed by Anthony Quinn, he

was the whoring, drinking, foul-mouthed companion of the twitchingly neurotic Van Gogh in *Lust for Life*. The sole exception was an intelligent interpretation of the role, by Donald Sutherland, in Henning Carlsen's Danish film, *The Wolf at the Door* (1986), which was faithfully based on Judith's memories of that brief period in the Rue Vercingétorix in 1894–5 – a story where the drama grows out of a sensitive reaction to the truth, rather than the desire to shock. Despite that, it is Anthony Quinn in *Lust for Life* who dominates the public's 'memory' of Gauguin. As the art critic Robert Hughes so succinctly expressed it: 'Everyone knows something about Gauguin.' Unfortunately, that something does little to increase an understanding of his art.

One cannot help wondering why Mette was so keen to see both works in print. Perhaps she thought they would show the world just how much she had been wronged. Certainly her attempts to get her hands on the manuscripts did nothing for her reputation as the people she tangled with in Paris clearly resented this strong Danish Viking, as she is most often called in French books about Gauguin, interfering in what they believed was their private business. Victor Segalen certainly thought so and left an unpleasant little record of a meeting with Mette in which he described her jealousy of the *vahines* displayed in the paintings, and recorded her remark that the man with noble and honest feelings that she had married had become a vicious, lying savage.

In truth Mette Gauguin seems to have lived her life with a remarkable and laudable independence of spirit. There is a wonderful photograph of her with some of her girls, the students she still taught, all wearing long ball-gowns with Mette, presumably standing on a chair or table, towering above them, also in a long gown but with her hair close-cropped and her arms raised in what looks like a gesture of triumph, so much is she enjoying her dominant role. She died on 27 September 1920, having witnessed the extraordinary reversal of fortune in her late husband's reputation. Life with Paul Gauguin would never have been easy and without him she had managed remarkably well, and with a certain dignity. Segalen's assertion that 'she hates the man, the basic man in him,' seems far-fetched. Paul Gauguin had gone his way, she had gone hers and to her credit, she had raised their children, paid for their education, wept at the deaths of two of them, and somehow kept the family going with no help from the man who was by then being lauded as the selfless martyr to art.

Just before her death, Mette gave all her husband's letters to their son Pola, to publish as he saw fit. Pola became an artist and art critic and eventually used this material to write a number of accounts of his father's life, though those are only really valuable when they touch on the family he knew, rather than on the artist whom he did not, and about whom

he had little to contribute. The eldest son Emil, the engineer, eventually ended up in America, but Jean-René became a sculptor and ceramicist, well-known in Denmark but also producing some pottery for the Manufacture nationale de Sèvres. Pola's son Paul-René carried on the artistic tradition as a lithographer and engraver, in direct descent from the Chazal brothers, over a century earlier, while also making woodcuts and sculpture like his grandfather. Other artistic offspring surface from time to time. In the late 1950s another grandson, Pierre-Sylvestre Gauguin, began to research the family's history, tracing the Moscoso line back to the seventh century and visiting Orléans where he managed to track down a vague cousin, Monsieur Frume Gauguin, presumably a descendant of one of the brothers of Guillaume Gauguin, the father of Clovis and Uncle Zizi. None of the remaining Orléanais Gauguins appear to have had any artistic pretensions but the creative impulse is not entirely dead – in 1990 the British press reported the fascinating information that a great-granddaugher of the famous painter had been responsible for the new *trompe-l'oeil* ceiling decorations of the famous Gold Room in London's Dorchester Hotel. Her name was Mette Gauguin, a granddaughter of Pola whose father had served with the Free Norwegian Army during the Second World War, and had settled in England. The English Mette was born in 1946 and tries to pursue a career as an artist, though she admits to finding it difficult, working in the shadow of such an illustrious ancestor. In 1987, she was invited to Copenhagen to join with other surviving descendants, in a family reunion. There were fifty-two descendants at the party, including three Alines and the impression the English Mette had was that the Danish Gauguins still tended to side with the original Mette when any question of blame for the broken marriage came up.

Paul Gauguin's sister Marie and her husband Juan Uribe had daughters, some of whose descendants live in Chile, some in Bogotá. There are still Echeniques in Peru and once, when the English Mette was buying a carpet in London, she was approached by a man who had overheard her name and who introduced himself as one of her family. He was the Peruvian Ambassador, a Senor Chauny, though the precise relationship was never made clear.

## The Last Tiki

It is impossible to say with any certainty what Gauguin's other family, his two children on the opposite side of the planet, felt about their missing progenitor. The daughter he probably never knew, Tahiatikaomata Vaeoho lived all her life in Hekeani, her mother's home. In 1954, when she was fifty-two, she was described by a French resident in Atuona

as looking remarkably like Gauguin, as was her daughter Appoline
Tohohina, who was then about thirty. Appoline had three daughters,
and it was said to be a touching sight to see the girls laying flowers on
their great-grandfather's grave on All Saints' Day, so at least some
memory of Koke had lingered on.

The grave itself saw several changes. For years it was simply a bare
plot, but in 1921 two passing Americans, Oscar F. Schmidt (who is
recorded as being a member of 'The American Fakirs') and his com-
panion, an artist, Hugh C. Tyler, were so appalled at the lack of any
respect towards Gauguin's last resting place, when dealers and collectors
were making so much money out of his art, that they found a large
boulder which they rolled onto the spot and chipped out the epitaph
PAUL GAUGUIN 1903, painting in the rather crude letters with white
paint. This was an improvement, but hardly satisfactory, and eight years
later, in 1929, the Société des Etudes Océaniennes shipped out from
Papeete a conventional marble headstone with the inscription:

CI-GIT
PAUL GAUGUIN
ARTISTE FRANCAIS
JUIN 1843
MAI 1903
SOCIÉTÉ
DES
ÉTUDES OCÉANIENNES

It also included the name of the monumental mason: S. Tansi-Tahiti,
and while this was hardly worthy of the genius it purported to commem-
orate, there seemed no better solution at the time. In 1957 another artist,
Pierre Bompart, obtained a grant to construct a tomb of his own design
but the matter was only satisfactorily resolved by the Fondation Singer-
Polignac when a series of bronzes were cast from Gauguin's statue *Oviri*,
the very work Gauguin had expressly wanted to have as his grave marker,
and one was shipped out to the Marquesas in 1973 when his wish was
finally honoured at a ceremony attended by his grandson Paul-René, the
artist.

Near to Gauguin's plot is the tomb of the French singer Jacques Brel
who also spent his last years on the island and whose wish to be buried
beside his hero was fulfilled after his death in 1978. Gauguin liked guitar
music and singing, so Brel is no doubt welcome. More so than Gauguin's
other neighbour, none other than Bishop Martin who was set down near
him, in a large white vault with its own crucifix in 1912. There they lie,
side by side, the two enemies, one under his symbol of salvation, the
other beneath his androgynous savage, the mother who smothers her

offspring. Today Gauguin's *Oviri* has a curious role to play: most of the great *Tikis* which were once scattered around the neighbouring hillsides have now been removed to foreign museums, so that the savage bronze, sent out from France, is the nearest thing to native art left. One can imagine a future archaeologist unearthing it in some far-distant time and extrapolating an entire cultural history for the island from this one, powerful, engimatic image.

Everything comes full circle. Mendana's ship took away some Marquesans, as 'examples' to display in Lima on his return and the islanders sometimes claim half-jokingly that one of them must surely have been among Gauguin's ancestors, which explains why he alone was able to give them back their lost art.

## Dust about the Doors of Friends

With so little of Gauguin remaining on the island, it is hardly surprising that few travellers bothered to make the difficult journey out to Hivaoa, preferring the allure of Tahiti whose mythic charms have survived report after report of just how far the island has fallen since the days of Wallace and Bougainville. Indeed, it was the new myth of Gauguin that did most to revive the old myth of the tropical Eden in the South Seas, not so much for artists – they had the paintings to emulate – but for writers who wished to experience the same sense of liberation that legend ascribed to Gauguin. The first was Rupert Brooke, the English poet who arrived on Tahiti in January 1914 to 'look for Gauguins' and instead spent four months, partially due to an accident caused by grazing against coral, but more poignantly because of a love affair with the beautiful *vahine* Taata, who in his poems – amongst the best he wrote – he renamed Mamua. For Brooke this was probably the only consummated affair of his short life and in a sense he was the only one to live out the love-story of Tahiti as proposed first by Loti then by Gauguin. As he lay dying of blood poisoning, on board a hospital ship off Skyros in 1915, Brooke's last wish was to get a message to Taata, the Mamua of his poems – though he had already written their farewells in his most touching poem Tiara Tahiti:

> *Mamua when our laughter ends,*
> *And hearts and bodies, brown as white,*
> *Are dust about the doors of friends,*
> *Or scent a-blowing down the night,*
> *Then, oh! then the wise agree,*
> *Comes our immortality.*

The poem could just as well serve as the obituary to Gauguin's Tahitian

love – only a week after the First World War officially ended, a boat from San Francisco docked at Papeete, bringing with it the terrifying Spanish Influenza, the unstoppable epidemic, sweeping the world, nurtured by the appalling carnage in Northern France. Within a month 600 people had died in Papeete alone, while it was estimated that anything up to twelve per cent of the population of the colony was eventually wiped out by the illness. Included amongst them were both Brooke's love Taata and Gauguin's Teha'amana, out at Mataiea, where she had lived with her husband after her last, brief return to her Koke in 1895.

It was during the War, in 1917, that the English writer W. Somerset Maugham paid his brief visit to Tahiti, and found the door at Anani's house and made his notes for *The Moon and Sixpence*, the novel based on Gauguin's life which would be published in 1919, much to Mette's displeasure. That romantic tale of flight and freedom may well have done more than any other single act to establish the myth of Gauguin and Tahiti in the popular mind, even though the story owes as much, perhaps more, to Rupert Brooke than it does to Gauguin. Few of the people Maugham met had anything much to say about Gauguin, but whenever Brooke's name came up, old friends still wept for the golden-haired youth they had known as 'Purpure'.

The islanders' reticence about Gauguin was not to last. As more visitors came in search of the artist, so memories 'revived' and stories spread and were absorbed into a common legend, available on demand. By the time the English writer Robert Keable arrived in 1922, the local people were well practised in telling their tales. Keable's account of Gauguin's house at Punaauia and of his talks with those neighbours who still remembered him is most useful, though as the years went by the stories became more and more improbable. When the poet Renée Hamon, a friend of Colette's, made the journey in the 1920s, all she collected was gossip, and the usual tales of arguments about colours and of paintings thrown away, so that the articles she published are so unreliable they must be handled with great care.

It is surprising that only one of the artists influenced by Gauguin bothered to see for himself what it was that had so appealed to him. In 1930 Henri Matisse at last set off 'to see its light' as he told a newspaper reporter while passing through New York. But once on the island, Matisse swam, and drew a little, but did his best to avoid any of the things Gauguin had touched on, lest he get too close to his inimitable predecessor. Matisse had realized that there was a side to Tahiti that belonged to Gauguin alone and it was not until the end of his life that he was able to distil his own unique memory of his visit in the bold, simple colours of his late cut-out images, in which one can see echoes of the tropical fish he studied through a glass-bottomed boat out on

the lagoon, the seaweed and the coral itself and the seabirds overhead.

Given Matisse's difficulties in coping with Gauguin's shadow, it was hardly to be expected that lesser artists would fare any better, and the handful of Europeans who decided to emulate him by settling on the island and painting the natives, need not detain us. More intriguing is the fact that Gauguin's achievement did not stimulate any potential Tahitian artists, for in other non-European countries he was seen as a liberating force in attempts to create a valid art for the modern world, that was neither slavishly Western nor hidebound by traditional forms. Gauguin's merging of cultures seemed to offer an honourable solution, one that can be seen in the rise of indigenous schools, a feature of the twenties and thirties when artists, often trained in the academies and studios of Europe, returned home and attempted to adapt what they had learned to local conditions.

In Peru, in the Museum of Art in Lima, one can trace just such a process: on the grand staircase leading up from the entrance hangs Louis Montero's vast canvas of *Atahualpa's Obsequies*, a classic example of colonial art, colonizing history with colonial images. From there, the visitor enters a large hall in which are displayed the real pre-colonial art, the ceramics that Gauguin had loved, but it is the painting galleries that best display the ineluctable cultural invasion. At first the Indian artists struck a balance. In Cuzco, jobbing painters were set to work copying church art sent out from Spain but did so in their own unique manner, clothing their saints and madonnas in the plumed hats and lace collars of the Spanish grandees who ruled over them, gilding them as if they were Inca gods. But as one progresses to the nineteenth century these last vestiges of Indianness drop away. The opening of the Panama Canal made it easy for Peruvian artists to travel to Paris to pick up the latest Salon fashions and Peru recedes, lost among society portraits and anywhere landscapes. One eclectic soul, Alberto Lynch, tried everything from John Singer Sargent through Millais to Van Gogh, all with little success, and it was not until the influence of Gauguin began to be felt in the 1920s that this slavery to European culture began to be challenged. The key figure was José Sabogal with the movement he called *Indigenismo*, to identify it as an art of and for Peruvians. At one level this meant Indian subjects, both people and places, but also a style, clear and bold, with hints of the plain forms and sharp colours of pre-Columbian pottery. It is clear from the work of Sabogal and of those who joined him, namely Enrique Camino Brent, Julia Codesido, Camilo Blas, that it was their one-time fellow countryman who had pointed them in this direction. Even those not directly associated with *Indigenismo* knew the message of Tahiti. Felipe Cossío de Pomar wrote the only Peruvian biography of Gauguin, naturally emphasizing the artist's Peruvian roots, and ramming

home the point that it was the ancient culture of Peru that was the first and the most lasting influence on him.

Sabogal and the others failed in their attempt to hold off Europe by building a home-grown art. The final galleries in the museum are filled with the usual range of fashionable international modernism you find everywhere. The best is sub-Picasso but at least he was Spanish and much influenced by Gauguin, so something lives on.

Outside on the pavement, the Indians sell Peruvian souvenirs, often based on invented folk styles, dreamed up by well-meaning artists trying to stimulate marketable crafts in needy villages, in a hopeless attempt to stem the drift to the cities. In much of the world such work is now as near as one gets to an indigenous culture. As one sails into Papeete's harbour today, the most prominent 'monument' to greet the arriving traveller is a tower-block topped by a gigantic Coco-Cola sign. Along the harbour-front Boulevard Pomare, the Chinese traders market Gauguin – Gauguin on T-shirts, on postcards, on trays and baskets and hats. He is everywhere and nowhere. The opening of an international airport in 1961 brought mass tourism, while French nuclear testing on Moruroa atoll brought military personnel and technicians. Gauguin's most notable achievement on the island may well be the Club Méditerranée, a sealed-off world where Europeans live out a fantasy of life in a *pareu*, without money, sleeping in a hut, bathing in the warm waters, enjoying easy-going relationships – though without his difficult struggle with the creative process.

A year after the airport opened, the tourist trade was given a tremen-dous boost by a sort of living re-run of the Gauguin legend, when Marlon Brando arrived to play Fletcher Christian in the filming of the *Mutiny on the Bounty*. Smitten with Tahiti, Brando had a much publicized romance with a local beauty, Tarita Teriipaia, who became the mother of his daughter Cheyenne. After the filming, Brando bought one of the smaller islands, Teti'aroa, on which he planned to live out his own fantasy of escape and tropical freedom – though as with Gauguin, this would eventually turn into a nightmare. Twenty years on, Cheyenne took up with Dag Drollet, son of Jacques Drollet, one of the leaders of the island's independence movement and a nephew of that same Alexandre Drollet who had once tried to teach Gauguin Tahitian. The relationship was far from happy, and tinged with violence, and on a visit to the Brando home in Los Angeles, Cheyenne's stepbrother Christian, appalled at the way she was being treated, shot and killed her lover, a crime for which he is still serving time, and a tragedy that is said to have over-whelmed their father, who is now a virtual recluse.

As Gauguin realized, there is a serpent in this Garden of Eden and a hundred years on, the island has moved even further from paradise than

it was when he first arrived in 1891. If you drive through Papeete's northern suburbs, heading out to King Pomare's bizarre mausoleum, the names on the garden gates are unchanged from Gauguin's day – there are Drollets, and Salmons, and Bambridges, but today it is not the powerful Anglo-Tahitian notables but the once ignored natives who sit in the Territorial Assembly, that half-way house to independence which allows them to run their internal affairs while remaining part of France. It is not an entirely happy arrangement – everything Gauguin dreaded has come to pass. Concrete branches of French superstores line the road out to Paea, blocking the view of the lagoon, built to serve the large military contingent sent out to service the nuclear testing programme. Now that that is in abeyance, no one is quite sure what the future holds for French Polynesia, which is entirely dependent on French subsidies to maintain an artificially inflated standard of living amongst a population which has exploded to the point where the traditional easy way of life, living off the land and the sea, is no longer possible.

The fact that Gauguin foresaw much of this hardly endears him to the people he wanted to save. The Tahitians have no especial desire to be preserved as amusing natives for the delectation of European artists, any more than they wish to be a testing ground for nuclear weaponry. In their view Gauguin came to take what he wanted just as his later fellow countrymen have. Apart from selling T-shirts and postcards, they find little to thank him for, less still the Chinese population, for whom he was one of the worst of their many enemies.

Any support for Gauguin on the island has usually come from the French. In the 1960s the Fondation Singer-Polignac, in Paris, funded the building of a Gauguin museum at Papeari, a few kilometres along the coast road from Mataiea. It is a beautiful site, set in flowered grounds by the sea, where the visitor can stroll through shady spaces, following the story of the painter's life in photographs and reproductions of his paintings and mementoes of his stay on the island – a harmonium, that little piece of his green beret that was so carefully preserved by the Vernier family, who donated it to the museum, a large-scale model of the House of Pleasure. On occasion the museum has managed to borrow work from abroad, there being none left on the island. This began in April 1968 when *Vairaumati* returned briefly to the land of her birth. As the museum's director Gilles Artur put it: 'For the first time since 1895, a painting by Gauguin covered that long route in the opposite direction.' As the painting hung in a room by the lagoon, Artur and his guests were surprised at how 'the light of the Pacific seemed to have given the wife of the God Oro a brilliant hue, a true wash of youth . . .'

Over the years Artur has managed to acquire a number of prints and one of the rare ceramic pots, and has built up an impressive library and

documentation centre which has enabled him to promote a number of publications – a facsimile edition of the *Racontars de Rapin* is currently being prepared. The museum even manages to make a contribution to the living arts by carrying out Gauguin's dream of a Studio of the Tropics, through grants to artists who are invited to travel out to Tahiti to live and work at the museum for a time.

But there is no denying that thirty years on, the displays now need a complete overhaul, nor that earlier hopes that at least some of Gauguin's paintings might somehow be returned permanently to the island have not been realized, much to the disappointment of many visitors who expect most of his art to be still on Tahiti and awaiting them at the museum. Since the opening in 1965, over a million people have visited the museum – fortunately, as the institution can only survive with their entry fees. In 1983, the Fondation Singer-Polignac handed over responsibility to the Territorial government which set up an administrative council, jointly with the Association des Amis du Musée Gauguin, but the grants offered by the administration are not munificent and concern seems slight. As Artur has said in another context: 'The inhabitants of the New Cythera have never been consumed with passion for Gauguin,' and one is not left with the impression that this is a place to which local people feel drawn. It is noticeable that most of those who come out to Papeari are tourists, arriving in air-conditioned coaches, to be rapidly wheeled round by their guides as part of the island circuit – a day away from the fantasy life of the beach, Gauguin in another guise! At the end of their tour, there is a museum shop with better quality T-shirts and up-market postcards, but with the same end in view, money, for it is here that the shortfall is met and the museum's continuance assured.

But not all Tahitians have turned their backs on their most famous visitor. There was one Tahitian artist who gained sudden international notoriety through the influence of that famous name – Gauguin's own son, Emile Marae a Tai. Brought up by the impoverished Pau'ura, Emile had no education and never learned to read or write. He passed his time, catching fish for his mother, or as often as not sleeping or drinking – for alcohol and a taste for quarrelling seem to have been his only inheritance from his absent father. He married in 1920, but divorced his wife to marry another woman by whom he already had six children. Not that he saw much of them, as he was frequently in prison, or slouching drunkenly around the backstreets of Papeete, sleeping in a garage in the Rue Jeanne d'Arc. His main source of drinking money came from posing for tourists, always happy to pay to photograph the son of Gauguin, until a local hotel keeper showed him how a few childish scribbles on bits of old cardboard could make money as long as he added the strange signature which he was taught to copy.

He seems to have been content enough – at least as long as he had money for booze. Dressed only in a *pareu*, drinking and painting after a fashion, he was a sort of grotesque caricature of his father, eloquently described by the historian Father O'Reilly as 'without doubt the only beggar and the only tramp on Tahiti, one of the island's curiosities'.

And there he might have stayed, save for the intervention of a Madame Josette Giraud, the French wife of an American businessman resident on Tahiti, who herself had artistic pretensions and who seems to have seen some sort of outlet for these through the poor Emile, as well as a means of making money. In 1961, Madame Giraud installed him in a hut, away from the centre of town, and left him with paint and brushes and canvases and instructions to get down to work. Of course he had no idea what to paint but Madame Giraud helpfully supplied some illustrations of his father's work and before long he was turning out child-like versions of the *Yellow Christ* and sets of Tahitian *vahines*, maybe even his own mother as a young woman, with himself in her arms – all in searing colours with stick-limbs, lollypop trees and spiky plants and, of course, all prominently signed with the magic word 'Gauguin'.

Two years on Madame Giraud was ready to act. First she went to London where the O'Hana Gallery in Mayfair gave Emile his first one-man show, with a catalogue introduced by his patron who described how she had saved him from his beggar's life and given him the opportunity to 'express himself, to write, to escape from his solitude, and finally, to take his place among men'.

Next came Paris, then the United States with Emile flying out to meet his public. In America Giraud passed Emile on to a Romanian called Marjorie Kovler who had an art gallery in Chicago and who paid a handsome, though undisclosed sum, for his services. Emile, of course, had no means of understanding any of these transactions and thus found himself stuck in the basement of a building on North Michigan Avenue, Chicago, turning out yet more paintings and eventually, under the guidance of a sculptor hired by Kovler, some abstract wood-carvings of a stunning banality. He spoke no English – he could barely swear in French – and no one could communicate with him in Tahitian. It was only when the anthropologist Bengt Danielsson was attending a scientific conference in Chicago and heard about his condition that anything was done. Danielsson went to the gallery but was refused permission to see Emile as he was, in Kovler's words, in the midst of an important 'creative period'.

At this point, Danielsson thought he would never see Tahiti's only tramp again, but only six months later Emile was back on the island, lodged in a luxury hotel, paid for by Kovler, who had been obliged to bring him back when he became morose and unable to paint. Her inten-

tion was to allow him a brief period of rejuvenation before transporting him back to Chicago, but one night Emile slipped his leash, evaded his guardians, and disappeared, going to hide at the home of one of his many children.

Emile's career as a painter was over. Ten years later, when he was seventy-five, a journalist from the *Los Angeles Times* tracked him down and listened to his rueful account of his artistic venture: 'I was no good as a painter. I tried, but it was all wrong. One eye up, one eye down. Ears twisted. My paintings made no sense then. They make no sense when I try now.'

Emile Marae a Tai died on 6 January 1980, leaving a tribe of descendants, none of whom has shown any sign of artistic yearnings . . . so far!

## The Jigsaw Puzzle

Incredible as it seems, through all the years when there were still people living on the islands who had known Gauguin, when the places where he had lived remained little changed and when copious documents still lay in public and private archives in Papeete, no art historian bothered to visit the colony to see what it was that had so inspired him. As a consequence biographers in America and Europe dredged up much detail on his early life and his Breton years but fell back on his letters and *Noa Noa* and *Avant et après*, when dealing with Polynesia. Henri Perruchot's *Gauguin* first published in 1961, was probably the best of these, the author having undertaken prodigies of research into the by-ways of the artist's life in Europe. He was, however, still stuck with unreliable material for the final, crucial years.

Many of these gaps were filled by the Swedish anthropologist Bengt Danielsson who originally visited Polynesia aboard the Kon Tiki expedition in 1947 and who returned to Hivaoa in 1951 where he was surprised to find people who still had memories of the artist forty-eight years after his death. Danielsson met and was befriended by an old French settler, Guillaume le Bronnec, who had made a detailed study of Gauguin's Marquesan years which the Swede persuaded him to publish. Later when Danielsson and his wife moved to Tahiti and he learned the language, he again found himself in possession of unique information on the artist which he began to publish – first in Swedish in 1964, followed by an English version a year later and finally in French in 1975, each edition adding a little more of the evidence which had continued to surface. Since then there has been a trickle of art historians to the island, but Danielsson's remains the classic account, referred to by all subsequent biographers.

Over the past thirty years several important studies have concentrated

on aspects of Gauguin's art – his pottery, carvings, drawings, and these researches were reflected in the exhibition held in 1988–89 at the National Gallery, Washington, the Art Institute, Chicago and the Grand Palais, Paris, the largest assembly of Gauguin's work possible at the time. Some 280 paintings, drawings, prints and carvings were displayed along with an equally monumental catalogue which offered a series of essays, as well as detailed analyses of individual works, which drew on all those individual studies that had been appearing in recent years. The crowds who queued to see it in America and France and the many who bought the catalogue elsewhere constituted a triumph for the organizers, but as they admitted at the time, even so important an event could not automatically persuade owners to part with their works. Some of the most important canvases were missing, most notably *Where Do We Come from?*, which was not allowed to travel from Boston for conservation reasons.

Those that were assembled were hung chronologically rather than arranged in series which seems to have been Gauguin's intention with his later works. Despite all the efforts of historians and curators, no one has yet re-created the sort of exhibition that Vollard held in 1898, the sole occasion when Gauguin's wishes were carried out. That this has so far not been possible is mainly due to the imprisonment of so many key works inside the former Soviet Union. Until the death of Stalin in 1953 only the most persistent and patient and favoured experts could study the 'decadent' collections. In 1959, I went with one of the first West European student groups allowed into Russia, a visit which included a tour of the Hermitage where we were permitted to see the upper rooms where Shchukin's and Morozov's Gauguins, Matisses and Picassos were kept, though our Intourist guard made it quite clear that we were being shown the foolishness of a deranged society. With the new Russia and the openness to the West, there ought not to be any barrier to the sort of exhibition I have suggested – save for one very determined woman, Irena Shchukina, who is still fighting a long legal battle to correct the wrong done to her father when his collection was nationalised. Her position is simple: Russia must formally hand back the family's appropriated collection, at which point she will carry out her father's promise and donate it to the city of Moscow, on condition that his original wish, to have it housed in the family mansion, the Trubetskoy Palace, is carried out. So far the matter is unresolved and the fact that Irena Shchukina intends to continue the fight makes it unlikely for the moment that we will be able to have the sort of thematic exhibition that I believe Gauguin's later works require.

## The Sexual Tourist

It is this imbalance in our perception of his paintings that has done much
to fuel criticism of Gauguin's aims. In the past it was his 'pillaging' of
other cultures that irritated those like Pissarro who had an enclosed view
of Western art. Today, it is his supposed failure to go deep enough into
the culture he chose to live amongst that most angers a new generation
of opponents. Now voices are raised which assume that his approach to
Polynesia, both its culture and its people, was patriarchal, that he was
at heart a colonialist and a sexual tourist and the initiator of an essentially
patronizing fashion for the simple art of tribal folk. Yet such a view is only
possible if one fails to recognize the profundity of Gauguin's thinking and
the layers of meaning in so many of his works. It was his fear that the
myths would obscure the meaning which led Charles Morice to oppose
the large retrospective in 1906, and when one reads some of the criticism
levelled at Gauguin ninety years on, one can see his point. But Morice's
worries were not entirely justified. One young artist did see more in the
work and did go on to follow where this led, and he was probably the
most important of them all: the 25-year-old Pablo Picasso, who was by
then living permanently in Paris and who was already a devoted admirer
of Gauguin's art. Back in 1902, as a lonely foreigner in the French
capital, Picasso had drifted into the circle of expatriate Spanish artists
which included Paco Durrio, the little sculptor who had been faithfully
guarding Gauguin's paintings since his departure from the Rue Vercingé-
torix eight years earlier. Durrio introduced Picasso to Gauguin's works
and, as John Richardson's recent authoritative biography stresses, it was
the 1906 exhibition which changed the course of the young Spaniard's
art:

> Gauguin demonstrated that the most disparate types of art – not to speak
> of elements from metaphysics, ethnology, symbolism, the Bible, classical
> myths and much else besides – could be combined into a synthesis that
> was of its time yet timeless. An artist could also confound conventional
> notions of beauty, he demonstrated, by harnessing his demons to the dark
> gods (not necessarily Tahitian ones) and tapping a vital new source of
> divine energy. If in later years Picasso played down his debt to Gauguin,
> there is no doubt that between 1905 and 1907 he felt a very close kinship
> with this other Paul, who prided himself on Spanish genes inherited from
> his Peruvian grandmother. Had not Picasso signed himself 'Paul' in
> Gauguin's honor?

Gauguin's statue *Oviri*, which was prominently displayed in 1906, was
to stimulate Picasso's interest in both sculpture and ceramics, while the
woodcuts would reinforce his interest in print-making, though it was
the element of the primitive in all of them which most conditioned the

direction that Picasso's art would take. This interest was to culminate in the seminal *Les Demoiselles d'Avignon*, a work that would have been impossible to imagine, had not the young Spaniard absorbed the lessons of the dead Savage from Peru. While Matisse and the Fauvists took colour from Gauguin, another line of descent was drawn from that unveiling of non-European cultures which Gauguin had initiated. The new passion for African and Oceanic carvings was a direct consequence of Gauguin having lifted primitive art out of the domain of scientific study, moving it to that of aesthetic appreciation.

The key factor here was *Noa Noa* – Paco Durrio had given Picasso a copy of the first *La Plume* edition, since when the young Spaniard had studied it as if it were his artistic Bible, annotating the margins, using the text to reinforce his understanding of the paintings. Alone amongst the new admirers at the 1906 exhibition, Pablo Picasso realized that there was more to Gauguin than colour and primitive simplicity, that there were layers of meaning within the paintings and that with effort, these could be explored and admired.

In 1984 another massive exhibition, 'Primitivism in 20th Century Art', at the Museum of Modern Art, New York, made Gauguin the starting-point for a *tour d'horizon* of those twentieth-century artists whose work had involved direct borrowings from non-European sources. A photograph of a corner of one of Picasso's studios, stuffed with African and Oceanic statues, some clearly traceable to the artist's best-known paintings, was only the most conspicuous example of a practice which the exhibition attributed to such diverse figures as Brancusi, Modigliani, Léger, Epstein, Klee, Giacometti and Henry Moore.

While Gauguin was seen as the prime mover, the catalogue noted that this was not without its ironies – unlike Picasso and the others, he had hardly been an actual collector of the things he admired, nor had he really made much effort to study them, save for his encounters at the various Universal Exhibitions and his one outing to the Auckland Museum. In a challenging introductory article, William Rubin pointed out the ambiguity inherent in Gauguin's intentions: 'On the one hand, he wanted to address the intellect, and constructed a complex symbolism based on what he called "Maori mythology". On the other, he wanted the form and color of these works to affect their viewers "naturally" – with the unmediated sensual impact of music.' Rubin implied that this has come to be seen as one of the artist's 'most damaging weaknesses', though others would see it as the creative tension which raises his work far above that of, say, the Nabis, for whom the musical or abstract qualities of colour were ultimately paramount.

But one other point which Rubin made seems both perceptive and unarguable, that while Gauguin loved craftwork and admired the simple

artisan, 'he none the less felt that all great art had been produced under mighty rulers, and recognized in himself a nostalgia for aristocracy (which may in part explain the dominant pattern of attraction, in his borrowings from non-Western sources, to the arts of the court rather than tribal cultures).'

Rubin's analysis fits well with everything we have seen of Gauguin's choices, from Pukaki the Maori chief, to the portrayal of his mistress as a Tahitian noblewoman, her aristocrat's fan acting as her halo. Gauguin may have proclaimed himself to be at heart an American Indian, but, as Rubin wittily reminds us, he arrived in Tahiti wearing the cowboy hat he had acquired after one of his many visits to see Buffalo Bill's Paris show in 1889.

Yet in the end, it is this identification with the aristocratic and hierarchal aspect of other cultures that clears Gauguin of the charge of simple colonialism. Where most have seen only the simple or the natural in tribal art, Gauguin saw a complex disappearing world, which he accepted as another, more laudable civilization, one which he admired intensely, mourning the fact that it was on the verge of extinction. His followers, as Rubin's article also points out, have failed to comprehend that on Tahiti 'as in the Primitive in general, Gauguin found the mirror image not of the simple man he wanted to be, but of the troubled and questioning one he was'. Put another way: where his followers saw 'otherness' Gauguin found 'oneness', he became, as he told Morice, 'a savage in spite of myself'.

Whatever his intentions and however mistaken the ideas we have drawn from them, no one can deny Gauguin's role in opening European eyes to non-European art and by extension to the peoples who made it.

More than that, a reverse process has taken place, for by this awakening in the West, so the people of Africa, Asia, South American and Oceania have come to appreciate their own art, setting aside the cultural self-loathing that was one of the worst consequences of colonialism, so tragically encapsulated in that image of the people of Rarotonga voluntarily bringing their 'idols' to be burned in front of the watching missionaries.

The people of Tahiti may feel little need to honour the foreign artist who came to their island for his own purposes, but the fact that they are liberated from the ridiculous Mother Hubbard and can spend their days wrapped in a simple *pareu*, much as their ancestors did, is not unrelated to the image Paul Gauguin created of their disappearing Eden. The proclamation of beauty, dignity and integrity by non-European peoples, after a century of brain-washing in the unquestioned superiority of all things white, was not a spontaneous outburst of the 1960s and 70s. We see what we know, and one of the most effective sources of our knowledge of other beauties was surely Gauguin's art. There may be a

sense in which he was using his Tahitian models, but at the time he was also breaking the great Taboo – as a white man he found non-white women beautiful and desirable, and portrayed them as such.

The dreadful feelings of self-loathing that Western culture instilled in peoples around the world are not yet finally cast out, but Gauguin's role in helping launch the cleansing process seems undeniable. When Nelson Mandela walked to the dais before the Union building in Pretoria in 1994, to be sworn in as President of South Africa, preceded by two 'praise singers' wearing approximation of traditional dress and waving beaded fly-whisks as they called down honours on his name, he and they were giving expression to that elevation of tribal culture which had begun when Paul Gauguin painted his Tahitian Madonna, a gesture then expressly forbidden by the Church, but which today is considered perfectly natural. A mere twenty years ago, President Mandela would have been wearing top hat and tails!

Eugène Henri Paul Gauguin was a man both of and beyond his time. He inherited all the confused uncertainties of the nineteenth century, often revelled in them, occasionally surpassed them. Although only fifty-four when he died, Gauguin had known a range of experiences spanning from the late eighteenth-century world of Don Pio Tristán to the birth of the twentieth century, whose cultural ethos his life and work helped shape. He knew this in a vague, uncertain way and in his last letter to Charles Morice, written in April 1903, he attempted to situate himself in time and history, with a statement of faith which can stand as his epitaph:

> In art, we have just undergone a very long period of aberration due to physics, mechanical chemistry, and nature study. Artists have lost all their savagery, all their instincts, one might say their imagination, and so they have wandered down every kind of path in order to find the productive elements they hadn't the strength to create; as a result, they act only as undisciplined crowds and feel frightened, lost as it were, when they are alone. That is why solitude is not to be recommended to everyone, for you have to be strong in order to bear it and act alone. Everything I learned from other people merely stood in my way. Thus I can say: no one taught me anything. On the other hand, it is true that I know so little! But I prefer that little, which is of my own creation. And who knows whether that little, when put to use by others, will not become something big? . . . .

# List of Illustrations

## Colour plates

## Black and white plates

A Gauguin family reunion, Copenhagen, 1987 (Private collection: Mette Gauguin)

## Illustrations in the text

# Acknowledgements, Bibliography and Other Sources

Because Gauguin's life-story ranges over so many places and touches on so many widely different subjects – from Peru to Tahiti, from stockbroking to pottery – I have relied heavily on the help and advice of experts in many fields. My gratitude is expressed in the following notes, which also list the books and other materials I have drawn on. I have not used footnotes, but to help anyone wishing to look further into a particular area, these sources have been broken down into the chapters for which they were first consulted.

## General background

Anyone embarking on a biography of Paul Gauguin must consult the catalogue of the massive exhibition held in Washington, Chicago and Paris in 1988–89. Because it lists all Gauguin's own writings in full, this bibliography only singles out those which are specifically dealt with in this book. The catalogue also contains a series of essays on the main periods of Gauguin's life and on the principal topics related to his work, written by a panel of specialists in Gauguin studies, charged with assembling the most recent thinking on his art. Alphabetically these were: Richard Brettell, Françoise Cachin, Isabelle Cahn, Claire Frèches-Thory, Gloria Groom, Marla Prather, Charles F. Stuckey, Peter Zegers. Even where I disagreed with the judgements made or wished to challenge the chronology offered, I was never anything but grateful for the thoroughness and scope of their work, returning constantly to this valuable document for easy reference and stimulating argument. The catalogue is still in print:

Brettell, Richard *et al.*, *The Art of Paul Gauguin*, Boston, Little, Brown and Company, 1988.

The definitive collection of Gauguin's correspondence is still in production. One volume has appeared:
Merlhès, Victor (ed.), *Correspondance de Paul Gauguin. 1873–1888*, Paris, Fondation Singer-Polignac, 1984.
Later letters are scattered through several publications, principally: Cooper, Douglas (ed.), *Paul Gauguin: 45 lettres à Vincent, Theo, et Jo van Gogh*, Gravenhage and Lausanne, 1983; Joly-Ségalen, A. (ed.), *Lettres de Paul Gauguin à Georges-Daniel de Monfreid*, Paris, rev. edn. 1950; Malingue, Maurice, *Lettres de Gauguin à sa femme et ses amis*, Paris, 1946; O'Brien, Frederick, (ed.) (trans. Ruth Pielkovo), *Gauguin's letters from the South Seas*, New York, 1992.

Writings by Gauguin used throughout this book are: Gauguin, Paul, *Avant et après*, Paris, 1923; English version: *The Intimate Journals of Paul Gauguin* (trans. Van Wyck Brooks), New York, 1921. The following contain useful selections of Gauguin's writings: Guérin, Daniel (ed.), *Oviri, Ecrits d'un sauvage*, Paris, 1974; English version: *The Writings of a Savage* (trans. Eleanor Levieux, New York, 1990; Prather, Marla and Charles F. Stuckey, *Gauguin: A Retrospective*, New York, 1987;

Thomson, Belinda, *Gauguin by Himself*, Boston, 1993.

The following books on Gauguin were consulted throughout: Anderson, Wayne V., *Gauguin's Paradise Lost*, New York, 1971; Gray, Christopher, *Sculpture and Ceramics of Paul Gauguin*, Baltimore, 1963; Hoog, Michael, *Paul Gauguin: Life and Work*, New York, 1987; Morice, Charles, *Gauguin*, Paris, 1919; Perruchot, Henri, *La vie de Gauguin*, Paris, 1961; Le Pichon, Yann, *Gauguin, Life, Art, Inspiration*, New York, 1986; Rewald, John, *Post-Impressionism from van Gogh to Gauguin*, New York, rev. edn 1978; Wildenstein, Georges (ed.), *Gauguin, sa vie, son œuvre*, Paris, 1958.

Useful sources of visual material are: Beauté, Georges, *Paul Gauguin vu par les photographes*, Lausanne, 1988; exhibition catalogue, *Le Chemin de Gauguin, genèse et rayonnement*, Musée Departemental du Prieuré, Saint-Germaine-en-Laye, 1985; Sugana, G. M. *Tout l'œuvre peint de Gauguin*, Paris, 1981.

The following are books and other sources listed by the chapter for which they were first consulted.

# Part One
# WHERE DO WE COME FROM?

## 1 *The Awakening of Evil*

Amishai-Maisels, Ziva, 'Gauguin's "Philosophical Eve" ', London, *Burlington Magazine*, 115, 1973; Birkett, Jennifer, *The Sins of the Fathers, Decadence in France 1870–1914*, London, Quartet Books, 1986; Duncan, Carol, *Virility and Domination in Early 20th-century Vanguard Painting*, Artforum, Dec 1973; Jirat-Wasiutynski, Vojtech, 'Paul Gauguin's Self Portraits and the Oviri: The Image of the Artist, Eve, and the Fatal Woman', *The Art Quarterly*, vol. 2 no. 2, Spring 1979; Nochlin, Linda, *Women, Art and Power and other essays*, London, Thames and Hudson, 1989; Nochlin, Linda, *The Politics of Vision –*
Essays on *19th-century Art and Society*, London, Thames and Hudson, 1991; Parker, Rozsika and Pollock, Griselda, *Women, Art and Ideology*, London, Pandora, 1981; Pollock, Griselda, *Avant-Garde Gambits 1888–1893, Gender and the Colour of Art History*, London, Thames and Hudson, 1993.

## 2 *A Savage from Peru*

I am grateful to Dr C. Zavaleta, Cultural Attaché at the Peruvian Embassy, London, 1991, for introducing me to Dr Estuardo Nuñez whose field of expertise covers foreign visitors to Peru in the nineteenth century and who traced for me the house in Lima where Don Pio de Tristán y Moscoso and the young Paul Gauguin had lived and who went with me to see it. We were both grateful to the Peruvian artist Sñr Dario Encinas Pareja who at the time lived and worked in the small section of the house not yet ruined and who kindly allowed us to see the building and to photograph it.

Sñr Cesar Abel Ugaz del Aguila of the Biblioteca Nacional, Lima was most welcoming and thorough in looking out those items from the exceptional collection of photographs of nineteenth-century Lima that I needed to see.

I am especially grateful to Dr Rory Millar of the Department of Economic and Social History at the University of Liverpool, an expert on Peru and particularly the history of Lima, who corrected many of the mistakes in the first four chapters of this book and suggested several ideas where further amplification was necessary. W. Iain Mackay, while at the Museum of Mankind, London and subsequently, offered invaluable insights into the history of the discovery of pre-Columbian pottery and also offered useful contacts in Peru.

**Peru: General Background and History**

Anon, *Presidentes del Peru*, Lima, 1987; Enock, C. Reginald, *Peru*, London, T. Fisher Unwin, 1908; Hutchinson; Thomas Joseph, *Two Years in Peru, with Exploration of its Antiquities*, London, 1873; Owens, R. J., *Peru*, Oxford

University Press, 1963; Roeder, Rudolf G., *Viaje a Lima*; Lima, 1988; Tauro, Alberto, *Enciclopedia Ilustrada del Peru*; Lima, Peru, 1987; Tristan, Flora, *Peregrinations of a Pariah*, London, Virago, 1986; Werlich, David P. *Peru: A Short History*, Southern Illinois University Press, 1978; Wu, Celia, *Generals and Diplomats: Great Britain and Peru 1820– 1840*, Cambridge, Centre of Latin American Studies, University of Cambridge, 1991.

**Peruvian Studies of Gauguin**
Del Pomar, F. Cossio, 'La Vida de Pablo Gauguin', In *Gauguin – Hommage au génial Artiste Franco-Péruvian*, Paris, Association Paris–Amérique Latine, 1926; Nuñez, Estuardo, 'El peruanismo de Paul Gauguin', Buenos Aires, *Historium*, August 1950.

**Pre-Columbian Pottery**
Bankes, Shire, *Peruvian Pottery*, London, Shire Ethnography, 1989; Bushnell, G. H. S. and Digby, A., *Ancient American Pottery*, London, 1955; McElroy, Keith, *Early Peruvian Pottery*, Ann Arbor, Michigan, USA, UMI Research Press, 1985.

**Gauguin's Family**
Buffon, *Œuvres Complètes* (20 vols), Paris, 1835; Chazal, Antoine, *Flore Pittoresque, ou Recueil de Fleurs et de Fruits Peints d'Après Nature*, Paris, 1818 (reprinted 1953); Dickenson, Donna, *George Sand*, Oxford/New York, 1988; Dolléans, Edouard, *Féminisme et Mouvement Ouvrier: George Sand*, Paris, 1951; Gattey, Charles Neilson, *Gauguin's Astonishing Grandmother*, London, Femina, 1970; Jordan Ruth, *George Sand*, London, 1976; McIntosh, Christopher, *Eliphas Lévi and the French Occult Revival*, London, Rider, 1972; Russell, John, *Eugène Delacroix: Selected Letters*, London, Eyre and Spottiswoode, 1971; Sand, George, *Correspondence de George Sand*, Paris, 1882; Sweetman, David, *The Borgias*, Hove, Wayland, 1976.

I am grateful to Maire Cross of the Department of Modern Languages, the University of Northumbria at Newcastle, for commenting on the sections relating to Flora Tristan.

# 3 *The Scramble*

## Gauguin's Education
I am grateful to the Abbé Louis Gaillard, a living repository of the history of the Diocese of Orléans, for guiding my research into the Petit-Séminaire de la Chapelle-Saint-Mesmin.

Bentley, James, *The Loire*, London, George Phillip, 1986; Dupanloup, Mgr F. *Où Allons-Nous?* Paris, Ch. Douniol, 1876; Huet, Emile, *Histoire du Petit Séminaire de la Chapelle-Saint-Mesmin*, Orléans, Pigelet et Fils, 1913; Lagrange, Abbé F., *Life of Monseigneur Dupanloup* (trans. Lady Herbert), London, Chapman and Hall, 1885; Marcilhacy, Christiane, *Le Diocèse d'Orléans sous l'Episcopat de Mgr Dupanloup 1849–1878*, Paris, Plon, 1962.

## General Background to the Second Empire
Aronson, Theo, *The Fall of the Third Napoleon*, Indianapolis, Bobbs-Merrill, 1970; Autin, Jean, *Les Frères Pereire*, Paris, 1983; Aycard, M., *Histoire du Crédit Mobilier 1852–1867*, Paris, 1867; Bierman, John, *Napoleon III and his Carnival Empire*, John Murray, London, 1989; Bouchy, M., *Autrefois . . . Le Coteau de Saint-Cloud*, Paris, 1970; Friedrich, Otto, *Olympia: Paris in the Age of Manet*, London, Aurum Press, 1992; Goncourt, Edmond and Jules, *Journal des Goncourt*, Paris, 1851–1896; Manéglier, Hervé, *Paris Imperial*, Paris, Armand Colin, 1990; Miquel, Pierre, *Le Second Empire*, Paris, Duponchelle, 1979; Pinkney, David, H., *Napoleon III and the Rebuilding of Paris*, Princeton, 1958; Trapp, Frank Anderson, 'The Universal Exhibition of 1855', London, *Burlington Magazine*, June 1965; Zola, Emile, *La Curée*, Paris, Gallimard, 1981; Zola, Emile, *The Kill* (La Curée), trans. (1895), A Texeira de Mattos, London, Weidenfeld and Nicolson, 1954.
I am grateful to Theo Aronson, acknowledged expert on the Bonaparte family, for the care with which he read

and corrected the many references to the history of the Second Empire in this book.

**Gauguin's Naval Career**
The first source of information on Gauguin's naval career is the thesis *Gauguin – ses Origines et sa Formation Artistique* by Ursula F. Marks-Vandenbroucke, part of which was published in *Gauguin Sa Vie, Son Œuvre* (ed. Georges Wildenstein) Paris, 1958, in which she traced the various French maritime records which established, where possible, the movements of the *Luzitano* and the *Chili*.

A copy of Gauguin's Military Record (*livret militaire*) is held at the Musée Gauguin, Papeete, Tahiti and I am grateful to its Director, Gilles Artur, for permission to consult it.

The official records of the *Jérôme-Napoléon/Desaix* and copies of messages between the Ministry of the Marine and Colonies and serving vessels are held in the Service Historique de la Marine, Pavillon de la Reine, Château de Vincennes. N.B. Matricule des Bâtiments 1863–1880.

Works of interest on the Prince Napoleon (Plon-Plon) are: De Beaufort, George, Biographical sketch in: *Napoleon and his detractors* by HIH Prince Napoleon, London, W. H. Allen, 1888; Flammarion, Dr Gaston, *Le Prince Napoléon*, Paris, Editions Jules Tallandier, 1939; Hauterive, Ernest, *The Second Empire and its Downfall. The Correspondence of the Emperor Napoleon III and his cousin Prince Napoleon*, London, Hutchinson, 1981.
Details of Ernest Renan's voyage aboard the *Jérôme-Napoléon* can be found in: Brandes, George, Interview with Renan in *Essais Choisis*, Paris, Mercure de France, 1914; Espinasse, Francis, *Life of Ernest Renan*, London, Walter Scott, 1895; Psichari, Henriette, *Renan et la Guerre de 70*; Paris, Editions Albin Michel, 1947; Tielrooy, Johannes, *Ernest Renan, sa vie et ses œuvres*, Paris, Mercure de France, 1958; Renan, Ernest, *Lettres Familières 1851– 1871*, Paris, Flammarion, 1947; Renan, Ernest, *Œuvres Complètes*, vol. 10, Paris, Calmann-Lévy, 1961.

Works on the naval engagements during the Franco-Prussian War are legion. The most useful were: Clarke, Capt. F. C. H., *The Franco-German War*, London, 1872; De Pont Jest, René, 'La Campagne de la Mer du Nord et de la Baltique; 8 articles du *Moniteur universel*', Bremen, 1871 (republished in English in the *Journal of the Royal United Service Institution*, vol. 33, London, 1889–90); Hamilton, C. I., *Anglo-French Naval Rivalry 1840–1870*, Oxford, Clarendon Press, 1993; Howard, Michael, *The Franco-Prussian War*, London, Rupert Hart-Davis, 1961; Jenkins, E. H., *A History of the French Navy*, London, Macdonald and Janes, 1973; Wilson, H. W., *Ironclads in Action*, London, 1896.
Details of vessels apprehended by the *Desaix* are set out in: Barboux, H., *Jurisprudence du conseil des prises pendant la Guerre de 1870–71*, Paris, 1872.
I am most grateful to Dr Dietur Jung, co-author with the late Martin Maas of the magisterial *Die Deutschen Kriegsschiffe* (Koblenz, Bernard and Graefe Verlag, 1990) for contacting Dr Meyer Gunther, an East German librarian specializing in naval history, who tracked down the strange history of the *Franziska* for me.

## 4 *The Bourgeois Gentleman*

**Gustave Arosa and Pottery**
Demmin, Auguste, *Guide de l'amateur de Faïence et porcelaines, poteries, terres cuites, peinture sur lave et émaux*, Paris, 1863; Demmin, Auguste, *Histoire de la Céramique*, Paris, 1875.

**Gustave Arosa and Photography**
Grangedor, J. 'Les Derniers Progrès de la Photographie', Paris, *Gazette des Beaux-Arts*, May 1869; Kane, M. William, 'Gauguin's "Le Chaval Blanc". Sources and Syncretic Meanings', London, *Burlington Magazine*, vol. 108, 1966; Lewinsky, Jorge, *The Naked and the Nude*, London, Weidenfeld and Nicolson, 1987; Scharf, Aaron, *Art and Photography*, London, Penguin Books, 1968; Société Français de Photographie, *Catalogues of Annual Exhibitions*, Paris 1869, 1870; and

*Bulletin de la Société Français de Photographie*, Paris, vol. 22, 1876.

**Achille-Antoine Arosa and Claude Debussy**
Dietschy, Marcel, *A Portrait of Claude Debussy*, Oxford, Clarendon Press, 1989; Holmes, Paul, *Debussy*, London, Omnibus Press, 1989; Lockspeiser, Edward, *Debussy*, London, J. M. Dent, and Sons, 1951; Lockspeiser, Edward, *Debussy: His Life and Mind*, vol. 1: 1862–1902, London, Cassell, 1962; Thompson, Oscar, *Debussy, Man and Artist*, New York, Tudor Publishing Co., 1940.

**Gauguin's Business Career**
This part of Gauguin's life has remained confused because there are few histories of the Paris Bourse. Happily, the present Archivist of the Bourse put me in touch with the sole historian to have consulted the largely uncatalogued archives, M. Patrick Verley of the Université de Paris, to whom I am deeply indebted for all the information he has so generously researched on my behalf. Anon, 'La Bourse il y a Cent Ans' in *Les Œuvres Libres*, 115, Paris, Fayard, 1933; Anon, 'Hommes d'Affairs du Second Empire' in *Les Œuvres Libres*, 148, Paris, Fayard, 1933; Bertant, Jules, 'Paris sous Mac-Mahon' in *Les Œuvres Libres*, 105, Paris, Fayard, 1933; Bertant, Jules, *La Bourse anecdotique et pittoresque 1933*, Paris, 1933; Colling, A., *La Prodigieuse Histoire de la Bourse*, Paris, 1949; Feydeau, Ernest, *Mémoirs d'un Coulissier*, Paris, Librairie Nouvelle, 1873; Verley, Patrick, *Les Sociétés d'Agents de Change Parisiens au XIXe Siècle*, Paris, Imprimerie Nationale, 1989; Verley, Patrick, *Nouvelle histoire économique de la France contemporaine. II L'industrialisation 1830–1914*, Paris, Editions de la Découverte, 1989.

**Camille Pissarro**
Fleming, Marie, *The Anarchist Way to Socialism: Elisée Reclus and Nineteenth-Century European Anarchism*, London, Croom Helm, 1979; Herbert, Eugenia W., *The Artist and Social Reform, France and Belgium 1885–1898*, Yale University Press, 1961; Hutton, John,

'Camile (sic) Pissarro's *Turpitudes Sociales* and Late Nineteenth-Century French Anarchist Anti-Feminism', London, *History Workshop*, no. 24, Routledge and Kegan Paul, 1987; Thomson, Belinda, 'Camille Pissaro and Symbolism', London, *Burlington Magazine*, Jan. 1982; Thorold, Anne, 'Learning from Pissarro', London, *Apollo*, Nov. 1992.

**Fritz Thaulow**
Mourey, Gabriel, 'Fritz Thaulow – The Man and the Artist', London, *The Studio*, vol. 2, 1897; Ostvedt, Einer, *Fritz Thaulow*, Oslo, Dreyer, 1956.

**Edouard Manet**
Friedrich, Otto, *Olympia, Paris in the Age of Manet*, London, Aurum Press, 1992; Needham, Gerald, 'Manet, "Olympia" and Pornographic Photography' in Hess and Nochlin: *Women as Sex Object*, London, Thames and Hudson, 1972.

**Mette Gauguin (née Gad)**
Pola Gauguin wrote books and articles about the father he had barely known as a child, but was mainly concerned to defend his mother against the attacks upon her in his father's letters, attacks often sustained by his subsequent biographers. When writing about his father all is hearsay but
with care one can learn much about his mother's life, when she was separated from his father. Gauguin, Pola, *Mette og Paul Gauguin*, Copenhagen, Gyldendal, 1956 (I am grateful to Ms Majken Steffes, formerly graduate student at Queen Mary College, London University, for translating verbally large tracts of this book); Gauguin, Pola, *My Father Paul Gauguin*, New York, Hacker Art Books, 1988; Malingue, Maurice, 'Encore du nouveau sur Gauguin' Paris, *L'Œil*, 58, Oct. 1959; Vasseur, Pierre, 'Paul Gauguin à Copenhague', Paris, *La Revue de l'Art*, 1935.

**Gauguin's Art 1871–1885**
Bodelsen, Merete, 'Gauguin's Cézannes', London, *Burlington Magazine*, May 1962; Bodelsen, Merete, 'The Dating of Gauguin's Early Paintings,' London,

*Burlington Magazine*, June 1965; Dorra, Henri, 'A Suburban Landscape by Gauguin', USA, *Bulletin*, nos 33–34, Smith College, Museum of Art, 1953; Hamy, Dr E. T., *Galerie Americaine du Musée d'Ethnographie du Trocadéro*, Paris, 1897; Rubin, William (ed.), cat: *'Primitivism' in 20th-Century Art* vols 1 and 2, New York, The Museum of Modern Arts, 1984.

**Spain**
I am grateful to Joachim Dolz of the University of Geneva for finding and translating material relating to Manuel Ruiz Zorilla and to Prof. E. Moradiellos of the Department of Spanish, Queen Mary College, London University for guidance on the general background of the period. Carr, Raymond, *Spain*, London, 1966; Gomez Chaix, Pedro, *Ruiz Zorrilla*, Madrid, 1934; Hennessy, C. A. M., *The Federal Republic in Spain 1868–74*, Oxford University Press, 1962; Kunstler, Charles, *Paul Gauguin et la Révolution Espagnole*, Paris, 1883; Leblond, Marius-Ary, 'La Vie Anarchiste d'un Artiste', Toulouse, *La Dépêche*, 1 Oct. 1903; Munoz Epelde, Melchor, *Memorias de un amnistiado*, Badajoz, Spain, 1901; Prieto y Villareal, Emilio, *Ruiz Zorrilla (D. Manuel)*, Madrid, 1885; Prieto y Villareal, Emilio, *Ruiz Zorrilla (D. Manuel)*, Madrid, 1903; Russell, P. E. (ed.), *A Companion to Spanish Studies*, London, Methuen, 1973; Siffler–725 (code name and number of a member of the Republican Junta), *Don Manuel Ruiz Zorrilla ante la ARM*, Madrid, 1883.

**Denmark**
Glyn Jones, W., *Denmark, a Modern History*, London, Croom Helm, 1986; Oakley, Stewart, *The Story of Denmark*, London, Faber and Faber, 1972.

## Part Two
## WHAT ARE WE?
## 5 *A Place in the Sun*

**Dieppe**
Blanche, Jacques-Emile, *Portraits of a Lifetime*, London, Dent, 1937; Ferrier, André, 'Jacques-Emile Blanche, peintre et mémorialiste', Paris, *L'Œil*, 89, May 1962; Sickert, Walter Richard (ed. Osbert Sitwell), *A Free House: or the artist as craftsman*, London, Macmillan, 1947; Taylor, Hilary, *James McNeill Whistler*, London, Tabard Press, 1978.

**Christopher Dresser**
I am grateful to the artists Gilbert and George for allowing me to see their extensive collection of Christopher Dresser's pottery.
Exhibition catalogue: *Christopher Dresser 1834–1904*, Camden Arts Centre, London 1979, Dorman Museum, Middlesbrough, 1980; Lee, Robert, 'A Forgotten Yorkshire Pottery', Bradford, *The Heaton Review*, vol. 17, 1934.

**Gauguin's Ceramics**
Bodelsen, Merete, *Gauguin's Ceramics*, London, Faber and Faber, 1964; Gray, Christopher, *Sculpture and Ceramics of Paul Gauguin*, Baltimore, Johns Hopkins Press, 1963.

**Félix Bracquemond**
Dufwa, Jacques, *Winds from the East*, Stockholm, 1981.

**Félix Fénéon**
Halperin, John Ungersma, *Félix Fénéon: Aesthete and Anarchist*, Yale University Press, 1988.

**Ernest Chaplet**
Berryer, Anne-Marie, 'A propos d'un Vase de Chaplet Décoré par Gauguin', Belgium, *Bulletin des Musées Royaux d'Art et d'Histoire*, nos 1–2, Jan.–April 1944; Marx, Roger, *Souvenirs sur Ernest Chaplet*, Paris, Art et Décoration, 1910.

**Gauguin's First Period in Pont-Aven**
I have drawn extensively on *Gauguin and the Impressionists at Pont-Aven* by Judy Le Paul, published by Abbeville Press in 1987. A resident of Pont-Aven, Mrs Le Paul assiduously tracked down the sites associated with Gauguin and his friends and I have used her material throughout this section.
Aslin, Elizabeth, *The Aesthetic Movement*,

London, 1969; Boyle-Turner, Caroline, *Gauguin and the School of Pont-Aven: Prints and Drawings*, London, Royal Academy, 1986; Cate, Philip Dennis and Welsh-Ovcharov, Bogomila, *Emile Bernard 1868–1941: The Theme of Bordellos and Prostitutes in Turn-of-the-Century French Art*, New Jersey, The Jane Voorhees Zimmerli Art Museum, 1988; Delouche, Denise *et al.*, *La Route des Peintres en Cornouaille 1850–1950*, Quimper, Groupement Touristique de Cornouaille, 1990; Engen, Rodney K., *Kate Greenaway*, London, Academy Editions, 1977; Exhibition catalogue: *Emile Bernard 1868–1941*, Amsterdam, Van Gogh Museum, 1990; Hartrick, A. S., *A Painter's Pilgrimage through Fifty Years*, London, 1939; Jaworska, Wladyslawa, *Gauguin and the Pont-Aven School*, Greenwich, 1972; Orton, Fred and Pollock, Griselda, 'Les Données Bretonnantes: La Prairie de la Representation', Oxford, *Art History*, 3, no. 3, 1980; Puget, Catherine *et al.*, *Gauguin et ses Amis à Pont-Aven*, Brittany, Editions Le Chasse-Marée/ArMen, 1989; Richardson, Sarah, *Painting in Brittany: Gauguin and his Friends*, Newcastle Upon Tyne, Laing Art Gallery, 1992; Welsh-Ovcharov, Bogomila, *Vincent van Gogh and the Birth of Cloisonism*, Toronto, 1981.

**The French Colonies**
Aldrich, Robert and Connell, John, *France's Overseas Frontier: Départements et Territoires d'Outre-Mer*, Cambridge University Press, 1992; Cooke, James J., *New French Imperialism 1880–1910, The Third Republic and Colonial Expansion*, London, David and Charles, USA, Archon Books, 1973.

**Pierre Loti (Julien Viaud)**
Blanch, Lesley, *Pierre Loti: Portrait of an Escapist*, London, Collins, 1983; Loti, Pierre, *The Marriage of Loti*, London, T. Werner Laurie, 1927.

# 6 *Among the Mangoes*

## The Panama Canal

Cameron, Ian, *The Impossible Dream: The Building of the Panama Canal*, London,
Hodder and Stoughton, 1971; Hammond, Rolt and Lewin C. J., *The Panama Canal*, London, Frederick Muller, 1966; La Feber, Walter, *The Panama Canal*, New York, OUP, 1978; McCullough, David, *The Path Between the Seas: The Creation of the Panama Canal 1870–1914*, New York, Touchstone, 1977.

## Martinique

The principal, indeed the only meaningful, source of information on Gauguin in Martinique is the Ph.D. Thesis of that name by Karen Kristine Rechnitzer Pope, The University of Texas at Austin, 1981. I have drawn heavily on her research.
Anon, *St-Pierre Avant et Après*, Martinique, Centre d'Art, Musée Paul Gauguin, 1983; Cucchi, Roger, *Gauguin à la Martinique*, Vaduz, Calivran Anstalt, 1979; Hearn, Lafcadio, *Two years in the French West Indies*, New York and London, Harper and Brothers Publishers, 1890; Henderson, James, *The Caribbean*, London, Cadogan Books, 1992; Joyau, Auguste, 'Une pléiade, Paul Gauguin à la Martinique', *Revue Française*, Avril 1960; Monet, Henri, *La Martinique*, Paris, A. Savine, 1913; Thomas, Gordon and Morgan-Witts, Marx, *The Day Their World Ended*, London, Souvenir Press, 1969; Vallery-Radot, Pierre, 'Gauguin (1848–1903) Misère et Maladies', Paris, *Presse Médicale*, vol. 65, 5 Jan. 1957; Waugh, Alec, 'La Martinique', Martinique, *The Geographical Magazine*, vol. 8, 1939.

# 7 *The Vision after the Sermon*

## Symbolism

Balakian, Anna, *The Symbolist Movement in the Literature of European Languages*, Budapest, Akademiai Kiado, 1982; Cassou, Jean, *The Concise Encyclopedia of Symbolism*, London, Omega Books, 1984; Delevoy, Robert L., *Symbolists and Symbolism*, New York, Rizzoli, 1982; Goldwater, Robert, *Symbolism*, New York, Harper and Row, 1979; Jirat-Wasiutynski, Vojtech, 'Gauguin in the Context of Symbolism', Princeton University, Ph.D. Thesis, 1975; Jullian,

Philippe, *The Symbolists*, London, Phaidon, 1973; Lucie-Smith, Edward, *Symbolist Art*, London, Thames and Hudson, 1972; Pincus-Witten, Robert, 'Joséphine Péladan and the Salons de la Rose+Croix', USA, The University of Chicago, Ph.D. Thesis, 1968; Schubert, Gudrun, '*Women and Symbolism: Imagery and Theory*', UK, *The Oxford Art Journal*, April 1980.

**Mallarmé**
Professor Gordon Millan of the University of Strathclyde kindly made a detailed critique of those sections of this book that dealt with Mallarmé and Symbolism. I was especially grateful for information concerning Henri de Régnier's unpublished diary and for guidance over the exact status of Jean Moréas in the Symbolist circle. Chassé, Charles, *Gauguin et Mallarmé*, Paris, L'Amour de l'Art, 1922; Millan, Gordon, *Mallarmé: A Throw of the Dice*, London, Secker and Warburg, 1994; Régnier, Henri de, 'Diary', Paris, Bibliothèque nationale: mss, Nouvelles acquisitions françaises 14976/folio 164 verso – 165 recto [et *Corr* VI 184]; Régnier, Henri de, *Nos Rencontres: Mallarmé et les Peintres*, Paris, Mercure de France, 1931.

**Esotericism**
Anon, *Ancient Wisdom and Secret Sects*, Alexandria, Virginia, Time-Life Books, 1989; Rifford, Pierre A., *L'Esotérisme*, Paris, Robert Laffont, 1990; Spence, Lewis, *An Encyclopedia of Occultism*, London, Routledge, 1920.

**Georges-Daniel de Monfreid**
Puig, Dr Renée, *Paul Gauguin, G D de Monfreid et Leurs Amis*, Perpignan, Editions de 'La Tramontaine', 1958.

**Guy de Maupassant**
Jackson, Stanley, *Guy de Maupassant*, London, Duckworth, 1938.

**Vincent van Gogh**
A comprehensive bibliography of Vincent van Gogh is given in my book: Sweetman, David, *The Love of Many Things, A Life of Vincent van Gogh*, London, John Curtis/Hodder and Stoughton, 1990.
Works relevant to Gauguin and Van Gogh include: Exhibition catalogue: *Van Gogh à Paris*, Paris, Musée d'Orsay, 1988; Exhibition catalogue: *Van Gogh et Arles*, Arles, Hôpital Van Gogh, 1989; Gogh, Vincent van, *The Complete Letters of Vincent van Gogh*, London, Thames and Hudson, 1958; Pickvance, Ronald, *Van Gogh in Arles*, The Metropolitan Museum of Art, New York, Harry N. Abrams, 1984; Pickvance, Ronald, *Van Gogh in Saint-Rémy and Auvers*, The Metropolitan Museum of Art, New York, Harry N. Abrams, 1986; Rewald, John, *Post-Impressionism, From Van Gogh to Gauguin*, New York, The Museum of Modern Art (3rd ed), 1978; Roskill, M. *Van Gogh, Gauguin and the Impressionist Circle*, London–New York, 1970.

# 8 *Master, Prophet, Messiah*

**Le Pouldu**
Andersen, Wayne, 'Gauguin's Motifs from Le Pouldu – Preliminary Report', London, *Burlington Magazine*, Summer 1970; Chassé, Charles, *Gauguin et son temps*, Paris, Bibliothèque des Arts, 1955; Gide, André, *Si le grain ne meurt*, published as *If It Die* (trans. Dorothy Bussy), London, Penguin Books, 1977.

**The Universal Exhibition 1889**
Druick, Douglas W. and Zegers, Peter, 'Le Kampong et la Pagode: Gauguin à l'Exposition de 1889', in *Gauguin, Actes du Colloque Gauguin, Musée d'Orsay*, Paris, La Documentation Française, 1991.

**Works by Gauguin**
Anderson, Wayne, *Gauguin's Paradise Lost*, London, Secker and Warburg, 1972; Chassé, Charles, 'De Quand Date le Synthétisme de Gauguin?' Paris, *L'Amour de l'Art*, no. 3, April 1938; Jirat-Wasiutynski, Vojtech, 'Paul Gauguin's *Self Portrait with Halo and Snake*: The Artist as Initiate and Magus', New York, *Art Journal*, vol. 46 no. 1, Spring 1987; Sutton, Denys, '*Le Perte de Pucelage* by Paul Gauguin', London, *Burlington Magazine*, vol. 91, 1949.

**Charles Filiger**
Amaya, Mario, 'The Recluse of
Pont-Aven', London, *Apollo*, vol. 78, 4 Oct.
1963; Anon, 'Charles Filiger, Les Fils du
Temps', Paris, *Quotidien de Paris*, 21 août
1990; Anquetil, Marie-Amélie, *Filiger –
Dessins, Gouaches, Aquarelles*,
Saint-Germain-en-Laye, Musée
Départemental du Prieuré, 1981;
Cooper, Emmanuel, *The Sexual
Perspective*, London, Routledge and
Kegan Paul, 1986; Eppendorfer, Hans,
cat: *Wilhelm van Gloeden und seine Welt*,
Berlin, Galerie Janssen, 1991; Exhibition
catalogue: *Hommage à Filiger*, Brittany,
Maison du Patrimoine Plougastel –
Daoulas, 1988; Jacob, Mira, *Charles
Filiger 1863–1928*, Strasbourg, Les
Musées de la Ville de Strasbourg, 1990;
Thomas, Gilda, 'Un Certain Charles
Filiger', Paris, *L'Œil*, 321, April 1982.

**A. H. Studd**
I am grateful to A. G. Greenwood for his
kindness in allowing me to read and use
material from his unpublished
dissertation: 'Arthur Studd 1863–1919:
His Life and Work.' I am also grateful for
the advice of Sir Edward Studd in tracing
information on his family, and to the
Deputy Keeper of Special Collections at
The Glasgow University Library for
permission to consult A. H. Studd's
correspondence with James McNeill
Whistler.
Rothenstein, William, *Men and Memories*,
London, Faber and Faber, 1931; Taylor,
Hilary, *James McNeill Whistler*, London,
Tabard Press, 1978; Thornton, Alfred,
*Diary of an Art Student*, London, Sir Isaac
Pitman and Sons, 1938.

**Meyer de Haan**
Carlyle, Thomas (writing as: Herr
Teufelsdröckh), *Sartor Resartus*, London,
Saunders and Otley, 1838; Tennyson,
G. B. *Sartor called Resartus*, Princeton,
New Jersey, Princeton University Press,
1965.

**Juliette Huet**
Kluver, Billy and Martin, Julie, *Kiki's
Paris*, New York, Harry N. Abrams Inc.,
1989; Loize, Jean, *Deux Amours de
Peintres*, Paris, La Murène, 1989; Milner,
John, *The Studios of Paris*, London, Yale
University Press, 1988; Mucha, Jiri
(*et al.*), *Mucha*, London, Academy
Editions, 1971.

## 9 *Hina, Goddess of the Moon*

The starting-point for any study of
Gauguin's first visit to Tahiti has to be
the book he attempted to make out of the
experience. There are many versions but
the most sumptuous is the facsimile
edition produced by L'Association des
Amis du Musée Gauguin à Tahiti and the
Gauguin and Oceania Foundation, New
York, 1987. However, to help extricate
fact from fiction and to read Gauguin's
original notes for the book, it is essential
to refer to: Wadley, Nicholas, *Noa Noa,
Gauguin's Tahiti*, Oxford, Phaidon, 1985.
Two works dominate the many studies of
this crucial time in Gauguin's life and both
have been constantly referred to during
the writing of this book: Field, Richard,
S., *Paul Gauguin. The Paintings of the First
Voyage to Tahiti*, New York, Garland,
1977. Field offers the most thorough
chronology of Gauguin's work. Our
understanding of his life owes much to
the investigations of the Swedish
anthropologist Bengt Danielsson who
first visited French Polynesia with the
Kon Tiki voyage and subsequently settled
there in the mid-Fifties, when he was able
to interview those survivors who had
known Gauguin and to study local and
private archives never previously
researched. I am especially grateful for
Bengt's welcome when I visited Tahiti
and for much subsequent good advice.
His main book on Gauguin is: Danielsson,
Bengt, *Gauguin in the South Seas*, New
York, Doubleday, 1966, updated as:
*Gauguin à Tahiti et aux Iles Marquises*,
Papeete/Tahiti, Les Editions du
Pacifique, 1975. This remains the classic
work on Gauguin's life in Polynesia.
Some details can be questioned:
Danielsson was told by Alexandre Drollet,
who as a young man had tried to teach
Gauguin Tahitian, that the painter had
befriended a teacher, Gaston Pia, with
whom he stayed in Paea in 1892. Drollet,

however, was by then a very old man and may well have confused the matter, as there is no record of a teacher called Pia until 1898, and then only on the island of Moorea. This detail aside, Danielsson's work remains the basic guide to the period. I am most grateful to Gilles Artur, Curator of the Musée Gauguin, Tahiti, for his welcome, his advice and the free run of his library, as well as for indicating several areas of research which proved most useful.

Other studies referred to are listed alphabetically, by author: Amishai-Maisels, Ziva, 'Gauguin's Early Tahitian Idols', USA, *College Art Association Bulletin*, 1978; Barrow, Terence, *The Art of Tahiti and the neighbouring Society, Austral and Cook Islands*, London, Thames and Hudson, 1979; Brown, Irving, *Leconte de Lisle: A Study of the Man and His Poetry*, New York, Columbia University Press, 1924; Danielsson, Bengt, *Love in the South Seas*, London, George Allen and Unwin, 1956; Danielsson, Bengt, 'Gauguin's Tahitian Titles', London, *Burlington Magazine*, 109, 1967; Dodd, Edward, *The Ring of Fire*, New York, Dodd, Mead and Co, 1983; Dorra, Henri, 'The First Eves in Gauguin's Eden', New York, *Gazette des Beaux Arts*, 41, 1953; Dorra, Henri, 'More on Gauguin's Eves', New York, *Gazette des Beaux Arts*, 69, 1967; Field, Richard S., cat: *Paul Gauguin: Monotypes*, Philadelphia Museum of Art, 1973; Guérin, David, 'Gauguin et les Jeunes Maoris', Paris, *Arcadie*, February 1973; Herdt, Gilbert, H. (ed.), *Ritualized Homosexuality in Melanesia*, Los Angeles, University of California Press, 1984; Howarth, David, *Tahiti: A Paradise Lost*, London, Harvill Press, 1983; Jénot, Lieutenant, 'Le Premier séjour de Gauguin à Tahiti', in: *Gauguin, sa vie, son œuvre*, Paris, Presses Universitaires de France, 1958; Joly-Segalen, Annie (ed.), *Lettres de Gauguin à Daniel de Monfreid*, Paris, 1950; Kushner, Maralyn S., Exhibition catalogue: *The Lure of Tahiti; Gauguin, His Predecessors and Followers*, Rutgers, New Jersey, The Jane Voorhees Zimmerli Art Museum, 1988; Langdon, Robert, *Tahiti, Island of Love*, Sydney and New York, Pacific Publications, 1968; Leconte de Lisle, C. M., *Poèmes Barbares*, Paris, 1862; Levy, Robert I., *Tahitians: Mind and Experience in the Society Islands*, Chicago and London, University of Chicago Press, 1973; Marqueron, Daniel, *Tahiti dans toute sa littérature*, Paris, Editions L'Harmattan, 1989; O'Reilly, Patrick, *Les Photographes à Tahiti et leurs œuvres 1842–1962*, Paris, Société des Océanistes, Musée de l'Homme, 1969; O'Reilly, Patrick, *Tahitiens: Répertoire biographique de la Polynésie Française*, Paris, Société des Océanistes, Musée de l'Homme, 1975; Pallander, Edwin, *The Log of an Island Wanderer*, London, Pearson, 1901; Rubin, William (ed.), *'Primitivism' in 20th-Century Art*, New York, The Museum of Modern Art, 1984; Stuart-Wortley, Colonel, *Tahiti – a series of photographs, with letterpress by Lady Brassey*, London, Sampson Low, 1882; Teilhet, Jehanne, cat: *Dimensions of Polynesia*, San Diego, Fine Arts Gallery of San Diego, 1973; Toullelan, Pierre-Yves, *Tahiti Colonial (1860–1914)*, Paris, Publications de la Sorbonne, 1984; Warner, Oliver (ed.), *An Account of the Discovery of Tahiti from the Journal of George Robertson, Master of HMS Dolphin*, London, The Folio Society, 1955; X, Jacobus (pseudonym for Louis Jacolliot), *L'Amour aux Colonies*, Paris, Isidore Liseux, 1893; Zink, Mary Lynn, 'Gauguin's *Poèmes barbares* and the Tahitian Chant of Creation', USA, *Art Journal*, 1978.

## 10 *The Spirit of the Dead Keeping Watch*

Bodelson, Merete, Exhibition catalogue: *Gauguin and van Gogh, Copenhagen, 1893*, Ordrupgaard, Copenhagen, 1984; Sutton, Denys, 'Notes on Paul Gauguin apropos a Recent Exhibition', London, *Burlington Magazine*, vol. 98, 1956.

## 11 *With a Fixed Smile*

The most detailed study of this period is *Molards Salong* by the Swedish historian Thomas Millroth, published by Forum, Sweden in 1993. Thomas Millroth kindly

read and commented on this chapter and provided an English summary of those passages in his book which concerned Gauguin and his associates.

**Durand-Ruel**
Distel, Anne, *Les collectionneurs des impressionnistes, Amateurs et marchands*, Switzerland, La Bibliothèque des Arts, 1989; Venturi, Lionello, *Les Archives de l'Impressionnisme*, New York, Burt Franklin, 1968; Weitzenhoffer, Frances, *The Havermeyers – Impressionism Comes to America*, New York, Harry N. Abrams Inc., 1986.

**Paco Durrio**
Plessier, Ghislaine, Un Ami de Gauguin: Francisco Durrio (1868–1940) sculpteur, céramiste et orfèvre, Paris, *Bulletin of the Société d'Histoire de l'Art française*, 1982; Richardson, John, *A Life of Picasso, vol. 1 1881–1906*, London and New York, 1991.

**The Rue Vercingétorix**
I am grateful to Billy Kluver and Julie Martin for access to their research notes on the Rue Vercingétorix studio from their book *Kiki's Paris*, Abrams, New York, 1989, and to Bengt Danielsson for permission to see and quote from his translation of Judith Gérard's unpublished memoir 'The Young Girl and the Tupapau'.

**Roderic O'Conor and Armand Seguin**
Johnson, Roy, 'Roderic O'Conor in Brittany', Dublin, *Irish Arts Review*, vol. 1 no. 1, Spring 1984; Seguin, Armand and O'Conor, Roderic, *Une Vie de Bohème (collected letters) 1895–1903*, Brittany, Musée de Pont-Aven, 1989.

**August Strindberg**
Dorra, Henri, 'Munch, Gauguin and Norwegian Painters in Paris', New York, *Gazette des Beaux-Arts* 88, 1976; Meyer, Michael, *Strindberg*, London, Secker and Warburg, 1985; Robinson, Michael, *Strindberg's Letters, vol. 2 1892–1912*, London, The Athlone Press, 1992; Soederstroen, G., 'Strindberg', Paris, *Revue de la Société d'histoire du théâtre*, vol. 3, 1978; Sprinchorn, Evert, 'The

Transition from Naturalism to Symbolism in the Theater from 1880 to 1900', Cambridge, MA, *Art Journal* (published by the College Art Association of America), Summer 1985; Strindberg, August, *Inferno, Alone and Other Writings* (trans. Evert Sprinchorn), New York, Doubleday, 1968.

**Frederick Delius**
Broekman, Marcel, *The Complete Encyclopaedia of Practical Palmistry*, London, Mayflower Books, 1975; Carley, Lionel, *Delius, the Paris Years*, London, Triad Press, 1975; Cheiro, (Count Louis Hamon), *The Cheiro Book of Fate and Fortune*, London, Barrie and Jenkins, 1971.

# Part Three
# WHERE ARE WE GOING?

## 12 *The Translation of a Dream*

Bronwen Nicholson could not have been more hospitable nor more generous with her time and knowledge during my visit to New Zealand. Her research has added to the list of artefacts which we now know Gauguin saw during his visit to the Auckland Museum and Institute. Richard Wolfe of the museum went to great lengths to find documents and photographs which show the collections as Gauguin may have seen them and Te Warena Taua, curator of the reserve collections, was exceptionally helpful in arranging for those objects identified by Nicholson *et al.*, now held in store, to be brought out for me to see. I was fortunate in visiting the museum at the same time as Terence Barrow of Honolulu University, one of the greatest living experts on the cultures of the Pacific, who was kind enough to find time to talk to me. All these, and other sources are listed alphabetically, by author:

**New Zealand**
Anon, *The New Zealand Herald*, Collections: Auckland City Library;

Barrow, Terence, *An Illustrated Guide to Maori Art*, Auckland, Reed Books, 1984; Bell, Leonard, 'The Represenation of the Maori by European Artists in New Zealand, *ca* 1890–1914, USA, *Art Journal*, vol. 49 no. 2, Summer 1990; Brownson, Ronald (ed.), *Auckland City Art Gallery, a Centennial History*, Auckland City Art Gallery, 1988; Collins, R. D. J., 'Paul Gauguin et la Nouvelle-Zélande', Paris, *Gazette des Beaux Arts*, 1977; Main, William, *Auckland through a Victorian Lens*, Wellington, New Zealand, Millwood Press, 1977; Nicholson, Bronwen, 'Gauguin: a Maori Source', London, *Burlington Magazine*, Sept. 1992; Park, Stuart, *An Introduction to Auckland Museum*, Auckland, Auckland Institute and Museum, 1986; Powell, A. W. B. (ed.), *The Centennial History of the Auckland Institute and Museum*, Auckland, The Auckland Institute and Museum, 1967; Teilhet-Fisk, Jehanne, 'Paradise Reviewed – An Interpretation of Gauguin's Polynesian Symbolism', Ph.D. Thesis, University of California at Los Angeles, 1975.

**Tahiti**
Agostini, Jules, *Tahiti*, Paris, J. André, 1905; Fontainas, Andrew, 'Art Moderne: Expositions Gauguin etc.', Paris, *Mercure de France* 1–1899; Geffroy, Gustave, 'Gauguin', Paris, *Le Journal*, 20 November, 1898; Gleizal, Christian (ed.), *Papeete 1818–1990*, Polynésie française, Mairie de Papeete, 1990; Hamon, Renée, 'The Recluse of the Pacific – Paul Gauguin's Life in Tahiti and the Marquesas', London, *The Geograpical Magazine*, vol. 8, 1939; Henrique, Louis, *Nos Contemporains, Galerie Coloniale et Diplomatique*, Paris, Ancienne Maison Quantin, 1896; Jacobs, Jay, *Where Do We Come From? What Are We? Where Are We Going? – Anatomy of a Masterpiece*, USA, Horizon, 1969; Kane, William, M., 'Gauguin's *Le Cheval Blanc*: Sources and Syncretic Meanings', London, *Burlington Magazine*, vol. 108, 1966; Keable, Robert, 'From the House of Gauguin', USA, *The Century Magazine*, vol. 106, no. 5, Sept. 1923; Keable, Robert, *Tahiti, Isle of Dreams*, London, Hutchinson (written

1923 no date of publication given); Lemasson, Henri, 'La Vie de Gauguin à Tahiti vue par un Témoin', *Encyclopédie de la France et d'Outremer*, Paris, 5th Year no. 2, February 1950; Natanson, Thadée, 'De M Paul Gauguin', Paris, *La Revue Blanche*, December 1898; Olivaint, Maurice, *Fleurs de Corail, Poésies*, Paris, Alphonse Lemerre, 1900; Wattenmaker, Richard J., cat: *Puvis de Chavannes and the Modern Tradition*, Art Gallery of Ontario, Toronto, 1975.

**Modern Thought and Catholicism**
Ms Pamela Paterson of the Saint Louis Art Museum provided me with a photocopy of the French transcript of Gauguin's original manuscript and with a photocopy of Frank Lester Pleadwell's English translation of 1927 and an unsourced article, written in Quebec 'Un Manuscrit de Gauguin: L'Esprit Moderne et le catholicisme' by Philippe Verdier. Ms Paterson was kind, prompt, efficient and generous, for all of which I am sincerely grateful.

The other main source relating to this document is: 'An Unpublished Manuscript by Gauguin' by H. Stewart Leonard, in the *Bulletin of the City Art Museum St Louis*, vol. 34 no. 3, Summer 1949.

I am grateful to Mme Françoise Viatte of the Département des Arts Graphiques, Le Grand Louvre, Paris, for permission to examine the manuscript of *Noa Noa* in order to study the subsequent writings contained within the exercise book.

The Curators of the Bibliothèque Nationale de France kindly allowed me to consult *Le Jésus Historique* by Jules Soury, which is now withdrawn and in the reserve collection.

**Gerald Massey**
Adams, Oscar, *A Brief Handbook of English Authors*, Boston and New York, Haughton, Mifflin, 1884; Beaty, Jerome, *Middlemarch from Notebook to Novel*, *Illinois Studies in Language and Literature*, vol. 47, Urbanan, The University of Illinois Press, 1960; Bray, Charles, *Phases of Opinion and Experience During a Long*

*Life*, London, Longmans, Green, 1884; Cockshut, A. O. J., *Middlemarch*, Oxford, Basil Blackwell, 1966; Dinnage, Rosemary, *Annie Besant*, London, Penguin, 1986; Eliot, George (ed., Haight, Prof Gordon S.), *The George Eliot Letters*, London, OUP, Yale University Press, 1954; Eliot, George, *Middlemarch* (first published 1871–2), London, Penguin Classics, 1972; Massey, Gerald, *The Poetical Works*, London, Routledge, 1861; Miles, Alfred H., *The Poets and the Poetry of the Century*, London, Hutchinson, 1893; Massey, Gerald, *The Secret Drama of Shakespeare's Sonnets Unfolded*, London, privately printed, 1872; Massey, Gerald, *The Book of the Beginnings*, London, Williams and Norgate, 1881; Massey, Gerald, 'Preface' to a *Book of the Beginnings*, London, Williams and Norgate, 1881; Massey, Gerald, *The Natural Genesis*, London, Williams and Norgate, 1883; Massey, Gerald, The Historical Jesus and Mythical Christ: a Lecture', collected in: *Massey Lectures*, London, priv. printed, 1887; Sharp, R. Farquharson, *A Dictionary of English Authors*, London, George Redway, 1897; Soury, Jules, *Morbid Psychology, Studies on Jesus and the Gospels*, London, Freethought Publishing Co., 1881, Printed by: Annie Besant and Charles Bradlaugh; Stedman, Edmund, *Victorian Poets*, Boston and New York, Haughton, Mifflin, 1887; West, Geoffrey, *The Life of Annie Besant*, London, Gerald Howe, 1933.

## 13 *Strange Occupation for an Artist*

Coppenrath, Gerald, *Les Chinois de Tahiti de l'aversion á l'assimilation 1865–1966*, Paris, Société des Océanistes, Musée de l'homme, 1967; Danielsson, Bengt and O'Reilly, P., *Paul Gauguin journaliste à Tahiti et ses articles des 'Guêpes'*, Paris, Société des Océanistes, Musée de l'homme, 1966; Hamon, Renée, 'Sur les Traces de Gauguin en Océanie', Paris, *L'Amour de l'Art*, July 1936; Rewald, John, *Studies in Post-Impressionism*, New York, 1986.

## 14 *The Right to Dare All*

Borel, Pierre, 'Les Derniers jours et la mort mystérieuse de Paul Gauguin', Paris, *Pro Arte* 1, September 1942; Le Bronnec, G., 'La Vie de Gauguin aux Iles Marquises', *Bulletin de la Société des Etudes Océaniennes*, no. 106 vol. 9 (no. 5), Papeete, March 1954; Chassé, Charles, 'Les Démêlés de Gauguin avec les gendarmes et l'évêque des Iles Marquises', Paris, *Mercure de France*, 15 Nov. 1938; Dong, Ky, *Les Amours d'un Vieux Peintre aux Iles Marquises*, Paris, Librairie a Tempera, 1989; Hodée, Paul, *Tahiti 1834–1984, 150 ans de vie chrétienne en Eglise*, Paris, Fribourg, Editions Saint-Paul, 1983; Jacquier, Henri (ed.), 'Une Correspondence Inédite de Paul Gauguin', *Bulletin de la Société des Etudes Océaniennes*, nos 133 and 134 – vol. 11 (nos 8 et 9), Papeete, December 1960 and March 1961; O'Reilly, Patrick, 'Miscellanées: "Les Amours d'un vieux peintre aux Marquises"', *Journal de la Société des Océanistes*, vol. 18, no. 18, Paris, December 1962; Puaux, Frank, 'Le Cyclone des Tuamotou', Paris, *L'Illustration, Journal Universel*, 11 April 1903; Theroux, Paul, *The Happy Isles of Oceania*, London, Hamish Hamilton, 1992.

## 15 *The Empire of Death*

My thanks are due to Elizabeth James of the National Art Library, the Victoria and Albert Museum, London for tracing information on the Shchukin family. Akinsha, Konstantin, 'Irina Shchukina versus Vladimir Lenin', USA, *Art News*, vol. 92, 1993; Artur, Gilles, 'Le musée Gauguin à Papeari', in: *Gauguin, Actes du colloque Gauguin, Musée d'Orsay*, Paris, La Documentation Française, 1991; Bacou, Roseline, 'Paul Gauguin et Gustave Fayet', in: *Gauguin, Actes du colloque Gauguin, Musée d'Orsay*, Paris, La Documentation Française, 1991; Bernier, Rosamond, *Matisse, Picasso, Miró as I knew them*, New York, Knopf, 1991; Blanche, Jacques-Emile, *De Gauguin à la Revue Nègre*, Paris, 1928; Blanche, Jacques-Emile, *More Portraits of a*

*Lifetime*, London, 1939; Bompard, Pierre, *Ma Mission aux Marquises*, Paris, Editions des Deux Miroirs, 1962; Clegg, Elizabeth, 'Whistler's Orange Seller and the beginnings of the Shchukine Collection', London, *Apollo*, vol. 137 no. 372, Feb. 1993; Danielsson, Bengt, 'Emile Gauguin Peintre Malgré Lui', in *Tahiti: De l'atome à l'Autonomie*, Papeete, Hibiscus Editions, 1979; van Dorski, Lee, *Gauguin: the Truth*, London, 1962; Exhibition catalogue, *Trésors du Nouveau Monde*, Brussels, Musées Royaux d'Art et d'Histoire, 1992; Giraud, Josette, cat: *Emile Gauguin*, London, O'Hara Gallery, 1963; Harrison, Charles *et al.*, *Primitivism, Cubism, Abstraction: The Early 20th Century*, New Haven and London, Yale University Press, 1993; Hillinger, Charles, 'The Sadness of the Son of Gauguin', Paris, *International Herald Tribune*, 1974; Jacquier, H., *Dossier de la Succession Paul Gauguin*, Société des Etudes Océaniennes, Papeete, Tahiti, 1957; Kantor-Gukovskaya, Asya, *Paul Gauguin in Soviet Museums*, Leningrad, Aurora Art Publishers, 1988; Kostenevich, Albert, 'Matisse and Shchukin: A Collector's Choice', Chicago, *Museum Studies*, vol. 16 no. 1, 1990; Manceron, Gilles, *Segalen et l'exotisme*, Paris, Fata Morgana, 1978; Manceron, Gilles, 'Segalen et Gauguin', in: *Gauguin, Actes du colloque Gauguin, Musée d'Orsay*, Paris, La Documentation Française, 1991; Menard, Wilmon, 'Gauguin's Tahiti Son', USA, *Saturday Review*, 30 October, 1954; Morice, Charles, 'Paul Gauguin', Paris, *Mercure de France*, Oct. 1903; Morice,

Charles *et al.*, 'Quelques Opinions sur Paul Gauguin', Paris, *Mercure de France*, Nov. 1903; Mourey, Gabriel, 'Les Statuettes de Jean-René Gauguin', Paris, *Les Feuillets d'Art* III, October 1919; O'Reilly, Patrick, 'La Mort de Gauguin et la Presse Française 1903', *Le Vieux Papier, Bulletin de la Société Archéologique, Historique et Artistique*, Paris, April 1965; O'Reilly, Patrick, *Catalogue du Musée Gauguin, Papeari Tahiti*, Paris, Fondation Singer-Polignac, 1966; O'Reilly, Patrick, *Painters in Tahiti*, Paris, Nouvelles Editions Latines, Dossier 23, 1978; Ramsden, Eric, 'Death of Paul Gauguin's Tahitian Mistress', Australia, *Pacific Islands Monthly*, January 1944; Schaire, Jeffrey, The People's Art: Moscow's hidden masterpieces come to light', New York, *Art and Antiques*, March 1986; Schlumberger, Eveline, 'Paris–Moscou', Paris, *Connaissance des Arts*, 329, July 1979; Segalen, Victor, *Les Immémoriaux*, Paris, 1956; Vasseur, Pierre, 'Paul Gauguin à Copenhague', Paris, *La Revue de l'Art*, 1935; Yakobson, Sergius, 'Russian Art Collectors and Philanthropists: The Shchukins and the Morozovs of Moscow', Washington, *Studies in the History of Art*, 1974.

I am very grateful to Lisa Johnson and Carolyn Brown who typed and retyped my manuscript and to my English copyeditor Claire Trocmé and the translator of the French edition Jean Autret, both of whom questioned dates and spellings in a noble attempt to save me from error. To all these many kind people, my thanks.

# Index

Page numbers in *italics* indicate illustrations

Gauguin's art works are listed directly under their titles; other
works appear under the name of artist or author

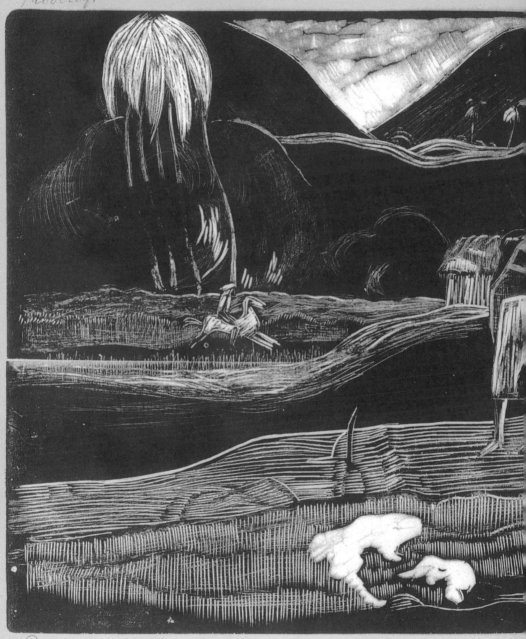

Provehyl

Paul Gauguin fait